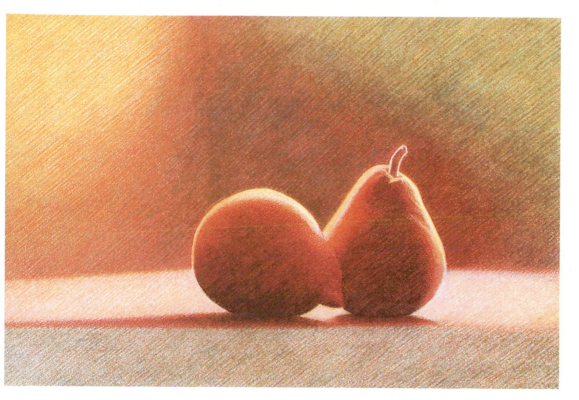

Plate 1. MARTHA ALF (b. 1930; American). *Two Pears No. 3. (for Michael Blankfort)*. c. 1982. Pastel pencil on paper, 12 × 18" (31 × 46 cm). The Museum of Contemporary Art, Los Angeles, CA.

Plate 2. JEANETTE PASIN SLOAN (b. 1946; American). *Silver Bowl Still Life*. c. 1978. Acrylic and colored pencil on board, 28 1/2 × 38 1/2" (72 × 98 cm). Security Pacific National Bank, California.

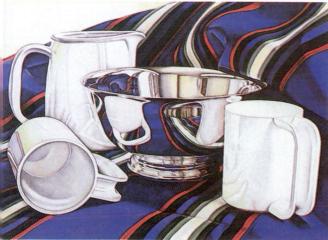

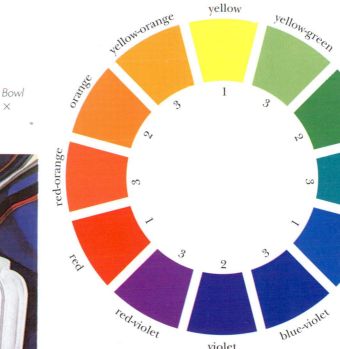

Plate 3. Color wheel with primary, secondary, and tertiary colors. The Birren Color Chart. By Alexander.

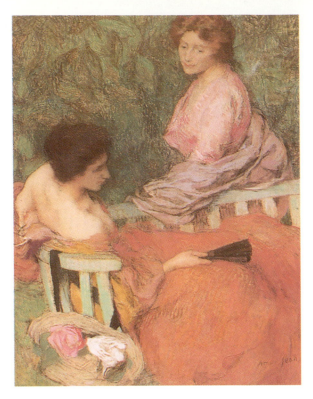

Plate 4. EDMOND-FRANÇOIS AMAN-JEAN (1860–1935; French). *Les Confidences.* c. 1898. Pastel on blue paper affixed to canvas, 4′ × 3′2″ (1.22 × .97 m).
Achenbach Foundation for Graphic Arts, Mildred Anna Williams Fund, The Fine Arts Museums of San Francisco.

Plate 5. WILLEM DE KOONING (1904–1997). *Two Women's Torsos.* c. 1952. Pastel, 18 7/8 × 24″ (48 × 61 cm).
© The Art Institute of Chicago.

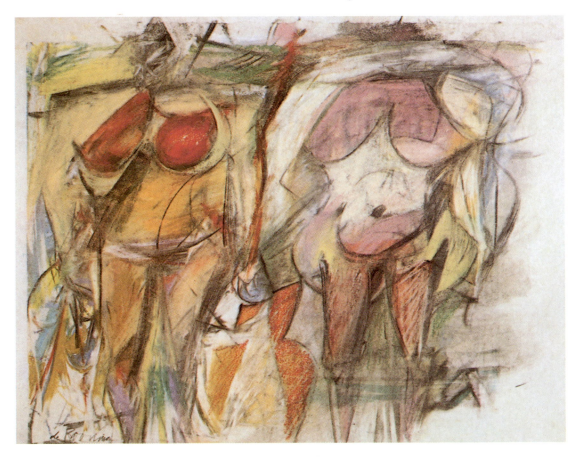

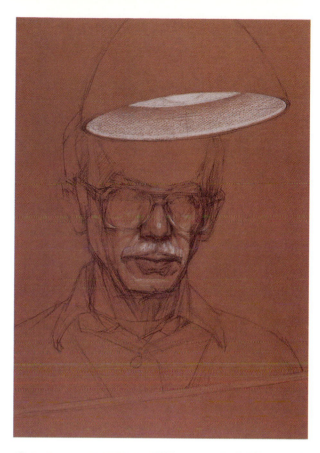

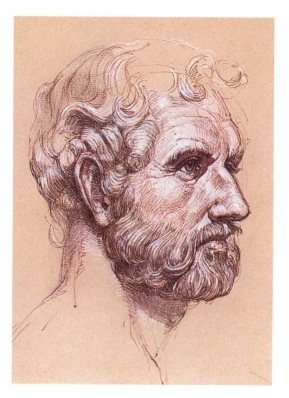

Plate 7. ALANSON APPLETON (1922–1985; American). *David Roinski.* c. 1976. Pen and ink with pastel, 10 × 8 1/2" (25 × 22 cm). Collection of Mrs. Alanson Appleton, San Mateo, California.

Plate 6. WILLIAM BERRY (b. 1933; American). *Self Portrait with Lamp.* c. 1988. Graphite and colored pencil on colored paper, 16 1/2 × 12 1/2" (42 × 32 cm). Courtesy of the artist.

Plate 8. WAYNE THIEBAUD (b. 1920; American). *Pastel Scatter.* c. 1972. Pastel on paper, 26 × 20 1/8" (66 × 51.1 cm). Private collection.

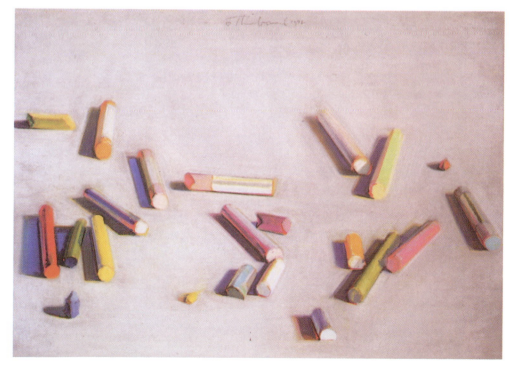

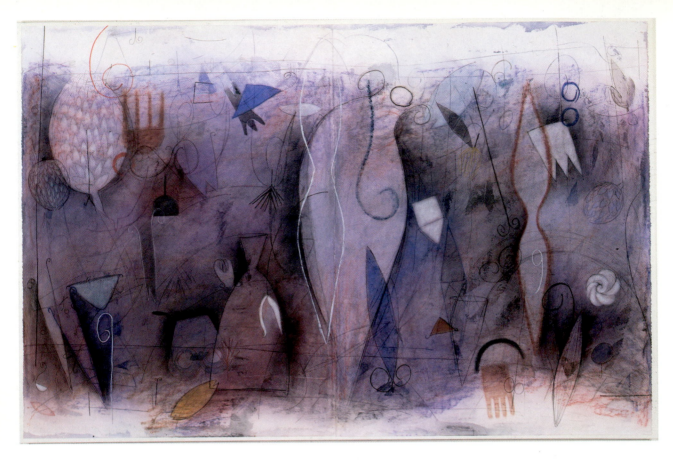

Plate 9. EMMI WHITEHORSE (b. 1957; Native American; Navajo). *The Conversion.* 1992. Pastel, oil, paper on canvas, 51 × 78"
(129.7 × 198.3 cm).
Courtesy of LewAllen Gallery, Santa Fe, New Mexico.

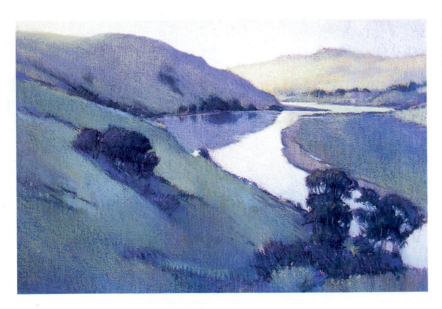

Plate 10. DUANE WAKEHAM (b. 1931;
American). *Russian River, Spring Afternoon.*
Pastel on paper, 19 × 29" (48.3 × 73.7 cm).
Collection of Lila Gold, New York City.

Sixth Edition

A Guide
to Drawing

Daniel M. Mendelowitz
Late of Stanford University

Duane A. Wakeham
Professor Emeritus, College of San Mateo

David L. Faber
Wake Forest University

THOMSON

WADSWORTH

Australia • Canada • Mexico • Singapore • Spain • United Kingdom • United States

To my father, a gentle-hearted guardian of the land,
who taught me how to draw a black line across a textured
field with a plow—and in memory of my mother, a
musician of sacred song, who taught me the difference
between the solo and the accompaniment in life.

THOMSON

WADSWORTH

Art and Humanities Editor: John R. Swanson
Senior Development Editor: Stacey Sims
Assistant Editor: Amy McGaughey
Editorial Assistant: Rebecca Fay Green
Technology Project Manager: Melinda Newfarmer
Marketing Manager: Mark D. Orr
Advertising Project Manager: Vicky Chao
Project Manager, Editorial Production: Kathryn M. Stewart
Print Buyer: Tandra Jorgensen
Production Service: Greg Hubit Bookworks

Text Designers: Serena Manning; John Edeen
Photo Researcher: Shirley Webster
Copy Editor: Jamie Fuller
Cover Designer: Brittney Singletary
Cover Image: Leonardo da Vinci, *The Virgin and Child with Saint Anne and Saint John the Baptist* (detail), 4'-6 3/4" × 3' × 3'-3 3/4", National Gallery.
Cover Printer: Transcontinental Printing
Compositor: Thompson Type
Printer: Transcontinental Printing

Printed in Canada
1 2 3 4 5 6 7 06 05 04 03 02

For more information about our products,
contact us at:
Thomson Learning Academic Resource Center
1-800-423-0563
For permission to use material from this text,
contact us by:
Phone: 1-800-730-2214
Fax: 1-800-730-2215
Web: http://www.thomsonrights.com

Library of Congress Control Number 2002110045
ISBN 0-534-62496-0

Wadsworth/Thomson Learning
10 Davis Drive
Belmont, CA 94002-3098
USA

Asia
Thomson Learning
5 Shenton Way #01-01
UIC Building
Singapore 068808

Australia
Nelson Thomson Learning
102 Dodds Street
South Melbourne, Victoria 3205
Australia

Canada
Nelson Thomson Learning
1120 Birchmount Road
Toronto, Ontario M1K 5G4
Canada

Europe/Middle East/Africa
Thomson Learning
High Holborn House
50/51 Bedford Row
London WC1R 4LR
United Kingdom

Latin America
Thomson Learning
Seneca, 53
Colonia Polanco
11560 Mexico D.F.
Mexico

Spain
Paraninfo Thomson Learning
Calle/Magallanes, 25
28015 Madrid, Spain

Contents

PART 5
SYNTHESIS IN DRAWING

Preface

In the mid-1960s the late Professor Daniel Mendelowitz of Stanford University perceived that although "drawing as it had been practiced in the past seemed about to disappear" and had "almost ceased to exist as a significant part of the curricula of art schools and of college and university art departments" during the previous two decades, "certain of the traditional disciplines were again emerging as functional and necessary elements in the training of artists." His reaction was to write *Drawing*, which combined a survey of the history of drawing, an analysis of the elements of art, and an explanation of the principal media used in drawing. In an accompanying *Study Guide*, Professor Mendelowitz presented a series of projects intended to provide a range of basic drawing experiences appropriate for either classroom or independent study. Nine years later the most important elements from the two previous volumes were combined in *A Guide to Drawing*, which in its various revisions has remained one of the most respected and widely used books in its field. Now, thirty-five years after *Drawing* was originally published, *A Guide to Drawing* appears in a newly revised sixth edition.

It should be well noted that Professor Wakeham has masterfully steered the development of the text through three revisions and at each juncture has advanced the text significantly by responding to expressed pedagogical needs and expanding the applications as necessary in the last two decades. His contributions have been timely, well orchestrated, and significant in a major way to the continued success and life of the book. As artist and teacher, Wakeham's voice speaks formidably alongside that of Daniel Mendelowitz, introducing new issues to complement the former states of the book. It has been my intent to remain faithful to both Professors Mendelowitz and Wakeham's original concept for the book: providing a comprehensive and systematic introduction to the art of drawing by focusing on the understanding of form and the mastery of traditional skills as the basis for descriptive and expressive drawing.

Because it is meant to be comprehensive, *A Guide to Drawing* includes much more material than can be covered in any one course, and it is unlikely that anyone—student or instructor—will choose to adhere strictly to the sequence as presented. Instead, all are encouraged to dip in and help themselves to that which interests them or seems appropriate to their needs.

The book, designed for use in beginning, intermediate, and advanced classes, as well as for specialized advanced courses such as life drawing, offers an introduction to the breadth and range of subjects, media, and techniques that provide a framework for developing individual ideas and approaches, with *seeing skills* and modes of *expression* as the primary artistic goals. Each topic is accompanied by a rich selection of master drawings as well as a progression of studio project assignments designed to allow beginning students, working alone or under the direction of a teacher, to master basic skills, and to encourage more advanced students to use those skills creatively and expressively. The

assignments have been made as flexible as possible so that they will serve the needs of many studio situations and creative intentions.

While not intended to provide a history of drawing, as the original volume did, the inclusion of such references and the selection of drawings for the book reflect the collectively shared desires of Professors Mendelowitz, Wakeham, and myself to arouse in students both curiosity and awareness about the long tradition of drawing. Time limitations generally discourage drawing instructors from attempting to include a full survey of the history of drawing in studio curricula, and the subject generally receives only minimal attention in art history survey courses. While many metropolitan and university museums boast of large collections of drawings, very few of those works are ever on exhibit at any one time, making it difficult for even the most avid student to see and study original drawings from the past. Looking at reproductions is not the same as viewing original works of art; however, for most of us, books and catalogues are our most convenient resource for beginning to appreciate the great range and wealth of drawings that have been preserved.

Perhaps the only great drawing that remains on constant view to the public is Leonardo da Vinci's *Madonna and Child with Saint Anne* (Fig. 17-5) at the National Gallery in London, where it is housed in its own room with light and temperature carefully monitored. For that reason, it seemed an appropriate choice to illustrate the cover of this new edition. It is a remarkably large drawing for its time. The cover focuses on the figure grouping of the Holy Family with its splendid array of lines, textures, colors, and tonal vestiges describing the figurative forms in space. As I see it, in the affirming and provocatively upward-pointing hand of Saint Anne, Leonardo beckons us to engage our creative wills and acts of faith in learning how to draw—and to draw with greater skill than ever before.

This new edition includes 102 new drawings in black and white and seven new color plates. It reproduces three images in both black-and-white and as color plates to illustrate the reduction of color to black-and-white tonal contrasts. Approximately 60 percent of the 408 drawings reproduced are twentieth-century examples and so can only hint at the richness and the diversity that exists historically in the field of drawing. As in previous editions, the harvesting of new drawings and the reorganization of many works carried over from the previous edition have resulted in substantial rewriting in almost every chapter. Whenever possible, I have selected appropriate new drawings related in subject but different in technique or expression to accompany the discussion of the topic so that students begin to develop an awareness of some of the various approaches to drawing that are available to them and which have been proven by the old masters and contemporary artists as well.

Two large groups of the new drawings selected came from two major collections: The Jalane and Richard Davidson Collection of Contemporary American Realist Drawings at the Chicago Art Institute and the very well-known major collection of drawings at the National Gallery of Art in Washington, D.C. From the Davidson Collection alone twenty-two new drawings were selected spanning three decades—the oldest, a drawing by Philip Pearstein dating from 1974. What I find most attractive about the drawings in this relatively young collection is their adherence to the timeless and traditional methods of media application and technical handling, bearing significant evidence of the great number of

contemporary artists involved in creating drawings using the same proven materials that have been in use for centuries.

I have also included many old-master drawings selected from much older collections such as the British, Albertina, and Ashmolean museums, the Rijksmuseum, and the Royal Collection at Windsor Castle to name a few. A formidable list of old masters' names, many familiar to previous editions of the book, although through different drawings, are Leonardo da Vinci, Albrecht Dürer, Raphael, Jacopo da Pontormo, Francesco Primaticcio, Pieter Bruegel the Elder, Jacques De Gheyn II, Peter Paul Rubens, and Gerbrandt Van Den Eeckhout. From this highly respected stable of artists, the student should be able to clearly observe the conceptual parallels as well as media associations between the old masters and contemporary artists working today.

Seeing and drawing go hand-in-hand, and the depth to which artists learn to see contributes to greater heights of interpretation and expression. For that reason, a new theme—the importance of seeing—has been introduced in this edition and now runs throughout the book. Seeing is continually discussed as a critical part of artistic activity, and the project assignments have been written and designed to remind students that the act of seeing comes before the act of drawing, whether with the *eye of the mind* or with the *physical eye*. Several new project assignments have been added to the book to develop seeing skills, and new critique questions ask students to apply those skills to their own work and their own development as artists. First-time critiques for beginning students can be intimidating experiences, but these questions clearly focus on the objectives of the assignment, and I hope they will thereby ease any apprehension or discomfort and instead instill a sense of confidence. When properly done, self-critiques can be immensely constructive, even intellectually enjoyable experiences.

The sixth edition now includes a new Chapter 18, Expressive Mixed Media, which provides twenty new illustrations to assist the student in identifying the concept of mixed media usage through drawing's long history. It calls on student experiences with various techniques and materials presented in the previous chapters and serves as a culmination of everything they have learned in the course.

Finally, the new edition now provides a glossary of approximately 250 terms, and marginal glosses appear on the pages where the terms are first introduced. These new features should make it more convenient for students to identify and reference major terms and their definitions.

It has been my intent that all the various features of the sixth edition be designed to emphasize the importance of drawing not only as an act of seeing subject matter deeply, but also as an approach to creative thinking and creativity itself.

Acknowledgments

I would like to acknowledge and thank a number of people for their steadfast assistance, which has contributed greatly to the book's final form. My thanks go out first of all to the many capable editors at Wadsworth: to John R. Swanson, Acquisitions Editor, for his initial telephone call in June of 2000 inviting and encouraging me to consider the co-authorship; to Stacey Sims, Senior Developmental Editor, who soon engaged me in the logistics of the revision process with constant encouragement, answers, and advice; to Shirley Webster, Photo Researcher

and Permissions Editor, who orchestrated the granting of many permissions of spectacular new images in record time; to Preston Thomas, Associate Art Director, and his freelance staff, who designed the beautiful cover of the new edition; my hearty thanks for your important role in helping to create the first image that people will see when they approach the book; to Kathryn Stewart, Senior Production Project Manager, who masterfully oversaw the placing of illustrations with text while steering the book's new formation through its final courses; to Greg Hubit, of Bookworks and "longtime publishing pro," as he is referred to by his colleagues, thanks for the many details of the book's final format that you so capably directed and for the great arrangements of the text passages and their illustration groupings; to Jamie Fuller, Copy Editor, whose invaluable assistance helped bring this revised text, along with the newly added Chapter 18, into its final form; to Alma Bell of Thompson Type; and to Joy Westberg for her assistance with the text layout on the back cover.

My thanks also to Dr. Eric Denker, Curator of Prints and Drawings at the Corcoran Gallery of Art, and Senior Lecturer in the History of Art at the National Gallery of Art, both in Washington, D.C., for his many kindnesses in inviting me to Washington and providing a place for me to stay while I studied the collections, collected books, and harvested new images, and to Mark Pascale, Associate Curator of Prints and Drawings at the Chicago Art Institute, who directed me to the recent publication of "Contemporary American Realist Drawings" of the Jalane and Richard Davidson Collection at the Art Institute of Chicago. Thanks also to my colleagues in the Art Department at Wake Forest University: Margaret Supplee Smith, Chair; Millie Herrin, Administrative Assistant; Martine Sherrill, Visual Resources Librarian and Print Curator; Kendra Weaver, Visual Resources Technician; and Paul Marley, Instructional Technology Specialist, for their timely assistance and organizational skills.

Finally, I owe much to the former author, Professor Emeritus Duane Wakeham, of the College of San Mateo. Duane wrote me a kind letter of invitation early on in the project sharing many of the things he had learned during his years as author of three revisions. He sent me materials and expressed his availability to me at any time I might need counsel. He also expressed to me his understanding of this very private and often solitary process of revision writing, and I have appreciated the respect he has shown me as new author. His direct connection to, and long friendship with Daniel Mendelowitz, has for me, enriched the passing of this book through his very capable hands into my comparatively inexperienced hands. His openness in sharing his seasoned thoughts, feelings, and aspirations for the book helped set a contextual tone for the revision process and gave me a place to start. And on a more personal note, Duane's kind and instructive voice on the phone has always reminded me of that of my former teacher, Professor Emeritus David Driesbach of Northern Illinois University. These two artists and teachers will remain very important mentors in my life.

The success of *A Guide to Drawing* depends in large part on the illustrations. I am most grateful to the many artists, collectors, and institutions that have enthusiastically given permission to reproduce their drawings. It has been an honor to work with all of you.

DAVID L. FABER

The Nature of Drawing 1

Drawing . . . is the necessary beginning of everything in art, and not having it, one has nothing.

—Giorgio Vasari

Drawing is the progenitor of art. The fundamental theme of this text is that the unique fine art medium of drawing is inseparable from the act of seeing. In fact, the acts of seeing and drawing are so intertwined that the diminishment of one or the other disturbs the symbiotic balance between the two, lessening their expressive powers. To draw is to **visualize** a subject through reinvention, using selected graphic media that possess highly descriptive capabilities. From this exquisite act of visualization comes the formative and visually expressive result that we call a drawing—the essential by-product of seeing deeply. Hence, responding to a subject through this pleasurable process of intense scrutiny is the *genesis of drawing.*

Drawing is unique from all other visual art forms in that it is the major boulevard leading to the avenues of painting, printmaking, sculpture, mixed media, illustration, and certainly architecture. The widely varied acts of seeing and drawing are embedded within the confines of these different disciplines. Since the *act of seeing* is paramount to the *act of drawing,* the consequence of *seeing deeply* is the harvesting and attainment of detailed information, which leads to more highly descriptive and expressive states of rendering. Above all else, drawing is a **visual language**—an eloquently expressive as well as graphic form of visual communication. As one develops the ability to visualize, one becomes more engaged in the thorough investigation of subject matter, inviting more articulately **rendered** visual forms, whether they are "live" or "still," "improvised" or "premeditated."

We characterize the acts of drawing and drawings themselves as "intimate," "delightful," "**spontaneous**," "immediate," "provocative,"

drawing
A division of the fine arts in which the artist makes a descriptive graphic mark of line, tone, texture, or value, by pulling or dragging a tool across a receptive surface or background—usually a piece of fine-quality grained or toothed paper.

visualize
To enact a mental picture or image not present to the sight; in the act of drawing, to give tangible form to what is imagined.

visual language
Regarding drawing, an inaudible and visibly eloquent expression that communicates a message through graphic form; the purest form of visual communication manifested in all of the visual arts.

rendered
Drawn, usually with a high degree of representation.

spontaneous drawing
Drawing activity performed as an instantaneous response to a subject or stimulus; as with *gesture drawing,* intended to capture the essential movement or vitality of a live form; to depict an artist's immediate and unique mode of expression.

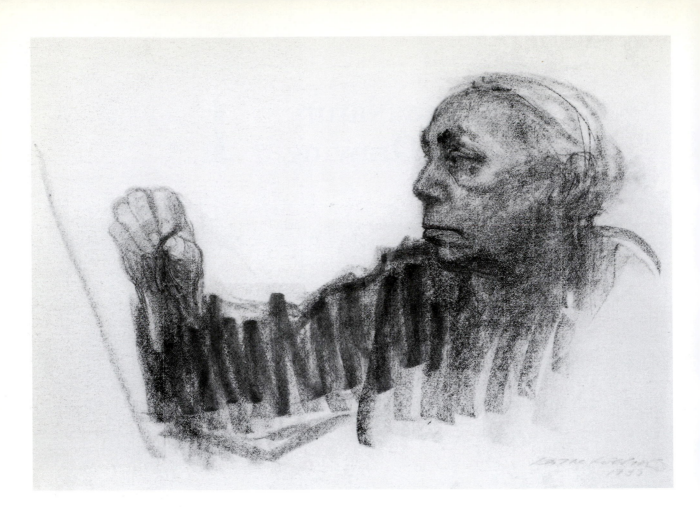

1-1. KÄTHE KOLLWITZ (1867–1945;
German). *Self-Portrait with Pencil.* 1935.
Charcoal on gray paper, 16 x 17"
(40.6 × 43.2 cm).
National Gallery of Art, Washington, D.C.
(Rosenwald Collection).

"spiritual," "direct," "unlabored," "weightless"—these adjectives carry special implications of the affection that many critics and connoisseurs feel for this extraordinary form of visual artistic utterance. Part of the reason for this fondness must certainly reside in the very informal and personal nature of the body of master drawings that comprise our legacy from the past. Unlike more elaborately finished works, drawings offer an intimate contact with the act of creation and thereby permit the viewer insights into the artist's personality. Like entries in a diary, drawings often present direct notation made by the artists for themselves alone, free of artificial elaboration or excess finish.

In her *self-portrait* (Fig. 1-1), Käthe Kollwitz not only represents herself at the drawing board but also allows the viewer to experience both the mental and physical process of drawing in the powerfully kinetic zigzag line that moves along the length of the arm connecting the eye, mind, and hand. The length of the piece of charcoal she grasps in her fingers is equal to the width of the bold strokes in the drawing. Perhaps nowhere has the act of drawing been more graphically illustrated.

If we compare a master painting with one of its preliminary sketches, not only do we see the different approach and manner of execution characteristic of the two processes, but we also find hints of the artist's progress in conceptualization as we begin to sense the impulses that formed the final work (Figs. 1-2, 1-3). An incomplete or fragmentary work, precisely because it does not provide a fully developed statement,

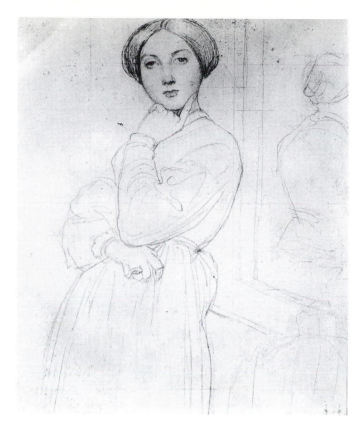

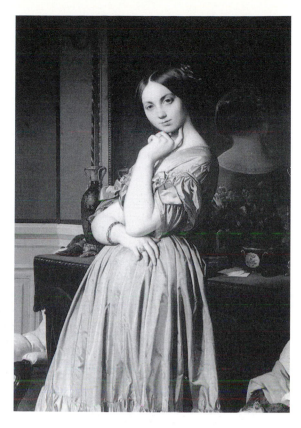

may evoke a greater play of the observer's imagination than does a more finished expression. A sketchy work can be interpreted and becomes meaningful as we supply unspecified details in terms of our own individual experience. By contrast, the closure of a carefully finished, fully detailed work largely excludes such imaginative wanderings on the part of the viewer.

What Is Drawing?

In both a historical and a conceptual sense, the words *genesis* and *drawing* are very similar. In the beginning, drawing is about "first sightings"; it is the initial approach to a subject through the pathways of both the physical and inner eyes; it is the first glimpse, the unfettered and artful penetration into the understanding of form that naturally invites a response. As *drawing* begins with *seeing*, our visual history begins with drawing. The oldest human records are the vividly lifelike images of animals drawn on cave walls between 10,000 and 20,000 years ago. Prehistoric drawings predated the written word, and the emergence of civilization, as we generally think of it, is linked to the invention of writing, which originated in easily recognized object drawings known as pictographs. Drawing has been present in all cultures throughout history—sometimes in the form of **naturalistic representation,** sometimes as stylized **abstract symbols.** Drawing is a visual barometer of a culture's given modes of expression.

The word *drawing* implies making a mark by pulling or dragging a graphic tool across a receptive background or surface, usually a piece of paper. Drawing, however, goes beyond the act of simply making marks; it is making marks that communicate visual language and

1-2. *above, left:* JEAN AUGUSTA DOMINIQUE INGRES (1780–1867; French). *Study for the Portrait of Mme. d' Haussonville.* c. 1843. Graphite on white wove paper, 234 × 196 mm.
Courtesy of the Fogg Art Museum, Harvard University, Cambridge, Massachusetts. Bequest of Meta and Paul J. Sachs.

1-3. *above, right:* JEAN AUGUSTE DOMINIQUE INGRES. *La Comtessa d' Haussonville.* 1845. Oil on canvas, 57 7/8 × 36 1/4″ (147 × 92.1 cm).
The Frick Collection, New York.

naturalistic representation
The depiction of subject matter in its most natural and unaltered state.

abstract symbols
Symbols that have been visually simplified or rearranged to create visual impact and enhance meaning; they are often specific to certain cultures or political eras that represent a quality or circumstance.

share pictorially by the most immediate means an artist's responses to perceptions and experiences. Additionally, thought, feeling, and judgment are essential to the process if drawing is to be more than mere representation. The simultaneous and intertwined acts of seeing and drawing, when fully operational, produce a combination of intellect, skill, instinct, and impulse that reveal the inaudible language of the artist's soul.

A quick glance through the illustrations of this book will reveal that drawing encompasses a potentially endless variety of media and techniques. While it is perhaps more common to think of drawing in terms of black marks on white paper, many drawings include color, even a full spectrum of colors. In recent years, contemporary drawing exhibitions have come to include almost any works done on paper, adhering to the concept that it is sometimes impossible to separate drawing techniques from the methodologies of painting and printmaking. There has been an expansion of the traditional drawing repertoire of materials and tools to include all types of wet media formerly relegated to watercolor or painting. Likewise, all forms of painting media are now seated onto a variety of different paper surfaces instead of the traditional cotton duck canvas, unbleached linen, and wooden panels. However, in the purest sense, the acts of drawing, painting, and printmaking are still singularly recognizable as the individually creative modes they have always been. It's just that now they are more likely than in previous periods of art history to interact with each other as a result of greater artistic experimentation and investigation with materials common to all three disciplines.

Nonetheless, categorization has become decreasingly important; the lines separating one area of creative endeavor from another have blurred, with some artists evidencing more concern about achieving a desired effect than about the process that is used. This has produced a myriad of hybrid drawings often referred to as **mixed-media** works that take the richness of drawing and combine it with the visual attributes of other materials not necessarily associated with the traditional assortment of drawing tools. In Michael Mazur's *Self-Portrait* (Fig. 1-4), the artist achieves a splendid effect by laying mixed-media drawing techniques over the tonal foundation of a previously made **monotype.** This image has evolved through a highly emotional process of realization and response, on the part of the artist, to the mixing of media. For a time during the execution of the piece, there was an ongoing process of action and response, acceptance and refusal, until the image attained its own clarity and the artist was no longer needed. By bringing together these various and seemingly incongruous elements, Mazur has produced a state of visual freshness free of mannerism and overworked convention—a pure artistic **vision.**

Drawings are no longer limited in size, as they were for centuries, by the dimensions of sheets of handmade paper. Both professional-grade and good-quality student-grade drawing papers are now available in rolls that make possible drawings on a scale previously associated with works on canvas. A photograph of Chuck Levitan standing before his drawing *Lincoln Split* (Fig. 1-5) clearly establishes the monumental size of his images. Without such reference, it is only by reading captions and taking note of dimensions that we can begin to fathom the scale of individual works, which in a book such as this, are all reduced to images of much the same size.

mixed media
A variety of different materials used in a creative process for the purpose of heightening surface effects and increasing the visual complexity of an image.

monotype
As a unique impression, a one-time drawing with printer's inks on a flat metal plate, which is then transferred to dampened paper with the use of a press. The French artist Edgar Degas is well known for his use of the monotype medium.

vision
That which the artist sees with either the physical eye or the *eye of the mind,* as in conceptualizing an idea, feeling, emotion, or premonition before or during the act of drawing.

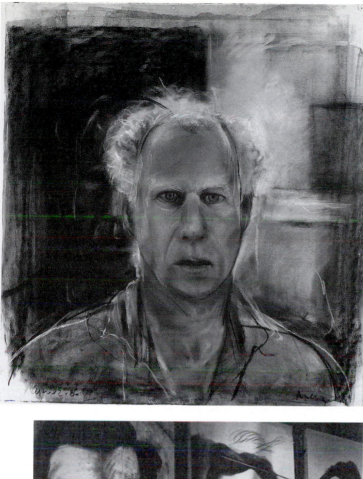

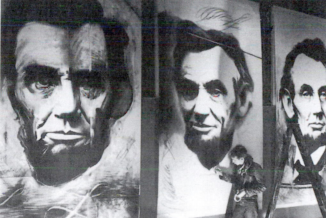

descriptive drawings
Usually highly detailed drawings whose
images articulately describe what is
seen.

visualized drawings
Drawings whose images represent
realities of sight or cause the viewer
to visualize or see what is imagined
in the mind of the artist.

symbolic drawings
Drawings whose images directly
symbolize ideas and concepts.

Types of Drawings

For an introduction to the art of drawing we should define the term
drawing from its origins, then briefly touch upon the various types of
drawings and functions they can perform. Drawing is defined most basi-
cally as the art of representing something by lines made on a surface
with a pencil or pen. How simple, how fundamental, and yet how true!
To expand this definition we might identify three broad categories—
drawings that describe what is seen **(descriptive drawings)**, that visu-
alize what is imagined **(visualized drawings),** and that symbolize ideas
and concepts **(symbolic drawings).**

 To many people, drawing means recording that which is seen. This
may entail a quick linear sketch or a carefully observed study, greatly

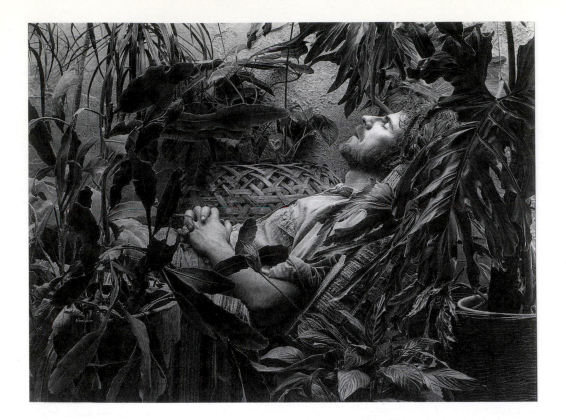

1-6. KENT BELLOWS. *Self-Portrait, Resting.* 1989. Charcoal with stumping and erasing, and white crayon, on white wove paper. 610 × 813 mm (24 × 32″). The Jalane and Richard Davidson Collection. © The Art Institute of Chicago.

eye of the mind
That which perceives subjectively apart from what the physical eye sees objectively or concretely. Often referred to as "the eye of the soul."

abstract vision
The imagined essence of premeditated forms arising in the mind of the artist whose intent it is to interpret a subject by analyzing and altering its recognizable forms and features by reassembling them into a nonrecognizable state with little or no reference to the original forms.

detailed and nearly photographic in its accuracy, as in Kent Bellows's *Self-Portrait, Resting* (Fig. 1-6). By using charcoal with stumping, white crayon, and erasing, the artist has ingeniously created as near a photo state as possible combing the human figure with botanical forms.

Drawing can also visualize through representation a nonexistent situation or an object conceived in the imagination of the artist, in the **eye of the mind.** Greg Colfax, a Native American artist of the Makah tribe of Neah Bay, Washington, works to preserve tribal traditions and symbols, while at the same time going beyond to introduce change through artistic invention. After completing the preliminary design for a hand drum (Fig. 1-7), he decided to use only the portion enclosed within the inner circle for the completed drum (Fig. 1-8). Although Colfax chose to focus on the eagle and the human head, he incorporated curvilinear abstract elements that represented whale, sea, and wind motifs in his original sketch into his final evolved composition.

As Paul Klee implies in his statement, "Art does not render the visual, but art renders visual," visualization is not limited to representational images. Klee shared with his colleagues of the Blaue Reiter movement his desire "to reveal the reality that is visible behind things." He explained that it is art itself which makes visible, and "it is the lines of the draftsman, which are going for a walk, that can lead to the land of deeper insight." Drawing can also be an **abstract vision,** such as Philip Guston's *ink drawing* (Fig. 1-9). This work gives few clues to its figurative origins—if needed, these origins certainly do exist on a spiritual level—but with its lines and shapes offering an expressive character of their own, the drawing seems to soar into a far more transcendent realm than mere representational depiction may allow. Latin American

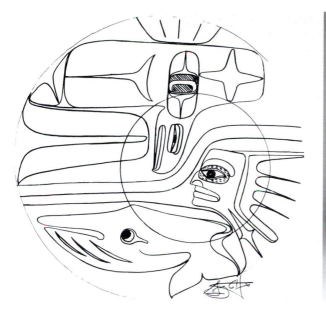

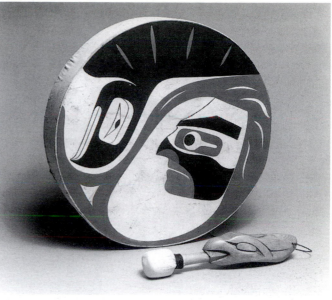

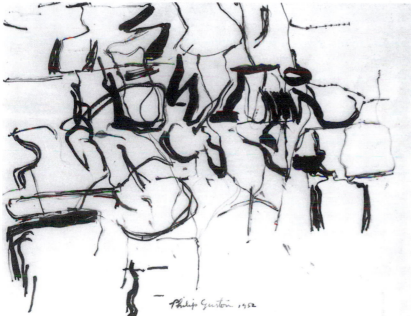

1-7. *above, left:* GREG COLFAX (b. 1947; American). *Sketch for a Drum.* 1982. Pencil on paper, 11 × 10 1/4" (28 × 26.1 cm). Courtesy of the artist.

1-8. *above, right:* GREG COLFAX (b. 1947; American). *Drum with Carved Beater.* 1982. Deerskin, paint, wood, cloth, drum, 13" diameter. Makah Indian Reservation. Neah Bay, Washington. Courtesy of the artist.

1-9. *left:* PHILIP GUSTON (1913–1980; Canadian-American). *Ink Drawing.* 1952. Ink on paper, 18 5/8 × 23 5/8" (47.2 × 60 cm). Whitney Museum of American Art, New York.

artist Rafael Soriano expands representation into the **eldritch** sphere of dreaming, imagining, and remembering with ambiguous figure and landscape references that preclude literal interpretation (Fig. 1-10). Richly rendered in conté crayon, Soriano's untitled drawing offers an evocative fusing of light and shadow, forms and space. There is a softness of quality as well as a translucency of visual presence within the drawing that does not rely upon the seemingly forceful strengths of highly representational interpretation.

The third category of drawings is based upon the use of symbols as enigmatic shorthand for nonliteral communication. Objects, ideas as concepts, and qualities can be presented as symbols that may or may not resemble the symbolized subject. The subject may, in fact, be a mere suggestion of a provocative idea, so transient in nature that only the viewer's interpretation at the moment of seeing gives the work any

eldritch
A word describing an unexpectedly rare and eerie quality or an unforgettable, otherworldly presence, usually conspicuously out of place when and wherever found.

1-10. RAFAEL SORIANO (b. 1920; Cuban). *Untitled.* 1987. Conté crayon, 30 × 40" (76.2 × 101.6 cm). Courtesy of the artist.

meaning. The stylized representations of the various forms in both Colfax's preparatory drawing and the drum itself are derived from symbols that are part of his tribal tradition. In David Suter's drawing, work gloves and a lunch bucket, which in themselves are blue-collar symbols, assume additional significance when cleverly anthropomorphized to illustrate the effect of unemployment for a magazine article entitled "A More Severe Slump" (Fig. 1-11).

The three categories need not be treated independently. Often elements of all three may flow together as one presence in the same drawing, producing a formidable conceptual structure of representational, imaginary, and symbolic icons that collectively depict an artist's sense of heightened awareness or spiritual prowess. In each category, however, drawings can range from simplified, preliminary indications of form and ideas to complex and intricately detailed, finished drawings. The effectiveness and completeness of any drawing as visual language depend not so much on elaborate development as on the degree to which the drawing conveys the artist's intent. By the same token, a drawing is both finished and effective, and may even be considered infinitely successful, when the intent of the artist is clearly and poignantly seen and felt even through the complex layers of media that suggest a careful and laborious execution.

Expressive Drawing

All drawings as visual language are expressive to greater or lesser degrees. Through their own specified modes of communication, they all tell us something. Drawings exist because they have their beginnings in the interactive, nonverbal dialogues between artists and their subjects that give rise to the responsive and expressive evidences of artistic creation. Visual expression is not something that can ever be explicitly defined. Nor can it be predicted or fully understood through the concrete meanings of words. Artistic expression is nonetheless an ever-present force that manifests itself within the artist's heart, mind, and soul. Like

1-11. DAVID SUTER (b. 1949; American). Illustration for "A More Severe Slump," *Time* Magazine. 1980. Felt-tip pen, 10" (25.4 cm) square. Courtesy of the artist.

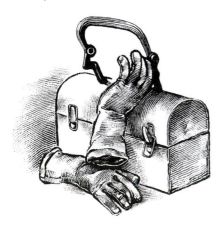

dormant seeds stored in a pod that eventually germinate in the presence of fertile soil, moisture, and sunlight, artistic expression is born from seeing, which gives rise to response and ultimate visual communication.

Gertrude Stein stated quite emphatically that Pablo Picasso was born knowing everything there was to know about drawing. In contrast, art historian John Rewald described Vincent van Gogh as a person with no natural talent who became an artist through sheer determination. Whether either assessment is completely accurate or not, they both acknowledge different degrees of innate ability.

Persons of "no natural talent," but having an interest in learning to draw, plus the willingness and persistence to master some basic skills, can develop the ability to record what they see with a certain degree of accuracy. Again, learning to see, and thereby learning to see deeply, is all-important to being able to draw. It is the eye that leads the hand in the act of drawing what is seen, not the other way around. Often beginning students (along with more advanced drawing students who have never learned the proper way to let the eye lead the hand) will draw with their hands, and then judge with their eyes instead of first judging with their eyes, then drawing with their hands. Furthermore, drawing, as suggested by the examples reproduced in this book, involves more than making an accurate rendering of a subject, just as it requires more than the skillful manipulation of media and technique. Drawing is primarily about content: it presents a point of view, interpretation, and expression unique to the individual artist.

As viewers we respond to those works that not only draw us closest to the artist by allowing us to share an interest, emotion, or insight, but also allow us to project our own experiences, thoughts, and feelings. We find most appealing drawings that offer more than an ordinary depiction of a subject, drawings that reveal qualities about the artist as well as the subject. What is most fascinating about Henry Moore's drawing *Sheep in Landscape* (Fig. 1-12) is his abiding interest in the size and scale-relationships between sheep and other elements of the landscape such as trees, fence posts, even his own sculpture. He once said, "I like

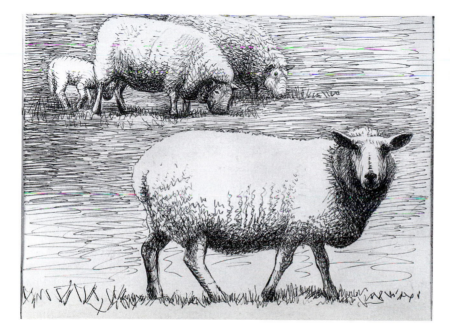

1-12. HENRY MOORE (b. 1898; British). *Sheep in Landscape*. 1972. Ballpoint pen, 8 1/4 × 9 7/8" (21 × 25.1 cm). Private collection, U.K.; The Henry Moore Foundation.

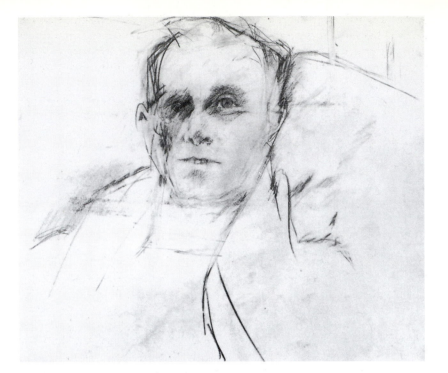

1-13. LARRY RIVERS (b. 1923; American). *Portrait of Edwin Denby.* 1953. Pencil, 16 3/8 × 19 3/4″ (41.7 × 50.2 cm). The Museum of Modern Art, New York. Given anonymously.

1-14. KÄTHE KOLLWITZ (1867–1945; German). *Woman with Dead Child.* 1903. Black chalk and charcoal heightened with white on two sheets of green paper, 390 × 480 mm (15 1/8 × 18 7/8 in.). Private collection.

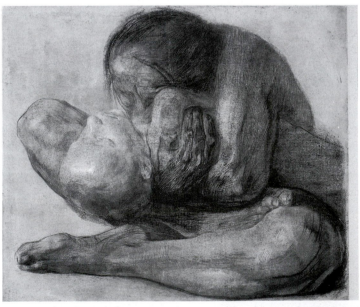

the size of sheep in relation to my sculptures as part of the overall landscape. Horses or cows would be too large, but sheep seem to be just the right size to be immersed into their surroundings." In this drawing Moore uses a variety of linear techniques to describe the forms of the sheep and their grassy surroundings into a unified whole.

Less literal, though nonetheless compelling, is Larry River's *Portrait of Edwin Denby III* (Fig. 1-13), which combines vigorous drawing in graphite with a keen sense of selectivity evident in the subtractive eraser whites and the tonal smudge marks. Equally effective in conveying not only a strong but also a powerful sense of humanity is Käthe Kollwitz's *Woman with Dead Child* (Fig. 1-14). In this drawing, Kollwitz has used the elements of line, tone, texture, and value as vehicles for the expres-

sion of anguish over the mother's loss of her little child. Käthe Kollwitz devoted her life to caring for the poor and needy. As the wife of a physician, she was no stranger to human suffering and death. Much of her expressive and highly emotional graphic work was influenced by the lives of people who needed compassion.

Comparing the works of these three artists, we can see that while the choice of medium and technique contributes significantly to the effectiveness of the drawings, it is the individual sensitivity, character, and intention of the artist that give unique expressive character to each of the works. It also becomes highly evident that artists select specific media in combination with a variety of techniques for emotional reasons in order to enhance the conceptual strengths of their images.

The Role of Drawing Today

Like much else in our artistic heritage, our conceptions about the role of drawing in the arts come to us largely from the Renaissance. During the early years of that period, drawing as we now practice it became established as the foundation of training in the arts. In the traditional master-student relationship, long-term apprenticeships called for drawing from nature as well as copying studies executed by known master artists and eventually prepared students for their profession. In later centuries this system, with only slight alteration, continued as the accepted means of artistic training.

In the twentieth century this procedure was seriously challenged. The impact of abstract drawings, collages, paintings, and prints, along with other contemporary movements, tended to make the arduous discipline of earlier times seem irrelevant to the formal training of later students. Many artists and teachers believed that highly structured training inhibited the development of original and innovative forms of expression by requiring that students depend on trite and outworn formulas, rather than allowing their inner resources free play. In light of this statement, one must remember that the human creative spirit is a mysterious and powerful entity filled with inner determination. The potent will of the artist to see, respond, and act is irrepressible. When given proper encouragement and sound pedagogy, this artistic force will thrive according to the established art conventions of the day. When artistic will is left to its own devices, it will still appear in one form or another. Also, it is important to mention that throughout history, the various established traditions and standards of artistic acceptance have not always served as a true and accurate measuring stick for an individual's talent. There have always been those artists who have chosen to go against the accepted standards of their times, and in doing so, have left the art world a legacy of renowned works well respected for their unprecedented daring and ambition. Who, other than the artists of the day, are better qualified to uproot the commonplace in search of something more profound and ethereal?

For example, the early training of artists as diverse as Pablo Picasso, Henri Matisse, Paul Klee, Josef Albers, and Joseph Stella—all schooled in the conventional regimen—would seem, as evidenced by their later and more mature works, to contradict this attitude of the necessity of requiring students to follow suit with the high and lofty academic training of the Renaissance. In addition to the early academic *Standing Male Nude* by Picasso (Fig. 1-15), this book includes some

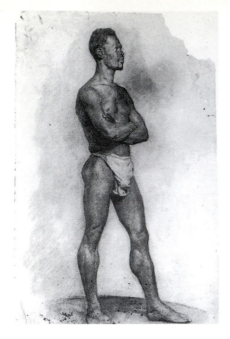

1-15. PABLO PICASSO. (1881–1973;
Spanish-French). *Standing Male Nude.*
1896–1897. Charcoal and crayon on
light tan paper, 18 5/8 × 12 1/2"
(47.3 × 31.8 cm).
Museo Picasso, Barcelona.

expressionism
The visual traits or character of a work
of art that communicates emotions and
feelings as opposed to only being con-
cerned with the *objective* and *subjective*
realms; the way in which a work of art
was conceived and made, as occurs in
an *expressionistic response* to a subject
by a particular artist.

abstraction
The extraction of an essence; an analyt-
ical study of an object or the formation
of an idea apart from its tangible or
recognizable form, as of the characteris-
tics of an object or idea, whereby the
virtues of an insightful rearrangement
of form are substituted for exact repre-
sentation.

abstract expressionism
An American movement in the field of
painting that began in the late nineteen-
forties and emphasized a nonrepresen-
tational style. The movement broke into
two branches: *action painting* and
color field painting.

rather surprising early drawings by Albers and Stella that are very differ-
ent from the images with which they are so closely identified. However,
one must understand that academic training is a fortifying element in
the way an artist ultimately chooses to compose and that as stylistic
changes occur throughout an artist's career, the work still reflects the
essence of that training.

In a letter dated 1948, Matisse wrote:

I am afraid the young, seeing in my work only the apparent facil-
ity and negligence in the drawing, will use this as an excuse for
dispensing with certain efforts I believe necessary.

While the rigidly maintained academic procedures taught in the ateliers
of past masters no longer seem appropriate, a program of introducing
instruction and guidance remains vital to skillful and artistic develop-
ment. The initial experiences of the beginner leave an indelible imprint
upon subsequent development. Although making accurate descriptive
drawings may not be the ultimate goal, learning to see size, shape, and
spatial relationships, along with surface textures within a play of lights
and darks, is necessary for representing any formal idea, whether it be
realistic, imaginary, or symbolic. Another vital part of artistic training is
the development of discipline and control so that the artist can con-
vincingly translate what is seen onto a piece of paper, thereby estab-
lishing a basic and essential working vocabulary with which to speak a
visual language effectively (Fig. 1-15). Having acquired that vocabulary,
the artist is then free to choose to draw in whatever style is pleasing
and seems appropriate to what is being expressed (Fig. 1-16). Picasso
is reported to have commented that if he could draw as well as Raphael,
as some observers suggested, he should be allowed to draw as
he chose.

As artists are confronted with new technologies, they are finding
that drawing is more important today than ever before as a way of see-
ing, understanding, and responding to forms in space. Rather than aban-
doning the discipline of drawing as irrelevant to contemporary art, we
will choose to reinterpret the craft in terms of today's artistic standards
and artists' needs, which accept an increased variety of styles and a
much wider range of **expressionism** than in the past. **Abstraction**
(Fig. 1-9) flourishes side by side with the most disciplined realism (Fig.
1-6) or with powerful emotion (Fig. 1-14). Our increased catholicity of
taste is, to an equal extent, the result of a greater understanding of the
psychology of human beings and a consequent sympathy toward a
broader range of expression.

Reveling in the glorious freedoms to mix and manipulate tradi-
tional as well as experimental media in whatever manner they choose,
many artists, representing all levels of artistic maturity, now feel chal-
lenged to work with media in more traditionally disciplined ways. For
some who came of age during the heyday of **abstract expressionism,**
using traditional, even "academic," drawing techniques in the pursuit of
naturalistic and highly representational imagery, sometimes in the mon-
umental scale characteristics of other contemporary styles, has been and
remains a truly novel experience. For present-day artists who regard
draftsmanship as important, however, revived interest in representational
styles and figure drawing is a welcome change.

Until this century drawing was viewed as a prerequisite to paint-
ing and sculpture. It provided the initial training for young artists, who

1-16. PABLO PICASSO. (1881–1973; Spanish- French). *Standing Female Nude.* 1910. Charcoal on white paper, 19 × 12 1/4″ (48.2 × 31.1 cm). The Metropolitan Museum of Art, New York (Alfred Stieglitz Collection).

then continued to draw primarily as a preparatory step in the realization of a more major work (Figs. 1-2, 1-3). Although drawings have been collected and admired since the sixteenth century, they were thought of as studies that would ultimately inform something else, rather than as complete and independent works in themselves. During the twentieth century, and now into the beginnings of the twenty-first century, drawing has come to be accepted as the unique and major art form that it has always been, although unrecognized as such. Because of the uniqueness of drawing (and all that drawing captures), it is no surprise that drawing has continued and will continue to serve artistic pursuits as a means to an end; often that end comes when the drawing is finished and it stands fully on its own, emitting all the visual power and drama present in other works of art. Since the 1960s, there has been, within the artists' community, a reemphasis on the directness of drawing and the intimacy an artist has with drawing media. Drawing has not only regained some of the identity it seemed to have lost, but it has taken on a new and more far-reaching identity that artists around the world have benefited from. Drawing, even during its low periods, has never needed a justification for its existence, since its justification is inherent in the act of drawing itself; rather, it has always led practicing artists to an increased understanding of form as well as to the development and conceptualization of their deepest expressions. Drawing is, as mentioned early in this chapter, the progenitor of art, as well as providing a means to an end in itself. Drawing has a continuing and an essential role to play in our world. Perhaps it is truly an art of the twenty-first century.

2 Initial Experiences

[I]t is essential for both hand and eye to grasp the form, and it is only by much drawing, drawing everything, drawing unceasingly that one fine day one is very surprised to find it possible to express something in its true spirit. . . .

—Camille Pissarro

This 1883 letter of Camille Pissarro to his son Lucien expresses the basic concept of *A Guide to Drawing*. Drawing is a matter of training the eye as well as the hand—the hand responds to what the eye sees. While learning to see is a major topic of Chapter 3, the essential relationship between observation and representation—the act of faith between the eye and the hand—will be a recurring theme throughout the book.

The subject chapters that follow have been structured around a series of projects with specific instructions for novice artists. Generally speaking, the exercises increase in difficulty throughout the book, although there is no rigid adherence to this scale. You are encouraged not only to read each project carefully but also to execute all of the project assignments in order to more fully understand the concepts presented.

Making Drawings

The purpose of the assignments is not solely to make beautiful drawings or even necessarily to make successful drawings. The purpose is to learn to draw by making drawings. Michelangelo is supposed to have said that his work contained 99 percent hard work and 1 percent genius. The value of each drawing experience that is to be derived from each individual assignment can be measured only by the discipline and dedication that the student is willing to invest.

Beginners can expect to make some awful drawings. Mistakes will be frequent, but they can be corrected and changed. The realization of why a mistake is a mistake is the first significant step toward learning how to draw. Success cannot be determined on the basis of just one ex-

perience, one drawing. Anything, whether it be playing a musical instrument, meditating, or drawing, becomes easier and more effective with continued practice, and practice contributes to increased technical competence, control, and eventual mastery.

Most drawings fail not from lack of skill but from lack of planning. Many artists and students mistakenly believe that planning automatically destroys freshness and spontaneity when, in fact, the contrary is more often true. Knowing what one intends to do allows one to enter into the drawing process directly and spontaneously. The uncertainty and confusion that accompany lack of planning frequently result in overworking a drawing, since the searching process never had a legitimate directive from the beginning. In such instances, once the drawing problems have been solved, it is advantageous to redo the drawing to achieve the desired freshness. Students are urged not to discard any of their drawings, since development and improvement become self-evident when later works are compared with the earlier attempts.

With increasing development of skills and confidence, the student may wish to concentrate on one type of drawing, one medium, or one variety of subject matter. This natural tendency should be fully exploited, since creative growth and expressionistic depth are important to artistic maturity. It is also true that any serious and intensive activity eventually demands an expansion of horizons with media usage and approach. Often, the beginner finds it all too compelling to act repeatedly on minor successes and finds it difficult to forge onward into the discoveries of other strengths and capacities. The directness of interpretive exploration that successful drawing requires keeps the artist honest and the art student humble, qualities that only lead to legitimate—even profound results.

The work of most mature artists reveals periods of intensive concentration within a narrow framework of special problems alternating with periods of experimentation. It is not only wise but also essential for the beginner to travel a similar path, focusing on areas of particular interest as long as they remain challenging. However, when success comes too easily, it is imperative to move on to new explorations.

Before one is familiar with the materials and has experience in using them, any new medium, technique, or subject may seem difficult, even for the accomplished artist. Serious art students, however, soon discover that the understanding and discipline leading to acquired skills in one area are directly applicable to other areas, and although success is not always immediate or insured, each project, each new experience contributes to creative growth and establishes the basis for eventual, mature artistic expression.

Looking at Drawings

In Chapter 4, and throughout this book, learning to draw by studying the works of other artists is appropriately emphasized and encouraged. *A Guide to Drawing* is richly illustrated with master drawings, both past and present, selected to acquaint you with creative uses of media and techniques and to introduce you to different approaches to handling form, composition, and subject matter. Understanding the ways in which master artists see expands your own abilities to see deeply. There is little value in copying any of the drawings line for line in order to produce a facsimile; however, the powers of seeing developed through your

study of the masters will foster a unique reinterpretation that will become evident in your own usage of line, tone, texture, and value. (The tradition of copying is discussed in Chapter 4.)

Presentation of Drawings

Drawings done as learning experiences are not necessarily intended to be exhibition pieces. There will be occasions, however, when more finished drawings will be exhibited, if only for classroom critiques, at which time it will be appropriate to consider how the work is to be presented and how best an individual drawing might be visually enhanced. Smudged, torn, wrinkled drawings pinned to a wall make much less of an impression than clean, neatly bordered, and obviously cared-for drawings. Critiques may not always require that drawings be matted, but when mats are called for, they should be clean, well cut, and as unobtrusive as possible so that the focus is on the drawings rather than what surrounds them. Naturally, white or off-white mats are recommended over colored mats, which tend to detract attention from the work of art. Mat knives or utility knives are satisfactory for cutting simple mats of four-ply thickness, whereas X-acto knives are suitable for the lighter-weight two-ply thickness. Beveled mats require a mat cutter that holds the cutting blade securely at an angle. For safety reasons, never use razor blades as they are too difficult to hold and control simultaneously. A metal straightedge or T-square offers the best cutting edge, and it helps significantly if two people work as a team, one holding the straightedge firmly down to avoid slippage, the other cutting the straight line. Always position the straightedge on the mat side of the line to be cut so that if the knife were to slip, it would cut into the center portion to be discarded rather than into the mat. Make sure that all surfaces are clean and free from any materials that might cause smudges or scuff marks.

The widths of mats can vary greatly and are often a matter of personal preference; however, the minimum width should be no less than three to four inches (7.7 to 10.2 centimeters) for the sides and top, and no less than four to five inches (10.2 to 12.8 centimeters) for the bottom (these measurements can be proportionally increased for much larger-scale drawings). The borders of your drawing will lie under the mat's overlapping perimeter with only the image exposed through the mat's opening. In determining the outer dimensions of the mat and the size of the opening to be cut, lay a clean straightedge ruler down across your drawing, allowing it to overhang each side. Determine the width of the image and add a minimum of three inches for the width of the mat on each side, or six inches plus the width of the image. This measurement represents the outer dimensions of the width measurement. Follow the same procedure of measuring for the height of the drawing, remembering to add an extra inch for the width of the bottom portion of the mat, which will give you the outer dimensions of the height measurement of your mat. After carefully measuring and cutting the mat, attach it along the top edge only to a piece of strong backing material such as acid-free foam-core board (with the identical outer dimensions), using acid-free linen tape. Lift the window mat from the backing board enough to position the drawing inside, then close the mat back down, loosely covering the edges of the drawing. Shift the drawing slightly—up, down, side to side, until it is correctly centered in relation to the window opening, se-

curing it with a paperweight (resting on a clean paper towel on top of the drawing). Then open the mat and hinge the drawing's top edge securely to the backing surface with two or three one-inch lengths of linen tape (the taped edge will be concealed under the top width of the mat when it is fully closed).

It is always best to use acid-free board for both the mat and backing, and linen tape for the hinges, particularly for permanent matting projects. A sheet of acetate may be cut to the identical size of the outer dimensions and slipped inside the mat and over the drawing's surface to prevent rubbing when drawings are to be stored on top of one another in flat file drawers. It is also a good idea to place clean sheets of paper in between the matted drawings when they are stacked in drawers.

Students who develop the habit of doing full-sheet drawings can prepare two standard mats—one vertical, one horizontal—for classroom presentation. Diagrams of matting and information on portfolio preparations are discussed at the end of Chapter 16, Illustration.

And now you are ready to begin the adventure of learning how to draw.

Beginner's Media

Adolphe William Bouguereau made the following statement to Matisse: "[B]ut first you must learn how to hold a crayon. . . ."

There is a universal familiarity with pens and pencils the world over, and it is strangely curious to suddenly enlist these common mark-making tools into the deeply profound mystery of drawing. Yet pens and pencils, along with charcoal and brush and ink, have always been the humblest and most easily obtained drawing tools for artists throughout most of recorded art history. The timeless familiarity with these ever common, yet highly expressive indelible tools is deepened by the drawing experience. Every artist, sooner or later, comes to realize that a particular drawing tool resonates in the hand, and in combination with a chosen working surface, produces an organically expressive marriage of materials.

As one approaches drawing for the first time, it is important to concentrate on the drawing media that are least demanding. One must pay attention to the drawing tools and the variety of ways they may be held, each producing a different effect, and then draw as freely and uninhibitedly as possible, so that the transmission of impressions, ideas, and impulses will be direct and un-self-conscious. Charcoal, pencil, ballpoint pen, felt-tip pen, and brush and ink should meet initial needs and provide ample possibilities for expression. The following equipment and materials are generally standard and suffice to commence working. Other materials and tools can be added later.

> drawing board (basswood or Masonite), 20 × 26 inches
> (51 × 76 cm)
> thumbtacks (to use with basswood board)
> masking tape (to hold sheets of paper to Masonite board)
> pad of multipurpose drawing paper, suitable for pencil, charcoal,
> and ink, 18 × 24 inches (46 × 61 cm)
> heavy clips (to hold drawing pad to the board)
> HB, 2B, 4B, 6B, and 8B graphite drawing pencils
> large, soft pencil erasers of different kinds

stick charcoal (soft) and compressed charcoal (0 or 00)
kneaded eraser
blending chamois, shading stump (*tortillon* or *estompe*)
fixative in pressurized cans (to be used with ventilation only)
ballpoint and felt-tip pens (medium and wide point)
India ink and dilution tray for washes
medium-size pointed brush (No. 10), of the best quality you can
 afford (not an oil painting brush)
Optional:
heavy-weight paper, charcoal paper, vellum
fine sandpaper sharpening pads for graphite
assorted gray crayons/pastels (available in boxes of 12 from
 Conté, NuPastel, or Weber Costello)
6B stick graphite
graphite powder
Conté crayon

Charcoal Charcoal, because it is easy to apply and equally easy to re-move, provides a rich and versatile medium for the beginner. Depending on the angle of the stick and the pressure exerted upon it, charcoal lines can be pale or dark, of uniform or varying widths, creating a vast and dramatic repertoire for line drawings. Line, which will be discussed often throughout this text as it pertains to different media and expres-

2-1. PABLO PICASSO (1881–1973; Spanish-French), *Still Life*. c. 1919. Charcoal on white paper, 28 × 20 3/4″ (71.2 × 52.7 cm). Private collection.

sion, is particularly important in the use of charcoal. The swelling and tapering of a charcoal line created by varying amounts of pressure is the descriptive lifeline of expression. Charcoal is an extremely responsive medium, and the effects of a live and pulsing line are easily attained. The discovery process of the descriptive qualities of line that ensue as the beginner draws is quite profound. In Pablo Picasso's *Still Life* (Fig. 2-1), we see this descriptive life in the line as it courses about the picture plane identifying the contours of each object. It is a delight to the eyes to be entertained by both the subtlety and boldness of the charcoal as if the line itself were breathing. A wide range of values from light gray to black can be produced by the application of parallel or cross-hatched lines (Figs. 2-2, 2-3) or by dragging the stick on its side, as demonstrated by Kollwitz in Figure 1-1. When grays of minimum texture are desired, tonal areas can be fused by rubbing the surface gently with the fingers, with soft paper, or with a paper stump known as a **tortillon** or **estompe.**

Project 2.1

Familiarize yourself with the nature of charcoal by drawing lines using varying amounts of pressure and changing the angle at which you hold the charcoal stick. Practice building tones with rapidly drawn clusters of diagonal parallel lines and cross-hatched lines. With the side of a piece of charcoal, lay down a smooth gradation of tone from black to very light gray. Do the same with lines fused by your fingers, reinforced by subsequent applications of charcoal and rubbing. Notice that excessive rubbing or rubbing with any slight presence of moisture on the surface can

2-2. *above, left:* JUAN GRIS (1887–1927; Spanish). *le Moulin à Café.* 1911. Charcoal, 18 3/4 × 12 1/2".
The Brooklyn Museum. Purchased with funds provided by Henry and Cheryl Welt.

2-3. *above, right:* ROBERT HENRI (1865–1929; American). *Portrait Head of a Woman.* Crayon, 6 1/2 × 4 1/2" (16.5 × 11.4 cm).
Susan and Herbert Alder Collection.

tortillon
A paper shading stump used in combination with dry media for blending tones.

estompe A paper stump used for shading or blending tones.

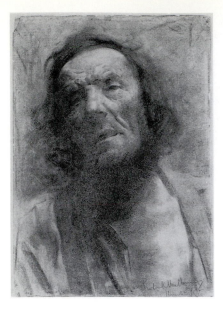

2-4. FREDERICK W. MACMONNIES (1863–1937; American). *Head of a Man.* 1884. Charcoal, 22 11/16 × 15 7/8" (57.8 × 40.3 cm). The Cleveland Museum of Art; gift of Mrs. Henry White Cannon.

result in the loss of freshness and perhaps a marked disturbance of the tooth of the paper. In these preliminary exercises you will quickly become aware that while charcoal can be easily blended, it can be just as easily smudged, which necessitates learning how to draw without resting your hand on the paper. To steady your hand for precise details, reach across and grasp the opposite side of the board with your other hand, using that arm to support your drawing hand.

The drawings in Figures 2-1 to 2-4 are all extensions of the exercises suggested in Project 2.1. Picasso's *Still Life* (Fig. 2-1) is drawn with a line of essentially uniform width. By wiping out rather than erasing completely, he allows us to see how carefully he has considered the exact shape and placement of each form. The drawing, which at first glance seems deceptively simple, suggests that it is unimportant that a line or shape be correct as first drawn as long as you can change it. Furthermore, as the artist orchestrated the composition through these changes, the vestiges of former lines add richness and soft vulnerability to each altered form. *Le Moulin à Café* by Juan Gris (Fig. 2-2) is a line drawing very much like Picasso's, augmented by diagonally hatched shading to create a greater illusion of volume and space. The added tone creates richness and a more formidable presence of the objects drawn.

The gradations in tone in Robert Henri's *Portrait Head of a Woman* (Fig. 2-3)—a crayon drawing identical in effect to the charcoal drawing—result from variations in pressure rather than from blending. Notice how the obvious diagonal stroking of the left half of the drawing changes to a more even tone on the right side. Henri gives definition to the figure by reinforcing his broad tonal areas with a few selected, expressive lines. Figures 2-3 and 2-4 are amazingly similar drawings that differ only in execution. Whereas the Henri drawing exhibits a loose yet descriptive directness and spontaneity, *Head of a Man* by Frederick W. MacMonnies (Fig. 2-4) is a more fully rendered portrait in which the details of form are defined through tonal variations created by dragging the side of the charcoal stick across the surface of the paper. Notice how the linear accents of the clothing appear to have been made by dragging the charcoal vertically and in the direction of the fabric lines it is describing. There is some blending of tone and also subtraction of the darks to create subtle highlights by the use of an eraser; this gives the drawing a spatially dynamic force setting it apart from the Henri work. Most of the grain, or surface characteristics, evident in these drawings derives from the texture or tooth of the paper itself.

A luxurious advantage of stick charcoal is that it can be easily manipulated through both additive and subtractive methods. Large areas can be wiped away with a piece of chamois; more precise corrections can be made with a kneaded eraser that can be shaped to a rather sharp point and used to lift off an undesired mark or area of tone. Broad strokes of highlights can be created with either a plastic or rubber eraser in the opposite fashion that dark strokes are created using the side of a charcoal stick. Be aware that erasing with excessive pressure can damage the surface of some papers and make it difficult to draw back into an area without the erasure marks being visible. The eventual accumulation of charcoal dust can be removed from a chamois by snapping it against something solid or by washing it, while charcoal picked up by the eraser disappears in the process of kneading and reshaping the eraser.

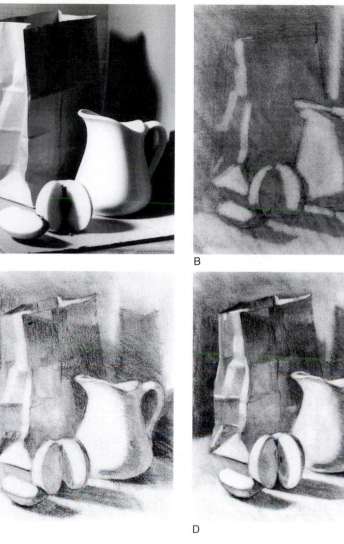

A

B

C

D

2-5. Tonal study in charcoal using chamois and kneaded eraser as drawing implements.
A. Light-colored objects, middle-value background, light source from side.
B. Middle-value charcoal tone on paper; middle lights lifted with chamois.
C. Darks added to further establish forms.
D. Kneaded eraser used for highlights and lightest tones; additional darks for detailing.
Courtesy of Duane Wakeham.

The concepts of both additive and subtractive elements in the activity of drawing are extremely important to the overall degree of finish and complexity of any drawing. In addition to their usefulness for making corrections, both chamois and a variety of different erasers can serve as drawing implements to create a wide-ranging tonal study in charcoal. As demonstrated in Figure 2-5, working into a homogenous middle value tone laid down with soft stick charcoal, a chamois is used to lift out middle light tones and an eraser is used for the lightest tones. Darks are easily added with direct applications of charcoal in selected areas.

Project 2.2

Place a few simple objects of light value against a middle value background. Provide a source of light above and to one side. Using stick charcoal, cover a sheet of smooth, good-quality paper with middle value tone. To achieve a uniform tone, blend the charcoal with a tissue, cotton puff, or a foam cosmetic blender. Establish the size, shape, and position of the objects by sketching them in very lightly with charcoal. Study the composition to determine what areas to lift out with the chamois, which lights to erase, and where to add darker tones. Be alert to patterns of light and shadow on the various objects, gaining a sense of the lightest and the darkest areas. Begin to be aware of the sharp edges that separate objects as well as the soft edges where light turns to shadow. Work as directly and deliberately as

possible and avoid overworking the paper surface in order to maintain a state of freshness. One reason for introducing this tonal approach to drawing as one of the first projects is to provide beginners with an early awareness that drawing doesn't have to begin with lines.

Compressed charcoal is charcoal ground to a powder and compressed into chalklike sticks. It is a far more saturated and potent black and offers deeper, richer darks than stick charcoal, but it is more difficult to erase, as are the gray crayons listed as optional materials.

Protecting Charcoal Drawings Spraying finished charcoal drawings with a protective coating of fixative will prevent smudges and help hold the charcoal powders to the paper surface. "Workable" fixative allows you to spray the working paper surface at intervals while continuing to work back into the drawing after it has been fixed. To apply, position the drawing in a well-ventilated area, hold the can about nine to twelve inches from the drawn surface, and spray with a back-and-forth motion, making sure to cover the entire drawn area. In the past, if ventilation was not available, spraying the drawing outside in the open air was recommended. This, however, is not very effective in terms of evenly coating the paper and doesn't ensure that stray vapors will not be inhaled. Always use spray fixative in a ventilated area intended for that purpose, such as a spray booth. Also, the spray should never be used near an open flame.

Pencil Pencil, or **graphite,** comes in varying degrees of hard and soft, and although not as flexible as charcoal, it is also an excellent beginning drawing medium, having the virtues of familiarity and relative cleanliness. Graphite, found in nature, is a soft, black, and lustrous material mixed with a binding material and compressed to form a wide range of light to dark effects. These light to dark effects are analogous to their manufactured hard to soft physical properties, ranging from 9H as the hardest and lightest, to 9B as the softest and darkest. The complete range of graphite grades starting with the hardest and working toward the softest is: 9H, 8H, 7H, 6H, 5H, 4H, 3H, 2H, H, F, HB, B, 2B, 3B, 4B, 5B, 6B, 7B, 8B, 9B.

We learn to handle pencils early in childhood, if not for drawing, then certainly for writing. As noted at the beginning of this chapter, there is a universal familiarity with pencils, along with several other common drawing instruments. But when a pencil graduates from its use as a primarily utilitarian tool to that of a fine art tool, it resonates differently in the hand of the artist, just as it will begin to in the hand of the beginning student. Holding a pencil in an upright position as for writing produces an essentially uniform line (Fig. 2-6) and encourages finger control most appropriate for working on small details. Although beginners generally feel most comfortable holding the pencil and other drawing tools in this conventional manner, the results are often small, cramped, and centralized images. Drawing on full sheets of paper with the intent to use the entire paper surface as the working picture plane, along with using broader movements of both the hand and arm, will result in looser, freer drawing.

Many artists let the pencil resonate by holding it under the hand (Fig. 2-7) because it permits easier variations in the thickness and darkness of the line. A slight shift in the hand position utilizes either the point or the side of the graphite to produce a line of greater interest and

graphite
A soft form of carbon found in nature and used as lead in pencils. It is manufactured in a wide range of soft to hard states and produces a lustrous, black, or gray-black mark when dragged against a receptive surface. The softer states produce darker, richer blacks than harder versions. It is also available in stick, chunk, or powdered form.

2-6. Line made by pencil held in handwriting position.

2-7. Line made by pencil held under the hand.

2-8. VINCENT VAN GOGH (1853–1890; Dutch). *Mill on the Hill.* 1887. Pencil, 11 × 20″ (28 × 50.8 cm). Vincent van Gogh Foundation/Vincent van Gogh Museum, Amsterdam.

in turn greater potential to describe the object being drawn. The latter position encourages a freer drawing, since neither the hand nor the arm rests on the paper and more of the artist's upper body is engaged in the act of drawing. It also prevents smudging when working with softer graphite, charcoal, and other media that tend to smear easily.

Project 2.3

Before starting to draw specific things, spend a little time playing with the pencil in your hand so that you begin thinking of it as a drawing tool rather than as a writing implement. Observe the quality of the line produced by the point of the pencil and by the side of the graphite as you scribble freely on your paper. Also note the difference in line quality achieved by holding the pencil in the writing position (Fig. 2-6) and by holding it between the thumb and forefinger but under your hand (Fig. 2-7).

Practice with a soft pencil, a 4B, 6B, or 8B, by drawing parallel lines in either a vertical or horizontal fashion from one edge of the paper to the other. As you draw, concentrate on changing the amount of downward pressure that you exert on the pencil, creating lines that swell and darken with more pressure and taper and lighten with lighter pressure. Fill the entire surface of the paper with these ever-changing lines. Notice how they seem to recede by dropping back into space and project forward as they weightlessly lift themselves off the page.

Project 2.4

As you have just discovered in the previous project, it is possible using a soft pencil to create a full range of light to dark tones (values) and rich, dark blacks by increasing or decreasing the pressure, as evidenced in Vincent van Gogh's *Mill on the Hill* (Fig. 2-8) and George Bellows's *Tennis at Newport* (Fig. 2-9). Fill in a series of six two-inch (five-centimeter) squares both with even tones of varying degrees of darkness and with gradations of tone, using broad strokes made with the side of the graphite rather than with the point. It is not necessary to work for a smooth blending without any visible strokes as long as you achieve the effect of a uniform tone.

Drawing with the point of the pencil, develop even gray tones of different values using closely spaced parallel and cross-hatched lines. Explore different directional

2-9.
GEORGE BELLOWS (1882–1925;
American). *Tennis at Newport.* c. 1918.
Pencil on paper, 18 1/4 × 20″ (46.3 ×
50.8 cm).
Arkansas Arts Center Foundation Collection—
Anonymous loan, 1980.

2-10. JACK BEAL (b. 1931; American).
Self-Portrait. 1969–1970. Pencil,
8 1/8 × 8 5/16″ (20.6 × 21.2 cm.).
© The Art Institute of Chicago, all rights
reserved; Gift of Mr. and Mrs. Douglas
Kenyon.

strokes and patterns—regular and uniform, also random and spontaneous—to create gradations, even gray tones, and the suggestion of textural differences. You will discover that the successful laying down of tones depends upon learning to control pressure. Care must be given not to tear the paper by bearing down too heavily in the attempt to achieve stronger darks.

Five pencil drawings of the human head (Figs. 2-10 to 2-14) begin to suggest the range of visual interest that evolves from using a variety of line, tone, texture, and value, rather than relying on the uniform line weight that results from drawing as though writing. In each of the drawings, we remain conscious of the pencil as an implement that produces

lines, but in each example it is the difference both in the quality of the line and the way in which the line is drawn that should be examined.

Jack Beal's *Self-Portrait* (Fig. 2-10) comes closest to the pure line drawing. The variation within individual lines that results from such factors as differing degrees of pressure, varying directions of movement, or positions of the hand in the act of drawing gives energy to the image and contributes to establishing the visual character of the artist. Looking at the deeper nature of the drawing, as a self-portrait statement, we notice that the thickening of the lines on the right side of the face and the strong, dark accent under the nose introduce a suggestion of light and shadow as a means of revealing three-dimensional form. Here, in the swelling and tapering of the line, there exudes a pulsing life that is inextricably fused with the power of varied and singularly expressive line.

To describe Paul Cézanne's small pencil drawing of Delacroix (Fig. 2-11)—done from a photograph—as "impetuous" is not to imply that the drawing is undisciplined. The foundation tone, or underdrawing, serving as enrichment and support for the superimposed bold, slashing, descriptive darks, is vitally necessary for the life and power of this small drawing. Notice how skillfully he gave form to the left cheek with a quick curve crossed by a number of equally quick diagonals. Cézanne's drawing and Alberto Giacometti's *Head* (Fig. 2-12) share much of the same sense of energy and expression that accompanies the viewer's being able to experience the physical act of manipulating the pencil. It is easy to imagine that Giacometti may have never lifted his pencil from the paper as he "scribbled" his image. The visual excitement of the drawing is indicative of the obvious presence of adrenaline

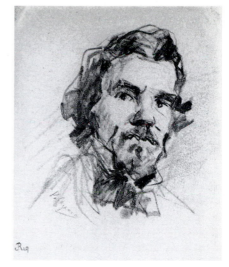

2-11. PAUL CÉZANNE (1839–1906; French). *Portrait of Delacroix.* c. 1870. Black pencil on white paper, 5 1/2 × 5 1/8" (13.9 × 13 cm). Musee Calvet, Avignon.

2-12. ALBERTO GIACOMETTI (1901–1966; Swiss-French). *Head.* 1946. Pencil, 5 7/8 × 4 1/4" (15 × 11 cm). Whereabouts unknown.

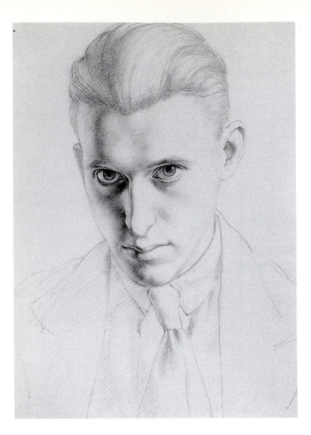

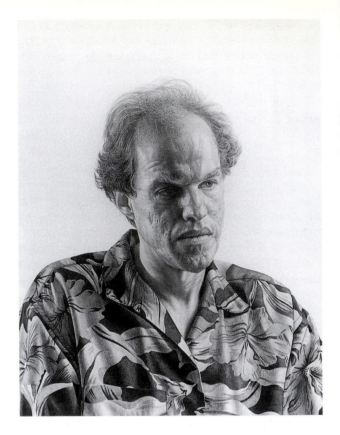

2-13. *above, left:* JOHN LUKE (1906–1975; Irish). *Self Portrait.* Pencil on white paper, 16 3/8 × 11 1/2" (41.7 × 29 cm). National Self Portrait Collection, Ulster Museum (no. 2526). Photograph reproduced with kind permission of the Trustees of the Ulster Museum.

2-14. *above, right:* JAMES VALERIO (b. 1938; American). *Portrait of Tom* (*Study for "Tom's Choice"*), 1991. Pencil on paper, 28 1/2 × 13" (72.5 × 33 cm). The Arkansas Arts Center Foundation Collection.

at work in the artist's mind, body, and spirit. Here, the pencil resonated in the hand of the artist quite differently than it did in either Cézanne's or Beal's portrait.

The most restrained and traditional of the five drawings so far is John Luke's *Self Portrait* (Fig. 2-13), in which line and tone are separate but skillfully integrated. In contrast to the ghostlike implication of the clothing and only slight interest in the hair, the features of the face, especially the eyes, are delineated with greater detail and with an intensification of shading done with carefully controlled diagonal hatching. The effectiveness and expressiveness of the drawing are attributable to Luke's use of selective emphasis and to his expert handling of the medium.

Finally, the most involved and labored pencil drawing is James Valerio's *Portrait of Tom* (Fig. 2-14). Here we see a full-blown repertoire of graphite handling at its very best, and it is the most complex of the five portrait drawings. Many of the descriptive uses of graphite and wide-ranging qualities of line of the previous drawings exist in Valerio's work, albeit on a highly revised level of refinement.

Project 2.5

Explore some of the approaches to developing lines, values, tones, and textures similar to those seen in Figures 2-8 to 2-14, using a soft pencil to depict subjects of your own choice. You might find it informative to work with the same subject, or choose a subject of your own such as a friend who agrees to pose for a portrait drawing. To break into other subject matter with this same approach, choose something as ordinary as a paper bag and draw it in the manner of each artist. Only Figures 2-13 and 2-14 seem to have been drawn with a well-sharpened pencil, while the heavier lines of the other three examples suggest the use of a pencil with a

blunted point or, more likely, one in which the graphite was exposed with a knife rather than by a mechanical sharpener. Whether exposed by a knife or a mechanical device, graphite can easily be sharpened to a broad chisel point or to a sharp point with fine-tooth sandpaper (sandpaper sharpening pads are available in most art supply stores).

Project 2.6

The range of graphite from hard to soft is also available in stick form in the soft "B" grades. Try several of the same drawing explorations of the previous project, but substitute a graphite stick for the pencil and see what expressionistic differences occur. This will bring back similar sensations of working with the charcoal sticks, and you will readily discover that the graphite stick can be manipulated in the exact same way as the charcoal stick. Draw by holding the soft graphite stick up on its end, using one of the four flat edges to make a wide line; then roll it slightly and draw with one of the corner points at the end of the stick to produce a narrow line. Finally, lay the stick down on its side to produce wide areas of tone of varying values by exerting different amounts of pressure. Through all of these assignment explorations, you will become aware of the vast array of mark making that can be obtained from each single tool. Artists think of this as an extended *vocabulary of marks*; and the word *vocabulary* in the context of art introduces to us the concept of *visual language*.

Ballpoint and Felt-Tip Pens The familiar, easy-to-use ballpoint, fiber-tip, and felt-tip pens are capable of producing a variety of line widths. They therefore provide the beginner with a graceful transition from pencil and charcoal to brush and ink. Some **inks** are insoluble; others are water soluble and can be smeared with a wet thumb or a brush with water to introduce a painterly quality.

When directed to draw with any tool that is associated with writing, there is a natural inclination to first draw in outline before considering texture or tone. Feliks Topolski's pen-and-ink drawing *E. M. Forster and Benjamin Britten* (Fig. 2-15) suggests a method, easily duplicated with ballpoint pen, that avoids strict outlining.

inks
Any fluid or semifluid drawing or printing materials that may be used in conjunction with various pens, brushes, brayers, or rollers. They are available in a wide range of colors. Some are soluble in solvents such as mineral spirits and turpentine; others are soluble in water.

2-15. FELIKS TOPOLSKI (1907–1989; Polish). *E. M. Forster and Benjamin Britten.* Pen and brown ink, 9 3/4 × 7 3/4″ (24.7 × 19.7 cm). Sotheby's.

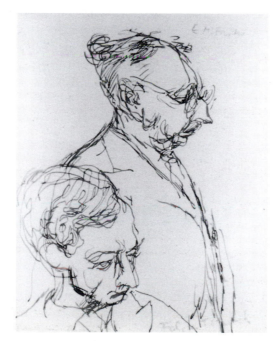

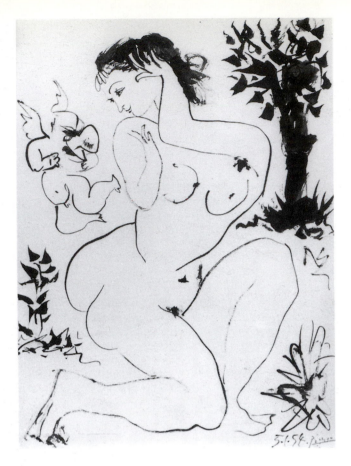

2-16. PABLO PICASSO (1881–1973; Spanish-French). *L' Amour Masque.* January 5, 1954. Brush and ink, 12 1/2 × 9 3/8″ (31.7 × 23.8 cm). Galerie Louise Leiris, Paris.

Project 2.7

Experiment using ballpoint and felt-tip pens of varying widths, taking full advantage of the unique linear strengths and rich textures these pens produce. The techniques suggested for pencil drawing are easily adapted to this assignment. Thumbing through the book and looking at examples of pen-and-ink drawings will suggest other drawing styles as well. Think of the inherent variety and endless possibilities of visual translation when substituting a pen for a pencil with any subject matter. There are some newly developed drawing pens of high quality available in art supply stores today that were not in use ten to fifteen years ago. Their pigments are permanent, lightfast, waterproof, and fast-drying. They will not bleed on most artists' papers and work especially well for underdrawing on surfaces that will receive watercolor washes. The pens come in black along with a variety of colors and points ranging from fine to wide.

Brush and Ink Brush and ink demand a certain assurance of execution, since lines and shapes cannot be erased. The bold, fluid lines that result from the free play of brush and India ink give a certain authority to a drawing, and a sense of self-confidence emerges from the deliberate, successful use of the brush. The flexibility of the pointed brush allows for rich variation in lines and their multiple effects. Drawing with brush and ink is immediate and dramatic, and allows for ultimate spontaneity and highly descriptive and expressive occurrences with a wide variety of subject matter.

The choice of line contributes to the expressive character of a brush drawing. The impression of lightness and aliveness in Picasso's brush drawing (Fig. 2-16) results, in part, from the contrast between the

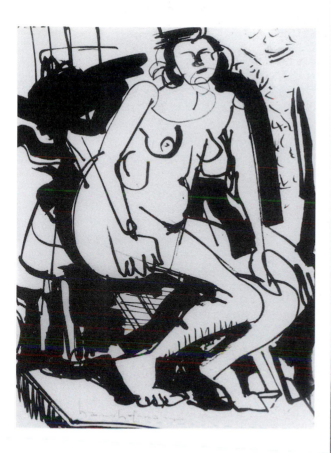

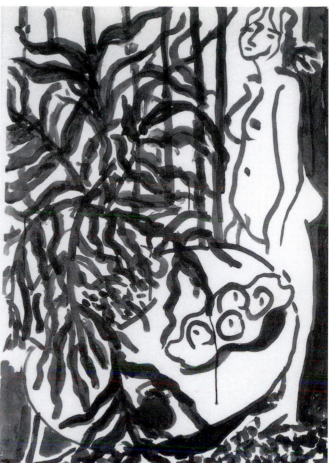

long, flowing lines of the figure and the broad, individual strokes of the vegetation. Using an almost weightless line, and without shading, Picasso subtly introduces a sense of volume through the swelling and tapering of the contour line. Notice also the dramatic diagonals created by the contours of the figure within the composition. Our eyes can't help but dance playfully along the contours and diagonals of this light and airy composition.

Hans Hoffman's *Seated Nude* (Fig. 2-17), executed with such directness and force, initially appears to be very different from Picasso's drawing, but going beyond the immediate visual impact we become aware of strong similarities, most noticeable by comparing Picasso's winged figure of Love with the left arm of Hoffman's figure. Looking deeper, we see that the physical act of manipulating the brush to produce long continuous lines looping about and changing direction is nearly identical. Hoffman's line that begins at the elbow, sweeps over the shoulder, curves across the upper chest, and ends with a swirling line at the chin imparts a certain delicacy to an otherwise blunt, graceless, and seemingly immovable figure.

Considering the large size of Henri Matisse's *Nude with Black Fern* (Fig. 2-18), the thinnest of his lines are at least equal in thickness to the heaviest black brush strokes in the much smaller Picasso and Hoffman drawings. In fact, there is much less distinction between line and brushed shapes in the Matisse drawing: everything is primarily broad bold brush work with few subtle variations to suggest volume or light

2-17. *above, left:* HANS HOFFMAN (1880–1966; German). *Seated Nude.* c. 1935–1940. Brush and India ink on paper, 11 × 8 1/2" (28 × 21.6 cm.). Chrysler Museum.

2-18. *above, right:* HENRI MATISSE (1869–1954; French). *Nude with Black Fern.* 1948. Brush and ink. 41 1/4 × 29 1/2" (105 × 75 cm.). Musee National d'Art Moderne, Paris.

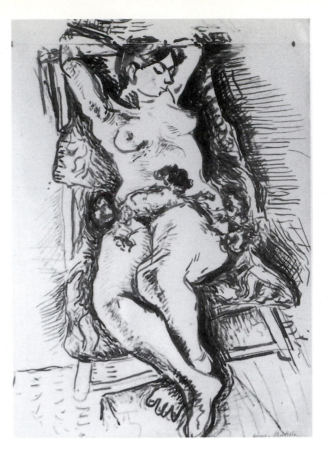

and shadow. In contrast to the fragmented, frenetic patterning of light and dark introduced by Hoffman, Matisse has deliberately layered dark against light against dark to define space.

These three drawings remain essentially two-dimensional because of the domination of pure black and white and the absence of internal modeling. Matisse, in *Nude in a Folding Chair* (Fig. 2-19), breaks away from two-dimensionality, suggesting volume by introducing modeling within the figure and thereby creating a three-dimensional illusion. Furthermore, Matisse creates space by combining broad areas of tone with linear patterns to produce a variety of different values along with interesting painterly effects. The textural patterns and more descriptive suggestions of modeling are done with a fully loaded brush. The ink flows most easily and fastest just after the brush has been newly charged with ink. There is also a subtle, but nonetheless true, element of variation that results when the brush is used with varying amounts of downward pressure. The greater the downward pressure, the wider the line as the brush even bends as it courses across the paper. The lesser the downward pressure, the thinner the resulting line will be. The absolute thinnest line is produced when the longest hairs of the brush, at its very point, delicately touch the surface.

Project 2.8

To commence drawing, dip your brush in India ink and then press it against the side of the bottle neck to remove excess ink and create a point by slightly swirling the brush hairs against the bottle as you lift it out. Begin by exploring the different kinds of lines you can make with the brush—lines similar to those illustrated, lines that

change from thin to thick and back to thin by increasing and decreasing the pressure with which the brush is applied to the paper. Practice this several times, keeping your hand, wrist, and arm relaxed and take full advantage of the springing action of the brush against the paper surface. Observe the results created by gently bouncing the brush while dragging it over the paper.

Your first attempts may seem hesitant and awkward and forced. Gradually, your attempts will become more refined and descriptive in a gesture-producing way. There is much to be gained from the wet drawing media in terms of spontaneity and fluidity. As you begin to feel more comfortable with the brush, you will also begin to develop the control necessary to give meaning and expression to the subject matter of your brush drawings.

Project 2.9

Make a number of drawings of the same subject or object using different kinds of lines for each drawing. Repeat individual drawings until you are satisfied that the quality of the line is effective and controlled. A good test is to ask yourself whether you would find the drawing interesting if someone else had done it. Next, do a group of drawings that will allow you to introduce solid and broken areas of tone and shape. Note the contrasting visual effects of the solid and broken shapes with the line variation in your drawings. How do they enhance and support each other visually?

Dragging a less-than-fully loaded brush lightly across a piece of drawing paper, especially one that has some texture or tooth to it, produces an irregular or broken brush stroke known as **drybrush,** which is useful in creating tonal and textural effects. In Emile Nolde's *Harbor* (Fig. 2-20), the drybrush passages begin to soften the harshness of the pure black

drybrush
The irregular or broken brush stroke effects of ink that ultimately diminish, created by dragging a less-than-fully-loaded brush lightly across a piece of drawing paper—especially one with some surface variation or high degree of tooth.

2-21. GERBRAND VAN DEN EECKHOUT (1621–1674; Dutch). *A Boy Lying Down.* Rijksmuseum, Amsterdam.

and to establish a sensation of atmosphere, space, and even reflections in this wonderful and powerful composition.

Project 2.10

To produce drybrush effects, wipe excess ink from the brush on paper toweling or a clean rag before dragging the brush lightly over the paper. Also try loading the brush with ink and drawing a vertical line through the paper. Then quickly remove excess ink from the brush and with quick horizontal strokes, drag the brush in a perpendicular direction over and through the vertical line. Notice how the semidry brush picks up and redeposits the ink from the still wet vertical line at right angles to the vertical line. Observe how the amount of ink quickly diminishes on the paper as the brush moves further away from the wet line.

The tonal effects in Figures 2-19 and 2-20 were created with full-strength black ink. Gerbrand van den Eeckhout (Fig. 2-21) has diluted his ink with water proportionally to create a wide range of light-to-dark wash values. In his drawing *A Boy Lying Down*, created exclusively by brushed applications of ink wash, we see a beautifully descriptive work of high spatial complexities and definition of form all within the human figure as it reclines before us. The variations of value within the tones are achieved by working back into the still-wet areas of the clothing particularly in the blanket draped over the left arm and in the low-cast shadow on the wall to the right of the figure. There are also areas where the wash was allowed to dry completely before later washes were added. Notice how delicately the artist has described the scarf sash around the figure's neck and the ribbing of folds in the sleeve of the right arm supporting the head. As the artist progressed with this brilliant work, there evolved a deeper and more profound expression of the fabric life and weight of the blanketed, clothed figure. This adds a high degree of definition and volume to the drawing.

Project 2.11

A simple still life of light objects placed against a middle- value background and lighted from the side, as in Project 2.2, would be an appropriate subject for the first experiments with ink wash drawings. Plan carefully as you view the lights and darks of the still life; find the positions of extreme lights and use the open white paper to represent those lightest areas of the composition. Keep the shapes and washes as simple as possible while still being descriptive yet spontaneous. Limit yourself to three to five grays plus black and white. At first, and as you are learning to control the medium, allow each wash to dry before adding the next to prevent them from bleeding into one another and negating individual values.

Summary

It is not important if the exercises done for the assignments in this chapter are not of exhibition quality. If you did more than a single drawing for each assignment, you probably began to experience, perhaps only in a limited sense, that practice contributes to the gaining of competence and control. Above all, remember that you have begun to speak a personal visual language with fine art tools. How far you take this language is up to you. But the rudiments of these techniques and the explanations of these drawing tools presented in this book will serve you well as a reference guide for your future endeavors in drawing.

Further explorations into the uses of media and technique will elaborate on these preliminary experiences. Other approaches to drawing and other techniques will be examined throughout the remaining chapters of this drawing text; Chapters 10 and 11 discuss various media and their uses.

3 Learning to See

[T]here's something that's very intense about the experience of sitting down and having to look at something in the way that you do in order to make a drawing or a painting of it.

By the time you've done that, you feel that you've really understood what you were looking at . . . and somehow it becomes a method of possessing the experience in a unique way.

—Robert Bechtle

The most fundamental discipline involved in drawing is learning to record what one sees, which contrary to popular misconceptions is not primarily a matter of manual skills. In fact, the physical requisites for drawing are minimal: average sight and average manual dexterity. The well-worn adage "seeing is believing" is well suited here since drawing is a matter of seeing and seeing deeply with both the physical eye and the "eye of the believing mind." There is a distinct difference between the physical eye and what it sees and the inner eye and what it envisions, and yet the two most often work together in a seamless symbiosis. But more important, successful drawing requires that one have the will to *extract an image* from a subject, and that this extracted image be self-sustaining, no longer needing its source. It has little or nothing to do with 20-20 vision and deft fingers, but rather, it is a process of internalizing form, then releasing that form in a new and uniquely translated tangible state—the physical state we call "a drawing."

Basically, a person who can look at an object, analyze the relationships of size, shape, value, and texture, and then create an analogous set of relationships on paper as a graphic record of those visual perceptions has made a drawing. Learning to draw necessitates learning to see in a new, more penetrating way. It is essential that we learn to see through all our senses rather than simply looking with our eyes alone. Seeing comes before speaking, and from earliest childhood our hands, our bodies, and most of all our eyes—placed in our swivel-pivoting heads—appraise objects in terms of their three-dimensional character and our relationship to them in space. This is how we recognize them and know their distinctive qualities. Consequently, rather than

looking at the object and drawing only what can be seen, the beginner frequently draws according to a preconception or remembrance of the object—and often cannot see the difference between the preconceived and the actual object.

When we commence to draw, we are surprised to discover the degree to which any object, except a sphere, presents a different appearance each time we change the position of our eyes in relation to it. Since actual spatial depth is absent from the surface of the drawing paper, three-dimensional reality must be interpreted as a two-dimensional pattern. *Descriptive drawing is an illusion.* Therefore, much of learning to draw consists of discovering how things *appear* rather than how they are, and it is not until we begin to draw that most of us realize the tremendous difference between what we *know* about objects and what we *see*.

Learning to draw, then, demands a reevaluation of **visual** experience, a new dependence on visual cues about the appearance of objects and their relationships in space. Most of us are familiar with the art of children, which is based upon concepts of how things are—near forms are placed at the bottom of the page, and more distant objects appear higher on the page. Daniel Mendelowitz, the original author of *A Guide to Drawing,* was interested in the psychology of children's perceptions when they looked at the world around them, and as a result, had a keen appreciation for the art of children. In his very first book, *Children are Artists,* he states:

> First the child selects the objects that constitute his world (most of the drawings done by children between the ages of four and six are of human beings). Then these objects are reduced to what constitute the essential elements for the child (a human for a five-year-old is usually a head plus arms and legs). Because the child's range of experience is very limited, many objects are unfamiliar to him and therefore are incomprehensible. The child cannot portray what he cannot comprehend. Studies have shown that a five-year-old can draw a circle best if it has two eyes, a nose, and a mouth in it: the child can understand the circle head but the abstract circle meaning nothing is difficult to understand and therefore difficult to draw.

Folk artist and traditional Oriental artists often employ the same devices for representing spatial depth. Most people in Western cultures, however, readily accept two other concepts relating to forms in space: (1) one object placed in front of another partially obscures the object behind (think how you shift your head in a movie theater to prevent the relatively small head immediately in front of you from obscuring most of the giant screen); (2) objects appear to diminish in size when seen at a distance. In Jan Matulka's still life (Fig. 3-1) the effect of overlapping shapes is evident, but no significant diminishing in size occurs because the space depicted is so shallow. In contrast, the deep exterior space in Henri de Toulouse-Lautrec's *The Laundress* (Fig. 3-2) results in extreme discrepancies in size relationships judging from what the viewer knows to be the actual size of the subjects. Although the basket the woman carries is indeed large, it does not approach the size of the carriage at the left, and yet the two shapes are drawn as measurably equal in size. The head of the laundress appears to be as large as the carriage behind her on the right, and twice the size of the full figure

visual
That which is seen or takes form in the "seeing" process.

3-1. JAN MATULKA (1890–1972; Czech-American). *Still Life with Guitar, Pears, Wine Pitcher, and Glass.* c. 1925. Charcoal, 18 × 12″ (45.7 × 30.5 cm).
Susan and Herbert Alder Collection.

perspective drawing
The systematic method of representing and describing forms as they appear to recede in space through the use of converging lines that meet at a central vanishing point located on the horizon line. Also, the depiction of forms as they appear to the eye relative to distance or depth.

foreshortening
A term that applies to organic and anatomical forms seen in radical perspective, as in the portrayal of lines being shorter than they actually are, in order to create the illusion of correct size-and-shape relationships in space.

farther to the right. While those comparisons refer only to the relative size of shapes drawn on a flat sheet of paper, it is precisely because the artist was thinking in terms of shapes, rather than heads and carriages, that he was able to transform a two-dimensional surface into the illusion of three-dimensional space. Without careful comparison of the size relationships as observed, the beginner probably would draw the individual forms in some other scale and sacrifice the powerful illusion of deep space.

Perspective, Foreshortening

The considerable difference in size of things of the same measure in Toulouse-Lautrec's drawing and the converging of what are assumed to be the parallel curbs of the narrow street are aspects of **perspective drawing,** which relates to the changes that occur in the appearance of three-dimensional forms—specifically, geometric and architectural objects—when seen from a variety of viewpoints. Drawing in perspective can be accomplished by following a system of rules (see Chapter 9). **Foreshortening,** the term that applies to organic and anatomical forms

3-2. HENRI DE TOULOUSE-LAUTREC (1864–1901; French). *The Laundress.* 1888. Brush and black ink, with opaque white on cardboard, 30 × 24 3/4″ (76.3 × 63 cm). Cleveland Museum of Art (gift of Hanna Fund).

seen in perspective, such as the horse in Figure 3-2, depends on the careful observation of overlapping shapes and diminishing scale rather than on a set of rules.

PROJECT 3.1

The perspective of simple rectangular forms can be introduced by making some drawings of a sheet of paper. The sheet will appear as a perfect rectangle only if held vertically at eye level or placed flat on a table and viewed directly from above. In any other position it becomes a rectangle seen in perspective and requires a non-rectangular shape.

As you draw the sheet in a number of different positions seen from varying viewpoints, do not think of it as either a sheet of paper or a rectangle. See it simply as a shape enclosed within four straight lines—lines that sometimes appear to be parallel, sometimes appear to converge. Though you know the actual shape and proportions of the rectangle, draw just what you see, even when what you know to be the narrow width of the rectangle appears to be much greater than its length. You will become aware that visual analysis of a geometric shape is unrelated to determining the exact dimensions of the object; it is a matter of establishing relative proportions. A more systematic development of perspective will be undertaken in Chapter 9.

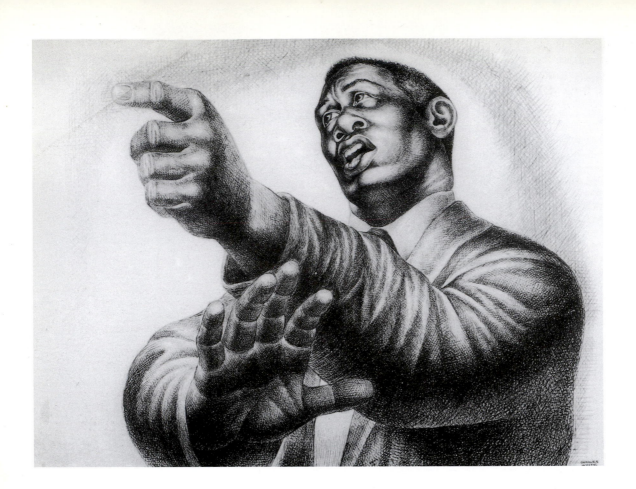

3-3. CHARLES WHITE (1918–1979; American). *Preacher.* 1952. Ink on cardboard, 21 3/8 × 29 3/8" (54.3 × 74.7 cm). Whitney Museum of American Art, New York (purchase).

Charles White's *Preacher* (Fig. 3-3) demonstrates the exaggerated foreshortening that occurs when a person is viewed at close range. Giovanni Paolo Lomazzo's study in foreshortening (Fig. 3-4) poses the figure somewhat theatrically well above the eye level of the viewer, as determined by the line defining the ledge on which he stands. If the full shapes of the bottom of the feet were shown, it would also be possible to read the drawing as a man lying down, which would establish the viewer's eye level as above the figure. This points out the importance of providing all the visual clues necessary to ensure a correct reading not only of forms in space but also of our relationship to those forms. In constructing his figure, Lomazzo simplified the arms into blocks. The head, trunk, and legs suggest anatomical features superimposed over a geometric substructure—imagined if not actually drawn.

Just as the rectilinear sheet of paper assumed different shapes when seen at different angles, so do all other objects. Consider a leafy plant or a simple branch with several leaves. A tracing of a single leaf pressed flat will provide one description of the leaf, but one having little to do with its actual appearance and as it exists in space (Fig. 3-5). As similar as they may be in size and shape, no two leaves will be seen as the same shape, nor will any single leaf retain the same appearance when viewed from a different angle, as demonstrated in Project 3.1 with the sheet of paper. Drawing the complex undulations of large leaves involves a careful analysis of the twistings and turnings of foreshortened forms in multiple directions toward, to the side, and away from the

viewer. The emphasis is on seeing as deeply as possible—seeing more intensely than one has ever seen before. Most drawing mistakes occur from not looking intently at the model and not seeing its well-kept visual secrets. If we draw what we think the shape should be rather than what we see, our intellects are working against our eyes and we have defeated the purpose of truly seeing. Our physical eyes tell us what we see, our intellects tell us what we think we see—and these can be at war with each other in the creative process. Experienced artists use their physical eyes to give them accurate and highly detailed information. The inner eye—the eye of the soul—then, if desired, embellishes the information given by the physical eye. This is called expression, and at this stage, has nothing to do with intellect.

PROJECT 3.2

Take a branch with three or four leaves on it—magnolia, avocado, or maple leaves are excellent. Draw the cluster of leaves from several different angles, noticing the constantly changing relationships of shape, size, and proportions. Remember that it is most important to base your drawings on visual analysis. Draw exactly what you see with the abiding sense that you are seeing accurately and deeply. As thoughts creep in of what you know about leaves and what you think they should look like, immediately disregard those wanderings and focus back on what you actually see! You will discover that you produce more accurate descriptions of the forms selected by steadfastly attending to the lines, shapes, and proportions than by thinking about drawing leaves.

CRITIQUE (Project 3.2) Compare your drawings to the corresponding actual positions of the leaves and branch. How accurately have you portrayed the actual visible reality of the subject? Did you have difficulty focusing on what you saw instead of what your intellect told you to see? If so, try the same exercise several more times, continually changing the position of the object until the pure act of seeing becomes more natural. It is extremely important that you develop a sense of confidence in relying upon your physical eyes to give you accurate and complete information. This sense of confidence will occur and grow with practice.

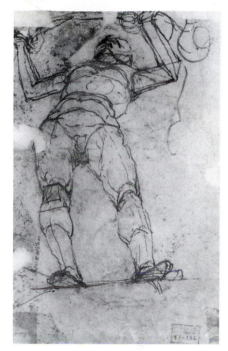

3-4. GIOVANNI PAOLO LOMAZZO (1538–1600; Italian). *Foreshortened Nude Man with Arms Uplifted Looking Up.* Pen and brown ink, 7 1/2 × 4 3/4" (19 × 12 cm). Art Museum, Princeton University (gift of Frank Jewett Mather, Jr.)

3-5. ELLSWORTH KELLY (b. 1923; American). *Five-Leaved Tropical Plant.* Pencil on paper, 18 × 24" (45.8 × 61 cm). Collection John Berggruen Gallery.

Mechanical Aids to Perception

A rectangle drawn in simple perspective without reference to anything else appears simply as a four-sided shape. Leaves drawn as a clump take on an identity, whereas one leaf drawn in isolation with an unembellished contour line might appear simply as an interesting irregular shape. In their singularity of form, neither shape provides any particular visual interest; however, it is the ability to abstract the object, be it rectangle or leaf, to a new shape and draw that *extracted shape* accurately that is the basis of representational drawing, no matter what the subject.

In the last two projects you were directed to base your drawings of the rectangles and leaves on careful visual analysis of shapes. In the critique of Project 3.2, you were asked to compare your drawings with the actual visual realities of the objects drawn. You should be interested in discovering how accurate your visual analysis and subsequent drawings are. With the leaves, deviations would be relatively unimportant. It is important, however, to adopt the attitude that "it needs to be right" in order to fully develop the discipline of seeing accurately. Once you have developed the ability to masterfully draw what you actually see, you will then be free to choose how you actually want to draw.

There are some simple methods for checking the accuracy of your previous drawings, methods that will play an increasingly significant role as you are challenged by more complex forms. Although the ultimate goal is to develop the eye, mind, and hand coordination, there are a number of simple mechanical aids that can help ascertain size and shape relationships and help determine the correct position or angle of a line. Sometimes such devices help to guide initial judgments at the start of a drawing; they also help to identify mistakes throughout the process of drawing.

The use of these aids will be discussed in relation to John Singer Sargent's *Reclining Nude Figure* (Fig. 3-6). While the foreshortened view of a reclining figure is a complex shape, the apparent clarity and simplicity of Sargent's drawing attest to his enviable visual acuity. Yet it is important for the beginner to notice that in spite of the artist's legendary drawing and painting skills, the drawing reveals faint traces of adjustments that were made in determining proportions and positions. These faint, visual vestiges of altered line and tone are referred to as **pentimento** (because the artist "repented," or changed his mind). At close examination we see that the right leg was longer, the right foot longer at the heel, the left leg shorter at the knee, the right buttock fuller, the head either wider or positioned farther to the side, the right elbow lower with a line suggesting that the arm was originally in a different position. Sargent perhaps made all those changes based solely on direct observation, or possibly he extended his arm to its full length and sighted along his stick of charcoal to determine critical vertical and horizontal alignments and to establish correct proportions. And what of the remaining faint lines that were deliberately altered? These are to be regarded as evidence of the creative process and not as mistakes. They were necessary in the ultimate establishing of correctness. Furthermore, with regard to the vulnerability of the human hand engaged in the act of drawing, this pentimento adds richness and authenticity to the finality and wholeness of the work of art. It is vitally important to understand that these vestiges, these remembrances of line, cannot be faked or con-

pentimento
From the Italian meaning "to repent," a subtle or radical revision made by an artist when he changes his mind, or *repents* during the execution of a drawing, painting, or print. The vestiges of the previous image, whether totally concealed or not, either become more apparent through the fading of the outer surface, or have remained apparent and bear evidence of the abandoned creative intent.

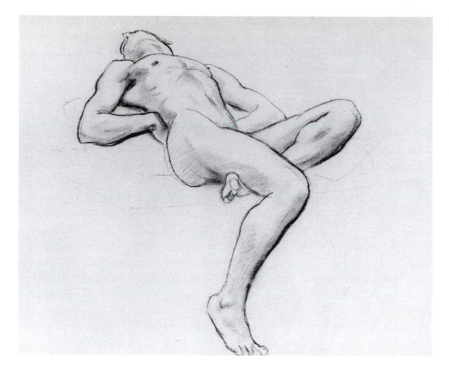

3-6. JOHN SINGER SARGENT (1856–1925; American). *Reclining Nude Figure.* Charcoal on paper, 24 1/2 × 19" (62.2 × 48.3 cm). Wadsworth Atheneum (gift of Miss Emily Sargent and Mrs. Francis Ormond 1930.314).

trived for the sake of adding richness to a drawing—because, for an artist or student to do so is grossly inauthentic and has nothing to do with the *birthing act* of drawing. But the "changes of mind" that the artist goes through in order to achieve "rightness" come as part of the natural struggle inherent in any genuine creative process.

Certain poses and gestures are frequently employed to identify particular activities. To mimic an artist at work, one has only to choose one eye and sight along an upright thumb extended at arm's length. In truth, this gesture depicts one of the most useful aids to perception. It is an action that even the most experienced artists employ to great advantage, especially during the preliminary stages of drawing, painting, and printmaking from life. Figures 3-7 and 3-8 illustrate how to hold a pencil to check critical vertical and horizontal alignments. Held in the same manner, it also serves as a measuring device to determine proportional relationships.

Vertical and Horizontal Alignments Leonardo da Vinci, who examined and commented on everything having to do with drawing and painting—and almost everything else as well—included the following instruction in one of his notebooks: "To draw a nude figure from nature, or anything else, hold a plumb line in your hand to enable you to judge the relative position of objects." Leonardo specified drawing from life, from an actual form existing in space. Successful figurative artists would all agree that there is no substitute for drawing from life. Looking at a drawing or at a reproduction of a drawing is not the same thing as looking at and studying the live model because the eye works in an entirely different way. When looking at a live model, the eye perceives forms as they exist in either shallow or deep space. When you look at a drawing or its reproduction, a three-dimensional form has already been flattened out into a series of marks on a two-dimensional surface.

3-7. Held in a vertical position, a pencil serves as a plumb line to determine vertical alignments.

3-8. Held as a true horizontal, a pencil helps to determine horizontal alignments.

However, because of the masterful way in which Sargent creates the illusion of three-dimensionality describing the volumetric aspects of the live figure on a two-dimensional surface, it would be easier for a beginner to make a successful copy of the Sargent drawing than to do a successful drawing of a live figure in the same pose, since the beginner does not yet know how to create illusion. Furthermore, there would be no value in introducing a photograph of a model in the same pose as the basis of discussion, because that, too, would be a flat representation, also lacking the heightened three-dimensional quality of Sargent's drawing. Making a copy from an already existing drawing or photograph is two generations removed from the live form and would not be considered an original drawing. Also, the element of struggle to find the "rightness" of the three-dimensional form would not be present—certainly not in an authentic and professional way.

Your immediate assignment is to visualize a model before you. He appears to recline on a flat surface, the upper body arched and slightly elevated on pillows, the left knee held a little higher than the right as it drops over the edge of the platform. Though all of that is observable in the model and can be made evident in the drawing, that is not what you would set out to draw. Instead, you would begin to find alignments, both vertical and horizontal, between a series of points on what just happens to be the body of a man. Although you are urged to think only of the shapes rather than of the body, the following discussion will be clearer if the parts of the body are referred to by name.

In Figure 3-7 the pencil, used as a plumb line, allows you to begin to establish vertical alignments that will determine where to begin blocking in the figure. Make sure the entire length of the figure from top to bottom falls within the length of the vertical pencil. You will immediately notice the visual elements of the figure that align themselves vertically. These vertical relationships can be thought of as the established givens with respect to the particular position of the figure. Once you've established the outer contour of the figure on your paper according to the established givens of the plumb line, place a pencil or straightedge vertically against the drawing and move it slowly from left to right across the drawing, noticing how things line up one above the other. (Check your drawing for accuracy against the plumb line of the vertical pencil held up once again over the figure and make any appropriate corrections.) Looking at both Figures 3-7 and 3-8, we can find several good examples of triangular-shaped alignments. First, the legs of the folding chair give us strong directional lines with which to align other elements of the figure. The two parallel legs that are in line with the back of the chair also run parallel to the right side of the torso. Notice the two adjacent triangles with their longest sides touching (forming the middle vertical) that together form the shoulders, chest, and stomach areas down to the point where the left buttock meets the chair seat. The center vertical line that separates the two triangles is parallel and to the left of the vertical plumb line. In Figure 3-8, the point of the left heel is in direct vertical alignment with the left hip joint and the left armpit, and also splits in half the downward contour line of the left shoulder. Notice also in Figure 3-7, the equilateral triangle formed by the left leg with its left side not only parallel but synonymous with the vertical plumb line, and the other equilateral triangle formed by the right arm with its right side parallel to the back of the chair. When no alignments exist, the plumb line and the horizontal line allow you to

determine whether one form appears to the left or right, or above or below the adjacent forms.

The pencil held in true horizontal position (Fig. 3-8) makes it possible to ascertain whether that detail should be drawn above or below some other feature. Above or below refers to placing a mark higher or lower on the page. There are two implications that can be drawn from the form's position on the page—distance from the viewer and elevation. The head, drawn highest on the paper, is farthest away, but by being connected to the figure is not elevated; the figure's left knee, although drawn higher on the page than the right knee, is nearer the viewer than all of the torso and is higher in actual space than the seat of the chair. The assumed crooked right wrist with the hand hanging downward is higher than the invisible left wrist, and closer to the viewer.

In addition to checking vertical and horizontal alignments, it is also possible to get a sense of the correct angle of a line or form by judging the degree relative to vertical or horizontal, as we touched on in our analysis of the triangles in Figure 3-7. Another approach is to locate and connect the points of termination of the major diagonal lines. For example: the angle of the lower leg follows a line connecting the figure's left knee to a point at the bottom of the imaginary vertical middle line; projecting a line from the same knee upward to the established midpoint provides the relative angle for the shape that becomes the left leg.

Proportional Relationships In spite of what we actually see, it is startling to discover how much our perception, unchecked, is influenced by what we know about an object—it is a form of built-in prejudice and it is hard to let go of the power of that influence. When we know that in physical reality one dimension is greater than another, our natural inclination is to draw it that way, being convinced that we also see it that way. Developing the habit of using the pencil as a measuring device to establish relative proportions is one of the most important aids in learning to see—thus learning to draw.

Looking again at Figures 3-7 and 3-8, you might have difficulty in determining the proportion of height to width of the overall figure or of its individual parts, or in determining the relative sizes of shapes. Holding the pencil horizontally at full arm's length and allowing the tip of the pencil optically to "touch" the outer point on the left of the figure, you can mark the overall width of the figure on the pencil by moving your thumbnail to the point corresponding to the extreme right point of the figure. Being certain to keep your thumbnail in place on the pencil, turn the pencil vertically to see how close the height is to the width. What is calculated and measured as height is an imaginary vertical line that corresponds to the distance between a horizontal line drawn at the bottom of the toes of the right foot and one touching the exact top of the head, which as you view the figure is naturally above everything else. The height is just slightly greater than the width. Remember that consistent measurements depend on holding the instrument at arm's length, since any change in distance between the pencil and the eye destroys the accuracy of the measurement. Also, closing one eye eliminates double vision. Having established the overall proportional relationship of height to width, you can begin to determine the size and placement of major subdivisions. The bottom of the buttock is just below the midpoint vertically; horizontally the halfway mark occurs exactly

where the curve of the thigh ends and the hip line begins, and also at the leftmost point of the left heel. Extending the two midpoints of the vertical and horizontal measurements places the midpoint of the overall image at the inside point of the left elbow. It is very likely that without measuring, most people would believe the midpoint to be higher and to the left.

Measurements and alignments need not be pinpointed down to fractions of an inch, nor do they have to be plotted out completely and with absolute precision on your paper. Although described as mechanical aids, they need not be adhered to rigidly. Their purpose is to provide assistance and guidance in establishing the approximate correct size, proportion, and shape relationships and in determining the placement of the shapes.

PROJECT 3.3

"Drawing without drawing" is an activity that requires no actual drawing materials, just your eyes and your finger as a substitute for a pencil to check vertical and horizontal alignments and make measurements. You simply take advantage of free moments wherever you are to look at things around you. Use your finger or thumb, or combination of fingers and thumb from both hands, to determine size and shape relationships, check angles and relative positions of above and below and right and left, and visualize how you would draw them.

PROJECT 3.4

If you do not have a model available to you, or if you would rather practice first using a similar inanimate object, a straight-back wooden chair would prove appropriate. Place it in front of you in a number of different positions: facing you, turned away from you, sideways, at an angle, on its side, turned upside down, and tilted. Note how the size and shape relationships between its parts change with each new and different position. Use your pencil and thumb in the manner described to locate and align major points, to determine correct angles, and to estimate relative proportions.

When you begin to feel comfortable using the pencil as an aid in perceiving the chair, do a number of drawings of the chair in various positions, letting your pencil serve you both as measuring device and drawing instrument. Objects of even greater complexity can be depicted with amazing accuracy when the pencil is used to search out the essential visual clues. You will be pleased at how well this simple method of measurement will assist you and your eye in quickly establishing an overall structure and correct placement of forms.

viewfinder
A flat, rectangular, usually black cardboard sheet with a cut-away center in the shape of a square or rectangle through which one looks to frame a composition. It functions the same way as a viewfinder apparatus in a camera.

positive line, shape, form
Established line, shape, or form that serves as the subject of a drawing and carries the intended visual dominance or subject meaning of a composition—whether representational or nonrepresentational. In figure-ground relationships it is defined by its opposite negative shapes.

negative space or area(s)
In figure-ground relationships, the spaces or areas surrounding the positive shapes that may also be referred to as ground, empty space, field, or void space. The negative spaces cause the positive shapes or forms to project forward, creating a three-dimensional illusion within a composition.

Proportional Rectangles Any single form or group of objects can be drawn in correct proportion by first drawing a rectangle that corresponds to the maximum height and width of the subject (Fig. 3-9). Lightly sketch a rectangle of that proportion on your paper and connect the four right angle corners of the rectangle with two diagonal lines. Divide the rectangle into quarters by adding a vertical and horizontal line through the point where the diagonals of the rectangle intersect. Locate the midpoint of the subject to determine what part of the subject fits into each section of the rectangle. Block in the major shapes—the main structure—before getting involved with details. If the subject is complex, individual quarters can be subdivided with diagonal or vertical and horizontal lines.

Fitting objects into proportional rectangles requires that you study each form carefully. Again the emphasis is on *seeing* intently, and drawing objects as the shapes you *see* rather than as specific, identifiable

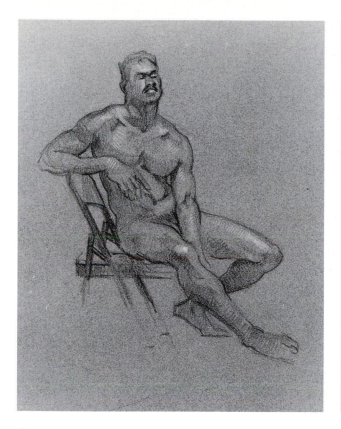

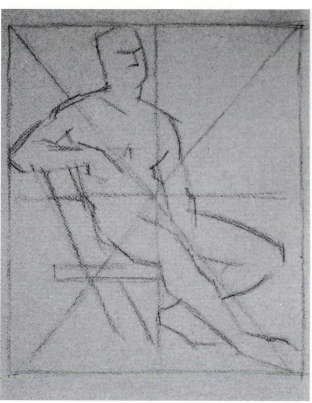

things. Drawing the shapes well is evidence of seeing well and results in more accurate representation.

3-9. Use divided proportional rectangle to block in major shapes. Courtesy of Duane Wakeham.

Defining Forms with Negative Space

A **viewfinder** created by cutting a small square or rectangle opening in a piece of lightweight cardboard or stiff paper serves as another aid to perception. It can be used to study vertical, horizontal, and proportional relationships, and if cut to the same proportions of the drawing paper, it can be used like the viewfinder of a camera to *frame* a composition. If taped to something transparent, such as Plexiglas or clear acetate on which a grid has been drawn, it can be used in a manner similar to that of a divided proportional rectangle.

Another function is illustrated in Figure 3-10, in which the viewer is held at a distance that permits the entire object (**positive shape**) to be seen through the aperture. By allowing the object to fill as much of the square as possible, it will be necessary to let the object touch the edges of the opening. The **negative space** (the shaded areas that surround the object) become defined as closed shapes between the outer edges of the aperture and the contour edges of the object. Often it is possible to draw an object more correctly by delineating the negative space rather than the object itself, since an artist generally has fewer understood concepts about the shape of the surrounding space as compared with what is known about the object.

3-10. A simple viewing square cut from black cardboard or stiff paper enables the artist to see vertical, horizontal, and proportional relationships, and permits analysis of negative space.

PROJECT 3.5

Cut a two-inch square (five-centimeter) opening in a piece of black cardboard or stiff paper of at least 8 1/2 × 11 inches to use as your frame (black because by contrast the viewed object will appear more luminous). Look through the viewer at a

3-11. EGON SCHIELE (1890–1918; Austrian). *Organic Movement of Chair and Pitcher.* Pencil and watercolor, 18 7/8 × 12 1/8″ (48 × 31 cm). Albertina Museum, Vienna.

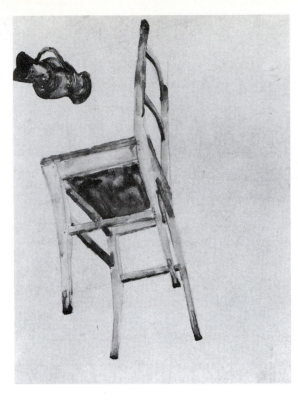

chair placed in a number of different positions. Do a drawing of the negative spaces—which, as mentioned above, are the areas left between the edges of the open square and the contour of the chair. Then, draw as shapes the internal spaces of the chair between the rungs, legs, stretcher bars, and any other openings. Even a simple wooden chair provides an excellent exercise in drawing, since it consists of a number of parts of varied shapes. It is also something extremely familiar to us yet poses a variety of different forms: geometric but not strictly geometric, subtle but not as subtle as anatomical or organic forms. Therefore, to be able to see it and reduce it to a mere group of shapes, irrespective of what we know or think about how it should look, is a positive advancement in learning how to see and draw. For additional drawings, arrange the chair so that it is viewed from an unusual angle—tipped on its side, turned upside down, or rotated to an unfamiliar position. Manipulating its position, or for that matter the position of any object, heightens aspects of seeing by posing unconventional visual possibilities. An unconventional view of objects is well demonstrated in Austrian artist Egon Schiele's pencil and watercolor drawing *Organic Movement of Chair and Pitcher* (Fig. 3-11).

PROJECT 3.6

As a variation of the previous assignment, and to get more involved with the drawing materials and an increase in scale, use masking tape to tape an 18 × 24-inch sheet of Strathmore or Rives BFK drawing paper with a moderate amount of tooth (do not use a slick-toothed paper) onto a hard surface such as your drawing table or a portable panel of masonite. Make sure the tape runs around the entire perimeter of the sheet and is pressed down firmly. With a soft, compressed charcoal stick lying on its side, darken the entire surface area of the drawing paper right to the taped edge by rubbing the charcoal stick with considerable pressure. With a piece of chamois hide, rub the charcoal further into the surface until you've created a rich black rectangle. Select one of your previous chair studies, or select a new position with the same chair, and with a white plastic eraser begin to erase the shape of the chair in the dark field, creating a light positive image against the dark negative space. You need not worry about erasing the shape of the chair back to the original

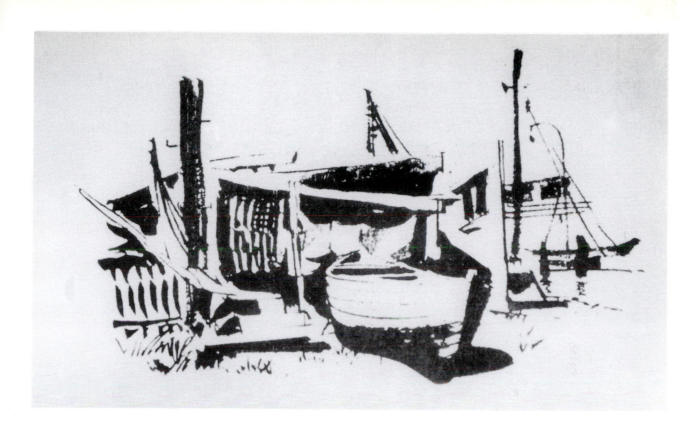

3-12. JAKE LEE (1915–1991; Chinese-American). *Boatyard*. Brush and ink, 5 × 7" (12.7 × 17.8 cm).
Collection Dolores Pharr Smith, Stockton, California.

white of the paper; instead, allow some of the marks resulting from the erasing activity to remain in the drawing as tonal, even textural, elements. The chair will dramatically emerge out of the darkness as a powerful three-dimensional illusion on the paper's flat surface. This illusion is a vital visual presence.

Make several of these drawings over a period of time to improve your seeing skills to the point of producing more accurate proportions of the chair form in space.

CRITIQUE (Project 3.6) The four critical visual elements at work in these drawings are (1) the breakup of the picture plane into interesting positive and negative shapes; (2) the contrast of lights and darks between positive and negative shapes; (3) the tonal richness of the erased or subtracted positive forms; and (4) the increased degree of interest, even mystery, evoked by the black negative shapes that create a push/pull effect with their positive counterparts. How effectively have you dealt with each of these elements as a means of strengthening your visual effects? Is the breakup of space interesting? Are the contrasts between the lights and darks dramatic? Is there visual richness in the erased areas? Do elements of both positive and negative shape simultaneously and or interchangeably advance and recede?

The process discussed in Project 3.6 is exemplified in Jake Lee's *Boatyard* (Fig. 3-12). Notice again the increased degree of mystery and drama evoked by the different black negative shapes, except that in this drawing several of the dark negative shapes function as both positive and negative elements. While far more complex than the chair in Figure 3-10, the drawing utilizes the same concept of defining forms by delineating the space that surrounds them. The picket fence, the foreground boat, the post and beam framework of the shed are positive shapes defined by the bold dark patterns of the surrounding negative space. The power pole, the shadow side of the boat and the shadowed areas of the shed, as well as the cast shadows on the ground, are seen as dark shapes in white negative space.

Once again we see the alternating patterns of light against dark and dark against light create an effect of three-dimensional space.

Negative space also plays a significant role in the drawings and paintings of Fairfield Porter. *Study* (Fig. 3-13) might appear at first glance to be a sheet of six separate landscape sketches in which one is uncertain whether Porter has drawn shapes or spaces. When the viewer becomes aware that the intervals between the individual parts are the window frames of a screened porch, what seemed to be negative space is transformed into positive shapes. The drawing defines both indoor and outdoor space, and a very noticeable shift in focus is necessary to move from interior to exterior. It is almost impossible to see foreground and background at the same time. Even though there is no variation in the line or any attempt to create space through the use of light and dark, once the notion of space is suggested, it cannot be ignored. If, however, you choose to overlook the clues such as the ends of the roof beams that cut notches into the tops of the upper rectangles, and think of the panels as drawings or prints hanging on a wall, everything, including the landscapes, becomes a three-dimensional illusion on a flat surface and no refocusing is required.

3-13. FAIRFIELD PORTER (1910–1975; American). *Study.* Ink on paper, 13 1/2 × 10 1/4″ (34.3 × 26 cm). Whitney Museum of American Art, New York (gift of Alex Katz).

Right Brain, Left Brain

Using a pencil or any other implement for measuring and as vertical and horizontal guides, using a cutout rectangle or square as a viewer and grids to clarify relationships of parts, and focusing on negative spaces to define positive shapes are valuable aids to perception because each activity isolates seeing and drawing from knowing and identifying. What is drawn becomes the result of perception (seeing intently), rather than conception (thinking intellectually). A drawing's beauty, poetry, and expressive impact collectively form the visual language that transcends the logic of human reason. When art emerges as the inaudible language of the soul, a situation of visual intrigue is captured and suspended in time. It is the extraction of an image from a subject that transcends the subject itself and creates this sought-after state of visual intrigue.

As a teacher of drawing, Betty Edwards, author of *Drawing on the Right Side of the Brain* (J. P. Tarcher, Inc., 1978), was puzzled as to why some students found it easy to draw when for others it was difficult, and why certain drawing activities produced better results than did others. The answer, she was convinced, related to different methods by which the two hemispheres of the brain process information—the left brain controlling verbal and analytical processing, the right brain controlling that which is intuitive, spatial, and relational, all that is part of visual processing, of seeing/perceiving.

In her classes, and in her book, Edwards provides drawing experiences that tap into the special functions of the right hemisphere of the brain. For some people the mental shift into what Edwards calls "right-mode" happens automatically; they are the persons who draw easily. For others, the process can be learned. The various activities that have been discussed in this chapter as aids to perception are all part of the process. They are methods that experienced artists use, part of what Edwards describes as "the magical mystery of drawing ability."

Seeing—More Than Physical Sight

From this chapter we've learned that seeing is a multifaceted activity and certainly involves more than just the penetration of an object with our physical eyes. However, the kind of seeing required of artists is not exclusive to artists alone, nor do all artists see to the depth that perhaps they should see when conceptualizing and making art. The revision author, as artist and teacher, is convinced that there are several types of seeing modes that people engage in, either naturally or otherwise. First, there are those for whom the gift of seeing is inherent in their makeup and they have exercised this ability since early childhood. Second, there are those who understand the need to see artistically and have been trained to see beyond their natural abilities. Finally, there are those people who do not have the ability or the desire to see any differently. They have trouble believing that the world around them is an environment of visual language. They see what they see and sincerely believe in the absolutes of what their physical eyes tell them—there is nothing beyond the concrete, physical object that they can prove the existence of by merely holding it in their hands. This is hollow expression.

However, life is filled with rich potential for both tangible and intangible forms of expression, and mysteriously, but not surprisingly, the arts respond to these facets of life. The artist's main expressive tools are

seeing and *sight,* and they can be comprised of either natural or learned ability, or both. The physical eye assesses and establishes the rudiments of compositional structure, along with formal technique, which is what has been discussed in this chapter. Then, the eye of the mind (soul) intercedes, penetrates, and prevails in places uninhabitable by the physical eye alone.

Often, it is those who have not had much exposure to the arts who eventually experience an epiphany in which a sunset, the wistful fragrance of violets, a particular passage of music, or a work of art stirs and transports them to where they have never been before. To be caught up in a moment of startling awareness, even to be overtaken by an unexpected impulse to respond in some way that is completely out of character for us is a remarkable thing. When this happens to an artist, the artist's perception is established as the impervious catalyst of an ensuing creative force, unaffected by our negligence of it and immune to critical words and disbelief.

The point is that everyone is capable of being moved by something visual, whatever it may be and whatever his or her level of exposure is to the arts. The fine arts reach places in the human being where no other catalyst reaches, and often, the activity of drawing is the first, certainly the most direct, symptom of some stimulating occurrence that successfully tugs at the heartstrings of the once artless personality. When we encounter what we cannot verbally explain, we draw it—we communicate it in a way independent of words, and the artist's audience receives it in silence—after all the words have been spoken and their meanings exhausted, for words are of no use at a certain point in the process of perceiving, creating, and interpreting a work of art.

This chapter closes with a poem written by Lisel Mueller entitled "Monet Refuses the Operation." In this imagist poem, the French Impressionist Claude Monet is confronted by his eye doctor, who is convinced that Monet needs eye surgery in order to correct what the physician feels are flaws in his painting. Keep in mind that Impressionist painting, as a movement in the art world in the latter half of the nineteenth century, was bucking the established aesthetic standards of the day. The name *impressionism* itself came from a painting by Monet exhibited in 1874, catalogued as *Impression Sunrise.* According to the physician, the deviation in Monet's painting from the accepted standard of ultrarepresentational art was something Monet could not help because of the assumed eye impairment. He simply could not paint well because he could not see well, thought the well-meaning doctor. It had not occurred to the physician that Monet's creative path had led him to paint deliberately in a still unknown style that often blurred images instead of striving for intricate detail in a hyperrealist or classicist fashion. It is important to point out that Monet had also allowed his inner eye to begin to speak and play a role in the creative decision-making process of his painting, as evidenced by Monet's reply to his doctor in the poem.

This poem is fictitious; nonetheless, it makes a clear point about the difference between the domain of *physical sight* and an artist's *inner vision*—or the paradox that the physical eye and the inner eye are antithetical. The physician believed in the concrete world—the world of the absolute where only those things that could be held in the hand and proven to exist had significance, and he had never considered the possibility of anything felt or perceived through the senses other than those over which logic and reason prevailed. The act of creating is an act of

faith, and faith is antithetical to logic and reason. Therefore, the intellect, by itself, would never have come to any conclusion other than one based on total absolutes.

MONET REFUSES THE OPERATION
Doctor you say there are no haloes
around the street lights of Paris
and what I see is an aberration
caused by old age, an affliction.
I tell you it has taken me all my life
to arrive at the vision of gas lamps as angels,
to soften and blur and finally banish
the edges you regret I don't see;
to learn that the line I called the horizon
does not exist and sky and water,
so long apart, are the same state of being.
It was fifty-four years before I could see
that the Rowen Cathedral is built
of parallel shafts of sunlight,
and now you want to restore
my youthful errors: fixed
notions of top and bottom,
the illusion of three-dimensional space,
wisteria separate from the bridge it covers.
What can I say to convince you that
the Houses of Parliament dissolve
night after night to become
the fluid dream of the Thames?
I will not return to a universe
of objects that don't know each other,
as if islands were the lost children
of one great continent. The world
is flux, and light becomes what it touches,
becomes water, lilies on water,
above and below water,
becomes lilac and mauve and cerulean lamps,
small fists passing sunlight
so quickly to one another
that it would take long streaming hair
inside my brush to catch it!
Our weighted shapes, these verticals;
burn to mix with air
and change our bones, skin, cloths
to gases. Doctor if only you could see
how Heaven pulls earth into its arms
and how infinitely the heart expands
to claim this world, blue vapor without end.
 —Lisel Mueller

4

Copying, Sketching, and the Power of Influences

I have always, undoubtedly for a number of reasons, wanted to copy and taken pleasure in copying, either from originals, but above all from reproductions, every work of art that touched my feelings or stirred my enthusiasm or just interested me particularly.

—Alberto Giacometti

The Tradition of Copying

When artist Mauricio Lasansky came from Buenos Aires to New York City in 1943 on a Guggenheim Fellowship, he spent most of his time at the Metropolitan Museum of Art looking at every print in the collection to learn about the field of printmaking. He felt the only way he could develop his technical vocabulary, as well as his insights into what the artists were thinking, feeling, and trying to express, was to look deeply at their work. There were, at that time, over 150,000 prints in the collection, and it is said that he studied every one of them.

In reading what artists say about their own work, one is struck by how much they acknowledge looking at, being influenced by, and learning from the work of other artists. Contemporary American painter Wayne Thiebaud credits most of his training to reading about artists and studying reproductions of their works in library books. He explains that art history remains a primary source for his paintings, and he acknowledges that he continues to make copies of paintings and drawings in order to learn from them.

Copying, in its various forms, is a legitimate activity, not for the purpose of imitation, but as a means of learning—learning to see, learning about styles and techniques—as well as stimulating the imagination through experiencing the expressive spirituality in the work of other artists. During the Renaissance, drawings existed primarily as preparatory studies for paintings and as patterns to be copied by apprentice artists as part of their training. It was not until the sixteenth century that drawings came to be considered works of art to be collected. At that time monarchs and wealthy families, usually of the aristocracy, began amassing impressive collections of drawings, but their collections were generally inaccessible except to those artists directly favored with their patronage. Museums and galleries as we know them did not come into existence until the early nineteenth century. Today, we are all the benefactors of this cultural facet of our society in that we do have access to the viewing of thousands of works of art, both historical

copying
The exact imitation of the drawings of the old masters strictly for the purpose of learning to see, learning technique, and learning about styles. The view is widely held that the most beneficial learning about drawing occurs from having as direct an experience of emulating the old masters as possible.

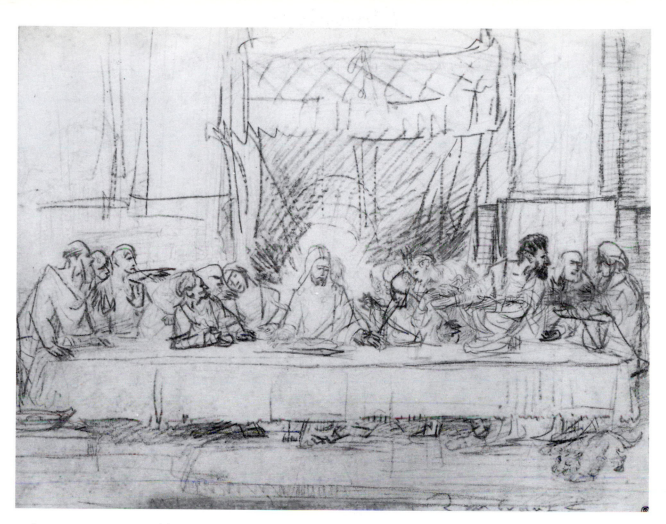

4-1. REMBRANDT VAN RIJN (1606–1669; Dutch). *Copy of Leonardo da Vinci's "Last Supper."* Red chalk on paper, 14 × 18 1/4" (35.6 × 46.3 cm). The Metropolitan Museum of Art, New York (Robert Lehman Collection).

and contemporary, in public museums and commercial galleries. In addition, we have unprecedented access to art through reproductions in books, catalogs, and periodicals. There has never been more art reproduced in print than exists today, and we tend to forget how difficult it was in the past for artists to see and study masterworks with the convenience and regularity that we enjoy today.

During the seventeenth century, the only place where Rembrandt was able to see and study masterworks was in auction houses. At the age of fourteen, he was sent to Leyden University and soon afterward became a painter's apprentice. Three years later he moved to Amsterdam, where under the tutelage of Pieter Lastman he learned Italian *chiaroscuro*. He was fortunate in that Amsterdam had become the world capital for trading art and that many major Italian collections were sent there to be sold. Rembrandt went to auctions not just to look but also to buy. Kenneth Clark describes him as an "eager and extravagant" collector, explaining that "certain works of art were absolutely necessary to him. He needed to possess them not simply to enjoy them, but to learn from them." Whenever he could not afford to buy, he made sketches of pieces that interested him. Clark, in tracing Rembrandt's debt to the Italian Renaissance, notes that "all great artists have studied the work of their predecessors and borrowed from it, if they felt the need." Rembrandt, for example, knew Leonardo da Vinci's *Last Supper* from engravings and made various studies based upon that work (Fig. 4-1).

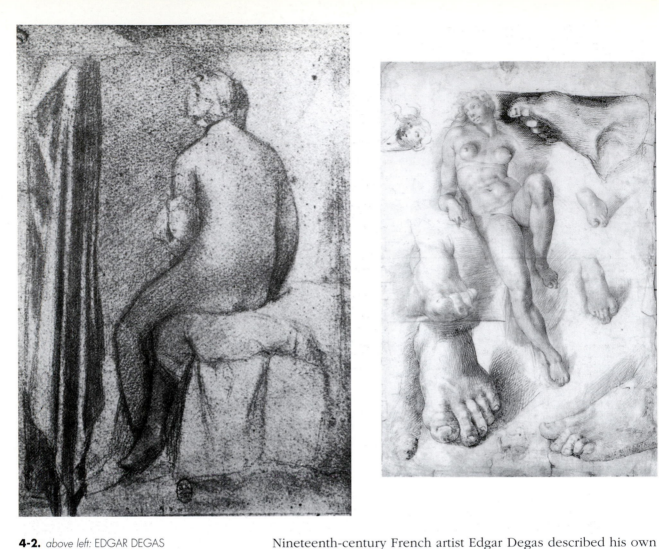

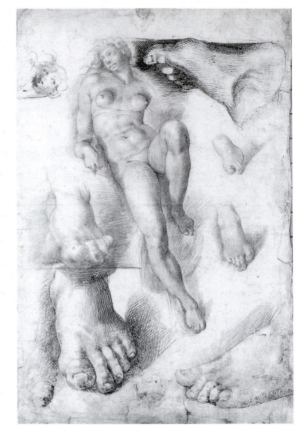

4-2. *above left:* EDGAR DEGAS
(1834–1917; French). *Sketch after Ingres's
"Bather."* 1855. Pencil on paper, 6 × 4 1/8"
(15.2 × 10.5 cm).
Bibliotheque Nationale, Paris.

4-3. *above right:* BARTOLOMMEO
PASSAROTTI (1529–1592; Italian). *Copy
after Michelangelo's "Dawn."* Brown ink
and red chalk, 17 3/8 × 11 1/2"
(44.1 × 29.2 cm).
The Nelson-Atkins Museum of Art,
Kansas City, Mo. (Nelson Fund) 39-37.

Nineteenth-century French artist Edgar Degas described his own art as "the result of reflection and study of the great masters." Like Rembrandt, Degas was an avid collector. His interest was focused primarily on Ingres, Delacroix, and Daumier, whom he regarded as the "three best draftsmen" of the nineteenth century. He owned 20 paintings and 90 drawings by Ingres, 13 paintings and 190 drawings by Delacroix, and 6 paintings and drawings, plus 1,800 lithographs, by Daumier. Degas made direct copies of the works he admired (Fig. 4-2) and frequently introduced ideas adopted from other artists' work into his paintings as an act of tribute.

It is important to distinguish between the benefits of copying for the sake of learning and copying in order to enhance or build upon an artist's idea through reinterpretation—as both of these activities are prevalent, meaningful, and essential in the art world. Copying for the purpose of learning the artist's technique must be done in such a way that the actual and perceived spirit of the artist is tapped into as much as is possible by the one attempting to copy. Experiences and perceptions revolving around a common subject vary greatly among artists and make it all the more challenging to attempt to copy a masterwork. Nonetheless, one must try to relive the situation as closely as possible in order to understand the original artist's creative experience both technically and conceptually. If this fails to occur, the creative experience as

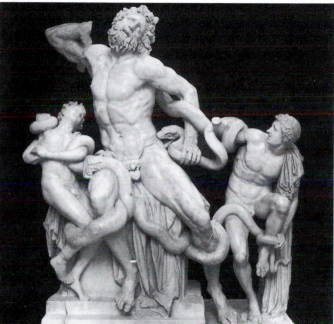

well as the resulting product is diminished. In essence, one steps into the artist's shoes.

Ancient and Renaissance sculpture, in the original or in plaster replicas similar to those still found in art schools, introduced the human figure to countless generations of art students and provided them with acceptable standards for "noble physiques" and "eloquent poses." Bartolommeo Passarotti's *Copy after Michelangelo's "Dawn"* (Fig. 4-3) shows particular interest in the left foot of one of the sculptured figures from the Medici tombs in the Church of San Lorenzo in Florence. Passarotti's drawing technique is patterned after that of Michelangelo (Fig. 14-5). In a similar manner, when Eugène Delacroix made studies of two pairs of legs and an arm from a painting by Rubens (Fig. 4-4), he employed a vigorous pen technique sometimes used by Rubens himself.

Looking at a drawing done from Greek sculpture, it is interesting to identify Giacometti's free-flowing, searching analysis of the exaggerated and complex movement of *The Laocoön* (Figs. 4-5, 4-6).

4-4. *top:* EUGENE DELACROIX (1798–1863; French). *Study after Rubens.* Reed pen and ink.
© The Art Institute of Chicago, all rights reserved; Charles and Mary F.S. Worcester Collection.

4-5. *above, left:* ALBERTO GIACOMETTI (1901–1966; Swiss-French). *The Laocoön* (Vatican Museums, Rome). Ballpoint pen on paper, 8 1/4 × 11 1/2" (20.9 × 29.2 cm). Collection Louis Clayeux, Paris.

4-6. *above, right:* AGESANDER, ATHENODORUS, AND POLYDORUS OF RHODES. *Laocoön Group.* c. 150 B.C. Marble, height 8' (2.44 m). Vatican Museums, Rome.

Giacometti copied from everything, tracing lines with his fingers when he had no pen or pencil in hand. He explained that in the evening and during periods of waiting he would open art books at random and make copies. For him, copying was a means of clarifying his knowledge about what he was seeing, not by a slavish line-for-line duplicating of the work or the photograph, but by feeling form, rhythm, and placement with his, pen, pencil, or finger.

Rico Lebrun's *Study from Goya's Portrait of Maria Luisa* (Fig. 4-7), taken almost directly from Goya's *Portrait of Charles IV and His Family* in the Prado, and John Piper's very similar ink-wash value study of Giorgione's *Tempest* (Fig. 4-8) both offer an analysis of the use of light and dark as an important aspect of pictorial composition.

The well-worn adage "art comes from art," is certainly true and validates the power of influence that is both universally generated and felt by artists in the creative disciplines throughout history. Furthermore, whether one is an artist, art student, or audience member, the power of inspiration takes us deeply into the source of that inspiration. Therefore, copying, both as a means of learning and as an expression of admiration for another's work is common practice in all the creative arts. It is perhaps the most apparent in music, where composers throughout history have learned and been inspired by studying the works of their predecessors and contemporaries, sometimes introducing themes from works they admire into their own compositions. Performance artists often acknowledge not only their teachers but also other artists whose styles they have studied.

Most writers will admit to the necessity of learning the rules of grammar, while stressing that you learn to write by studying what others have written. A much-heralded event in the world of fiction was the 1991 publication of the sequel to *Gone with the Wind,* fifty-five years after the famed novel was published and forty-two years after the death of its author, Margaret Mitchell. When Alexandra Ripley was selected to write the long-awaited sequel, she prepared for the task by copying lengthy sections of the original novel in longhand, explaining that she did so to get a better sense of Mitchell's style than could be gained by numerous rereadings of the book, even though her intention was not to imitate the earlier writer.

The purpose of copying, as discussed in this chapter, is to provide an understanding of how someone has done something, rather than to produce a duplicate of what that person has done. However, in the case of appropriating an exact copy for purposes of artistic restatement, as a matter of ethics, the appropriating artist must acknowledge the original authorship. In other words, even the most convincing facsimile must be acknowledged as a copy because to misrepresent it as anything else is unethical and will destroy the integrity of the artist's intention and restatement.

Copying Activities Each of the drawings illustrated in this chapter thus far represents an aspect of copying, but not one of them is an exact copy, nor are you encouraged to attempt to copy any drawing line for line. It would be appropriate and beneficial, however, to practice drawing in the manner of some of the many examples reproduced in this book, which have been selected to acquaint you with a variety of creative uses of media and techniques, and to introduce you to different approaches to handling form, composition, and subject matter. In doing

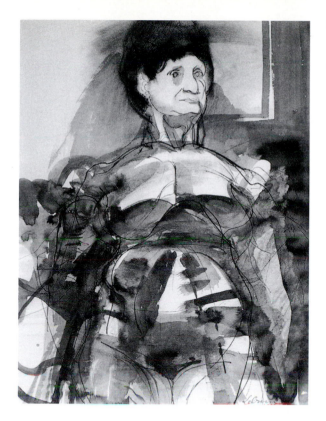

4-7. RICO LEBRUN (1900–1964; Italian-American). *Study from Goya's "Portrait of Maria Luisa."* 1958. Pen and brush, black carbon ink, and watercolor on white paper, 25 × 18 15/16" (63.6 × 48.2 cm). Worcester Art Museum.

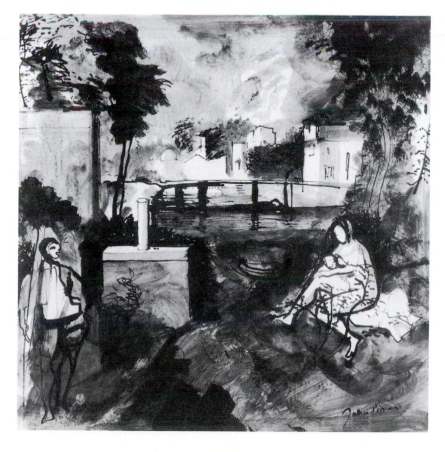

4-8. JOHN PIPER (1903–1992; English). *Copy of Giorgione's "Tempest."* 1952. Black ink and gray wash over purple crayon on white paper, 15" (38 cm) square. The Fogg Art Museum, Harvard University, Cambridge.

so, you will begin to gain an understanding of why an artist chooses a particular medium with which to work. Every medium has its own inherent expressive qualities that the trained artist recognizes and selects specifically in order to produce a desired effect. When an artist chooses several different media to work with in the same drawing, he does so in an effort to produce a multiplicity of effects, as evident in Figures 4-7 and 4-8, where Rico Lebrun and John Piper use both wet and dry media to produce their gloriously rich compositions. Again, the emphasis is on "seeing," and naturally, copying activities require that you look closely and see deeply in order to recognize how the various drawing media blend to form their unique and even eldritch effects. This begins to touch on the subject of mixed-media drawing and how it offers up a unique set of expressive circumstances. Mixed media will be discussed in Chapter 18.

Along with this text, use other art books and museum catalogs as well to study and broaden your pictorial vocabulary of the vast history of drawing. In the process of looking, seeing, and copying, do not allow yourself to become intimidated if your drawings do not exhibit the same mastery of media and technique—it is highly unlikely that they will, at least at first. Keep in mind that what you are looking at has been generated only through years of discipline and hard work that eventually enable an artist to acquire a high degree of skill and mastery over not only the subject but the media as well.

Looking at reproductions, however, is a poor substitute for studying original works. Try to see original drawings whenever possible. If it is not convenient to copy directly from them, make a mental picture of them by studying them line for line, detail by detail, as you would if you were making a copy directly on paper.

The Tradition of Sketching

The late-nineteenth-century French painter Gustave Moreau stunned his more conservative teaching colleagues at the École des Beaux-Arts in Paris by sending his students, including Henri Matisse, into the streets to observe and sketch life around them. While it might not have been deemed an appropriate academic procedure, sketching in the streets was certainly not a new concept. Just as artists throughout history have copied, so too have they done quick drawings from life, frequently in the streets and in the marketplaces where people gather. Here they acted as visual reporters witnessing and recording everyday occurrences. The images in these marketplace drawings came directly from sketches, or from mental sketches if pencil and paper were not readily available.

An artist whose work illustrates the daily myriad of human activity in the marketplace is Pieter Brueghel the Elder. The seven compositions of his series *The Seven Virtues,* although highly abstract, portray surroundings familiar to people of his day. The pen and dark-brown ink drawing entitled *Prudentia* (Prudence) (Fig. 4-9), done in 1559, illustrates the layered density of the artist's mind. Whether the images are derived from sketchbooks or mental pictures and recollections, they find merit in the complex orchestration of Brueghel's marketplace scenes. As a visual composer, Brueghel was a progenitor of a variety of potent theatrical treatments of his main characters. In the drawing *Prudentia,* he embellishes both the common and uncommon in the context of an everyday scene depicting the chores of life: harvesting, butchering, stor-

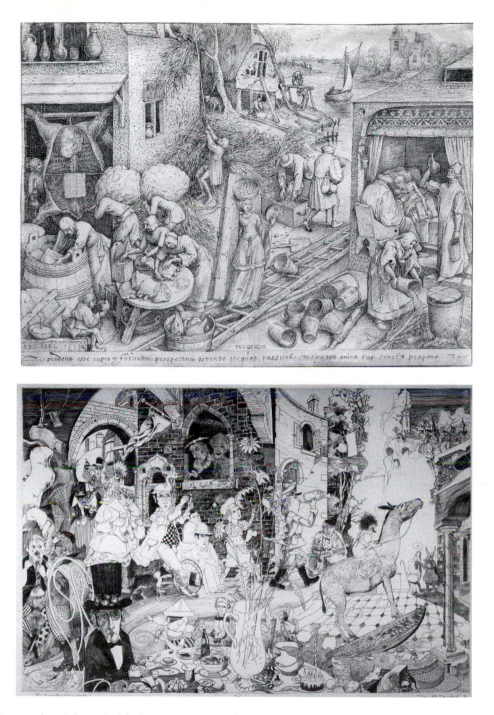

ing, and repairing, even tending to the sick and elderly as we see in the middle right-hand side of the composition.

Reminiscent of Pieter Brueghel the Elder is David Driesbach's engraving *The Everyday Occurrence* (Fig. 4-10), which in similar fashion exemplifies the collective array of street and marketplace activities that produce rich and varied statements of form and space within the composition. These fictitious accounts of human interaction recall motifs from much earlier periods in art history, although, metaphorically, they occur today with as much unpredictability as in the past. Driesbach chose to freeze this imaginative frame of improvised activities to reflect his own personal symbolism. In his work, the marketplace serves as the

4-9. *top:* PIETER BRUEGHEL (1525/30–1569/70; Flemish). *Prudentia (Prudence).* 1559 Pen and dark-brown ink on paper. Musées Royaux de Beaux-Arts de Belgique. Koninklijke Musea voor Schone Kunsten van Belgie, Brussels.

4-10. *above:* DAVID DRIESBACH (b. 1922; American); *The Everyday Occurrence.* 1973. Engraving on copper printed on white wove paper, 23 3/4 × 35 3/8″ (60.3 × 90 cm). Courtesy of the artist. Collection of David Faber.

CH. 4 Copying and Sketching **59**

main stage of daily activities where everything appears to be in motion simultaneously. As in Brueghel's drawing, the characters in Driesbach's engraving seem to be engaged with, yet strangely unaware of, each other. Upon viewing it, one begins to anticipate the unexpected within the incidental, everyday occurrences of this energized and highly symbolic composition. The revision author of this book was a student of the artist, and he remembers the ease with which his professor engraved on a copper plate using a burin as if it were merely a pencil on paper. For his work *The Everyday Occurrence* there were no preliminary sketches, but only mental pictures generated from the artist's imagination. He started with the man wearing the top hat seated at the table in the lower left-hand corner—meant to be a self-portrait. Uniquely, every subsequent image in this engraving radiated outward from the self-portrait as if coming directly from Driesbach's imagination or recollection, and was sliced into the copper with all the mastery and skill of an improvisational film director working on his set.

Human activity provided the emotional force behind the drawings of crowded street scenes, and often the artist worked unobserved. For instance, the denizens of Union Square in New York City—unemployed men standing and sitting about in the street during the Depression, young working women perched on stools in drugstore soda fountains—became the unsuspecting models of Isabel Bishop. For drawings such as *Men, Union Square* (Fig. 4-11), she was forced to work rapidly before the men altered their poses.

Sketchbooks Leonardo da Vinci suggested: "You will be glad to have by you a little book of leaves [pages] . . . and to note down notions in it with a silverpoint . . . when it is full, keep it to serve your future plans, and take another and carry on with it." Leonardo's "little book of leaves," what we refer to as a sketchbook, is one of an artist's most important tools. As Leonardo indicated, a primary purpose of the sketchbook is collecting information and recording ideas, either jotted down quickly or explored and developed more fully, depending on the occasion. A second purpose of perhaps greater importance, particularly for beginners, is that the ongoing activity of sketching helps train the eye and the hand. Degas did as Leonardo directed. Preserved in the Bibliotheque Nationale in Paris are thirty-eight of Degas's notebooks containing more than 2,000 pages of sketches, studies, and copies.

A sketchbook can be of any form—bound, spiral, a loose-leaf binder, even loose sheets carried in a folder or envelope. While some sketchbooks are manufactured with quality drawing paper that can be used with a variety of media, an adequate and inexpensive substitute is a bound or spiral notebook with blank pages, commonly available in college bookstores. The obvious advantage of a bound or spiral book is that both eliminate the problem of losing individual sheets. A disadvantage of a bound book is the inevitability of wanting to discard one or more pages and not being able to. A sketchbook, however, is not meant to be a book of finished drawings with the book itself being considered a work of art. Anyone looking through the pages of Degas's notebooks immediately perceives that he did the drawings only for himself, yet in spite of the inclusion of bad drawings, false starts, and seemingly meaningless doodles, the collection represents a remarkable record of creative activity.

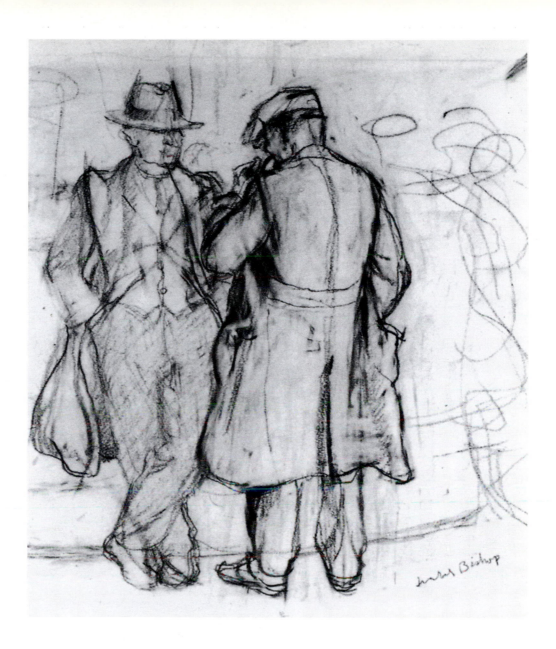

4-11. ISABEL BISHOP (1902–1990; American). *Men, Union Square.* Pencil on paper, 12 1/2 × 12 3/4″ (31.8 × 32.3 cm).
Courtesy Midtown Galleries, New York.

Approaches to Sketching The term **sketch** generally implies a drawing done quickly with minimal or no elaboration, using scribbled lines and tones to suggest form, texture, and shadow. Sketching successfully requires that one have the ability to see quickly and clearly, to concentrate and make judgments—to glean only what is essential from a particular subject or scene.

The activity of sketching is essential for both amateur and professional artists in collecting and recording information. The regular practice of sketching contributes to continuous development, so that in time the response of the hand to the eye becomes spontaneous. Frequent sketching does for the artist what daily workouts do for the athlete—it not only keeps the artist's eye and hand in shape, but also strengthens the artist's ability to see and understand form. But sketches are of little value as reference unless the lines, shapes, and forms have meaning. George Luks, a member of the early twentieth-century "Ash Can School" who depicted the turbulence and vigor of life in New York City,

sketch
A drawing done quickly with minimal or no elaboration but that may use scribbled lines or tones to suggest form, texture, and shadow.

4-12. GEORGE LUKS (1867–1933; American). *River Junkman*. Plumbago on tracing paper, 11 1/4 × 9 1/4″ (28.6 × 23.4 cm).
University of Michigan Art Museum (1972/2.36)

4-13. JIM WESTERGARD (b. 1939; American-Canadian). *Trespass*. Pen and ink on paper, 4 1/2 × 6 7/8″ (11.4 × 17.4 cm).
Courtesy of the artist.

plumbago
Same as *graphite*.

achieved an amazing degree of energy in his *River Junkmen* (Fig. 4-12). In this **plumbago** sketch, he captures effects of light, sound, texture, movement, and space, using only soft graphite and zigzag lines seemingly drawn without taking time to think too consciously, but instead feeling the subject and space instinctively. Jim Westergard's sketch of an aerial view of the Canadian Prairie, *Trespass* (Fig. 4-13), depicts a sense of light, depth of field, atmospheric airiness, and deep pictorial space accentuated by the increasing scale change of the footprints coming toward us as if made by an outdoorsman in the snow.

Rembrandt's *Three Studies of Women, Each Holding a Child* (Fig. 4-14), sketched directly with a fast-moving pen, reveals that clarity of concept is not dependent on completeness or detail. Even without drawing full figures, the artist presents a strong sense of life and human caring. As an intended bonus, Rembrandt includes a sketch, full of character, of a bearded man in a large fur hat. The incongruity of the different subjects of the man and three women perhaps indicates that Rembrandt's attentions were divided between two concepts. Nonetheless, the pages of artists' sketchbooks are often visually interesting because of their composite nature—their multiple, singular concepts forming compositional complexities on a single page. In the mind's eye, however, one can see that the lone figure of the bearded man might work well by itself and that the drawings of the three women without the man could form an equally interesting but entirely different composition. Regardless of his intent, Rembrandt's drawings were done mostly on individual sheets that he filed according to subject for later use in his painting and prints.

Somewhat similar to Rembrandt's example of a group of separate sketches assembled on a single sheet is Picasso's *Scene de Bar* (Fig. 4-15). The various studies are related only in that, as the title indicates, they depict figures observed in a bar. Individual heads and figures are placed wherever space is available rather than to establish a composition. Although it is barely definable, in the center of the page Picasso suggests what appears to be a tangled party of inebriates struggling to hold each other upright. The figure in the lower right corner is indicated in a very simplified manner, while the woman at the left is defined with greater detail and individuality. Picasso maintained a daily routine of sketching as evidenced by the 175 sketchbooks discovered following his death in 1973. As with many of the old masters, sketching was for Picasso as important and sustaining an activity as anything else he did in life.

The Camera as a Tool It is unfortunate that in the twentieth century the camera came to be accepted as a kind of substitute for the sketchbook. It is true that the camera is useful in gathering and recording information, which was traditionally a function of the sketchbook, but its inventors never intended the camera to replace an artist's need for the

4-14. REMBRANDT VAN RIJN (1606–1669; Dutch). *Three Studies of Women, Each Holding a Child.* Pen and brown ink, 7 3/8 × 5 7/8" (18.7 × 14.8 cm). Pierpont Morgan Library, New York.

4-15. PABLO PICASSO (1881–1973; Spanish-French). *Scene de Bar,* page of studies. c. 1900. Conté, 5 × 8 1/8" (12.7 × 20.6 cm). Courtesy Christie, Manson & Woods, Ltd.

4-16. JEAN FRANÇOIS MILLET (1814–1875; French). *Morning.* Black crayon on paper, 6 3/4 × 10" (17.1 × 25.4 cm.). Louvre, Paris.

visceral activity of seeing, understanding, and drawing. However, the camera, albeit far advanced from its earlier days, has established itself as a ubiquitous tool in all fields of the fine arts, and in particular, photographic processes of all kinds have come to be of great assistance to visual artists in widening their scope of media involvement. The camera, as a tool, should no longer be regarded a threat to the act of drawing, for it has become an important means in the making of art, not strictly a means to an end, as traditional artists once might have feared. The camera is "art friendly" and has enabled artists to reach greater heights, especially in the areas of scale manipulation. As we forge deeper into the twenty-first century, we can expect photographic technology to afford artists even more advanced methods of manipulating imagery, but none of this takes the place of the joy, the sensation, or the power inherent in the act of drawing.

What a camera cannot do is perform a second function of much greater value to the beginning artist—that of training the eye, mind, and hand. It is precisely that training, gained through years of sketching, which permitted Jean François Millet, in his crayon sketch *Morning* (Fig.4-16), to suggest the strong, steady, yet graceful movement of the donkey with lines, some tentative and searching, some direct and assertive, some not even drawn. The effectiveness and beauty of the sketch lie in the skill and sensitivity with which he responded to the moment of vision with the appropriate choice of lines. Even though awkwardly drawn, the stride of the figures provides an interesting visual contrast to that of the animal. It seems unlikely that a drawing done from a photograph of the same grouping would have produced so satisfying an image—a testimonial to the fact that an artist needs to witness life in order to capture its essence. This is often where photographs fall short.

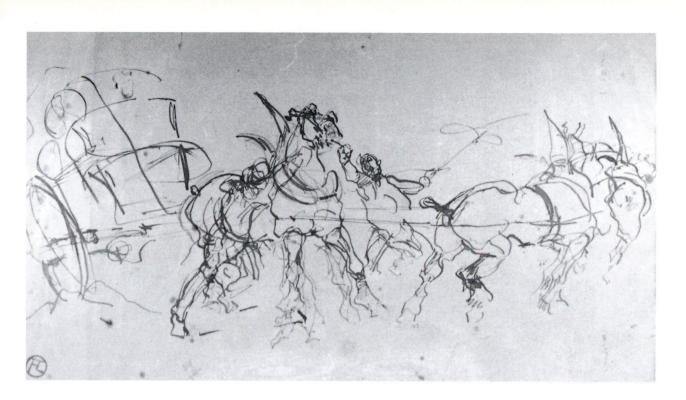

4-17. HENRI DE TOULOUSE-LAUTREC (1864–1901; French). *Vintages a Celeyran*. 1883. Pen and ink, 9 3/8 × 13 3/4" (23.8 × 34.9 cm.). Musee Toulouse-Lautrec, Albi.

Toulouse-Lautrec lived at a time when cameras and photography were becoming popular and sometimes used photographs as a source for his work (Figs. 14-29, 14-30), but he also sketched obsessively. According to one writer, "He had a sketchbook everywhere he went, and his pen or pencil was always running in nervous fluid lines through it, or on any other surface that was handy. . . ."

Defining Style through Sketching Individual artists evolve their own style or styles of sketching by sometimes using different techniques, depending on the subject being depicted and the medium used. Many artists are drawn to a particular medium that seems right or comfortable to them and through which they can display their virtuosity by working with a particular motif or subject. This marriage of individual strength and mastery of skill decidedly enhance the subject, causing it to reach newfound, even sublime, heights of translation or reinvention. The translation of an image through an artist's channels often establishes an indelible relationship between artist and subject matter, as in the case of Pablo Picasso (Fig. 2-16) or Philip Pearlstein (Fig. 5-14), where the image of the human figure becomes readily identifiable as a result of the authentic, technical handling of the figure by each artist. Style, the ever-changing and elusive gown that works of art wear, is what separates the look of one artist from that of another. In decided contrast to the quiet, gentle mood created by Millet, Toulouse-Lautrec's *Vintages a Celeyran* (Fig. 4-17) depicts energy and power with a pen line equal in strength and intensity to that of the straining animals.

Sketches are not intended to be highly detailed, finished drawings, and yet they exude a remarkable amount of information that may, at times, surpass that of a highly detailed drawing because of the infinite power of line energy, as exemplified in Toulouse-Lautrec's work (Fig. 4-17). The degree to which individual sketches are developed is determined by time limitations, the purpose for which the sketch is

4-18. CHARLES MOVALLI (b. 1945 ; American). *Landscape Sketch*. Pencil, 4 1/4 × 4″ (10.8 × 10.1 cm). Collection Dolores Pharr Smith, Stockton, California.

4-19. THEODORE ROUSSEAU (1812–1867; French). *Forest Landscape*. Pen and Bistre, 4 × 6 5/16″ (10.1 × 16.1 cm). Museum of Fine Arts, Budapest; Majovsky Collection. (MFA 1935-2783)

intended, and the amount of information needed. There is little doubt that Charles Movalli's shorthand-like landscape notation (Fig. 4-18) represents for him a more vivid visual experience than would a photograph of the scene. While Theodore Rousseau's *Forest Landscape* (Fig. 4-19) provides only a summary indication of shapes and masses, his years of accumulated experience as a landscape painter would allow him to extract the necessary information from such a simplified sketch. Rousseau's sketch, however, might well seem useless to someone such as Thomas Cole, one of America's first important landscape painters. Cole would hike into the beckoning wilderness with a sketchbook in his backpack to make highly detailed drawings, including written statements and notations, for paintings to be done in his studio during the winter months (Fig. 4-20).

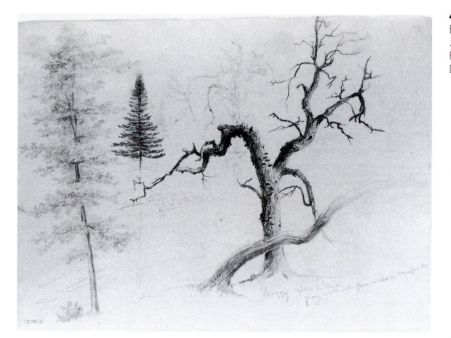

4-20. THOMAS COLE (1801–1848; English-American). *Maple, Balsam Fir, Pine, Shaggy Yellow Birch, White Birch.* 1828. Pencil, 10 3/4 × 14 1/2". (27 × 37 cm.). Detroit Institute of Arts.

4-21. JOHN SLOAN (1871–1951; American). *Sketch for "McSorley's Bar."* 1912. Pencil, 6 × 6 1/2" (15.2 × 16.5 cm.). Huntington Library and Art Gallery, San Marino, Calif. (gift of the Virginia Steele Scott Collection).

Remember that sketches are not meant to be finished drawings; more often they are merely notations in which an artist records a visual impression of something seen, remembered, or imagined. Often, an impulse to depict something he has seen occurs from deep within the artist. When an experienced artist receives a signal, even on impulse, it is time to act. John Sloan's *Sketch for "McSorley's Bar"* (Fig. 4-21), which

was developed into one of his finest paintings, was drawn on two overlapping scraps of paper, apparently all that he could rummage together as he stood at the bar. Perhaps he had never expected to come away from the bar with a potent idea in hand, but the moment took him by surprise and culminated in the birth of a wonderful work of art.

Sketchbooks for artists are like journals for writers. They provide a continuous source of motifs and ideas for compositions as well as an entertaining record of the past. Sketchbooks provide the artist with an ever-growing repository of images, and whenever an artist has the choice of selecting an idea from a host of different possibilities, the concluding choice could be thought of as a "proven concept" that has stood the test of time against a myriad of other images.

PROJECT 4.1

Choose to follow Leonardo's guidance and carry a sketchbook with you at all times and draw in it whenever you have a few free moments, sketching anything and everything—people, animals, things around you that you'd ordinarily not think to draw. Objects that do not seem "artistic" can prove intriguing to draw. Whether it is intriguing or not, draw whatever you see before you. It will eventually become clear that every drawing you do is a learning experience regardless of subject matter.

The more you practice drawing in your sketchbook, the more visually trained your eye will become. As you confront an unpredictable variety of subjects, your eye, mind, and hand will learn to adapt to the different requirements of various subjects that present themselves to you unannounced.

CRITIQUE (Project 4.1) It may seem superfluous to critique a sketchbook, but it is important to consider how the experience of sketching frequently throughout your daily life has benefited you and increased your seeing, your sketching, and ultimately your drawing skills. Has the notion of sketching something unpredictable at a moment's notice become more natural to you? Have you found that you have captured common objects in interesting ways? Do you have a sense that even the act of sketching can endow certain subjects with renewed visual importance, even intrigue?

Line 5

*Everyone knows that even a single
line may convey an emotion.*

—Piet Mondrian

A line is a dot that takes a walk.

—Paul Klee

Throughout art history **line** has been the most important of all the descriptive graphic elements employed by the visual artist. Line possesses the inherent life contained within any work of art. It is the circulatory system of visual composition. Line can be used objectively to record visual observations and to describe forms in space, or subjectively to suggest, evoke, and imply an endless variety of experiences, conceptions, and intuitions. Line is the visual pathway for the eye to travel along as one looks at art, whether it is a drawing or an etching, a painting or a sculpture. There is almost nothing that cannot be symbolized or reinvented with line. The student learning to draw soon discovers what is involved in assuming control over so powerful a tool.

Line, even in its simplest form, possesses the power to suggest direction and describe contour, define and divide space, and capture motion. It is a highly descriptive force with its varied repertoire of length, width, tone, value, and texture. As soon as a line begins to change direction—to move in curved or angular fashion, to fluctuate in width, and to have rough or smooth edges—its active and descriptive powers increase many times. Every mark made on paper, whether it be a consciously determined line or just a scribble, will inevitably convey something of the maker as well as the subject to the sensitive observer. It is therefore possible for the viewer to conclude that Robert Blum's lively, energized sketch of the painter and teacher William Merritt Chase (Fig. 5-1) is as revealing of the temperament of the artist as it is expressive of the nature of the subject. We see the power of line in an entirely different way in Jasper Johns's drawing *Flag, 1955* (Fig. 5-2), where again a revelation of the temperament of the artist is evident, but in this case line is used to describe the flag in an unconventional

line
The pathway of a moving point; the trail of deposited material or a scratch resulting from dragging a drawing tool or stylus over a surface. A line is usually made visible by contrasts in value or surface.

69

5-1. ROBERT BLUM (1857–1903; American). *William Merritt Chase.* Pencil on buff paper, 6 3/4 × 4 1/2" (17.2 × 11.4 cm).
Collection of Paul Magriel. The Arkansas Arts Center Foundation Collection.

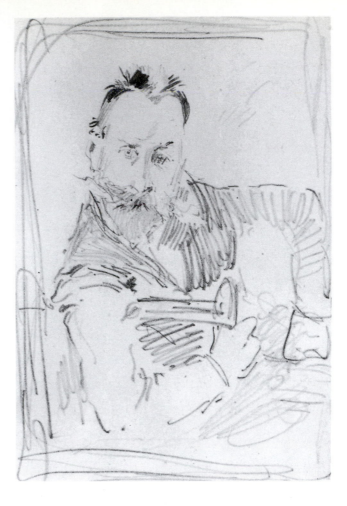

5-2. JASPER JOHNS (b. 1930, American). *Flag,* 1955. Graphite pencil and lighter fluid on paper, 8 7/16 × 9 7/16" (21.4 × 24 cm) sight.
© Jasper Johns/licensed by VAGA, New York, N.Y. Collection of the artist. Photo by Harry Shunk.

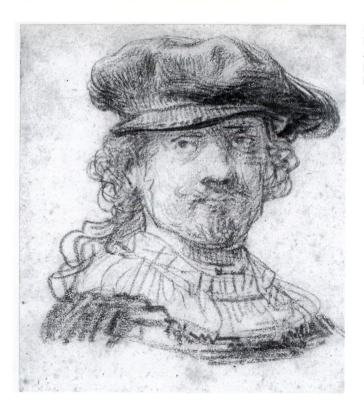

5-3. REMBRANDT VAN RIJN (1606–1669; Dutch). *Self-Portrait.* Red chalk, 5 1/8 × 4 3/4″ (13 × 12.1 cm). National Gallery of Art, Washington, D.C., Rosenwald Collection.

way. This is a beautiful and sensitive drawing composed entirely of line and the building up of linear density into a formidably descriptive, tonal, and textural presence. Let's look at the use of line once more in the work of Rembrandt van Rijn's *Self-Portrait* in red chalk (Fig. 5-3), where the tonal and textural qualities of line are once again uniquely descriptive. Here the capabilities of the drawing material, the temperament of the artist, and the characteristics of the subject (the artist) come together succinctly as one essential expression.

The Contour Line

Line is a convention that artists use to translate three-dimensional images into visual symbols on a flat, two-dimensional surface. As we observe forms, we do not see lines; we see edges or **contours** of forms that produce lines. As the subject moves or is moved, as the position of the artist as viewer changes in relation to the subject, other aspects of the form and new edges are revealed. Lines that delineate the edges of forms, separating each volume or area from neighboring ones, are termed **contour lines.**

To develop sensitivity and skill at **contour drawing,** the student tries to master an exact and almost unconscious correspondence between the movement of the eye as it traces the precise indentations and undulations of the edge of a form and the movement of the hand holding the drawing instrument. You will find that a pencil or pen will be more responsive and more articulate than charcoal. The development of this faculty of eye-hand coordination is invaluable in all drawing activities because it relies once again upon the penetration and accuracy of sight and seeing. The eye tells the artist what the line should reveal before it is drawn by the hand. In Henri Gaudier-Brzeska's *Standing Female from the Back* (Fig. 5-4), the contour line, at

contour
The outermost extremities or limits of a shape, whether two-dimensional or three-dimensional, as in the skin or shell of an object, form, or volume; contour may be associated with the outline of a subject and may change with different viewing positions.

contour lines
Lines that delineate the very edges of forms and separate each volume, mass, or area from its adjacent or neighboring forms.

contour drawing
Drawing that focuses on capturing in a highly descriptive way the extreme edges of a shape, form, or object, depicting it as separate from its adjacent or neighboring forms.

5-4. HENRI GAUDIER-BRZESKA
(1891–1915; French). *Standing Female
from the Back.* Pen and blue ink on paper,
14 5/8 × 10" (37.1 × 25.4 cm).
The Art Museum, Princeton University
(Acc. No. 48-137).

its most expressive, appears to follow the artist's eye as it perceives the
edge of the form.

Project 5.1

Any soft graphite pencil such as 4B or 6B is best for beginning contour drawing be-
cause it produces a firm, relatively unmodulated line. Erasing is not encouraged in
this assignment because the point of the assignment is not to make proportionally ac-
curate drawings but to produce line drawings of high description. Contour drawings
can be made of any object, but geometric forms are not as interesting to draw as ir-
regular subjects such as a shoe or boot, a book bag, a baseball mitt, or your own
hand or foot. Strictly symmetrical objects are not good because beginners are likely
to be discouraged by the inevitable deviations from symmetry that occur.

Start drawing at some clearly defined point, attempting to work about life
size. Look only at the subject, not at your drawing—this is referred to as **blind con-
tour.** Remember that your hand must follow your eye—not the reverse. (If you posi-
tion the object so that you must turn away from your paper to see it, you will be less
tempted to keep glancing at your paper.) This will be difficult at first because looking
at your paper will be involuntary and you must break the habit of naturally looking
back and forth from subject to paper. Let your eye move slowly along the contour of
the form; do not let your eye get ahead of your pencil. Both looking and drawing
should be slow and deliberate; speed is not your goal. As your eye moves, follow
that movement with your hand and the pencil. Imagine that the exact point of eye

blind contour

A drawing process where the eye is
trained to follow the contours of what
is being drawn, looking only at the
subject, not at the paper. In this
process, the hand moves the drawing
tool in synchronization with the move-
ments of the eye.

72 PART 3 The Art Elements

contact on the edge of the form is the same as the pencil point on your paper and that your hand exactly follows your eye movements. Try to respond to each indentation and bulge with an equivalent hand movement. When you come to a point where the contour being followed disappears behind another or flattens out to become part of a larger surface, stop drawing. You may, if necessary, glance back at your pencil and drawing surface to determine another starting point.

You will discover that contour drawings done with minimum reference to the paper often grow wildly out of proportion, but as mentioned earlier, this is not the primary concern; rather, contour drawing is an exercise in coordinating the eye and the hand.

Change the position of your subject and repeat the procedure. Placing objects in other than their usual position and seeing them in a different perspective forces you to look more carefully and to see the object more intimately than before.

Project 5.2

As a challenge and a valuable exercise, close your eyes and draw the object from memory by re-creating the visual and physical sensations. In your mind's eye, see the entire picture plane of the paper in front of you and note through sensation the distance between your hand and the edges of the picture plane. The process of stimulating visual recall is more important than the results. This provides the basis for drawing from memory.

Project 5.3

Do a contour drawing of a more complex form or group of objects—a bunch of bananas, celery, beets, or carrots; a basket with onions or leeks, or other vegetables or fruits of irregular shape. Because it is more important to be drawing than searching for the perfect objects, just draw whatever is readily available to you. Kitchen utensils such as an eggbeater or electric mixer are familiar, inanimate objects that make interesting drawings. Remember that very ordinary objects increase in visual interest when tipped on their sides or seen in other than their customary positions. Why have artists had a long fascination with still-life objects? Because they live with them—they are always around and artists have always had an interest in giving uncommon life to common objects through artistic reinvention.

As you look at your still-life objects, begin with the closest form or the most forward part. Try to draw all around each form or part without looking at your drawing. Draw with long, continuous lines rather than short sketchy lines; do not be concerned about making corrections. The inevitable distortions that will occur might well contribute an expressive character to your drawing. Later you may deliberately choose to select and introduce a similar kind of distortion into other drawings.

Sketchbook Activities

Practice contour drawing in your sketchbook, establishing the habit of looking at the subject rather than at your drawing. Effective drawing depends upon learning to see accurately and deeply. When you are not drawing, continue to practice looking at objects as if you were engaged in drawing them by letting your eye slowly examine every fraction of an inch of contour. Later, try drawing those objects from memory.

Contour and Line Variety

Line variation in and of itself is a powerfully expressive tool. The swelling and tapering characteristics of line command the interplay of spatial relationships as well as descriptive contours. A continuous contour line of uniform width and weight results in a persistently two-

dimensional effect. By introducing variations in thickness and weight, you can make a line appear to advance and recede in space. In this sense, line controls the activation of spatial relationships as it describes form in space and establishes the illusion of three-dimensionality of form. Thick and thin lines made from a variety of different drawing materials used with varying amounts of pressure produce varying degrees of dark and light, a key factor in understanding volume. The variations that result from changing the pressure of the hand can be in response to a particular visual stimulus such as a descriptive detail, to a shift in the direction of a contour, or perhaps to an overlapping of forms. The decisions affecting the use of light and dark are artistically provoked with the intent to be visually expressive. Often the subject itself will initiate a certain artistic response; at other times the artist deliberately chooses to infuse the subject with specific, selected linear elements that transcend mere academic description. Let's look ahead for a moment at a more complex and transcendent drawing where the artist made obvious choices using line and line variation in order to enhance, even exaggerate, form. We see this in Peter Paul Rubens's wonderfully composed *Study of Cows* (Fig. 5-5), where the quality of line variation is extensive and hits on a number of different levels of tonal, textural, and even atmospheric effects. In this drawing, Rubens has carried the manifestation of expressive contour line into the interior of the volume of the cows' bodies. There is an undeniable spatial dynamism occurring from form to form within the picture plane, and the lines, like the composition itself, are deliberately strong, highly descriptive, and graceful. Look at the symphony of acutely descriptive linear work in the head, neck, and shoulder region of the largest cow. These levels of complexity will be revisited later in this chapter, but for the moment let's return to the simplicity of line as a descriptive force.

The very act of drawing, involving as it does such factors as varying directions of movements or modifications in hand position, produces thicker and thinner lines. In fact, the overall physical action of the artist's body comes into play and determines the fluidity and gracefulness of line quality. The viewer is very much aware of the physical manipulation of the pen and changing positions of the artist's hand in Philip

5-5. PETER PAUL RUBENS (1577–1640). *Study of Cows.* Pen and ink, 13 3/8 × 20 1/2″ (34 × 52.2 cm). Reproduced by the courtesy of the Trustees of the British Museum, London.

5-6. PHILIP GUSTON (1913–1980; American). *Untitled.* 1966. Ink on paper, 19 × 25″ (48.3 × 63.5 cm). Minnesota Museum of Art, Saint Paul. Given in memory of Warren Towel Mosman. 68.20.11.

Guston's untitled still-life drawing (Fig. 5-6). Aesthetically and conceptually speaking, placing the individual forms so that they just touch or nearly touch adds tension and drama to otherwise ordinary subject matter. Guston has been both selective and deliberate in the choices he made to artfully infuse a common subject with a fresh visual curiosity.

Project 5.4

To explore the use of contour line that varies in width, select a subject that has overlapping forms—a house plant with broad distinctive leaves, leaf lettuce, a bunch of beets or radishes. Alter pressure on the pencil to describe overlapping forms, darkness of shadow, movement in space, weight, and any other aspects of form that can be implied by changes in the width and darkness of line. Vary the pressure on the drawing instrument in accordance with your instinctive appreciation of the importance of each contour, rather than changing line widths in a consciously calculated manner.

Critique (Project 5.4) Now, in the form of a self-critique, observe the results. Does the drawing seem to hold together as a unit? Are there distinct levels of space described by the darks and lights of line variation? Do some of the darker lines seem to project forward simply by virtue of their profound darkness, or do they recede? Do the lighter, more delicate lines seem to recede because of their translucency, or do they appear to be floating off the surface? It is important to notice that these situations can be different from one drawing to the next, and we may assume or perhaps have been taught that dark lines always recede and lighter lines project. But sometimes the reverse is true. Dark, heavy lines often project outward in a composition simply because of their boldness, whereas light, ethereal lines may seem to drift into the distance, falling back in space. Much of the spatial definition of a composition depends upon the position and placement of these lines within the particular picture plane of a given drawing.

Rembrandt van Rijn and Josef Albers offer two very different and expressive personal approaches to contour drawing. Rembrandt's *Saskia Sleeping* (Fig. 5-7) depicts an intimate moment of quiet observation in the life of the artist through the contours of an intrinsically expressive composition done with pen, brush, and ink. The drawing is highly descriptive and charged with emotion and feeling, and these qualities are

5-7. REMBRANDT VAN RIJN (1606–1669;
Dutch). *Saskia Sleeping*. Pen, brush, and ink,
5 1/8 × 6 3/4" (13 × 17.1 cm).
The Pierpont Morgan Library, New York.
I, 180.

5-8. JOSEF ALBERS (1888–1976; German-
American). *Self-Portrait VI*. c. 1919. Brush and
ink, 11 1/2 × 7 3/4" (29.2 × 19.7 cm).
Collection Anni Albers and the Josef Albers
Foundation, Inc.

heightened by Rembrandt's efficient use of line. Every line is visually poignant and describes the forms in space in a meaningful way. We observe that, in keeping with Rembrandt's mastery over the medium, there are no extraneous lines. In Albers's *Self-Portrait VI* (Fig. 5-8), we see the efficient use of radically different lines to make a minimum number of strokes, which are highly descriptive. Here Albers selected a bold brush line—the inside and outside edges of which are distinctly different and seem almost a contradiction to the subtle perception of form evident in the drawing. Instead of drawing a contour line of the face, he has actually drawn the negative space that in turn defines the contour of the form. The few strokes of the hair drawn in a more usual manner provide a variation that serves to heighten visual description. We see from this that drawings have greater interest when lines, and the edges they define, receive different treatment.

Project 5.5

If someone you know is willing to be a model, you might feel ready to attempt a contour drawing of the human figure. Be assured that contour drawings can be made from clothed, as well as unclothed, models. If no one is available, be your own model. Sit before a mirror and draw a self-portrait. An arrangement of two mirrors will allow you to see yourself from other than a head-on frontal view. Focus your efforts on creating a sense of volume with descriptive lines that vary in width, weight, and value (the degree of light and dark that will be dealt with in the next chapter). This is an assignment not about achieving an exact likeness but about assessing form and volume in space expressively.

Critique (Project 5.5) As you study your results, do you perceive a sense of shallow and deep space in the composition? Are your limbs positioned in space in a logical way in relation to your torso? Does the drawing portray sensitivity to your likeness, albeit not an exact likeness? Finally, is your line descriptive and expressive?

Lost and Found Edges

When we view forms we do not always perceive visible edges as complete contours, depending on the light the form receives and its relationship to surrounding objects. A strong light falling on a smooth, unbroken surface; overlapping forms of the same or similar value; the turning away of a form—all can result in the disappearance of the separating contour line. The edge becomes lost only to reappear when another condition exists. Leaving out the line when it cannot actually be seen duplicates, in part, the effect that causes the line to disappear. Therefore, omitting a line in a drawing can become a highly useful tool to depict a hot spot or the unanimous convergence of several planes into one. The condition of an absent line, but an implied edge, is a powerful visual force that describes through absence the actual presence of an important contour necessary to complete the form. This begins to be evident in Rene Bouche's portrait of Frederick Kiesler (Fig. 5-9). Departing from simple outline, Bouche produces a splendid example of selected emphasis of features and details that both conveys the thoughtful attentiveness of the sitter and transforms the paper into the light, air, and space in which the form exists apart from the surface upon which it is drawn.

It is also possible to "lose a line" by stopping it short before it passes behind another form, thereby creating a sense of space between forms. Broken or discontinuous contours should not provide a problem

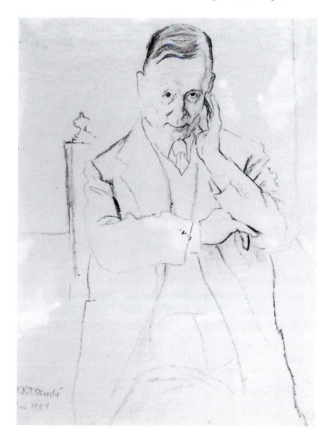

5-9. RENÉ ROBERT BOUCHÉ (1905–1963; Czech-American). *Frederick Kiesler.* 1954. Pencil on paper, 25 × 19″ (63.5 × 48.3 cm). The Museum of Modern Art, New York (gift of the artist).

for the viewer because the eye of the mind is perfectly capable of completing the outline.

Project 5.6

Using lost and found edges effectively depends on training your eye to be aware of the conditions that allow a line to disappear and those that demand that a line be drawn. As you look at forms and draw them, notice when an edge seems to disappear. Begin to rely on your understanding of that form to know that the edge, although not visible, is still there. As your understanding of form strengthens, try to determine when you can appropriately leave a line out, knowing that the absence of the line has a powerful visual effect. Furthermore, as you begin to trust your sense of form, you will be less inclined to dispense with lines randomly.

The Searching Line

The approach to contour drawing that has been discussed depends first of all upon the penetrating and accurate ability to see. The artist's eye is then able to carefully delineate form as structure. In any successful work of art, an understanding of structure becomes evident through the subtle nuances of media handling, as portrayed in the pen, ink, and wash drawing by Isabel Bishop, *Waiting* (Fig. 5-10). Notice the tremendously descriptive elements of the contrasting ink lines with their corresponding wash tones. Here we see an extended and masterful visual vocabulary of mark making that purely excites the eye. The sense of weight of the child's head and shoulder resting in the mother's lap is astoundingly real and at the same time highly sensual. The line variation and repeated contours of the child's legs imply there has been recent movement—a shift in the child's position perhaps in a semi-wakeful state—which brings us to consider another technique that encourages greater freedom and spontaneity: the use of a **searching line.** The artist's deliberate use of a searching line is clearly demonstrated in Honoré Daumier's *Man on a Horse* (Fig. 5-11). It is an approach to drawing in which the hand and drawing instrument move freely and quickly across the surface of the paper, either in continuous rhythm or in a series of more broken lines, sometimes following contour, at other times drawing through, around, and across form **(cross-contour)** to find the gesture and major lines of movement of the form. In cross-contour, the contour line has graduated from a primarily external descriptive force to both external and internal graphic pathways for the eye.

Unlike contour drawing with its singularly descriptive outline, the searching line results in a multiplicity of line generally suggestive of energy and vitality. The rapid movement and frequent directional changes produce variations in pressure, line width, and degree of darkness that automatically produce accents plus a feeling of volume. The sincerity of the searching line is another uniquely expressive force. It is not to be construed as undisciplined, meaningless scribbling as the untrained eye might at first assume it to be, but rather it is a fluid, linear gesture that captures and defines form. As a technique for capturing the wholeness of form, it requires that you begin to see, feel, and draw the total experience of that form, rather than isolated details.

Project 5.7

For beginning students the searching line works best with pencil, ballpoint pen, graphite stick, Conté crayon, or chalk. Select any readily available subject. Although

searching line
An approach to drawing in which the hand and drawing instrument move freely and quickly across the paper surface either in continuous rhythms or in a series of broken lines. Sometimes they follow contour; at other times they draw through, around, even across form in order to find the gesture and major lines of movement within the form.

cross-contour
Lines that are drawn through, around, over, under, and across form to find the gesture and major lines of movement within the form.

we are all inclined to want to draw things that interest us, realize that these projects are meant as learning exercises and that the subjects need not be chosen for any particular aesthetic value. Furthermore, try to select subjects that you've never before selected or wouldn't ordinarily choose to draw.

Before you begin drawing, spend some time looking at the object you have chosen. Without stopping to focus on any one part, let your eye roam freely around, through, and over the form. Become conscious of the continual movement of your eyes, and then begin to feel, describe, and draw with just your fingertips, allowing your hand the same freedom of movement. The relaxed movement of both your eyes and hand should be much swifter than the slow, deliberate pace of your initial contour drawings.

When you actually take up the pencil, draw as Giacometti did in his *Laocoön* study (Fig. 4-5), using one continuous line without lifting your pencil from the paper. Look at the object as you draw, glancing at your paper only when necessary. The purpose in drawing without looking at your paper is to develop a direct connection between seeing and drawing, trying not to think about how to record what you see or whether you have drawn it correctly.

Repeat this assignment frequently, eventually drawing the human figure or other living forms. Remember that mirrors allow you to be your own model. Try to re-create the experience of drawing with your eyes closed, as in Project 5.2.

Project 5.8

If possible, visit a park where people are out with their dogs, or a zoo where you have visual access to a variety of living forms. Select an animal to draw both in a stationary position and in movement. Sit and observe the animal for a few moments before drawing. Begin drawing, incorporating the procedures of Project 5.7. You may be tempted to hurry the drawing, not knowing how long the animal will remain posed. Make this necessity to hurry work for you by trying to capture as much information about the form in as little time as possible. You may be amazed at the length of time the animal actually remains posed, but more important, you'll become aware of your increased ability to capture more information in less time the more you practice drawing from life.

5-10. *above, left.* ISABEL BISHOP (1902–1988). *Waiting* (1935). Ink on paper (pen, ink, and wash), 7 1/8 × 6" (18.1 × 15.2 cm). Collection of the Whitney Museum of American Art, New York.

5-11. *above, right:* HONORÉ DAUMIER (1808–1879; French). *Man on a Horse.* Pen and ink, 19 × 17" (48.2 × 43.2 cm). Vincent Van Gogh Foundation, Vincent Van Gogh Musuem, Amsterdam.

The Modeled Line

Artists frequently feel the need to reinforce pure outline or single-line contours with suggestions of modeling, since many subtleties of form cannot be revealed by the single line, even one of varying thickness. There is a natural tendency when drawing to amplify differences in line width by means of additional lines, hatchings, or other graduated tonal values to help describe the complexity of form perceived in the model.

The drawings by Edgar Degas (Fig. 5-12) and Raphael (Fig. 5-13) reveal remarkable similarity in form, concept, and compositional handling, and yet they are stylistically and expressively quite different. Both artists have augmented a degree of lost and found contour with modeling to give the figures greater plasticity. In Degas's drawing, *Three Studies of Manet,* the contour line is almost nonexistent in places while the modeling maintains a delicate boldness and strength. Through tonal and textural variations in his modeling of the figure, Degas has used line to define his subject in space, leaving the viewer with a sense of

5-12. EDGAR DEGAS (1834–1917; French). *Three Studies of Manet.* Pencil on paper.
Reunion des Musées Nationaux/Art Resource, New York.

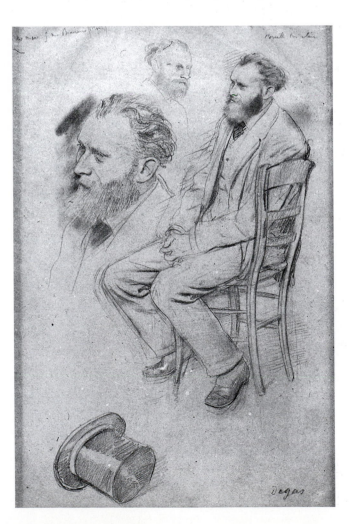

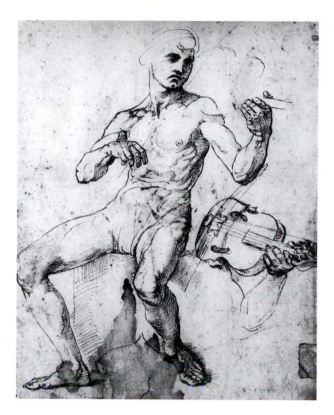

5-13. RAPHAEL (1483–1520; Italian).
Apollo Playing a Violin, Study for "Parnassus."
Pen and ink, 10 5/8 × 7 7/8" (27 × 20 cm).
Musee des Beaux-Arts, Lille.

the importance of **analytical sight.** Likewise, in Raphael's drawing, *Apollo Playing the Violin,* we see the same precision in the modeling of the figure carried to a slightly higher degree of discipline. In both drawings, the lost and found effects result from giving some contours greater weight and definition than others, as in the more detailed handling of Manet's facial features, beard, and tie versus the more ephemeral handling of his folded hands. We see the same antithetical visual effects in Raphael's figure by simply comparing the areas of high detail with those of lesser definition.

analytical sight
Scrutiny; the impetus for drawing only what the artist actually sees; the opposite of intuitive or instinctive drawing. All works of art are to varying degrees analytical.

Project 5.9

Select a subject of some complexity, one that seems to call for more than contour or cross-contour. Employ your practiced methods of seeing the form deeply. Draw it freely in outline, allowing your hand to move easily so that the lines are not rigid. Continue to observe the form carefully as you draw, letting your line be sensitive to roundness, flatness, and meeting of surfaces. When the initial drawing is complete, shade the form near the contour with groups of light, parallel lines that curve according to the direction the form seems to take. Study the edges carefully, and modify the curvature of the shading lines in any way that seems to describe the form more fully.

Develop your facility with this method of using line by drawing many different objects. Do not attempt full modeling in light and shadow—merely add supplementary lines, tones, and textures to reinforce the contours to create a fuller sense of form than can be achieved by pure contour outline.

Critique (Project 5.9) Does your drawing show more surface life and character than your previous drawings? Are you more aware of linear, tonal, and textural variations in the way you draw? Has your mark-making vocabulary increased? Has this increase broadened your visual language skills? Are your drawings more descriptive in general?

Hatching, Cross-Hatching, and Scribbled Tones

At the beginning of this chapter, the author refers to the important role line has played throughout art history. As this chapter has progressed, we have seen the many creative possibilities of line. Artists must believe in the infinitude of expressive possibilities contained within line which keeps them searching and constantly exploring these possibilities in their search for new forms of expression.

Line has a role to play that is not limited to defining contours, as became apparent with the introduction of modeling in Figures 5-12 and 5-13. Line used as **hatching** (parallel lines), **cross-hatching** (crisscrossing patterns of parallel lines), and **scribbling** (random, multidirectional lines) builds tones and spatially defines surface texture, shape, and volume.

Philip Pearstein uses line hatching very effectively to describe form and volume in his *Male and Female Models on Iron Stool and Bench* (Fig. 5-14). There is a beautiful display of continual tonal and textural variety throughout the drawing manifested in the use of line hatching. The light and dark patterns created by different grades of graphite and varying amounts of applied pressure not only define the forms as they exist in space but also enhance the spatial relationships of the forms within the picture plane. **Contour hatching** (curved lines that follow the turning of form) allows a more descriptive modeling of cylindrical and spherical subjects. The Italian artist Domenico Beccafumi (Fig. 5-15) demonstrates the use of **cross-contour hatching** to define volume and reveal anatomical details in his *Studies of Legs and Male Nudes*. While simple hatching and cross-hatching are easy to use, meaningful and successfully creative cross-contour hatching demands careful analysis of the form followed by intellectually conceived and deliberate drawing, as in the example of Leonardo da Vinci's pen-over-chalk drawing *Outcrop of Stratified Rock* (Fig. 5-16).

John Singer Sargent's selection of graphite as the medium for his *Nude Man* (Fig. 5-17) permits him to build both the descriptive airiness and the density of varied tonal transitions more subtly than the pen-and-ink examples do. While his hatching does not appear to be particularly complex, the directional changes reveal an enviable understanding of form. In Jacques de Gheyn's pen-and-ink drawing *Woman on Her Death Bed* (Fig. 5-18), there is a convincingly effective use of scribble drawing embodied once again in varied linear, tonal, and textural manifestations. The act of scribble drawing requires one to be somewhat facile in the handling of media, for the act of scribbling must be both immediate and precise in order to successfully capture the trueness of the form. It takes much devoted practice for the beginner to be able to consistently produce beautiful and at the same time strikingly descriptive scribbles.

Project 5.10

Make an arrangement of several relatively simple objects that possess a fullness of form—two or three apples, pears, or tomatoes grouped together on a slightly ruffled tablecloth surface. Do separate drawings using hatching, cross-hatching, and scribbling to define forms and produce tonal differences. Vary both the thickness of the line and the spacing between lines to produce different tones. Experiment with a variety of drawing tools—crayon, pen and ink, as well as pencil. After having done several drawings with these media, shift to a more radically different drawing tool—a bamboo skewer or dried wooden stick dipped in ink. The scale of the forms and sizes of your drawing will in part be determined by the drawing medium selected.

hatching
Repeated parallel strokes with a drawing tool that produce clusters of lines creating compositional values and tonal variations usually descriptive of form or surface.

cross-hatching
A series or cluster of parallel lines, whether continuous or broken, that traverse other clusters of the same kinds of lines creating tonal and textural variations within a composition.

scribbling
Random, multidirectional lines used to build varied tones, textures, and densities and to define surface qualities, shape, and volume, or to capture gesture or movement as in a searching line.

contour hatching
Curved lines that follow the outer contours of the turning of form, allowing a more descriptive modeling of cylindrical and spherical subjects.

cross-contour hatching
Hatched lines existing on multiple planes that follow and describe the outer extremities of the three-dimensional surface undulations of a form.

5-14. *above:* PHILIP PEARLSTEIN (American born). *Male and Female Models on Iron Stool and Bench,* 1976. Graphite on ivory wove paper, 571 × 724 mm (22 1/2 × 28 1/2").
The Jalane and Richard Davidson Collection.
© The Art Institute of Chicago. All rights reserved.

5-15. *left:* DOMENICO BECCAFUMI (1486–1551; Italian). *Studies of Legs and Male Nudes.* Pen and brown ink, 8 7/16 × 5 3/4" (21.4 × 14.6 cm).
The Art Museum, Princeton University, gift of Miss Margaret Mower for the Elsa Durand Mower Collection.

5-16. LEONARDO DA VINCI (1452–1519; Italian). *Outcrop of Stratified Rock*. Pen over chalk, 7 1/4 × 10 9/16" (18.5 × 26.8 cm).
Royal Collection, Windsor Castle.

5-17. JOHN SINGER SARGENT (1856–1925; American). *Nude Man*. Graphite on paper, 9 7/8 × 7 3/4" (25.1 × 19.7 cm).
Wadsworth Atheneum (Bequest of George A. Gay).

Project 5.11

Line hatching can exist independently from contour drawing, as in Harold Altman's *Matriarch* (Fig. 5-19), where a rather hefty woman appears to be seated amidst a symphony of undulating forms. Choose an appropriate subject that interests you and lay out the drawing with a very light contour pencil line. Then develop the forms using hatched lines within the contour lines without actually relying on the contour. Try this again several times, each time relying less on the initial contour line. Eventu-

5-18. *above:* JACQUE DE GHEYN
(1565–1629; Flemish). *Woman on Her
Death Bed*. Pen and ink, 5 3/4 × 7 5/8"
(14.6 × 19.4 cm).
Rijksmuseum, Amsterdam.

5-19. *left:* HAROLD ALTMAN (b. 1924;
American). *Matriarch*. 1961. Felt-tip pen,
16 1/2 × 20" (41.9 × 50.8 cm).
Philadelphia Museum of Art (gift of Dr. and
Mrs. William Wolgin).

ally you'll be able to describe a form interestingly and accurately with just the use of
hatched lines. Notice how different the character of an object becomes in the draw-
ing as the hatching describes the surface while devoid of any graphic contour pres-
ence. Remember to always use varying amounts of pressure when drawing with
these tools so as to increase your range of light and dark patterns.

Critique (Project 5.11) As you observe these project drawings, make a note
to yourself of how far you've come with your understanding and use of a simple

line. You should begin to have a sense of the magnitude of possibilities of linear expression as evidenced in a small way by your own early explorations of line drawings set before you. Do the natures of the objects or subjects used begin to take on a visual retranslation of their forms? Are the forms themselves evident to you in a transformed way? Are there identifiable passages within the forms that have been heightened in visual importance by the varied use of descriptive line? As your range of lights and darks increases, do the spatial relationships become more pronounced? Is there a greater sense of spatial depth in your picture planes?

The Calligraphic Line

Calligraphy is defined as "beautiful writing." When, in writing, drawing, engraving, and painting, the beauty of line becomes a major aesthetic aim, the result is a true **calligraphic line,** as seen in Figure 5-20, a collaboration of two Japanese masters—the underpainting by Sotatsu, who needed no more than two or three deft brush strokes to place a crane in flight; the calligraphy by Koetsu.

Rico Lebrun's *Seated Clown* (Fig. 5-21) and Willem de Kooning's *Woman* (Fig. 5-22) are splendid examples of the calligraphic virtuosity of Western artists. It should be noted that the de Kooning drawing, as well as Philip Guston's *Ink Drawing* (Fig. 1-9) and Frans Kline's Untitled (Fig. 8-8), which also are calligraphic, have their origin in abstract expressionism.

Beautiful and meaningful calligraphic line demands more than taking brush in hand to make lines of varying thickness. The beginner, without months, perhaps even years, of practice, cannot hope to do more than become aware of the factors involved. Variations of line width, which characterize a calligraphic line, are determined by the gesture with which the line is made, in combination with the amount of pressure with which the brush, by tradition held in an upright position, is applied to the drawing surface. For example, a sweeping stroke—made rapidly, commenced while the hand is in motion in the air, and finished by lifting the hand while still in motion—usually creates a tapered line that reveals both the action by which the line was drawn and the variation in pressure. In the work of an experienced draftsman, such gestures, far from being self-conscious and deliberate, result naturally from the action of drawing. It might be mentioned that calligraphers of the world value beauty of line, flourish of execution, and individuality more than legibility.

Beyond the gesture of execution, the character of a calligraphic line results from the medium used, for medium, to a degree, controls the gesture. A pointed brush with ink permits the greatest fluidity (Fig. 5-21); a flat bristle brush produces a more abrupt, slashing change from thick to thin (Fig. 5-22). Pencil, charcoal, and chalk also respond to the differing emphasis and reflect the movement of the hand in changes of width and value when these media are held under the hand, as illustrated in Figure 2-7; lines become progressively fuller and darker with increased pressure. Holding your pencil or charcoal parallel to the direction of your line will make a narrow mark; turning it at right angles to the direction of the line increases the width.

Project 5.12

As an introduction to drawing with calligraphic line, either with brush or ink, or with soft pencil, charcoal, or chalk, choose a subject that offers undulating contours—running shoes, a backpack, a cluster of large leaves, potted geraniums and other

calligraphy
Beautiful writing. In western culture it is done with a pen, in Chinese and Japanese cultures with a brush.

calligraphic line
Beautiful line. In the visual arts, when writing, drawing, engraving, etching, and painting, the beauty of line becomes a major aesthetic aim.

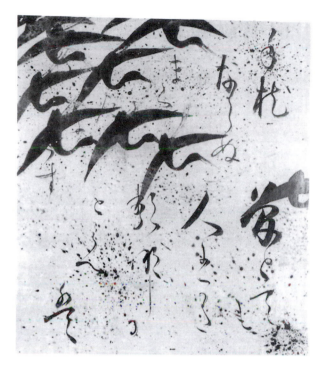

5-20. *above, left:* UNDERPAINTING BY NONOMURA SOTATSU (1576–1643; Japanese), calligraphy by Honnami Koetsu (1558–1637; Japanese). *Poem, with Birds in Flight.* Ink on gray-blue paper, gold-flecked; 7 5/8 × 6 5/8" (19.4 × 16.8 cm). Nelson Gallery-Atkins Museum, Kansas City, Mo. (gift of Mrs. George H. Bunting, Jr.).

5-21. *above, right:* RICO LEBRUN (1900–1964; Italian-American). *Seated Clown.* 1941. Ink and wash, with red and black chalk; 39 × 29" (99.1 × 73.6 cm). Santa Barbara Museum of Art, California (gift of Mr. and Mrs. Arthur B. Sachs).

5-22. *left:* WILLEM DE KOONING (1904–1997; Dutch-American). *Woman.* 1961. Brush and ink on paper, 23 3/4 × 18 3/4" (60.3 × 47.6 cm). Hirshhorn Museum and Sculpture Garden, Smithsonian Institution, Washington, D.C.

plants, or a few vegetables. Spend some time looking at the subject, seeing it in terms of both contour and searching line; then begin to draw freely, allowing variations in line width to grow and develop from the act of drawing. Keep your drawing sufficiently large so that your gestures can be free and unconstricted. Learn to work as quickly as you can while keeping in mind the importance of immediacy and spontaneity of mark making. Since drawings of this type should be executed quite rapidly, repeat this procedure and do several drawings in succession.

Critique (Project 5.12) Compare the drawings to determine which have the most linear character and best express the character of the subject, the nature of the brush and ink, and the quality of immediacy in the act of drawing. As you look at the works, select several of the most visually exciting passages, and then relive the sensations of making them in your mind and spirit. Do these sensations recall any other moments in previous drawing experiences?

Experiencing Different Line Qualities

Line functions objectively to define and describe shapes, spaces, volumes, surfaces, gestures, and movements; line used subjectively focuses on the expressive and spiritual qualities of drawing.

The expressiveness of a drawing is determined not only by the choice of drawing instrument, materials, and technique, combined with skill and manipulation, but also by the artist's emotional and intellectual attitude. If line were not expressive of the individual artist, all drawings would be very much alike—and yet the drawings selected to illustrate this chapter are all very different from one another in their quality of line. They are expressive of the individual personalities of the artists whose reflected feelings and emotions, attitudes, and points of view are made tangible and manifested in the wholeness of the drawings. These drawings are so intensely reflective of their human inventors that they describe, define, and speak a visual language that may be both academic and spiritual. Artists, as cultural problem solvers, find ways of working that are challenging, satisfying, exhilarating, and "right" for their temperaments. Note, for example, the contrast between the two drawings of trees by Jacques de Gheyn and Vincent Van Gogh (Figs. 5-23, 17-15). Where de Gheyn relies on cross-contour hatching and delicacy of mark making, Van Gogh creates a rich, linear density of branches with a wide range of contrasting values highly descriptive of dormant trees in the bleak of winter. We see intrinsic merit in the characteristically unique representation of these two trees not only because they were done by accomplished artists, but because they need no justification for their existence beyond our own acceptance and appreciation of them. These different presentations offer us a glimpse into the distinct personalities of the two artists and the visual choices they made. In consideration of line, diversity is what gives artists their individual styles of expression and audiences their joy of interpretation.

Project 5.13

Using the medium of your choice, explore some of the different ways to handle line that you have observed in these illustrations. Draw in the manner of the examples rather than engaging in self-conscious copying. It does not matter what your subject is or how accurately you draw it. The most important thing is to gain a feeling for how the artist worked. The flow of adrenaline and the release of the chemical dopamine in the brain occur spontaneously during the experiencing of a pleasant and creative activity. The feelings of exhilaration and joy are a welcome accompa-

5-23. JACQUE DE GHEYN (1565–1629; Flemish). *Chestnut Tree with a Man Sitting on the Roots.* Pen and ink over black chalk, 14 1/4 × 9 3/4" (36.2 × 24.8 cm). Rijksmuseum, Amsterdam.

niment to the creative acts of drawing. Gain a sense of exhilaration through your own drawing activities, and realize that this is an essential part of creativity—part of the vehicle of personal expression, and often the catalyst that pushes works of art to greater heights of expressive power.

As you draw, you will discover that certain kinds of line movements come naturally to your hand. Be aware of that and continue experimenting. Work to develop familiarity and versatility with the various drawing media you are using. When you have also developed a familiarity with a variety of line qualities, make your own selection of subject matter that appears appropriate to each way of working, trying not to limit yourself to subjects similar to those illustrated.

Project 5.14

Acknowledging that expressiveness is to be found in choice of line as well as in subject matter, develop a series of drawings of the same subject, allowing the quality of line to convey different moods. The nature of the subject is less important than the handling of the line. As you draw, make sure to keep your focus on line and the expressiveness of the line you are presently making. Generally speaking, as you become more and more skillful and creatively assertive with your use of line, your depiction of the nature of subject matter will often become freer and possibly more natural.

Whatever subject you select, consider the placement of your drawing on the paper. Avoid letting images float in the middle of an essentially blank page by drawing large and using as much of the full sheet as possible.

Critique (Project 5.14) As you observe the last drawings you've done for this chapter, take an overall account of your use of line. By now you should feel as though you've used line in previously unimaginable ways. You should detect within yourself a newfound excitement over the descriptive and expressive use of line, knowing that you've worked hard and that this dedication has afforded you new creative opportunities. You may only begin to see an emerging style or personal characteristic about the line you make, and this may change often as you continue to draw—after all, remember that you have just begun a venture that artists spend a lifetime investigating. If you do begin to recognize "personal line traits," this sensitivity, unique to you, may be the route through which deeper expressions will ultimately flow.

Conclusion

Whenever you commence drawing, think about the kind of line that seems equally right for the subject, for the medium, and for your own artistic temperament as you know it thus far. Gradually, you will discover that you have developed an intuitive sensitivity to line, as well as to the other art elements, and that choices need not always occur at a conscious level. The most important goal now is to work freely, instinctively, experimentally, even playfully, realizing that impulse and feeling remain the catalysts for creative activity, along with intellect and skill.

Art critic and writer Joshua C. Taylor in his essay on Robert Rauschenberg's work wrote the following: "The provocation of unsettling alertness . . . to sense, to association, to memories and the flexibility of the mind . . . renders the inert alive, and gives voice to what might otherwise remain mute."

Value 6

*If I could have had my own way
I would have confined myself
entirely to black and white.*

—Edgar Degas

In the visual arts the term **value** denotes degrees of light and dark. White under brilliant illumination is the lightest possible value, black in shadow the darkest. Between these two extremes occurs a range of intermediate grays. Pure black, white, and gray seldom occur in the natural world, for almost every surface has some local coloration, which in turn is influenced by the color of the source of illumination. Every surface, however, no matter what its color, possesses a relative degree of lightness or darkness that the artist can analyze and record as value.

While line adequately represents the contours of an object, subjects as a rule display characteristics and suggest moods that cannot be described fully by contour alone. Values clarify and enrich the space defined by simple line in five readily identifiable ways.

1. Three-dimensional form becomes apparent through the play of light and shadow, represented by shading.
2. The degree of value contrast determines the placement and relationships of form in space. Forms can be made to advance or recede through the degree of value contrast employed.
3. Value provides a fundamental element for creating pattern, for modulating and describing surface texture.
4. The pervasive mood of a drawing—dark and ominous, light and cheerful—derives from the artist's emphasis on tones at either end of the value scale. The emotional impact of a highly descriptive drawing can be delineated through value alone without the supporting influences of line.

value
Degrees of light and dark; the light and dark characteristics of color; the amount of light reflected by a particular color.

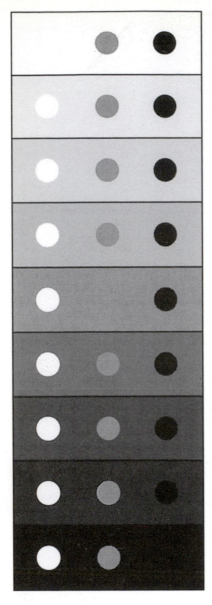

6-1. Value scale with nine progressions.

6-2.
RODOLFO ABULARACH (b. 1933; Guatemalan). *Circe.* 1969. Ink on paper, 23 × 29″ (58.4 × 73.6 cm).
San Francisco Museum of Modern Art (gift of the San Francisco Women Artists).

value scale
A progressive range showing the incremental and consistent steps of change between extreme light and extreme dark.

5. Value contrasts convey dramatic power. Strong contrasts of light and dark, for example, can be manipulated to create points of accent in a composition and so draw attention to areas in terms of their importance.

The Value Scale

Learning to see relationships of value is essential to producing convincing visual images. The full range of values that exist in nature cannot be duplicated, which means that an artist can only approximate the effect of natural light. A **value scale** of nine steps (Fig. 6-1) duplicates the number of value changes that most people can distinguish.

Perception of value depends upon a number of factors: (1) the actual coloration of the subject, (2) its lightness or darkness relative to its surroundings, and (3) the degree to which the subject is illuminated or in shadow. (Compare Figures 6-22, 8-15, and 18-20 with Plates 4, 9, and 19.)

Beginners often lose sight of value, seeing only color instead. Yet color has value, which must be analyzed as to its relative lightness or darkness, not only when being translated into a black and white drawing, but also for drawing in color. The apparent value of an area is relative to the area that surrounds it. The white, middle gray, and black dots superimposed on the value scale (Fig. 6-1) reveal the optical variations that occur in the apparent lightness or darkness of the same value when seen in relation to tones of greater or lesser contrast. The optical effects of contrast are powerfully descriptive tools that when used effectively are capable of extreme distortion and exaggeration.

Rodolfo Abularach's fine pen-and-ink drawing *Circe* (Fig. 6-2), with its rich range of values from the heavily cross-hatched, deep black pupil to the gleaming white, central highlight provided by the exposed paper ground, duplicates the value scale in a pictorial form. Notice how the highlight and dark of the pupil are intensified by being placed side by side and against the low dark of the iris.

The artist must learn to see value relationships, rather than be influenced by what is known to be the **local value,** which can be perceived only when seen free from the effect of light and shadow. Under illumination, local values are lightened or darkened depending upon the degree of light. In Sidney Goodman's double portrait *Ann and Andrew Dintenfass* (Fig. 6-3), the only local value that can be identified with any degree of certainty is the darkness of the young woman's hair. Notice, however, that the highlights of her hair and the lighted portion of her face are the same value, while the shadowed areas of the face and arm are nearly as dark as her hair. The local value of the young man's hair and pants might be either light or dark as influenced by intense sunlight. The novice often fails to acknowledge such effects by thinking of a white form as entirely light (although its shadowed areas appear as medium or dark values) or representing a dark surface as dark even though it is brilliantly illuminated. Only with experience do artists attain a sharply analytical sense of value as they are affected by color and lighting. (Note that having chosen white paper, Goodman used charcoal to draw everything that appears dark; on black paper he would have drawn everything that appears light with white pencil, pastel, or chalk.)

Part of an artist's basic vocabulary is the ability to utilize an extended range of value through the control of dry and wet media (Chapters 10 and 11). Another vitally important element of an artist's working knowledge is that of the receptive surfaces upon which the artist draws. Every combination of drawing tool and particular paper will produce a different effect. It is only through experimentation and experience that

6-3. SIDNEY GOODMAN (b. 1936; American). *Ann and Andrew Dintenfass.* 1971. Charcoal, 27 × 32 1/2" (68.6 × 82.5 cm). Courtesy Terry Dintenfass Gallery, New York.

local value
The actual, known value of objects perceived only when seen free from the effects of strong light and shadow.

the artist is able to make specific choices in order to attain desired visual effects. Therefore, the artistic choices extend beyond mere selection of drawing tools.

Because of the vigorous range of lights and darks that can be created from all media, either charcoal, Conté crayon, or soft graphite stick (4B or 6B) will prove sufficient for many of the activities suggested in this section (Conté crayon and stick graphite are cleaner to work with and smudge less easily than charcoal). Assorted gray crayons would also be appropriate for many of the suggested projects, but it would be unwise to rely completely on manufactured grays instead of developing the control necessary to produce your own grays with charcoal, Conté crayon, or graphite. Charcoal, Conté crayon, and soft graphite stick all make it easier to move from contour drawing into full three-dimensional modeling of form. They also seem to encourage drawing in a larger scale than does pencil, pen and ink, or ballpoint pen, partly because the drawing process seems faster than that from the fine points of pencils or pens. However, the dimensions of Figure 6-2 suggest that the use of pen and ink is not limited to small-scale works.

For projects using charcoal, Conté, or graphite stick, you may wish to use **charcoal paper** because of its more interesting surface texture, referred to as **active tooth,** or select another drawing or printmaking paper that has a good weight and an active tooth rather than using anything too smooth. It is best to try several different papers and learn to distinguish among them according to their weight and tone (white, off-white, cream, or buff) and their amount of active tooth, whether rough or smooth.

Project 6.1

Assemble or arrange four or five objects of different colors. Study the value relationships and do a drawing of corresponding tones—a drawing that, in effect, would duplicate a black and white photograph of the objects. Limit your concern to general shapes rather than details; apply tones flatly rather than introducing gradations of value to reveal volume. (Assorted gray crayons would be perfect for this preliminary exercise in matching relative values.) Placing the forms in direct sunlight (Fig. 6-3) or introducing artificial light will alter the value relationships. (Small, high-intensity reading lamps provide strong illumination and offer adjustable positioning as well as ease in moving.) Each repositioning of the light source, each regrouping of the objects, will alter the relationships. Focusing just on the objects by squinting at them through a cardboard viewfinder will allow you to determine the tonal differences more accurately.

Form Defined by Light

Every object has a specific three-dimensional character that constitutes its **form.** The simplest forms are spheres, cylinders, cubes, cones, and pyramids; humans, animals, and botanical forms, in contrast, are forms of greater three-dimensional complexity. We are made aware of the unique aspects of each form as it is defined by **light** and **shadow,** and by changes of value. Direction of light determines what portions of a form will be lighted. Surfaces at right angles to the direction of the light source receive the most light; those areas that turn away from the light and are hidden from receiving direct rays of light fall into shadow, possibly receiving softer reflected light from neighboring objects or surfaces. Changing the position of the source of illumination can greatly

charcoal paper
Textured paper abrasive to charcoal because of its hardness of tooth. In the drawing act, it receives a deposition of black carbon charcoal particles that adhere to its relief as well as fall into its recesses; available in different weights in white, gray tones, and muted colors; also for use with chalk, Conté crayon, and pastels.

active tooth
The degree to which a paper's surface texture retains particles of dry drawing media and influences the resulting surface qualities of those media. An artist will choose a particular paper because of its active grain in order to attain the desired expressive results.

form
The positive aspect or complement of space; the visible or recognizable configuration or shape of any object existing in atmospheric space; any structural art element separate from color, line, texture, material, etc.

light
The illumination of an object; a major component of chiaroscuro helping to define forms in space within a composition; that which makes sight possible.

shadow
The state of being blocked or partially blocked from directional light or illumination; a precise area of shade cast by an object intercepting directional rays of light.

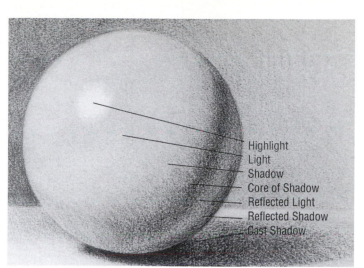

Highlight
Light
Shadow
Core of Shadow
Reflected Light
Reflected Shadow
Cast Shadow

alter the appearance of any object, the formation of cast shadows, and the degrees of illumination of reflected surfaces. Angular forms result in abrupt changes from light to dark (Fig. 6-4); spherical forms are defined as subtle gradations of tone (Fig. 6-5).

Project 6.2

Place a white or very light-colored geometric form (a cube or other polygonal shape) on a piece of white paper or a light surface, positioned so that it receives strong light from above and to one side. (Most drawing departments in college and university art departments will have a series of geometric, three-dimensional forms made from white illustration board that are used precisely for this purpose.)

As you position the form differently, notice how its actual form is revealed by light since the angular edges dividing its planes create sharp changes of value. (If you do not have access to white geometric forms, a small cardboard carton with flaps opened at varied angles would be suitable.) Observe the object and its **cast shadow** carefully. Begin drawing by using any suitable technique to build gradations in value corresponding to the separate planes of the form. Leave the white paper for the lightest surface, defining that plane by surrounding it with continuous gray areas of tone that define adjacent planes rather than merely outlining each separate plane with a contour line (Fig. 6-4). The darkest value will be the shadow cast by the object.

Notice how the edges of each plane appear either darker or lighter, depending on the value of the adjoining planes. (The same optical illusion can be detected between the steps of the value scale.) Creating a slight exaggeration of the light and dark values where planes join results in a stronger feeling of three-dimensionality.

Project 6.3

Do a series of quick studies depicting the changes that occur as the form is lighted from different angles—side, three-quarter view, front, overhead, behind, and below. Notice the shifting position of the cast shadow as the direction of light changes (see Chapter 9, Perspective).

In this and other project assignments, draw the objects as large as is practical for the medium you have chosen. Learn to use the full sheet of paper. Students have a tendency to draw too small, partly because smaller scale seems easier to master. A pencil drawing may be too large when it becomes difficult to build values of even texture; a charcoal, Conté crayon, or graphite stick drawing is too small when the stick seems clumsily oversize.

6-4. *above, left:* Polyhedron with value planes suggesting illumination from a single source of light.

6-5. *above, right:* Sphere showing the value gradations of traditional chiaroscuro.

cast shadow
A shadow cast or thrown by an object onto an adjacent plane; one of the value gradations of traditional chiaroscuro. A cast shadow is darker than the core of the shadow.

Chiaroscuro

chiaroscuro
From *chiaro* (light) and *oscuro* (dark), the continuous gradations of value, to create the illusion of three-dimensional form; systematic changes of value that produce visual states of high or low contrast in the depiction of forms as they exist in pictorial space or atmosphere.

highlights
The lightest values present on the surface of an illuminated form, occurring on very smooth or shiny surfaces; the intense spots of light that appear on the crest of the surface facing the light source.

core of shadow
The most concentrated area of dark on an illuminated sphere; one of the value gradations of traditional chiaroscuro; the core of the shadow receives no illumination.

reflected light
Light bouncing back from reflective surfaces; functions as fill-in light, making objects appear rounded by giving definition to the core of the shadow; one of the value gradations of traditional chiaroscuro.

reflected shadow
A shadow that bounces back from a nearby surface or object; one of the elements of the system of chiaroscuro. A reflected shadow is never as dark as a cast shadow.

Since the Renaissance, artists have employed **chiaroscuro,** or continuous gradations of value, to create the illusion of three-dimensional form in space or atmosphere. Chiaroscuro, which combines the Italian words *chiaro* (light) and *oscuro* (dark), involves systematic changes of value, easily identified in Figure 6-5, which shows a sphere under strong illumination. Study Figure 6-5, and notice that the elements of the system are highlight, light, shadow, core of the shadow, reflected light, reflected shadow, and cast shadow. **Highlights,** the lightest values present on the surface of an illuminated form, occur on very smooth or shiny surfaces that in turn bounce light directly off themselves since very light, shiny, ultrasmooth surfaces cannot absorb light. They are the intense spots of light that appear on the crest of the surface directly facing the light source (compare with Fig. 6-4). Light and shadow are the intermediate values between the more defined areas of highlight and the **core of shadow,** which is the most concentrated area of dark on the sphere itself. Being parallel to the source of light, the core of the shadow receives no illumination. **Reflected light**—light bounced back from nearby surfaces—functions as fill-in light, making objects appear rounded by giving definition to the core of the shadow. Reflected light is never lighter than the shadow area on the lighted portion of the form. Often there is a visibly darker portion of shadow existing on the extreme edge of an object that we refer to as **reflected shadow.** Reflected shadow defines that portion of the object farthest from the light source and is caused by the effects of the reflected, extreme darkness of the cast shadow bouncing back to the object's edge. The value of the reflected shadow lies between that of reflected light and cast shadow. Shadows thrown by objects onto adjacent planes are known as cast shadows and are always darker than the core of the shadow.

Sculptor Isamu Noguchi, possibly influenced by the years he spent as an assistant to Brancusi, presents his *Standing Nude* (Fig. 6-6) as simplified volumetric forms defined by chiaroscuro, the right buttock being almost identical to Figure 6-5.

Project 6.4

Place a white or light-colored sphere, such as a beach ball or Styrofoam ball, on a light surface. Provide strong illumination angling downward from above—a single light source plus reflected light is best, since multiple light sources create confusion. Study the form carefully before you begin to draw, observing relative values. The shadow becomes intensified as the form turns away from the light, with the core of the shadow receiving neither direct nor reflected light. No portion of the surface in the shadow is as light as the part that receives direct light. The light reflecting up into the shadowed portion of the sphere from the tabletop is lighter than the core of the shadow but darker than the lighted surface of the sphere.

Proceed with your drawing, using the method you prefer to create smooth gradations of value. If the surface of the sphere is shiny, reserve the white of the paper for the highlight. Adding a light gray background will intensify the effect of brilliant illumination.

The amount of the sphere's surface that is lighted or in shadow and the position of the cast shadow depend on the placement of the light source. If positioned directly at the side, one half of the sphere will be lighted and one half in shadow, with the core of the shadow perpendicular to

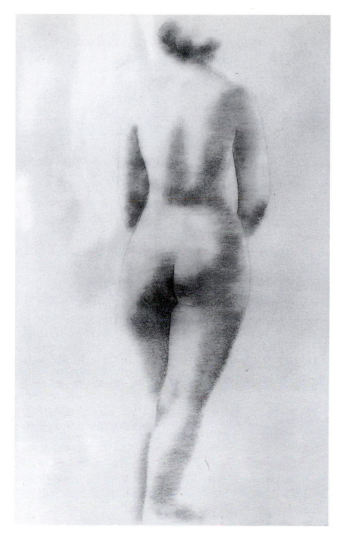

6-6. ISAMU NOGUCHI (1904–1990;
American). *Standing Nude.* c. 1930.
Pencil and charcoal, 19 1/4 × 12 3/8"
(48.9 × 31.4 cm).
Gift of Winslow Ames. © Addison Gallery of
American Art, Phillips Academy, Andover,
Mass.

the angle of light. **Rim lighting** occurs when light from behind illumi-
nates only the outer edge of a form, as demonstrated in Martha Alf's
Two Pears No. 3 (Pl. 1). Alf's drawing also allows us to see chiaroscuro
interpreted in color.

rim lighting
Illumination of only the outer edge of
an object or form by light from behind
the object or form.

Project 6.5

Make a number of simplified drawings of a sphere indicating the relative amounts
of light and shadow as the direction of light changes, giving emphasis to the core of
the shadow. Pay attention as well to the shape and position of the cast shadow.

George Biddle's portrait of Edmund Wilson (Fig. 6-7) follows the same
system used for the sphere, modeling form with broad areas of light and
shadow separated by a clearly defined core of shadow. Although there
are no highlights, small areas of cast shadow under the nose and chin
help define the form, while the absence of dark accents at the back of
the neck and ear causes the form to recede. A sense of luminosity results
from the drawing's generally light tone in combination with the broad
simplification of light and shadow. Biddle's handling of the shadow side
of the face reveals that it is not necessary to render everything you see.
Notice also how the same tonal area just to the right of the core of the

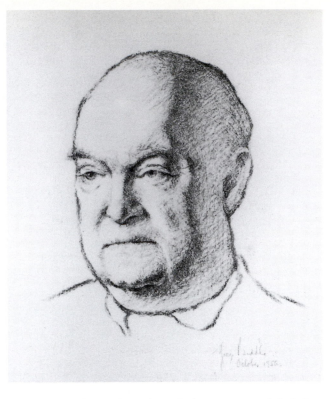

6-7. GEORGE BIDDLE (1885–1973; American). *Edmund Wilson.* 1956. Charcoal, 13 × 11 1/2″ (33 × 29.2 cm). Sotheby's.

shadow nearly reads as though there is a modeled depression in the side of the head. This is an example of how effectively an artist can create and define form with either subtle or bold value changes.

Project 6.6

Try drawing a head from life using value, rather than line, to define form. If you are self-conscious about asking a friend to pose, do a self-portrait working with a mirror. However, agreeing to exchange poses with a friend is more advantageous than a self-portrait approach at this point. Above all, do not draw from a photograph.

Position your model so that the play of light and shadow from a light source above and to the side clarifies the structure of the head. Work for solidarity of form, rather than concentrating on achieving a likeness. Do not be overly concerned with details. Just as you did in the geometric assignment (Project 6.2) to eliminate the use of a line that defines edges, remember to lay in a gray tone next to the lighted side of the face to eliminate once again the need for a contour line.

Studies for a Figure of St. Carlo Borromeo by Carlo Maratta (Fig. 6-8) illustrates how artists employ chiaroscuro to describe a complex form with broadly established areas of light, shadow, reflected light, and cast shadows. The core of the shadow functions effectively to delineate the division between light and shadow and combines with the reflected light to give sculptured fullness to the folds. Since most cloth, other than silk and satin, does not have a shiny surface, rendering of fabric rarely requires highlights.

Project 6.7

Pin a light-colored piece of fabric (a napkin or a handkerchief will do) to a wall or vertical surface. Gather and drape the fabric to create folds of some complexity. Add a strong light source to provide definition to the forms of the folds. As you draw with charcoal or graphite, pay particular attention to the way in which the core of the shadow, reflected light, and cast shadow cause the folds to stand out in bold relief. Once again, remember to delineate the edges with value changes rather than contour line.

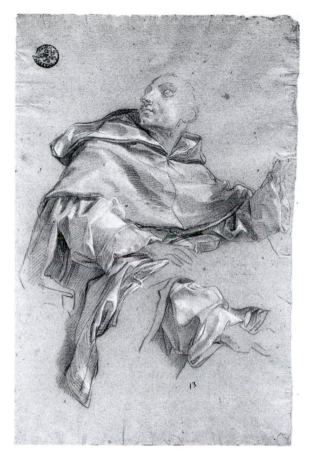

6-8. CARLO MARATTA (1625–1713; Italian). *Studies for a Figure of St. Carlo Borromeo* (?). Red chalk, heightened with white, on blue-gray paper, 16 1/4 × 10 5/8" (41.3 × 26.9 cm). Kunstmuseum, Düsseldorf, Lambert Krahe Collection.

6-9. KENT BELLOWS (b. 1949; American). *Angela, Full Standing.* 1988. Pencil, 30 × 12" (76.2 × 30.4 cm). Toledo Museum of Art.

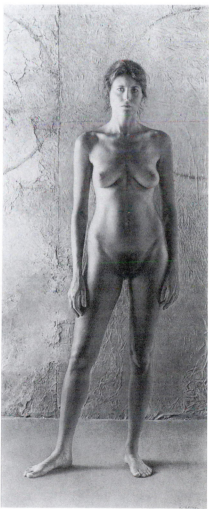

Qualities of Light

Value changes can be gradual or abrupt, depending on the character of the form and the suddenness with which it turns away from the light (Figs. 6-4, 6-5). The degree of value change, or contrast between light and shadow, also depends on the source of illumination. Brilliant light in Kent Bellows's graphite drawing *Angela, Full Standing* (Fig. 6-9) results in strong light-dark contrasts with sharply defined dark shadows (Fig. 6-3). This drawing is an excellent example of the chiaroscuro system of lights and darks defining form, and upon close examination, you can locate each element of the system: highlight, light, shadow, core of the shadow, reflected light, reflected shadow, and cast shadow. Even rim lighting occurs on the model's legs from the knees downward, where the contour edges of the legs are illuminated by reflected light bouncing off the wall from behind. Figure 6-9 illustrates the dramatic effects of the positioning of artificial light. Nine years later Bellows did another drawing in graphite pencil with touches of erasing (or subtractive drawing) of a figure showing the high contrasts of natural lighting (*Nicole, March 1997*, Fig. 6-10). Here we also see the system of chiaroscuro at work defining form in what appears to be an outdoor setting that is reminiscent of a black and white photograph taken in a garden.

A different light, one of a diffused nature in Martha Mayer Erlebacher's *Male Back* (Fig. 6-11), produces less contrast and softened cast shadows. Because of the amount of reflected light in nature, shadows cast by sunlight are generally lighter and more luminous than those

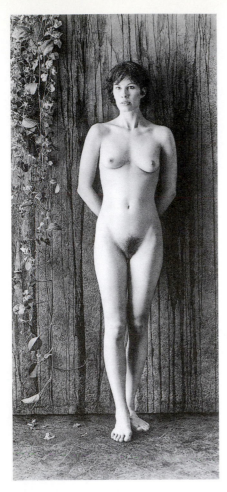

created by artificial light. To maintain consistency in a drawing such as is illustrated in Figures 6-9, 6-10, and 6-11, an artist must skillfully consider the source and quality of light with regard to the desired compositional definition of form.

When we consider the abundance, intensity, and ever-changing properties of light found in nature, along with its unique effects on natural forms, we become aware of what a powerful, expressive, and necessary tool light is to the artist. Sunlight changes day to day, season by season, and continuously redefines the forms it illuminates. Artists are irretrievably attracted to the particular presentations of light in nature, never knowing entirely what they may find. Artificial light, on the other hand, is a powerfully expressive tool that gives the artist control over the amount, quality, and directional source of light to meet the desired compositional and expressive needs.

Form and Space

Space is the existing atmosphere surrounding and enveloping all form. In a compositional sense, space equals negative, form equals positive; therefore, space is generally understood as the negative aspect, or complement, of form. Space can have finite or infinite properties in the visual world as well as in the physical realm. Space is also a vehicle for illusion. Space, like form, is defined by light, which artists re-create in terms of value. Value not only defines objects, it also places and sepa-

6-10. *above:* KENT BELLOWS (b. 1949; American). *Nicole; March,* 1997. Graphite with touches of erasing on ivory wove paper, 32 1/2 × 14 1/2″ (826 × 369 mm). The Jalane and Richard Davidson Collection. © The Art Institute of Chicago. All rights reserved.

6-11. *right:* MARTHA MAYER ERLEBACHER (b. 1937; American). *Male Back.* 1980. The Arkansas Art Center Foundation Collection.

space
The negative aspect or complement of form; the atmosphere surrounding forms or objects.

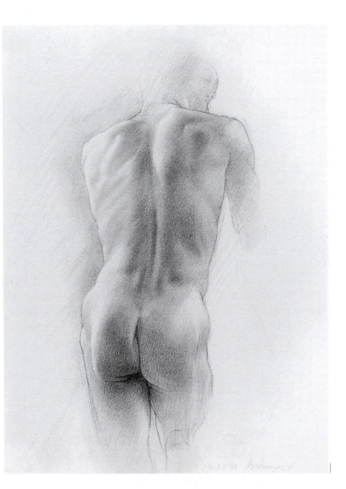

6-12. RICHARD DIEBENKORN (1922–1993; American). *Seated Woman with Hat.* 1967. Pencil and ink wash, 14 × 17″ (35.6 × 43.2 cm). Estate of the artist.

rates forms in space. Using boldly simplified patterns of light and dark with almost no modeling of tone, Richard Diebenkorn creates both volume and space in his drawing of a woman seated in bright sunlight (Fig. 6-12). The strong light-dark contrast between the figure's right arm and her upper garment makes the arm appear to project; less contrast in value between the face and the background places the head deeper in compositional space than the arm. The brim of the sun hat exists between the arm and face, and as it shades the side of the face, this also sends it deeper into the picture plane, creating a spatial dynamic as it defines this human form.

Project 6.8

Do a drawing in which you establish spatial relationships by attending to the principle that light forms advance and dark forms recede. Arrange a group of simple, familiar objects such as cups, jars, canisters, and pots so that by their placement you are aware of space. Define space through the deliberate manipulation of value, using the lightest value for the closest object and increasingly darker values as the forms recede in space. Reserve the darkest value for the background. A strong light seen against a bold dark will appear to project more than the same light against a less contrasting value.

Use drawing media that produce wide-ranging values and do several different drawings, stopping occasionally to rearrange the objects while drawing them from different viewpoints as well. Strive for high contrasts and dynamic spatial results. The wider the value range, the greater the contrasting elements of the defined forms in space.

Critique (Project 6.8) As you assess your drawings from Project 6.8, can you see how important value is to their compositional structure? Do they contain wide-ranging values? Are the contrasting elements visually interesting? Do the drawings have visual impact because of the way in which you used value? What do you feel are the weakest elements? How would you improve upon these drawings? Would you say these drawings look decidedly different from the drawings in previous assignments?

In your general approach to subject matter of all kinds, begin to see form and space as defined by light and shadow. In your sketchbook, instead of beginning a drawing with contour outlines, try to avoid any use of line and draw with masses of dark and light values whether you are drawing an object, figure, or landscape. Approach even the shadow shapes by blocking them in with areas of appropriate tonal value without depending on preliminary contour lines. If at first this seems awkward, persist and you will eventually find that you can define forms more quickly by relying on shapes of tonal value than by first establishing lines as boundaries for shapes. Even a complicated object can be reproduced with amazing accuracy when the artist concentrates on duplicating patterns of shapes and value rather than trying to draw the object itself. Learn to simplify! You do not have to define everything.

Pattern

The term **pattern** has a number of connotations as it relates to drawing, painting, printmaking, and even sculpture. When the Diebenkorn drawing (Fig. 6-12) was described as "simplified patterns of light and dark," the term referred to all of the individual shapes, defined by changes of value, that combine to construct form and space within the composition. Perhaps a more common use of the term is as it applies to the regular **repetition** of a design or shape. While subtle variations in size and spacing do much to prevent the repeated shape in *Six Persimmons* (Fig. 6-13) from becoming monotonous, it is the arbitrary changes in value that Mu-Ch'i has introduced that make the piece so distinctive.

Pattern, in addition to defining form and space, can also function decoratively. Flat, unmodulated surfaces of dark and light produce pattern rather than form. We see the shape of an area and are conscious of its silhouette, but the sense of volume is minimized. Pure silhouette, whether black on white or white against black, provides the greatest possible value simplification, yet by itself is not sufficiently complex to be very entertaining. We can see how Aubrey Beardsley's elaboration of

pattern
Any compositionally repeated element or regular repetition of a design or single shape; pattern drawings in commercial art may serve as models for commercial imitation.

repetition
The unifying visual sense of regularity in the appearance of similar elements—lines, shapes, patterns, textures, colors, values, and movements within a composition.

6-13. MU-CH'I (13th century; Chinese). *Six Persimmons.* Ink on paper, 14 1/2 × 11 1/4″ (36.8 × 28.6 cm). Ryoko-in, Daitokuji, Kyoto.

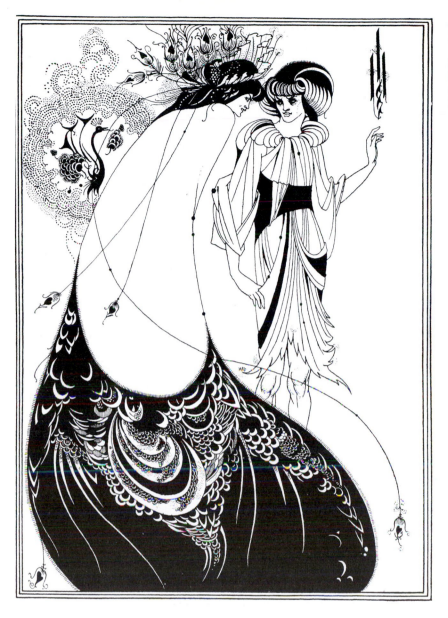

6-14. AUBREY BEARDSLEY (1872–1898; English). *The Peacock Skirt, from Salome.* 1894. Pen and ink, 9 1/8 × 6 5/8" (23.2 × 16.8 cm). Fogg Art Museum, Harvard University, Cambridge, Mass. (Grenville L. Winthrop Bequest).

pattern in *The Peacock Skirt* (Fig. 6-14) increases the visual interest of his illustration. In the lower portion of the composition the pattern design is white against a black shape that is further silhouetted against a white background. The peacock fan and the headdress use black patterns and lines on a white ground, while other elements in the composition, such as the woman's face and the bodies of both figures, are dark outlines creating the effect of white pattern against white ground. The stippled border of the fan and the linear complexity of the man's garment and head wear further enrich the decorative scheme.

Texture

Choice of value and manner of application are important in creating the illusion of different textures and surfaces. Value permits the depiction of characteristics that cannot be described by line alone, such as the smooth sheen of heavy brown wrapping paper in Claudio Bravo's *Package* (Fig. 6-15). In fact, the powerful descriptive effects of the drawing

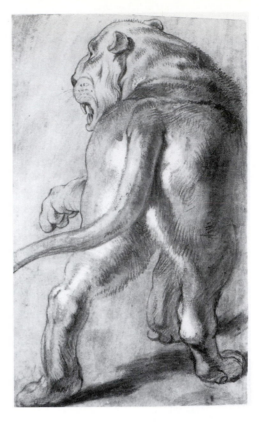

6-15. *above, left:* CLAUDIO BRAVO (b. 1936; Chilean). *Package.* 1969. Charcoal, pastel, and sanguine, 30 7/8 × 22 1/2" (78.4 × 57.2 cm).
Baltimore Museum of Art (Thomas E. Benesch Memorial Collection).

6-16. *above, right:* PETER PAUL RUBENS (1557–1640; Flemish). *Lioness.* c. 1618. Black, white, and yellow chalk, 15 5/8 × 9 1/4" (39.7 × 23.5 cm).
British Museum, London (reproduced by courtesy of the Trustees).

media with its subtle but poignant value changes transcend the tactile properties of mere brown wrapping paper by emulating another smoother material such as oilcloth or perhaps a rubber apron. Even gradations of tone best describe hard, smooth, polished objects, while broken patterns of light and dark are appropriate to surfaces with stronger textural characteristics, as exemplified in Peter Paul Rubens's drawing *Lioness* (Fig. 6-16), done with black, white, and yellow chalk. These two drawings are almost identical in the use of value, exhibiting strong light patterns integrated into large areas of predominantly darker values while using high contrast as a means of defining form dramatically and implying a definite light source. While the gradations of tone in the drawing by Rubens are less smooth, the major difference in effect results from the superimposed patterns of hatched lines on the animal's coat.

Project 6.9

It is possible to develop a rich variety of textures and surfaces, smooth or rough, hard or soft, by drawing on middle-value gray charcoal paper, using white chalk to build lights, even highlights, and adding dark with charcoal or Conté crayon as in Figure 6-16. Reserve the gray of the paper for all middle values; avoid mixing the chalk and charcoal to produce gray tones as this destroys the freshness of surface effects. By building the light and dark tones separately, you will make your drawing appear cleaner, crisper, and more certain.

Explore a number of different subjects that offer textural contrasts. A starched napkin, folded and pressed, provides an interesting pattern of crumpled angularity and soft flowing surfaces when pinned to a wall. A very different quality characterizes silk, satin, or taffeta, which require exaggerated highlights. The broad flat planes of a fresh new paper bag must be rendered differently from those of a used, limp sack that has been worn and crushed. Try to distinguish between a transparent object such as a glass or jar and the polished reflective surface of something

metallic (Pl. 2). In doing so, you'll become aware of the vast difference in visual effects between transparent and reflective objects when at first glance you may have thought them to be very similar.

Project 6.10

Make your own gray paper by laying an even tone of charcoal over a full sheet of white paper, using either a soft charcoal or crushed compressed charcoal, which can be applied by rubbing gently with a soft cloth or chamois hide. Avoid using a paper towel that may be too stiff, as it will tend to form streaks, causing the tone to be uneven. Choose a subject in the landscape with a potentially interesting value and textural range and begin composing. Darker values are drawn in with compressed charcoal, while lighter tones and whites can be lifted out with a clean chamois and kneaded eraser. Try to work quickly and directly, not overdrawing areas that may seem fussy or problematic. Let the defining abilities of the drawing media become expressively alive without overemphasizing detail. The subject of landscape will be dealt with in depth in Chapter 13.

Critique (Projects 6.9, 6.10) When you look at your drawing from Projects 6.9 and 6.10, is it apparent that value is the major factor in defining and creating interesting textural surfaces on a variety of different objects? How descriptive are your surfaces? Do they satisfactorily emulate the objects you've drawn? Do they emphasize or exaggerate any aspects of your chosen subjects? Is this emphasis or exaggeration visually pleasing? Does it heighten the visual statement in an interesting and provocative way? Does your handling of the medium begin to emulate surfaces other than those you've attempted to draw?

In the landscape drawing from Project 6.10, is there a visually readable space within the composition? Were you able to manipulate the media well by laying down definitive darks and also subtracting tone by erasing to create vibrant lights, even whites? Starting from the middle-value gray of the paper, do the drawings show an interesting range of added darks and lights?

Range of Values and Expressive Use of Value

Value assumes a dominant role in determining the expressive mood of a drawing and allows all aspects of the drawing to work together as a "**visual whole.**" A work that exploits full contrasts of value may convey a feeling of visual life and conceptual vigor (Fig. 6-14). However, if some aspect of composition fails in its unified attempt at visual communication, the potential sense of life and vigor may be stunted or destroyed. Furthermore, compositions in which close value relationships dominate while contrasts are minimized may create a sense of quiet, soothing restfulness or of introspection and brooding subjectivity, provided that all elements of the drawing are working together. Predominantly light compositions may carry a feeling of illumination, clarity, and perhaps a rational, optimistic outlook. On the other hand, compositions predominantly dark in value often suggest night, darkness, mystery, and even fear. Keep in mind however, that the sheer mysteries of drawings may preclude any reasonable attempt at categorizing them or their visual effects in this way. To observe a drawing in a museum or gallery exhibition, or for that matter on a wall in someone's home, is to be immersed in the mysterious circumstance of responding and interpreting according to your own level of exposure and command of a visual language. Every successful drawing is different; each has its own origin and personality. Additionally, the viewer brings another important element to the interpretation of a drawing—his or her perspective regarding mood.

visual whole
The quality of a unified compositional state brought about by the correct degrees of balance, contrast, pattern, rhythm, etc., that produce oneness.

Often the most interesting drawings reject any attempt to discover in them a specific mood or feeling, but drawings, like all works of art, are self-defining mysteries, without the need for categorization or justification. This is precisely what keeps us coming back to look at them, time and time again.

Consider how lighting is used to establish mood for films and television—popular television comedies are brightly lighted while darkness lends a heightened sense of theatricality to serious dramas. Consider also the multifaceted qualities of light and their vastly different emotive effects in black and white and in color films. Light, when used in modes of high contrast, still produces the greatest visual impact, as we saw in Figure 6-3.

High Key, Middle Key, Low Key An artist selects and chooses from the value scale (Fig. 6-1) in much the same manner that a composer works with scales and keys to give mood and expressive character to a musical composition. For example, consider the expressive differences of minor chords as compared with major chords and how they affect you emotionally. In visual art, as in music, the terms *high key, middle key, low key,* and *full range* are used to describe the general tonality of a drawing, etching, lithograph, painting, or woodcut. They each have their intrinsic powers of provoking emotive responses and are used by artists for that purpose.

Drawings categorized as high key, middle key, and low key are those based upon a limited number of closely related values. **High key** refers to the light values—white through middle gray on the value scale, in which case the darkest value is no darker than middle gray. This is evident in *Still Life with Shadows* by William A. Berry (Fig. 6-17). The various faces of what appear to be pieces of folded cardboard, and the diffused shadows they cast as they stand upright on a box or table draped with a cloth that falls into full folds at the corners, allow Berry to translate the upper half of the value scale into a very complete drawing of lyrical beauty. This is further accomplished by building up his repertoire of middle- to light-range values with slow, deliberate, mechanical crosshatching. That something as ordinary and seemingly uninteresting as six

high key
The lightest values—white through middle gray on the value scale, in which case the darkest value is no darker than middle gray.

6-17. WILLIAM A. BERRY (b. 1933; American). *Still Life with Shadows.* 1988. Colored pencil, 30 × 40″ (76.2 × 101.6 cm).
Courtesy of the artist.

pieces of folded cardboard could be the subject of such a poetic drawing might well surprise students who find it difficult to believe that it doesn't really matter what you draw—only how you choose to draw it. Although the drawing is done in colored pencil, Berry's primary concern is value. Here again we see that when a color work is reduced to black and white, its contrasting values, whether high-, middle-, or low-key, are the overriding factors that produce visual impact.

Another beautiful example of a high-key drawing with even less contrast and slightly more softened shadows than in Figure 6-17 is William Bailey's graphite drawing *Still Life—Via dell'Oca* (Fig. 6-18). In this subtle but powerful work we see the chiaroscuro system of defining forms in space limited to light, shadow, core of shadow, reflected shadow, and cast shadow. There are no discernible elements of highlight or reflected light. Because Bailey produced this drawing on not white but cream wove paper, he could have used white chalk or white pencil to add highlights, but chose not to.

A **middle-key** drawing such as Frank Pietek's *Abstract Configuration #2* (Fig. 6-19) includes the five values in the middle of the scale equidistant between extreme light and dark; the dark half of the scale provides the **low key** (Fig. 6-15). In practice, it is the overall tonality, rather than an exact duplicating of specific values, that determines the key of any drawing.

Project 6.11

Select a subject appropriate to a high-key (light value) rendering—for example, a still life devoid of strong darks and extensive shadow areas, perhaps one composed of basically light forms, such as eggs or lemons in a white bowl; a white paper bag resting on a well-lit draped white sheet; a sunlit landscape of ripened wheat fields or an open meadow in winter. As a greater challenge, you can transpose any subject, no matter what its actual tonality, into a high-key drawing. To do so, establish what will be the lightest and darkest values and work within that range. It will be

middle key
On a nine-step value-range scale, the five values in the middle of the scale.

low key
The darkest half of the value scale with the lightest value being no lighter than middle gray.

6-19. FRANK PIATEK (b. 1944; American). *Abstract Configuration #2*, 1987–1890. Gesso, graphite, white lead, and oil on paper, 46 × 60 1/2" (116.9 × 153.7 cm). The Arkansas Arts Center Foundation Collection.

necessary to simplify the values you see in order to compress them into the allowable number of values stages.

Determine size and shape relationships quickly, lightly, and without elaboration; block in broad value patterns as simply as possible; then study and define edges of forms, adding dark accents and highlights.

To produce a similar effect, create a drawing surface of an even tone of pale gray by rubbing a small amount of powdered graphite into the tooth of a sheet of paper (soft graphite in stick form can easily be powdered on sandpaper). Use a fairly hard graphite pencil (2H or 3H) to delineate your composition, add middle and darker values with pencil or rub in more graphite, and erase out lights. If you need darker accents, draw them with a soft pencil (4B or 6B). Selecting a very fine white paper such as Bristol board results in a pale tonality of great elegance.

Project 6.12

Select a theme that would lend itself to a predominantly dark (low-key) composition. Night subjects are, or course, ideal, but a wide variety of less obvious representational or symbolic concepts can be given a special character when presented in low key. A subject as radiant as a bouquet of summer flowers can be transformed into something ominous and mysterious through a change of value. You may wish to work on gray charcoal paper, allowing the value of the paper to determine your lightest light.

full range
A complete gradation of tones from the lightest to the darkest values.

Full Range As the term implies, a drawing with a **full range** of values is one that uses a complete gradation of tones from white to black. Full range does not require equal distribution of all values. As in Charles Sheeler's *Interior, Bucks County Barn* (Fig. 6-20), many of the tones play only a supporting role to the feature values, black and white.

In developing any drawing, it is a valuable practice to determine the lightest light and darkest dark as a gauge from which to work. As a student, Paul Cézanne is said to have determined his values in relation to a black hat and a white handkerchief that he placed beside his models. Without establishing some reference points, it is easy to overwork an area. It is generally advisable to err on the side of lightness since it is easier to darken an area than to lighten it. Many student

6-20. CHARLES SHEELER (1883–1965; American). *Interior, Bucks County Barn.* 1932. Conté, 15 × 18 3/4″ (38.1 × 47.6 cm). Whitney Museum of American Art, New York (purchase).

drawings intended as full-range drawings lack interest because strong lights have been lost through overworking the surface while the darks have not been made rich enough. This practice of additive and subtractive drawing (both laying down tone and erasing it) allows the artist to test the tenacity of the drawing materials—to push them to their limits. In doing so, one becomes very familiar with what a particular paper can withstand.

Value Contrasts for Emphasis

Strong contrasts of light and dark, along with linear movements, create **focal points** that can direct the viewer's attention to parts of the composition according to their relative significance. Emphasis through dramatic value contrasts works equally well whether a composition is representational (Fig. 6-20) or abstract (Fig. 6-21). In Elizabeth Murray's *Untitled* work in charcoal and colored chalks on paper, we experience the quintessential drama of high contrasting values on an irregularly shaped picture plane, which adds to the overall complexity.

focal points

The elements or portions of a composition that form the main thrust or central emphasis and are visually supported or fortified by all other surrounding compositional elements.

Project 6.13

Review the various drawings you have done for the projects in this chapter. Could some forms be made to appear more solidly three-dimensional by stronger modeling in light and dark? Could objects be made to exist more convincingly in space by increasing the light-dark contrasts to make forms project, or lessening contrast to make them recede? Do the weakest drawings lack interest because everything is presented with equal emphasis? Or are the strongest drawings as strong as they could be?

It is possible, by intensifying focus on some forms or areas, to produce a greater sense of drama, visual interest, and emotive impact. Make whatever changes seem appropriate by altering value relationships through darkening and lightening. In some cases the paper surfaces may be fatigued through overworking, and you may prefer to make a new drawing of the same or similar subject. Rarely are problems solved or techniques mastered with a single drawing.

6-21. ELIZABETH MURRAY (b. 1940; American). *Untitled*, 1984. Charcoal and colored chalks on paper, 37 1/4 × 38″ (94.7 × 96.6 cm). The Arkansas Arts Center Foundation Collection.

color

In its purest sense, the condition produced by white light passing through a glass prism. A spectrum of color is the visual evidence of refracted or dispersed light rays of different wavelengths that stimulate the retina to see the different hues. The hue red produces the longest wavelengths; violet produces the shortest. Chromatic color is distinguished by qualities of hue: red, blue, and yellow as the primary colors; violet, green, and orange as the secondary colors.

local color

The true color or hue of a surface as seen free from the effects of light and shadow; under illumination. Local hues are lightened or darkened depending upon the degree of lightness or darkness.

Color and Value

Although **color** can be considered a separate element, it is introduced in this chapter because it is so closely linked to value. All that has been discussed about value as black and white is applicable to drawing/painting/printmaking in color.

Almost every beginning student eventually feels limited working in black and white and longs to discover the beauty and excitement of color. To draw in black and white requires translating color into corresponding tones of gray; to draw in color demands perceiving color in terms of light and dark instead of thinking of it only in terms of **local color.** Seeing only local color, failing to notice value relationships within and between colors, is the most common error that is made in moving from black and white into color. The test of an artist's success in using color as value is revealed when a full-color drawing, painting, etching, or lithograph is photographed in black and white. The introduction of color into a drawing does not negate the fact that variations in degrees of dark and light provide one of the most effective means for giving definition to forms in space, yet many students seem reluctant to accept the concept that the success of a drawing in color depends more on correct values than on correct colors. Defining and separating forms require more than simply a color change.

Color Assembling objects for a drawing in black and white requires no particular concern or even thought about color. However, making drawings, prints, and paintings in color is another matter. Not everyone has access to a variety of objects harmonious in color, and consequently, duplicating the colors of one's assembled objects might not produce a pleasing balance of color. Artists are free, however, to alter color and create variations in hues as they choose.

Dimensions of Color Color has three dimensions: hue, value, and intensity. **Hue** corresponds to local color. It is the quality that distinguishes one color from another—redness, blueness. The quality of color warmness pertains to the red hues and all hues related to red, and color coolness pertains to blue hues and all hues related to blue. In the context of color, **value** refers to the lightness or darkness of a color in comparison with white and black. **Intensity** describes degrees of strength and brilliance—the brightness or dullness of a color. Value and intensity can be changed, but the hue remains. Although light red might commonly be referred to as pink, it is actually a light-value red; "shocking pink" would suggest a high-intensity light red.

Hue The basic hues—violet, blue, green, yellow, orange, and red—and their intermediate gradations are designed as primary, secondary, or tertiary colors. **Primary colors**—red, yellow, and blue—are so called because they are pure colors that cannot be obtained by mixing together any other hues. **Secondary colors**—orange, green, and purple (violet)—are derivative hues produced by mixing two primaries. **Tertiary colors** are the intermediate steps between the six basic hues. They are given hyphenated names—blue-green, yellow-orange, and red-violet. (Ordinarily the primary color is named first, followed by the secondary hue. A reversal, as in "orange-red," implies that the hue contains more orange than red.)

When arranged in a circle to form a color wheel (Pl. 3), hues opposite each other are called **complementary colors.** Yellow and violet are complementary, as are red and green, blue and orange. Complementary tertiary hues also face each other across the color wheel. The role of complementary colors will be discussed in relation to intensity.

Value Each color has its own value; it also has its own range of values. Yellow is the lightest, violet the darkest; orange, blue, red, and green all cluster near the middle of the value scale, with orange just above the middle, blue just below, and red and green generally corresponding to middle gray. Each color can be lightened to a **tint** (high value or high key) by the addition of white, or darkened to a **shade** (low value or low key) by adding black. The value of a color will appear to change when it is placed against different backgrounds, in the same way that spots of white, gray, and black are seen to change in the value scale (Fig. 6-1). Value is always relative. It is imperative to begin to see and analyze color in terms of value, determining whether what is seen is lighter or darker than something else, not just a different hue. Many aspects of color value are evident in comparing Edmond-François Aman-Jean's richly developed pastel drawing *Les Confidences,* as reproduced both in black and white (Fig. 6-22) and color (Pl. 4).

When you work in color, degrees of value contrast are equally important in creating and describing volume and space within a composition. Greater contrast projects forms forward and tends to create dynamic spatial relationships of "push and pull" between forms; less contrast causes forms to recede and tends to flatten space. Along with spatial interplays produced by contrasting variants, there are dramatic effects and states of mood that are also influenced by the range of values employed. Aman-Jean has skillfully manipulated value both to define space and to establish mood. Although he has chosen a very limited range of values, subtle light-dark differences serve to define three-

hue
Local color; the quality that distinguishes one color from another.

value
Degrees of light and dark; the light and dark characteristics of color; the amount of light reflected by a particular color.

intensity
The degree of strength or brilliance; as related to color, the strength or saturation of a pigment; the brightness of a color.

primary colors
Red, yellow, and blue; called *primaries* because they are pure colors and cannot be obtained by mixing together any other hues.

secondary colors
Violet, orange, and green. The three colors resulting from the pairing and mixing of any two of the three primary colors: blue and red produce *violet*; red and yellow produce *orange*, yellow and blue produce *green*.

tertiary colors
The intermediate steps between the six basic hues—the three primary and three secondary colors; colors obtained by mixing two secondary colors.

complementary colors
Hues opposite one another on the color wheel; yellow and violet; red and green; blue and orange. Complementary tertiary hues also face each other across the color wheel.

tint (high key value)
Any color that has been lightened by the addition of white.

shade
A lessened degree of light caused by the blockage or partial blockage of directional light rays; as pertaining to color (low value), any color that has been darkened by the addition of black.

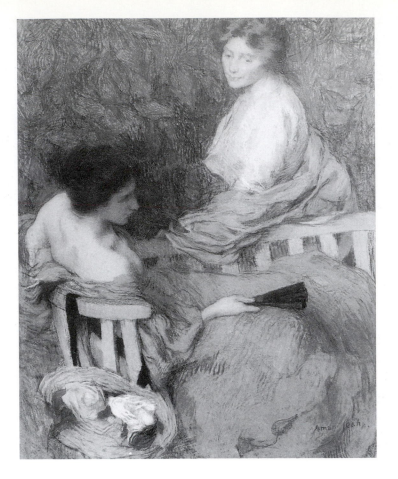

6-22. EDMOND-FRANÇOIS AMAN-JEAN (1860–1935; French). *Les Confidences.* c. 1898. Pastel on blue paper affixed to canvas, 48 × 38″ (1.22 × .97 m). Achenbach Foundation for Graphic Arts, Mildred Anna Williams Fund, The Fine Arts Museums of San Francisco.

dimensional forms and space in a more subtle way, bringing into play the power of subtlety. The separation of the seated figure's left shoulder from the foliage results from change of value as much as from color change. The highlight on her right shoulder indicates fullness of form. The ribbon of the hat and the slats of the garden bench provide the strongest light-dark accents to project that part of the bench forward, whereas darker and closer values place the back of the bench deeper in space. Value differences in the leafy background are almost imperceptible. The closeness of values and the lack of bold contrasts contribute significantly to the mood of gentle reverie.

The power of subtlety within a relatively tight range of values, aside from the light and dark accents, is also seen in Warrington Colescott's *God Destroys Bourbon Street* (Fig. 6-23). This large watercolor translated into black and white is highly definitive in its spatially descriptive powers of subtlety encased within its predominantly middle-range value scheme.

It is not necessary to be conspicuously conscious of the subtle handling of color, value, and intensity to respond to the beauty of Aman-Jean's drawing or Warrington Colescott's watercolor; but as art students, you should sharpen your awareness by studying all such drawings carefully and thoroughly.

Intensity Looking once again at the Aman-Jean drawing, you will see that the colors in the lower half of the drawing are generally stronger and brighter than those above. The foreground colors have somewhat

6-23. WARRINGTON COLESCOTT (b. 1921; American). *God Destroys Bourbon Street*, 1995. Watercolor on paper, 40 1/4 × 59 3/4" (102.3 × 151.8 cm). The Arkansas Arts Center Foundation Collection.

greater intensity, which combines with aspects of value to reveal space. The dominant red-orange of the seated figure's dress is obvious. It is perhaps more interesting, however, to compare the rose on the hat with the dress of the standing figure. Although they are almost identical in value, the light area of the sleeve is almost colorless in contrast to the more vibrant color of the rose. It is also important to note that the hair of the standing woman is the same hue as the dress of the seated figure—red-orange, but of a darker value and lower intensity.

The intensity of color is affected by light and by its surroundings. Color seen in strong direct light, either natural or artificial, is more brilliant and vibrant than the same color viewed in subdued light or on a gray day. The degree of believability and articulate representation in art not only derives from but is dependent upon the ability to accurately read color. Color is rarely seen in isolation but rather is influenced by neighboring colors. Colors of similar intensity placed alongside one another hold together, whereas contrast produces separation. The higher the intensity of a color, the more it appears to project; the lower the intensity, the more a color recedes.

Project 6.14

Although Willem de Kooning's *Two Women's Torsos* (Pl. 5) is a decidedly different interpretation of figures juxtaposed with each other than that of Aman-Jean's figures in the landscape (Pl. 4), careful examination of the two drawings reveals strong similarity in the way in which color has been employed. Analyze de Kooning's use of color—hue, value, and intensity. Determine the points of similarity between the two

works. Which artist do you feel has used the elements of color more successfully to convey what he intends to say? Why?

Altering the intensity of a hue by adding white or black is, in and of itself, of limited effectiveness, since the addition of either also results in changing the value. In painting and printmaking, most pigments (whether paint or ink) are at their most intense as they come from the container. Blue and violet are the exceptions; their brilliance increases slightly by adding a small amount of white. It is possible to alter a color's intensity by adding some other color, but not without changing the hue as well.

Color Schemes

A number of **color schemes** have been formulated to provide a sense of color harmony and unity. An understanding of the three most widely recognized color schemes provides a point of departure for selecting and combining colors.

Monochromatic Color Scheme A **monochromatic** scheme involves varied hues (colors) and varying intensities in value of a single hue. For example, a wide-ranging monochromatic color scheme can be created with any hue by adding prescribed amounts of white to form progressively lighter stages known as tints of the hue. Conversely, prescribed amounts of black can be added to the same hue, forming progressively darker stages known as shades of the same hue or color. Both black and white, not being colors, are deliberately introduced without violating the one-hue limitation, which precipitates a "pure" monochromatic situation.

Analogous Color Scheme An **analogous** color scheme employs unlimited values and intensities of neighboring hues on the color wheel, the range not to exceed the bounds of two consecutive primary colors. Analogous character is most emphatic when a single primary hue dominates. Though more animated than the monochromatic scheme, the analogous scheme can also create a harmonious and quiet mood due to the close relationship of its component hues. Martha Alf's *Two Pears No. 3* (Pl. 1) is suggestive of analogous color.

Complementary Color Scheme Contrasting hues are the basis of the **complementary** color scheme. The addition of other hues is permitted, as long as they do not overwhelm the requisite pair of complementaries (Pl. 4).

Two pairs of complementary colors, such as blue and orange plus red and green, comprise a **double-complementary** scheme. Willem de Kooning's *Two Women's Torsos* (Pl. 5) introduces yet a third pair, yellow and violet producing a **triple-complementary** color scheme.

A **split-complementary** scheme poses one hue against the two hues flanking its complement; an example would be yellow with red-violet and blue-violet.

According to Henri Matisse, the quality of color is determined by the quantity of color. Some color theorists who advocate a proportional use of color suggest that a balance between complementaries requires equal amounts of red and green, two times as much blue as orange, and three times as much violet as yellow. (Plate 4 comes close to meeting the red-green specifications.)

color schemes
Systems of color combinations that provide a sense of color harmony and unity.

monochromatic color scheme
A color scheme in which an entire composition is composed of the descriptive value ranges of a single color with its shades and tints.

analogous color scheme
A color scheme comprised of any combination of adjacent colors on the color wheel as the main color statement of a work of art.

complementary color scheme
A color scheme that poses two pairs of complementary colors, such as blue and orange plus red and green, working together in the same work of art.

double complementary color scheme
A color scheme that poses two pairs of complementary colors, such as blue and orange plus red and green, working together in the same work of art.

triple complementary color scheme
A color scheme that poses three pairs of complementary colors, such as blue and orange, red and green, and yellow and violet, all working together in the same work of art.

split complementary color scheme
A color scheme that poses one hue against the two hues flanking its complement; an example would be yellow with red-violet and blue-violet.

Project 6.15

While most artists settle for a pleasing balance of color, it is instructive to experiment with various color schemes. To experience the interaction of color, use graph paper with a quarter-inch grid and colored pencils or pastels to create images, even portraits, by filling in individual squares with a single color. Let gradations of color and tonal variations result from changing colors in adjacent squares. The completed drawing will resemble Figure 15-15. The mosaic or needlepoint effect will soften and disappear when viewed at some distance. Do a drawing, again on quarter-inch grid paper, in which the juxtaposition of the three primary colors of red, yellow, and blue creates the secondary colors orange, green, and violet.

Project 6.16

Do a drawing based on the proportional balancing of complementary colors. It is not necessary to have equal amounts of each pair of colors; you may allow one set to be dominant. Value and intensity changes will contribute to a more painterly effect, as will **broken color,** which eliminates color purity by introducing more than one color into a specific shape or object through mixing.

Complementary colors play two roles: they can either nullify or intensify each other. In theory, true complements combined in the correct proportions will produce a neutral or colorless gray. However, in practice it is difficult to find exact complementaries, and the resulting mixture usually retains traces of one of the two colors. Placed in juxtaposition, complementaries increase the apparent intensity of each other, or truly "complement" each other; the effect is called **simultaneous contrast.** A spot of low-intensity orange placed against a surrounding field of high-intensity blue will appear distinctly more intense. When orange and blue of corresponding high intensities are placed together, the colors will appear to vibrate almost to the point that the eye can barely discern a precise separation. (This fact is borne out in the color vibration paintings of the Pop and Op Art movements.)

Warm and Cool Colors As alluded to earlier in this chapter, color temperature has psychological and spatial impact. The hues of one side of the color wheel (Pl. 3)—yellow, orange, red, and their neighboring tertiaries—are called **warm** colors; the hues on the opposite side of the wheel—green, blue, violet, and the intermediate tertiaries—are termed **cool.** Warm colors seem to project forward in space; they are considered aggressive, psychologically arousing, and stimulating. Cool colors, in contrast, tend to recede in space, seem quiet, and add a sense of restfulness to a composition. The effects of warm and cool are more evident when seen together. Temperature is relative, and any color can be made to appear either warm or cool, or both, as evidenced in the hair, shadowed face, and hat of the seated woman in Plate 4. The color of any object or surface is influenced by the temperature of the light, as are shadows. Warm light casts cool shadows; cool light casts warm shadows.

Temperature also plays an important role in color mixing. In theory, secondary colors or hues can be produced by mixing two primary colors; but in practice, special consideration must be given to the temperature of the primary colors if the resulting secondary colors are to be clean and bright. Because pure primary colors are unavailable, it is necessary to work with both warm (w) and cool (c) reds, yellows, and blues. Recommended colors for producing the purest and brightest

broken color
A color scheme where more than one color is introduced into a shape or object to produce varied painterly effects. Also, a pure color that has been altered by the invasion of another color.

simultaneous contrast
A visual effect produced when complementary colors are placed in juxtaposition, which increases the apparent intensity of both so that they truly complement each other.

warm color
A hue on one side of the color wheel—yellow, orange, red, and their neighboring tertiary colors; any color opposite the cool colors on the color wheel.

cool color
A hue on one side of the color wheel—green, blue, violet, and their intermediate tertiary colors; any color opposite the warm colors on the color wheel.

secondary colors are Alizarin Crimson (c) and French Ultramarine Blue (w) for violet, Pthalo Blue (c) and Lemon Yellow (c) for green, and Cadmium Yellow (w) and Cadmium Red (w) for orange, because each of the two primaries suggested already contains some of the other color. Other combinations will produce dull or subdued variations of the secondary colors—mixtures that might be appropriate when purity of color is not the goal.

Drawing in Color

Aman-Jean's use of color in his drawing (Pl. 4) is so fully developed that it might well rival the color usage in painting, yet it remains a drawing. Drawing is one of the purest acts of visual creativity an artist can hope to engage in. When color is introduced, the distinction between drawing and painting may be arbitrary; however, painting is a second-generation image of which the pure act of drawing is the progenitor. Color mixing is generally more related to painting than drawing, and although drawing is conceived as employing less than full modulations of color, an acute familiarity with the components of color is immeasurably useful to the artist in the act of drawing.

To explore the use of color in drawing, it will be necessary to expand your supply of materials. Today there is an unparalleled supply of colored drawing materials that provide extensive ranges of hues, values, and intensities equal to that available to painters and printmakers with their paints and inks of tremendous versatility. Colored chalks, pastels, colored pencils, colored pens, oil crayons, and colored inks—all readily available, relatively inexpensive, and easy to use—will equip the beginner for an adventure in the use of color. Although at some time you will want to experiment with a variety of media and techniques, any one of the suggested media will be sufficient for initial excursions into color. (See Chapters 10 and 11, covering drawing media.)

Adopting a technique that first came into use in Italy in the early sixteenth century, William Berry introduced a limited sense of color in *Self Portrait with a Lamp* (Pl. 6) by drawing with black and white on colored paper, adding reddish touches on the nose, cheeks, and lips. The color of the paper provides the middle value; the white and black are never blended together. Colored paper is most effective when the color and tone of the paper are incorporated into the drawing, as Berry has done. The same technique would accommodate the substitution of drawing materials of a lighter-value warm color for the white pencil, and a darker-value cool color for the graphite or black pencil.

Red chalk (red or iron oxide) is one of the oldest pigments known; the color warmth, intensity, and accessibility made it a popular medium for over four hundred years, and it remains so today. But it did not become popular as a drawing medium until the late fifteenth/early sixteenth century. Because it is partially composed of iron oxide, it produces chromatically strong marks on receptive surfaces. Used for **monochromatic** value studies, red chalk alone imparts a certain vitality to figure drawing because of its closeness in hue to the color of flesh.

Adding first black and then white to red expanded the range of color possibilities, as demonstrated in Alanson Appleton's portrait study (Pl. 7). Appleton chose to combine pen and ink with pastel in place of chalk, but the color concept remains unchanged, except for the addition of blue for the eyes. Examine this work as the pure act of drawing that

monochromatic

A word describing a hue or chromatic variation of shades and tints of the same color attained by adding black to create shades or white to create tints.

it is, and you will notice how it possesses the true life and expressive vitality of drawing at its best.

The addition of yellow ochre to red, black, and white makes possible an even fuller range of color. Drawing with these four colors of chalk or crayon on medium gray paper permits the approximation of a full spectrum of color. Ochre and red combine to make orange; ochre and black make green; seen in relation to the other colors, black and white produce bluish-gray; red and black, similarly, result in violet. None of the colors match their pure-spectrum counterparts, but seen within the context of the drawing, the effect is of a full spectrum of color. All the color mixtures will be of a low intensity, even more so if the component colors have been blended, which tends to deaden the color and also eliminates the sense of the directness of drawing. Chalk and pastel drawings have greater vibrancy and vitality when color is applied directly as areas of unmodulated color (Pl. 1) and juxtaposed strokes of pure color (Pl. 4). The separate strokes of color are mixed by the eye/mind of the viewer, not by the thumb of the artist, to create **optical color.** Lights and darks are achieved by selecting light- and dark-value chalks, rather than by adding white or black to a middle-value color.

The popularity of colored pencils as a drawing medium has increased, partly because they are cleaner and less susceptible to smudging, but perhaps more because of their versatility (Pls. 2, 6). Drawing with colored pencils is similar in a way to drawing with graphite pencils in that value and intensity are determined by pressure. Light pressure produces marks that are light in value and color that lacks brilliance; greater pressure produces darker, more intense color. Colored pencils also have a degree of transparency. Applying one color over another, on a quality drawing paper with adequate tooth, produces a third color, which is often richer and more interesting than either of the originals, since individual colors may tend to be somewhat harsh. A color can also be lightened by applying white or some other lighter color, or darkened with black or other darker colors. (An age-old question remains about the permanency of color. In spite of manufacturers' claims, art conservation laboratories caution artists that the color in pencils tends to fade because of ultraviolet rays and should be tested for permanency by controlled exposure to light.)

optical color
Color effects that are seen and read optically; the actual color the eye reads and the mind understands; tiny strokes of "pure red" in close proximity to tiny strokes of "pure blue" will be read and mixed by the eye to produce violet.

Project 6.17

Select one of the color media—pastels, colored pencils, pen and colored ink, possibly in combination with chalk—and adopt the various techniques discussed and illustrated to subjects of your own choosing. (Characteristics of individual media and suggested methods for using each are the subject of Chapters 10 and 11.) As you commence to draw, use limited color at first before launching into full color, gaining a sense of the hue, value, and intensity of each color and how it handles. Gradually increase the numbers of colors with thoughtful selection and usage, again being cognizant of qualities of value and intensity, as well as hue.

Project 6.18

Arrange a group of several objects into a still life and light them. Ignore the color that you see; draw only the values that you see and translate them into pure hues. Use yellow for the lightest areas, violet for the darkest, and middle-value hues for the intermediate areas, depending on the value of each and the value to be matched. (Hues become increasingly darker as you move in either direction on the color wheel away from yellow toward violet.) Consider color temperature in relation to both light

and shadow and advancing and receding forms. Actual individual objects in the still life will be multicolored. Although the colors in the drawing will not correspond to what you see before you, the values should, and if they do, the sense of volume and space should be well defined, producing a visually convincing composition—a drawing in color.

Color, whether used literally or more expressively, can describe form and create the illusion of space, if attention is given to all three dimensions of color—hue, value, and intensity. Such concern is not limited to representational drawing, painting, or printmaking; it is a consideration for abstractionists as well.

Color carries the expressive power and vitality of light, as manifested in the value scale from intense to weak. Its ability to describe forms with provocative brilliance or somber elegance will be realized in many different venues, provided the artist uses color with thoughtful directness and assertive deliberateness. Drawing in color introduces you to the realms of painting and printmaking and expands the expressive potential of drawing to the other studio disciplines. Perhaps also, drawing in color helps students realize anew the expressive power and provocative beauty of the numerous traditional black and white compositions and the major role they play in art history.

Texture 7

In real life one did not see a high gloss on nature; it had roughness and textural variety. Constable represented these qualities. . . .

—Diana Hirsh

When we look at the world around us, we are conscious not only of form, color, space, light, dark, volume, and atmosphere, but also of tactile qualities, a sense of the feel of surfaces, of roughness and smoothness, hardness and softness—**texture.** Texture, whether actual or illusional, is a catalyst for the senses. It is, in fact, one of the things that catches our eye, that makes us notice something and causes us to reach out and touch it. Skillfully used, texture can contribute significantly to descriptive expressiveness; lacking a decisive sense of texture, a drawing tends to appear flaccid, weak, or generally uninteresting. The textural character of a drawing is determined by several factors: the particular surface portrayed, the drawing materials employed, including the tooth or slickness of the paper surface used, the method of application, and the artist's sense of invention.

texture
The surface character or the tactile qualities experienced through touch; a sense of the "feel" of surfaces, of roughness and smoothness, hardness and softness; the illusion of tactility as in the illusion of a drawn texture albeit on a smooth two-dimensional surface.

Familiar Surfaces

The convincing duplication of surface texture—the actual visible and tactile surface characteristics of an object—lends a sense of authenticity to representational drawing. In drawing we are concerned primarily with reproducing the visual aspects of texture, yet we know that our most immediate experiences with texture are tactile.

Most children, at one time or another, have reproduced the images that appear in relief on coins by placing a piece of paper over a coin and rubbing it with the flat side of a pencil lead. Robert Indiana's *The American Eat* (Fig. 7-1) was created by exactly the same method. The technique is called **frottage,** a rubbing process that takes an articulate

frottage The technique of placing a sheet of paper over an actual, physical texture and rubbing the topside of the paper with the side of a graphite stick or Conté crayon, producing a positive impression of the relief of the physical texture. Artist Max Ernst was the first to use the technique in the production of a work of art.

119

impression from a relief texture. The beauty of Indiana's drawing lies not so much in the letters of the brass relief stencil as in the variety and richness of the undulating dark and light tones created by his hatching with Conté crayon.

Max Ernst was perhaps the first artist to use the frottage technique to create a work of art. In the charcoal drawing *La Forêt Pétrifiée* (Fig. 7-2), he superimposed rubbings made from various pieces of weathered plank. Although the natural patterns of the wood grain are perceptible, the drawing seems to be of, but not necessarily about, wood. Whatever his intention, he has produced texture that is both visual and tactile. Not only do we see texture, we also experience what it would be like to touch it, because the texture no longer seems to reside in the wood, but in the drawing. Another beautiful example of the extremely tactile quality the frottage technique can offer is Ernst's *Wheel of Light* (Fig. 7-3), done with graphite. Here we see an altogether different presentation of a delicate and more refined surface delineation. Notice the well-orchestrated linear textures that are so descriptive of the eye surface and create a powerful illusion of three-dimensionality.

The wood grain patterns in Rene Magritte's *The Thought Which Sees* (Fig. 7-4) resemble those in Figure 7-2, but beyond that, the character of the two drawings is very different. Unlike Ernst's frottage works, Magritte employs a variety of complex, obviously drawn linear patterns

7-2
MAX ERNST (1891–1976; German). *La Forêt Pétrifiée.* 1929. Charcoal frottage.
Musée National de l'Art Moderne, Centre Georges Georges Pompidou, Paris.

7-3 MAX ERNST (1891–1976 ; German). *Wheel of Light.* 1925. Graphite frottage, 10 × 16" (25.4 × 40.6 cm). Musée National de l'Art Moderne, Centre Georges Pompidou, Paris.

to suggest texture. The pattern chosen for the wood grain texture is appropriately the most descriptive, since it defines the only element in the drawing that is not ambiguous.

The precisely ruled vertical and horizontal ink lines of Ilya Bolotowsky's *Blue and Black Vertical* (Fig. 7-5) can be seen as texture of elegant richness, suggestive of, though not representing, sections of beautifully finished fine-grained wood. Whether or not the Bolotowsky drawing actually depicts wood, if for the moment you think of it as such, it allows a valuable comparison with Figures 7-2 and 7-4. Of the three examples, the first offers the most authentic description of wood texture because it was lifted directly from pieces of real wood, while the suggestion of texture in the other two is based on linear patterns. In each drawing the character of line conveys specific visual and tactile qualities of the texture. Thinness and regularity of ruled ink lines create the sensation of smoothness, and variations in darkness suggest the sheen of

7-4 *above, left:* RENE MAGRITTE (1898–1967; Belgian). *The Thought Which Sees.* 1965. Graphite, 15 3/4 × 11 3/4″ (40 × 29.8 cm). The Museum of Modern Art, New York (gift of Mr. and Mrs. Charles B. Benenson).

7-5 *above, right:* ILYA BOLOTOWSKY (1907–1981; Russian-American); *Blue and Black Vertical.* 1971. Pen and ink, 30 × 22″ (76.2 × 55.9 cm). Private collection.

polished wood in the black and white reproduction of Bolotowsky's drawing, in contrast to the rough, weathered feeling of the heavy, irregular patterns of Ernst's charcoal rubbing. In spite of pattern variations, Magritte's repetitious use of short vertical lines creates a wall nearly devoid of character. However, Magritte has provided sufficient variety in the wood grain pattern to avoid monotony and also to form an interesting textural variation between the night-and-day depictions of the sky and the lapping waves of the shoreline contained within the silhouetted figures.

Project 7.1

Rubbings, as in the technique of frottage, do not produce reversed images, as in the pulling of an impression from an etching plate or woodblock, because the frottage image is created on the top side of the paper—not the underside that rests against the textured surface. We often become more conscious of the visual qualities of texture when we see them presented as a pattern of marks on a sheet of paper, isolated from the object or surface itself. This project is intended to integrate the visual with the tactile, to increase visual awareness of familiar textures through seeing them translated into images on a sheet of paper.

Use a soft pencil, graphite stick such as a 2B or 4B, or a black crayon with bond paper or any lightweight, relatively smooth drawing paper. Make rubbings comprising an area of several square inches by placing the paper over textured surfaces in your immediate area (making sure to hold the paper securely to avoid slippage). Select a variety of different textures that are from either interior or exterior surfaces, natural or manufactured, hard or soft, fine or rough. The possibilities multiply in relation to your awareness and sensitivity. As you study the samples, you will be aware that more durable materials result in stronger, even crisper-looking patterns

than soft materials such as fabric, a distinction that provides you with a clue about rendering textural differences. Rubbing methodically while holding the paper steadily in place will produce an effect close to that of the actual surface. Remember to use varying amounts of pressure that will yield a range of lighter and darker patterns as you rub the surface of the paper. A freer, irregular approach will result in a more visually interesting, tonally blurred, perhaps even double texture, as in the effects of Figure 7-1.

Critique (Project 7.1) Observe your results and assess the crispness and/or softened effects that resulted from the different suggested ways of performing the frottage technique. Have you produced some successful results? Which do you find most visually interesting? Note how the harder surfaces you selected produce a more clearly defined texture than do the softer surfaces, which yield more tonal results with a somewhat obscured ghostly essence of texture.

Rendering Textures

Representational drawing demands a more three-dimensional **rendering** of different surface characteristics than does the relatively two-dimensional pattern of texture created by rubbing. The word *render* often is used as a synonym for *draw* or *represent,* but in the context of this discussion it refers to a convincing duplication—an exact re-creation, even a heightening, of the visual effects of surfaces, textures, and details. Joseph Stella's *Tree Trunk* (Fig. 7-6), in which **raking light** from the side reveals both texture and volume, presents a reality very different from the stylized linear description of a similar subject by Jacques de Gheyn in Figure 5-23.

7-6 *above, left:* JOSEPH STELLA (1877–1946; Italian-American). *Tree Trunk.* Pencil and crayon, 17 × 11 1/2″ (43.2 × 29.2 cm). New Jersey State Collection, Trenton (gift of the Friends of the N.J.S.M. in recognition of the services of Mrs. Robert D. Graff as its president 1974–76).

7-7 *above, right:* YASUHIRO ESAKI (b. 1941; Japanese-American). *Blue Sheet No. 9.* 1979. Pencil and acrylic on paper, 28 7/8 × 21 1/2″ (73.3 × 54.6 cm). Courtesy of the artist.

rendering
A drawing displaying a high degree of detailed representation, interpretation, rendition, and other specific information about a subject; the word *render* is often used as a synonym for *draw* or *represent.*

raking light
The planned, controlled, and directed position of a lighting source that causes a "washing over" of illumination, producing a specified lighting effect usually limited to one side of an object or form.

trompe l'oeil
Rendering in its most meticulous form (from a French term meaning "deceive the eye"); usually applies to still life where the creation of poignant illusions convinces the viewer that he is looking at the actual object or objects represented.

Rendering in its most meticulous form is called **trompe l'oeil** (fool the eye). An example is Yasuhiro Esaki's *Blue Sheet No. 9* (Fig. 7-7), one of a series of full-page drawings produced over a five-year period in which the artist explored the wrinkled and folded surface of a bedsheet, transforming the soft cloth into both a topographical map and a lyrical abstraction. The textural character that Esaki achieves is very different from the sheen of smooth paper rendered by Claudio Bravo (Fig. 6-15).

Project 7.2

Enlarging the scale of a surface provides an excellent means of becoming aware of its exact character. Close examination of the texture of many familiar surfaces—a natural sponge, the skin of a cantaloupe—proves visually fascinating. Select a familiar textured surface and light it sharply from above and to one side (a raking light) to emphasize and clarify its texture. Using an HB or 2B graphite, fill a 4- by 5-inch (10- by 13-centimeter) rectangle with a pencil rendering of the surface magnified many times, using varying degrees of pressure and dark and light values to create a maximum sense of its texture. Next, using a wider variety of soft and hard graphite pencils on Bristol board, duplicate the texture as accurately as possible. Plan to spend several hours on this project, working slowly and methodically in whatever intervals your patience allows.

Project 7.3

Do a pencil rendering that contrasts the smooth polished surface of an apple with the subtle texture of the rind of an orange or lemon. Include a slice of the orange or lemon as another element in your composition. Light the forms to show chiaroscuro.

Critique [Projects 7.2 and 7.3] These are the most involved and time-consuming drawings you've done so far from this drawing text. Assess the descriptive qualities of your drawings. Do they appear to portray texture in an enormous and significant way? Do they describe the surfaces of the objects by their textures in an articulate way? Has this exercise helped you become more aware of texture and its fascinating descriptive nature? Have you successfully employed the methods of differing amounts of pressure along with using a variety of different hard and soft graphite pencils? Does the drawing stand on its own as an interesting surface composition irrespective of what the subject was?

Textures of the Artist's Media

Different drawing media produce vastly different textural results according to how they lie on, and fuse with, the surface of paper. The way in which drawing media are applied to a surface—even by the hand of a particular artist, and the textural or "toothy" variations of paper are also important main ingredients in the creation of a drawing. For example, crayon or coarse chalk on rough paper renders greatly contrasting results to fine graphite on smooth paper, and an artist makes definitive choices as to what materials to use according to what desired effects are to be attained. The textural pattern of George Seurat's *The Artist's Mother* (Fig. 7-8) is determined solely by choice of materials. Uniformly textured paper and soft Conté crayon applied without indication of direction of stroke combine to create an impersonal surface. The drawing is more concerned with materials and technique than with a description of the subject. Nevertheless, as with all art that exhibits integrity of materials, there is an emerging character that flows from the work.

Textural quality, as determined by various combinations of media and paper, significantly influences the expressive character of a

7-8 *left:* GEORGES SEURAT (1858–1891; French). *The Artist's Mother.* Conté crayon on paper, 12 1/2 × 9 1/2" (31.7 × 24.2 cm). The Metropolitan Museum of Art, New York.

7-9 *below, left:* KÄTHE KOLLWITZ (1867–1945; German). *Self-Portrait.* 1911. Chalk, 13 3/4 × 12 1/8" (34.9 × 30.8 cm). Kupferstich Kabinett, Staatliche Kunstsammlungen, Dresden.

7-10 *below, right:* DANIEL M. MENDELOWITZ (1905–1980; American). *Portrait of Annie.* 1963. Rubbed graphite pencil and eraser, 16 × 12" (40.7 × 30.5 cm). Estate of Mrs. Daniel Mendelowitz, Stanford, California.

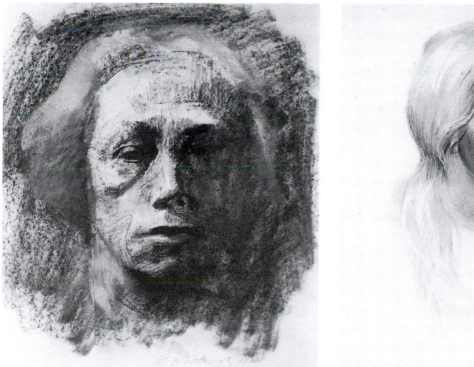

drawing. In both Käthe Kollwitz's *Self-Portrait* (Fig. 7-9) and Daniel Mendelowitz's *Portrait of Annie* (Fig. 7-10), there is an appropriate fusion between the choices of paper (rough, smooth), media (coarse

chalk, pencil), and method of application (bold, forceful; gentle, caressing) that contributes to the haunting beauty of each woman. Once the images are created, it is impossible to conceive of reversing them. Once viewed, they are impossible to forget—such is the power of art.

Project 7.4

To explore the effects produced from different combinations of media and papers it is necessary to gather papers of varying roughness, smoothness, and surface grain, referred to as "paper tooth" (see Chapter 10), as well as collect different grades of graphite pencils and sticks, charcoal, chalk, crayons, color pencils, ink, and assorted pens, brushes, and sponges. To minimize individual expense, consider sharing the cost of several sheets of large-size paper that can be halved or quartered. Experiment on both sides of the paper to extend the paper supply even further. Draw with both the sides and points of dry media; cross-hatch and stipple in both dry and wet media; combine all types of pens, sponges, brushes, and so forth. The tendency will be to overwork the drawing surfaces with so many different media at your disposal, and this can happen before you realize it. Try not to overwork the individual surfaces by working on several different drawings simultaneously and consciously refrain from using too many media on any one surface, allowing the developing images to breathe.

Project 7.5

Explore the expressive potential of texture by doing two drawings of the same subject, perhaps a still life with some textural variety, using two contrasting combinations of media and paper. Do not make meticulously detailed renderings, but devote some attention to suggesting textural differences. Try to draw with as much textural variation as possible, employing tonal ranges of lights and darks throughout.

Critique (Project 7.5) Study your completed drawings and determine the effectiveness of each in relation to the subject. Are the drawings highly descriptive of the surface textures of the subjects drawn? Is there an expressive quality created by the textures that transcends the mere description of the subjects?

Take account of which subjects, materials, and techniques seem to be the most satisfying to use and seem to be the most successfully descriptive combinations, and repeat them with several new drawings, aiming at improvement with each new attempt.

Actual and Uniform Texture

Actual texture is texture that represents a real surface and can be experienced through the sense of touch. In the act of drawing, **simulated texture** is texture that emulates an actual surface. **Uniform texture** is the overall surface quality that results from a particular drawing medium and the relief texture or character tooth of the paper. The graphic characteristics of the drawing medium and the nature of the paper surface produce the total visual effects, and the masterful control and consistency with which an artist deliberately works produce the uniformity of effects.

Actual or uniform texture, whether deliberately drawn or determined by a particular combination of medium and paper, introduces a prevailing pattern. This pattern is often determined by the materials and is generally abstract in character rather than dictated by the nature of the subject matter. For example, an artist working in the style of photo realism with a high degree of fine detail will find a considerable diminishment in the quality of detail when coarser drawing materials and heavier-toothed papers are used to render an image in the same style. The visual effect arising purely from the nature of materials tends to em-

actual texture
A texture that is a real surface and can be experienced through the sense of touch; often used in collage or mixed-media works where the actual textured material is applied to the work of art and left unaltered by the artist—as in the art of the found object.

simulated texture
A drawn textural illusion that emulates an actual texture or surface quality and is dependent upon the degree of illusion for its various visual effects.

uniform texture
Texture or textures that appear to be very similar and together create a tight harmony or an overall consistent quality, regularity, and oneness within a composition.

phasize the formal aspects of drawing, as is evident in Seurat's portrait of his mother (Fig. 7-8). Here we see that certain formidable characteristics of materials and paper surfaces produce mannered effects as uniform textures and may seem best suited for stylized modes of expression.

Theophil Groell deliberately uses uniform texture as an overall pattern of small dots by applying lithographic pencil (litho crayon) with a light touch to the rough surface of handmade papers, making no textural distinction between rocks, fallen tree trunks, and tangled thicket (Fig. 7-11). Groell has developed the technique as a visual metaphor for expressing beliefs about "the process of decay and renewal" in nature. By comparison, we see in the work of Jack Beal a similar visual situation that is highly textural in his *Study for "Wisconsin Still-Life"* (Fig. 7-12), but the objects in the still life are texturally treated as individual entities.

7-11 THEOPHIL GROELL (b. 1932; American). *Rivers End*. 1981. Litho pencil on textured paper, 20 1/4 × 20" (51.4 × 50.8 cm). Collection Rita Rich. Courtesy of the artist.

Beal's method of drawing with lithographic crayon, as Groell did, only on frosted Mylar instead of handmade paper, exhibits greater surface description and variation.

Project 7.6

Select an appropriate subject or plan a composition permitting a range of values using one uniform texture throughout. Simplify your forms by relegating them to the same surface treatment with your selected media. Work to achieve a maximum sense of volume and space. The size of your drawing should be influenced and determined by the scale of the texture chosen. Identify the presence of actual textures that are a result of the particular medium and paper surface used.

Some suggested ways of working are (1) scribbling in curved and circular movements; (2) scribbling in angular and straight-line movements; (3) cross-hatching; (4) stippling, using dots or commalike marks; and (5) combining or modifying one or more of the above methods.

Project 7.7

Select an alternative surface to paper such as frosted Mylar, easily obtained from an art supply store in the paper section, and draw with a variety of different, but soft-grade graphite pencils. Try the same textural assignment procedures with these materials and do several drawings utilizing different subjects. By using variations in pressure you'll find that the frosted surface of the Mylar takes the soft graphite very well, resulting in rich depositions of descriptive light and dark sensual marks. You'll notice that drawing with graphite against frosted Mylar produces a different sensation than drawing with graphite on paper. This sensual difference will undoubtedly give your drawings a different look of vigor, sumptuousness, and expressionism resulting from the combination of a different mark-making tool and drawing surface.

Critique (Projects 7.6 and 7.7) Examine your results from Projects 7.6 and 7.7. Identify the passages of both uniform and actual textures. Do you have an understanding of how each came to be what it is? Do you have a sense of accomplishment from your methods of using the various drawing media to create texture on the two-dimensional surface of the paper or Mylar? Would you say that the power of the illusion of texture is strong? Have you used the illusion of texture to create volumetric forms that describe the three-dimensional properties of those forms effectively? Do the works stand alone as powerful visual forces irrespective of their subjects?

Invented or Synthetic Texture

Creating uniform textures, other than those derived from the combination of materials, calls forth a sense of invention. **Invented textures** are created textures whose only source is the imagination of the artist. Giorgio Morandi's **etching** on copper, *Large Still Life with Coffee Pot* (Fig. 7-13), and Josef Albers's *Pine Forest in Sauerland* (Fig. 7-14) are examples of both uniform and invented texture, as is Mark Tobey's *Long Island Spring* (Fig. 7-15). Although the hatching and cross-hatching used by Morandi suggests light flickering on the surfaces of the still-life objects, it is a formal device that he employs to define shape and mass, no matter what his subject. In this case, tonal hatching is also texturally descriptive. Albers, on the other hand, seems to have chosen (invented) his linear texture deliberately to describe the appearance and feeling of a pine forest, while Mark Tobey's abstract spattering and flecking explode with the vibrancy of new growth.

Expressive Use of Texture

To summarize, the textural character of a drawing is influenced by the nature of the surface being depicted, the choice of materials, and the manner in which they are used, plus the inventiveness of the artist. Collectively, then, expressiveness is determined by the textural character of each artist's style. Vincent van Gogh's *Tree in a Meadow* (Fig. 7-16) and Jean Dubuffet's *Garden* (Fig. 7-17), each employing essentially the same medium (although van Gogh's ink drawing was done over a charcoal sketch), have responded to somewhat similar subjects with uniquely expressive textural drawings.

invented texture
A fictional or improvised texture created to heighten the imagined and descriptive forces of the surface quality of objects or forms within a composition.

etching
The action of a corrosive material, such as an acid, incising a design into metal, as in *copper plate etching*. One of the techniques of *fine art printmaking* that falls into the category of *intaglio*, where lines and textures are incised into and below the original surface of metal plates forming grooves and rough textures that will hold ink that can then be transferred to dampened paper with the use of an etching press.

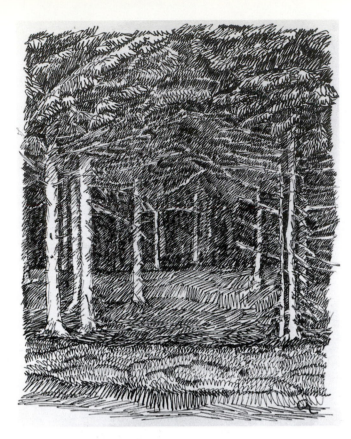

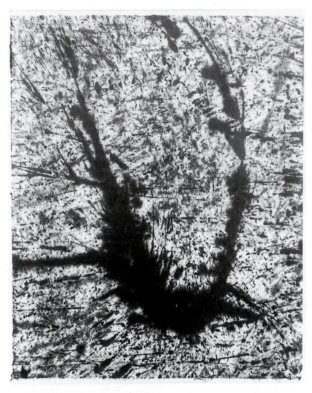

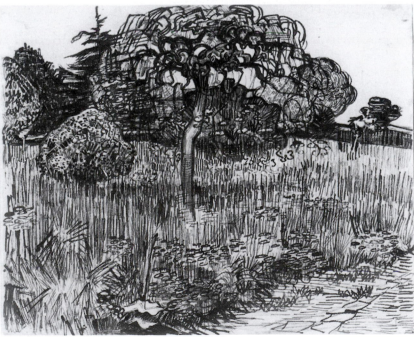

7-14 *above, left:* JOSEF ALBERS (1888–1976; German-American). *Pine Forest in Sauerland.* c. 1918. Pen and ink on paper, 12 5/8 × 9 5/8″ (32.1 × 24.5 cm). Collection Anni Albers and the Josef Albers Foundation, Inc.

7-15 *above, right:* MARK TOBEY (1890–1976; American). *Long Island Spring.* 1957. Sumi ink, 24 × 19 1/2″ (61 × 49.5 cm). Private collection.

7-16 *right:* VINCENT VAN GOGH (1853–1890; Dutch-French). *Tree in a Meadow.* Reed pen, black and brown ink over charcoal sketch on ivory wove paper, 19 1/8 × 24″ (48.6 × 61 cm). © The Art Institute of Chicago. All rights reserved.

The beginner frequently shows conscious preferences for one master's way of working and very often gives legitimate expression to these preferences by following the manner of the master. As the student matures as an artist, gaining assurance and independence from admired models, a unique and personal style of working will evolve. Later in an

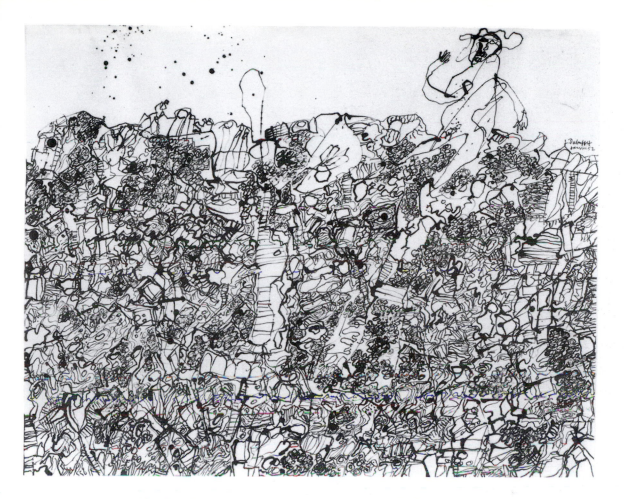

artist's career a highly developed mature style becomes the abiding trademark of an artist's work, as in Henry Moore's *Women Winding Wool* (Fig. 7-18). What an absolutely beautiful use of both uniform and invented texture, executed by a well-seasoned artist in midcareer.

Project 7.8

Study drawings with texture, not just the ones included in this chapter. From the drawings you've studied, select ways of working that achieve descriptive, vigorous, appealing textural character, and adapt the methods to objects and subjects of your own choosing; perhaps you might want to reinterpret some of your earlier drawings as a means of revisiting an idea and improving on it through reinvention. To become familiar with any one technique, it will be necessary that you do numerous drawings in the same manner. At first you will want to refer to the master drawing; then as you acquire a feeling for the technique, put aside the model and go solo with the subject, the media, and the technique. It is important to work with the same, or at least similar, materials if you wish to achieve similar effects. Van Gogh's patterns and textures, for example (Fig. 7-16), depend upon the quality of line produced by a reed pen, for which a bamboo pen offers a suitable substitute. Let it be your intention to learn to use a technique, not to make a copy. Feel the mood of the style and the manner in which it was carried out, whether slowly and methodically or rapidly and impulsively, whether with small finger strokes or with large hand movements. Allow deviations to occur. It is important to discover the most satisfying ways of developing texture with a minimum of self-consciousness so that it becomes an integral element of your compositions, contributing to expressiveness.

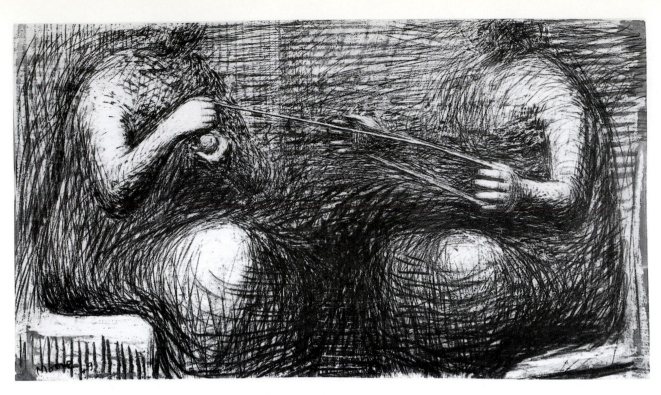

7-18
HENRY MOORE (1898–1986; English).
Women Winding Wool. 1949. Crayon
and watercolor, 13 1/4 × 25". (33.7 ×
63.5 cm).
Collection of the Museum of Modern Art,
New York. Reproduced by permission of the
Henry Moore Foundation.

Orchestration

With each new chapter of study in this drawing textbook, it is the revision author's desire that you begin to attain a level of orchestrational skill over the increasingly complex project assignments. The activity of creative drawing itself is complex—it is a *highly emotional process of realization* where the artist seeks to metaphorically write the visual statements that he or she desires to speak. The repertoire of possible materials, subject matter, and technical methodology increases with each new project. It is important that you begin to gain a sense of balance and harmony between these visual elements, and that you see yourself as sitting in the director's chair calling those elements into play at the appropriate time. We will visit the subject of artist as orchestrator several times throughout this book, particularly in Chapter 18.

Composition 8

Composition . . . alters itself according to the surface to be covered. If I take a sheet of paper of given dimensions I will jot down a drawing which will have a necessary relation to its format—I would not repeat this drawing on another sheet of different dimensions.

—Henri Matisse

The success of a drawing evolves in part from the appropriate matching of medium to subject matter and from the artist's skills of visual planning and orchestration within a selected picture plane. Effective drawing, however, requires more than learning how to choose and manipulate media successfully to produce a satisfying representation of an object, for neither choice of subject nor beauty of technique is sufficient if the artist has not also been concerned with composition. At its height of *aestheticism,* the Greek civilization used the word *form* in much the same way as we use the word *composition.* They defined form as having three distinct aspects: (1) the idea or concept an artist starts with, (2) the media and technical method an artist chooses, (3) that which fuses the idea and media together as one.

In a broader sense, **composition** is the **structure** of a picture as separate from both subject and style, and is essentially an underlying matrix of abstract design. It is the selection and organization of line, shape, value, texture, pattern, and color into an aesthetically pleasing arrangement embodying such principles of design as balance, harmony, rhythm, repetition and variation, dominance and subordination, and focus. The final desired effect of composition is a sense of unity—a oneness. It has been suggested that good composition supports the image so discreetly that it is never noticed.

Principles of composition are not hard-and-fast rules, never to be broken. They should be considered guides or suggestions that have been recognized and used effectively by successful artists for centuries. The same artists felt free to interpret the principles, and you are urged to do the same, as long as the result justifies whatever you choose to do. To break rules effectively, it is first necessary to know what they are.

composition
The structure of a picture as separate from both subject and style; the essential abstract design; the selection and organization of line, shape, value, texture, pattern, and color into an aesthetically pleasing arrangement embodying such principles of design as balance, harmony, rhythm, repetition and variation, dominance and subordination, and focus.

structure
The inner core that determines, identifies, and organizes outward form; the planned or methodical network that serves as a matrix supporting and delineating the organizational elements in a work of art.

133

A drawing, engraving, etching, painting, or sculpture (music, or literature as well) is composed of three elements—subject matter, form or composition, and content. Each of these three elements possesses force, and collectively they generate the total impact and longevity of sustained visual language. Subject matter alone is not a sufficient condition for a work of art. The significance of any work lies in its content or meaning. The meaning given to a subject depends largely upon its characteristic form, or composition selected by the artist. Beyond having the skill to reproduce the likeness of an object and control media, the artist must know the principles of composition and be able to use the art elements expressively to ensure full meaning to every drawing.

The focus of this chapter will be on composition as the underlying matrix, or abstract structure, of drawings, painting, printmaking, and sculpture, with attention given to subject, style, and content only as they relate to pictorial design. The projects will be represented primarily as design problems that, depending on individual preference, can be approached abstractly or representationally.

Many drawings fail from lack of planning. Compositional studies made from quick "thumbnail roughs" allow you to consider different alternatives and to solve many major compositional problems in advance. In a sketchbook page of rough sketches (Fig. 8-1) for what appear to be two separate paintings, it is evident that for Theodore Gericault the distribution of light and dark is as critical to composition as the placement of forms. Boldly simplified shapes of light and dark provide an effective visualization of his dramatic talent.

Sketchbook Activities

When you visit museums, and as you look at drawings, paintings, prints, and sculpture reproduced in art books and periodicals, analyze the compositions of various

works. Develop the habit of making rough thumbnail sketches of the works. Although they need be no more complete than Figure 8-1—forms reduced to bold shapes, values simplified to white, black, and middle gray—it is important that the proportions of your study match those of the original. If you are enrolled in an art history class, you have the perfect opportunity to engage in this activity. Doing such sketches will make you more aware of how the elements of composition are integrated into a finished work of art.

Selecting Format

Composition begins with the size and shape of paper, referred to as the **picture plane,** with the edges of the paper becoming the first four lines of the drawing. Composition is the arranged relationship of all lines, shapes, and elements to the four edges as well as to one another.

Students have a tendency to start drawing without regard for the size of the paper, sometimes drawing objects so large that they run off the sheet or picture plane, but more frequently drawing forms so small that wide borders of blank paper are left. It is very important to learn to use the full size of the paper. If a drawing is to be smaller than the full sheet, four lines can be drawn to define the perimeter of the picture plane and establish the format of the composition—a rectangle being the most common. When working from nature or life, you will find it helpful to use a viewfinder with a rectangular opening to select what and how much to include in the composition. Moving the viewfinder closer to your eye or holding it farther away controls how much you see. Use it exactly as you would the viewfinder of a camera to find the most interesting view of the subject and to determine whether a horizontal or vertical format is more appropriate. Two artists might well arrive at totally different compositions, both equally satisfying and strong, particularly in the presence of each other.

While photographers are limited essentially to what they see in the viewfinder, artists have the option of shifting objects around, adding or eliminating forms to achieve better balance, create stronger visual interest, and improve composition according to what it is they want to say with the picture.

Closed and Open Composition

Within the format selected, elements can be arranged into a **closed composition,** in which the forms seem well contained by the edges of the picture plane, or into an **open composition,** in which images appear unrelated to the size of the paper, creating the impression that the composition, unlimited by the outer edges, extends beyond the boundaries of the picture plane. "Open" implies something free, expansive, flowing, unrestrained, spacious, magnified, undefined; "closed" suggests images that are contained, controlled, compact, reduced, complete. (See the discussion on separation and integration in the section on value, later in this chapter.)

Balance

Among the principles of composition, balance is given first consideration. In fact, composition is defined as the balancing of the elements of design. **Balance** exists within the confines of either symmetry or asymmetry; there is no other visual situation.

picture plane
The area of a flat surface defined by its outer borders on which an artist creates an image; often the picture plane, out of necessity, becomes transparent, allowing the artist to create three-dimensional forms and objects that exist in both deep and shallow space as three-dimensional illusions.

closed composition
Compositional format in which the art elements of form and structure are visually well contained by the edges of the picture plane.

open composition
Compositional format in which the images of form and structure appear unrelated to the size of the paper, creating the impression that the composition, unlimited by the outer edges, exceeds the boundaries of the picture plane.

balance
A major underlying principle of composition that unifies all the elements of design. It can be either symmetrical or asymmetrical.

8-2. *above, left:* REMBRANDT VAN RIJN (1606–1669; Dutch). *Canal and Bridge beside a Tall Tree.* Pen and brown ink, brown wash, 5 5/8 × 9 5/8″ (14.3 × 24.4 cm). Pierpont Morgan Library, New York.

8-3. *above, right:* GEORGES SEURAT (1859–1891; French). *The Lighthouse at Honfleur.* 1886. Conté crayon heightened with white gouache, 9 13/16× 12 1/8″ (24.9 × 30.7 cm). The Metropolitan Museum of Art, New York (Lehman Collection)

symmetrical balance
The dividing of a composition into two equal halves with seemingly identical elements on each side of a vertical axis.

asymmetrical balance
Balance based upon a visual sense of equilibrium that can be felt more than it can be measured. There are no specific rules for asymmetrical balance except that of diversity.

Symmetrical balance calls for dividing the composition into two halves with seemingly identical elements on each side of a vertical axis. Rembrandt's *Canal and Bridge beside a Tall Tree* (Fig. 8-2) demonstrates that the two sides need not be exactly identical as long as a feeling of balanced is maintained. The freshness of the pen line and the degree of variation between the two halves of the drawing prevent the composition from seeming stiff and static, which can be an effect of symmetrical balance. Symmetry, while it may lend an aura of dignity and formality to a composition, may lack a sense of mystery or provocative visual tension.

Most artists, agreeing that diversity offers greater interest than sameness, prefer **asymmetrical balance.** There are no precise rules for asymmetrical balance; it is based upon a visual sense of equilibrium that can be felt more than it can be measured. It can be likened to a teeter-totter. For children of the same size the board is placed with one half on each side (symmetrical), whereas with a small child and a larger person it becomes necessary to shift the position of the board to provide more weight for the smaller of the two (asymmetrical). In Seurat's *The Lighthouse at Honfleur* (Fig. 8-3) the fulcrum shifts to a point near the right edge of the sail as it intersects the horizon. The lighthouse with its accent of pure white, the flanking buildings, and the four figures, plus the light area in the lower right corner, all combine to offset the weight of the simplified dark mass at the left. Curiously, what remains if you crop everything at the left is an almost perfect symmetrical balance within the composition, very similar to the Rembrandt example.

Asymmetrical balance offers the artist greater compositional freedom. The composing process itself is one of organic origins surrounding an idea and naturally not predisposed to symmetry either concretely or abstractly. For most artists—Seurat being an exception—asymmetry is more flexible, more dynamic, and more exploratory. It allows the introduction of greater movement, greater action, and greater possibilities for resolution of a working composition.

Directional Lines

Line fulfills a number of compositional functions: It defines shapes; divides space; sets up movement, rhythm, and pattern; provides structure, and is one of the definitive elements of textural description.

Learning to control the placement of each line, and the patterns created by combinations of line, provides a means of adding expression to a composition.

While any composition incorporates various linear elements, a dominant mood can be established by placing the emphasis on **directional lines.** Long, relatively unbroken, horizontal lines are calm and restful, suggestive of peace, tranquility, infinity, and serenity, while vertical lines convey a feeling of dignity, stateliness, stability, and strength. Combining vertical and horizontal elements produces a solid, confident, and orderly sense of structure similar to architectural construction. Diagonal lines are dynamic, suggestive of action, and highly complementary to both horizontal and vertical lines. Broken patterns of diagonals can result in confusion and disorder; opposing diagonals create conflict and strife. Diagonal compositions are generally more forceful and disturbing than those based on a vertical and horizontal organization. While the apparent inertness of Wayne Thiebaud's scattered pastel sticks (Pl. 8) seems to belie such description, the composition offers strong hints of the characteristics mentioned, particularly when the calming empty horizontal bands at the top and bottom are cropped. However, because of the presence of the upper and lower areas of compositional rest, the forms appear spontaneously contained as well as unified within the picture plane.

Curved lines are associated with grace, elegance, and gently flowing movement, while more complicated patterns of curves with frequent reversals produce greater animation, even agitation (Fig. 8-1). By combining arcs and diagonal lines, Charles Sheeler's drawing *Yachts* (Fig. 8-4) and Cy Twombly's oil on canvas *Untitled* (Fig. 8-5) create strongly contrasting moods, the first gentle and relaxing as if one were being consoled by a playful breeze, the second expressing turbulence and a sense of heaviness characteristic of diagonal lines, which often radiate a downward thrust.

Directional lines, or directional compositional thrusts, can be introduced without actually being drawn, as evidenced in the invisible

directional lines
Compositional linear treatment that establishes a particular or dominant mood or emotion from its linear emphasis through a variety of different line treatments yielding a visual sense of compositional weight and balance. The linear treatments may flow in the same direction or in opposite directions, each conveying different feelings.

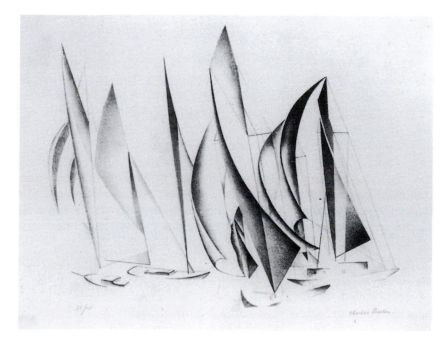

8-4. CHARLES SHEELER (1883–1965; American). *Yachts.* 1924. Lithograph, 8 1/4 × 9 3/4″ (21 × 25 cm).
National Museum of American Art, Smithsonian Institution, Washington, D.C. (Museum Purchase).

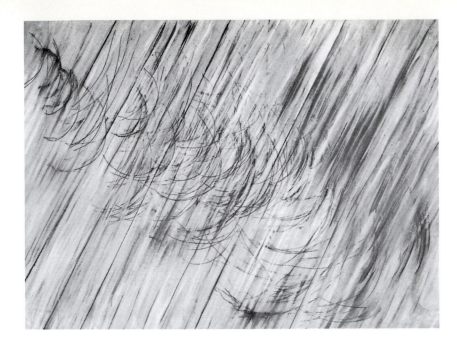

8-5. CY TWOMBLY (b. 1929; American). *Untitled.* 1972. Oil on canvas. 4' 9 3/8" × 6' 4" (1.47 × 1.95 m). Collection Nicola Roscio, Rome. Courtesy of the artist.

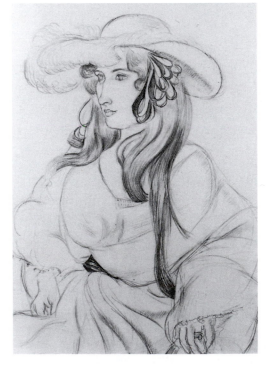

8-6. HENRI MATISSE (1869–1954; French). *The Plumed Hat.* 1919. Pencil on paper, 29 7/8 × 14 3/8" (75.9 × 36.5 cm). Detroit Institute of Arts (bequest of John S. Newberry).

shape
The flat, two-dimensional aspects of form as opposed to three-dimensional volume; when a three-dimensional form is reduced to a silhouette, the viewer is conscious only of its shape.

though unmistakable verticality of Matisse's *The Plumed Hat* (Fig. 8-6). Although softened by the rich pattern of loops and gracefully undulating curves, it is the figure's almost rigidly upright pose that evokes such playful and sensual effects of directional lines.

Shapes

Shape refers to the flat, two-dimensional aspects of form as opposed to volume. Donald Sultan's drawing *Three Lemons and an Egg* (Fig. 8-7) illustrates beautifully that when a three-dimensional form is reduced to silhouette, we become conscious only of its shape. Silhouetted shape

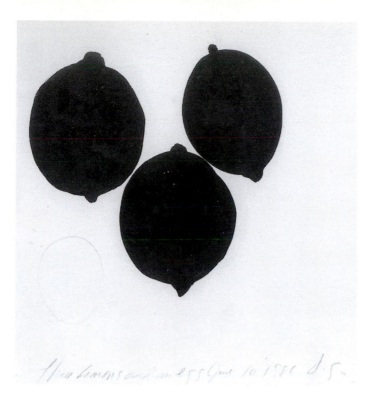

8-7. DONALD SULTAN (b. 1951; American). *Three Lemons and an Egg.* 1986. Ink and pencil on paper, 15 × 16" (38.1 × 40.6 cm). The Arkansas Arts Center Foundation Collection: The Stephens Inc. City Trust Acquisition Fund, 1986.

can therefore be a powerful illusion for three-dimensionality. Shapes can be defined by contour line and by changes of value, texture, and color, alone or in combination.

Project 8.1

One shape drawn on a piece of paper immediately sets up a relationship between it and the paper. Select a single shape, either a geometric shape such as a circle or triangle or the simplified silhouette of a familiar object like a cup or pitcher. In a series of thumbnail studies explore the relationship between the shape and the surrounding space as you move that shape by drawing it in different positions within the areas of the small picture planes. Enlarge and reduce the size of the shape by letting the shape dominate the space; then let the space dominate the shape. Create visual situations of both pleasing balance and disturbing tension. Introducing a second shape will introduce a new set of relationships that must be balanced. Each shape that is added sets up other conditions requiring adjustments to previous solutions—decisions about placement, keeping forms separate, letting them touch, maintaining equilibrium, or allowing one shape to dominate and overlap another. Figure 5-6 presents another variation of this project.

Critique (Project 8.1) Have you created some interesting relationships between your shapes and the surrounding space within the picture plane? Are there some studies in which the configurations of the remaining space are more interesting than the shape itself? How would you define the effects of balance in your resulting thumbnail drawings? How would you define the effects of **visual tension** in the same drawings?

A shape cannot exist alone in a drawing; it can be seen only in relation to adjacent shapes and the space that surrounds it. Composition, therefore, involves positive shapes defined by negative space, and negative shapes defined by the spaces that positive shapes occupy (see Chapter 3). It is as necessary to compose negative space as it is to be concerned with positive shapes; in fact, there is an undeniable synergy between the two in any strong composition.

visual tension
A visual situation within a composition where the elements of shape, pattern, balance, harmony, and contrast all interact to produce interesting imbalances or cacophonies; some of the elements may be more pronounced than others, which creates a higher level of compositional interest.

8-8. FRANZ KLINE (1910–1962; American). *Untitled.* 1960. Ink on paper, 8 1/2 × 10 1/2" (21.6 × 26.7 cm). Whitney Museum of American Art, New York (gift of Mr. and Mrs. Benjamin Weiss).

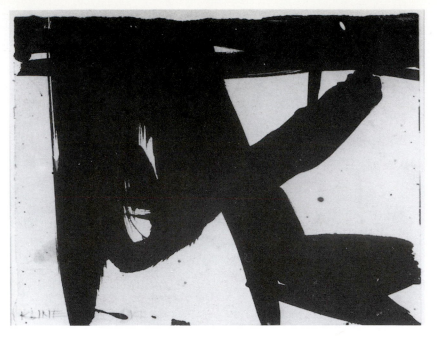

The interlocking of positive and negative is perhaps the most apparent when represented in the extremes of black and white (Fig. 8-8). Franz Kline's intention was "to create definite positive shapes with the whites as well as with black." It is surprising, considering the force of his gesture and the scale of his brush strokes, to realize that his drawing is only slightly larger than the page size of this book.

Project 8.2

With a series of sketches, or studies, not larger than 4 × 6, or 5 × 5 inches, explore positive shapes and negative space. Using an X-acto knife, begin by cutting five shapes inward from the edges of the rectangle or square picture plane. The shapes may be large or small and of any type—amorphous or geometric—although similar shapes result in a more unified design. Using charcoal or soft graphite stick, shade either the remaining shape or the cut-away segments to emphasize positive and negative by contrasting light and dark. Experiment with symmetrical and asymmetrical balance by doing several small studies of each; then do several utilizing *dominance* and *subordination*. Try leaving one, two, or even three edges of several small picture planes unbroken to create different visual tensions.

Rotate your drawings to view them from another angle to alter the compositional impact. Artists frequently look at their works in progress upside down, or view them in reverse in a mirror to determine compositional weaknesses, particularly regarding aspects of balance, compositional weight, and lateral and longitudinal tensions.

Critique (Project 8.2) As you look at your small positive-negative studies, it should be readily evident whether or not you achieved interesting relationships of equality and balance, dominance or subordination, even tension and calm within your compositions. Which drawings are of greatest intrigue to you as positive-negative studies: the symmetrical or asymmetrical drawings?

Do you have a deeper understanding of the aspects of composition after having performed these thumbnail exercises? Can you see how these fundamental compositional theories can be applied to nearly every work of art that has ever been created?

Visit an art museum or gallery exhibition and scrutinize the compositions of the works you see before you. Try to apply every fundamental exercise that you performed as a study to the works of art you see in the professional setting.

repetition
The unifying visual sense of regularity in the appearance of similar elements—lines, shapes, patterns, textures, colors, values, and movements within a composition.

unity
That ephemeral quality suggesting compositional "wholeness"; the quality of harmony, balance, and cogency of the art elements within a composition.

multiple
The term applied to the regular appearance of shapes or forms in a *pattern*. Also refers to fine art processes where it is possible to produce a series of consecutive images. In printmaking, for example, an edition of prints is a series of "multiple originals."

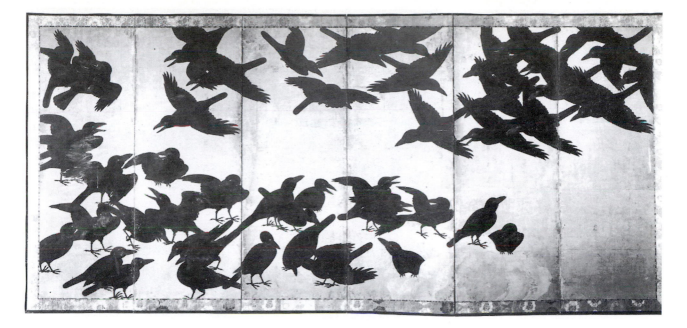

Repetition-Pattern

The **repetition** of similar visual elements—lines, shapes, patterns, textures, and movements—contributes to a sense of **unity.** The purposeful repetition of a particular shape or other **multiple** visual elements to create or suggest an overall harmonious design is **pattern.**

Pattern need not be limited to either regularly or identically repeated design. The crows on the seventeenth-century Japanese screen (Fig. 8-9) create the impression of a strongly decorative pattern, yet very few of the shapes have been repeated in identical fashion, and the groupings are highly irregular. The birds, which in reproduction appear as silhouettes, are seen in bold value contrast to the gold-leafed background.

Variation-Contrast

To prevent the repetition of any element from becoming either too obvious or too monotonous, variety can be introduced to provide **contrast.** Looking at a work of Karen Kunc, *Tumbleweed* (Fig. 8-10), we see a delightful repetition of circular and amorphous shapes, almost all boasting some uniquely tonal and textural embellishments.

Unified compositions are not built on sameness. There can and must be **variety;** yet with each element introduced, with each principle considered, the determining factor is always balance. Observe again the drawing *Tumbleweed*. Notice how Kunc uses an ever-changing value range of textural lights and darks to emphasize important visual details such as the abstract tumbleweed branch. She pulls every drawn mark as an orchestrated element into a unified whole in support of the tumbleweed form as it courses through the midsection in a powerful downward arch as if trellised by the strong dark vertical pole.

That which applies to two-dimensional design applies equally to compositions built around recognizable subject matter rendered three-dimensionally. Students too frequently think of design as existing apart from representational drawing, when in fact the two are inseparable, as

8-9. ANONYMOUS (early seventeenth century; Japanese). *The Hundred Black Crows,* one of a pair of six folded screens. Gold leaf and black ink with lacquer on paper, height 5' 1 3/4" (1.57 m).
Seattle Art Museum (Eugene Fuller Memorial Collection).

pattern
Any compositionally repeated element or regular repetition of a design or single shape; pattern drawings in commercial art may serve as models for commercial imitation.

contrast
The visual effect of a striking difference between art elements creating a condition of compositional intrigue; opposites or complementary art elements that through their visual forces *set each other off* or draw attention and focus to each other or to particular areas within a design.

variety
A generic or specific condition of established diversity; descriptive term used to identify any number of conditional states of ranging multiplicities in a work of art; the antithesis of what is obvious or monotonous.

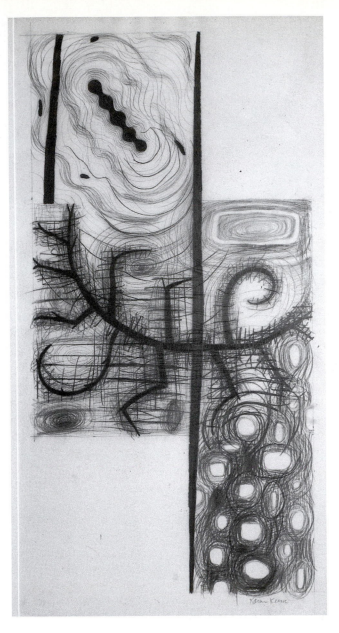

8-10. KAREN KUNC (b. 1952; American). *Tumbleweed.* 1997. Graphite on frosted mylar, 36 × 18" (91.5 × 45.7 cm). Wake Forest University Art Department Collection, Winston-Salem, North Carolina.

evidenced by the work of Sidney Goodman in his charcoal drawing *Model on a Draped Table* (Fig. 8-11). This drawing is laden with powerfully contrasting elements of lights and darks, positive shapes and negative spaces laced together with the vestiges of partially drawn, once acknowledged form. There is a tremendous sense of push-pull to the composition with its spatial dynamic and strangely compelling visual tensions of shape variation and contrast. This is an undeniably powerful embodiment of asymmetrical design, representation, readable content, visual poetry, and mystery at its best.

Dominance-Subordination

In successful composition certain visual elements assume more importance than others. As a center of interest, such elements become dominant; all other parts are subordinated to them, as in Figure 8-10. Although the artist wants the viewer to be conscious of everything in

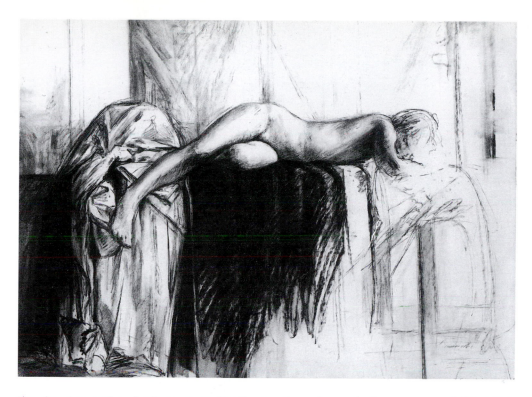

the drawing and to look at every detail, attention ultimately focuses on a dominant element. However, when the dominant element becomes so strong that it overwhelms everything else, it then throws the composition out of balance. In symmetrical composition the center of interest will be placed in the middle of the composition. Generally, the **focus** of interest will not be centered in asymmetrical composition.

Movement

A picture with only one center of interest not only bores the viewer but also shows the artist's lack of compositional understanding of what it takes to invigorate the eye of the audience. Like a dramatist, novelist, or composer, an artist introduces secondary focal points—subplots, as it were—leading the eye of the viewer from one to another, eventually directing attention back to the dominant focal point. The artist determines the sequence in which the eye moves from one area to the next, ultimately focusing on the center of interest. Often during the execution of a work of art, the artist begins to discover the pathway that the eye takes, regardless of what he may have intended, and builds on the strengths of how his eye is directing him. He or she may not be consciously aware of this at the time it is occurring. Frequently, it is only after a work is finished that full realization of the degrees of compositional success become apparent. Elements of movement within a composition are powerfully engaging, and once an artist fully learns to trust his eye, he is ready to meet the demands of the composing visual elements. He learns where the eye will confidently lead and responds trustingly.

In Edward Hopper's *Study for "Evening Wind"* (Fig. 8-12), the viewer's gaze seems to focus first on the white rectangle of the open window, as does that of the woman in the drawing. But the viewer's attention does not remain fixed there. That space is essentially empty and devoid of any real visual interest. Instead, it is the woman, particularly

8-11. SIDNEY GOODMAN (b. 1936; American). *Model on a Draped Table.* 1977–1978 Charcoal. 29 × 41". (73.6 × 104.2 cm). Photo courtesy of Terry Dintenfass, Inc., New York.

focus
The prime center of visual importance within a composition to which all other visual elements yield; it holds the viewer's attention because of its attractive and dominant influence on its surroundings.

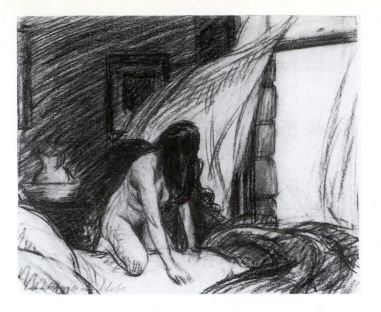

8-12. EDWARD HOPPER (1882–1967; American). *Study for "Evening Wind."* 1921 Conté and charcoal on paper, 10 × 13 7/8" (25.4 × 35.7 cm). Whitney Museum of American Art, New York.

her head, nearly centered on the page, that is the focal point. The contour of her head silhouetted against the curtain is the most sharply delineated detail in the drawing. The curtains billowing into the room and the circling back of the bed covers direct attention to the figure. A seemingly incidental detail—the dimly suggested pitcher and washbasin at the left—contributes to compositional balance and functions as a secondary focal point pulling the viewer back into the room.

Just as the flow of traffic can be programmed, so, too, the way the eye of the viewer moves through a composition can be controlled by a skillful artist who follows the dictates of his own eye when drawing. When looking at art, our eye tends to move rapidly between large shapes, moving more slowly through small, complicated passages as it pauses to examine details. What appears as casual disarray in Richard Diebenkorn's *Still Life/Cigarette Butts* (Fig. 8-13) is actually a very thoughtful traffic flow pattern in disguise created from the highly credible clues his own eye gave him during the execution of the drawing. As we further examine this creation in pencil and ink, we can recognize both the power of subtlety and the intrigue of complexity contained within the compositional elements that cause the eye to playfully course over the tremendously varied surface of the drawing.

Project 8.3

Determine the compositional details in the drawing that set up eye movement. When you focus on the center of the picture plane, the eye tends to travel in a counterclockwise direction, taking in the expressive variations of media handling so skillfully performed by the artist. Notice that the most dramatic compositional elements are the two sheets of white drawing paper lying next to each other. They define the visual impact of the tonal range by providing the extreme whites of the drawing in contrast to the darks that comprise most of the remaining surface area.

It would be instructive to do a diagram of the composition. Begin by drawing a pair of lines corresponding to the left and bottom edges of the white shape (sheet of drawing paper) centered at the right, continuing both lines across the full width and height of the drawing. Repeat with the bottom and right edges of the white shape at top center. (Notice how we previously identified the white shapes as the representative sheets of white paper that they are. However, we now refer to them as shapes, thereby neutralizing their significance as representative objects so that

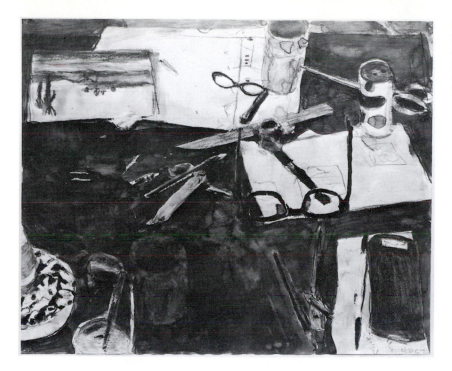

8-13. RICHARD DIEBENKORN (1922–1993; American). *Still Life/Cigarette Butts.* 1967. Pencil and ink, 14 × 17" (35.6 × 43.2 cm). Courtesy of the artist. National Gallery of Art, Washington, D.C.

we can separate the literal object from its visual function in the work of art. As you finish drawing the lines corresponding to the two sheets of paper, indicate all elements that fall into alignment with those four major compositional lines by drawing them in contour fashion. Then add the important diagonals, curves, and circles. Notice how masterfully Diebenkorn has integrated all aspects of composition thus far discussed in this chapter into this one drawing.

From this kind of analytical study, it becomes apparent that there is need for a governing matrix or superstructure within composition, as Diebenkorn so well exemplifies.

Project 8.4

Using simple soft graphite pencil or charcoal, break up the space of a picture plane by dividing a rectangle of any size (from 4 to 6 inches to a full sheet of paper) into shapes that are interesting both individually and in relation one to another. The shapes should be varied in size and outline and at the same time provide elemental areas of both simplicity and complexity. The design can be derived from straight lines, curved lines, irregular and/or free-formed shapes, or a combination of forms. Remember that similar shapes create unity, but variety contributes to pictorial interest.

Next, introduce white and black, plus an intermediate value, to establish centers of interest. Simplify shapes or engage in additional breaking up of space as you develop a flow of movement through the composition. Allow directional lines, linear patterns, and the repetition of shapes, spaces, intervals, and values to set up pathways of eye movement. Try several of these and incorporate as many principles of design as possible into your compositions.

Critique (Project 8.4) As you observe your designs, describe the directional movement of your eyes. Then, consider the following concepts: Is there a focal point? If so, where is it? Where does your eye tend to focus first? What design details cause your eye to move away from the focal point? What design details cause your eye to keep moving from point to point? What part does the element of value contrast play in the direction of eye movement?

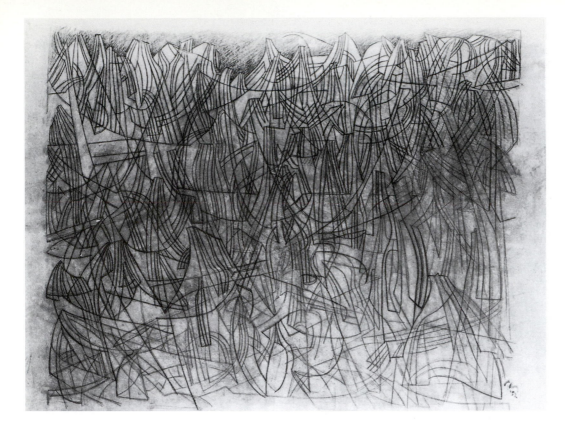

MARK TOBEY (1890–1976; American).
Mountains. 1952. Crayon on paper
mounted on cardboard, 37 3/8 × 47"
(95 × 119.5 cm).
Private Collection.

rhythm
The visual manifestation and flow of
repetition, variation, patterning, harmony
of form, and movement within a compo-
sition; a flowing and regular recurrence
of the art elements within the composi-
tional structure of a work of art.

Rhythm

Repetition, variation, and movement combine to create **rhythm** in both
musical and pictorial composition. The word *rhythm* automatically
seems to evoke an image of consecutively flowing lines, as evident in
Mark Tobey's crayon drawing (Fig. 8-14), yet it is not limited to curvilin-
ear forms. Undulating patterns of both straight and curved lines with at-
tention to the repetition of groupings and intervals of similar forms as
well as direction of lines also establish compositional rhythm. All the vi-
sual attributes of a well-composed drawing, etching, painting, or sculp-
ture play into varying manifestations of visual rhythm. In the
mixed-media work by Navajo artist Emmi Whitehorse entitled *The Con-
version* (Fig. 8-15 and Pl. 9), we see a definite matrix of underlying com-
positional structure utilizing all the aforementioned attributes of rhythm;
the artist has fused drawing and painting media so well that we are al-
most unaware of the incidental intricacies of the different media. They
flow and blend, and they are welded together into an undeniable or-
ganic unity. It is a large work, measuring 51 × 78 inches, and there is
much to visually analyze in order to determine its compositional merits
and strengths. The subtle use of contrasting values, amorphous and geo-
metric shapes, irregular patterns, and multilayered compositional forms
that exist between deep and shallow space keeps the eye moving. The
viewer pauses only momentarily to focus on the intriguing strangeness
of a particular form before moving on to the next one.

Project 8.5

Develop a composition with a rhythmic pattern created by only vertical, horizontal,
and diagonal lines. Let each straight line intersect two borders of the paper or rec-

tangle with no change in direction (keep them straight) within any single line. Establish rhythm through changes in spacing and density of lines. Concentrate on creating an interesting composition with balance and centers of interest, employing what you have learned to date about media variation and line. Try to avoid repetitious pattern, yet at the same time establish an interesting structural pattern that will serve as the compositional skeleton or superstructure.

Project 8.6

Follow the same instructions for the last assignment, substituting curved lines. Reverse curves or S-curves can be used, as they easily establish a pattern of curving lines, and when you enhance them with line variation, you can create a spatially dynamic illusion on the two-dimensional surface of the paper.

Critique (Projects 8.5, 8.6) Do your drawings exhibit an immediate and interesting breaking up of the picture plane? Are the individual shapes curious or even mysterious? Is there a center point of focus? Are there several centers of focus? How would you assess the balance within each composition? Do the patterns seem to flow, allowing the eye to move with ease and delight around the picture plane? In your later drawings employing curved lines, does the pictorial space become more alive? Can you readily distinguish between what appears to be shallow and deep space?

Depth

In both two-dimensional design and three-dimensional representation, overlapping forms suggest spatial depth, as in Edgar Degas's *Six Friends* (Fig. 8-16). We automatically see the figures as being one in front of another in space. The effect is heightened when overlapped shapes also diminish in scale. When two similar shapes are represented in different scale, we are inclined to see the larger form as being closer. That interpretation comes from our actual experience of seeing how similar forms of the same size become different in size according to their distance from us when we view them. Illusionist art plays on the reality of actual experience and allows the artist to create dynamic spatial relationships between forms and the viewer on a two-dimensional surface. We never view as flat a room we are sitting in or the space around us as we walk through a park or meadow. We are continually experiencing the motion of our three-dimensional bodies within three-dimensional space, and we navigate by judging the size and scale of objects according to the distance between the objects and ourselves. Thus, our experiences in day-to-day seeing and moving in space provide us with the instincts of being able to create those three-dimensional illusions on a two-dimensional surface.

Project 8.7

Select several interestingly shaped objects, including a teapot or some similar form that has both positive and negative elements inherent in its design. Line them up on a table without grouping them into a composition. Study each form and see it as a flat shape. It will be helpful to do a simple contour drawing of each object.

Create a composition representing the objects as two-dimensional shapes, overlapping the forms to suggest spatial depth. Explore different ways of overlapping the shapes so that partially revealed forms are interesting as shapes apart from the objects they depict. Organize the objects to provide visual interest to the surrounding space. Develop the drawing further by creating flat areas of light, dark, and intermediate values, using contrast as a means of providing focus. Overlapping shapes of the same value will result in new shapes, which may enhance the

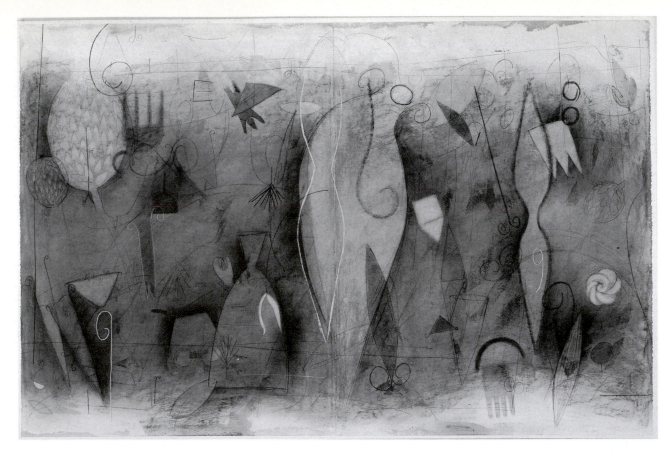

8-15. EMMI WHITEHORSE (b. 1957;
Native American: Navajo). *The Conversion.*
1992. Pastel, oil, paper on canvas, 51 ×
78" (129.6 × 198.2 cm).
Courtesy of LewAllen Gallery, Santa Fe, New
Mexico. Photography by Dan Morse.

composition overall. As long as the original shapes of the forms and the new shapes created by the overlapping of forms can be understood and do not interfere with spatial relationships, they need not be separated. Remember that a balance of simplicity and complexity contributes to an interesting composition.

Value

Value, as we learned in Chapter 6, is an essential element in pictorial composition. It functions to define and separate forms in space, establish balance, provide movement, maintain spatial unity, and introduce expressiveness. A common failure in many pictures by inexperienced artists is a lack of purpose in their tonal structure. An artist who understands how to control value, rather than being bound to a literal copying of what is seen, can rearrange, reverse, or intensify patterns of light and dark to strengthen a composition and create a new visual statement, whether working from life or from imagination.

Distribution of Value The impact of a work of art is based to a large degree on the distribution of light and dark. Strong patterns of dark against light and light against dark (Fig. 8-16) create a much different effect than light and dark used with middle-value grays (Fig. 8-15). Even against middle values the impression of white and black depends upon whether they are separated, appear side by side, or are surrounded one by the other.

Project 8.8

Arrange three simple shapes (squares) in a rectangle so that one shape is completely surrounded by two shapes that appear to float in front of the background.

This will appear as three squares of different sizes—the smaller squares inside the largest and all inside the rectangle. A good example of this is Josef Albers's *Homage to a Square* series (Fig. 8-18), where the center of focus is the smallest square contained inside all other larger squares. Using compressed charcoal or assorted gray crayons, fill in each separate area with a different value—white, light gray, dark gray, and black. Repeat the exercise four times, using each of the values as the background and altering the values of the other shapes. Observe the changes in visual impact.

Project 8.9

Compose a second, more elaborate composition using either abstract or representational shapes. Plan a major center of interest and two minor ones. Develop the composition in different values using the previous assignment as reference. Areas of greater contrast create focal points and spatial separation; subtle value changes provide transition and subordination.

Critique (Projects 8.8 and 8.9) Identify the center points of focus in all the drawings you've made and consider the degree of eye movement that occurs in each drawing. Do the drawings with multiple focus points of interest create more or less eye movement? How do you feel about your ability to create more or less eye movement in an image? How does eye movement enhance your image? How does it strengthen a visual statement?

Defining Space with Value Forms are made to advance and recede through degrees of value contrast. Against a dark background, light shapes advance to the degree of their brilliance; against a white background, light tones are held closer to the background while dark shapes are projected forward as in the value scale (Fig. 6-1) and David Faber's monotype entitled *Aberdeen Headlands* (Fig. 8-19). (A monotype is a drawing done with printer's ink on a blank plate and then transferred to paper with the use of an etching press.) (Monotype will be discussed further in Chapter 11.) In this work we see a defined spatial separation

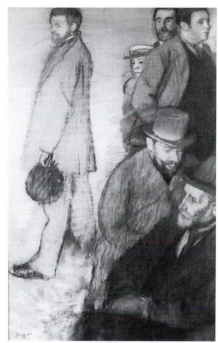

8-16. EDGAR DEGAS (1834–1917; French). *Six Friends.* c. 1885. Pastel and black chalk, 45 1/2 × 28" (115.6 × 71.1 cm).
Rhode Island School of Design, Providence (Museum Appropriation).

8-17. IRWIN TEPPER (b. 1947; American). *Third Cup of Coffee.* 1983. Charcoal on paper, 39 7/8 × 40 7/8" (111.1 × 130.8 cm).
The Arkansas Arts Center Foundation Collection, 1984.

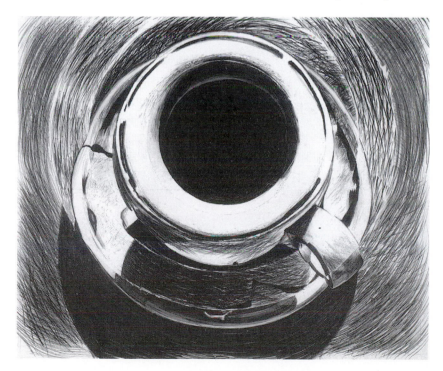

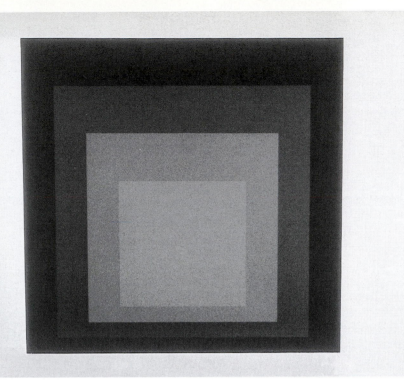

8-18. *above:* JOSEF ALBERS (1888–1976; German-American). *Homage to a Square* c. 1955. Four-color silkscreen, ed. 8/100. Reynolda House Museum of American Art, Winston-Salem, North Carolina.

8-19. *right:* DAVID FABER (b. 1950; American). *Aberdeen Headlands.* 1988. Monotype with etching and litho inks on gray wove paper, 39 3/4 × 26 7/8" (101.1 × 68.3 cm). Collection of the artist.

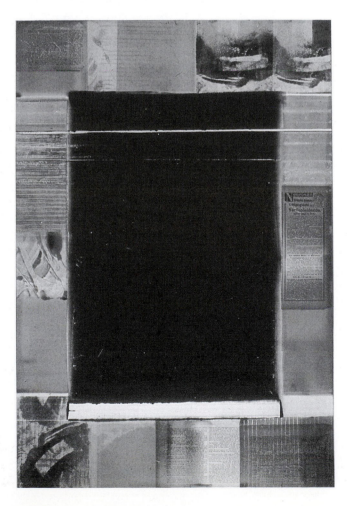

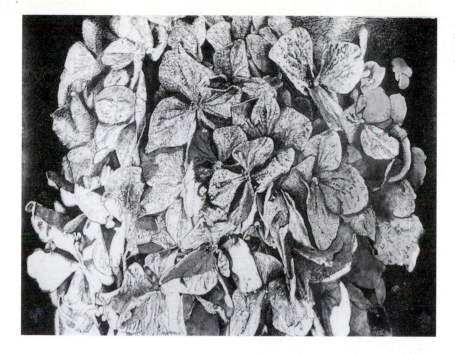

8-20. JOSEPH RAFFAEL (b. 1933; American). *Hyacinth.* 1975. Ink and ink wash, 22 1/2 × 30″ (57.2 × 76.2 cm). Courtesy of Nancy Hoffman Gallery.

between the black center rectangle and the lighter, ethereal outer portion of the composition. This separation phenomenon causes the dark rectangle to hover in an advanced position in front of the lighter outer background. In the reverse situation a lighter center will advance against and in front of a dark background. The stronger the contrast, the more a form advances. When contrast is lessened, forms appear to recede. These are powerful visual tools that artists use to endow their compositions with both subtle and bold spatial dynamics.

Separation and Integration In opposite fashion to Faber's dark-against-light monotype, Joseph Raffael solves the problem of defining and separating light shapes against other light shapes by creating dark halos where the flower petals overlap in his drawing *Hyacinth* (Fig. 8-20). Shapes separated in this manner may take on a strongly decorative character, yet notice the way the petals stand out in relief. Charles Sheeler employed a similar technique in Figure 8-4, as did Richard Ziemann in his graphite drawing *Behind the Garden* (Fig. 8-21).

Project 8.10

Using such objects as teakettles, cups, jars, and other familiar objects, develop a composition in which shapes of similar value are made to stand out in bold relief one from another through the method of separation described above. The method is spatially most effective when it combines both sharp and softened edges.

Closed form, in which a value is confined within the contour or silhouette of an object, stresses separation. **Open form,** in which a value blends into a similar surrounding area without any obvious separation, allows the integration of various elements as well as producing a feeling of aliveness. When the same or similar values are placed side by side, edges begin to disappear and forms begin to merge. Such transitions serve to introduce movement by permitting the eye to flow from one area to another.

closed form
The area of a composition where a color, value, tone, or texture is confined within the contour or silhouette of an object or shape and thereby stresses visual separation from its surrounding elements.

open form A form whose value or values blend into the similar surrounding areas of the composition without noticeable or obvious separations; also, a form that allows the integration of various compositional elements, producing a feeling of movement and vitality.

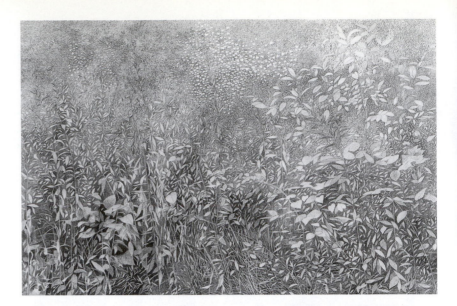

The same value came be made to function as both foreground and background without any loss of spatial depth, as seen in Elmer Bischoff's *Girl Looking in a Mirror* (Fig. 8-22). The figure and its reflection are joined together where the reflected foot becomes one with the upper leg of the figure, allowing the eye to move from the foreground into the space of the mirror. Bischoff has used value contrast to separate the figure from the background in some areas; in other areas closely related values allow the figure to merge into the background. The eye is invited to move freely into and out of the picture space. Notice that volume is suggested through relatively flat areas of tone without extensive modeling.

Project 8.11

In a series of charcoal or wash studies, explore the use of limited value to establish the effect of movement both into and out of space. Reserve white and black values

for accents. Use broad, simplified shapes to describe the subject and its surrounding areas. Use contrast to separate forms and focus attention, letting closely related values provide transition. It is important to let light and dark flow from one area to another in order to provide movement and to prevent individual shapes from becoming too isolated. Avoid equal emphasis on light and dark; balance does not depend upon an even distribution of values. In each study, let one value predominate. You will discover that a limited number of values, well handled, can convey the impression of many tones.

Expressive Use of Value The choice of value scale determines the expressive tone of each drawing. Although it is difficult to exactly categorize emotional responses to works of art, generally, light pictures suggest vitality or exuberance, while dark pictures can evoke a sense of heaviness, or perhaps gloom and even despair. In drawings, prints, and paintings, the exaggerated use of chiaroscuro (discussed in Chapter 6) contributes to a heightened sense of theatricality.

Point of View

Even after careful consideration and application of the principles of composition, a drawing might well seem dull and uninteresting simply because the subject has been presented from a very ordinary point of view.

Artists, not just students, frequently let themselves become trapped into relying upon a single point of view, either out of habit or because of a deeply set mannerism often referred to as an "artist's rut." Other factors that play into artistic monotony are the restrictions imposed because of studio space or the environment in which an artist must work. In drawing classes, instructors often confront space limitations when arranging setups, which must be visible to everyone in the room. Because it is rarely possible to provide a rich variety of viewpoints, students must take the initiative to find interesting positions from which to draw. They should not, however, select one drawing bench or easel and remain there for the entire semester, so that every still life or figure tends to be viewed from exactly the same eye level and distance away.

Compositions need not and should not be monotonous if the point of view is varied. Develop the habit of making quick thumbnail sketches to examine possibilities for expanding your compositional vocabulary. Add variety, drama, and interest by shifting to high or low eye levels; even an eccentric viewpoint can be well orchestrated and produce fresh new results from the most common of subjects. Try to see beyond a mere academic approach to subject matter by allowing your sense of instinct and impulse to clue you into different approaches, to different points of view.

A composition can be enhanced either by cropping or by opening up and adding more space than actually exists. When the will arises, let radical alterations happen and begin to direct your sense of compositional instinct by looking for only the unconventional approach or viewpoint. Everything must be planned by the artist's skills and working knowledge, whether the creation results in a deliberate and academically true representation or an altogether unconventional reassembling of the subject into a nonrepresentational or abstract composition. Therefore, be certain that if cropping is used as a technique, it is intentional and not the result of poor planning. Thumbnail sketches allow you to consider different alternatives, as in Figure 8-1.

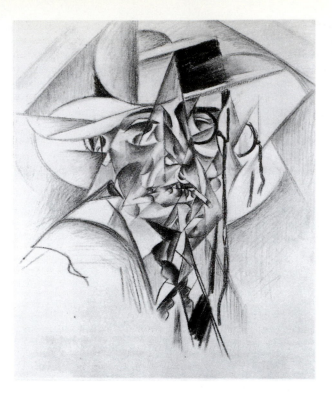

Multiple Points of View Representational drawing traditionally assumes a consistent point of view—each object drawn from the same eye level, each object occupying its own space—yet no single fixed viewpoint exists for either the artist or viewer. Our visual perceptions of three-dimensional form and space depend upon continuous eye movement. Interestingly, to experience a drawing, the eyes of the viewer must shift from one area to another in exactly the same manner that the eyes of the artist move around objects to draw them.

Acknowledging this aspect of seeing has resulted in a freer approach to drawing, which introduces movement through the use of multiple points of view. Paul Cézanne, recognizing that no object could be fully explained when drawing from one viewpoint, chose to look at individual objects from different vantage points. By combining the various views into a composite image, he strengthened the sense of volume and structure.

Unlike Cézanne, the cubists used multiple viewpoints to shatter the solidity of three-dimensional form. Objects were broken into fragments, which were reassembled in such a manner as to tell the viewer more about the original object than could be visible from a single point of view, as in Gino Severini's *Self-Portrait in Straw Hat* (Fig. 8-23).

Project 8.12

A cubist approach involves juxtaposing segments of three or more separate views—top, front and/or back, and side—into a composite drawing, creating the impression of movement around the object in space. On separate sheets of clear acetate, using a black design marker (made for use in impervious surfaces), draw at least four different views of the same object, keeping all the drawings in the same scale. Place the drawings one over the other. By shifting them slightly, incorporate the most interesting sections into a single drawing that reveals the character of the object as fully as possible and suggests movement around it. There will be many interesting and vastly different possibilities of depicting the object when using this method. Do

not attempt to maintain a literal representation with a recognizable contour. Begin to respond more to the total visual effects of the overlying sheets of acetate, allowing those image variations to be your creative guide. Allow for distortion that will require the viewer to reassemble the fragments of information. Use shading and variations in heavy pressure and release of pressure to emphasize important contours and to suggest volume and space. Integrate the form into a complete composition, allowing the appropriate lines to run to the edge and off the sheet of paper. Remember that the first and most important lines of a picture plane are its borders. The initial planning of the composition can be done on acetate or tracing paper. Select a good-quality drawing paper and do a finished drawing in a medium of your own choosing.

Critique (Project 8.12) Consider your drawing a finished statement, and one that is perhaps the most complex of any drawing you have done to date. Is there a sense of life and vitality in the representation of your subject? To what do you attribute this vitality? Did you feel reluctant to depart from the representational elements into the abstract realm of image rearrangement and restatement? Are you intrigued by the ultimate recognition of what the object has become through an entirely unique approach? Do you sense that the resultant composition is the object itself? Are you able to glean a great deal of visual information about the object or subject matter from the drawing? Do you have the sense that you are looking at your drawing from many different viewpoints simultaneously?

Does the composition hold together as a unit? Do you have a sense that this drawing exists on its own visual merits regardless of its derivation? Would you consider the drawing a visual generation once removed from the subject matter? Was there a decisive moment when you knew that the drawing was flying on its own compositional strengths? At what point did you stop drawing, and when did you realize that the drawing didn't need you any longer? Was this the mark of its being finished? How well do you feel your choice of media fits the statement?

How do you feel about this drawing, knowing that it is your creation? How would you feel about it if someone else had done it?

Summary

The principles of composition outlined in this chapter apply to other creative disciplines as well. Artists who make images can be thought of as "visual poets" and poets can be thought of as "literal imagists." Both are composers. Musicians and lyricists are both composers and poets, evoking images with sounds, rhythms, and cadences that call up memories and transmit emotions. In the arts, the common threads that weave the different disciplines together are as visually tangible and spiritually provocative as they are literally contextual. Each artist in his or her own discipline strives for unity, harmony, and oneness between concept and material. One of these most important common threads is that of composition, which all artists use.

9 Perspective

To create depth on a flat surface is to create an illusion. Much of the success of illusionistic art depends upon the successful use of perspective.

—Duane Wakeham

linear perspective
A scientific method of determining the correct placement of forms in space and the degree to which such forms appear to diminish in size at a given distance.

Linear perspective is a scientific method of determining the correct placement, scale, and spatial relationships of forms in space and the degree to which such forms appear to diminish in size at a given distance. Early in the fifteenth century young Italian Renaissance artists, who were seeking a logical means of creating unified, measurable space, formulated the system of perspective based on a set of visual principles. Filippo Brunelleschi's interest in perspective stemmed from direct observation and analysis of visual phenomena. His original experiment involved painting a building on a small panel into which he drilled a peephole at a point corresponding to the eye level of the artist. Rather than looking directly at the painting, people viewed its reflection in a mirror by peering through the peephole from the back of the panel. By confining the image to what could be seen with one eye through the small hole, Brunelleschi restricted vision to precisely the fixed point of view upon which linear perspective is predicated.

With the invention of the camera, photographs duplicating views previously depicted by artists (Figs. 9-1, 9-2) verified the system devised by the Florentines—the lens of a camera being a single eye in a fixed position. In both Giovanni Battista Piranesi's eighteenth-century etching *Interior of St. Paul Outside the Walls, Rome* and a photograph of the same structure, the converging horizontal lines and regular diminution of equally spaced elements create the illusion of vast, deep interior space on a flat, two-dimensional surface. (Many aspects of perspective, as they will be discussed in this chapter, can be seen in Figures 9-1 and 9-2.)

9-1. *above:* GIOVANNI BATTISTA PIRANESI (1720–1778; Italian). *Interior of St. Paul Outside the Walls, Rome.* c. 1749. Etching, 16 × 23 3/4″ (40.6 × 60.3 cm). Reprinted from *Views of Rome Then and Now* by Herschel Levit.
Published by Dover Publications, Inc., 1976

9-2. *left:* Interior of St. Paul Outside the Walls, Rome. Photograph.

9-3. ADOLPH MENZEL (1815–1905; German). *Interior of the Rolling Mill at Konigshutte.* Pencil, 8 3/4 × 12" (22.3 × 30.4 cm). Berlin, Staatliche Museen, Nationalgalerie, Sammlung der Handzeichnungen (271).

empirical perspective
Perspective, that, unlike **linear perspective,** relies upon direct observation rather than a set of rules.

Empirical perspective, unlike linear perspective, relies upon direct observation rather than on a set of rules. An artist with a well-trained eye for seeing shape, size, and scale relationships, who can determine angles by sighting against verticals and horizontals, can create convincing and relatively accurate perspective without having to engage in the mechanical construction of space on a large drawing board using T-squares, triangles, and thumbtack vanishing points. Adolph Menzel displays this ability to accurately sight visual relationships in his drawing of an iron-rolling mill (Fig. 9-3).

Fixed Viewpoint and Cone or Vision

fixed point of view
A mandatory rule for linear perspective; an established, unchanging position from which an object or scene is viewed that enables the rules of linear perspective to be enacted.

The rules of linear perspective are dependent upon a single **fixed point of view,** when in fact we almost never view anything under that condition. At the location depicted in Dominique Papety's *Via Gregoriana* (Fig. 9-4) for example, it is possible to look into the two converging streets from the same spot, but only by moving your head. Even when we hold our heads in a fixed position, our eyes are almost constantly in motion. Perspective drawing, in theory, demands that you not shift the position of your head or the direction of your gaze.

cone of vision
The shape of containment of all that can be seen from one stationary position without moving the eyes.

All that can be seen without moving your eyes is contained within a **cone of vision.** The limits of your cone of vision—between 60 and 80 degrees—are easily determined by extending your arms and inscribing within a vertical circle all that can be seen clearly as you look directly forward. Only a small portion of the immediate foreground falls within your lines of sight in contrast to the expansive distant view.

Picture Plane

picture plane
The area of a flat surface defined by its outer borders on which an artist creates an image; often the picture plane, out of necessity, becomes transparent, allowing the artist to create three-dimensional forms and objects that exist in both deep and shallow space as three-dimensional illusions.

The **picture plane** is an imaginary vertical line that slices through the cone of vision. If you placed a sheet of glass before you with the intention of drawing just what you see through the glass, the glass would represent the picture plane. Substitute a sheet of drawing paper for the glass, and the paper becomes the picture plane. How much is seen through the glass and represented on the paper picture plane depends on how close you stand to the picture plane.

9-4. DOMINIQUE PAPETY (1815–1849; French). *Via Gregoriana.* c. 1838. Graphite pencil with blue ink wash, on gray paper, 13 × 17 3/4". (33 × 45.1 cm). Musée Fabre, Montpellier.

9-5. LORRAINE SHEMESH (b. 1949; American). *Paint Box.* c. 1983. Graphite on paper, 22 1/4 × 30 1/8" (56.5 × 76.5 cm). Glenn C. Janss Collection. Courtesy of the Allan Stone Gallery.

The closer an object is to the picture plane, the larger it will be projected. Lorraine Shemesh creates an almost overwhelming sense of immediacy as well as monumentality by placing the front edge of the paint box right at the line of the picture plane (Fig. 9-5).

Horizontal Line, Ground Plane

The **horizon line** indicates where sky and earth would appear to meet if the ground were perfectly flat and nothing blocked the view. It also corresponds to the eye level of the viewer. In perspective drawing, as the viewer is elevated higher above ground level, the horizon line rises on the picture plane to reveal more of the ground (Fig. 9-6); the closer to the ground level, the lower the horizon line (Fig. 9-4). It is the artist who determines eye level; the viewer has no choice but to accept it. No matter how you look at David Macauley's pen-and-ink drawing of the Gothic cathedral under construction (Fig. 9-6), whether holding it above your head or at waist level, you cannot change the point of view he has

horizon line
A line that corresponds to the eye level of the viewer in linear perspective; the line where sky and earth appear to meet (provided the earth is perfectly flat and nothing blocks the view). The vanishing point (VP), central vanishing point (CVP), and the furthest end point of the center line of vision are all located on this line.

9-6. DAVID MACAULAY (20th century; English-American). *Constructing a Gothic Cathedral*. Pen and ink. From *Cathedral* by David Macaulay. Copyright 1973 by David Macaulay. Reproduced by permission of Houghton Mifflin Company.

ground plane
A flat horizontal plane on which the viewer stands that extends to the horizon. In drawings of interior spaces it is referred to as the floor plane.

floor plane
Same as ground plane albeit for interior spaces.

table plane
Same as ground plane or floor plane, a term used to denote the flat plane of a drawing table surface when drawing objects on a table.

central line of vision
An imaginary line centered in the cone of vision, extending from the eye and meeting the horizon line at a right angle.

center of vision
Same as the **central vanishing point;** the point of intersection of the central line of vision and the horizon line.

central vanishing point
The point of intersection of the line of vision on the horizon line; same as the point of the **center of vision.**

160 PART 3 The Art Elements

selected. The placement of the horizon line determines the angles from which all objects are viewed, and its location must be established even when it does not appear on the picture plane.

The **ground plane** is a flat horizontal plane that extends to the horizon. It is also called the **floor plane** in drawings of interior spaces and the **table plane** when drawing objects on a table. Only when drawn at eye level will the back edge of a floor plane or table plane coincide with the horizon line.

Line of Vision, Central Vanishing Point

The **central line of vision,** centered in the cone of vision, is an imaginary line from the eye to the horizon line. Anything, such as the edge of a table, a line between floorboards, or a curb line, that lies exactly in the line of vision will appear as a vertical line. Extended, it will meet the horizon line at a right angle. The point of intersection, the **center of vision,** or **central vanishing point** (CVP), lies directly opposite the viewer.

One-Point Perspective

Parallel lines by definition always remain equidistant, yet in our common visual experience they appear to converge as they recede. The basis of one-point perspective is that all lines parallel to our line of vision, whether to the side, above, or below, will appear to meet at the CVP, as in Robert Bechtle's charcoal drawing (Fig. 9-7). One-point perspective seems most effective when the central vanishing point is placed near the center of the horizon line. In one-point perspective,

lines parallel to the picture plane are drawn parallel to the horizon line. When three-dimensional forms are set at some distance from the viewer, there is no problem with our visual perceptions of them, but a natural, visual distortion occurs when the forms are at close range.

Establishing a Grid A series of "seeing" exercises, starting with direct observation of forms in space, then moving to some basic drawings with horizon lines and vanishing points (VPs), will demonstrate a system of determining the position and scale of objects in space. *Understanding how to draw just one square in perspective is really all that is necessary to create complex perspective studies.*

Project 9.1

An 8-inch (20 centimeter) square of heavy paper or cardboard appears perfectly square only when you look at it directly from above or held vertically in front of your eyes with the horizon line in the exact center of the square. From all other points of view it is a square in perspective. Held horizontally at arm's length, which forms a line that is square to your body, it will appear as a single line at eye level but will change as you move it above or below eye level. Move it from side to side, viewing it without turning your head. Make similar observations with the card held vertically and parallel to your line of vision. Although the shape enclosed by its four edges changes with each different position, if you hold it horizontally while maintaining it at arm's length, the dimensions of the front and back edges will remain constant while the length of the sides will change. They will become longer as the square is raised and lowered from eye level (the horizon line) and when it is moved out to the left or right sides (away from the CVP).

9-7. ROBERT BECHTLE (b. 1932: American). *Parking Garage with Imapla.* Charcoal, 9 1/2 × 14″ (24.1 × 35.6 cm). Courtesy of the Gallery Paule Anglim.

Project 9.2

While sitting down, study the square lying on a table surface in front of you placed at arm's length, square to and centered on your line of vision. Hold your pencil also at arm's length to determine the measurable vertical distance between the front and back edges (depth of the square) as compared with the width of the front edge. Calculate the angle at which the sides converge by checking them against the vertical of your pencil held at arm's length. Since the back edge of the square is farther away from you, it is shorter than the front edge. The difference in these lengths divided by two will equal the distance the back edge comes inward from each side of the front edge of the square.

Using graphite, draw the shape empirically as observed through sight and pencil calculations; then, using ballpoint pen, T-square, and triangle, overdraw it on the graphite drawing according to your mechanical measurements to see how accurately your eye recorded the square. The depth measurement is critical; be as accurate as possible. Center the square near the bottom of a full sheet of newsprint, letting the front edge be approximately 3 inches (8 centimeters) in length. The result will be a **foreshortened square**—or a square seen in perspective. Locate the CVP by extending the side edges until they meet. Draw the horizon line through that point. Visual believability and visual accuracy can be two distinctly different things to the beginner. However, the more you practice seeing and drawing objects in perspective, the more accurate your eye will become. Using a T-square and triangle to check the accuracy of your empirical drawing and making adjustments or corrections when necessary will give a good indication of how your sights skills are improving.

Project 9.3

Moving the cardboard square one full width to either side places it in a new perspective. The overall shape changes as the back edge shifts in relation to the front edge and the side edges both angle somewhat in the same direction. Each additional move will continue to alter the shape enclosed by the lines representing the four edges.

On the basis of the one square drawn empirically, it is possible, using linear perspective, to develop an elaborate drawing in one-point perspective without having to move, study, or draw the cardboard square. All necessary measurements have already been established; no further decisions need be made.

Project 9.4

Extend the lines of the front and back edges of the original square horizontally across the page. Mark off equal widths of the front edge of the original square along the bottom line, connecting each mark to the CVP to create a full row of squares. Although the shapes are different, each represents a foreshortened square in perspective. Notice that the units of measurement representing the back edges of the squares are also equal.

Project 9.5

To continue adding rows of squares is relatively simple, but first draw a 2-inch (5-centimeter) grid on the 8-inch cardboard square (creating four 2-inch squares per side) and add a diagonal line connecting two opposite corners. If you have measured accurately, the diagonal line will intersect the opposite corners of each of four squares. Place the square back on your table and return to your drawing.

Starting from the lower outside corner of one of the end squares, draw a diagonal through the square and extend it to cut across all of the converging lines.

foreshortened square
A square seen in perspective while lying flat on the ground plane whose parallel sides converge into the central vanishing point on the horizon line.

Add a horizontal at each point of intersection to create a grid as many units deep as it is wide. The width of all the squares has already been established, and since the diagonals of equal squares are equal, the diagonal establishes the depth for each additional row (Fig. 9-8).

Repeating the procedure using one of the squares in the back row allows you to continue extending the grid toward the horizon line. The grid can be expanded to either side by extending all horizontal lines across the width of the picture plane and repeating the horizontal measurement of any line laterally.

Project 9.5 demonstrates that *once the depth of the first unit has been determined, the depth of all other units of equal size is automatically established.* No additional decisions are necessary; therefore, it is imperative that the first unit be measured and drawn as accurately as possible. When creating perspective from imagination, it is necessary to have a keen sense of how much depth would be seen at the eye level selected.

Project 9.6

To construct a matching vertical grid, add exact vertical lines where each horizontal intersects one of the outer receding ground lines. Transfer the unit of measurement from one horizontal line to its adjoining vertical; complete the vertical grid by connecting each mark to the CVP (Fig. 9-9).

Equal units of measurement on adjoining horizontal and vertical lines that are parallel to the picture plane remain constant. Equal units diminish only on lines that recede from the picture plane. Such observations will aid you in seeing and understanding foreshortened forms as you draw from life and will allow you to draw convincingly from imagination.

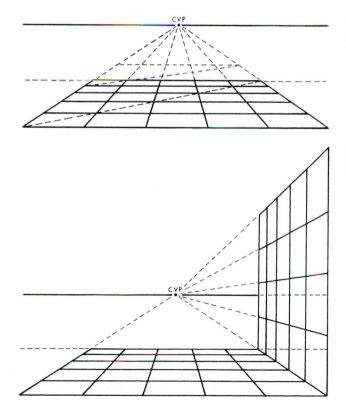

9-8. Use of diagonal to establish horizontal grid in one-point perspective.

9-9. Constructing vertical grid in one-point perspective.

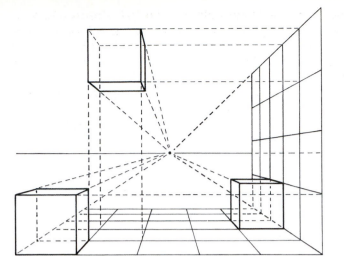

Horizontal grids can be raised or lowered to any level; vertical grids can be swung to the left or right. As the horizontal plane approaches eye level (the horizon line), you will see less space between the lines defining the front and back edges of each row until it reaches exact eye level and becomes a single line identical with the horizon. The same changes occur as the vertical plane swings toward the CVP, where it eventually becomes identical with the vertical central line of vision.

Project 9.7

Diagonals of the squares of a grid are parallel lines and, as such, appear to converge at common points—on the horizon for those of the horizontal plane, on a vertical line drawn through the CVP for those of the vertical plane. Draw one or two diagonals in each direction on both grids to verify this. (The horizontal diagonals will become the basis for two-point perspective; the diagonals of the vertical grid will become the means for determining the perspective of inclined planes.)

Almost everything else included in this chapter will be but a variation on what you have already done.

Project 9.8

Three-dimensional solids, such as cubes and blocks, are merely a series of contiguous vertical and horizontal planes. To create a cube, add vertical lines from each corner of a square on the horizontal grid. Carry a line across from the vertical grid to establish the height for one corner, and complete the cube with the help of the CVP (Fig. 9-10).

Project 9.9

You now have the information necessary to create a one-point perspective "fantasy image" constructed out of solid square blocks and units composed of multiples of blocks. Spread the blocks across the width of the page, push them deep into space, stack them, and let some of them float above the ground plane, as in Figure 9-10. You might prefer to do these drawings on tracing paper in order to preserve the grids so that you may reuse them for future drawings. If so, lay the sheets of tracing paper over the grid drawings and proceed. Include only the horizon lines with each drawing, not all of the grid lines. Simple shading of the cubes will increase the sense of solidity and volume. (Later you will be able to add cast shadows; see p. 174.)

Establishing Scale; Using Diagonals to Establish Depth Scale is established by assigning a specific dimension to the length of one side of one square. The dimension may be changed for different drawings done from the same grids as long as the scale remains constant within any single drawing.

The illusion of depth is particularly noticeable when objects of the same size recede into space at regular intervals, such as the columns in Figures 9-1 and 9-2. Using the grids developed in the preceding projects, it would be possible to contrast a facsimile of the church interior. Linear perspective also provides alternatives for determining size and distance that are not dependent upon a complete grid system.

A relatively simple method employing the use of diagonal lines might well be the manner in which Jacopo Bellini determined the spacing of the figures in *Funeral Procession of the Virgin* (Fig. 9-11). The system is based on the principle that diagonals cross at the exact center of a plane; lines drawn through the center point divide the plane into equal halves, as demonstrated in Figure 9-12.

Project 9.10

Draw a set of converging lines more or less corresponding to the heads and feet of the figures in Figure 9-11. Add vertical lines to represent the first two figures in the procession. Forgetting for a minute about people, notice that the verticals and converging horizontals create a plane seen in perspective. Locate the center of that plane by connecting the four corners with diagonals. A line from that center point to the VP will establish the midpoint of any additional verticals. A diagonal line from the top of the first vertical through the midpoint of the second to the base line establishes the position for a third vertical spaced at the same interval (Fig. 9-12).

The use of diagonals allows for the repetition of any regularly spaced elements—vertical or horizontal. Notice, however, that the spacing of figures in Bellini's *Procession* (Fig. 9-11) is not mechanically repetitious; the distance between the last two figures in the first group is almost double that between the other figures, which adds a note of visual interest to the composition.

Calculating Scale and Distance *An object or form whose size can be comprehended establishes the scale for everything else in a perspective drawing.* It is possible, for example, judging by the height of an average human figure, to state with some accuracy that the city wall in Bellini's drawing (Fig. 9-11) is just over 30 feet in height (9 meters) and lies

9-11. JACOPO BELLINI (c. 1400–1471; Italian). *Funeral Procession of the Virgin.* Pen and brown ink over black chalk underdrawing on tan paper, 3 3/4 or 8 1/8 × 11 7/8" (9.5 or 20.6 × 30.2 cm). The Fogg Art Museum, Harvard University, Cambridge, Mass. (bequest of Charles A. Loeser).

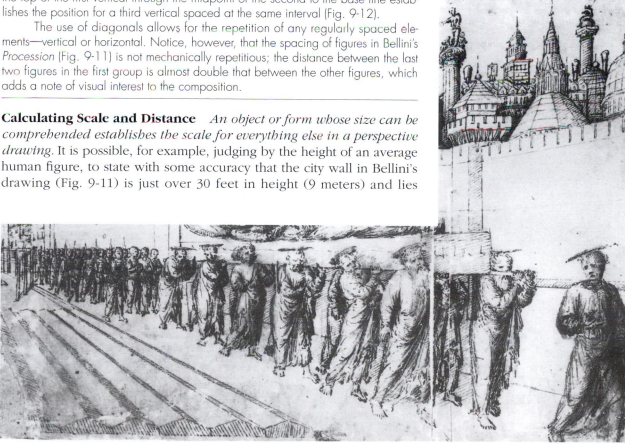

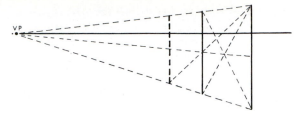

9-12. Use of diagonals to determine spacing of repeated intervals.

approximately 120 feet (37 meters) from the viewer, and that the procession passes between 15 and 20 feet (5–6 meters) to the right. These dimensions can be calculated by placing a figure against the wall seen between the two figures at the far right. The height of such a figure has already been established; since all the figures in the drawing are viewed at eye level, his eyes would fall on the horizon line, his feet at the base of the wall. Repeating the height of the figure (probably less than 6 feet [1.8 meters]) vertically gives us the height of the wall; marking off the same unit of measurement on a horizontal line projected from his feet to a point immediately below the CVP (just outside the left edge of the drawing) provides the other dimension.

The logical systems of perspective are an extremely valuable and creative tool, as is evident in this chapter. Once the systems are established, an artist can compose spatially by defining forms as true and accurate in relationship to their surroundings. Like attempting to solve a puzzle with a few preliminary but significant clues, the visual mystery of defining subject matter in space by applying the principles of perspective becomes clearly evident and irrefutable at the drawing board. One portion of visual definition generates the definition of successive forms. For example, it was possible, without a grid, to add a distant figure of equal size to the Bellini drawing because scale, ground plane, and eye level were already established. When all three conditions are known, a figure can be placed at any spot within perspective space with the assurance that the size of the figure will be correct at the distance selected.

Two-Point Perspective

Learning to draw cubes in perspective provides the raw material for constructing almost any form, since very few objects exist that cannot be enclosed within a square or rectangular container. Blocks or cubes placed square to the picture plane (one side parallel to the picture plane) are drawn in **one-point perspective;** blocks set at an angle necessitate the introduction of **two-point perspective.** Nineteenth-century American painter Thomas Eakins, a dedicated practitioner of linear perspective, uses both one-point and two-point perspective in his study for *Chess Players* (Fig. 9-13). The drawing also illustrates how simple blocks below began to be transformed into detailed specific forms above.

Project 9.11

The characteristics of two-point perspective can be studied empirically by placing a cube or square box just close enough to you that you can reach out and move it easily. A clear plastic cube, such as those used for displaying photos, would be particularly effective.

Begin with the cube directly in front of you, square to your line of vision. Observe the changes that occur as you slowly rotate the cube clockwise. The front, ver-

one-point perspective
A visual condition where all lines parallel to our central line of vision, whether to the side, above, or below, appear to meet at the central vanishing point (CVP).

two-point perspective
The system of drawing objects not set square to the picture plane but set at an angle; it requires the use of both left and right vanishing points (LVP and RVP).

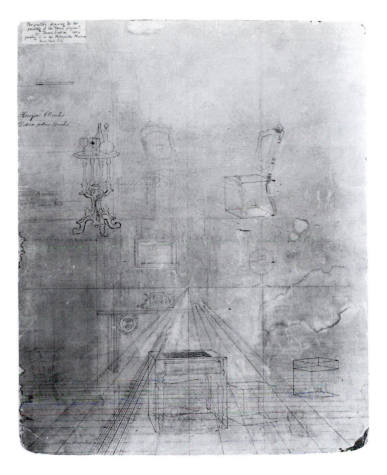

9-13. THOMAS EAKINS (1844–1916; American). *Perspective Drawing for Chess Players.* c. 1876. Pencil and ink on cardboard, 24 × 19″ (61 × 48.3 cm). The Metropolitan Museum of Art, New York (Fletcher Fund, 1942).

tical surface becomes the left side as the right side appears as the front; the configuration of the top begins to change, and the bottom edges are seen as diagonal lines. As the rotation continues and you see less of the left side and more of the right, the measurable height dimension of the left corner begins to diminish, and that of the right outer corner increases. The less you see of a side, the greater will be the angle between the base of that side and the horizontal of a pencil held at arm's length. When the cube reaches a 45-degree angle, you see equal amounts of both side planes receding at the same angle, the front and back corners in exact vertical alignment. Until that moment, the back corner was to the left of the front corner; rotated beyond 45 degrees, it will move to the right. Depending on the size of the cube, you might be able to detect the convergence of the sets of parallel lines delineating the separate planes.

Drawing a cube in two-point perspective requires two VPs. For a cube sitting at a 45-degree angle, both VPs will be equidistant from a CVP. At any other angle, the less you see of a side, the closer its VP will be to the CVP; the more you see of a side, the farther away will be its VP.

Project 9.12

Draw a series of cubes rotated to different angles seen above, at, and below eye level in relation to one horizon line. You might want to compare your drawing with the plastic cube. When one cube is positioned at random angles to the others, it must have its own set of VPs.

Do a second drawing of a number of cubes spread across the width of the paper, with each constructed in relation to just one set of VPs placed near the outer ends of the horizon line. A single set of VPs automatically positions the cubes square to one another.

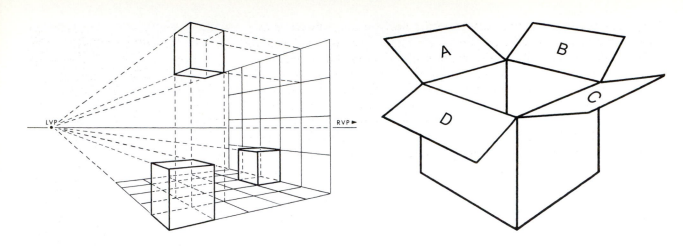

9-14. *above, left:* Figure 9-10 seen in two-point perspective.

9-15. *above, right:* Drawing inclined planes: box with flaps.

inclined planes
Planes not parallel to the ground or floor planes whose vanishing points exist on vertical lines that pass through the corresponding vanishing point on the horizon line.

ascending planes
Planes not parallel to the ground or floor planes whose vanishing points appear above the horizon line.

descending planes
Planes not parallel to the ground or floor planes whose vanishing points fall below the horizon line.

Project 9-13

Either on tracing paper or as a new drawing, select one cube positioned below eye level and extend it in both directions, using the system of parallel lines from Project 9.10 to determine the depth of each additional cube. Extending the top or bottom edges of all the cubes in the two rows to the VPs will produce a horizontal grid drawn in two-point perspective. Vertical grids can be constructed exactly as in Project 9.5. Figure 9-14 rotates Figure 9-10 into two-point perspective.

Inclined Planes Look at Figure 9-15. The flaps of the box represent **inclined planes**—planes not parallel to the ground plane.

Project 9.14

Make a tracing of Figure 9-15. Use a straightedge to locate the VPs for all planes of the box, including the flaps. Draw the horizon line through the VPs of the sides. Notice that because they are parallel to the ground plane, the long edges of the flaps vanish at those points on the horizon line, while the short sides of the flaps converge at different VPs above or below the horizon line.

VPs on the horizon line relate only to lines and planes parallel to the ground plane. Here we see how the flaps, being inclined planes, are not parallel to the floor or to the ground plane. They have VPs on vertical lines that pass through the corresponding VP on the horizontal line. VPs for **ascending planes** appear above the horizon; those for **descending planes** fall below the horizon. (Review Project 9.6.) Ascending planes angle upward away from the viewer, as in flaps A and B; descending planes angle downward from the viewer, as in flap C. Flap D might appear as a descending plane because it falls below the rim of the box, but extending its short sides reveals that they converge upward. Viewed from the opposite side of the box while being closer to the inside long edge, flap D would be seen as a descending plane.

Uphill and Downhill Streets Inclined planes are to be found with surprising frequency in landscapes and cityscapes. Pitched roofs, for example, are inclined planes, as are uphill and downhill streets and roads.

You may experience total confusion the first time you are confronted with the challenge of representing an uphill or downhill street lined with buildings. Until you have attempted to draw such a scene, it is very probable that you have never really looked at buildings on a hill in terms of perspective. The scene becomes easier to draw when you remember that in spite of the inclined street plane, houses are built with level floors and vertical corners. All horizontal elements, such as the flat roof of the house in the left foreground of Wayne Thiebaud's *Ripley*

Ridge (Fig. 9-16), are drawn to VPs on the horizon line, always at eye level of the observer, whereas lines of inclined planes— sidewalks, curbs, and objects parallel to the street, such as automobiles—will converge at VPs either above (looking uphill) or below (looking downhill) the true horizon line. Thiebaud has placed the VP so far above the horizon that the street appears to be nearly vertical, which is precisely the impression many first-time visitors have of San Francisco's hills. Rarely can an uphill or downhill street be drawn as one continuous inclined plane since the roadbed levels out at street crossings, as it does in the immediate foreground of Figure 9-16, where the surface of the intersection must be drawn to true horizon.

A puzzling phenomenon occurs when you do a drawing looking downhill. The imaginary horizon line is below the VP of the converging lines of the street curbs, but the angle of ascent is less than for lines representing a level plane; thus VPs of downhill street lines appear below the true horizon line. In fact, only in a drawing of the underside of a descending plane, viewed from below, would the edges converge downward.

Three-Point Perspective

Blocks or cubes placed square to the picture plane are drawn in one-point perspective, or one vanishing point, as in Figure 9-10. Blocks or cubes set at an angle necessitate the introduction of two-point perspective utilizing two vanishing points, as illustrated in Figure 9-14; and finally, **three-point perspective** requires three vanishing points in order to accommodate forms both distant and near that are positioned at different angles to one another in space.

In perspective, vertical lines remain vertical as long as the head is held level while viewing. The corners of a rectangular object placed above or below eye level continue to appear vertical if the object is viewed from sufficient distance (Fig 13-24). When the same object is viewed from such close range that you must tip your head to look up or down at it, the corners appear to converge at a VP above or below. Looking up or down, by itself, does not create three-point perspective unless the object, as in Charles Scheeler's *Delmonico Building* (Fig. 9-17), is also placed at an angle. In this age of skyscrapers, when we have frequent opportunities to view great heights from both above and below, three-point perspective has become a familiar visual experience for most people—whether they realize it or not. Figure 16-17 provides an exaggerated bird's-eye view of three-point perspective.

9-16. WAYNE THIEBAUD (b. 1920; American). *Ripley Ridge.* c. 1976. Pencil on paper, 22 × 15" (55.9 × 38.1 cm). Collection Robert A. Rowan, Pasadena, California. Courtesy of the artist. © Wayne Thiebaud/licensed by VAGA, New York, N.Y.

three-point perspective
A system for drawing three-dimensional objects in space on a two-dimensional plane that requires three vanishing points: both the left and right vanishing points of two-point perspective where lines recede on the horizon, and a third vertical vanishing point where lines parallel and vertical to the ground appear to converge.

Project 9.15

In Figure 9-14 one cube floats above eye level. Imagine all three hovering above your head at different angles and draw them in three-point perspective. You will need a third VP for the vertical corners of the cubes. If you locate it above the left front corner of the floating cube in Figure 9-14, that corner and the hidden back corner of the lower cube in front will be drawn as vertical lines—or, as the figure illustrates, it is the same vertical line. In three-point perspective, all other corners will converge to the VP above.

First, try drawing the cubes as you think they might appear. Do a second drawing using the grid system to establish location and size. Be aware that in three-point perspective equal units of measure diminish as they move in the direction of all three VPs. Turn your finished drawing upside down to view cubes floating below eye level.

9-17. CHARLES SHEELER (1883–1965; American). *Delmonico Building.* c. 1927. Lithograph, 9 3/4 × 6 3/4″ (24.8 × 17.2 cm). Library of Congress, Washington D.C.

Critique (Project 9.15) How well are you able to envision the aspects of one-, two-, and three-point perspectives in your drawings? Has the study of perspective thus far helped you in your understanding of the relationships of forms in nature, in the landscape, in the cityscape? Has perspective helped you better understand space? How accurately do you measure when drawing with a straightedge? How accurately are you able to draw forms in their correct proportions and spatial relationships to one another? Has this chapter deepened your understanding of the importance of seeing?

Circles in Perspective

A look at the rims and bases of bowls, cups, and other circular objects in the drawings of most students, and even those of some advanced artists, indicates that the perspective of a circle is little understood. The three most frequent errors are re-created in Figure 9-18: (1) outer edges drawn as points, (2) front and back edges flattened, (3) upper circle drawn too full as compared with lower circle.

A circle seen in perspective assumes the shape of an ellipse (compare examples 1 and 2 in Figure 9-18 with the circles in the floor pattern of Figure 9-2). The exact shape of an ellipse can best be visualized as a circle inscribed within a square projected into perspective—or a foreshortened square.

Project 9.16

Figure 9-19 provides the necessary clues for drawing an ellipse. In the foreshortened square provided, draw diagonals to locate the centered lines accurately. The correct positioning of the points where the circle crosses the diagonals can be deter-

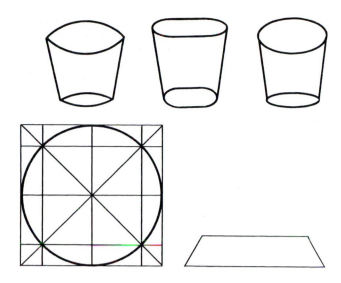

9-18. Drinking glasses with circular edges drawn in faulty perspective.

9-19. Diagram: determining circle drawn in perspective.

mined by transferring the measurements from the bottom edge of the diagram to the front edge of the square and drawing lines to the CVP. Draw the circle/ellipse so that it touches each of the eight reference points. Make certain that it is a continuous and consistently curved line with no points and no straight passages.

The center point of a circle, inscribed within a square drawn in perspective, is not equidistant between the front and back edges. The widest dimension of the ellipse, however, is tangent to the side edge of the square at points equidistant between the front and back edges, making the front half of the circle—if drawn correctly—measurably larger and fuller than the back portion.

Ellipses in Varying Perspective The third common error—mismatched ellipses—creates an effect of a shifting point of view (Fig. 9-18). The fullness or openness of an ellipse is determined by eye level (Fig. 9-20). Viewing the rim of a drinking glass in a sequence of positions from well below eye level to high above will allow you to duplicate the diagram three-dimensionally. Hold a transparent drinking glass vertically in your hand in front of your face so that the top is a perfect horizon line at eye level. Keep your eyes focused on the top plane of the glass and raise the glass slowly and vertically, letting your eyes follow upward while viewing the top plane of the glass begin to form an acute ellipse. As you raise the glass higher, the ellipse opens up more and more. Then, lower the glass and watch the ellipse close down back to the horizontal plane of the top of the glass. Continue lowering the glass and observe again how the top opens up into an ellipse. By turning the glass sideways so that the top of the glass forms a vertical plane, move it from left to right and observe the same progression of the formation of the ellipse as though it were a circle standing vertically or a disk rotated on a vertical axis.

Drawing Circular Objects Cups, plates, bowls, glasses, bottles, teakettles, coffee pots, pans, flowerpots, baskets, lamp shades, records, computer disks, wheels—the list of circular objects in our immediate environment available for drawing is not easily limited. When drawing a circular object from life, the correct degree of openness for an ellipse can be determined by using your drawing tool as a measuring device (discussed in Chapter 3) to calculate the proportional relationship of the vertical measurement between the front and back midpoints of the ellipse as compared with its maximum width.

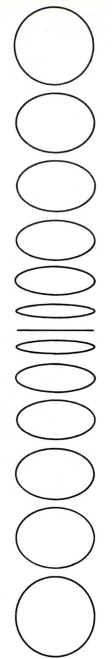

9-20. Ellipses drawn in varying perspectives.

Project 9.17

To draw two circles of the same size in perspective, one above the other, and ensure that they are correctly foreshortened, first draw a cube in one-point perspective. Add circles to the top and bottom planes using diagonals and center lines as in Figure 9.19.

Connect the two circles with vertical lines at the outer edge to create a cylinder. The verticals should join the lower ellipse just behind its widest point to create the fullest effect of roundness. The width of the cylinder, as drawn, will be greater than the dimension of the center line of the circle, but less than the full width of the front plane of the cube because of the large corner segments that are cut away.

Project 9.18

Do a tracing that includes the complete upper ellipse, the two connecting verticals, and only the front portion of the lower ellipse. The cylinder will appear more three-dimensional. Notice that the curve of the bottom rim is fuller than the curve of the upper rim. When students cannot see the full ellipse, they have a tendency to draw the bottom curve flatter than it should be.

Do a series of tracings in which you treat the cylinder first as hollow, then solid, and with various vertical sections cut out. Remove a full quarter of the cylinder, various quarters, one diagonal half. For each separate image, trace only those portions of the upper and lower ellipses that would be visible, adding necessary verticals and connecting lines.

Project 9.19

Turning the paper sideways transforms the drawing into a cylinder resting on its side at eye level. Practice drawing vertical ellipses and cylinders resting on their sides, seen from both above and below. Using the one-point and two-point grids from earlier projects and the diagram from Figure 9-19 will allow you to place cylindrical forms both parallel to the picture plane and at angles.

Few circular objects we see and draw are plain cylinders. In profile the sides curve, bulge, or flare, sometimes all in the same object, so that circles of various diameters are involved. To draw such objects correctly, you must center all the ellipses one above the other.

Project 9.20

Small plastic glasses with tapered sides are perfect for studying forms with ellipses of different sizes. Observe how the space between the upper and lower ellipses changes when a glass is viewed from the same eye level, but at different distances. As you pull the glass toward you, the ellipses get fuller and closer together until they overlap. Draw the glass as it appears at various distances and when held at different levels. In each drawing the upper and lower ellipses must be centered on each other. Remember to calculate proportional relationships, not only of the separate ellipses, but also of the overall dimensions of the glass.

While the tapered forms that you have drawn could also represent flowerpots, the reason for using the plastic glass is that the transparency of the glass allows the lower ellipse to be seen. Although glass or flowerpots best serve their function when maintained in an upright position, they become interesting and challenging drawing problems when resting on their sides.

Project 9.21

Study a plastic glass or flowerpot tipped on its side. In profile, neither the top nor the bottom is vertical, nor is an imaginary center line connecting top and bottom horizontal. Be aware, however, that both the top and bottom are at right angles to a center line. Slowly rotate the object. The ellipses open as you look more directly into the container and become narrower as it approaches profile position. Make freehand drawings of the object in several positions.

Ellipses in an Architectural Setting Arches, circular windows, the capitals and bases of columns, domes, and towers—all involve the perspective of circles and partially circular forms. These curvilinear elements usually appear in conjunction with rectangular forms, and if the two are not handled consistently, the drawing will be weakened. It is frequently helpful to use divided squares as a basis for constructing elliptical forms (Fig. 9-19).

Two mid-eighteenth-century architectural fantasies, both of which project a series of arched forms into planes at various eye levels, provide an interesting comparison. Piranesi's *Monumental Staircase Leading to a Vaulted Hall* (Fig. 9-21) is an imaginative freehand study, admirable for its directness and its vigorous, expressive drawing rather than for accuracy, since neither the architectural forms nor the spatial relationships can withstand careful analysis in search of formal accuracy.

Equally imaginative is Giuseppe Galli Bibiena's architectural perspective design for the theater (design for painted stage scenery) with its tiers of arcades and endless corridors (Fig. 9-22). Meticulously constructed in two-point perspective, the design combines a beckoning and brilliant use of scale with the repetition of architectural elements to create a feeling of spaciousness that cannot be contained within the frame. With the view of the inner courtyard seen through the arch at the left comes the realization

9-21. *above, left:* GIOVANNI BATTISTA PIRANESI (1720–1778; Italian). *Staircase Leading to a Vaulted Hall.* c. 1755. Pen and brown ink over red chalk with brown wash, 15 × 10 1/2″ (38.1 × 26.7 cm). British Museum, London (reproduced by courtesy of the Trustees).

9-22. *above, right:* GUISEPPE GALLI BIBIENA (1696–1757; Italian). Architectural perspective design for the theater. From *Architectural and Perspective Design* (Vienna, 1740). Republished by Dover Publications, Inc., 1964.

that the columns partially visible at the top of the drawing are but the bottom half of another story towering above. Except for the staggering amount of intricate architectural detail, careful analysis of the perspective—basically two sets of parallel planes set at right angles—reveals that the drawing is merely an elaboration of the assignments in this chapter.

Shadows

Both Piranesi and Bibiena recognized the importance of using light and shadow artistically in establishing volume and creating drama in their perspective fantasies. It appears that Piranesi introduced his shadows somewhat arbitrarily, no doubt for the sake of compositional effects, while Bibiena calculated his as methodically as he graphically constructed the architecture. Whether or not to adhere to the accuracy of mechanical means, is, of course, the artist's decision. It is important, however, to note that an artist must have a full working knowledge of perspective in order to use it more freely and to his advantage regarding compositional elements of exaggeration and distortion.

All objects in direct light (regardless of the direction of the light source) cast shadows that can be determined by perspective. Three factors govern the drawing of shadows.

1. The **source of light** may be either natural or artificial. Natural light produces parallel rays; artificial light creates radiating rays. It is true that light radiates from the sun, but from a distance of about 92 million miles away, the rays are virtually parallel when they reach the earth.
2. The **direction of light** determines the direction in which shadows fall. When the source of light is to one side, shadows are cast to the opposite side. In a standing position, with the light at your back, shadows are darkest at your feet and begin to lighten slightly as they fall away from you frontally. When you look into the light, shadows are cast behind you and fall away from your back.
3. The **angle of light** determines the length of shadows. A high-positioned source of light creates short shadows; a low-positioned light produces long shadows.

Drawing Designs in Perspective

Complex patterns and designs whether actual or imaginative—geometric paving tiles, the patterns of Oriental rugs, curvilinear designs, lettering, and even fluid text—can be drawn into one- or two-point perspective on horizontal, vertical, or inclined planes, or even on a curved surface, by squaring off the design and transferring it to a grid, properly scaled and drawn in correct perspective. The smaller the scale of the grid, the easier it is to transfer complicated designs.

Seeing and Using Perspective

Perspective need not be restrictive. Used imaginatively, it offers an artist great freedom, serving as a valuable aid to creative interpretation, playful distortion, and visually penetrating expression. As with any academic stricture of any technique in the arts, to learn it well better prepares the artist to expressionistically alter its manifestation in pursuit of the sought-

source of light
Light that may be either natural or artificial. Natural light produces parallel rays; artificial light creates radiating rays. It is true that light radiates from the sun, but from a distance of 93 million miles, the rays are virtually parallel when they reach the earth.

direction of light
The position of light that determines the direction in which shadows fall. When the source of light is to one side, shadows are cast to the opposite side. With the light at your back, shadows fall away from you. When you look into the light, shadows of objects before you are cast toward you.

angle of light The proximity, position, and direction of a light source in relation to an object that determines the length of shadows. A highly positioned source of light creates short shadows; a low light position produces long shadows.

9-23. RACKSTRAW DOWNES (b. 1939; English-American). *The IRT Elevated Station at Broadway and 125th St.* c. 1982. Graphite on paper, 19 × 35" (48.3 × 89 cm). Collection of Glenn C. Janss. Courtesy of Hirshl & Adler Modern.

after effects. Freshness and spontaneity of expression, whether premeditated or impulsively executed, is an artist's springboard to visual impact.

We can identify elements of one-, two-, and three-point perspective in Rackstraw Downes's graphite drawing *The IRT Elevated Station at Broadway and 125th St.* (Fig. 9-23). A panoramic view of upper Manhattan sweeps from left to right in an arc so broad that it reveals the curvature of the earth and seems to include a broader view than would fall within the usual cone of vision. It is the subtle shift and tilt of perspective that causes us to notice the interpretive expression of Downes. We pause at this—we even marvel at how it entertains, provokes, and pleases our sense of sight. Downes's provocative approach to the picture plane is even more emphasized in Figures 13-18 and 13-19, where the panoramic view is hyperextended even beyond that of Figure 9-23.

Continuous practice in perspective drawing sensitizes the eye, so you will readily perceive errors. By studying the diagrams and doing projects, you are better able to see forms as they exist in space and can avoid the errors most commonly made. You will be able to see when objects do not appear to rest on the same ground plane and when they are drawn incorrectly out of scale.

Sketchbook Activities

In your sketchbook do perspective drawings from observation and from theory, and do drawings of forms both simple and complex. A partially open door, a jumbled array of drawing benches and easels in an art classroom, the confusion of plates and cups and textbooks on a table in the cafeteria all offer opportunities to consider size, shape, and space relationships. Draw objects from memory or imagination. Construct large general forms first; then modify them creatively by using value and texture as expressionistic forces. Remember that most objects can be placed in boxes, which can be visually transformed by cutting away a portion of the box. Incorporate every opportunity to instill good composition practices in your drawings.

With much looking and much drawing, your uncertainties will become less frequent, your drawings more accurate.

10 Dry Media

I recall how I loved the material itself, how the colors and crayons were especially alluring, beautiful and alive.

—Vassily Kandinsky

newsprint
An inexpensive paper made of wood pulp used by art students for all types of practice drawing and expedient classroom studies such as gesture, contour, blind contour, etc. It has a smooth surface, yellows badly due to its acid content, and is most appropriately used with soft graphite pencil, charcoal, Conté crayon, and chalk.

charcoal paper
Textured paper abrasive to charcoal because of its hardness of tooth. In the drawing act, it receives a deposition of black carbon charcoal particles that adhere to its relief as well as fall into its recesses; available in different weights in white, gray tones, and muted colors; also for use with chalk, Conté crayon, and pastels.

tooth
The abrasive texture of paper that makes drawing with dry media possible by enabling graphite, charcoal, chalk, crayon, or pastel to adhere when dragged across the surface, leaving rich deposits of drawn marks.

soft sketching papers
Papers manufactured with a smooth tooth for use with soft graphite pencils, ballpoint and felt-tip pens, and colored crayon.

As a prelude to this chapter on dry media, as well as to the remaining chapters of this text, a discussion regarding artistic sensitivity to the different drawing materials and papers most commonly used by professional artists is in order. A feeling for media, an intuitive awareness of their intrinsic beauty and expressive potential, and a delight in manipulating them are part of the creative sphere of most artists. For the novice, it is essential to discover the medium best suited for one's temperament and talents; exploration is the first step toward discovery. Since pleasure in the craft is an important component of the artistic temperament, the joyful savoring of the particular qualities inherent in each material and each surface contributes to the total effect.

There are many different artistic personalities. Artists who enjoy working patiently and methodically naturally gravitate to those media that demand precise control, disciplined manual dexterity, and careful manipulation of difficult and demanding tools. At the other extreme are the artists who cannot put down ideas with sufficient speed; they can formulate and express an idea in a brief burst of creative energy. To facilitate this rush of enthusiasm, the ideal medium is one that demands neither great precision nor extensive preparation, one that encourages rapid visualization and realization, one that can be worked and modified easily without seeming to imply a lack of technical skill. Between the two extremes lie a host of talents, temperaments, and artistic wills—all of which can be accommodated by the wide range of available media. In fact, any attempt to define or limit the use of a medium to

176

one type of temperament suggests a categorizing inherently false to the need for experimentation and self-discovery.

Chapter 2 introduced the media most commonly employed by beginning drawing students. Chapters 10 and 11 will explore a fuller range of drawing materials, some more sophisticated and requiring greater skill than others. While the accompanying projects have been designed to encourage students to experiment with a wide range of materials, esoteric methods and recipes have been purposefully avoided. Unduly detailed directives about the use of media, tools, and materials have also been avoided since step-by-step instructions frequently encourage self-conscious and mechanical procedures that interfere with direct and vigorous natural expression. In general, after accepting certain fundamental and very general procedures, artists work out their own methods. Students are urged to play freely with media before embarking upon their use, for only by a free and inventive manipulation of materials, whether wet or dry, on a variety of different receptive surfaces, do artists discover and develop their personal preferences and characteristic methods of working.

It is suggested that you first read through the chapters on media and then select those media and exercises that sound interesting. When you fix upon a medium or technique that proves uniquely satisfying, it is wise to explore it rather fully before moving to another. Single cursory encounters with a wide variety of materials and methods can result in confusion, while the creation of works that satisfy the artist remains the greatest encouragement and stimulus toward further development.

Papers

Before exploring the categories of dry and wet media, a brief survey of standard drawing papers will afford the student a basic reference. **Newsprint,** manufactured from wood pulp, is the cheapest paper; it has a smooth surface, yellows badly because of its acid content, and is appropriate only for quick sketching in pencil, charcoal, Conté crayon, and chalk. **Charcoal paper** has considerably more **tooth** (degree of roughness created by an embossed texture imprinted in combination with fine sand) and is available in white, gray tones, and muted colors for use with charcoal, chalk, Conté crayon, and pastels. **Soft sketching papers** are manufactured for use with soft pencils, ballpoint and felt-tip pens, and colored crayons. **Handmade Oriental papers** (mistakenly referred to as **rice paper**), are the traditional surfaces for Oriental brush-and-ink drawings, and provide a soft, very absorbent ground. **Bond papers,** familiar as stationery and typing or computer paper, are smooth, relatively hard-surfaced, lightweight papers appropriate for use with pencil or pen and ink; they are available by pad or in bulk in various sizes. The serious artist, however, will avoid using bond papers; since they have a rather uninteresting surface, they are limited in their expressive capabilities and considered inferior to the more professional rag papers. **Bristol board,** a very fine, hard-surfaced paper, is manufactured in two finishes: **Kid finish,** by virtue of its very slight tooth, facilitates fine pencil work and rubbed pen-and-graphite combinations; **smooth (plate) finish** encourages elegant studies in pen and ink or very hard pencil. It is available in different weights. **Illustration board** is manufactured by mounting papers of different surfaces onto a cardboard backing for stability. While relatively expensive, illustration board tends to justify its price in

handmade Oriental papers
Papers that are made by manually pulling a flat screen or sieve up through a water vat containing finely shredded mulberry fibers. The fibers come to rest in a flat, consistent sheet on the screen, which allows the water to drain through. The fibers are extracted from the inner, white bark layer of the mulberry tree.

rice paper
A misnomer for Oriental papers made by hand predominantly from the inner fibers of the mulberry and other plants and having no relationship to the rice plant. Handmade Oriental papers provide flexible writing and drawing surfaces used in China primarily for sumi painting and woodblock printing.

bond paper
Familiar as stationery and computer paper, a lightweight, relatively smooth paper with a hard surface and tight grain appropriate for use with graphite or colored pencils, ballpoint pen, or pen and ink. It is available in pads or in bulk in various sizes.

Bristol board
A very fine, hard-surfaced paper, manufactured in two finishes: *kid finish,* by virtue of its very slight tooth, facilitates fine graphite pencil work of medium hardness and rubbed pen and graphite combinations; *smooth (plate) finish,* a very finely toothed paper, encourages elegant studies in pen and ink or very hard graphite pencil and is available in different weights.

kid finish paper
Bristol board paper with a slightly toothed surface; it facilitates fine graphite pencil work and rubbed pen-and-graphite combinations.

smooth (plate) finish
Bristol board paper with an extremely fine tooth that encourages elegant and detailed studies in pen and ink or very hard graphite pencil, and is available in different weights.

illustration board
A medium made by mounting different papers of relatively fine quality onto cardboard backing; available in three standard surface finishes: *rough,* which has the most active tooth; *cold press,* a versatile, medium-toothed surface; and *hot press,* the smoothest and least absorbent surface that is excellent for very refined, controlled techniques. It is expensive but highly durable and resists wrinkling when wet.

watercolor paper
As the name indicates, paper used primarily for watercolor or wash techniques. It is an acid-free, cotton-fiber paper available in a variety of different weights and degrees of sizing with an active grain or tooth that comes in three standard finishes: *rough,* a surface produced in the highest-quality papers not by mechanical graining but as the result of the hand-manufacturing process and best adapted to splashy, spontaneous techniques; *cold press,* a moderately textured matte surface paper; and *hot press,* the smoothest and least absorbent surface, excellent for very refined, controlled techniques. The different finishes come with varying capabilities of absorption and wet strengths, according to the weight and degree of sizing.

rough tooth
A characteristic of heavily toothed papers with a readily visible and pronounced surface texture as in charcoal or some watercolor papers.

cold press
Paper with a moderately textured, matte surface, softer and toothier than "hot press" paper.

hot press
One of the three standard grades of illustration board and watercolor paper characterized as having a hard surface that has been ironed and press-cured with heat and weight and possesses the smoothest and least absorbent surface; excellent for very refined, controlled techniques.

its durability and resistance to buckling when wet. **Watercolor papers,** as the name indicates, are used primarily for ink wash and watercolor drawings and paintings. The heavier the weight of the paper, the more expensive it will be. However, heavier weights are more absorbent and less likely to wrinkle or buckle when wet. There are three standard finishes for watercolor paper and illustration board. **Rough tooth,** a surface characteristic of the highest-quality papers endemic to the hand-manufacturing process, is best adapted to the spontaneous and expressionistic techniques attained by all types of wet media. **Cold press** is moderately textured matte surface. **Hot press,** the smoothest and least absorbent surface, is excellent for very refined, controlled techniques.

Papers made of 100 percent cotton rag are the most permanent and the most expensive and should be used whenever serious drawing is to be undertaken. Avoid using inferior papers. They will not yield the degree of expression and surface qualities that most artists are after, nor will they withstand the rigors of media exploitation and experimentation as well as paper of higher quality. The cost of supplies is an understandable concern for beginning students, particularly when they are asked to explore a variety of drawing materials; however, there are some good-quality student-grade papers available that afford the student the experience of working on high-percentage rag papers at a lower cost. It is important when learning technique and exploring different drawing media that the student have the best possible results from the tools at hand. The resulting difference in surface quality between the cheaper wood pulp papers and rag papers is immediately apparent; therefore, students are not encouraged to spend time attempting to develop their skills with inferior materials. As one's drawing abilities improve, works intended to be finished drawings should be done only on pure cotton rag papers.

Drawing Media

The dry media—vine and compressed charcoals, chalks, pastels, Conté crayon, wax crayon, grease crayon, color pencils, graphite, and silver-point—are materials that leave granular deposits when they are drawn across a receptive surface.

Charcoal

The Nature of Charcoal Charcoal, probably the oldest drawing medium, is a crumbly, versatile material that readily leaves a mark when rubbed against any but a very smooth, nontoothed surface. With it, tentative lines can be put down to establish positions of form and subsequently erased or permanently drawn over. The same piece of charcoal can generate subtle, sensitive, and dramatic line drawings, or, turned on its side, it can produce broad tonal areas and even dark, intense masses, as in Käthe Kollwitz's drawing (Fig. 1-1). Charcoal is equally suited to sketches and rapidly executed compositional plans or to fully developed, large-scale drawings as value studies (Figs. 10-1, 3-1). The nature of charcoal is such that it can be easily smeared by careless movements of the hand or arm across the drawing surface, which, to the artist, is a disadvantage. However, this smearing ability can serve the artist advantageously as well. Because the material is not deeply imbedded or fused into the ground surface, its propensity to smear can be utilized to create full-scale ranges of tone. In Willem de Kooning's charcoal drawing *Two Women* (Fig. 10-2), it is evident that the artist used smears of tone to en-

10-1. JOSEPH STELLA (1877–1946; Italian-American). *Miners.* Charcoal, 15 × 19 5/8" (38.1 × 49.8 cm).
Yale University Art Gallery, New Haven, Conn. (H. John Heinz III Fund).

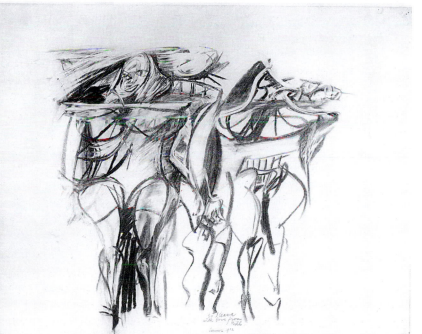

10-2. WILLEM DE KOONING (1904–1997; Dutch-American). *Two Women.* c. 1952. Charcoal, 22 1/2 × 28 1/2" (572 × 724 mm).
National Gallery of Art, Washington, D.C.

hance the forms and movements of the two figures. Note how tonal areas of smearing tend to soften the forms, and coupled with the darkest lines add richness to the overall spatial effects of the drawing. To minimize the occurrence of unwanted smears, however, it is recommended that a workable spray fixative (use only in a well-ventilated area) be used at intervals during the execution of a charcoal drawing to help seal the carbon particles to the paper surface; but keep in mind that spraying alone does not eliminate the occurrence of smearing. One must also take precautions against anything rubbing across the drawing surface—a good practice regardless of the drawing medium.

In a passage from James Watrous's book *The Craft of Old Master Drawings,* he states:

> During the seventeenth and eighteenth centuries charcoal was extensively used, although it was not necessarily preferred by many of the artists. However, as the use of natural chalks declined, and in the nineteenth century was ultimately abandoned, it became the principal medium for figure studies. And in the academies, it was the traditional tool for life drawing exercises, a preference which is still common today.
>
> The methods of preparing charcoal were quite simple and had few variations over the several centuries during which artists produced their own drawing sticks. Although vine charcoal was used in the nineteenth and twentieth centuries, the manuals of the preceding centuries suggested that woods were the common source. The favorite wood was willow (or sallow, a species of willow), but linden, plum, "dogge-woode," and spindle wood were also recommended. The charcoal was made by carbonizing the wood in heated chambers from which air was excluded in order that the sticks would not burn and be reduced to ashes. Cennino described how the artist formed bundles of willow wood slips by binding them with iron or copper wire, placed them in a casserole, the cover of which was luted with clay to make it airtight. The vessel was put into a baker's oven or under the hot ashes of a fire and left overnight to produce carbonization. Borghini, at the end of the sixteenth century, paraphrased these directions of Cennino but added a third method which made use of linden wood placed in an iron box whose cover and lock had to be luted before the baking took place. And Volpato, in the late seventeenth century, suggested the use of an iron tube, into which plum or willow sticks were placed, the ends of the tube being carefully covered with ashes to exclude the air.
>
> During these early centuries there was no simple method by which artists could control precisely the softness or hardness of their charcoal sticks as is done in the manufacturing processes of today. But Cennino and Volpato were aware that the longer one left the wood slips within their airless chambers in the hot oven or under the ashes, the softer the charcoal became.

Types of Charcoal Today, in a similar fashion, **stick charcoal** is made by heating or firing sticks of wood about 1/4 inch (.6 centimeter) in diameter in kilns until the organic materials have burned away through high-heat evaporation, leaving only dry carbon behind. The finest quality, known as **vine charcoal,** comes in varying diameters and is made in very thin sticks or rods of an even, soft texture. Much of the willow wood used for this fine-quality vine charcoal is grown and harvested from the wetlands of southeastern England. Manufacturers classify charcoal in four degrees of hardness: (4B) very soft, (3B) soft, (2B) medium, and (HB) hard. **Compressed charcoal** is different from stick or vine in that it results from pulverizing the charcoal to powder, then mixing it with varying amounts of binder and compressing it into chalklike round or 4-sided sticks about 3/8 inch in diameter. Compressed charcoal is also graded according to hardness, ranging from 00, the softest and blackest, through 0 to 5, which contains the most binder and is consequently the palest and hardest. In general, because compressed char-

stick charcoal
Charcoal made by heating sticks of wood about one-quarter inch in diameter in kilns until the organic materials have evaporated and only the dry carbon remains. The finest quality of the stick form is called **vine charcoal.**

vine charcoal
The highest quality of stick charcoal. Named for plant vines from which it is made and extracted through heating.

compressed charcoal
A substance made by grinding charcoal into powder and compressing it with a binding material into chalklike sticks that are then labeled according to hardness ranging from 00, the softest and blackest, through 5, the hardest and palest.

coal is less easily erased, it is not well suited to beginners' needs. It is most effective for quick, dramatic sketches, or for large-scale drawings when rich darks are desired. **Powdered charcoal** is simply pulverized charcoal left in a "powder state" which produces deep, rich blacks by rubbing it into the paper surface.

Charcoal pencils, made by compressing charcoal into thin rods and sheathing them in paper or wood, offer cleanliness but lack the versatility and flexibility of stick charcoal because only the point can be used effectively. (The same criticism applies to using metal holders with stick charcoal.) Charcoal pencils are graded: 6B (extra soft), 4B (soft), 2B (medium), and HB (hard). White charcoal pencils are also available.

Charcoal Techniques There are four common methods of working with stick or compressed charcoal. The direct spontaneous attack, using both the point and side of the charcoal stick, offers maximum flexibility of stroke and tone without the time-consuming fussiness of more labored or refined modes (Fig. 1-1). An alternative process, involving a disciplined and relatively "pure" application of charcoal, is to build value relationships through systematically hatched and cross-hatched lines drawn with a pointed stick of charcoal (Fig. 10-1), or using line hatching as a shading technique (Fig. 3-1). A third manner of applying charcoal is the standard academic technique of the nineteenth century, which produces graduated tones through repeated application of charcoal rubbed into paper with dry fingers or a tortillon (shading stump). Craig Marshall Smith's imaginative *Chimerical Friend* (Fig. 10-3) combines aspects of the academic method of building and controlling tone with a fourth method of working with charcoal (introduced in Chapter 2) that relies heavily on wiping and erasing. In addition to rubbing, Smith uses a chamois to wipe away unsatisfactory charcoal lines and tones and an eraser to eliminate small areas of tone, sharpen edges, pick out small light accents, and clean up smudges. We see the same combined methods of charcoal handling techniques and their effects used by Chuck Levitan in Figure 1-5.

Jim Cogswell's *Face and Hands #2* (Fig. 10-4) appears to have been drawn in the same manner. However, his gray tones were produced by applying turpentine (or an odorless solvent) with a cotton rag, and in the process, dissolving what was the initial drawing done in compressed charcoal. This technique produces a "wash look" similar to that of wet media ink or watercolor washes used in conjunction with dry media. Because only limited erasing is possible after the solvent evaporates, Cogswell uses gesso (a white gypsum ground used to size canvas in painting) to reestablish whites—most evident along the left side of the head. He arrives at his final image by working back and forth, in a mixed-media fashion with black, gray, and white in a painterly way.

Rich and varied effects are possible by spraying, wiping, and brushing charcoal—and all other dry media—with turpentine or odorless mineral spirits, or water. These techniques will be dealt with in greater depth in Chapter 18, Mixed-Media Expression.

Charcoal can be applied to many different kinds of drawing and printmaking papers—Arches, Bristol, Fabriano, Rives, Somerset, Stonehenge, Strathmore, Twinrocker, and Zerkall are the major professional paper brand names and companies. (These may be purchased at artist supply stores, although you may not find as extended a variety as if you order by catalog.) Newsprint suffices for quick sketches and

powdered charcoal
Charcoal in a powdered state that produces intense blacks and is used in combination with a chamois to produce rubbed areas of rich darks.

charcoal pencils
Thin rods of compressed charcoal encased in paper or wooden sheaths that offer cleanliness but lack the flexibility of stick charcoal because only the point can be used. Charcoal pencils come in different grades: 6B (extra soft), 4B (soft), 2B (medium), and HB (hard). (White charcoal pencils are also available.)

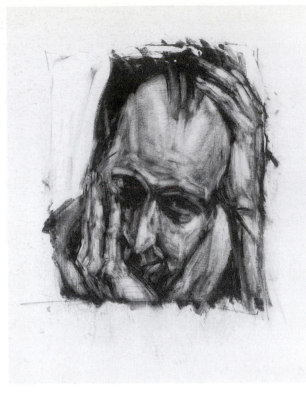

10-3. *above, left:* CRAIG MARSHALL SMITH (b. 1947; American). *Chimerical Friend.* c. 1988. Charcoal, 40 × 30" (101.7 × 76.2 cm).
Courtesy of the artist.

10-4. *above, right:* JIM COGSWELL (b. 1949; American). *Face and Hands #2.* c. 1989. Charcoal and gesso, 30 × 22" (76.2 × 55.9 cm).
Courtesy the artist. Collection of Michael Spivak, Houston, Texas.

paper grain
Same as paper tooth; the surface texture of a paper; the degree of roughness or smoothness of a paper. See *tooth*.

studies that do not demand erasing or the careful buildup of smooth tones, mixed media, or permanence. Coarse drawing papers also provide acceptable grounds for quick sketches with all types of charcoal. The texture of paper—its coarseness or smoothness—is referred to as grain or tooth and is the main consideration when choosing an appropriate paper. The textures or grains of the coarser papers are visible to varying degrees with dry drawing materials, particularly graphite sticks, chalks, and charcoals when used on either their sides or their blunt points. Figure 10-5 shows a microphotographic enlargement of a detail of *Study for a Portrait of Diego Martelli* by Edgar Degas. These charcoal strokes made from the end of a charcoal stick illustrate the manner in which weightless carbon particles fall into the pits or depressions of the **paper grain** or tooth of the paper. Little holds them there until they are sealed with a workable spray fixative, shellac, or varnish recommended for drawings on paper.

Regular charcoal paper, a tenacious surface allowing repeated erasures and rubbing without losing its grain, is best for sustained studies. In Picasso's *Two Fashionable Women* (Fig. 10-6) we see a high-quality drawing paper surface that obviously held up well while worked in both additive and subtractive methods; the artist used charcoal with extensive pressure to achieve the rich darks and subtracted tone with an eraser to achieve the lightest whites. This drawing is a testament to Picasso's virtuoso sense of composition and power of line done at the young age of nineteen.

Compressed charcoal can be used effectively on relatively smooth bond or printmaking papers with slightly more grain. Heavier-weight hot-press papers, charcoal, printmaking papers such as Murillo, and Bristol boards are recommended when working with solvents. Most charcoal papers are manufactured in the standard 18-by-24-inch (46-by-

10-5. Microphotographic enlargement of a detail of *Study for a Portrait of Diego Martelli* by Degas. Charcoal strokes illustrating the manner in which the weightless carbon particles tend to fall in the pits of the grain of paper (from James Watrous's *The Craft of Old-Master Drawings*).
The Fogg Museum, Harvard University, Cambridge, Mass.

61-centimeter) size. Other suitable drawing papers are available in larger sheets or by the roll, which accommodates the needs of contemporary artists such as Chuck Levitan (Fig. 1-5), who works in charcoal on a more monumental scale.

Project 10.1

Select a subject that encompasses a wide range of value relationships—a complex still life, a self-portrait, or an abstraction of a winter landscape on an overcast day. Before embarking on a high finished drawing, establish a preliminary visualization of the linear and tonal patterns as thumbnail sketches on a piece of newsprint (Fig. 8-1), using the side of a short piece of charcoal to lay in the darks. Having determined the value pattern, develop a large-scale, full-value-range, finished drawing on charcoal paper. While it is possible to combine techniques, take care to achieve a consistency of handling throughout the drawing. Endeavor not to overwork any area—keep it freshly executed.

Chalk The word **chalk** covers a variety of drawing materials ranging in texture from coarse to fine, from hard to soft and crumbly, and from dry to greasy, shaped into rounded or square sticks. It is impossible to

chalk
The term *chalk* covers a wide variety of materials ranging in texture from coarse to fine, from hard to soft and crumbly, and from dry to greasy, shaped into rounded or square sticks. It was originally obtained from natural colored earths that were cut or sawed into sticks. Fabricated chalk is made with prepared pastes of water-soluble binding media mixed with dry pigments and sometimes with additional substances such as inert clays, then rolled, pressed into sticks, and dried.

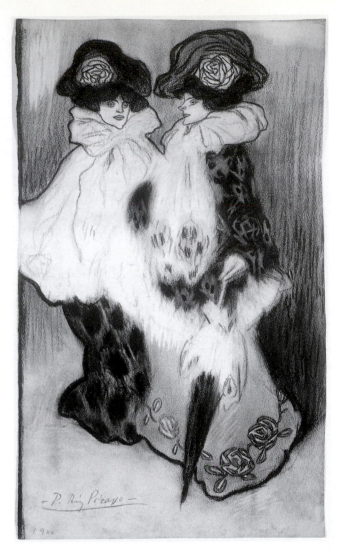

10-6. PABLO PICASSO (1881–1973;
Spanish-French). *Two Fashionable Women,*
c. 1900 or 1901. Charcoal, 16 1/4 ×
9 5/8″ (413 × 244 mm).
National Gallery of Art, Washington, D.C.

establish the point at which chalk becomes crayon or pastel, and the dividing line between chalk and compressed charcoal is equally tenuous.

This is due to the many ambiguities handed down from historical literature as to the descriptions of chalks, pastels, and crayons. To a great extent, this ambiguity still exists simply because artists do not know or have never been taught the basic categories of these materials: where they come from (whether in natural or manufactured state), how they are presently manufactured, and what their ingredients are that make them distinctively different as drawing tools.

Natural chalks (black, red, and white) were harvested and made from colored earths containing minerals. The natural earth substances of black and red chalk were not pure minerals, but amorphous compositions that contained a natural binder—clay. The pigmentation of these earths had to possess enough density and saturation to produce the strong effects sought by artists. The deposits of natural red and black chalks were distributed over different parts of Europe; however, these lodes have been mined out and become extinct, along with any present knowledge as to the whereabouts of these mines. They simply no longer exist as direct sources of these natural, amorphous pigments. However, in the United States, in peninsular Michigan near Negaunee, there are

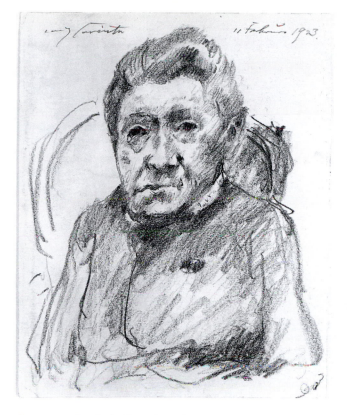

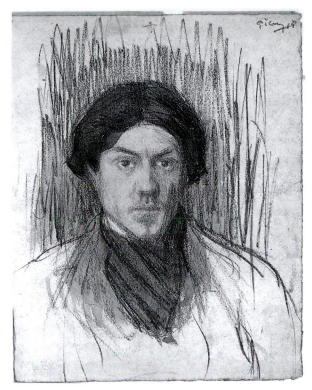

deposits of red chalk referred to as "red ochre variety of hematite" that possess the correct natural blending of substances (iron oxide and clay) to render it an excellent drawing chalk.

Today, fabricated chalks or pastels are made by mixing dry pigments and pastes together with binding media and allowing them to dry. One major and notable difference between fabricated color sticks and natural chalks is that since most available dry pigments are used in the preparation of these fabricated chalks, the range of available colors is much greater than that of the natural chalks.

Chalk affords the artist a technical versatility similar to that of charcoal. Like compressed charcoal, chalk is somewhat difficult to erase, but it offers ample compensation with the potential for richer, darker lines and solid masses. The numerous and satisfying visual possibilities are evident in the open, energetic swirls of Lovis Corinth's black chalk drawing *Mrs. Hedwig Berend, 1923* (Fig. 10-7), where the subject looks directly at the viewer, showing a tinge of self-consciousness as though she is aware she is being sketched. Other examples are seen in Picasso's mixed-media self-portrait, using black chalk with watercolor (Fig. 10-8), and in the carefully finished drawing of Annibale Carracci's *Portrait of Mascheroni, the Lute Player* in red chalk highlighted with white chalk (Fig. 10-9). The chalk medium's chief advantage is color, permitting enriched hue and tonal and compositional relationships.

10-7. *above, left:* LOVIS CORINTH (1858–1925; German). *Mrs. Hedwig Berend.* c. 1923. Black chalk, 12 7/16 × 10" (316 × 254 mm). National Gallery of Art, Washington, D.C.

10-8. *above, right:* PABLO PICASSO (1881–1973; Spanish-French). *Self-Portrait.* c. 1901/1902. Black chalk with watercolor, 12 × 9 3/8" (304 × 238 mm). National Gallery of Art, Washington, D.C.

Project 10.2

Using black and white or dark-colored and light-colored chalks on a middle-value paper facilitates both rapid visualization of tonal relationships and finished drawings of great beauty (Fig. 10-9). Select a subject that will allow a full range of values—a piece of drapery or a rumpled paper bag would be appropriate, or if you want to tackle something more ambitious, a well-lighted nude, costumed model, or a head

10-9.
ANNIBALE CARRACCI (1560–1609; Italian).
Portrait of Mascheroni, the Lute Player. Red
chalk highlighted in white chalk, 16 1/8 ×
11 1/8" (40.9 × 28.2 cm).
Albertina Museum, Vienna.

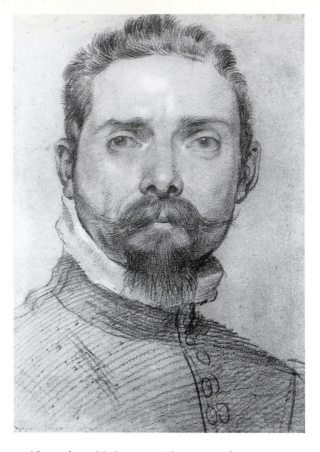

pastels

Pure powdered pigments mixed with just enough clay, gum, or resin to bind them into stick form; except for differing amounts of wax and grease, they are similar to crayons and especially to chalks in composition. Pastels come in soft, hard, and oil versions in a wide range of colors. Pastel drawings tend to be fragile and require care in storing as their surfaces are easily abraded. Spray fixative may help preserve the surface but may also dull the color with too much use.

soft pastels

Pastels made from dry pigments mixed with an aqueous binder and compressed into cylindrical form. They are soft and crumbly and nonadhesive, requiring use on a paper of decided tooth.

hard pastels

Pastels made from dry pigments mixed with a higher proportion of aqueous binder than in soft pastels, which makes them harder with a firmer texture. They are compressed into square sticks; their flat side planes afford rapid coverage of broad areas; the sharp corners make them effective for detailing and accenting. They can be sharpened with a razor blade and are also manufactured in pencil form.

oil pastels

Drawing media that are similar to hard pastels except that oil has been added to the binder, creating a semihard state that adheres more readily to paper. Because oil pastels are not easily smudged, they work well for outdoor sketching. They are not easily erased.

and face of an elderly person. Place your subject against a middle-value background and draw on toned paper of a comparable value. Letting the paper provide the transitional middle-tones, as demonstrated in Plate 4, rather than mixing light and dark to create intermediate tones, will result in a fresh, spatially alive drawing instead of a muddied dead flatness.

Pastels **Pastels** are high-quality chalks of fine, even texture, available in a wide range of hues of graduated value and intensity (color saturation). **Soft pastels** consist of dry pigment mixed with an aqueous gum or binder, usually compressed into cylindrical form. Soft and crumbly, this type of pastel is nonadhesive and thus requires paper of decided tooth. **Hard pastels,** which contain more binder than soft pastels, are compressed into square sticks with a firm texture. The flat side planes provide rapid coverage of broad areas, and the sharp corners make them effective for detailing and accenting. They can be sharpened with a razor blade. Pastels are also manufactured in pencil form. Oil added to the binder allows semi-hard **oil pastels** to adhere more readily to paper. Because oil pastels are not as easily smudged, they work well for outdoor sketching. Both semi-hard and hard pastels are difficult to erase, so it is wise to make a small preliminary color sketch before commencing on a large-scale composition. This can be done more quickly with colored pencils of hues and values similar to those of the pastels.

Pastels, with more than five hundred distinct colors and values available, permit the artist to revel in the directness of drawing while immersed in a total color involvement. The greatest richness of color results from the direct application of analogous or complementary colors side by side or with cross-hatching (Pl. 1), letting the color mix opti-

cally. Excessive blending of colors through rubbing and overapplication produces lifeless color and uninteresting surfaces. The generally recommended procedure is to lay in middle and dark values first, then work toward light, saving details and accents for last. In this way, the artist controls the process of building up value ranges and color, form, and space simultaneously. Artist Duane Wakeham, former coauthor of this text, is an accomplished pastel artist. In his composition *Russian River, Spring Afternoon* (Pl. 10), we see a vibrantly orchestrated value scale, which defines light and dark passages of a well-mastered spatial dynamism in the landscape. We cannot help but look at the spatial infinity beyond the intersecting horizon lines of the two mountain ranges in the distance, while being equally soothed by the gentle roll of the hills before us as we bring our eyes back to the immediate foreground—a dichotomous and pleasurable feast for the eyes. Notice the presence of both **analogous** and complementary colors in Wakeham's work.

"Fixing" pastels with spray fixative provides some protection, but at the cost of surface freshness. Without it, colors stay brighter, but pastel drawings smudge easily and color (pigment) falls off. To store pastel drawings, place a slip-sheet of **glassine,** a frictionless and translucent barrier sheet, over the drawing and secure a sheet of newsprint as a cover sheet over the glassine with masking tape. This will prevent the drawing from shifting and thereby rubbing against another surface, causing the pastel particles to disengage from the grain of the paper.

Any of the exercises in the sections on chalk and Conté crayon afford practice in the use of pastel.

Conté Crayon Conté crayon is a semi-hard chalk of fine texture containing sufficient oily material in the binder to adhere readily and more or less permanently to smooth paper. Conté crayons, 1/4 inch (.6 centimeter) square, and 3 inches (8 centimeters) in length, come in three degrees of hardness—No. 1 (HB, hard), No. 2 (B, medium), No. 3 (2B, soft)—in white, black, brown, and **sanguine** (Venetian red), which is the most popular color. (Lithographic crayons are similar to Conté crayons, albeit far waxier and greasier.) In *Girl Seated* (Fig. 10-10), Maurice Sterne has made advantageous use of the square format of the crayon, using both the thickness and the flat side to create broad strokes of graduated tone, while making sharp accents with its corners. On textured paper, Conté crayon produces the interesting granular effect seen in Seurat's study of his mother (Fig. 7-8). Conté, which is also available in pencil form, erases with difficulty and consequently best serves the needs of the sure and experienced draftsman.

Project 10.3

Break a stick of Conté crayon into two or three pieces. Work on an 18 × 24-inch newsprint pad and do a series of rapid, full sheet drawings of any subject that appeals to you—posed figures, animals, trees, plant forms, a casual grouping of fruit or vegetables. Work for a broad representation of essential forms and movements. When you view your subject through half-closed eyes, details fall away and you see basic forms as simplified patterns of light and dark. Use the side of the crayon to block in the shadow shapes; then add linear accents with the sharp corners of the crayon. Practice drawing contours and accents with the corner held flat to the paper rather than raised. Experiment with shifting from the corner to the flat edge of the crayon within a single stroke, both for interesting line quality and to describe the contours of three-dimensional forms.

analogous colors
Those colors adjacent to each other on the color wheel; any colors existing side by side on the color wheel.

glassine
An ultra-thin, frictionless, and translucent paperlike material used to "slip sheet" in between stacked works of art on paper—drawings, prints, or watercolors—protecting them from smears or surface abrasions.

Conté crayon
A semi-hard chalk of fine texture containing sufficient oily material in the binder to adhere readily and more or less permanently to smooth paper. It comes in sizes of ¼ inch (.6 centimeter) square and 3 inches (8 centimeters) long, in three degrees of hardness—No. 1 (hard), No. 2 (medium), and No. 3 (soft)—and in four colors—white, black, brown, and sanguine (Venetian red), which is the most popular.

sanguine
Natural red chalk ranging from the color of blood to a brownish-red used for drawing and first discovered prior to the fifteenth century in European mine deposits; its first documented usage came in the late fifteenth century around the time of Leonardo da Vinci and other Renaissance artists; its usage spread shortly thereafter to other countries.

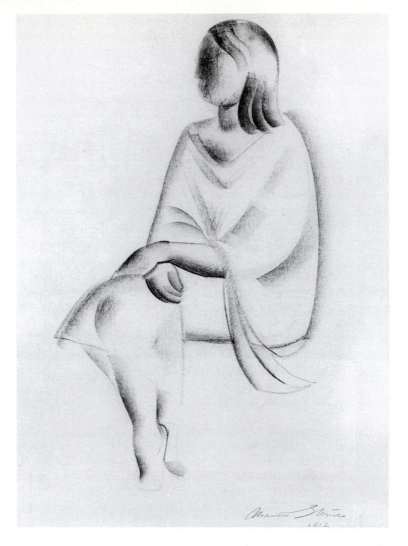

The fine texture of Conté crayon lends itself to the creation of carefully finished drawings of high refinement and with a full range of value, as evidenced in Charles Sheeler's *Feline Felicity* (Fig. 10-11). Conté crayon is greasy enough that it does not rub off easily, yet its softness allows smooth, homogenous gradations of dark to light.

Project 10.4

Choose a subject for a highly finished drawing in Conté crayon; plan your composition from a series of rough layouts on newsprint. When you arrive at a composition you are satisfied with, select a smooth, firm paper. Lay in your initial lines lightly, and then develop the drawing to full value. You may wish to strengthen drawings done in brown or red Conté with black accents and white highlights. Push this drawing to a greater degree of finish than perhaps you have ever done before. Concentrate on the freshness of the look of the medium as it joins with the paper surface. Avoid overworking the surface.

Critique (Project 10.4) Have you arrived at a state of finish that surpasses your previous drawings? If not, how can you achieve this? Assess your composition, remembering what you learned from Chapter 8. Is the composition a striking one? If not, how might you improve it? Assess the value ranges in relation to the textural and tonal ranges. Are they visually interesting? If not, how might you rework or

10-11. CHARLES SHEELER (1883–1965; American). *Feline Felicity.* c. 1934. Conté crayon on white paper, 21 3/4 × 17 7/8" (55.7 × 45.4 cm). The Fogg Art Museum, Harvard University, Cambridge, Mass. (purchase, Louise E. Bettens Fund).

recompose these ranges more interestingly in the next drawing you do? Would you say your drawing is expressive? What does it say?

How would you feel about the drawing if someone else had done it?

Wax Crayons Inexpensive, brightly colored **wax crayons** manufactured for children are familiar to everyone. The waxy substance adheres firmly to most paper surfaces—there are no powdery fugitive particles to worry about—and so presents a relatively clean medium to handle. Some artists find wax crayons appropriate only for sketching and preliminary color planning; others produce handsome finished drawings. It is the artist who decides which particular medium or tool can best express what he or she wants to say. You may have already experienced a sense of resonation when you hold a particular drawing tool in your hand. The tool says something to you—it transmits an impulse to strive for that unusual mark which may be unfamiliar to you.

Lithographic crayons (because of their grease content and variable grades from very soft to hard) when applied to heavyweight papers with considerable tooth or grain yield vigorous, clearly defined textures and richness of values, as seen in the works of Eduardo Iglesias and Jack Beal (Figs. 10-12, 7-12). The disadvantages of crayons are that they do not erase or allow lines to be blurred easily as with charcoal or pastel. However, on firm, smooth paper (less tooth), it is possible to retrieve light areas and even highlights by scratching or scraping with an X-acto knife or razor blade. This must be done carefully and gradually so as not to cause visible damage in the form of a blemish to the surface of the drawing.

Graphite Pencils The graphite pencil, in its manufactured form, has been an important and versatile drawing medium since the end of the eighteenth century. Graphite, although discovered much earlier in its natural form, did not come into common use until the mid-seventeenth

wax crayons

Inexpensive and brightly colored crayons made from dry pigments and waxy binders that adhere firmly to most paper surfaces, making them a relatively clean medium to handle.

lithographic crayons

Greasy crayons in both pencil and stick form that produce rich blacks and are made from carbon black, animal fat, wax, and soap. They come in a variety of hard and soft grades ranging from No. 00 (softest) through 5 (hardest). The softest crayons contain the most grease, making them adhere well to most paper surfaces.

10-12. EDUARDO IGLESIAS (b. 1940; Brazilian). *Florista*. Lithographic crayon and black pencil on cream paper. 12 1/2 × 8 1/2″ (31.8 × 21.6 cm). Courtesy of the artist.

pencil
A wooden or paper cylindrical tool encasing a graphite, charcoal, crayon, or colored pigment rod of a wide variety of hard and soft grades; the most important and versatile drawing instrument since the end of the eighteenth century and the most commonly used drawing implement until the invention of the cartridge pen.

century, and up until the invention of cartridge pens, it was the most commonly used implement for drawing and sketching both inside and outside the studio. According to James Watrous, the "lode" that provided all of Europe with its finest quality graphite was discovered around 1560 at Burrrowdale, Cumberland, England. For nearly three centuries it remained the most sought after and highly prized European deposit—jealously guarded at the source, and also by severe export restrictions.

Webster's dictionary defines graphite as "a soft, black, lustrous form of carbon found in nature and used as lead in pencils." The term *lead,* however, is misused, as it is a carryover term from the early days of lead-alloy metal point drawings. When the graphite pencil succeeded the lead-alloy metal point, the term *lead pencil* continued to be used. James Watrous writes:

> Although the basic mixtures of graphite pencil manufacture were established in the late eighteenth and early nineteenth centuries by Conté, Brookman, and Hardmuth, materials in addition to graphite and clay were sometimes introduced to vary the type of product. These included antimony, spermaceti and other waxes, shellac, rosin, gums, and at times, undoubtedly to produce a greater blackness, lampblack.

The word **pencil** in general refers to a variety of mark-making substances formed into long, slender rods that have been sheathed in wood, or in the case of lithographic pencils, paper. Along with the most popu-

lar graphite pencil, we have an astonishing variety of other types—carbon charcoal, Conté, lithographic, and grease—and a wide range of colors, both soluble and insoluble, each offering a particular quality that renders it valuable in the attainment of certain effects. Specifically, the common graphite pencil is composed of a crystalline form of carbon having a greasy texture. Graphite pencils are manufactured in as many as twenty degrees of hardness—9B, the softest, possesses the highest graphite content; 9H, the hardest, contains the greatest proportion of clay. The range of graphite from hardest to softest is: 9H, 8H, 7H, 6H, 5H, 4H, 3H, 2H, H, F, HB, B, 2B, 3B, 4B, 5B, 6B, 7B, 8B, 9B (also mentioned in Chapter 2, Beginner's Media). The so-called carpenter's pencil, with its wide (3/16 inch, or .5 centimeter), flat, soft graphite that must be sharpened with a razor blade or knife, is useful for laying in broad areas of tone, while the corner allows fine line work. It is also possible to buy drawing leads, for lack of a better term, to be inserted into metal holders, eliminating the need for sharpeners, knives, or razor blades as they can be sharpened on a draftsman's sandpaper pad.

Soft Graphite Pencil Soft pencils (9B to 2B) are particularly well suited for contour drawings or other primarily linear notations. Soft graphite lends itself beautifully to line variations by responding to the artist's handling variations of applied pressure and release of pressure when drawing, producing a line that rhythmically swells and tapers. Soft graphite also lends itself to informally applied parallel hatchings and loosely executed cross-hatching, as seen in Claes Oldenburg's *Colossal Fagend in Park Setting* (Fig. 10-13), where the artist used soft graphite with

10-13. CLAES OLDENBURG (b. 1929; American). *Colossal Fagend in Park Setting.* c. 1967. Graphite and water color, 30 × 22 1/8″ (762 × 562 mm). National Gallery of Art, Washington, D.C.

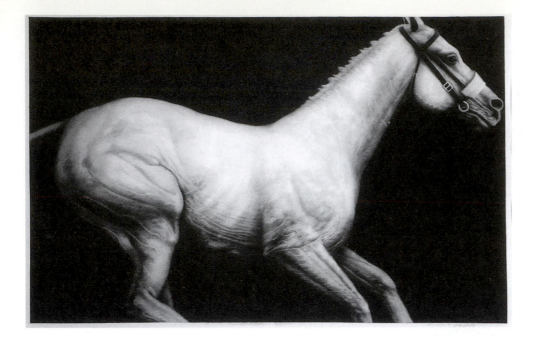

10-14. JOSEPH PICCILLO (b. 1941;
American). *Horse Study.* c. 1979. Graphite
with erasing on ivory wove paper, 30 ×
40" (762 × 1,016 mm).
The Jalane and Richard Davidson Collection.
© The Art Institute of Chicago.

watercolor. Notice the variety in Oldenburg's vocabulary of line: Its
thickness, density, value, and energetic character all contribute to the
finished impact of the drawing. In stark contrast to Oldenburg, Joseph
Piccillo's graphite drawing *Horse Study* (Fig. 10-14) shows the artist's
masterful ability to use graphite and eraser in an almost photo-realistic
way by creating a sumptuous dark background that projects the horse
forward as a decidedly three-dimensional form in motion. Piccillo's tech-
nique involves laying down graphite tone, then erasing light passages to
intricately describe not only the volumetric aspects of the horse, but also
the folds of the skin and flexing of muscle as the horse runs. As one
studies this work, the rich density and beauty of soft graphite are easily
recognized and accounted for.

Working with soft pencils, it is possible to produce elegant tones
using various techniques: direct application, smudging (stumping) with
a paper stomp or rag, dissolving graphite into a wash with solvent, or
brushing water over a drawing surface done with water-soluble pencils.

Project 10.5

Make a drawing of tonal and linear marks on good-quality, smooth paper, produc-
ing a full range of values with soft pencils, either by using the same pencil and
changing pressure, or by selecting different grades of graphite for different strokes
and changing pressure when necessary. The softer grades (9B is softer than 2B) pro-
vide richer darks but are not well suited for fine details as they lose their points too
quickly. Less-soft grades are better for linear detail but require more pressure to build
up dark tones, sometimes resulting in a shiny, mottled surface marked with indenta-
tions from repeated strokes and excessive pressure.

Project 10.6

Select a pencil or pencils with the degree of softness most pleasing to you and make
some drawings of any subject you choose. Frequently, whatever just happens to be
in your field of vision has a fresh appeal and visual interest because it has not been
carefully selected and arranged. A pair of hiking boots or running shoes, a friend

sprawled in a chair, or a shirt and jeans tossed on a bed or carelessly draped over the back of a chair provide apt, ready-made subjects for this kind of drawing.

Try to focus on what you've learned thus far about concepts of variation and compositional interest and let your drawings be free and gestural. Define shapes by tonal changes without relying on outlines. Block in forms and shapes lightly so that the lines will disappear as you introduce stronger, darker patterns of strokes and values. Provide several dark accents, but only enough to begin to give definition to the objects, and only after general value relationships have been established. Experiment with different methods of producing tones and linear passages.

Project 10.7

Create patterns of directional strokes to indicate the shifting angles of planes and tonal variations of a group of paper bags, a broad-leafed plant, or other interesting objects. Define forms by changes in the direction and value of the pencil strokes, rather than with outlines.

Critique (Projects 10.5, 10.6, 10.7) Have you accomplished an extremely full range of values by manipulating the graphite well? Are the marks and tones interesting visually? Do they possess visual life? Were you able to transfer that vital and extreme range of values to the subject matter? How well have you defined shapes without relying on line? Has this helped you begin to see shapes and the visual power of shapes more than seeing mere outlines? How well were you able to define different angles and shifting planes with strokes?

How would you improve upon these drawings?

Hard Graphite Pencil: The Modeled Line The clean-cut, silvery tone of hard graphite pencil (2H to 9H) can yield effects of great elegance, either used as pure line or augmented with light shading to convey a fuller sense of form than can be suggested by outline alone. The delicacy and sensitivity with which forms can be modeled and details rendered are nowhere more evident than in the figure studies, portraits, and architectural renderings of Jean Auguste Dominique Ingres, the acknowledged master of pencil drawing (Fig. 10-15).

Rendering, as a drawing technique, demands the most precise depiction of form, texture, and value in its quest for verisimilitude. Hard pencil is well adapted to that purpose. Bill Richards, described as a "meticulous realist," uses a full range of hard pencils, from 2H to 9H, in his rendering *Blinn Valley* (Fig. 10-16).

Project 10.8

The darkest dark of a hard pencil is considerably lighter than the richest darks of the softer B grades. The delicately interlocked petals of a single rose provide a perfect subject for this medium, as do intricate glass objects or other multifaceted forms. Life drawings, portraits, costumed figures—in fact, almost any subjects—are appropriate, provided the artist concentrates on outline reinforcement with only a suggestion of modeling. Since a degree of pressure is necessary when using hard graphite pencil, a firm, not too thin paper such as kid-finish Bristol board is recommended to avoid an excessively engraved paper surface. (Take some time to find the right combination of graphite grade with the right paper.) Drawings in hard pencil are best if kept small; if they are too large, the pale lines and tones lack visual presence and do not carry well as a visual statement.

Colored Pencils Contemporary artists in both fine and commercial art, architects, engineers, and medical illustrators have used colored pencils for a long time alone and in combination with other media, for

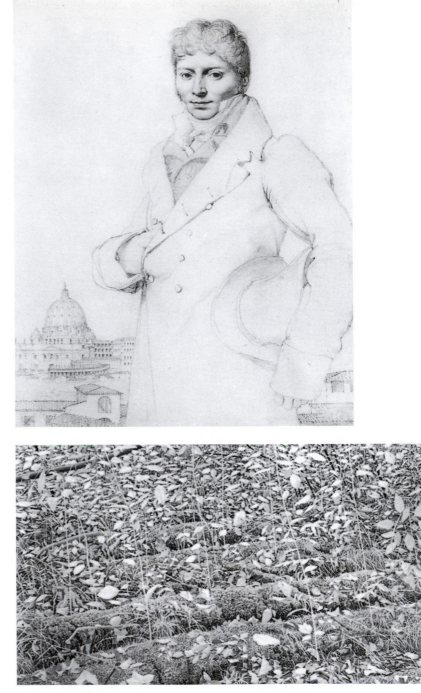

10-16. BILL RICHARDS (b. 1944; American). *Blinn Valley.* c. 1981. Pencil on paper, 10 × 17 1/2″ (25.4 × 44.5 cm).
Courtesy Nancy Hoffman Gallery, New York.

works ranging from sketches to highly detailed renderings. Color has proven to have its advantages for the commercial designer in that color-coding can be utilized to illustrate common and different parts. Think about maps and how color is used to locate different elevations and geographical terrains.

To the fine-art artist, colored pencils, which respond in a manner similar to that of graphite pencil, provide a plethora of color usage. A uniform method of loose cross-hatching is used to define shapes and values, and to create optical color in Jennifer Bartlett's colored pencil drawing *In the Garden #122* (Pl. 11). Bob Ziering employs a more stud-

ied and tighter hatching, "layering" one color over another to produce blurred color that instills the effect of rapid movement (Pl. 12). The secondary colors—green, violet, and orange—emerge from the layering of the three primary colors—yellow, blue, and red.

The overwhelming illusion of patterned fabric, molded plastic forms, and mirror-like metallic surfaces in Jeanette Pasin Sloan's acrylic and colored pencil on board drawing *Silver Bowl Still Life* (Pl. 2) is created, in part, by the artist's use of colored pencils to give increased definition to the acrylic washes. Pencil lends itself to a precise delineation of contour and to the skillfully controlled rendering that differentiates between the subtlety of the reflections in the plastic surfaces and the crisp clarity of the reflections in the silver bowl.

Drawing Method for Colored Pencils Paper texture, pencil pressure, and even shape of the point of the pencil influence the quality and intensity of the color granules deposited on and into the surface material. Colored pencils seem to work most effectively on medium-grained paper, but it is always best to experiment with any new paper before initiating a full drawing. Applied with light pressure, color touches only the raised portions of the paper's texture, resulting in a granular, light tone because the open, white, depressed portions of the paper texture still show through the color. Applied with greater pressure, the color begins to fill in the hollows, eliminating the white of the paper and producing a more continuous, solid, darker, and richer tone. A sharp point contributes to stronger color because it gets into the depressions, whereas a blunt point glides across the paper's surface.

Bartlett's open cross-hatching (Pl. 11) demonstrates a linear approach to creating strong color and varied tonal hues—the effects being lyrical and seemingly weightless. Using a fine point, and by varying the directions of the strokes with greater density so there is little or no space between the lines, produces linear textures of more intense color. Medium pressure with frequent directional changes in stroking gives the greatest uniformity of tone.

As you look at the Bartlett drawing, notice the presence of all the primary and secondary colors harmoniously working together. Observe also the occurrence of a **triple complementary color scheme** similar to that of Willem de Kooning's *Two Women's Torsos* (Pl. 5), where all three pairs of complementary colors—blue and orange, red and green, and yellow and violet—occur in the same composition. To further heighten the effects of light and shadow, and in turn strengthen the spatial dynamic within the picture plane, Bartlett has created *shades* of several colors by fluidly superimposing black pencil lines over selected color lines.

The semitransparency of colored pencils permits colors to be changed by deliberately applying one color over another. A color used alone has a degree of rawness; combining colors by layering produces richer, more luminous colors. The maximum darkness of an individual colored pencil is that of the colored shaft material itself. If a darker-value pencil is not available, a color may be deepened by lightly applying a layer of black over the previous color. Using any other dark-value color will change the color as well as the value. Layering with white or some other light-value color both lightens the value and brightens the intensity of a color without sacrificing solid tone. The intensity of a color can be diminished by either layering with neutral gray or using the complement of the color.

triple complementary color scheme
A color scheme found within a single composition where three pairs of complementary colors work together contributing to the visual statement in a pronounced and harmonious way.

Project 10.9

Experiment with building tones and changing colors, values, and intensities. Begin by making several squares of the same color such as yellow. Then alter all the squares but one by layering with different colors. Because yellow is a light-value color to begin with, changes in value and intensity will readily occur.

burnishing
The excessive layering of various drawing media under pressure resulting in **wax bloom,** which can be corrected πor lifted by pressing a kneaded eraser against the burnished surface, eliminating the polished appearance.

fixative spray (workable)
A type of fine, granular mist that dries quickly, forming a semiprotective, porous coating, and *fixes* or *holds* the fine particles of graphite, charcoal, chalk, and pastel in place yet allow the surface to be reworked.

wax bloom
An undesired foggy quality on a drawing's surface created by the repeated layering of colored pencils under pressure, which usually can be eliminated by rubbing the surface of the drawing lightly with a soft cloth; it is usually preventable by a light application of spray fixative.

The surface quality of a drawing changes with increased layering of color. The most noticeable change occurs when white or other light colors are applied to a darker color using heavy pressure. The result is a smooth, polished surface; the technique is called **burnishing.** (Burnished areas can be lifted and lightened by pressing a kneaded eraser against the surface.) If the surface becomes too slick, making it difficult to add more color, apply a light spray of **fixative spray** (workable)— the fixative will dry, forming minute granules of texture on the surface and allowing further application of colored pencil.

Repeated layering of color under heavy pressure can produce a foggy quality called **wax bloom,** which usually can be eliminated by rubbing the surface of the drawing lightly with a soft cotton cloth or chamois. Provided it does not alter the color, a light application of spray fixative can be used to prevent bloom also.

Some colored pencils are water-soluble and can be used to create effects similar to watercolor. Almost all colored pencils are soluble in turpentine, and although the result is not as fluid in appearance as that of water-soluble pigments, turpentine as a solvent has the advantage of drying almost immediately.

Project 10.10

Practice various drawing techniques, ranging from loose sketches to carefully finished drawings. Explore the possibilities of the medium in a series of small studies before undertaking a large-scale composition. Practice following the methodical approach of lightly laying in the shapes of your chosen composition with a light-value colored pencil such as a flesh or light-yellow hue instead of graphite. (Note that if you begin laying in contours with graphite and then apply colored pencil over the graphite contours, the graphite will tend to smear or drag under the strokes of colored pencil and be difficult or impossible to remove.)

Critique (Project 10.10) Assess your colored-pencil drawings in terms of their compositional soundness coupled with the added degree of interest created by color ranges of value and intensity. Also, assess the surface condition of your drawings. Often beginners end up with overworked areas that are either burnished or waxbloomed beyond hope of correcting.

Do the surfaces appear technically well handled, fresh, and alive, or are there areas that seemed to get away from you through too much stroking and too much color material being pushed around on the surface? How would you assess your drawings in terms of color statements? Has color helped in describing form, or has it detracted from the form? Is there an obvious necessity for the color you chose, or does it appear to be mere decoration? Is the color range of values a broad and exciting range, or too mute?

Graphite in Stick, Powdered, and Oversized Pencil Form Graphite is available in other than the familiar and conventional-sized pencil form. Stick graphite, available in grades of softness from B to 6B, lends itself to drawing in an open, sketchy manner on a large scale in a similar way to Conté crayon, square chalks, and even charcoal (although the softest

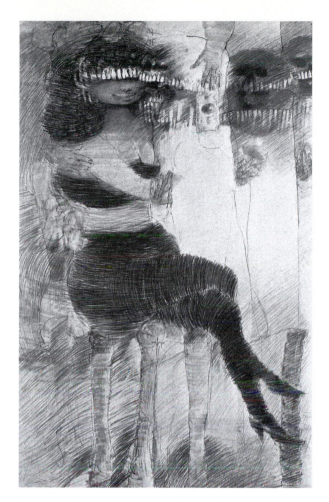

10-17. MAURICIO LASANSKY (b. 1914; Argentine). *The Nazi Drawings #11.* c. 1961–1966. Graphite pencil, water-soluble red earth wash, and turpentine wash, 74 × 45" (188.1 × 114.4 cm). The University of Iowa Museum of Art. (On long-term loan to The Cedar Rapids Art Museum, Cedar Rapids, Iowa)

stick graphite is much harder than the hardest charcoal). Look again at the beautifully poetic, bold, and varied hatched strokes of graphite in Oldenburg's drawing (Fig. 10-13). Here we see graphite functioning as the main character—so tonally descriptive, so direct, so luscious, and so responsive to the sensitivities of pressure and paper surface that we almost assume it to be a more extravagant material—yet it is the common, plentiful, and inexpensive material we have used since childhood.

Regarding Mauricio Lasansky's famed series *The Nazi Drawings* (Fig. 10-17, Pl. 13), the artist stated the following:

> I tried to keep not only the vision of the Nazi Drawings simple and direct, but also the materials I used in making them. I wanted the drawings to be done with a tool used by everyone everywhere— from the cradle to the grave—meaning the graphite pencil. I felt if I could use a tool like that, this would keep me away from the temptations that would arise from the virtuosity that a more sophisticated medium would demand.

One cannot overlook the expressive power of Lasansky's *Nazi Drawings* done with water-soluble red earth powder, graphite, and turpentine wash—materials so humble yet with such a riveting impact. Upon seeing the drawings, one finds it hard to look away; and yet looking away, one cannot help but see them again in the mind's eye. In large part, their richness is attributed to what happens when graphite meets a dissolving agent—such as an organic or hydrocarbon solvent like turpentine.

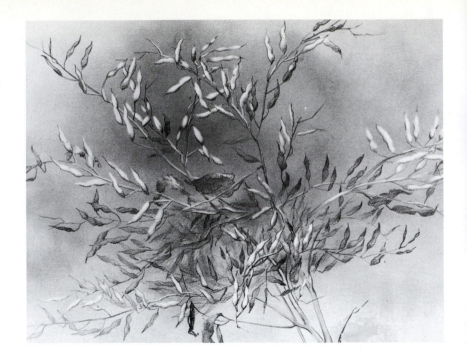

10-18. DANIEL MENDELOWITZ (1905–1980; American). *Wild Radish.* c. 1965. Hard graphite pencil and rubbed graphite, 15 1/2 × 21 1/2″ (39.4 × 54.5 cm). Estate of Mrs. Daniel Mendelowitz, Stanford, California.

Technically, when soft graphite is used on paper that has been soaked or sprayed with turpentine, the solvent momentarily dissolves the graphite, causing the graphite stick to glide across the paper with liquid ease, leaving a heavy, rich, black, linear deposit in its wake. The turpentine dries very quickly, and the rich black line is permanently absorbed into the paper rather than merely residing on the surface. (This will be explained further in Chapter 11 on Wet Media as a wash technique.)

Graphite in either stick or pencil form, of any hardness or softness, can be powdered on sandpaper and applied to paper with a finger, soft cloth, or chamois to provide a smoothly textured tone that contrasts effectively with sharply drawn lines, a combination particularly descriptive and elegant in the modeling of life forms—such as the human figure or animals. When the need for a larger quantity exists, finely ground, powdered graphite, prepared for drawing, can be purchased from art supply stores or graphic supply distributors in 6-ounce jars or larger containers.

Also available in yet other forms are large-diameter (5.6 mm) graphite shafts called "woodless pencils" (graphite shafts coated with a thin plastic skin) along with "graphite chunks" in 8-ounce pieces. (Mechanical holders designed to hold larger-diameter graphite shafts are available from the same supply source and prevent breakage.)

For many years artists have purchased graphite powder packaged in squeeze tubes (used for lubrication) from hardware stores. Harder than stick graphite, it produces a pale, even, silvery tone of great beauty when rubbed onto a kid-finish Bristol board with a soft cloth or chamois. Daniel Mendelowitz, the original author of this book, used this silvery graphite powder to develop such a toned background in his *Wild Radish* (Fig. 10-18). He drew the images of foliage using medium-hard and hard graphite pencil lines with white highlights recovered through erasure. The technique is well suited to drawings meant to convey a sense of elegance and delicacy evident in Mendelowitz's work.

Project 10.11

Leafy plants (Fig. 10-18), portraits (Fig. 7-10), glass or metallic objects with reflective surfaces (Fig. 12-6), or an abstraction of organic forms will prove workable for this assignment.

Rub powdered graphite into kid-finish Bristol board until you have a smooth tone of light gray. Begin drawing with light pencil lines using a hard grade of graphite; add darker shading with softer graphite and erase out whites. A firm eraser cut to a fine, sharp edge (with a razor blade) allows you to lift out narrow white lines and small, precise areas of light. Plan and work carefully since all marks, whether penciled darks or erased lights, show on the gray background. Working with an extra piece of paper under your hand will prevent smudging. Use workable fixative only after all erasures are completed.

Silverpoint As has already been pointed out in this chapter, lead-alloy metal points preceded graphite pencils as drawing implements. They were, in fact, used for that purpose in ancient Rome. Over the centuries silver has seemed to provide the most satisfactory metal point, its lovely gray tone oxidizing to a gray-brown hue with the passing of time. A stout, silver wire (available at jewelry and craft supply stores) not more than 1 inch (2.5 centimeters) long, and made pointed by rubbing on sandpaper, provides a fully adequate tool for **silverpoint.** For ease of handling, the wire can be inserted into a drafting-pencil holder, a mechanical pencil, or a wooden stylus. Mount all four edges of a two-ply sheet of Bristol board on a drawing board with masking tape and coat the paper with at least four thin applications of gesso, thinned to the consistency of cream. When a smooth opaque surface has accumulated and the gesso has been burnished with a soft cotton cloth, the ground is ready for silverpoint.

Silverpoint yields a thin line of even width, like that of a hard pencil. Lines executed in silverpoint will not blur; hence, gradations of value must be achieved through systematic diagonal shading, clusters of lines, or cross-hatchings, evident in Alphonse Legros's *Head of a Man* (Fig. 10-19). Since silverpoint does not erase, students are advised to do a preliminary study in hard graphite pencil, perhaps 4H. Silverpoint is most rewarding to individuals who enjoy methodical procedures and painstaking workmanship to produce drawings of exquisite finish. Although students are encouraged to work relatively small while they are developing a familiarity with the medium, silverpoint drawings need not always be limited in scale, as evidenced by Howard Hack's *Silverpoint #97, Lily #6* (Fig. 10-20), which measures 30 by 40 inches (76 by 101 centimeters). Rather than duplicate the natural light-and-dark relationship between blossoms and leaves, Hack focuses on the complexity of the combined forms seen almost as a reverse silhouette against the soft, gray-toned background.

silverpoint
A methodical drawing procedure where a thin rod of silver (about the size of a graphite shaft) is inserted into a mechanical pencil and used to draw on an elaborately prepared gesso surface. The silver metal point, which may be sharpened on sandpaper, yields a thin line of even width with a lovely gray color oxidizing to a grayish-brown with the passing of time. A highly recommended pencil-style mechanical holder is the Faber-Castell E-Motion Mechanical Pencil.

Project 10.12

Prepare a piece of Bristol board with four coats of gesso applied thinly to avoid brush strokes. Let each coat dry thoroughly between applications. Brush alternate layers in opposite directions with a good-quality brush and a "feather-touch" handling (light pressure). Select relatively simple forms for your first attempt. Avoid subjects that call for rich, dark tones. One or two yellow apples, lemons, or pears, or an egg placed on a saucer or in a small bowl would be fine. For greater interest, consider cutting a wedge or two out of a piece of fruit—drawing an apple doesn't require that it be left whole. A partially peeled lemon or orange with the strip of peel

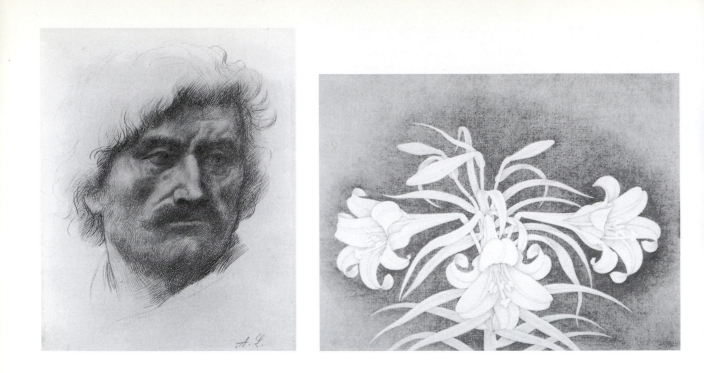

10-19. *above, left:* ALPHONSE LEGROS (1837–1911; French). *Head of a Man.* Silverpoint on white ground. The Metropolitan Museum of Art, New York.

10-20. *above, right:* HOWARD HACK (b. 1932; American). *Silverpoint #97, Lily #6.* c. 1980. Silverpoint, 30 × 40" (76.2 × 101.7 cm). Courtesy of the artist.

still attached offers interesting possibilities. Do not neglect the cast shadows of any object. Have patience; be willing to build your forms and values slowly.

Critique (Project 10.12) How well did you prepare the board with gesso coatings? Were there visible brush strokes either before or after you began silverpoint drawing? If so, next time you may want to use some extra-fine sandpaper with light pressure on the gesso ground before drawing.

How descriptive is your drawing? Have you utilized what you've learned about light and shadow to define forms in space? How would you assess your line quality? Does it appear deliberate or overrehearsed, free or tentative? Were you able to manipulate the silverpoint enough to create subtle variations in line character?

How does the composition work? How would you feel about the drawing if someone else had done it?

Wet Media 11

A truly sensitive artist does not find the same image in two different media, because they strike him differently.

—Odilon Redon

Any fluid preparation an artist chooses to use could conceivably be termed a "wet" medium. For instance, artists sometimes draw in brush and oil paint or in printer's ink. Our primary interest, however, will be liquid **drawing inks**—full strength or diluted for **wash** techniques.

Inks, applied with pen or brush, were used for writing and drawing in Egypt, China, and elsewhere long before the beginning of the Christian era. Although inks can take paste or solid form, the most distinguishing quality of ink is fluidity. Inks are identified by their purpose (relief, intaglio, lithographic, calligraphy, writing, and drawing); by special qualities (indelible, soluble, transparent, opaque); by color; and also according to place of origin (India, China, even specific cities like Frankfurt or Chicago). While most writing inks tend to be too thin and pale for other than sketching purposes, the deep, velvety black of India ink has long been prized as an artistic medium. Inks can be diluted to provide a tonal range in a drawing and can simulate watercolor effects. Because of the liquidity of ink, drawn marks extended into brush strokes, fluid linear qualities produced by a variety of pen nibs, or even spatter techniques all add to the mark-making vocabulary of drawing as a fine art form.

Pen and Ink

For its elegance and clarity, the medium of pen and ink is unexcelled. It is a linear medium that demands precise and subtle control and does not indulge mistakes (Fig. 11-1). Michelangelo is reported to have acknowledged that it was a greater art to draw masterfully with the pen than with the chisel. Although the beginning student will probably have

drawing inks
Saturated liquid pigments possessing great fluidity that may be used full strength with various types of pen nibs (points) for linear effects, or diluted with water to varying degrees of transparency, producing washes applied by brush to enhance pen-and-ink drawings. Among the most popular are India ink, China ink, sumi ink (all black), and various other quality colored inks such as Walnut, Koh-I-Noor, and Windsor-Newton brands.

wash
Ink diluted with varying amounts of water or solvent that produces a broad range of transparent or semi-transparent tonal effects when brushed against a receptive surface, usually an absorbent paper.

201

11-1. GERALD P. HODGE (b. 1920; American). *The External Anatomy of the Eye.* c. 1980. Pen and ink, 8 1/2 × 11" (21.6 × 27.9 cm). Courtesy of Gerald P. Hodge, University of Michigan.

11-2. Pen nibs and the lines they produce (top to bottom); turkey quill; reed pen; bamboo pen; two drawing pens with metal points; two lettering pens, with flat and round metal nibs; "crow quill" pen; Rapidograph pen; nylon-tip pen; felt-tip marker and pen; ballpoint pen.

to tolerate initially clumsy results before achieving expertise, ink is a medium that allows the development of distinctly personal styles (Figs. 2-15, 4-14, 5-15, 5-16, 7-14, 7-16, 11-3, 11-10, 11-11, 17-15, 17-16). (An added benefit is that ink, once dry, does not smear or smudge in a sketchbook as do pencil and other dry media.)

Pen Types The requirements of a pen are that it be pointed and also have a tubular body to hold the ink that will flow from its hollow reservoir through the point to the paper (Fig. 11-2). To a much greater extent than with any other media, the choice of **pen nib** (specialized split pen point) determines the style of drawing.

Quill and reed pens have been in use for both drawing and writing since ancient times. **Quill pens,** cut from the heavy pinion feathers (the largest feathers with the thickest shafts near the leading edges of the wings are preferred) of large birds (goose, swan, crow) and shaped to a sharp or angular, coarse or fine point, respond readily to variations in touch and pressure to produce a responsive, smooth, and flexible line. Today, traditionally trained calligraphers are more inclined than artists to make and use quill pens.

Reed pens are hewn from tubular reeds or the hollow wooden stems of certain shrubs and cut to suit the user's taste. (Japanese and bamboo reeds are the most common and make good pens.) In general, reed pens are stiff; their nibs, or points, are thick and fibrous. The lack of supple responsiveness results in a bold, generally wide line. Because the reed pen does not glide easily across the paper surface, it contributes to a deliberate or even awkward strength of handling that tends to challenge the artist and thus inhibit overfacility and technical display. Interestingly, it seems to have been the favored drawing tool of Vincent van Gogh (Figs. 11-3, 7-16, 13-23, 17-16). In comparison, one notices a slight similarity of surface stroking character between his drawings and paintings.

Contemporary artists who value similarly strong, brittle qualities of line draw with **bamboo pens,** a specific type of reed pen imported from the Orient (Fig. 11-4). Bamboo pens can be greatly varied in diameter—some even thick and "stalky," which contributes to the strong character

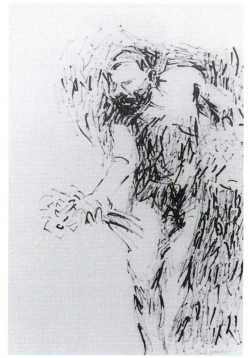

11-3. *above, left:* VINCENT VAN GOGH (1853–1890; Dutch-French). *Fountain in the Hospital Garden.* c. 1889. Black chalk, pen, and brown ink on paper, 19 1/2 × 18" (49.5 × 45.7 cm). Vincent van Gogh Foundation/Vincent van Gogh Museum, Amsterdam.

11-4. *above, right:* PAUL WONNER (b. 1920; American). *Figure with Flowers.* c. 1960. Bamboo pen and ink, 18 × 23 1/2" (45.7 × 59.7 cm). Courtesy the artist.

and organic quality of line. Reed and bamboo pen nibs wear out quickly but can be resharpened fairly easily.

The **metal pen** point first appeared at the end of the eighteenth century. Used on very smooth, partially absorbent paper, the steel pen can be more completely controlled than either of its precursors as the vehicle for sharp detailed observation, as demonstrated by Gerald P. Hodge's *The External Anatomy of the Eye* (Fig. 11-1). Nibs of varying sharpness, pointedness, and angularity permit almost any desired effect to suit the artist's purpose. Every artist has a particular preference for specifically designed nibs according to his or her own mode of operation, etc.

The multiplicity of steel pens available for drawing demands much experimentation and exploration. For general sketching purposes, many artists prefer a penholder and interchangeable nibs. **Lettering pen** points come with round, straight, or angular nibs raging in width from 1/10 millimeter to more than 1/4 inch (.6 centimeter). The straight-nibbed lettering pen yields a line that in its stiff regularity recalls the reed pen. Wide lettering pens allow the rapid filling in of large areas. **Fountain pens** are generally more convenient for sketchbook drawing—once filled, they eliminate frequent recourse to a bottle of ink (always a risk when being transported as unwanted drips on the artwork may occur). Two general fountain-pen types are specifically manufactured for sketching and drawing: **quill-style pens,** which dispense India ink for a sustained period of time without clogging or dripping, and **stylus-type pens,** generally termed **Rapidograph pens,** with a central cylindrical point that enables the artist to move the pen in all directions

pen nib
The point of a pen whether *quill, reed, bamboo,* or *steel,* which comes in a variety of different types and sizes and is used with fluid drawing ink; the nib itself acts as the ink reservoir and controls the flow and dispersing of the ink on paper; the style and width of the nib determine line quality.

quill pens
Pens cut from the heavy pinion feathers of geese, swans, or wild turkeys, hardened by tempering with wet, heated sand, and shaped to a sharp or angular, coarse or fine point. They respond readily to variations of touch or pressure, producing a responsive, smooth, and flexible line. Today traditionally trained calligraphers are more inclined than artists to make and use quill pens.

reed pens

Pens hewn from tubular reeds or the hollow wooden stems of certain shrubs and cut with various points to suit the user's taste. In general, reed pens are stiff; their nibs, or points, are thick and fibrous. The lack of supple responsiveness results in a bold line.

bamboo pen

A type of *hollow* reed pen imported from the Orient.

metal pen

A pen that first appeared at the end of the eighteenth century; when used on very smooth, partially absorbent paper, the steel pen can be more completely controlled than its predecessors (quill, reed, bamboo pens) as the vehicle for sharp, detailed observation.

lettering pens

As the name implies, pens used for lettering; they are available with round, straight, or angular nibs ranging in width from 1/10 millimeter to more than ¼ inch (.6 centimeter). Straight-nibbed lettering pens yield a line that in its stiff angularity recalls the line made by a reed pen. Wide lettering pens allow the rapid filling in of large areas.

fountain pens

Pens that are generally more convenient for sketchbook drawing—once filled, they eliminate frequent recourse to the bottle of ink (always a risk as dripping may occur when the pen is transported). The two types of fountain pens manufactured for drawing are the *quill-style* pen and *stylus-type* pen, generally termed *Rapidograph*.

quill-style pen

One of several types of fountain pens. See **fountain pens.**

stylus-type pen

A type of fountain pen. See **Rapidograph pens.**

without varying the line width. The latter must be held perpendicular to the drawing surface for the ink to flow evenly. Thorough cleaning of pens—their nibs and reservoirs—after usage greatly prolongs their effective life. Rapidograph pens, in particular, should be flushed out frequently in accordance with the manufacturer's instructions to prevent irreparable clogging of their delicate internal mechanisms. (It is also wise to use manufacturer-specified ink.)

For sketching purposes, nylon, felt-tip, ballpoint, and marking pens offer convenient substitutes for traditional pen and ink. Some dispense black, indelible ink very similar to India ink; some use water-soluble ink. Some have replaceable ink cartridges; others are to be thrown away when the ink supply is exhausted. Although they lack the flexibility of a metal pen, their bold, simple lines have a special character (Figs. 1-12, 11-2). Illustrators producing artwork for reproduction rely upon them heavily, but uncertainty as to the performance of their inks after prolonged exposure to strong light limits their use for fine art.

Simple Line Drawings Pure, direct, and abbreviated, a black ink line drawn with an open pen on a white paper creates with incisive brilliance and energy a kind of shorthand impression of reality by recording only what the artist considers absolutely essential, eliminating all distracting details. *Femme à la Blouse Russe* (Fig. 11-5) demonstrates what Matisse acknowledged as a seeming liberty of line, contour, and volume that "does not depend on the exact copying of natural forms, nor on the patient assembling of exact details." The virtuosity evident in Matisse's line drawings resulted from making one drawing after another in rapid succession until he was satisfied that he had achieved maximum simplicity, fluidity, and freshness.

Picasso approached pen and ink, as he did with all other media, with authority. *El Tio Pepe Don Jose* (Fig. 11-6) reveals a direct, bold, and brilliant use of the conventional flexible pen. The variations in the thickness of line are doubly descriptive—first, in revealing the physical mass of the circus clown; second, in describing the process of drawing by documenting the pressure with which each stroke was made.

Today artists have more varieties of paper to choose from than ever before; in selecting the right one, they may consider size, weight, tone, color, degree of grain/tooth, naturally deckled edges, whether or not it contains sizing (a binding starch), and so forth. Selecting paper is a matter of personal choice. Smooth paper is generally recommended, since metal pen points tend to pick up the raised paper fibers of heavier-grained papers. Bond paper is satisfactory for preliminary studies; for finished pen-and-ink drawings, smooth-finished Bristol board provides a brilliant white, takes ink well, and permits pen lines of fine quality. You are encouraged to try a heavy-grained paper to experience a different line quality and surface absorbency of ink. Fluid ink lines drawn on unsized or unstarched papers will tend to bleed slightly, creating a velvety line quality, whereas those drawn on sized papers will tend to remain crisper and more true to the way they were drawn. In an untitled drawing done as a student, Andy Warhol (Fig. 11-7) created a slightly blurred, irregular transfer image by blotting freshly inked lines with a second sheet of paper. It was a technique he relied on during his years as an illustrator.

Ink drawing offers little opportunity for revision, other than in quick sketching, making it necessary to consider each line/mark before

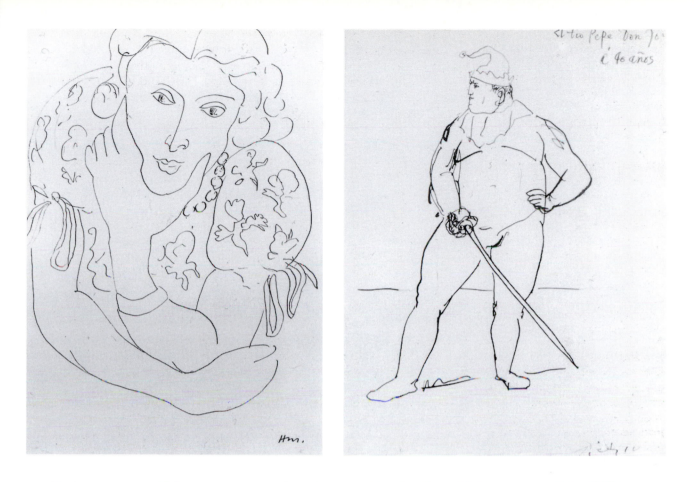

11-5. *above, left:* HENRI MATISSE (1869–1954; French). *Femme à la Blouse Russe.* c. 1936. Ink, 15 1/8 × 11 1/8" (38.4 × 28.3 cm).

11-6. *above, right:* PABLO PICASSO (1881–1973; Spanish-French). *El Tio Pepe Don Jose.* c. 1905. Black ink on cream paper, 10 × 8" (25.4 × 20.3 cm). Collection Lee A. Ault, New York.

touching pen to paper. Take care not to overload the pen with ink; wipe the point against the side of the bottle before starting to draw, or the pen may deposit a large drop of ink when it first touches the paper. Should you have such an accident when drawing on good-quality Bristol or illustration board, allow the ink to dry, gently scrape away the excess ink with a razor blade, and then remove any remaining vestiges with an ink eraser. If you attempt to draw over the scraped portion, the ink may bleed even more drastically into the disturbed surface. Except for drawings intended for reproduction, resist any temptation to block out mistakes or smudges with white paint, as the paint will always be far more obvious than the mistake or the correction made by scraping.

Project 11.1

Explore variations of line using simple pen-and-ink techniques in a series of line drawings—line for line's sake. With a small sheet of Bristol board (9 × 12"), begin at the top edge of the sheet, making lines that traverse the entire width of the surface. As you move the pen, practice changing hand positions and angles as you draw. Use rapid and slow movements and differing amounts of pressure, being sensitive to the changes in line character as you go. Fill the entire picture plane with lines of all kinds.

Set up a simple still life of organic forms. Vegetables, fruits, leaves, or even flowers make logical subjects, since deviations in contours from those of the actual model are insignificant (Fig. 5-6). Portraits and figure studies present greater difficulties for the same reason but may compensate with increased interest. You will find it valuable to follow Matisse's lead and make a number of drawings of the same subject, one after another.

Rapidograph pens

Types of fountain pens that hold a supply of ink and have a central cylindrical point enabling the artist to move the pen in all directions without varying the line width; must be held perpendicular to the drawing surface for the ink to flow evenly.

11-7. ANDY WARHOL (1928–1987; American). *Untitled.* c. 1948–1949. Pen and ink on paper, 29 1/16 × 23 1/16" (73.8 × 58.6 cm). The Carnegie Museum of Art, Pittsburgh, Pa. (gift of Russell G. Twiggs, 68.25.1).

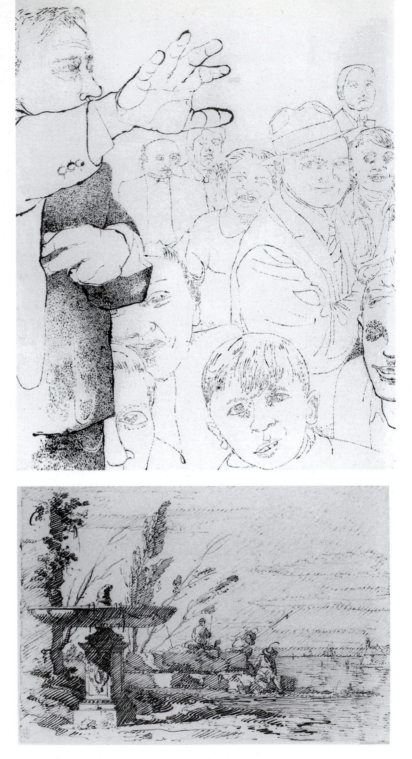

11-8. CANALETTO (1697–1768; Italian). *Veduta Ideata: A Fountain on the Shrine of a Lagoon.* Pencil, pen and ink, black pencil, pen, and brown ink; 7 1/2 × 10 3/4" (19.1 × 27.3 cm). Royal Library, Windsor Castle, England (reproduced by the gracious permission of Her Majesty Queen Elizabeth II).

engraving A form of intaglio printmaking where line or stipple textures are cut into the surface of a copper plate, or other suitable surface, with a tool called a burin. The burin's lozenge point cuts and removes the surface material, leaving a relatively smooth V-gouge or depressed groove in its wake. Printer's ink is forced into the grooves. The effect is a crisp line quality similar to that of certain pen-and-ink drawings.

Value, Texture, Pattern Because pen and ink is essentially a linear medium, dark values must be built up line by line or dot by dot. Two standard methods for building pen-and-ink values are hatching, the system of parallel lines seen in Canaletto's *Veduta Ideal* (Fig. 11-8), and crosshatching, the crisscrossed patterns of parallel lines of Jacques Villon's engraving *Jeune Fille* (Fig. 11-9). At first glance, there is a similarity between

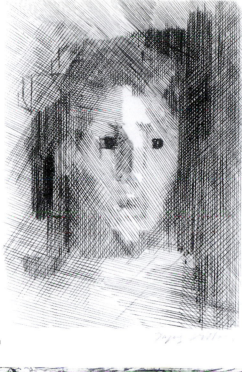

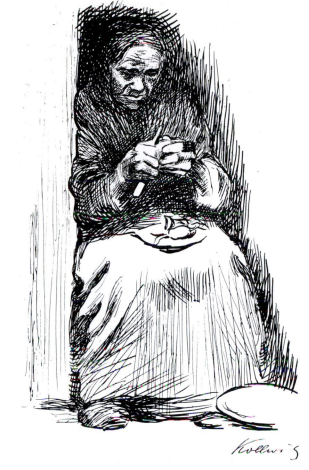

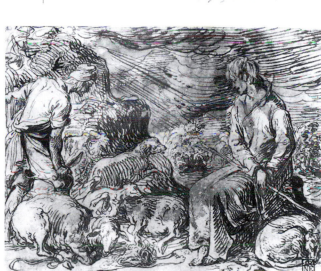

the lines of an **engraving** and a pen-and-ink drawing; however, to the trained eye the two are quite different in line quality. There is a richness of surface in the engraving that differs extensively from that of an ink drawing: In an ink drawing, the line of absorbed ink is flat, or planographic, with the paper surface, whereas on the engraving surface the lines of ink are actual berms or ridges of ink raised in relief on the paper surface.

Both hatching and cross-hatching can be executed with painstaking, evenly spaced lines or with bold patterns of lines that move in many directions (Fig. 11-10), sometimes as cross-contours (Fig. 11-11), or by scribbling (Fig. 4-5).

Initial attempts at pen-and-ink cross-hatching inevitably seem stilted, but in time, each artist develops a personal style. The beginner need not be unduly concerned with blotches and mistakes; fluent, consistent, unmarred pen-and-ink lines come only with much practice and experience.

11-9. *upper left:* JACQUES VILLON (1875–1963; French). *Jeune Fille.* c. 1942. Engraving, 11 1/8 × 8 1/8″ (28.2 × 20.7 cm).
Courtesy of the Boston Public Library, Print Department, Boston, Mass.

11-10. *above:* KÄTHE KOLLWITZ (1867–1945; German). *Woman Peeling Potatoes.* c. 1905. Pen and ink on white paper, 12 5/8 × 9 7/8″ (32.1 × 25.1 cm).
Courtesy Galerie St. Etienne, New York.

11-11. *left:* JACOB DE GHEYN (1565–1629; Flemish). *Hippocrates Visiting Democritus.* Pen and brown ink, 6 7/8 × 9″ (17.5 × 22.9 cm).
Museum of Fine Arts, Budapest.

11-12. PAUL KLEE (1879–1940; Swiss-German). *A Garden for Orpheus.* c. 1926. Pen and ink, 15 1/2 × 12 1/2" (39.4 × 31.8 cm).
Paul Klee-Stiftung, Kunstmuseum, Bern.

It is important to have a fine-quality, smooth paper for cross-hatching (lest the surface tear from repeated applications of the pen, or become blurred). Cross-hatching actually appears crisper and cleaner when one set of directional lines is allowed to dry before the next set is applied. To reiterate, it is important to work on good-quality paper to be able to experience the best possible results and not waste time and energy with a material whose visual and expressive offerings are limited.

Project 11.2

Practice cross-hatching until you gain some measure of control; then select a few simple objects and proceed to model them in dark and light. Do one drawing in the manner of Figure 11-11. In a second drawing, let the forms suggest the directional pattern for your lines (Fig. 11-10; Pl. 7).

At the beginning, draw brightly illuminated, simple forms with clearly defined areas of shading and minimum surface texture. When you are ready to attempt a more complex study, you might find it profitable to translate some of your pencil drawings from earlier project assignments into pen and ink, having already established a familiarity with those subjects.

Pen and ink is well suited to drawings in which clearly defined patterns are desired for their descriptive, expressive, and decorative values. Van Gogh made extensive use of pattern—both descriptive and decorative—to impart vitality to his drawings (Figs. 7-16, 11-3, 17-15, 17-16). Paul Klee has fancifully embroidered a system of essentially straight lines into an entertaining complexity of pattern and texture (Fig. 11-12).

Project 11.3

Approach this assignment as if you were doodling with pen and ink. Using lines of all types and directions—straight, curved, meandering—begin to invent patterns, letting them evolve, perhaps into an imaginary landscape.

In *The Survivor* by George Grosz (Fig. 11-13), a rich array of textural patterns has been employed both to characterize form and surfaces and for expressive effects. The patterns reveal many different uses of the pen (as you practiced in Project 11.1), while some textures appear to result from pressing fabrics or other materials dampened with ink against paper, a form of "wet frottage."

Project 11.4

Develop a pen-and-ink drawing in which you introduce textural patterns for descriptive or expressive purposes. Textures can be suggested rather than meticulously rendered. While some hatching and cross-hatching is inevitable, incorporate a variety of linear patterns. Rocks, brambles, weeds, weathered wood, a derelict truck in a field offer interesting surfaces and textures (Figs. 7-16, 7-17). Introduce a range of values in addition to textural variations.

Take note of the fact that the more inventive you become with line, the more visual life your drawings will have, and the greater the possibilities of arriving at a higher plane of creative and descriptive visual power and expression. This is when an artist's particular style may first begin to emerge.

Project 11.5

While we tend to think of ink drawings as rich black lines against a white background, try drawing with black and white ink on a medium gray or middle-value paper.

11-14. BRYONY CARFRAE (20th century; British). *Stone Crab.* c. 1977. Pen and ink, life-size; 2 × 3 3/4" (5.1 × 9.5 cm). Courtesy of the artist.

In highly detailed ink drawings, especially in scientific illustrations such as Bryony Carfrae's *Stone Crab* (Fig. 11-14), **stippling** (patterns of dots) serves to describe the very smooth gradations of value that define form, texture, or color modulation. Even the sharpest photograph would not reveal the details of form, texture, and surface patterns with the clarity of this drawing, for in a photograph reflected lights and shadows would be intrusive. Stippling takes time and patience; the pattern of dots should be random, inventive, varied, but never careless. It is the size of the pen, not the pressure, that determines the size of the dots; it is the density of the dots that produces darker tones. Rapidograph pens are ideal for stippling, but any pen can be used as long as the dots are kept uniform.

stippling
The building up of surface and tonal descriptions through the concentrated use of tiny dots; the dots when closer together produce darker passages; further apart, lighter tones.

Project 11.6

In an earlier assignment you were asked to make a pencil rendering of a familiar surface, duplicating the texture as accurately as possible according to its exact character (Project 7.2). Do a similar rendering of a familiar object, emphasizing and clarifying its character using pen and ink stippling to delineate a textured surface or object in as disciplined a manner as possible. A detailed preliminary pencil study will prove useful.

Once you've gained confidence, begin drawing directly with pen and ink, remembering to be inventive with line, line hatching, and stippling to create passages of varying values that become more and more visually descriptive.

Pen, Brush, and Ink

Pen and ink, amplified by brush, provides an obvious transition from pure pen-and-ink to brush-and-ink drawing. The surrealistic superimposing of images in Pavel Tchelitchew's *The Blue Clown* (Fig. 11-15)—possibly the elaboration of a doodle—demonstrates how a pen allows linear detailing, while a brush facilitates lines of greater width than can be obtained with pen nib, as well as extended areas of dark. Attempting to fill in large areas with a pen produces a scruffy and uneven surface, not to mention the uninteresting look of an overly deliberate surface.

Project 11.7

Depict a subject with bold contrasts of dark and light—perhaps a self-portrait illuminated by strong light from one side—combining pen outlines and brushed ink masses to create transitional values and textures.

Brush and Ink

The narrowness of line produced by pen and ink gives it its crisp bite and energy and at the same time limits its degree of flexibility and painterliness. When artists wish to expand the scope of mark making beyond line, they pick up a brush (Fig. 11-16).

All kinds of brushes can be used with ink. Each brush imparts its particular character to a drawing—a stiff bristle oil-painting brush produces brusque, angular lines, often with heavy dry-brushed edges (Fig. 11-17); the long, very pointed Japanese brush is more responsive to pressures of the hand and so creates lines of unusually varied widths (Fig. 11-18); a red sable brush, while not as flexible as a Japanese brush, can be used in somewhat the same manner. Frequent and thorough rinsing of brushes, as well as careful storage (especially important so that brush fibers maintain their proper shape) ensures continued quality and

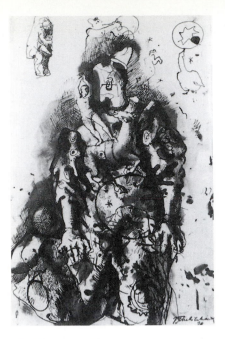

11-15. PAVEL TCHELITCHEW (1898–1957; Russian-American). *Study for "The Blue Clown."* c. 1929. Pen and brush and ink, 16 × 10 1/2" (40.6 × 26.7 cm). The Museum of Modern Art, New York (Mrs. Simon Guggenheim Fund).

11-16. JOSEF ALBERS (1888–1976; German-American). *Two Owls.* c. 1917. Brush and ink, 19 7/8 × 28 1/2" (50.5 × 72.4 cm). Collection Anni Albers and the Josef Albers Foundation, Inc.

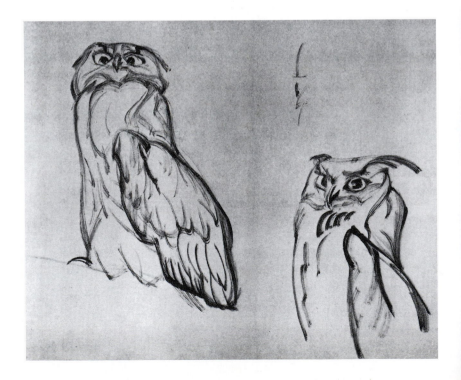

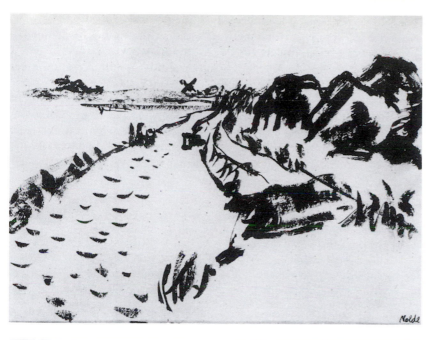

11-17. EMIL NOLDE (1867–1956; German). *Landscape with Windmill.* Brush and black printer's ink on tan paper, 17 1/2 × 23 1/4" (44.5 × 59.1 cm). Private collection.

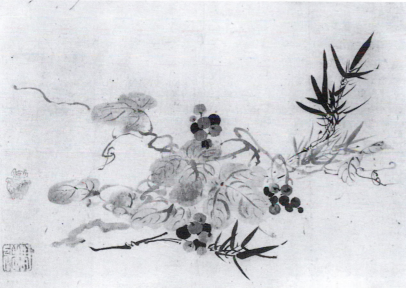

11-18. SESSON (1504–1589?; Japanese). *Grapes and Bamboo.* Ink on paper, 12 1/2 × 17 1/2" (31.7 × 44.5 cm). Collection Kurt Gitter, New Orleans.

dependability of the materials. Manufacturers have produced a brush designed like a fountain pen with an ink cartridge and cap that facilitates impromptu sketching and drawing with brush and ink without having to carry a bottle of ink. It offers much of the flexibility of the Japanese brush.

Different types of papers' textures, weights, whether sized or unsized, also have much to do with the quality of line in brush-and-ink drawing (see pp. 177–178). Soft, absorbent papers (unsized), like handmade Japanese papers such as Mulberry, soak up ink the moment the brush strokes touch them and so create lines that vary considerably in width and the character of the edge (Figs. 11-16, 11-17). Hard-surfaced papers (sized), on the other hand, absorb a minimum of ink from the brush, and this contributes to continuity of line and clean-cut edges (Figs. 1-9, 8-8). A dry-brush effect inevitably occurs when a very rough,

textured paper is used as the brush skims the uppermost relief surface of the textured paper; conversely, it is almost impossible to achieve an interesting dry-brush quality on a very smooth paper.

Other media—gouache, printer's inks, watercolor, tempera, acrylics, and oils—are appropriate for brush drawings. Many experienced printmakers and painters prefer to draw with tools and materials they use for printmaking and painting to facilitate developing drawings into monotypes, prints, and paintings on paper. In such cases, the activity of drawing is extended and becomes naturally embodied within other creative realms, dictated by the use of other tools and materials.

Project 11.8

Explore the use of brush and ink using whatever brushes you may have available. Larger (2-inch) household paintbrushes as well as smaller 1-inch acrylic brushes down to the smallest watercolor and oil paint brushes should be used.

India ink is excellent to start with. First, experiment with small pieces of a variety of different papers of differing textures, taking note of how each receives the ink along with the type of line and stroke qualities they offer. On a larger sheet size, practice with altering amounts of downward pressure as you draw with brush and ink, keeping your arm, wrist, and hand loose and held above the paper while moving freely about the surface. Concentrate on making a variety of different marks.

Oriental Calligraphy Among the most sophisticated and beautiful brush-and-ink drawings are those of the Oriental masters (Figs. 5-20, 6-13, 11-18, 11-19, 14-28). There has always been a particularly close relationship between the arts of writing and drawing in China and Japan, since the techniques involved in manipulating the brush are the same, and in both, the ornamental character of the line produced by skillful brush handling, known as **calligraphy,** has been highly prized. Long

calligraphy
Beautiful writing. In western culture it is done with a pen, in Chinese and Japanese cultures with a brush.

11-19. CHU TA (1626–1705; Chinese). *Bird, from an Album of Flowers, Birds, Insects, and Fish.* Brush and ink on paper, 10 1/16 × 9 1/16" (25.5 × 23 cm). Courtesy of the Smithsonian Institution, Freer Gallery of Art, Washington, D.C.

years of copying the works of acknowledged masters and mastering an exact vocabulary of strokes constituted an arduous apprenticeship for the Oriental artist. In the drawings of such masters as Japanese artist Sesson (Fig. 11-18) and Chinese artist Chu Ta (Fig. 11-19), one is aware of pure virtuosity of technique and decorative charm.

Oriental-brush master artists employ **sumi,** a stick of carbon ink that is ground and mixed with water on a shallow stone or ceramic block. This procedure permits great control over the density of tones. The brush itself is held in a vertical position above a flat ground, neither hand nor wrist being allowed to touch the paper or table support. By raising and lowering the hand and loading the brush with ink in different ways—using the side of the brush or the tip alone, or combining heavy black ink in the tip with very thin, watery ink in the body of the brush—the artist can regulate an extensive repertoire of strokes. Since the traditional Japanese paper and silk fabrics are very absorbent, lines cannot be altered or deleted, and a skilled craftsman never repeats a line.

Project 11.9

A Japanese brush, watercolor paper, or Mulberry paper, water-soluble India ink, and a saucer and water will allow you to explore the technique. For an initial experience, study Figure 11-18 to gain a sense of the hand and brush movements and the changes in pressure required for each stroke. Practice one stroke at a time rather than attempting to copy the entire drawing.

Remember the techniques used in Project 11.8. Try to employ them here as skillfully as you can and also in a more expressive manner.

11-20. *above, left:* GIOVANNI BATTISTA TIEPOLO (1696–1779; Italian). *The Rest on the Flight into Egypt.* Pen and brown wash (bistre), 16 7/8 × 11 3/8". (42.8 × 28.9 cm). The Fogg Art Museum, Harvard University, Cambridge, Mass. (Meta and Paul J. Sachs Collection).

11-21. *above, right:* GIOVANNI DOMENICO TIEPOLO (1727–1804; Italian). *Abraham Visited by the Angels.* Sepia, wash drawing, 15 3/4 × 11" (40 × 28 cm). The Metropolitan Museum of Art, New York (Rogers Fund, 1937).

sumi
A stick of solid carbon ink that is ground and mixed with water on a shallow stone with a water well. This procedure permits great control over the density of tones.

11-22. Demonstration of simple wash technique described in Project 11.10. Drawings by Duane Wakeham.

Critique (Projects 11.8, 11.9) Simply assess your line and stroke qualities. Are strokes clean and unrehearsed-looking? Is there freedom of expression with your brushed marks? Are you able to note the differences in tonal variations between different strokes, and are those variations expressive? Are they descriptive of form? How do they exist in space?

Wash Drawing

wash drawing
A drawing created exclusively by the use of ink washes of differing concentrations and dilutions applied to the paper surface with brushes.

A **wash drawing** offers an instructive transition between drawing and painting, and, in fact, often serves as a preliminary value study for a monotype or painting. Unlike brush-and-ink drawing, which depends for its effectiveness on more or less solid black contrasting with white, in wash drawing the medium is freely diluted with water to produce a wide range of grays. Both the brush and the diluted medium are extremely flexible vehicles that encourage an unusually fluid play of lines, values, and textures (Figs. 11-20 through 11-22).

Two undisputed masters of wash drawing were the eighteenth-century Venetian father-and-son duo Giovanni Battista Tiepolo and Giovanni Domenico Tiepolo. The father's dexterous handling of pale translucent washes, light-value pen lines, dark accents of brushed ink, and large areas of untouched white paper in *Rest on the Flight into Egypt* (Fig. 11-20) produces an image of amazing radiance. As we examine his son's more fully developed tonal study *Abraham Visited by the Angels* (Fig. 11-21), less is left to our imaginations. Domenico's greater use of middle and middle-light values and his focusing of light and dark on the figure of Abraham introduces an element of drama in contrast to the lyrical mood created by the pervasive light in his father's drawing. Hence, the father's work appears more open and artfully mysterious

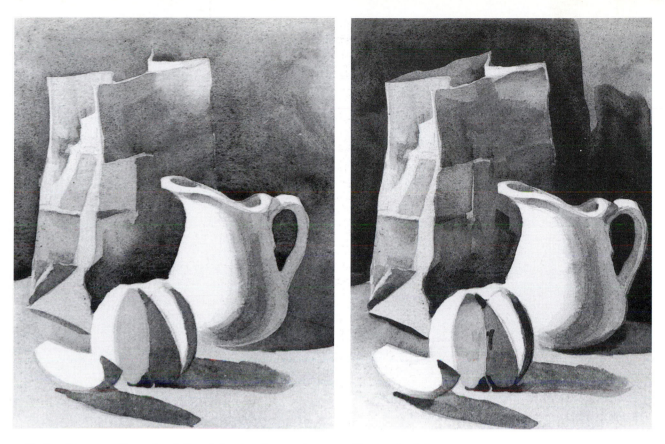

with its absence of overly defined forms, the son's more illustrative in its assertion of the absolutism of defined forms.

Wash commonly refers to ink or watercolor that has been thinned with water to various value gradations. It can also encompass **gouache** (opaque watercolor), tempera, acrylics, oil paints, and printer's inks thinned with turpentine, although these later media tend to be less fine-grained than ink or watercolor. Whatever the pigment or color, it is the principle of dilution that characterizes wash drawing.

The equipment needed for wash drawing is modest: brush, ink, black watercolor or tempera, and heavier absorbent paper. Because good-quality watercolor paper and illustration board will not wrinkle or buckle when wet, it is an excellent ground for wash drawings. Illustration board can be thumbtacked to your drawing board surface; watercolor paper is best mounted. To mount or stretch watercolor paper, wet it thoroughly on both sides with water in a spray bottle; then lay it on the drawing board for about five minutes or until the water has been absorbed, smooth it out slightly, and fasten the edges with paper tape (not masking tape). Allow the paper to dry, shrink, and stretch to a perfectly flat state. (If the paper is still buckled once dry, repeat the procedure of wetting and taping until a perfect flat sheet is achieved.)

You will need a quantity of clean water and absorbent rags. A natural sponge will prove helpful for wetting the paper or for soaking up areas of wash that appear too saturated. A white saucer, plate, watercolor palette, or glass slab can serve as a container/surface on which to mix your pigments.

Flat Washes While the medium encourages free, spontaneous handling, a rather more cautious and systematic procedure demonstrated in

gouache
From the French word "wash," opaque watercolors used in painting whose pigments contain a *gum binder* and filler of *opaque white* such as clay that give a chalky appearance to the surface of the painting.

Figure 11-22 and described in Project 11.10 is recommended for those with no experience in wash or watercolor drawing.

Project 11.10

For your first wash drawing, select a subject with clearly defined planes of light and dark. If you have any sketches or drawings of buildings, they would be appropriate, as would the by-now-familiar cardboard boxes and paper bags. Keep to a modest size, no larger than 9 by 12 inches. Make a preliminary outline drawing. Plan the distribution of values, leaving pure white paper for the lightest areas. Place a couple of teaspoons of water in your saucer or palette and add enough ink to make a light gray. Load your brush with this light gray wash tone and spread it over all the paper (right to the taped edges) except those areas that are to be left white. Be patient and allow the first wash to dry thoroughly before applying a second wash to the areas that are intended to be the next darkest value. Laying one wash over a partially dry surface inevitably results in an ugly or uncontrolled mottled effect. To achieve deeper tones and darker values much more quickly, add more pigment to your wash.

Modulated Areas: Wash and Other Media Wash is particularly suitable for producing free, fluid effects, and also produces a semitransparent ground that is receptive to yet other drawing media. Wash tones can be applied directly to paper without preliminary drawing or can be combined with graphite or colored pencil, pen and ink, charcoal, or chalk. When wash is augmented by other media, it is up to the artist to decide whether the wash precedes or follows the pencil, pen, or charcoal lines and to determine the amount and strength of linear support.

In Francesco Primaticcio's *Hercules and Omphale* (Fig. 11-23), the artist uses a relatively subtle yet rich value range that reveals a dramatic definition of volume and space through the combined use of pen and ink and **bistre** wash (a transparent brown pigment made by boiling soot). Käthe Kollwitz employs an even greater range of values with her brush-and-ink washes in *Mother and Child by Lamplight at the Table* (Fig. 11-24). She relies almost completely on a painterly wash technique to create extremes of light and dark that depict the effects of lamplight, introducing pen line only to detail the forms and features of the two heads and the chair's structure. (Compare Figure 11-24 with Figure 2-21, taking note of how the artist of the latter drawing built up its rich and varied value range almost exclusively with brush and ink wash.)

Project 11.11

To develop a painterly approach to wash drawing, mix a puddle of middle-value gray ink wash in your palette. Proceed to paint, adding water to the middle-value gray when you want lighter tones and concentrated pigment to yield darker tones. Do not strive for flat washes or smoothly toned effects, as this is antithetical to the wash process. Permit your brush strokes and the gradations of value to show (Figs. 2-21, 11-20 through 11-24). Work into the washes only while they are still fresh. While an area is still wet, it is possible to recover lights by squeezing or pressing all the water from a rinsed brush with your fingers or a rag and lifting out the desired light with the brush. Once the washes have begun to dry, allow them to become completely dry before introducing additional washes. For clearly defined edges, apply the wash to a dry surface; for softened contours, wet the paper with clear water before applying the wash.

After experimenting freely with this technique, select a subject that lends itself to a more fluid handling of form. Choosing a subject already drawn from an earlier project not only allows you to work with familiar forms but also offers you the opportunity to see clearly the differences that occur in treating the same subject in dissimilar media.

bistre

A transparent brown pigment used to produce wash tones in pen and ink drawings obtained by boiling soot.

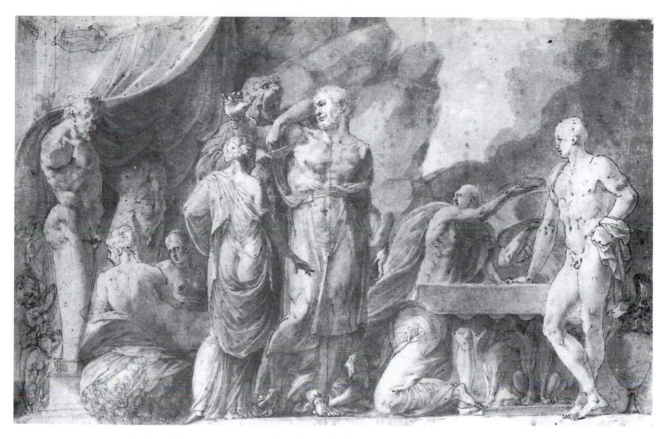

11-23. *above:* FRANCESCO PRIMATICCIO
(1504–1570; Italian). *Hercules and
Omphale.* Pen and ink, with bistre wash,
11 1/2 × 17 7/8" (29.2 × 45.4 cm).
Albertina Museum, Vienna.

11-24. *left:* KÄTHE KOLLWITZ
(1867–1945; German). *Mother and Child by
Lamplight at the Table* (self-portrait with son,
Hans?). c. 1894. Pen and ink with brush and
wash, 8 × 10 5/8" (20.3 × 27 cm).
Courtesy Deutsche Fototek Dresden.

Project 11.12

An interesting variation of traditional wash drawing is to draw with ink or concen-
trated pigment (oil paint, printer's inks) on wet paper. Wet another piece of paper
with clear water. Because the paper surface is wet, there will be some resistance
between the oil paints and printer's inks and the water, leading to some interesting
reticulation textures between these antithetical elements. The unpredictable runs,
spottings, and granular deposits create evolving textures and lines quite unlike the
limpid fluidity of typical wash drawings.

Another variation is to draw with pen and ink on dry paper, and then, while
the lines are still wet, to touch them with a water-filled brush. This will allow for an

monotype

As a unique impression, a one-time drawing with printer's inks on a flat metal plate, which is then transferred to dampened paper with the use of a press. The French artist Edgar Degas is well known for his use of the monotype medium.

printer's ink

A heavy-bodied, oil-based, saturated ink made of carbon blacks or color pigment powders mixed with plate oil (derived from linseed oil). Printer's inks can be diluted with solvents so that they will flow from a brush to produce the painterly effects of monotype or ink wash.

subtractive method

In the dark-field manner, the gradual removal of the dark drawing materials from within a black field creating shapes, forms, tones, or textures of lighter values by allowing light to enter into the composition; the building of light-value visual forms from within an initial dark field.

dark field manner

A technique in which the artist prepares a dark field on a picture plane and proceeds to remove the darks, allowing light to enter the field. This creates a composition of lighter passages that describe forms or objects existing within the dark pictorial space. It is the opposite of **light field manner.**

additive method

The drawing activity of beginning with a white or blank surface and building up positive marks as lines, tones, textures, values; working from light to dark by the progressive addition of tonal marks.

light field manner

A technique in which the artist begins with a light surface and progressively builds up an image by adding darker forms or shapes comprised of line, tone, texture, and value. Opposite of **dark field manner.**

irregularly interesting swelling of the line and yet offer some control of the direction and the extent to which the ink spreads. Experimentation with this procedure will provide a method by which the character of lines can be altered in future ink drawings.

Project 11.13

Colored wash reinforced by colored inks, pencils, chalks, and the other tinted media offers an excellent vehicle by which students can make the transition to painting or printmaking. Do a number of drawings with colored media calling forth various wash and line techniques. Limit the selection to two colors for your initial experience—sepia brown as a warm color, French ultramarine blue as a cool color. Applying a wash of one color over the other or allowing the colors to blend will create a range of colors. Colored inks are brilliant and seem to retain their brightness even when they are mixed; however, to maintain the purity of the color in each bottle, avoid dipping an ink-filled brush from one bottle into another (it is advisable to use a separate brush for each color, then rinse and dry the brushes with a rag when necessary).

Drawing and Monotype

Monotype is a "hybrid medium" that combines the elements of drawing, printmaking, and painting into one immediate act. Because of its dependence upon the drawn, graphic, and painterly activities, it is a medium that artists from all disciplines use in producing works of great virtuosity that, in the end, possess a uniquely identifiable immediacy and directness.

Further defined, **monotype** is a drawing made with thinned **printer's ink** on a blank surface, such as a Plexiglas or metal plate or a heavy sheet of acetate. In the **subtractive method,** or **"dark field manner,"** the artist uses small inking rollers (called brayers), brushes, rags, or tarlatans (starched cheesecloths) to cover the entire surface of the plate with ink. Wooden dowel rods (used as drawing sticks), Q-tips, cotton balls, rags, brushes, fingertips, and solvents—anything that will remove the ink and create the desired compositional effects—may be utilized to create a design in the ink film. Then the image is transferred to dampened, heavy rag paper with the use of an etching press.

Another approach to monotype, referred to as the **additive method,** or **"light field manner,"** is to create the design by adding ink directly to a blank plate with brushes or rags, then building up and supplementing the image with full ranges of tones and textures by continually adding ink. The image is then transferred to dampened paper with a press, as with the subtractive method.

Because the flat surface is either metal, Plexiglas, or acetate (all nonabsorbent materials), the inks can be as easily removed as they were laid down. In fact, dramatic highlights are quickly obtained by wiping the ink away, partially or entirely, creating tonal areas of lighter values or extreme whites.

Well-known Washington, D.C., artist Jack Boul applied the dark field manner in his monotype *Cow in a Barn* (Fig. 11-25), a tonally rich drawing executed in highly descriptive films of thinned printer's inks. Notice how amazingly luminous the very lightest films of ink are on the cow's body—and the highlights of the rear udder and right hipbone so sensitively orchestrated through the subtle manipulation of tone. Artist Nancy Hersch Ingram, once a student of Jack Boul's, employed the additive method to produce *Cow Skull #1* (Fig. 11-26), a monotype of rich

11-25. JACK BOUL (b. 1927; American). *Cow in a Barn.* c. 1993. Monotype in black printer's ink and turpentine wash on heavy white wove paper (dark field manner), 5 × 7" (12.7 × 17.8 cm). Courtesy of the artist. Collection of Ursula and Frank Ferro. West Tisburry, Mass.

11-26. NANCY HERSCH INGRAM (b. 1930; American). *Cow Skull #1.* Monotype in black printer's ink and turpentine wash on cream wove paper (light field manner), 7 13/16 × 5 3/4" (19.8 × 14.6 cm). Courtesy of the artist.

and delicate proportions. Notice the reticulated textures and the grain of the ink washes coupled with the deep rich black of saturated ink in Ingram's drawing. Boul's and Ingram's choices of both the subtractive and additive methods (the dark and light field manners) yield wonderfully sensitive interpretations—a strong testament to these artists' abilities to

11-27. EDGAR DEGAS (1834–1917; French). *La Toilette (Le Bain), The Bath.* Monotype in black ink on heavy white laid paper in the dark field manner. 12 3/8 × 11″ (31.2 × 27.7 cm). © The Art Institute of Chicago, The Clarence Buckingham Collection.

plasticity
The physical body characteristics of a material or substance, whether liquid or solid, that determines its use as an expressive art material; also the characteristics of form, concept, and compositional handling of subject matter. For example, a subject may be drawn in such a way as to increase its mass or volume and thereby increase its plasticity.

see deeply, then translate what they see into these tonally varied and exquisitely expressive drawings.

Edgar Degas, a master at the technique of monotype, employed extreme darks and lights to emphasize his figurative composition in *La Toilette (Le Bain)* (Fig. 11-27). In this intimate scene the French master's use of extended tonal ranges—from the intense blacks of the interior's receding spaces to the projecting white linear highlights of the woman's hair—poses a formidable yet delicate definition of the human form in space. As she rises from her bath, the viewer gleans a powerful sense of this *ethereal* presence mysteriously infused within the atmospherically thin, vulnerable films of ink.

These stellar works by Boul, Ingram, and Degas, created by skilled and potent acts of drawing, are so indicative of artistic sensitivity to the ephemeral **plasticity** of the less-than-paper-thin films of ink. The hypersensitive penetrations into both the *dark and light field manners,* resulting in this mastery of interpretation of subject, bears evidence to these artists' skills as draftsmen and visual poets. Their fluidly drawn marks are palpable to the point that one can almost identify the tools used in making the different strokes and descriptive textures of these willfully poetic impressions (Figs. 11-25 through 11-27 and 17-8).

Still Life 12

*Common objects become strangely
uncommon when removed from their
context and ordinary ways of being seen.*

—Wayne Thiebaud

A certain artist in ancient Greece prided himself on the ability to paint fruits so convincingly that birds would peck at them. With comparable enthusiasm, artists of fifteenth-century Flanders reveled in the skill with which they could depict glass, ceramics, fabrics, wood, and fruits. Throughout the Renaissance and Baroque periods artists repeatedly drew upon still-life materials to create an atmosphere of everyday reality in their works. The emergence of a bourgeois society in the seventeenth century, with its glorification of middle-class values, made the portrayal of material wealth a major thematic concern. In Flanders, artists depicted tables laden with fruit, vegetables, fish, poultry, and meat in what to our more health-conscious age seems a gluttonous display. The Dutch masters of the period added flowers to their repertoire, painting prodigious arrangements complete with sparkling drops of dew and insects. Early nineteenth-century American still-life painters patterned their works after Dutch precedents; late-nineteenth-century American ***trompe l' oeil*** artists William Harnett and John Peto originated a brilliant style of still-life painting employing very shallow space, clearly defined cast shadows, and a meticulous rendering of surface textures.

An interesting development of the second half of the twentieth century is the realistic representation of still-life subjects in enormously oversized close-up views, such as Mary Ann Currier's *Turnips* (Fig. 12-1). The concept derives in part from Georgia O'Keeffe, who in the 1920s—possibly influenced by close-up photography—began to produce drawings and paintings of greatly enlarged images of flowers, bleached animal skulls, and shells (Fig. 12-2). Additionally, the contemporary large-scale close-up was spawned by the Pop Art movement, which owed much of its genesis to the omnipresent American billboard.

trompe l'oeil
Rendering in its most meticulous form (from a French term meaning "deceive the eye"); usually applies to still life where the creation of poignant illusions convinces the viewer that he is looking at the actual object or objects represented.

221

12-1. MARY ANN CURRIER (b. 1927; American). *Turnips.* 1985. Oil pastel on museum board, 39 × 56 1/4″ (99.1 × 142.9 cm).
Courtesy of the artist.

12-2. GEORGIA O'KEEFE (1887–1986; American). *Shell.* c. 1925. Charcoal, 19 × 25″ (48.3 × 63.5 cm).
National Gallery of Art, Washington, D.C. (Anonymous gift).

Advantages of Still Life

Still-life drawing presents a number of advantages, which have determined the preponderance of still-life subjects suggested in the preceding projects. Working alone in a quiet studio, the artist is free from many of the problems that accompany portraiture, life drawing, and landscape drawing. There is no need to schedule sittings with models or portrait subjects. The artist can ignore the caprices of weather and work uninhibited by wind, rain, changes in light, and all the other unpredictable elements that go with working out of doors. And the studio and equip-

ment demands for the still life are minimal; any quiet room with good light, whether natural or artificial, will serve.

For the novice, still life has yet another advantage. The subject, as the name clearly indicates, does not move. Thus, the beginning student has ample time to observe, absorb, and learn to portray the tremendous variety of surface qualities that characterize all objects. Once again, the all-important activity of learning to see deeply, and to develop the skills involved in depicting the appearances of what is seen, is of paramount importance to the challenging and successful portrayal of the visually potent and highly detailed curiosities of still-life objects. The rendering of form, light and shadow, texture, color, and such subtle phenomena as luster and transparency can all be attempted at an unhurried pace. Problems of perspective and foreshortening, both elementary and complex, will arise, and these problems can be worked on at the student's leisure. If the arrangement is placed where it need not be moved for some time, and if the subject is not susceptible to withering or decay (an old boot, for instance, in contrast to fruit or flowers), the student can experiment in as many media as desired over a longer period of time, perhaps allowing artistic growth and development to be evident in works done from the same still life.

Finally, still life involves little expense. Every home is filled with potential still-life subjects. You need only glance at the illustrations in this section to see that anything from old clothing to edibles, from tableware to cooking utensils, even sections of rooms and furniture, can serve as subject matter for the artist with imaginative vision and a sense of composition, as in Catherine Murphy's *Still Life with Pillows and Sunlight* (Fig. 12-3). It is the sympathetic observation of familiar objects, accompanied by the capacity to project these observations into arresting and revealing works of art, that characterizes the true still-life artist.

Jane Lund's drawing entitled *Still Life* (Fig. 12-4) portrays an elegant display of interestingly different household items of hard and soft, smooth and textured, inanimate and perishable. It is an astonishingly accomplished work done in graphite, with stumping (blending) and erasing, on ivory wove paper. (The word *wove* refers to the woven fabric used as the sieve or screen, which is stretched flat inside a rectilinear

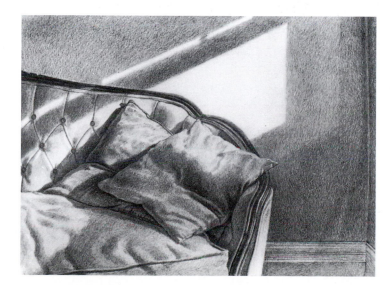

12-3. CATHERINE MURPHY (b. 1946; American). *Still Life with Pillows and Sunlight.* 1976. Pencil, 8 5/8 × 12 1/2" (21.9 × 31.7 cm). Courtesy Lennon, Weinberg, Inc., New York. Private collection.

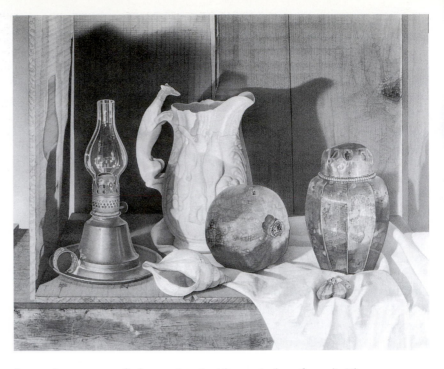

frame (as a pane of glass exists inside a window frame). The wet paper fibers settle on the screen as the water drains through it, leaving a flat, wet sheet of paper pulp on top. When the wet sheet dries, it carries the imprint of the woven pattern of the fabric sieve as its own surface texture or tooth. (Wove paper has the finest and most consistent surface, devoid of any lines or thinner textural patterns that may have resulted from the type of screen used.)

The trained artist's eye finds interesting compositions almost everywhere, as is suggested by the Wayne Thiebaud quote at the beginning of this chapter. It is the still-life artist's role in society to endow the common with uncommon interest—to pull something out of context and give it significance. This is what draws an audience, and this is what holds audience attention. Therefore, an interesting composition need not be complicated or even "artistically arranged"; often interesting compositions are found in the simplest of casual arrangements that happen from life and not from anything contrived. Learn to recognize that almost every object or group of objects can be interpreted in an interesting way through an artist's eyes.

Project 12.1

Select a few ordinary, nonperishable household items. Once the objects have been arranged, if that is necessary, it is essential to place the lighting from above and slightly to one side. Daylight has no particular advantage over artificial light, as long as the artificial light is brilliant. Often, high-intensity reading lamps work well because of their flexible design. Once the set is established, concentrate on form and texture, light and shadow, and employ as many of the drawing skills as have been discussed thus far, using different drawings of the same still life to perform the different techniques.

Critique (Project 12.1) Observe the results of Project 12.1 and assess the degree of visual interest that comes from each individual object, as well as from the entire composition. Is there a sense of uncommon importance given to the common

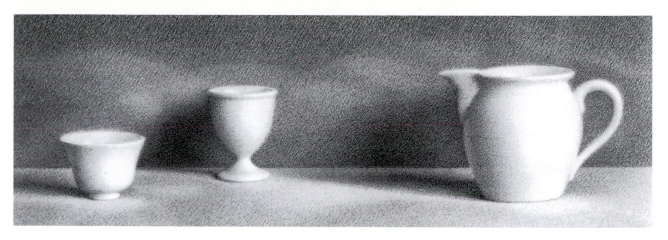

objects? Has the context of the subject(s) changed in the drawing from the real-life arrangement? Have you employed your imaginative forces; and is there strong evidence of your skills of reinterpretation?

12-5. MARTHA ALF (b. 1930; American). *Still Life #6.* 1967. Charcoal pencil on bond paper, 8 1/2 × 24 1/2" (21.6 × 62.2 cm). Courtesy the artist.

Still-life Forms and Value Studies

Much early training in nineteenth-century academics of art in Europe and America was devoted to techniques of rendering forms through traditional chiaroscuro. Still-life compositions provided ideal subjects for the study of value gradations and the elements of chiaroscuro—highlights, light, shadow, core of the shadow, and reflected light (see the section on chiaroscuro in Chapter 6). Smooth white plaster casts used as still-life objects allowed for easy observance and analysis of chiaroscuro and all its effects. Martha Alf's *Still Life #6* (Fig. 12-5) is in that tradition, but beyond technique her drawing is distinguished by a deceivingly simple elegance that results from concern for the "visual organization" of shapes and spaces. Note that the subtle shadows cast onto the backdrop appear almost landscape in quality.

Catherine Murphy (Fig. 12-3), Jane Lund (Fig. 12-4), and Akira Arita (Fig. 12-6) display similar virtuosity of technique and vision. All reveal form solely by value change with dramatic value contrasts in some areas to define forms in space. Arita has chosen brilliant back lighting to silhouette simple cylindrical shapes that have been given specific definition by the way the light picks out the rims of the open cans and by the handles. The drawing is admirable for Arita's skill in rendering the smooth, hard, reflective surfaces of the paint cans and the juxtaposition of the radiating shadows and reflections on the tabletop. Equally enviable is his sense of composition—the grouping of the cans, the repetition of the ellipses, and the variations of the upright handles.

Project 12.2

Compose a still-life arrangement containing rather simple forms, closely related in value and preferably light so that the use of chiaroscuro will not be complicated by differences in color or extreme value differences. Lemons, yellow apples, or white onions, for example, would be well suited for this project rather than items of darker colors. Illuminate the objects with a strong light from above and to one side. Place a simple background, neutral in value such as light gray, close enough behind the grouping so that the shadows cast by the objects fall on the background, while the background surface reflects light into the shadowed portions of the objects. Develop the drawing with one of the dry media. Sketch the objects in light outline to establish size and shape relationships; then proceed to model the forms in dark and light.

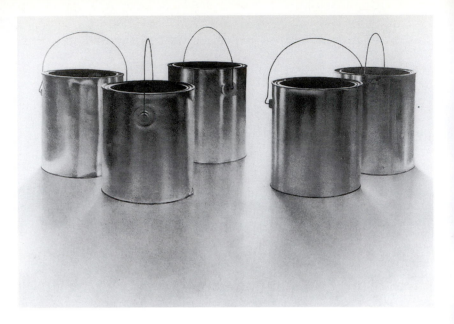

12-6. AKIRA ARITA (b. 1947; Japanese). *Five Paint Cans.* 1982. Graphite, 28 3/4 × 37″ (73 × 94 cm). Collection of Rita Rich.

Study the shapes of the cast shadows carefully and render them as thoughtfully as you do the actual objects, paying particular notice to their degree of darkness as compared with the darkest shadow on the objects themselves. To the mature artist, all aspects of the visual experience are significant; the shadows cast by objects provide interesting elements of pattern equal in importance to the objects. If these delicacies of cast shadow are overlooked, the composition suffers greatly in terms of visual dynamic and power of subtlety.

Critique (Project 12.2) The main question to ask in the aftermath of this assignment is, How modeled and volumetric are the forms? Any slight underemphasis in the play of lights and darks dramatically decreases the solidity of form and readability of the objects as they exist in space. Consider these questions: Are the forms technically well drawn? Are they believable as they exist in relation to each other and in space? Are the light source and its directional flow well evident? Have you used as extensive a range from light to dark as possible without overdramatizing the drawing?

Schematic Form

One of the basic problems in drawing is learning to create a convincing sense of solid, three-dimensional form, particularly when a solid object is translated into a series of lines, shapes, and shadings on a flat, two-dimensional sheet of paper. It is not uncommon for initial drawing assignments to be based upon simplified forms that require learning how to perceive size, shape, and space relationships by using the measuring techniques described in Chapter 3, as well as learning how to use chiaroscuro. Mastering such simple geometric shapes virtually assures equal success with even the most complex subjects, provided the same basic approach is followed—looking, measuring, duplicating shapes rather than drawing objects. Learning to see complex shapes schematically—reducing objects to their nearest geometric equivalents—is one of the most successful methods of understanding and representing three-dimensional form. When drawing overlapping objects, it is essential that you understand and depict the amount of space that each requires. It is not uncommon for beginners to do drawings of a group of objects that

viewed from above would reveal some forms occupying the same space. One senses immediately that each paint can in Figure 12-6 exists in its own space.

Project 12.3

Notice in Figure 12-6 and in Plates 1 and 2 how conscious we are of the basic structure of all the objects depicted. Set up a still life containing objects with clearly structured forms, but not necessarily only those objects that are simple geometric shapes—in fact, there should be some slight deviation from pure geometric form. Your assignment is to reveal the structural relationships of objects by simplifying them into basic geometric shapes or interrelated combinations of shapes, and to intensify the sense of volume with bold chiaroscuro. For instance, a pear can be reduced to a sphere and a cylindrical cone. Now use the power of chiaroscuro to intensify the presence of sphere and cylindrical cone.

In this assignment, to be able to see the geometric forms contained within each object is the first step of seeing; the second step is to be capable of reducing the objects through the process of seeing and drawing. Again, remember to focus on the geometric shapes contained within the forms.

Critique (Project 12.3) You should notice that the objects in your drawings reflect an emphasis on geometric form—perhaps even exaggerated geometric form. In fact, the objects may seem to have been constructed from parts highly descriptive of their nearest geometric equivalents. Have you drawn them that way? Or are you still too focused on the common shape of the object and unable to reduce the object to a geometric shape? This takes practice; if you haven't fully succeeded, try again. It may require that you divorce your thought processes from anything having to do with the context of the shapes of familiar objects, and in doing so, allow yourself to see geometric shape beyond the shape and meaning of the original form.

Composition and Treatment

The selection of subject matter is a problem for many beginning students, who are reluctant to relinquish the concept that what they draw must be "artistic." It can truly be said that subject matter is unimportant. It is the way in which an artist approaches any given subject matter that brings artistic life or death to the subject. Throughout the history of art, significant subjects have been rendered meaningless, while seemingly meaningless subjects have been elevated to great artistic significance. While expression remains a critical determinant of significance, subject matter achieves coherence and interest through the artist's sense of composition, intent, or viewpoint, and the chosen method of treatment, which is enhanced by the artist's unique skills of portrayal.

The most popular main characters of still life—fruits and vegetables, pots, plates, bowls, flowers, tablecloths, and so on—all relatively unimportant subjects, might seem trite, but still-life artists, past and present, have transformed them into drawings of fresh and original effect. After all, this is the point of artistic challenge—to elevate the common into new and provocative heights. Although Piet Mondrian is most familiar as a nonrepresentational geometric abstractionist, recent growing attention has been focused on his drawings and paintings of single flowers. The flower head of *Chrysanthemum* (Fig. 12-7) is drawn in the analytical manner of realism approaching that of a medical or scientific illustration: the shapes of a few leaves are accurately described, but without elaboration, while others are merely suggested by a scribbled line that seems to disintegrate as it approaches the bottom of the sheet.

12-7. PIET MONDRIAN (1872–1944; Dutch). *Chrysanthemum.* 1906. Charcoal, 14 1/4 × 9 5/8″ (36.2 × 24.4 cm). The Museum of Modern Art, New York (gift of Mr. and Mrs. Armand P. Bartos).

Mondrian was obviously being selective while fully aware of the points of articulate elaboration he chose through the use of chiaroscuro. First of all, he introduced enough background tone to spotlight the blossom and to make it project off the page, creating the illusion of a three-dimensional sphere on the flat surface. Then he used the light and dark of chiaroscuro to delineate the intricacies of each convoluted petal. Each of these effects is visually palpable. It is interesting to see this early work as part of the lineage that led to what Mondrian did later in his career. He, like nearly every old master, had a profound understanding of form.

Project 12.4

Do a close-up drawing of a single flower. Choose one at first that is not too complex. Define each petal, using light and dark chiaroscuro techniques to describe the three-dimensionality of the blossom. Thumbnail roughs will assist you in developing an interesting composition.

Let's look at an artist who vitalizes objects with imagination and heightened embellishment. In James Valero's *Still Life with Flowers and Mirror* (Fig. 12-8) we see the use of multiple blossoms displayed with various inanimate objects against a background of floral patterned fabric. Notice the positioning of the mirror to include a reflected image of one of the blossoms, and the placement of the comb in relation to the mirror. The darkest blacks are those of the mirror frame and comb that together define an extended range of lights and darks throughout the composition. Notice also the elegant and plush textures of the fabric as it cascades from the top of the picture plane to the bottom. A triangular portion of the cloth reveals the reverse side of the fabric texture as quite mute compared with the top side. These are things that are infinitely familiar to us, and yet we've never really witnessed their delicate sub-

12-9. JIM BUTLER (b. 1945; American). *Still Life with Glass and Clay.* Lithograph. 1995. 24 × 34" (61 × 86.4 cm). Collection of the artist.

tleties as poignantly as we do in Valero's work because of the artistic decisions that he made.

Another artist whose work lives in the transcendent and sublime nature of the object and its surroundings is Jim Butler. His **lithograph** entitled *Still Life with Glass and Clay* (Fig. 12-9) gives us a sense of standing before a shrine in reverance of not only the objects on the table but also Butler's arrangement of them. In *Burnished Sky/River Mist* (Pl. 14) the buildings, silos, and groves of trees positioned in the landscape are draped with texture and washed with light and shadow. Valero's and Butler's works have similarities, to be sure, but each is visually provocative in its own recondite way and each is orchestrated to be the deliberate visual language of the artist acting on his passions.

A study of the works of Giorgio Morandi reveals the harmony and sensitivity with which he was able to rearrange the same objects over

lithograph
A print made from a drawing done with greasy lithographic crayons greasy inks on Bavarian limestone.

12-10. TONY HEPBURN (b. 1942; English-American). *Workbench*. 1986. Charcoal on paper, 60 × 84″ (152.4 × 213.4 cm). The Stephens Inc. City Trust Grant, 1986. The Arkansas Arts Center Foundation Collection.

and over again (Fig. 7-13). The viewer soon develops a familiarity with Morandi's bottles, pitchers, tin boxes, and canisters, which appear so deceptively unarranged each time they are regrouped. The simplification of shapes and the integrity with which they are rendered lend a monumental dignity to very ordinary objects in a texturally different way than they do to the objects of Valero and Butler, yet each artist skillfully and poignantly elevates the common object to ephemeral heights, allowing us to see it differently, magically.

Project 12.5

Arrange several objects in close proximity so that they take on a group identity without losing their sense of individuality. Use a range of graphite pencils and employ varying amounts of pressure to emphasize dark and light passages. Utilize uniform texture as you draw, and subordinate surface details and patterns to concentrate on volume and space. Regroup the same objects into yet another configuration and make a second drawing. Do additional drawings with different media and techniques using Conté crayon, pen and ink, and ballpoint or felt-tip pen. Explore the use of closely related values—high-key and low-key—to create contrasting moods, as discussed in Chapter 6.

Bowls, cups, pitchers, and bottles are frequent victims of cliché, but need not be. There is also a host of other tools and implements as familiar still-life objects from our everyday routines that artists use to carry fresh and unprecedented messages to the viewer, as we see in Tony Hepburn's *Workbench* (Fig. 12-10). Here we see an orchestrated gathering of tools as objects portrayed as if each were defined by means of a two-dimensional floor plan rendered in charcoal on paper with all the richness of visual poetry produced by the deliberate and playful vestiges of the drawing process. These objects are used in an extraordinarily unannounced way—a way that we wouldn't expect.

Project 12.6

Do a number of thumbnail compositional sketches in which you see how many different ways you can group three to five familiar objects. Pay particular attention to

the space intervals between forms if they are separated, and to the overlapping and degree of touching if they are clustered. Do not limit yourself to the same vantage point. Select the most interesting compositions and develop them more fully, using a variety of media and techniques. By now you have developed a sufficient repertoire of drawing techniques so that you can range beyond straightforward descriptive drawing. Begin to let the vestiges or remembrances of earlier laid marks continue to exist on the drawing surface.

Critique (Project 12.6) As you look at the drawings, do you see a uniform handling of the different objects, shapes, and compositional segments throughout the drawing? Does the composition overall exhibit cogency? Are you struck by the unconventional portrayal of the familiar objects? Has the drawing caused the individual objects to lose their conventional identities? Is there indeed something transcendent about the objects drawn? Has the drawing taken on an organic force? Would you consider it opposite of anything cliché?

A pair of scissors, a knife, a spoon, and a fork—common utensils, ordinary in design, of no particular artistic qualities, and without any real significance—provide the subject matter for a wash drawing by Richard Diebenkorn (Fig. 12-11). Though the objects are seemingly casual in arrangement, careful analysis reveals the skill with which Diebenkorn has produced a sense of drama through the precise positioning of each of the four forms.

Like Diebenkorn, Frantisek Lesak is "interested in observing an isolated object and its relationship to other objects." In a drawing of almost undecipherable complexity (Fig. 12-12), spoons, forks, plates, cups, bottles, and bottle openers, numerous beyond counting, are defined in the most precise perspective. Lesak explains the drawing as an accumulation of many separate studies of the same objects shifted to many different locations on the table.

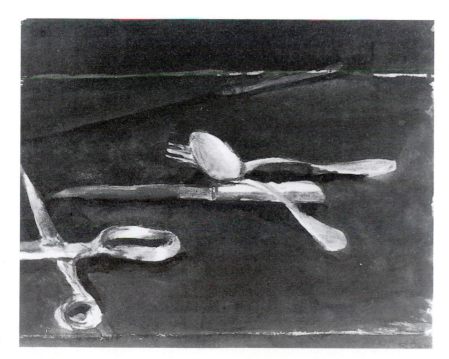

12-11. RICHARD DIEBENKORN (1922–1993; American). *Untitled*. Ink wash, 9 1/2 × 12" (24.1 × 30.5 cm). Collection of Theophilus Brown.

12-12. FRANTISEK LESAK (b. 1943 ; Czech). *Untitled.* 1974. Pencil on paper, 4' 9" × 5' 8 1/2" (1.45 × 1.74 m). Stedelijk Museum, Amsterdam.

Project 12.8

Choose a few kitchen utensils or household tools. Do one drawing of the most interesting grouping of the objects selected, with major emphasis on positive shapes and negative spaces. Make a second drawing of multiple images of the objects seen in perspective, as in Figure 12-12. Let the placement be random in order to avoid the suggestion of patterned design by rotating the sheet of drawing paper every fifteen minutes or so as you draw. As you rotate the paper, pay as little attention as possible to the previously drawn marks—responding as though you were drawing on a fresh, clean sheet of paper each time you rotate the image.

Transparency and Reflective Surfaces

Attention to the surface qualities of objects—rough or smooth textures, shininess, transparency—remains one of the prime concerns of many still-life artists. Glassware arranged on and reflected in sheets of plate glass in *Three Restaurant Glasses* fascinates Janet Fish as a subject for both drawings and paintings (Fig. 12-13). The images are depicted and executed with exaggerated patterns and drawn in pastel with a crisp clarity. The artist deliberately complicated her task by working with objects filled with water to distort the shapes of forms that stand behind.

Distortion and cropping transform strict representation into near abstraction in David Kessler's virtuoso rendering of the reflections seen in the highly polished surface of a new car (Fig. 12-14). A more gentle handling of reflective surfaces is evident in Walter Murch's *Study for the Birthday* (Fig. 12-15). There is a quiet, provocative appeal through the use of diffused light, softened shadows, controlled light and dark accents, and broad areas of generalized texture produced by the interaction of wet and dry elements on the surface that heightens the effect of this mixed-media drawing.

Project 12.9

Eggplants, bell peppers, apples, and other smooth-surfaced vegetables or fruits, if polished and brightly lighted, can provide subject matter for studying reflection and highlights on shiny surfaces of different value. An eggplant is a rather simple shape; peppers can be far more complex.

Shine, transparency, and translucence are perhaps the most subtle and intriguing of all surface qualities. Although glass and metal objects are generally thought to be difficult to draw, careful analysis of shapes, patterns, and values, divorced from any concept of what they are supposed to represent, is the key to rendering such effects (Pl. 2). You are rendering the actual reflective visual situation you are looking at and not making a picture of the utilitarian context of the item.

Concentrate your first efforts on a single relatively simple object—one spoon, a stainless steel or copper bowl, or a tin can, for example—and then proceed to more complicated subjects. Glass objects that are both reflective and transparent present one problem; highly polished metallic objects, such as a toaster, that reflect whatever is nearby (even the artist), offer a greater challenge. Analyze the quality of the surface and the nature of the reflections to determine the most effective combination of media and technique. Think of the areas of reflection as compositions in themselves and focus on drawing those compositions without regard for the entire

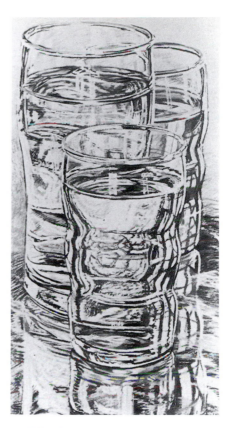

12-13. *above:* JANET FISH (b. 1938; American). *Three Restaurant Glasses.* 1974. Pastel, 30 1/4 × 16" (76.8 × 40.6 cm). Minnesota Museum of Art, Saint Paul. © Janet Fish/licensed by VAGA, New York, N.Y. Acquisition Fund Purchase 75.43.08.

12-14. *left:* DAVID KESSLER (b. 1950; American). *Cadillac #2 Reflection Off Cadillac Fin.* 1975. Colored pencil, 36 3/4 × 24 3/4" (93.4 × 62.8 cm). Minnesota Museum of Art, Saint Paul. Gift in memory of Ruth F. Lien Miller 75.45.13.

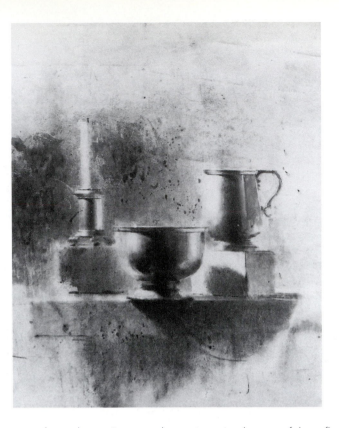

immediate object. Drawing the proportioned areas of the reflective surfaces correctly within the object begins to define the shape of the object almost by default. Try making several drawings with graphite on a relatively durable, smooth-toothed paper. As the reflective surface descriptions begin to take form, use an eraser in the highlight areas to enhance the reflective brightness of the surface. Often through the course of working a drawing, stray smudges may develop over the surface. Using an eraser to eliminate unwanted smears in the intended lighter areas is especially helpful. This is referred to as both additive and subtractive drawing, where the media are added to the surface, then removed for special effect.

Critique (Project 12.9) Assess the reflective nature of the drawings you've made. Are they relatively accurate according to the model? Are the overall shapes of the forms recognizable as the objects that they are? Or does the abstract nature of the reflections and distortions overpower the object? In your estimation, what are the most interesting qualities in the drawings? Is there a transcendent quality to the life of the objects in the drawings? Do the drawings possess force and visual impact? How would you feel about these drawings if someone else had done them?

Expanded Subject Matter

While our conception of appropriate subject matter for still-life drawing is apt to be limited to small objects commonly found around the house, it can logically be extended to include large pieces of furniture and rooms and other inanimate or "still" things. Catherine Murphy's *Stairs* (Fig. 12-16) and Susan Kraut's *Untitled (Studio)* (Fig. 12-17) both have as a primary concern the depiction of interior spaces with a deeply set window on the farthest wall that opens into a still deeper outdoor space. Everything rendered in these two compositions is "still" and rather realistically described according to its own surface texture and its ability to

12-16. *above, left:* CATHERINE MURPHY (b. 1946; American). *Stairs.* 1987. Colored pencil on white wove paper, 30 1/4 × 27" (769 × 686 mm).
The Jalane and Richard Davidson Collection.
© The Art Institute of Chicago. All rights reserved.

12-17. *above, right:* SUSAN KRAUT (b. 1945; American). *Untitled (Studio).* 1979. Graphite with stumping on ivory wove paper, 13 × 19" (330 × 483 mm).
The Jalane and Richard Davidson Collection.
© The Art Institute of Chicago. All rights reserved.

12-18. *left:* JACQUES VILLON (1875–1963; French). *Interior.* 1950. Pen and ink, 9 1/8 × 6 3/4" (23.2 × 17.2 cm).
The Museum of Modern Art, New York (gift of John S. Newberry Collection).

reflect light. Jacques Villon departed from the initial "real" image to create his richly textured, semi-abstract *Interior* in pen and ink, a drawing that is elegant, fresh, and light in mood (Fig. 12-18). Executed in open cross-hatching, the volumes and forms play against one another with a beautiful and luminous now-I-can-identify-it-now-I-can't ambiguity. This

is a brilliant example of radical subject transformation brought about by media handling with a free yet masterful technique.

Project 12.10

Rooms that have been "accessorized" for magazine photographs are very different from the rooms we occupy daily. Without changing the position of anything in your room, study areas through a viewfinder and select a few interesting compositions. Sketch and or draw them in the medium of your choice. Look at Edouard Vuillard's *Interior of the Artist's Studio* (Fig. 17-7). As you draw, use all the facets of media variation in order to heighten visual effects and artistic expression.

Other frequently overlooked interior sources include closets, utility rooms, garages, basements, workshops, greenhouses, and deserted drawing studios with easels and drawing horses in disarray before plaster casts and still-life setups. Try to find these places and select them to draw as they are; something is lost when you contrive a certain look to a "lived in" or "worked in" space.

Critique (Project 12.10) The main feature to assess in your drawings is how the media usage and the surface concerns you've created have transformed the "still space" into a statement that stands on its own. What essential visual differences are there between your drawings and the actual spaces you've drawn? Did you perhaps find it irresistible to embellish a particular aspect of the interior through a total transformation or exaggeration of the textural surface? How well have you defined the existing actual textures within the space? How well have you defined the existing space? How well have you defined deep space? Is space something that you find to be a beckoning visual element awaiting your methods of alteration or distortion in order to enhance a particular statement you are trying to make?

Landscape 13

Once Leonardo established that the structure of landscape was interesting, other artists too were fascinated by the subject, and landscape drawing was thereafter done for its own sake.

—Winslow Ames

When one surveys the drawing and painting of the Orient, western Europe, and America one realizes that landscape provides a major stimulus for artistic expression. Its potentialities are infinite; variations of weather, seasonal changes, the thrilling expanse of great stretches of distance and space, the beauty and fascinating complexity of patterns and textures revealed in close-up details—all contribute to the diversity that inspires and evokes artistic response the world over.

Carol Graham's pencil drawing *Garden, Ballywater* (Fig. 13-1), a study in light, texture, and stillness, reveals an intense love of nature and its moods, as well as the "sensation" of overgrown grasses and twisted trees. Tangled yet graceful patterns of tree trunks and branches contrast with the geometric backdrop of the house. Graham intensifies the pure white of the paper by the addition of a full range of pencil tones and textures to produce a brilliant raking light that defines volumes and textures and the positions of natural forms in space. The beautiful and eldritch play of light and shadow on the compositional rhythms of the trees and grasses provides a sense of atmosphere and aliveness that conceals a slow and meticulous rendering technique.

Karl Schrag's ink drawing *Tall Grasses* (Fig. 13-2) is altogether different in feeling as well as technique. Patterns of thick and thin ink lines partially describe the plant forms in space and partially symbolize the textures of nature in the landscape.

Needs of the Landscapist

It is important for the landscape artist to be as comfortable as possible, for drawing *en plein air* (out of doors) can involve many discomforts.

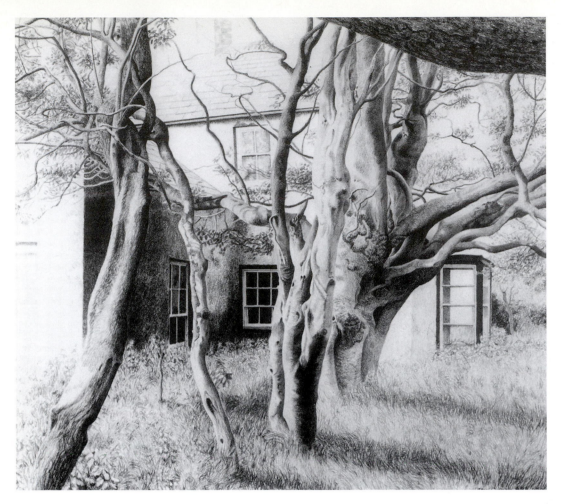

13-1. *above:* CAROL GRAHAM (b. 1951; Irish). *Garden, Ballywater.* 1982. Pencil on white paper, 11 × 12 1/2″ (28 × 31.8 cm.).
Collection of Arts Council of Northern Ireland, Ulster Museum, Belfast. Courtesy of the artist.

13-2. *right:* KARL SCHRAG (1912–1995; German-American). *Tall Grasses.* c. 1970. Ink on paper, 11 1/2 × 15 1/2″ (29.2 × 39.4 cm.).
Minnesota Museum of Art, St. Paul. Acquisitions Fund Purchase 71.05.39.

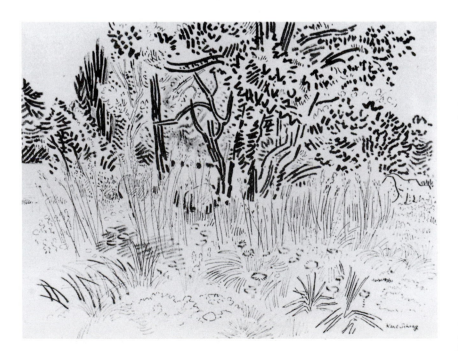

Heat, cold, glare, wind, precipitation, human and animal intruders, insects, and changing lights and shadows are only a few of the problems. The famed nineteenth-century portrait painter John Singer Sargent, who painted landscapes as a welcome change from the demands of his portrait commissions, was able to hire a servant to accompany him and carry a great umbrella, a solid stool and easel, and other pieces of equipment that enabled him to work in comfort.

Few of us today can afford such luxury, so we have to care for our own needs. Dark glasses, gray rather than colored, will help cut the glare of bright sunlight on white paper. Some artists are perfectly comfortable seated on the ground holding drawing boards on their laps. For others, a firm stool and lightweight easel are important. A small toolbox provides a convenient carryall for pencils, charcoal, blending stumps, erasers, a small sketch pad, and other miscellaneous items particular to the individual artist's needs. A portable lightweight drawing board is essential for other than working in a sketchbook.

The most logical media for the landscapist are those which permit one to work rapidly and easily to produce drawings that can be transported back to the studio without smearing or other damage that may occur out of doors. Pencils, various pens and brushes equipped with their own ink supply, and oil pastels allow the beginner to draw out of doors with a minimum of difficulty. It may be advisable to have a plastic bag that can be used to cover the drawings when transporting them back to the protection of an indoor studio.

Landscape Imagery

While we tend to associate the term *landscape* with a panoramic view, artists often choose to focus upon a single facet of the landscape, both as an approach to understanding landscape texture and composition as a whole and as a rich source of particularly expressive forms.

Cesare da Sesto's handsome study of a tree (Fig. 13-3) reveals sensitivity to detail, but while the drawing is most certainly accurate, it is not a slavish copy of nature. The artist has sought instead to define the tree's essence by focusing a selective eye on the characterizing joints, bumps, and movements of branches, and shadow accents. Except that Graham (Fig. 13-1) defines her forms with greater particularity and strangeness of light, it is possible to visualize Cesare's tree in the garden at Ballywater.

Mid-nineteenth-century American landscape painters working in the Hudson River School tradition were expected to be able to draw trees so that both their species and individuality were identifiable. Charles H. Moore's *Pine Tree* (Fig. 13-4) more than satisfies the requirements. It is a large (slightly larger than a standard sheet of drawing paper) rendering of meticulous detail and superb draftsmanship, providing greater clarity than one would expect from a photograph. Nothing has been suggested, nothing has been generalized; media have been totally subordinated to the image. Few artists possess the patience and stamina necessary to undertake such a rendering; however, to hyperextend the realism of nature is one of the most challenging and rewarding approaches for many artists.

Trees can be identified by their shape (silhouette) and by their foliage. Landscape drawing calls for an awareness of the characterizing features of both. In Moore's *Pine Tree* we see first the silhouette, then

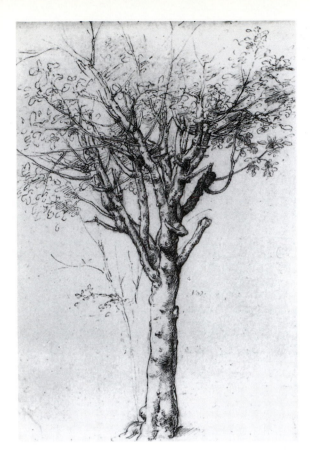

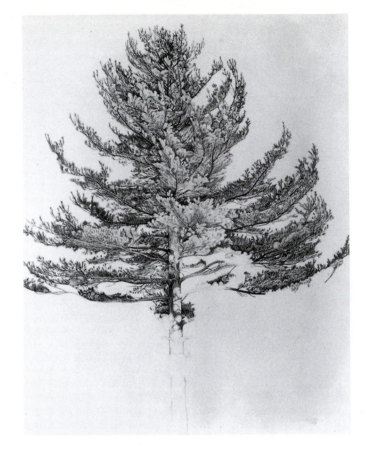

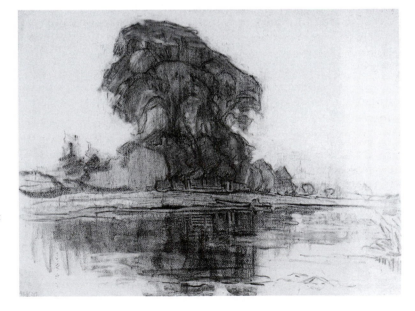

13-3. *above, left:* CESARE DA SESTO (1477–1523; Italian). *Study of a Tree.* Pen and ink over black chalk on blue paper, 15 1/2 × 10 3/8" (39.4 × 26.3 cm.). Royal Library, Windsor Castle, England (reproduced by the gracious permission of Her Majesty Queen Elizabeth II).

13-4. *above, right:* CHARLES HERBERT MOORE (1840–1930; American). *Pine Tree.* Pencil with pen and black ink, 24 7/8 × 19 3/4" (63.2 × 50.2 cm.). Art Museum, Princeton University, N.J. (gift of Elizabeth Huntington Moore).

13-5. *right:* PIET MONDRIAN (1872–1944; Dutch). *Trees by the River Gein.* c. 1907. Charcoal on canvas, 18 7/8 × 24 1/2" (48 × 62.2 cm). © The Art Institute of Chicago. All rights reserved.

the foliage patterns. In *Trees by the River Gein* (Fig. 13-5), Mondrian presents only a simplified silhouette, but he has broken and softened the edges and provided enough variations of tone so that it does not appear to be a two-dimensional cutout. Describing a painting by Leonardo da Vinci, Kenneth Clark wrote, "[T]he black trees silhouetted against the gray evening sky are one of those effects which first, in our childhood,

13-6. LI K'AN (1245–1320; Chinese). *Ink Bamboo*, detail. 1308. Hand scroll, ink on paper; entire work 1' 2 5/8" × 7' 8 5/8" (.38 × 2.38 m.). Nelson Gallery-Atkins Museum, Kansas City, Missouri.

made us feel the poetry and, as it were, the closeness of nature." Mondrian's drawing evokes similar feelings.

Nature was one of the major themes of Chinese poetry and painting, landscape having first appeared as a major subject in painting in China. The calligraphic kinship of writing and painting has already been noted. Chinese and Japanese artists, in fact, can be said to "write" their paintings. A feeling of poetry is present in a detail section of a hand scroll by the fourteenth-century Chinese artist Li K'an, who shows a deft, masterful handling of the conventionalized Oriental vocabulary of brush-and-ink strokes to describe the appearance and nature of bamboo (Fig. 13-6). The subtle gradations of value, which prevent the leaves from appearing flat and decorative, achieve a gentle effect of atmospheric space.

How an artist perceives and treats individual elements of the landscape obviously has much to do with the overall sense of a landscape drawing. Richard Wilson's *Study of Foliage* (Fig. 13-7) pays close attention to the characterizing edges of individual leaves, which are made to stand out in relief by combining linear detail and accents with a suggestion of texture within the tonal areas. Much of the beauty of the drawing derives from the gentle mood Wilson created, which contrasts with the greater drama of the equally beautiful Mendelowitz drawing *Wild Radish* (Fig. 10-18). Although the two drawings differ in both technique and effect, it is interesting to note how similar they are.

Project 13.1

Select a close-up detail from the landscape around you—a cluster of rocks, a section of foliage, the complex branching patterns that become visible when you look up into a tree from below or into the interior of a bush, or the structure of a patch of wild weeds. Decide which media and techniques would permit the most effective and sympathetic interpretation of the subject. Concentrate on the most characterizing attributes of your subject and attempt to convey its uniqueness. Do several drawings; they will take time, so remember to equip yourself with everything you'll need

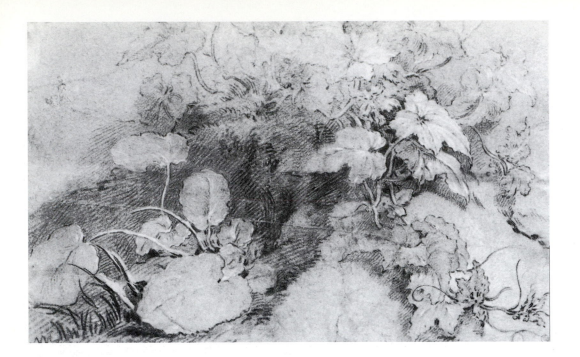

13-7. RICHARD WILSON (1713–1782; English). *Study of Foliage.* Black chalk heightened with white, 11 3/8 × 17 1/8" (28.9 × 43.5 cm.). National Gallery of Scotland, Edinburgh.

for an extended drawing session. After you've done several drawings, try changing media and do several more drawings.

Critique (Project 13.1) Examine your collection of drawings and determine whether the media were right for the subject. Have you infused your drawings with a certain amount of descriptive detail? Did the experience of outdoor drawing seem somewhat natural and even comfortable to you, or were there unavoidable distractions? Did the experience of drawing in a specific place inspire you to want to return to the same location? If so, this is an indication that upon seeing and examining your subjects closely, you found a plethora of drawing material from nature in a particular spot of interest. The more we study nature, the more we see.

Texture and Pattern

The textures of landscape and the patterns they compose in conjunction with the play of light have fascinated artists for centuries. As explained in Chapter 6, the overall textural interest of a drawing derives from both the depiction of actual surface qualities in the subject and the medium employed—that is, the medium's own texture and the way in which it is applied. While not precisely rendered, Asher B. Durand's *Sketch from Nature* (Fig. 13-8) is a rather detailed depiction of the texture of bark while excluding other descriptive forces contained in the immediate vicinity of the tree. In contrast, the total effect of texture in a drawing as seemingly detailed as Camille Corot's *Forest of Compiègne* (Fig. 13-9) is based on impression and suggestion. It is constructed with masses of hatching and cross-hatching in combination with quick, short, gesture marks and strokes of varying tonal range that give definition and character to the foliage. Treated as light patterns, the lacy foliage stands out in relief against the rich dense darkness of the trees beyond.

Winslow Homer's *Study for "Waverly Oaks"* (Fig. 13-10) introduces a reverse order of dark against light to define the foliage masses by attending to the animated broken patterns of sky seen through the tree. The drawing is done in graphite pencil and white gouache on

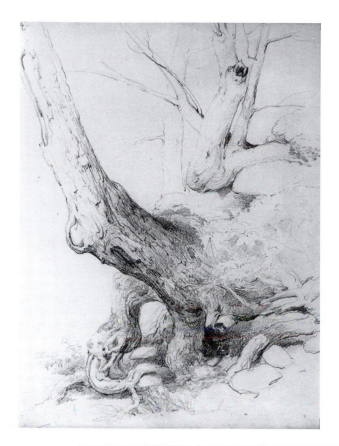

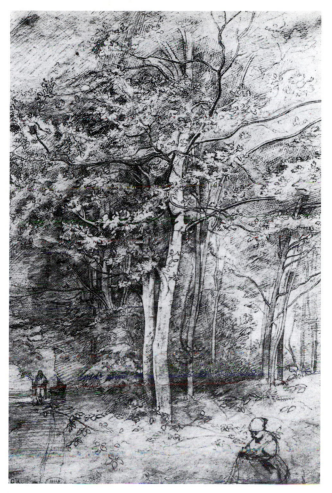

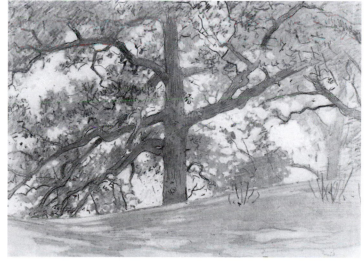

13-8. *above, left:* ASHER B. DURAND (1796–1886; American). *Sketch from Nature.* n.d. Pencil on gray paper, 14 × 11″ (35.5 × 28 cm.).
The Metropolitan Museum of Art, New York (gift of Mrs. John D. Sylvester, 1936).

13-9. *above, right:* JEAN BAPTISITE CAMILLE COROT (1796–1875; French). *The Forest of Compiègne, with Seated Woman.* c. 1840. Crayon and pen on white paper, 15 5/8 × 10 1/2″ (39.7 × 26.7 cm.).
Musée Beaux-Arts, Lille.

13-10. *left:* WINSLOW HOMER (1836–1910; American). *Study for "Waverly Oaks."* 1875–1878. Pencil, white gouache on brown paper, 5 7/8 × 8 1/8″ (15 × 20.7 cm.).
Cooper-Hewitt Museum, the Smithsonian Institution's National Museum of Design, New York.

brown paper. The subtle variations in linear detailing and tonal enhancement with both graphite and gouache combine to create a sense of volume and space that counteracts the silhouette effect, and of course the use of the tree form's increased scale to compositionally divide the picture plane negates any possibility of the tree's assuming a silhouette shape.

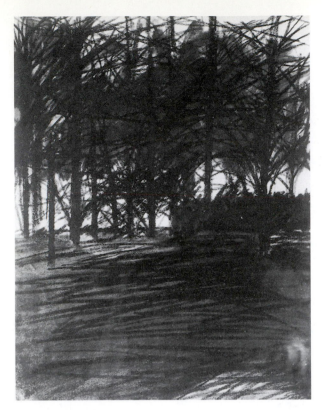

13-11. *above, left:* JOHN LOFTUS (b. 1921; American). *Dark Landscape #1.* Charcoal, 25 × 19″ (63.5 × 48.3 cm.). Philadelphia Museum of Art.

13-12. *above, right:* JEAN FRANÇOIS MILLET (1814–1875; French). *The Curtain of Trees.* Black crayon, 7 1/4 × 11 1/8″ (18.4 × 28.3 cm.). Louvre, Paris.

Except for some slight tonal variations within the main dark masses, most evident at the bottom right of the drawing, John Loftus has relied almost completely on silhouette in creating his powerful and evocative *Dark Landscape* (Fig. 13-11). He has used compressed charcoal to cover nearly half the full sheet with a dense velvety black. Running across the top and middle of the page is an irregular, organic pattern of white shapes broken by boldly drawn angular lines that gives definition to the trees, separating the viewer from the open space beyond. The scale of the trunk and branch pattern, plus the indication of treetops along the upper edge of the drawing, gives evidence that the thicket of trees is at some distance removed from the spot where the viewer stands in what can be imagined as an open but dark field. As the artist "feels the sense of place," he transmits the passionate and emotive qualities that are so wonderfully apparent in this stellar work. Loftus beautifully demonstrates the degree of simplification that is possible without loss of information. It should be further noted that, although not precisely defined, as in an academic sense, the configuration of the branches reveals keen observation of the characteristic branching patterns, and this alone is adequate to portray the artist's visceral response to the place.

Millet's *The Curtain of Trees* (Fig. 13-12) bears a certain similarity to the previous drawing. In both examples, foreground and background are separated by a row or cluster of trees, and in both there is a feeling of fading evening light. However, Millet's trees offer no real barrier, and his light is gentle and poetic. He has suggested texture and pattern with amazing economy, and every line is necessarily and actively engaged in expression. His broad, broken horizontal strokes describe rough, barren fields lying fallow until the next season, thin verticals echo the tall slender trunks of poplars, and lines deviating from the vertical describe the vulnerable laciness of branches.

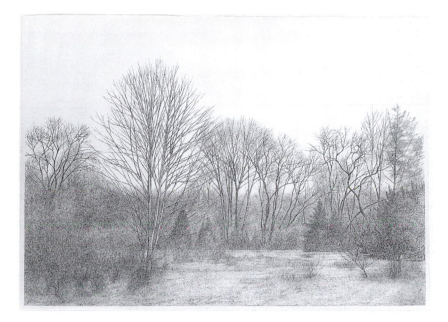

In Richard Ziemann's drawing *Back Field III* (Fig. 13-13), done with brush and black ink over graphite, we see the tonally descriptive placement of a deeper dimension of trees that seem to exist far behind the spatially intermediate row of leafless trees that take our full attention. Ziemann has used brush and ink very effectively to bring the live but dormant branches of the middle-range trees into articulate focus, establishing them clearly in front of the deepest row of trees, while simultaneously, the same articulated trees separate the foreground from the deeper tonal space where the farthest trees exist in the picture plane.

Project 13.2

Texture and pattern in landscape drawing, as evidenced in the foregoing illustrations, can be, and should be, as rich as the textures of landscape itself, depending upon the temperament of the artist, the media chosen, and the effect desired. As an ongoing assignment, explore the complete range of media and techniques, alone and in combination, to realize the fullest degree of expressive possibilities in the depiction of landscape. The task might well take a lifetime, as evidenced by the lifelong pursuits of landscape artists. The purpose of this is to go beyond mere representation, beyond manipulation, trickery, and technical dexterity, to ultimately draw with expression and feeling—to create an image that stands on its own expressive merits as something mysteriously extracted from the landscape.

Spatial Relationships in Nature

The conventional linear perspective devices of converging lines, diminishing scale, and overlapping forms are often sufficient to create the illusion of space in landscape drawing. Artists who wish to display a greater degree of spatial complexity in their landscape drawings, original prints, and paintings introduce **aerial**, or **atmospheric perspective** to reinforce the illusion of depth initially mapped out by linear perspective. Atmospheric perspective is based on two observations: (1) contrasts of value diminish as objects recede into the distance, with lights becoming less light, darks less dark, until all value contrasts merge into a uniform, medium-light tone; (2) color contrasts also diminish and gradually assume the bluish color of the air (more of a concern for the painter or

aerial perspective

A drawing technique that reinforces the illusion of depth (initially mapped out by the rules of linear perspective) where contrasts of color and value diminish as objects recede into the distance, with lights becoming less light, darks less dark, until all contrasts merge into one uniform, medium-light tone.

atmospheric perspective

A drawing technique pertaining to landscape where the attributes of linear perspective are viewed through special atmospheric effects created by the artist in order to display a greater degree of spatial complexity uniquely altering the vision of perspective by reinforcing the illusion of depth.

printmaker). If J. Francis Murphy's *Untitled Drawing* (Fig. 13-14) were presented as pure line drawing, the illusion of space would be a factor of linear perspective. The addition of tonal gradations—lights to dark, then back to light—suggests not only light and shadow but also atmospheric space—hence, the operative of atmospheric perspective is in play.

John Singer Sargent's *View of Ponte Vecchio, Florence* (Fig. 13-15) moves from the deep, rich, shadowed foreground to a fully lighted middle distance to a broken pattern of halftones beyond. It seems likely that Sargent developed the dark tones first in order to determine how to fully develop the intermediate values, preserving the pure light tone of the paper for the sunlit buildings beyond the bridge. The full and convincing illusion of light and space results from the skillful combining of aerial and linear perspective. We see the same phenomenon occurring in the more modern work of Sidney Goodman in his blended charcoal drawing *East River Drive* (Fig. 13-16). This is another excellent example of both linear and aerial perspective at work as the tonal gradations

13-15. JOHN SINGER SARGENT (1856–1925; American). *View of the Ponte Vecchio, Florence*. 1870–1872. Pencil on cream wove paper, 3 3/4 × 5 3/4″ (9.5 × 14.6 cm.). Corcoran Gallery, Corcoran Museum of Art, Washington, D.C. (gift of Miss Emily Sargent and Mrs. Violet Sargent Ormond).

13-17. JOSEPH STELLA (1887–1945; American). *Bridge*. c. 1908. Charcoal on laid paper, 14 9/16 × 23 1/2" (37 × 59.7 cm.).
Carnegie Museum of Art, Howard N. Eavenson Memorial Fund, 58.62.

move from light to dark and back to light again, all encased in the defining structure of linear perspective as the trees and buildings shrink in size and recede into the distance.

In Joseph Stella's *Bridge* (Fig. 13-17), drawn in Pittsburgh early in the century, simplified silhouettes of structures seem to dissolve into fog and smoke. Nothing is delineated with the clarity seen in Sargent's Florentine view. Stella used an eraser to recover the white of the snow-covered foreground, but his strongest light and dark remain separated by transitional gray tones of poetic atmosphere. Even within the density of atmosphere, Stella produced a powerful spatial relationship between structures in this evocative transformation of the industrial city.

The diminishing of values that creates the effect of aerial perspective is not dependent solely upon the graduated tones that can be achieved with graphite or charcoal. Canaletto's *Veduta Ideata* (Fig. 11-8) demonstrates the use of **optical grays** that result from varying pressure and spacing of ink lines. The atmospheric effects of bleakness, stillness,

optical grays
The actual gray values that the eye sees resulting directly from a variety of drawing techniques, usually involving dry media that can be blended for heightened atmospheric effects.

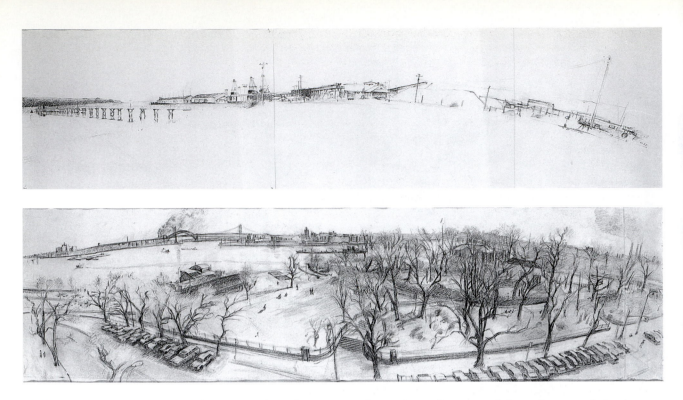

and isolation are the emotively powerful attributes of Rackstraw Downes's *The Searsport Docks* (Fig. 13-18), where the ivory wove paper serves as sky, sea, and land separated only by an almost nonexistent horizon line; nonetheless, the horizon line is strongly implied in the extreme panoramic format of the landscape composition.

We see the same effects of linear and atmospheric perspective in another work by Downes, *The East River with Gracie Mansion and the Triborough Bridge* (Fig. 13-19) as an eminently tangible visual portrayal of foreground, middle ground, and deep space defined once again by the descriptive properties of linear and aerial or atmospheric perspective. There is striking clarity in these two drawings, each atmospheric in its own way. Notice the distortion of the implied, arched horizon lines giving the viewer a greater sense of seeing from a distance while the artist simultaneously renders a high degree of detail and articulation as if the viewer were actually closer to the subjects, particularly in Figure 13-18.

Project 13.3

Select a landscape scene encompassing numerous levels of distance, and do a drawing in which you attempt to delineate clearly a sense of deep space. Remember that the boldest darks and the whitest highlights occur in the foreground. As you look at your landscape, see how as the scene moves into the distance, the light and dark contrasts merge into neutral gray tones. For the sake of creating a greater sense of drama in your drawing, keep in mind that there is still a slight, but ever-present, subtle value range within the distant space you are defining. To overlook this facet of deep space description is to somewhat deaden the spatial poignancy and mystery of the composition.

Next, try a brush-and-ink technique using full-strength blacks contrasting with white paper in the immediate foreground. Dry media such as charcoal, chalk, or crayon, and the wet medium of pen and ink work equally well to create bold textures in the foreground to contrast with paler textures in the distance.

Critique (Project 13.3) Compare your drawings with the actual landscapes you selected. Is there a convincing sense of extracted space in your drawn descriptions of those landscapes? Is the visual impact of the spatial dynamic you created greater or lesser than the actual sense of space you "feel" as you are standing while looking at the landscape? What media seemed to serve you most effectively? What visual attributes did each different medium contribute to the overall effects of your drawings? Can your drawings stand alone as successful visual extractions of the landscape? If so, what do you attribute this to? If not, what changes might you bring into effect to improve the drawings?

When first beginning to draw landscapes, artists often overlook the importance of cloud configurations in determining the overall character of the scene. Clouds, like land, trees, and buildings, are also subject to the laws of linear and aerial perspective; the size and distance between forms diminish as the clouds recede, as does the contrast between light and dark. Clouds are visually elusive and can be difficult to describe in the context of a landscape. Skies, however, because of clouds, are very easy to draw attention to, and one must remember not to overdraw cloud formations.

Project 13.4

Do a series of skies with different cloud types—cumulus, cirrus, stratus, and so on. (You may need to look up the different images of various cloud formations in order to recognize them as such.) Rub charcoal or powdered graphite into your paper to produce a graduated gray ground, darker at the top of the page, lighter as you near the intended horizon. Wipe out cloud patterns with a chamois or eraser. You will soon discover that the difference between clear sky and clouds is often ethereal, and you may not always fully realize whether you are drawing clouds, sky, or some of both. This searching activity in the drawing process will tend to give character and animation not only to your depictions of clouds but also to the drawing surface. Consider also that clouds tend to appear more rounded overhead, becoming progressively flatter and more horizontal as they near the horizon.

Try another set of drawings where you purposefully give more attention to sky and cloud features than to the landscape elements. Try using an extremely low-positioned horizontal line on the page, devoting at least 80 percent of the picture plane to sky area. Again, this is not to overdraw the clouds but to focus more deeply on their subtleties and the way they are constructed. This will deepen your understanding of the immeasurable spatial factors that play into the use of sky elements when drawing landscapes.

Critique (Project 13.4) Have you described space effectively in your cloud drawings? Do the clouds intended to be overhead appear closer (as if they were the foreground of the sky) than the clouds intended to diminish gradually as they get closer to the horizon line?

How effectively did you use the media? Did you find the processes of addition (initially laying down the grays) and subtraction (performed with the eraser) to be a satisfying way to create?

Cityscape

Whereas nineteenth-century artists often chose to represent the picturesque charm of old or foreign cities, such as in Sargent's *View of the Ponte Vecchio, Florence* (Fig. 13-15), twentieth-century American artists sought to depict and give dignity to the raw, intense vigor of the modern industrial city. The city itself, with its bridges, buildings, rooftops, fire escapes, streetlights, fire hydrants, underpasses, and outdoor advertising,

becomes the subject, instead of just providing a background for human activity (Figs. 9-16, 9-17, 13-22).

The repetition of strong vertical shapes in contrast to the firm horizontal line across the foreground in Edward Hopper's *Study for Manhattan Bridge Loop* (Fig. 13-20) gives solidity to both subject and composition. The position in space and the volume of the buildings are emphasized through the broad simplification of linear perspective and light and shadow, respectively. Hopper partially relieved the severity of the geometry and perhaps mundane quality of the scene by giving prominence to the curvilinear design of the street lamp in the foreground and by utilizing the positive-negative aspects of the lamp, bridge structure, and broken roofline as they are silhouetted against the clear, strong light of the sky. There is some ambiguity, however, in each extreme side of the composition. Were these elements deliberately left only partially observed and drawn by the artist, or was his intent to carry the eye away from the less important focus of the lamp in the foreground while establishing the bridge structure and corner building solidly in the middle ground?

Robert Cottingham explains that he "got turned on to art" at the age of twelve when he saw a painting of an urban scene by Edward Hopper (Fig. 13-20) at the Whitney Museum. Cottingham's *Ideal Cleaners* (Fig. 13-21) reveals his fascination with what he describes as "that magic combination of neon, chrome, brick, and glass" of outdoor signs. A photo-realist, Cottingham uses his camera as a sketchbook to provide the slides from which he works. Before making a painting, he makes a preliminary drawing to establish a value scale.

Yvonne Jacquette, in her charcoal drawing *Park Row Aerial—Black and White* (Fig. 13-22), has adopted an idiosyncratic bird's-eye view of inner-city landscapes at night in which the forms of buildings are defined by patterns of lighted windows and life is depicted by the headlighted vehicles moving antlike through an intricate web of parallel and intersecting beams of lights.

13-20. EDWARD HOPPER (1882–1967; American). *Study for Manhattan Bridge Loop,* detail. Lithographic crayon on paper, entire work 8 5/8 × 11 1/8″ (21.9 × 28.3 cm). Addison Gallery of American Art, Philips Academy, Andover, Mass. (anonymous gift).

13-21. ROBERT COTTINGHAM (b. 1935; American). *Ideal Cleaners.* 1979. Pencil on vellum, 15 1/2" (39.4 cm) square. Courtesy of the artist.

Project 13.5

While you may not have a metropolitan view outside your window, do not neglect the urban setting in your search for subject matter. In older communities that have not been completely transformed by urban renewal, commercial buildings, particularly those facing away from the street, often provide considerable visual interest for artists. Rooftops and window designs of older apartment buildings are always interesting, as are the peculiarly structured buildings in industrial areas. Notice the pattern of light and shadow as the sunlight washes across the facade of a building. Often the sheer drama of light and shadow as it streams between buildings in early morning or near sunset provides a powerful source of artistic material. These types of subjects are not necessarily picture-postcard material. On the other hand, as artists search for these inner-city peculiarities and visually reinvent them, audiences become more appreciative of moments of light and shadow, even in the most unlikely places.

Draw from the most interesting sights you find with the intent to give importance to the visual effect of a place, rather than visual effect to the importance of a place. Try this first with any dry media, establishing a wide and interesting range of lights to darks. Don't hesitate, if you feel the impulse, to exaggerate the play of lights and darks and use this as a major compositional and structural device. The point is to see acutely the details in the ranges of value changes and shifts of light on surfaces that are ubiquitous to city life in an effort to draw out the beauty from within, just as any landscape artist would do with the countryside.

Seascape

Throughout time, water and the ocean have fascinated human beings and challenged the expressive powers of artists. The "sense of place" that we discussed earlier in this chapter is often what draws individuals to a particular spot along a shoreline. Part of the attraction lies in the

13-22. YVONNE JACQUETTE (b. 1934; American). *Park Row Aerial—Black and White*. Compressed and vine charcoal, 55 × 42″ (139.8 × 106.8 cm). Collection of Mr. And Mrs. Harry W. Anderson, Atherton, California. Stanford University Museum of Art.

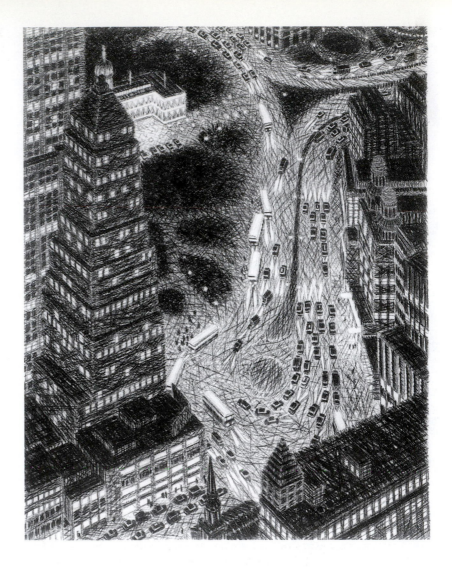

complexities of water: Its transparency and reflections, its unceasing movement, its color and moods, the turbulent excitement of its surface in storms, and its capacity to yield patterns of calm repose or unsettling tension have proved to be endlessly intriguing to all kinds of people. Artists are certainly not immune to this kind of spiritual attraction. In fact, it is the very thing that deepens an artist's desire to give visual tangibility to those visceral feelings. It is interesting to note how closely Van Gogh's bold reed-pen patterning (Fig. 13-23) parallels that in Vija Celmins's photo-realist study of waves (Fig. 13-24), and yet they are so different in size and scale, and media expression. Both works observe the gradual diminishment or lightening of tonal values as the space recedes.

Abstraction

The landscape serves as a basic artistic resource even for those artists whose concerns lie in abstracting relationships of form and space. We have discussed how linear and aerial perspective can provide the means for representing space in a somewhat orderly fashion. Michael Mazur, however, prefers to abstract landscapes by treating them as "ambiguous

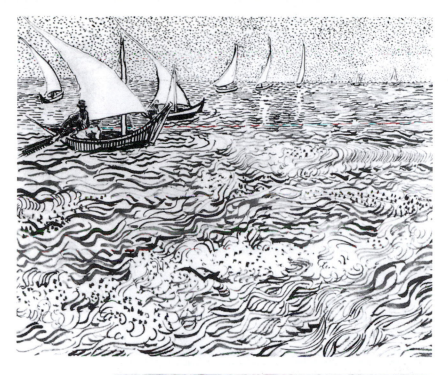

13-23. VINCENT VAN GOGH (1853–1890; Dutch-French). *Boats of Saintes-Maries.* 1888. Reed pen and ink, 9 1/2 × 12 5/8" (24.1 × 32.1 cm). Justin K. Thannhauser Collection, Solomon R. Guggenheim Museum, New York.

13-24. VIJA CELMINS (b. 1939; Latvian-American). *Untitled (Big Sea #1).* 1969. Graphite on paper, 34 3/8 × 45 1/2" (87.3 × 115.6 cm). Chermayeff and Geismar Inc. New York.

spatial illusions." The pastel drawing *Yard, November III* (Pl. 15), one of Mazur's many drawings and paintings of the view from his studio, reveals his preference for color rather than pattern and texture. Much of the spatial ambiguity results from the placement of color. In the immediate foreground an unbroken element—a corner post of the porch—extends from the top to the bottom of the drawing. Its color is violet; the adjacent color on the left is yellow. By choosing intense violet and very dull yellow, Mazur has reversed basic color theory of yellow as the most advancing color and violet as the most recessive. Another spatially puzzling element is that the strongest dark—the tree trunk at the right—appears in the middle of an area of color that is softened as though viewed through screens.

Let's look at another Mazur drawing, a black and white work in charcoal with smudging and erasing entitled *Landscape—Ossabow* (Fig. 13-25). This work is not nearly as ambiguous as the pastel in terms of its readability and descriptive qualities. Yet in a sense it is very

abstract. Mazur's devotion to the technical manipulation of his media has given us an interesting depiction of plant life as if seen through a thick glass. The ambiguity rests with portions of the image going in and out of focus, although we are assured of their positions in space within the picture plane. These are both masterful works—works that teach as well as stimulate our sensations.

Philip Pearlstein's *Ridged Rock* (Fig. 13-26) demonstrates that the term *abstraction* does not in itself preclude representational drawing. As he does with the human figure (Figs. 5-14, 14-14), Pearlstein transforms a strongly literal study (here of rock formations) into an abstract composition by cropping the subject to eliminate necessary clues that would allow the viewer to relate the shapes to a specific location. Probably everyone has experienced the inability to recognize a very familiar object as seen out of context and without certain critical details that would permit immediate identification. This is a testament to the visual power of analytical abstraction, where we see form only, not meaning, association, or context.

13-26. PHILIP PEARLSTEIN (b. 1924; American). *Ridged Rock.* 1956. Ink wash on paper, 18 3/4 × 24 3/4″ (47.6 × 62.9 cm).
Courtesy of the artist.

Project 13.6

Abstraction involves analysis, alteration, simplification, and reorganization, all without losing the essence of the subject. Do some drawings that evoke a feeling of growth in nature without relying upon naturalistic or obviously symbolic representation of landscape elements. Study the structure of bare trees or look up into a tree from below and make a series of drawings suggested by the branching patterns, attending to the negative spaces as well as the branches. Develop drawings that are rich in line, pattern, texture, and value without concern for specific details. Think of this series also as the development of more sophisticated visual attributes that evoke a spiritual sense of dynamic space, of atmosphere and atmospheric layering, of a sense of "place." Use whatever media and techniques seem expressionistically appropriate and right for the subject.

Critique (Project 13.6) These are appropriately more abstract questions than in earlier critiques. Try to follow suit with the development of your thought processes just as you are developing technical procedures for abstracting images.

What kinds of essences do these drawings emit? Are there signs, indications of what these images were construed from? What degree of abstraction would you say works best for these images as convincing drawing compositions? Is there a strong sense of connection between the image and its source? Do you feel that there needs to be some visible connection or not? Is there a sense of emotion transmitted from these visual statements? Is there a sense of meaning or association that helps define a new context for these images? And finally, the familiar question: How would you feel about these drawings if someone else had done them?

14 Figure Drawing

The nude figure does not simply represent the body, but relates it, by analogy, to all structures that have become part of our imaginative experience.

—Kenneth Clark

The human figure was depicted in prehistoric cave art as a crudely simplified symbol compared with the extraordinary realistic images of bison, cattle, horses, and deer. We see this early form of human stick figure animation in the hunt scene (Fig. 14-1), where slightly greater detail, sense of three-dimensionality, and more correct proportion, particularly about the head and horns, is given to the body of the bull. As early civilizations evolved, the human figure came to be represented according to stylized conventions dictated by concepts of life and spirituality. Figures in Egyptian art, based on conceptual images rather than on direct observation, combined profile and frontal views into the same image (Fig. 14-2); differences in **scale** designated degree of importance rather than **spatial** relationships. Later, Greek and Roman artists developed remarkable skill in depicting the complex form of the human body, mastering the proportional relationships of its parts and the principles of foreshortening (Fig. 14-3). With the emergence of Christian art in the fourth century, and for almost a thousand years thereafter, **anatomical drawings** of the human figure were replaced by more symbolic, even stylized forms stressing the spiritual rather than the physical qualities of its visual presence. By the beginning of the fifteenth century, the human figure reappeared to become the dominant theme in Renaissance art and established a tradition that continues to absorb experienced and inexperienced artists.

Anatomical Drawings

In the years of the European Renaissance with its heightened focus on the visual, the need to understand natural phenomena and their

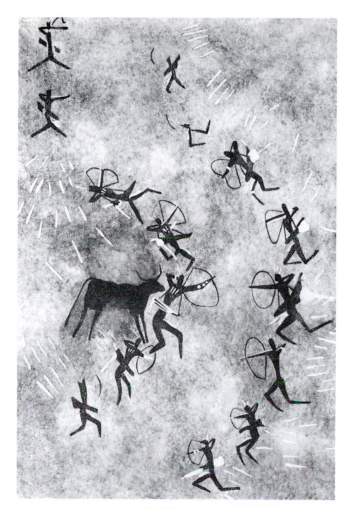

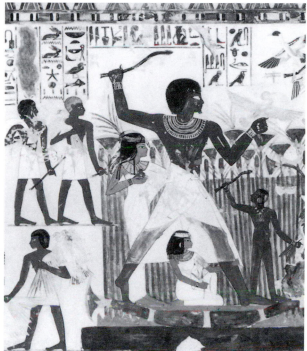

14-1. *above, left:* Facsimile of neolithic rock painting: A fight, apparently for possession of a bull. Khargur Table, Libyan Desert. Frobenius-Institut, Frankfurt am Main.

14-2. *above, right:* Duck hunting and fishing scene, detail of wall painting from tomb of Nakht, Sheikh abu el Qurna. c. 1425. Copy in tempera.
The Metropolitan Museum of Art, New York.

14-3. *left:* Karneia painter. *Detail of red-figure lerater.* Ceglie del Campo, c. 410 B.C. Terra Cotta.
Museo Nazionale, Toronto.

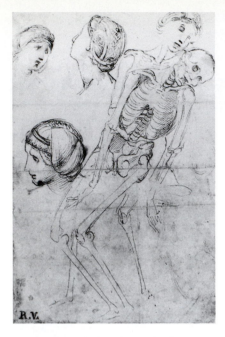

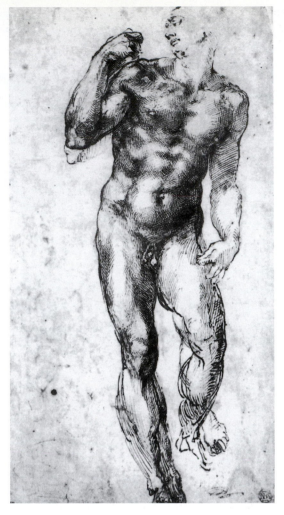

14-4. *above:* Attributed to Raphael (RAFFAELLO SANGIO, 1483–1520; Italian). *The Virgin Supported by the Holy Women,* anatomical study for the Borghese Entombment. c. 1500–1507. Pen and brown ink over black chalk, 17 7/8 × 12" (45.4 × 30.5 cm).
British Museum, London (reproduced by courtesy of the Trustees).

14-5. *right:* MICHELANGELO (1475–1564; Italian). *Figure Study.* Pen and ink. Louvre, Paris.

interrelationships led to the inevitable merging of artistic and scientific inquiry—the catalyst for the development of linear perspective (Chapter 9) and the study of human anatomy. Not satisfied with mastering outward appearance, artists developed a curiosity about the underlying structure of the body and by the late fifteenth century were engaging in the clandestine dissection of cadavers. Raphael's rather scrutinizing study is evidenced in a preliminary sketch entitled *The Virgin Supported by the Holy Women* (Fig. 14-4).

Only meticulous study of anatomy with the resultant understanding of the forms of muscles, bones, and tendons, as they interlock and combine below the surface to create projections and hollows could have made possible the superhuman figures with which Michelangelo populated his world (Fig. 14-5). These powerfully muscled bodies—with their small heads, hands, and feet, and their great torsos, thighs, and arms—are convincing because they are based on a profound, studied knowledge of bone and muscle structure. The musculature clearly articulated in these drawings is less evident when one looks at a living nude figure. Nonetheless, the grandeur of Michelangelo's figures was such that they established a stylistic ideal that was perpetuated throughout the Baroque period and into modern times.

With their new understanding of the human body, Renaissance artists moved from direct observation to creating ideal figures by establishing

14-6. LEONARDO DA VINCI (1452–1519; Italian). *Vitruvian Man*, the study of human proportions.
Venice, Gallerie dell' Accademia.
ARS, New York.

a system of proportions as the ancient Greeks had done. Leonardo da Vinci's drawing relating the male body to the perfect geometric forms of the square and circle is the best known example of this systematic approach to human proportions (Fig. 14-6). C. Bruce Morser has transformed Leonardo's study into an exceptional medical illustration (Fig. 14-7) that includes bone and muscle structure as well as diagrammatic illustrations of the movements of the body parts.

Project 14.1

Studying and drawing the nude figure permits one a clearer understanding of proportion and construction. Have a model take a standing pose, feet slightly apart, one arm hanging at the side and the other hand on the hip. While away from drawing class assignments, or if no model is available, use a full-length mirror in which you can see your reflection from head to feet. (Renaissance artists depended upon their students and apprentices as models; hence the preponderance of male nudes in the art of that period.)

Measure the distance from the chin to the crown of the head (use the system of optical measuring described in Chapter 3); calculate the number of "head heights" composing the total height of the figure. Use that same unit of measurement to determine the placement of nipples, naval, groin, knees, ankles, elbows, and so on. Draw in charcoal or soft graphite to facilitate erasures and changes.

Critique (Project 14.1) Is there a natural sense of proportion to your first figure drawings? Having a good amount of experience with the dry media thus far, are you now better able to use the charcoal or graphite descriptively, through additions and subtractions (erasures)?

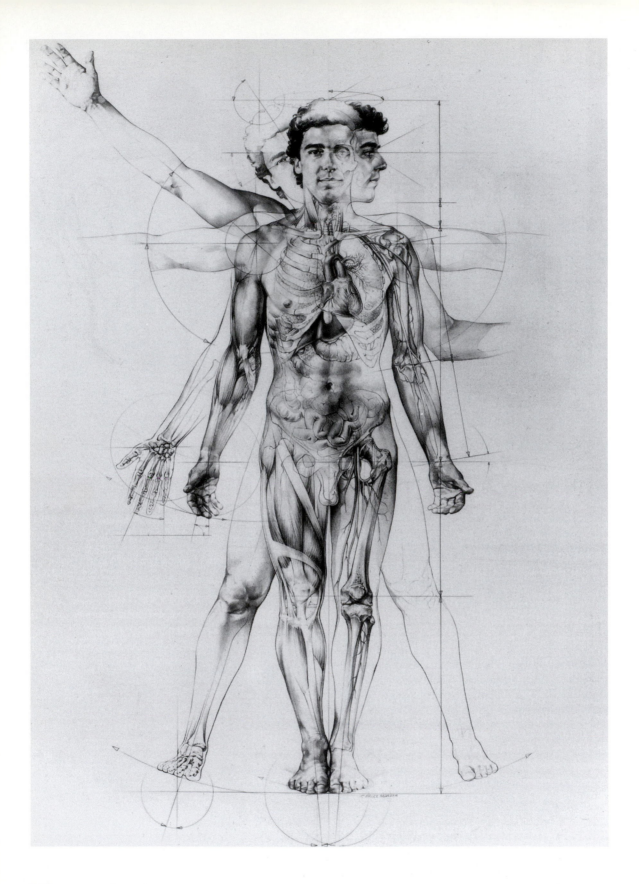

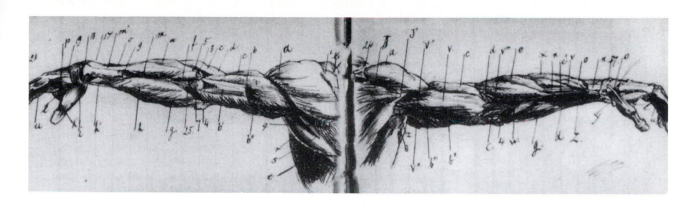

The papers of sculptor Adolf Alexander Weinman indicate that two times a week for two years he drew from skeletons and cadavers in a class in anatomy for artists at Columbia University's College of Physicians and Surgeons. Anatomical study from one of Weinman's sketchbooks (Fig. 14-8) shows the muscles of the left arm viewed from the back (left) and from the front (right). Once an integral part of life-drawing classes, the study of anatomy is only occasionally incorporated into today's curriculum, sometimes as a series of anatomy plates to be executed. Some instructors, however, continue to lecture on the subject, drawing diagrams on the chalkboard and pointing out on obliging models the relationship between tense, bulging muscles and the bony protrusions of the body (shoulders, elbows, ribs, knees, ankles, and so forth), helping students analyze what they see. An awareness of the body's basic construction is of obvious assistance in drawing the human form, since inner structure influences outward appearance. It is the intention of this chapter that you become highly aware of the beauty of the live human form so that you can apply what you've learned about the natural movements of the body to other life forms as well. As a supplement to this chapter, you will find value in looking at one of the standard artists' anatomy books while drawing from a live model (Peck, Stephen Rogers, *Atlas of Human Anatomy for the Artist,* New York: Oxford University Press, 1951; Brown, Clint and Cheryl McLean, *Drawing from Life,* Fort Worth: Harcourt Brace Jovanovich, 1992).

14-7. *page 260:* C. BRUCE MORSER (b. 1954; American). Copyright 1987 by Bruce Morser. All rights reserved.

14-8. *above:* ADOLPH ALEXANDER WEINMAN (1870–1952; American). *Anatomical study,* (sketchbook page). Ink on lined paper, 4 × 14 3/4″ (10.2 × 37.5 cm). Adolph Alexander Weinman Papers, Archives of American Art, Smithsonian Institution.

Project 14.2

Almost every art department can provide a skeleton, or a plastic replica of one, for study purposes. Although such skeletons are generally seen hanging from a stand in a decidedly lifeless manner, it is possible to move the limbs into positions approximating those of a living figure. Study the skeleton to become familiar with the underlying structures of the body. As you look at the different positions assumed by the skeleton, replicate those same positions with your own body to feel the sense of musculature and the various tensions placed on the limbs and joints to gain an intuitive sense of movement, flexibility, and gravitational weight of your own body. This exercise greatly aids the development of one's artistic instinct and helps provide a working understanding of the human body.

Having just mimicked the movements and different positions of the skeleton, continue to consider your own inherent skeletal structure with regard to twisting, turning, stretching, bending, and the general ease and grace with which you move. Sense the way each shoulder can be moved independently; feel the rotation of your upper arm in the shoulder socket as you extend your arm over your head. Notice the simple change that occurs by turning your hand front to back as your arm hangs at your side. Extend your arm, palm up, and then as you reverse the position of your hand, palm down, notice how the two bones of the lower arm respond.

Project 14.3

Do a drawing using dry media, again preferably charcoal or soft graphite, of the skeleton in a more interesting and challenging pose. Place the skeleton in a seated position on a wooden ladder-back chair with one leg crossed over the other and one arm raised and resting on the top corner of the chair's back. Position the head in a slightly turned pose in either direction. You may have to use white string to temporarily tie the limbs in these positions and to stabilize the seated skeleton on the chair's seat against any sudden gravitational shifts with the arms or legs, etc. Select an interesting viewing position, not too far away, and study what you see before you. Take your time and draw everything, including the chair supporting the skeleton. Describe the forms as they exist in space and in relationship to each other. Draw the entire forms of chair and skeleton as if the skeleton were transparent; if your vantage point is from the back side of the chair, draw the entire forms of skeleton and chair as if the chair were transparent, allowing full visual description of each.

Later, it will be useful and further challenging to superimpose over your original a drawing, perhaps in colored pencil or red Conté crayon, of a nude model seated in the same position as the skeleton on the same chair. Using a colored medium for the seated live nude will help avoid linear confusion by distinguishing what you are presently drawing from what you've already drawn. You should notice your drawing becoming dimensionally alive, spatially active, and powerfully illusionistic. Practice this procedure several times, changing the positions of chair and skeleton. As you continue working in this way over a period of time, your understanding of different forms and their interrelationships will deepen significantly.

Life Drawing—The Nude Model

life drawing

The act of drawing from live models in order to record the movement, gesture, and essential physical capabilities of the human body as an aesthetically pleasing art form. Also, drawing from life in order to gain a mechanical as well as visual understanding of live forms and how they exist and move in space.

Drawing from a live model—**life drawing**—serves as the principal discipline whereby students acquire knowledge of and sensitivity to the intricacies of the human form. The vitality that results in drawing from a live model cannot be duplicated when drawing from plastic models, plaster casts, or photographs.

In most life-drawing sessions, quick poses held for one to five minutes provide the student with a warming-up period and a chance to relax in the studio arena. Quick poses are generally more animated than longer poses. Note the stellar capturing of movement and exuberant expression of the human figure in Jacopo da Pontormo's gesture drawing *Dancing Figure* done in red chalk (Fig. 14-9). No matter how brief the pose, it is valuable to devote the first seconds or minute to looking at and projecting oneself into the pose before beginning to draw. Quick gesture sketches, using charcoal or soft stick graphite, are beneficial and best executed on an 18 × 24-inch newsprint pad allowing for larger drawings and greater utilization of the picture plane. Since gesture drawings are done rapidly, the pages can be easily flipped for frequent starts on fresh pages. In a soft graphite gesture drawing far more complex than Pontormo's single dancing figure, Susan Rothenberg has utilized the gesture line to build density into her untitled figurative composition (Fig. 14-10). Note the extended vocabulary of line variation and how descriptive of movement and rhythm the linear elements become throughout the composition..

The figure studies in Figure 14-11—drawn by Käthe Kollwitz, probably when she was a student—are typical of twenty- or thirty-minute poses, which usually follow the *warm-up gesture* and *quick drawing* periods and permit more fully developed drawing with some modeling of forms in dark and light masses in addition to some indication of

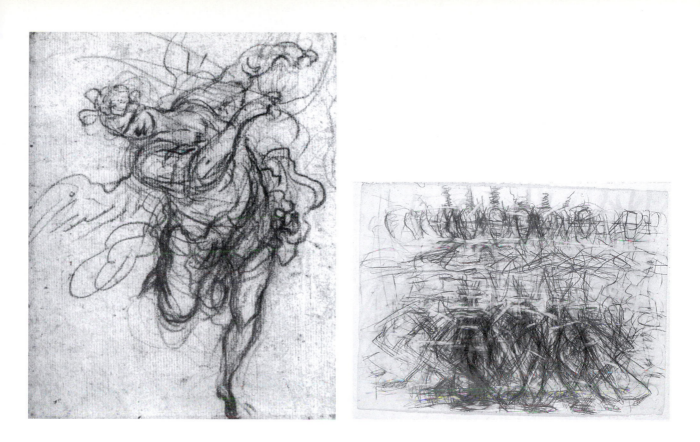

anatomical details. Except for one pose, Kollwitz has avoided outlining the figure. Instead, she has introduced background tones to establish contours, in some areas allowing the outer contour to disappear by merging shadows on the figure with the background as tones of the same value. While the diagonal marks slashed across the sheet suggest some dissatisfaction with the drawings, we can learn much by studying her use of lights and darks to define volumes and their placements in space. It is also interesting to notice her sense of proportional logic along with her understanding of the underlying structures of the different figures in their respective positions. Notice in particular the standing figure's left leg—the knee in a locked position—defined by dark accents at the hip and the knee.

Jacopo da Pontormo's *Study for the Pieta* (Fig. 14-12) suggests the kind of drawings a skillful student could accomplish in thirty minutes. Pontormo assertively develops a chalk drawing of three human forms with line variations and blending of tones to delineate musculature, bone, and flexibility of joint movements, all poignantly described and deriving expressive life from the dry medium.

After the longer sketching period, the model generally assumes one pose for the remainder of the session. It is a good idea to take breaks at timed intervals for the benefit of both model and student when drawing from an extended pose. Repeating the same pose at successive class meetings allows the student to complete a more fully developed drawing over a longer period of time.

Whereas college and university art departments and art schools provide regularly scheduled life-drawing classes as part of the curriculum, students working independently often have only limited access to models. The cost of employing a professional model is generally

14-9. *above, left:* JACOPO DA PONTORMO (1494–1556/7; Italian). *Dancing Figure.* Red chalk. The Metropolitan Museum of Art; Gift of Cornelius Vanderbilt, 1880.

14-10. *above, right:* SUSAN ROTHENBERG (b. 1945; American). *Untitled.* 1987. Graphite on paper, 22 3/8 × 31" (57 × 78.8 cm). Collection of Charles Lund.

14-11. KÄTHE KOLLWITZ (1867–1945; German). *Four Female Nude Studies.* 1888–1889. Charcoal (55.4 × 42.2 cm). Cologne District Savings Bank, Käthe Kollwitz Collection.

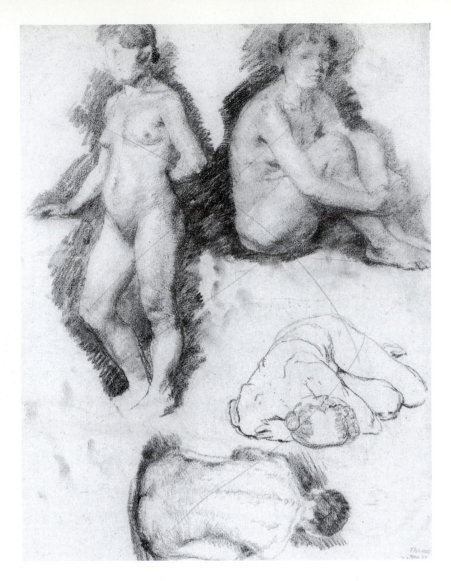

14-12. JACOPO DA PONTORMO (1494–1556; Italian). *Studies for the Pieta.* Chalk, 7 × 9 3/8″ (17.8 × 23.8 cm). Museum Boymans-van Beuningen, Rotterdam.

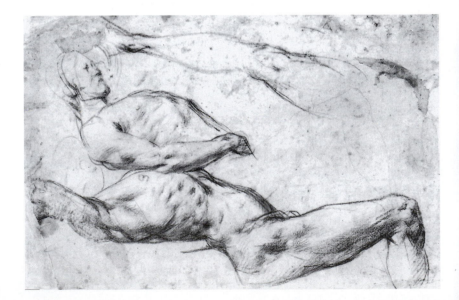

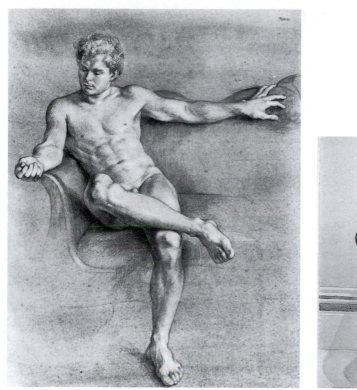

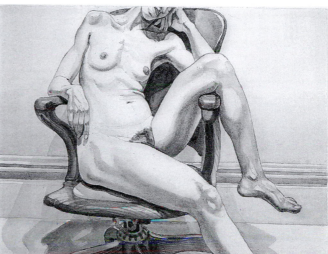

prohibitive for most art students. Even professional artists who enjoy and find value in weekly life-drawing sessions join together to share the expense of engaging models. Some adult education programs provide figure-drawing classes that attract both beginners and professional artists; local art associations sometimes organize life-drawing sessions for their members. The models' fees are generally divided among the participants so that the cost to each person is minimal. While individuals have little control over the model and length of pose, a variety of poses and lengths of time should be incorporated to facilitate the needs of everyone.

From Renaissance times to the present, artists have taken pleasure in enacting the beautiful drawings of the human figure, sometimes as studies for projected paintings, prints, or sculptures, but just as frequently for their own sense of satisfaction. The figurative tradition multifariously continues in drawings ranging from the lyric classicism of Paul Cadmus (Fig. 14-13) to the articulate realism of Philip Pearlstein (Fig.14-14) and on to the metaphorical and melodramatic images of Alfred Leslie (Fig. 14-15).

14-13. *above, left:* PAUL CADMUS (1904–1999; American). *Male Nude NM 50.* Crayon, 24 × 18 1/8". (61 × 46 cm). Private collection.
Courtesy of Midtown Payson Galleries, New York.

14-14. *above, right:* PHILIP PEARLSTEIN (b. 1924; American). *Nude Sitting on a Chair.* Brush and brown wash on white wove paper, 22 3/8 × 30 1/4" (568 × 769 mm).
The Jalane and Richard Davidson Collection.
© The Art Institute of Chicago. All rights reserved.

Project 14.4

The novice in life drawing derives the greatest benefit from working no more than half an hour on a single pose. Approach a thirty-minute drawing in exactly the same manner as the quick gesture—the five-, ten-, and fifteen-minute poses— using the preliminary contour lines to indicate the essential shape of the full figure. Then, as in Project 14.5, begin to establish general size-and-shape relationships of all the individual parts by laying in tone, using the measuring devices described in Chapter 3. Be alert to the formation of the negative spaces as they define the positive shapes.

Beginning students have a natural tendency to start by drawing the head, then slowly working their way down the figure, often running out of paper before they reach the feet. Learn to utilize the full sheet of paper for the full figure by studying the

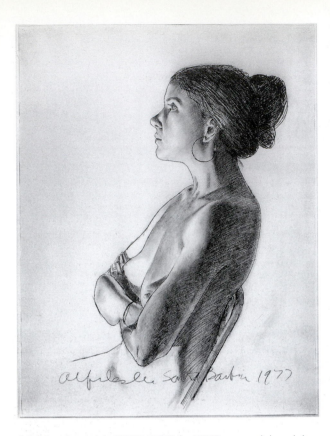

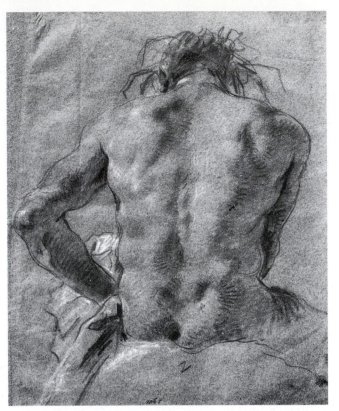

14-15. *above, left:* ALFRED LESLIE (b. 1927; American) *Santa Barbara.* c. 1977. Graphite with smudging and erasing on white wove paper. 40 × 30" (1,016 × 762 mm). The Jalane and Richard Davidson Collection. © The Art Institute of Chicago. All rights reserved.

14-16. *above, right:* GIOVANNI BATTISTA TIEPOLO (1696–1770; Italian). *Nude Back.* Chalk on tinted blue paper, 13 9/16 × 11" (34.4 × 28 cm). Staatsgalerie, Stuttgart.

model and then visualizing the entire figure on the page before you start drawing. Start with a lightly drawn sketch to determine the overall height and width of the figure, and then begin to break up the space, locating the shoulders, hips, knees, and so on. Remember to check the width of each form in relation to its length. Sometimes, even when the length is correct, an arm or leg will appear too long or too short because it has been drawn too thin or too wide. As before, incorporate broadly simplified patterns of light and dark to provide a sufficient indication of volume.

Project 14.5

As you become more skilled, you will benefit by increasing the time spent on individual drawings of the figure. Begin to broaden your use of dry media. For more fully developed studies from longer poses, use a harder graphite stick or black Conté crayon as these will not smear as easily, they permit reworking, and they can be used successfully in conjunction with each other. (To incorporate a simple color, try red and black Conté crayon with hard graphite on the same drawing.)

You will want to work on good quality charcoal paper, heavy drawing vellum, or Bristol board (something with enough tooth or grain to take the particles of the dry media successfully (Fig. 10-5). Have your model assume a comfortable, seated pose, since you might well spend a total of three or four hours developing a finished drawing. Illuminate your subject with a strong light to reveal the anatomical forms. A muscled back, properly lighted, offers an interesting play of convexities and concavities (Fig. 14-16). Study the model carefully and build a sense of form through the use of chiaroscuro. Use empty areas on your paper to make separate studies of difficult forms, as suggested in Figures 14-4, 14-11, 14-12).

Hands and Feet—Foreshortening The Austrian artist Herbert Boeckl is quoted as instructing his life drawing students, "Draw the feet—draw the hands—the rest is easy." Feet and hands, perhaps the most complex and problematic parts of the body, rarely receive sufficient attention in

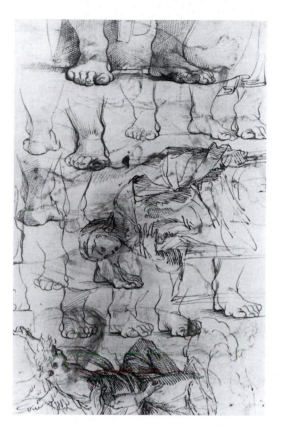

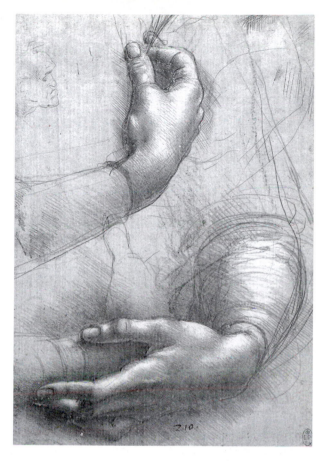

most student drawings. Because they are more complex body forms, they are more difficult to draw, and students often avoid them by allowing them to disappear off the edge of paper. In a simplified sense, a leg or an arm is a similar, jointed, flexible form, only much larger than a finger or toe. An instructional sheet of drawings of feet by Agostino Carracci (Fig. 14-17) and a study of hands, wrists, and forearm foreshortening by Leonardo da Vinci (Fig. 14-18) reveal a concern with mastering the complexities of form present in the extremities, recognizing that the hands in particular (Michelangelo and Leonardo) fulfill a significant expressive function. No matter how well the head and torso are drawn, poorly drawn hands and feet substantially diminish the effectiveness of the figure. (The accumulation of details seen in Figures 14-17 and 14-18—in particular, the Carracci feet drawn over an earlier study of an *Annunciation*—suggests that during earlier periods, when all paper was hand-made, it was not only scarce, but a precious commodity.)

14-17. *above, left:* AGOSTINO CARRACCI (1557–1602; Italian). *Feet, over an earlier sketch for an Annunciation.* c. 1595. Pen and brown ink, 10 1/4 × 6 3/8" (26 × 16 cm). Royal Library, Windsor Castle, England (reproduced by gracious permission of Her Majesty Queen Elizabeth II).

14-18. *above, right:* LEONARDO DA VINCI (1452–1519; Italian). *Study of Arms and Hands, based on Verrocchio's Lady with a Bunch of Flowers.* c. 1475. Royal Library, Windsor Castle, England.

Project 14.6

Select a dry medium and do extended studies of hands, feet, and heads of differing sizes, filling several entire sheets of paper. The foreshortening of hands and feet presents a major challenge (keep in mind, as has been mentioned often throughout this text, that seeing intently and accurately is imperative to understanding form in order to draw it well). If no model is available, use yourself. Figure 14-19 appears to be a drawing of Degas's own leg and foot. Remember that your task will be simplified if you concentrate on drawing size-and-shape relationships, rather than thinking about drawing hands and feet. Do several drawings until you see improvement and have gained confidence in this important area of drawing.

14-19. EDGAR DEGAS (1834–1917; French). *Sketch for Man's Leg* (probably the artist's). *Seen Foreshortened from Above.* Bibliotheque, Nationale, Paris.

One of the most challenging aspects of life drawing is that almost any view of the figure involves some degree of foreshortening—and indeed, the most interestingly descriptive drawings possess well-rendered views of foreshortened body parts (Figs. 3-3, 3-4, 3-6, 5-13, 5-14, 14-19, 14-20, 14-32, 17-24). An understanding of the figure based on a simple frontal standing pose is not sufficient to allow you to handle a more complex— and more visually interesting—pose. Initially it will be difficult to draw a figure seen at an unusual angle; but it will be easier if you concentrate on drawing *shapes* rather than *body parts,* and also if you use alignments and other visual aids to clarify what you see. If you were looking at the model for Ludovico Gimignani's *Hercules* (Fig. 14-20) rather than his drawing, you might not be aware that the figure's right shoulder appears at nearly the same level as his mouth, the top of the right hand is one head length below the chin, the extended lower left arm is a full arm's width lower than its counterpart, the thickness of the body at the waist is equal to the length of the head, the right knee appears higher in space than the bottom of the left buttock, and the left knee and right heel are centered under the chin. Such observations—similar to those made for Figure 3-6—are made as you study the model either before you commence drawing or when you pause to check alignments and proportions as you draw. Although the body parts were named for this analysis, you are urged to think only of shapes as you draw.

Project 14.7

To do a drawing that involves maximum foreshortening, pose the model in a reclining position so that you see the body from head to toe or vice versa. Allow the model to lie in a relaxed pose, perhaps with one arm extended above the head. For a more

14-20. LUDOVICO GIMIGNANI (1643–1697; Italian). *Study for the Figure of Hercules.* Red chalk, heightened with white. Gabinetto Nazionale delle Stampe, Rome. (154)
Inv. Vol. 158-H-Z, 1277746 recto.

visually interesting composition, view the figure from a slight angle. Focus again on drawing size-and-shape relationships as you *see* them, not as you *think* them to be.

Project 14.8

Degas recommended platforms of various heights so that by switching positions, the artist could view the model from above or below. Sitting on the floor below a model standing on a desk or solid table, or vice versa (you standing on the table looking down at the model standing on the floor), will provide you with an exaggerated foreshortening of the figure.

Do several studies from these various positions until you have a greater understanding of the foreshortened positions of the human figure's parts and their correct size-and-shape relationships.

Critique (Projects 14.7, 14.8) The most important thing to assess in your foreshortening drawings is whether you've attained a convincing image of the figure read as a foreshortened image. In Project 14.6 you were instructed to pay attention to the size-and-shape relationships of the figure as you saw them, not as you know them to be. Were you able to set aside preconceptions of the human figure well enough to draw a convincingly foreshortened form? Did you find several good compositional views of the figure as you repositioned yourself or the figure between drawings? Does the foreshortened element in your drawing lend itself to a more dramatic reading of compositional space? Do you detect any exaggeration or distortion of the foreshortened forms? Finally, are your drawings expressive? Do they display skilled media handling along with sound compositional elements that you've learned in previous projects?

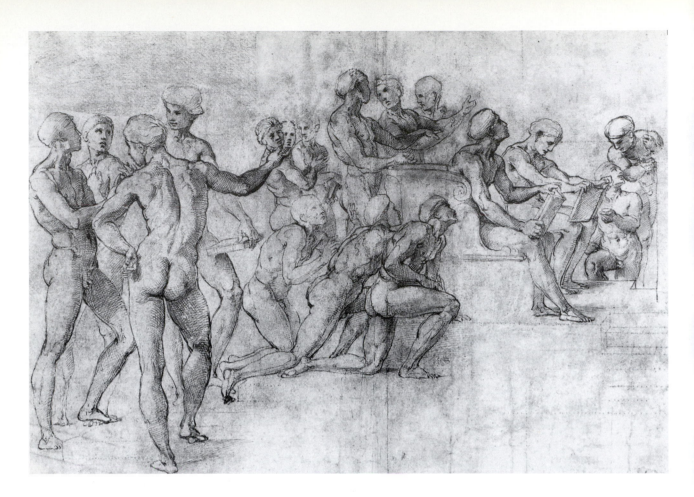

14-21. RAPHAEL (1483–1520 ; Italian). *Preliminary Study for "The Disputa."* Pen and ink, 11 × 16 3/8″ (28 × 41.5 cm). Stadelsches Kunstinstitut, Frankfurt am Main.

Figure Groupings Students may become skilled at depicting single figures but remain unable to compose a successful group of related figures collectively, largely because the problem is rarely addressed and the actual opportunity to do so never exists. Economic limitations restrict most life-drawing classes to a single model; only occasionally do two models pose together. One must realize, however, that large-scale paintings from history, often done with a cast too numerous to count, were composed from individual figure studies, combined with imagination, visual memory, and accumulated knowledge and experience (Figs. 4-1, 9-11, 14-21).

Project 14.9

The problem of integrating three or more figures into a single composition will be somewhat simplified if you work with two models, since certain spatial relationships can be directly observed. If only one model is available, consider carefully the placement and scale of each figure. Since figures must not appear to occupy the same floor space and also must appear to be drawn from a consistent point of view, an understanding of perspective will prove useful (Fig. 9-11). Without changing your position, relocate the model in space to conform to the composition; chalk marks on the floor will assist you in this. Include reclining, semireclining, standing, and foreshortened figures by positioning them in a variety of the necessary poses displaying foreshortened figural forms. Work on good-quality paper and in charcoal or graphite stick so that confusing overlaps can be erased or reworked suitably. It is possible to construct a multifigure composition from an accumulation of individual figure studies done at different times, as with the old masters, but unless all were drawn from the same eye level, an inconsistency in point of view will probably occur.

Gesture Drawing

Life drawings can appear lifeless and without vitality if the figure is treated only as an academic accumulation of parts and details rather than as a complete form having within it an essential line of movement called **gesture.** Having touched upon it previously in this chapter, let's explore the concept of gesture more thoroughly.

First of all, movement or gesture is not limited to "motion" in the sense of physical action. It is also the inherently intrinsic grace of movement of the human figure—and the provocation of the artist's sensibilities embodied in graphic form that stirs us deeply in response to the live, expressive human body. Raphael (Fig. 14-21), for example, has drawn the figure in multiple standing poses, yet not one shows the figure standing rigidly at attention. Each pose has a unique sense of movement, a gesture that characterizes the attitude of the figure. Looking at any figure, we tend to perceive the essential gesture before we become aware of anything else. In fact, the eye, more often than not, makes a rapid sweeping movement that corresponds to that gesture since we are naturally inclined to look at the whole before we proceed to examine the parts.

In **gesture drawing** the hand and the medium follow the same sweeping movements of the eye in setting down the gesture that sums up the pose or action. It might be accomplished with just a single line; sometimes the "searching line" discussed in Chapter 5 is more appropriate. Peter Paul Rubens's pen and brown ink with ink wash (Fig. 14-22)

gesture
The essential line or depicted state of movement of a live form.

gesture drawing
A drawing done for the sole purpose of studying gesture whose objective is to capture the essential, descriptive movements of live forms in space, whether human or animal.

14-22. PETER PAUL RUBENS (1577–1640; Flemish). *Studies for "The Presentation in the Temple."* Brown ink and wash, 8 3/8 × 5 1/2" (21.4 × 14 cm). The Metropolitan Museum of Art, New York.

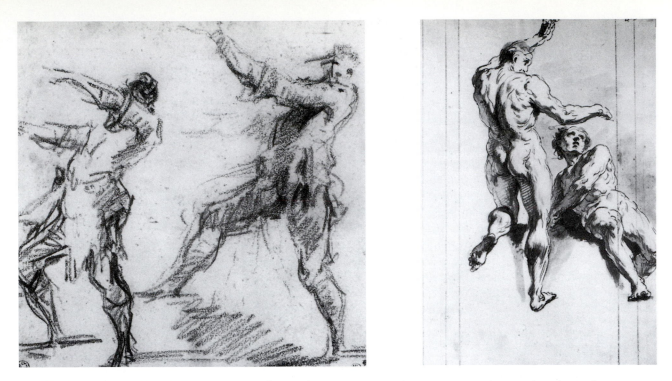

14-23. *above, left:* GIOVANNI BATTISTA PIRANESI (1720–1778; Italian). *Figure.* Black pencil and sanguine, 8 1/2 × 8 1/4″ (21.6 × 20.9 cm). Louvre, Paris.

14-24. *above, right:* Attributed to FRANCESCO FONTEBASSO (1709–1768/69; Italian). *Male Nude Standing and Gesturing and a Second Reclining.* Pen, dark brown ink, brown and gray wash over black chalk; 15 × 10 1/2″ (38 × 26 cm). Art Museum, Princeton University (bequest of Dan Fellows Platt).

combines the two approaches—one continuous brush stroke summarizes gesture and movement, not only of the models, but also of the hand and eye of the artist, while the searching pen line begins to give definition to the figures. What splendid visual poetry there is in these master works of figure drawing.

Quick thirty-second to one-minute poses allow for little more than a line or two to establish the gesture. Using the flat side of a piece of charcoal or crayon or a fully loaded brush allows mass to be suggested at the same time. Structure, contour, and detail follow after, depending on the length of the pose. Figures 14-22 through 14-24 are identical in concept, differing only in degree of definition and refinement. Francesco Fontebasso's greater attention to chiaroscuro produces a fuller sense of volume (Fig. 14-24). To see the gesture of the pose, one need only look at the core of the shadow as it moves from the back of the head to the left shoulder, then sweeps down the back, pausing slightly to describe the buttock before continuing down to the right ankle.

As we see in these masterful illustrations (exemplified by Leonardo da Vinci on the cover of this book and in Figure 17-5), the ability to capture gesture is what makes a drawing live.

Project 14.10

With your 18 × 12-inch newsprint pad and a stick of compressed charcoal, make several gesture sketches of the nude model. Gesture drawings resemble scribbled drawings that assume a descriptive form usually depicted in motion such as twisting, stretching, or bending. A gesture drawing should be done as quickly as possible from the entire visual impression the artist takes from the model. If the drawing becomes labored or too calculated, the gesture impression is lost. Think of the model as a hollow vessel inside of which a fast-moving marble is bouncing continually off the sides of the outer skin from head to toe. Then think of the pathway of the marble as a continuous line made with your charcoal in response to the form of the figure posed before you.

For beginners at gesture drawing, the tendency will be to draw with too much focus on the outline of the figure and not the interior mass, which ultimately describes

the volume, movements, and positions of the gesturing figure. If your drawings look too much like outlined figures, stop drawing and concentrate on the fast-moving marble bouncing inside the imagined shell (skin) of the hollow figure. The marble moves every possible way—laterally, longitudinally, through deep and shallow space, from extreme top to absolute bottom. Imagine the marble moving inside your own body. Then try drawing again; draw quickly—each gesture should take no longer than twenty to thirty seconds before the model assumes a new pose that describes motion.

Expect your gesture drawings to exhibit a highly energized and varied line, and be highly descriptive of the motion while revealing a powerful essence of the figure's different positions.

Project 14.11

After doing several quick warm-up gesture drawings on newsprint, draw a nude model in five-minute, ten-minute, and fifteen-minute poses. Use a more substantial paper this time with a short stick of compressed charcoal or soft graphite stick—1 inch or 1 1/2 inches in length (2.4 to 3 centimeters). Keep the flat side of the dry medium against the paper and build broad areas of dark rapidly with a back-and-forth motion. You might well begin your drawings as a slightly expanded version of the simplified skeletal drawings in Project 14.2. Establish the essential lines of movement—the gesture—followed by an indication of volume and size-and-shape relationships. As you become more confident, pay greater attention to patterns of light and dark. Leave the contour line until last and draw it in only as time allows.

Avoid the temptation to plunge into drawing without taking time to look at the figure and glean its essence. Your drawing activity will be better served if you would spend the first half of each pose studying the model—drawing with your eyes—before setting charcoal or graphite to paper.

Critique (Projects 14.10, 14.11) Do your gesture drawings come alive in describing the positions and movements of the human figure? Have they improved in their lifelike and descriptive qualities with the added experience of continually doing them?

How lifelike and descriptive are your five-, ten-, and fifteen-minute posed drawings? Do the tonal ranges and light and dark patterns you've established provide adequate definition of the human forms in space?

What might you improve about each of the above?

For longer poses and more detailed drawings, it is particularly advantageous to lay in a light gesture drawing first to provide an inner line of movement for the figure, as well as locating it on the paper. Without that initial indication of gesture, size, and position, it is all too easy to get caught up in drawing the figure piece by piece, losing in the process the rhythm, movement, and unity of the pose and the symbiotic, proportional relationships of the different parts of the body.

The Figure in Action

Depicting the figure in action successfully depends upon the ability to isolate and represent the essential underlying gesture of that action (Fig. 14-25). Life drawing presupposes a model's holding a pose without moving, if only for a short time, even when the pose is meant to convey an action or motion. No matter how skilled the model, the mere act of assuming a pose transforms animation and movement into a frozen and static form. It is in short one-minute (or less) poses that the model can most successfully convey the impression of movement, which means that quick sketches have a significance beyond that of warming-up exercises.

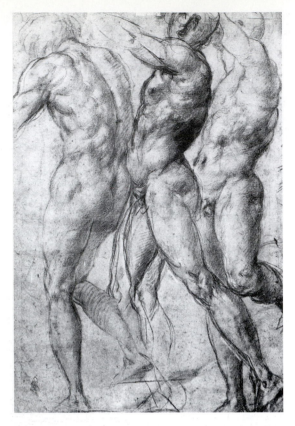

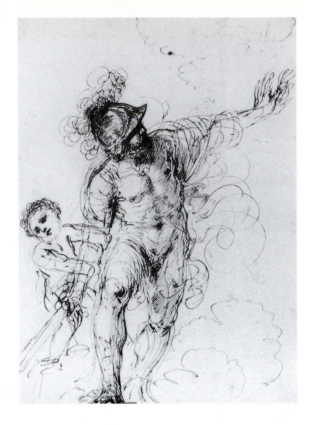

14-25. *above, left:* JACOPO DA
PONTORMO (1494–1556; Italian). *Three
Walking Men, Study for the "Story of Joseph"
Series.* Red chalk, 16 1/8 × 10 5/8"
(41 × 27 cm).
Musée des Beaux Arts, Lille.

14-26. *above, right:* GUERCINO
(1591–1666; Italian). *Mars and Cupid.*
c. 1645. Pen and brown ink on paper,
10 × 7 1/8" (25.4 × 18.1 cm).
Allen Memorial Art Museum, Oberlin College,
Ohio (R. T. Miller, Jr., Fund).

Many artists, skillful in depicting posed figures, cannot communicate a visually convincing sense of movement. One solution is to practice gesture drawing at every opportunity, always searching for the essential line or lines of movement that characterize a pose or action. Draw live figures in action as often as possible, projecting yourself into the action, re-creating as much as possible the physical sensation of performing the action (refer back to Project 14.10). Perhaps most important is honing one's perception of the way the structure of the body influences visible form. The slightest movement affects the whole figure; the slightest gesture results from a muscular response; the slightest change in position can alter the vitality of the image.

Observing master drawings may suggest how to approach the problems involved in representing figures in action. The figure of Mars that emerges out of the almost frenzied searching line of Giovanne Guercino's pen-and-brown ink drawing (Fig. 14-26) conveys the impression of sequential movement that is the basis of film animation.

Sweeping, curving lines implying both motion and transparent draperies carry the eye in an unbroken flow of visual movement from the dancer's ankles to her upraised arms in Matisse's fine drawing *Le Guignon* (Fig. 14-27). In delightful contrast to the smooth graceful arc of Matisse's dancer, Hokusia's *Mad Poet* leaps about with wild, carefree abandon (Fig. 14-28), his head, arms, and legs projecting at unexpected angles from a complex swirl of drapery and cascading pages of poems. It should be noted, however, that in spite of the poet's expansive gesticulations, the parts of the body have been thoughtfully positioned to ensure the effect of equilibrium.

It is interesting to compare Toulouse-Lautrec's poster image *Jane Avril* (Fig. 14-29) with the photograph of the famed Parisian entertainer herself

(Fig. 14-30). The photograph is obviously posed, since late-nineteenth-century cameras were not sufficiently sophisticated to capture a figure in motion. The poster reveals Toulouse-Lautrec's amazing ability to animate the figure through exaggeration of gestures and shapes, most evident in his drawing of the legs and feet, creating an image far more convincing than the photograph. The sense of equilibrium conveyed is similar to that of Hokusai's *Mad Poet*. This sense of the greater presence of life in a drawing than in a photograph is particularly evident in the field of **medical illustration** (Chapter 16), where it is important to portray more than a single, outer layer of vision. A drawing has a special ability to enhance a physician's understanding of three-dimensional forms within the human body.

Project 14.12

Draw figures engaged in relatively simple, repetitive motions—walking, running, or bending—beginning with quick gestural sketches to establish the lines of action. Next, attempt drawing a series of successive movements as overlapping images to suggest flowing, progressive movement. When you feel ready, undertake more dynamic movements. While dancers and athletes seem to be obvious subjects, their movements are generally much too rapid for a beginning artist. "Freeze framing" a videotaped sports event will allow you to study, perceive, identify with, and draw a sequence of movements. Avoid the temptation to spend too much time on individual images. As soon as you have indicated the essential gesture, advance the tape to reveal the figure/figures in the next slightly different pose (Fig. 14-25). Notice how Guercino (Fig. 14-26) employs directional line patterns to suggest roundness and describe weight and mass as well as movement.

14-27. *above, left:* HENRI MATISSE (1869–1954; French). *Illustrations for Mallarmé's "Le Guignon."* c. 1930–1931. Graphite pencil, 13 × 10 1/8" (33 × 26 cm). Baltimore Museum of Art (Cone Collection).

14-28. *above, right:* HOKUSAI (1760–1849; Japanese). *Mad Poet,* detail from a page of drawings. Ink on paper, entire page 15 5/8 × 10 3/8" (39.7 × 26.8 cm). Bristish Museum, London (reproduced by courtesy of the Trustees).

medical illustration
A type of illustrational drawing that offers visual clarity to medical conditions or anatomical circumstances, whether normal or abnormal, beyond that of a photograph since drawings have the capability to contain far more information than a camera is able to capture in an instant.

14-29. *above, left:* HENRI DE TOULOUSE-LAUTREC (1864–1901; French). *Jane Avril, Jardin de Paris.* 1893. Lithograph, 4′ 2 3/4″ × 3′ 5/8″ (1.3 × 0.94 m). Musée Toulouse-Lautrec, Albi.

14-30. *above, right:* Jane Avril, c. 1892. Photograph. Reprinted from *Lautrec by Lautrec,* by P. Huisman and M. G. Dortu. Published by Edita, S. A. Lausanne.

Critique (Project 14.12) Do your drawings evoke a sense of logical movement relative to the descriptive elements of your figure drawings? Do your drawings express a figural sense of having evolved from a previous state of movement through their present state and onward toward a future state of slightly altered movements? How might you improve upon them? Have the chosen media amplified the visual effects or detracted from them? How might you improve upon this aspect?

Drawing the Clothed Figure

Mastery in drawing the clothed figure equals the depiction of the nude form in importance but is often neglected in the training of beginning artists. The clothed figure represents a double challenge for the artist: drawing the body and the drapery. Solid background in anatomy and figure drawing gave a particular authenticity to Renaissance artists' treatment of costumed figures (Figs. 11-23, 14-22). We see another beautiful treatment of draped fabrics in the two clothed figures in Raphael's Renaissance masterpiece *Figures of the Greek Philosophers Plato and Aristotle* (Fig. 14-31). We have seen Raphael's skeletal study for his *Virgin Supported by the Holy Women* (Fig. 14-4); similar nude studies for paintings of the Madonna by Raphael also exist.

Skeletal and muscular details strongly influence the way clothing drapes on the body. Folds and creases are determined by the structure of the body, and it is important that they be accurately observed and rendered if the body inside is to be believable. While clothing can conceal as well as reveal, it is the later effect that is important. Still-life studies of cloth of various weights and textures draped over protrusions or layered by

14-31. RAPHAEL (1483-1520; Italian). *Figures of the Greek Philosophers Plato and Aristotle*. The School of Athens, painted in 1510–1512, in the Stanza della Segnatura in the Vatican.
Art Resource, New York.

falling into complex, natural folds, so often part of the basic drawing curriculum, provide valuable and necessary background for drawing the clothed figure, but as Robert Henri cautioned his students, "Without knowledge and sense of the body, wrinkles and folds remain wrinkles and folds."

Theophilus Brown's succinct graphite drawing *Seated Man* (Fig. 14-32) conveys a remarkable sense of physical presence—each fold and crease of the clothes lends emphasis to the weight and structure of the body underneath. The full weight of the figure settles solidly into the chair, the feet merely resting on the floor. Every logical and weighted fold of the clothing is familiar to us, as we have assumed the same seated position while having worn the same clothing.

Toulouse-Lautrec (Fig. 14-33), through the stance of his figure—the feet widely and firmly placed—allows no doubt that the weight of the man is on his feet. Whereas Brown delineated the patterns of folds with a certain precision, Toulouse-Lautrec offers only a few hints, a few directional, gestural lines describing the enveloping of the standing figure—coattail swung backward, flaring directionally off the contour of the right buttock while the trouser fabric projects forward, concealing but defining the volume of the hand in the pocket. By attending to the silhouette and selecting only a few details, he gives character to both the man and his well-worn suit. The heavy confluence of contour lines providing the sharp dark accent at the outer edge and bottom of the belly reveals more about the man's body than any other part of the drawing. Eliminating or changing those contours would considerably alter the character of the body. Significant also are the positions of the feet with toes pointing outward as if to express an air of security along with a sense of contented approval over something he sees—hence, the portrayal of the figure's *psychological state*.

14-32. *above, left:* THEOPHILUS BROWN (b. 1919; American). *Seated Man.* Graphite pencil. 14 1/2 × 11 1/2" (36.8 × 29.2 cm).
Courtesy of the artist.

14-33. *above, right:* HENRI DE TOULOUSE-LAUTREC (1864–1901; French). *Portrait of a Man.* 1899. Crayon, 19 1/4 × 11 3/4" (49 × 30 cm).
Louvre, Paris.

visual
That which is seen or takes form in the "seeing" process; also, one of the two extreme poles of artistic personality (the other being **haptic**) where visual people concern themselves primarily with the visible environment instead of their feelings, emotions, or bodily sensations.

Project 14.13

Practice drawing the clothed figure as often as you can, both inside and outside the studio. Make it a practice to take sketchbook and pencils along wherever you go and anticipate the act of drawing in unlikely places, as discussed in Chapter 4. Include the clothed figure as part of your ongoing drawing regimen. Since you are so constantly in the presence of other people, the possibilities are limitless—on campus, in the cafeteria, library, and classrooms, at shopping centers and outdoor cafes, at sporting events, even in church, wherever people congregate. Be continuously aware of the body inside the clothes and concentrate on revealing the physical, even psychological stance or gesture of the figures. (To study a variety of visual relationships between fabric texture, weight, and body mass, refer to figures 3-2, 3-3, 4-11, 8-6, 14-32, 14-33, 15-17, 15-21, 15-22, 15-23, 16-9, 16-10, 17-1, 17-5, 17-10, 17-13, 18-3, and 18-15.) In longer studies, learn to simplify the clothing, emphasizing lines, folds, and details that most poignantly define the body form. Refer again to the aforementioned list of figure examples and determine which of them use clothing in a simplified but highly descriptive way.

Temperament and the Human Figure

Viktor Lowenfeld, one of the most systematic students of the development of pictorial expression, perceived that various types of personalities react to visual experiences in different ways. He theorized that there are two main types of expression representing two extreme poles of artistic personality: the **visual** and the **haptic.** Visual people concern themselves primarily with the visible environment; their eyes constitute their primary instrument for perception, and they react as spectators to

experience. Haptic, or nonvisual, people, on the other hand, relate their expression to their own bodily sensations and the subjective experiences in which they become emotionally involved; they depend more on touch, bodily feelings, muscular sensations, and emphatic responses to verbal descriptions or dramatic presentations.

The suggested projects in this chapter encourage both visual and haptic approaches to the figure. Some assignments stress concern with the visual appearance of form; others urge students to project themselves into the pose of the model; many combine the two forms of expression into a more encompassing visual statement.

Synesthesia

The provocative nature of various stimuli and our resulting sensations give rise to the need to visually express our responses as a work of art. More specifically, when an artist receives an impression through one of the senses—seeing, hearing, smelling, tasting, or feeling— and then channels the impression through the outlet of another sense, the artist has practiced **synesthesia.**

Webster defines synesthesia as "a sensation felt in one part of the body when another part is stimulated; a process in which one type of stimulus produces a secondary, subjective sensation, as when a color evokes a specific smell." The provocative response of a stimulus by one of the five senses triggering a response from another one of the senses was a practice used by the artists of Dada and the Abstract Impressionism movements. In fact, it occurred in the caves of the prehistoric artist, when after witnessing a herd of bison or elk, he painted the scene as the news of the day, for his fellow huntsmen, as the visual language that predated the written word.

Synesthesia is haptic in nature. Almost no one is completely haptic or visual in orientation. But one or the other, or a combination of both, is necessary to the creation of a profound, sensual, and mysterious work of art.

More than ever before, contemporary artists are exploring their experiences through senses and sources other than their eyes. Rico Lebrun's anguished image *Running Woman with Child* (Fig. 14-34) forcefully re-creates the physical "truth" of the bodily sensation of running, which we, having seen this image, feel in our own beings as a synesthetic response. The rhythmic movement of Irmagean's *Emerging* (Fig. 14-35) conveys a strong haptic response to dancing figures while the handling of the voluminous drapery suggests an equally strong visual response. Forms that at one moment seem to define individual dancers suddenly disappear into broad sweeping strokes of charcoal that duplicate the actual movements of dancers' arms and bodies in time and space.

Imagination and the Figure

In our discussion, we have emphasized seeing deeply as a fundamental factor in learning to draw and have taken an essentially representational approach to figure drawing. Once you develop your perceptive abilities and gain technical proficiency with media and techniques, you are free to begin interpreting what you see that transcends the truth of the actual visual subject. While subject matter, choice of media, and technique all contribute to the effectiveness of a drawing, it is the imaginative and

haptic
A word describing one of two extreme poles of artistic personality (the other being **visual**). Haptic, or nonvisual, people relate all forms of their expression to their feelings, bodily sensations, and subjective experiences in which they become emotionally involved.

synesthesia
In art, a subjective sensation that occurs when one type of stimulus or response to a subject evokes another reaction or secondary response. In psychological terms, a specific color, for example, may evoke a specific smell, or a specific smell may arouse a particular memory.

14-34. RICO LEBRUN (1900–1964; Italian-American). *Running Woman with Child.* Ink on gray paper, 18 3/4 × 25 3/8" (47.6 × 64.5 cm). Sheldon Memorial Art Gallery, University of Nebraska, Lincoln.

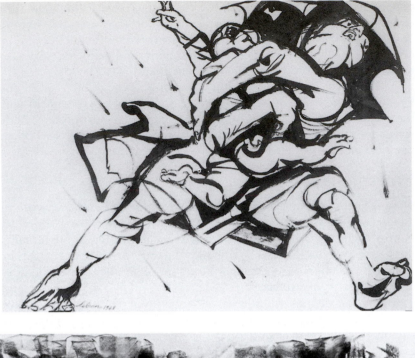

14-35.
IRMAGEAN (b. 1947; American). *Emerging.* c. 1980. Charcoal on paper, 24 1/2 × 42 1/8" (62.2 × 107.1 cm). Courtesy of the artist.

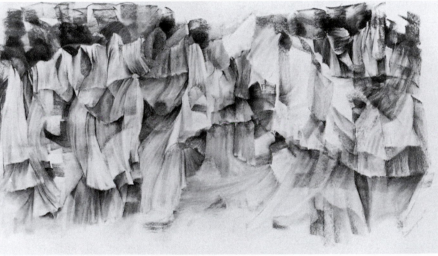

expressive qualities that the artist most enjoys and to which the viewer most responds.

It is easy to settle into certain pleasing habits of drawing and neglect other avenues for perceiving and recording the rich and complex form, the human figure. The use of distortion and abstraction, for example, lends zest and variety to modern interpretations of the figure (Pl. 5, Figs. 8-23, 10-2, 14-35, 15-15). To the degree that one remains receptive to a wide variety of stimuli, and learns to respond unreservedly, a rich and diverse imagination develops.

Project 14.14

Distortion, fragmentation and discoloration, ambiguity, analytical rearrangement, shifting points of view, juxtaposition of multiple images, stylization, and flat patterning are all means of approaching the abstraction of any subject. De Kooning sometimes used the process of shuffling drawings on sheets of tracing paper placed one over the other to create new images. Working with some of the drawings done for

other projects in this chapter, experiment with abstracting the human figure while exploring a variety of media and techniques.

You might begin by selecting several of your previous drawings that resemble each other, considering their likenesses and differences, then combining them into a new working drawing, not giving too much attention to any one particular drawing—let them all play a role in the new visual arrangement. Then select several images that are very different and allow their unique visual forces to join together into a new composition. Again, do not overemphasize any one drawing; treat them as equally as possible, giving importance to the individual attributes that each drawing brings to the composite image.

Critique (Project 14.14) Consider the provocative aspects of your new drawings. Do they speak independently of their origins yet indicate a genetic connection to their sources? How have the individual visual statements of the former drawings changed after having been assimilated into the new compositions? How would you assess the visual impact of your abstracted works? Is the content of greater emotional or spiritual impact? Do the images prompt and lead the imaginations of the viewer? How would you assess the presence of visual and haptic expression?

Finally, how have your compositional skills grown throughout the study of this book? Do you feel well equipped to handle the complexities of richer compositions and deeper associations of meaning and content? As genuine visual language, do your images speak clearly and convey meaning or sensation? What do they say? Are you overtaken by the impulse to create successive images that hint at further meanings?

15 The Portrait

Do portraits of people in familiar and typi-
cal attitudes; above all, give to their faces the
same choice of expression given to the body.

—Edgar Degas

The face has long been an object of scrutiny for artists, because through its myriad expressions pass all the fleeting thoughts, emotions, and vicissitudes of human experience. From earliest times the making of portraits has been a means whereby human beings have tried to achieve some degree of immortality. Until the invention of the camera in the early nineteenth century, **portraiture,** whether sculpted, painted, engraved, or drawn, was the only way that physical likenesses could be preserved.

The illustrations in this chapter and elsewhere in the book reveal the tremendous variety of approach to portraiture by individual artists from different historical periods. Some portraits strive for exact replication of every bump and hollow in the face (Fig. 15-1, 15-2); others go even further by describing individual hairs of the eyebrows as well as pores of the skin on the face with hyperrealistic detail (Fig. 2-14). In still others, there is a revealing selectivity (Figs. 15-3, 2-10, 2-11). Stylization sometimes becomes caricature, at other times idealization, and more often than not sidesteps the importance of seeing and recording accurately. It is a matter of dispute whether the portrait involves psychological perceptions made and incorporated in the work by the artist or whether the telling irregularities constituting the "psychological" element—particularly those that convey tension, strain, and lack of inner quietude—are "read into" the drawing by the viewer. Because of the inordinate complexity and expressive potential of the subject matter, no field of drawing is more demanding, and perhaps rewarding, than the portrait.

The impersonal, idealized portrait in which distinctive aspects of appearance are sacrificed to a bland, generalized version of the sitter has long been the accepted standard for "official" portraiture. Con-

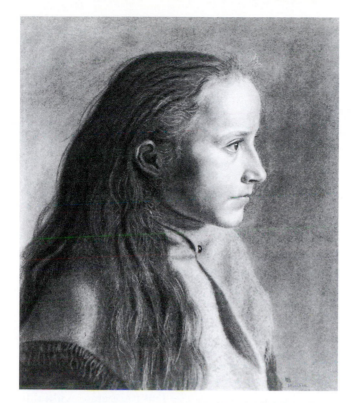

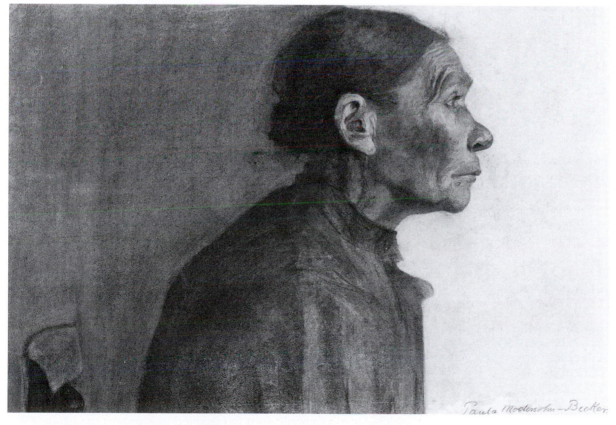

versely, too great a likeness can be as much at fault as too little, depending on what the expressive overtones are intended to be. Nearly all respected portrait artists, at some point in their careers, have had to

CH. 15 The Portrait **283**

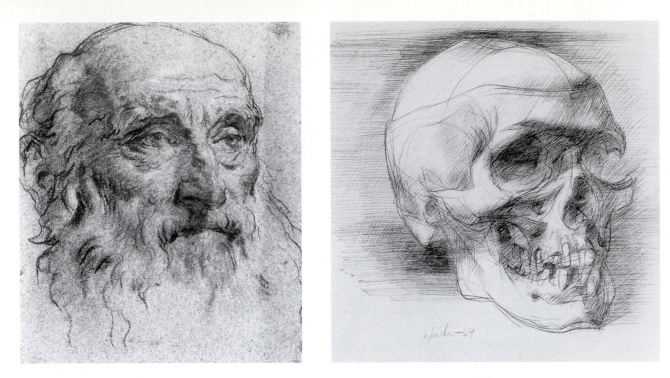

15-3. *above, left:* GIOVANNI BATTISTA TIEPOLO (1696–1779; Italian). *Study after Vittoria's "Bust of Giulio Contarini."* Weimar, Schlossmuseum.

15-4. *above, right:* HOWARD WARSHAW (1920–1977; American). *Skull.* 1964. Silverpoint on paper, 12 × 8 7/8″ (30.5 × 22.5 cm). Mark Ferrer, Executor, Estate of Howard Warshaw.

structure
The inner core that determines, identifies, and organizes outward form; the planned or methodical network that serves as a matrix supporting and delineating the organizational elements in a work of art.

form
The positive aspect or complement of space; the visible or recognizable configuration or shape of any object existing in atmospheric space; any structural art element separate from color, line, texture, material, etc. See **space.**

wrestle with issues of aesthetic virtue versus commercial appeal, and more often than not, they've had to operate within the constraints of a commission. The drawings reproduced here, however, have been chosen for their aesthetic and expressive interest rather than their commercial acceptability. Each work by a great portrait artist manifests a characteristic emphasis, a personal touch that constitutes the artist's genius and distinguishes such work from the thousands of adequate but merely routine likenesses that predominate in conventional portraiture.

Form and Proportion

A problem beginning students experience in drawing the head is conveying a convincing sense of **structure.** Too frequently, even though accurately positioned, the features viewed frontally appear to float on the surface of the paper rather than existing as part of a three-dimensional **form.** An awareness of the skull's structure and the acknowledgment of it as the underlying form, or **superstructure,** of the external features is essential to drawing the head effectively, as evidenced by a comparison of Tiepolo's *Giulio Contarini* (Fig. 15-3) with Warshaw's **silverpoint** on paper, *Skull* (Fig. 15-4).

Despite the fact that we are constantly observing faces as we move about and meet people, and given the vast amount of time we spend looking into each other's faces, most of us have surprisingly little knowledge of the general proportions and relationships between parts of the face. Perhaps because we attend to the individuality of each person, which is the basis of portraiture, we fail to be alert to the general system of proportions that determines the placement of features. Familiarity with some of the general rules of proportion enables us to avoid the mistakes most commonly seen in unskilled drawings of the head.

Alanson Appleton's classically rendered portrait of David Roinski (Pl. 7), combines a masterful knowledge of proportions and underlying anatomical structure with thoughtful observation to create a sense of

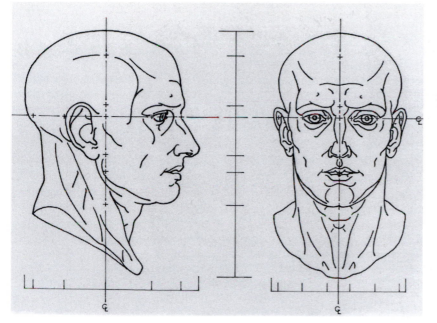

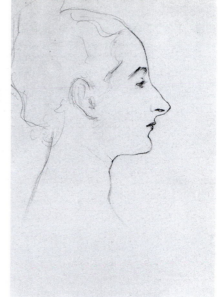

solidity and individuality. Careful analysis reveals how closely the drawing adheres to the system of proportions presented in Figure 15-5 while at the same time concentrating on the uniqueness of the individual. John Singer Sargent's elegant profile portrait of Mme. Pierre Gautreau (Fig. 15-6), although based on observation rather than on rules of proportion, closely matches Figure 15-5 and the measurements listed in Project 15.2.

The Frontal View

Project 15.1

Study the general proportions diagrammed in Figure 15-5 and compare them with your own reflected image in a mirror. Then use a pencil for a measuring device (as explained in Chapter 3) and study the following eight points of facial proportions as they apply to your own face. We gain much vital understanding from the associations of these proportional rules through the study and sensations of our own bodies as three-dimensional forms.

1. Hold a pencil in front of your nose to create a vertical center line. The eyebrows, eyes, base of the nose, and mouth can be seen as horizontal lines perpendicular to it. When you incline your head to the left or right, your features remain at right angles to the center line. As you tip your head forward or backward, the feature lines are seen as downward or upward curves corresponding to the curvature of the skull.
2. Accurate proportion of the head width to height is a critical factor in portrait drawing if the features are to assume their correct relationships.
3. The line of the eyes lies about halfway between the top of the skull and the base of the chin. It might appear to be lower depending on the fullness of your hairstyle. With infants the eyebrows mark the halfway point, with the eye line dropping approximately one quarter into the lower half (Fig. 15-7).
4. The distance between the hairline and the chin is divided roughly into thirds by the eyebrows and the base of the nose. The lower section may be slightly greater.
5. The center line of the lips, like a flattened letter M, falls approximately one-third of the way between the nose and chin—sometimes more than a third, but always less than half.

15-5. *above, left:* ALANSON APPLETON (1922–1985; American). *General Proportions of the Head; Frontal and Profile.* Pen and ink, 8 1/2 × 11" (21.6 × 28 cm). Permission of Mrs. Alanson Appleton, San Mateo, California.

15-6. *above, right:* JOHN SINGER SARGENT (1856–1925; American). *Mme. Pierre Gautreau.* c. 1883. Pencil, 12 5/8 × 8 1/4" (32.1 × 21 cm). The Metropolitan Museum of Art, New York.

superstructure
The usually unseen inner armature or skeletal network that directly supports and defines the shapes and outer forms of a subject or form; for example, the skeleton is the superstructure for the internal organs, muscles, and skin of the human body.

silverpoint A methodical drawing procedure where a thin rod of silver (about the size of a graphite shaft) is inserted into a mechanical pencil and used to draw on an elaborately prepared gesso surface. The silver metal point, which may be sharpened on sandpaper, yields a thin line of even width with a lovely gray color oxidizing to a grayish-brown with the passing of time. A highly recommended pencil-style mechanical holder is the Faber-Castell E-Motion Mechanical Pencil.

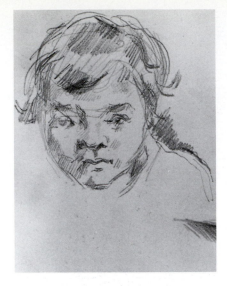

15-7. PAUL CÉZANNE (1839–1906; French). *Portrait of His Son,* detail from sheet with *Self-Portrait.* Pencil on white paper, entire page 4 7/8 × 8 1/2″ (12.4 × 21.6 cm). © The Art Institute of Chicago, all rights reserved.

6. The tops of the ears align with the eyebrows; the bottoms of the ears fall just below the bottom of the nose.
7. The distance from the side of the head to the outer corner of the eye, the width of the eye, and the space between the eyes are all nearly equal measurements.
8. The width of the nostrils corresponds to the distance between the eyes.

The Profile View

Project 15.2

It is possible to study your profile by using two mirrors. While the frontal view of the head resembles an upright egg, in profile it appears as a tilted egg. Again, it is important to increase your knowledge through the study of and familiarity with your own facial features. Your most convenient model is yourself.

1. A common error in drawing the head in profile is placing the eye too close to the forehead plane and the nose.
2. The ear is located in the back half of the head. The distance from the outer corner of the eye to the back edge of the ear is about equal to one-half the height of the head.
3. The measurement from the ear hole to the tip of the nose and the distance from the chin to the eyebrows are equal. (In the frontal view the distance between the ear holes is equal to the measurement from the chin to the eyebrows.)
4. The earlobe indicates the position of the jawbone.

Project 15.3

Observe heads wherever you are. Notice how consistently the placement of the features adheres to the general proportions as seen in Figure 15-5 and as listed. The greatest deviation will occur in the width of heads.

Project 15.4

A plaster head—a standard fixture in most art departments—provides an excellent means for studying general proportions of the head and relationships between its parts. A plaster cast has the virtue of remaining motionless, thus permitting leisurely and accurate observation. It can be repositioned easily so that it can be viewed from above and below eye level, as well as in frontal, profile, and three-quarter views. While most portraits are drawn at eye level, there may be occasions to represent the head viewed from above or below, or to draw the head tilted up or down (Fig. 15-8), in which case the features must follow the curvature of the front of the skull.

Use your pencil or stick of charcoal for comparative measuring and to establish the correct alignment of features.

Project 15.5

Three-dimensional form becomes most apparent through the use of light and shadow. In a line drawing it is possible to impart a degree of three-dimensionality through overlapping shapes and lines and to introduce light and shadow by gradations in the thickness of lines. When the study of form is intended, adequate directional light is essential.

Working from a plaster head or your own reflected image, lighted from above and to one side, do two drawings—one in line and tone, the other fully modeled in light and dark tonal areas, using line only to clarify those areas where tone is insufficient. As you begin the first drawing, as you look, see deeply, compose, and draw, strive for the development of solid, three-dimensional, descriptive form. Emphasize

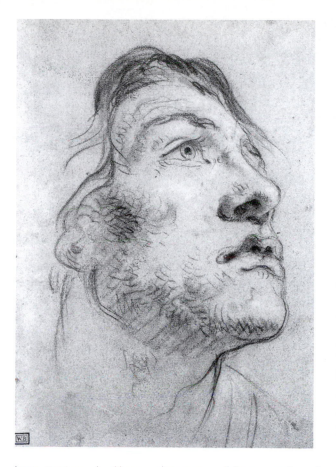

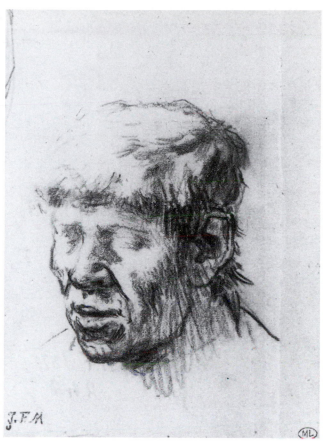

bone structure, cheekbones, depressions of the eye sockets, the turn of the forehead from frontal plane to side plane, bony protuberances in the nose, and so forth. Concentrate on revealing the form rather than creating a likeness. Make sure that the front surfaces of the eyes appear to sit within the socket and not on the same plane as the forehead or cheekbones.

For the second drawing, done primarily in tone, begin by sculpting the basic form with patterns of light and dark before turning your attention to defining and detailing the features (Fig. 15-9). Drawing the head is very similar to modeling it out of clay. First you create the general form by establishing the mass and volume, then you move to the details. Establishing the mass and volume correctly makes the subsequent establishing of the general proportions and detail refinements much easier. Charcoal, white chalk, graphite stick with erasing, or any combination of light and dark colors, on a middle-value paper works well for portrait studies, as evidenced in David Hardy's elegantly understated drawing (Fig. 15-10).

15-8. *above, left:* GIOVANNI BATTISTA TIEPOLO (1696–1779; Italian). *Head of a Young Man.* Red chalk over traces of black chalk heightened with white chalk on blue paper, 8 3/4 × 6" (22.2 × 15.3 cm). Cleveland Museum of Art.

15-9. *above, right:* JEAN FRANÇOIS MILLET (1814–1875; French). *Man's Head in Three-Quarter View to the Left.* Black crayon, 6 1/4 × 4 5/8" (16 × 12 cm). Louvre, Paris.

The Features

Once correct relationships of form and features are firmly settled in the beginning artist's perception, and there emerges a sense of skillful interplay between artist, media, and subject, the symbiotic activity of drawing can fully begin. Depending completely on your sight skills and your newfound sense of proportion, achieving a likeness derives from the accurate analysis of a set of individual features to be superimposed over the preliminary plan. Seeing is paramount to successful results, and the most common errors result from failure to look at the shape of each feature, drawing instead what one thinks to be the shape of that feature, and not what is actually seen. The novice, for example, has a tendency

15-10. DAVID HARDY (b. 1929; American). *Untitled.* 1984. Charcoal and chalk, 11 × 8" (28 × 20.3 cm). Courtesy of the artist.

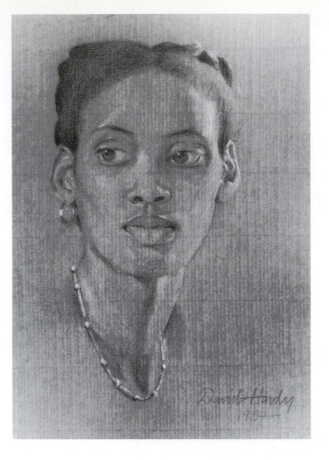

to represent the eye as an almond shape with the upper and lower lids as matching curves meeting at symmetrically equal points at each end. Careful observation of the eye reveals that it is more irregular in shape— the high point of the curve of the upper lid occurs closer to the nose; the low point of the lower lid is nearer to the outer corner of the eye. At the inner corner the lids come together to form the tear duct; at the outer corner the upper lid overlaps the lower lid. Eyelids also have thickness, though the assumption might be they are paper-thin. The iris of the eye appears to rest on the lower lid, while the upper portion is partially hidden by the upper lid. In profile view, the eye appears as the letter V with slightly curved lines lying on its side; the upper lid projects beyond the lower lid, overlapping it with its outer corner; the inner corner of the upper lid also lies forward of the outer corner of the lower lid (Fig. 15-5).

Lips also present a problem for beginners, who are inclined to outline them, when the only actual line is between the lips. What we think of as the upper and lower lip lines are really changes in coloration, texture, and directional planes. Notice in Figure 15-11 that the bottom of the lower lip is defined only by the shadow centered beneath it. Moving toward the corners of the mouth, the lips tend to flatten, almost to disappear, except for the tonal difference.

Project 15.6

You must understand a form before you can draw it. Study your own features carefully at close range (a handheld mirror is recommended). You are urged not to work from photographs for this assignment, since the flattened image does not adequately

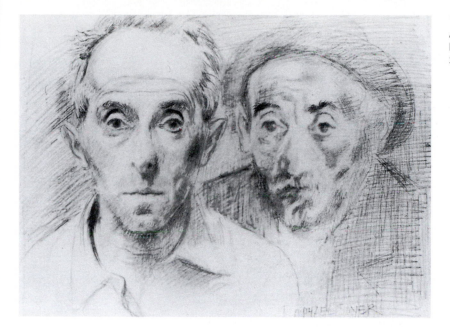

15-11. RAPHAEL SOYER (1899–1987; American). *Self-Portrait with the Artist's Father.* Pencil, 9 3/4 × 12 1/8" (25 × 31 cm). Sotheby's.

convey the three-dimensional form. Practice by drawing separately your eyes, nose, lips, and ears, in frontal, profile, and three-quarter views. You will probably discover that your eyes are not identical in size and shape and that your mouth is not the same on both sides (Fig. 15-11). Making additional studies by drawing the individual features of other persons will increase your awareness of differences that exist, pointing to the absolute necessity of drawing exactly what you see.

Remember that the head and face with its features are antithetical to anything flat. Try to avoid any semblance of flatness. Do not just outline shapes. A single light source above and to the side will reveal the strongest sense of three-dimensional form.

Project 15.7

Drawing someone with a distinctly unusual face is a good exercise in developing sensitivity to the peculiarities of likeness. When confronted with this challenge, even certain proportional rules may not be adequate. The unusual in nature often has no precedent; therefore, stress all departures from regularity, differences between eye shapes, and the length and structure of the nose, mouth, lips, and chin. Notice wrinkles, muscularity or flabbiness of flesh, heaviness of eyebrows and lashes, and quality of hair and the direction of its growth. Although it may not please your model, you are encouraged to be as accurately analytical as possible in depicting truth. The compromising of any distinct irregularity only produces an inaccurate and flaccid likeness.

The Self-Portrait

The **self-portrait** may serve either as an opportunity for serious exploration or merely as a chance to work one's technical prowess on an obliging model. A glance at the following group of drawings will suggest that self-portraits can span a considerable range of disparate styles and approaches. For the beginning student, the self-portrait offers decided advantages. First, the sitter is always available and easily manipulated. Second, there is no need to worry about offending the sitter's "self-image," and no need to apologize for any unflattering drawing.

Raphael Soyer's drawing (Fig. 15-11) reveals a most subtle study of himself accompanied by his father. The self-portrait's thoughtful

self-portrait

An artist's portrayal of himself or herself using artistic expression to underscore temperaments or emotions related to his or her unique individual traits. The self-portrait has two functions: it allows the artist to use a cheap and available model, and it serves as a means of self-immortalization—often in an idealized way.

expression, the slight irregularity of eye shape and size, the sensitive mouth and furrowed brow all bespeak the introspective artist. Soyer displays skillful use of selectivity as he emphasizes some features more than others. In contrast, most beginners feel obliged to delineate every detail with equal clarity, not realizing that the overpronouncement of one visual aspect can imply powerful yet subtle nuances of expression. The prominence given to his eyes and the intensity of their gaze seem to underscore the essential linkage of drawing to seeing. In spite of the almost elusive nature of the modeling, except around the eyes, the head is strongly structured. The divisions of the head and the placement of the features correspond almost exactly to the general proportions diagrammed in Figure 15-5. The head of Soyer's father mimics that of the artist in structure but is less well defined in form and may well have been done from memory. The application of middle grays produced by the hatched lines positions his father behind and deeper in space, perhaps implying his father's continuing presence with him after his passing.

In his self-portrait *Myself Paranoiac* (Figure 15-12), it is evident that John Wilde's penetrating observation of himself has led to a heightened state of visual poetry with a host of nuances perhaps only partially understood. Art historian Gerald Nordland wrote of Wilde: "His watchword is *discipline*, which is observed in the careful rendering of the most telling angle and incident in realizing his frolicsome, sympathetic, and sometimes profound subject matter." Wilde's work has been further characterized as having a kinship with the Surrealists, the artists of the Italian Renaissance, and fifteenth-century Flemish masters.

15-12. JOHN WILDE (B. 1919 ; American). *Myself Paranoiac.* c. 1944. Pencil on wove paper, 16 1/4 × 12 1/2″ (41.3 × 31.8 cm). The Arkansas Art Center Foundation Collection.

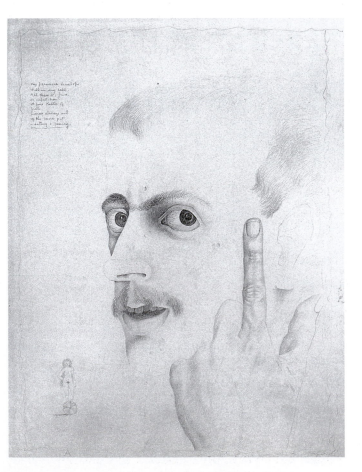

In a comparison of portraits by artists John Wilde and Jonathan Thomas (Figs. 15-12, 15-13), we see two highly contemplative poses, one head centered, the other done in the upper half of the picture plane in such a way that the remaining pictorial space is completely activated by the implied presence of the figure's torso. Each artist has been selective in his composing, giving us the necessary visual information and stripping away any extraneous elements. In Wilde's *Myself Paranoiac* (Fig. 15-12) we see a sensually charged depiction of a man's face where the handling of pencil on paper is not only texturally and tonally alive but also highly descriptive. In Thomas's etching *Bed Head* (Fig. 15-13), drawn on a copper plate with etching needle, the long arms, hanging like pendulums, suggest a heavy mood, while the facial features reinforce a feeling of momentary uncertainty—even surprise. The vertical position of the figure implies that she has just risen from sleep but is not yet not fully awake, and there is a sense of unexpected confrontation.

Project 15.8

Learning to draw heads and portraits is one thing—endowing them with unique expression is quite another. Take full advantage of your availability as a model and do several portraits in which, by relentlessly concentrating on the forms you see before you, you strive for a drawing that is not merely a portrait likeness but an expressive interpretation of yourself. Käthe Kollwitz left a lifelong record of herself in self-portraits (Figs. 1-1, 7-9). To achieve expression will require drawing your own face frequently, using various media, techniques, lighting effects, and unconventional poses. Two mirrors will allow you to draw the more interesting but difficult three-quarter view without the awkward "eyes to the side" look. Proceed from structure to features, then to expression. For your drawing to achieve a state of mystery, which usually happens more unconsciously than consciously, observe the expression—not just facial expression, but the *expressive whole* of the drawing. Everything plays a role in the total effects of the drawings.

Critique (Project 15.8) What would you describe as the most powerful visual elements of your drawings? How would you characterize their effects? What single-word adjectives would you use as synonyms for each drawing? If you have a friend or classmate who is working on the same project exercises, exchange drawings so that the two of you can write a critical analysis or review of each other's work. Discuss media handling—citing specific techniques used—effects of lighting, and positioning of the subject, and finally, describe the resulting visual impact of the drawings. Be honest and candid, knowing that criticism is not to be either doled out or received in a personal way.

The Objective Approach

Since "pure" objectivity exists only as a theoretical state of mind, in terms of artistic endeavor an objective approach involves depicting exactly that which is observed, free from distortion and interpretation. Josef Albers offers a straightforward depiction of a man, unidentified but with a strong sense of individuality (Fig. 15-14). Albers has used a line that matches in firmness and clarity the chiseled profile of his model. The essentially planar treatment of the hair contributes to a sculptured effect, while the lighter values lend softness to the beard.

William Michael Harnett's charcoal drawing *Portrait of a Young Girl* (Fig. 15-1) exemplifies the best qualities of nineteenth-century academic tradition—solidly realized form and modeling of exceptional delicacy. The nuances of texture have been rendered with amazing fidelity,

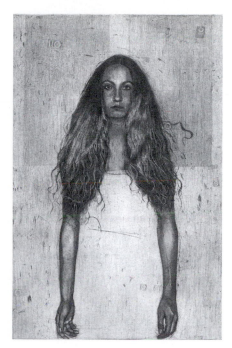

15-13. JONATHAN THOMAS (b. 1973; American). *Bed Head*. c. 2001. Etching on copper printed on German Hahnemulhe paper. 17 3/4 × 11 7/8" (45.2 × 30.2 cm).
Courtesy of the artist.

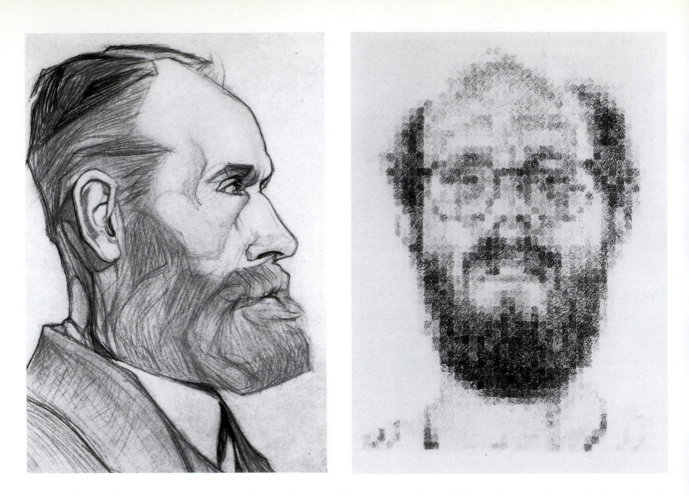

15-14. *above, left:* JOSEF ALBERS
(1888–1976; German-American). *Man in
Profile.* c. 1914. Pencil, 14 3/8 × 10"
(36.5 × 25.4 cm).
Collection of Anni Albers and the Josef Albers
Foundation, Inc.

15-15. *above, right:* CHUCK CLOSE
(b. 1940; American). *Self-Portrait/Conté
Crayon.* 1979. Conté crayon on paper,
29 1/2 × 22" (75 × 56 cm). Private
Collection.
Courtesy of the Pace Gallery.

the softness of skin, hair, and wool shawl contrasting with the sharply
defined profile and the accented clarity of the eye. Without deviating
from his intended objectivity, Harnett has created an image of haunting
intensity that is somewhat similar to the drawings of John Wilde and
Jonathan Thomas in Figures 15-12 and 15-13, although it is a profile
view in a more tonally developed picture plane.

We often equate pure objectivity with photographic likeness, and
indeed the meticulous realism of Wilde, Thomas, and Harnett bears strong
similarities to a photograph. Chuck Close's *Self-Portrait* (Fig. 15-15) can
appropriately be termed a photographic likeness since it is a transcription
of a photograph. Working with two grids—one superimposed over a pho-
tograph he selected to reproduce, the other an enlarged grid on a sheet
of drawing paper—Close methodically analyzes and summarizes the tonal
value of each square of the photograph, then duplicates it with a scrib-
bled or hatched line tone. He has created several similar grid portraits
with dots the size of the end of a round pastel crayon. The resulting im-
ages bear strong resemblance to the device used by television stations to
blur and disguise the identity of individuals who wish to remain anony-
mous. This methodical, scrutinizing approach is called *modular analysis*.

Project 15.9

For an exercise in objective portraiture, you might find the weathered face of an
older model more interesting to draw than the smooth features of a young person.
Find a black and white photograph or photo magazine portrait illustration of an
interesting head and face. With an acetate page the same size as the selected

image, draw a one-half-inch grid with a design marker (one that will dry immediately and not bead up on the acetate surface) over the entire acetate page. Superimpose this grid over the photographic image that has been attached to a large white or off-white sheet of good drawing paper or illustration board. With the image centered on the large page, draw two flanking outlines of the same dimensions as the image—one to its left, one to its right. Then with very hard graphite pencil (4H or 6H), very lightly draw the identical grid in each flanking outline. Once this has been accomplished, you may want to spray the light grids with fixative in a well-ventilated area (even though the graphite is of a hard nature, there may still be slight smearing over the long period of time it will take to complete this drawing).

Have at your disposal a complete set of graphite pencils ranging from 9H (hard) to 9B (soft) and begin drawing the value study. If you are right-handed, do the value study to the left of the image; left-handed, to the right of the image. Observe each single module one at a time, very closely avoiding visual interference from the neighboring modules. Determine the average value of the module and evenly shade in the corresponding module on the value study side. As the value drawing progresses, step back periodically to witness the formation of the image—the farther back you stand, the clearer the image forms itself. Use workable fixative periodically to avoid smearing.

Begin the rendering upon completion of the value study by studying each single modular again, one at a time, and render in as highly a descriptive way as you are able. Think of each module as a composition unto itself while divorcing all thoughts of the surrounding modules. Again, use workable fixative periodically to avoid smearing.

This assignment with its analytical approach to any subject will prove to be highly efficacious. In fact, you may be pleasantly surprised at how well you've seen your subject, and how articulately you've depicted what you saw.

Critique (Project 15.9) Carefully pin your drawing to the wall in a studio or large room and stand back a good distance from it (at least twenty feet). Compare the two flanking drawings with your selected image in the center, and then compare them with each other. If your drawing technique exemplifies lively variations with interesting textural and tonal finesse, along with wide-ranging descriptive values of extreme lights and darks, the two drawings will each bear a much stronger illusion of three-dimensionality than the selected image.

If you feel your drawings are a bit anemic, needing more life and power, determine the areas of visual weakness and rework the necessary portions, staying within the working method of a single module at a time.

The Idealized Portrait

Idealization in portraiture can take many forms but, in general, it means a restructuring of features to conform to a concept of perfection and a minimizing of all irregularities.

The major challenge of drawing an **idealized portrait** is to achieve a resemblance that satisfies the sitter as a "likeness" and at the same time irons out the less-than-ideal aspects of the face. Ingres had this amazing capacity, as evidenced in his portrait of Doctor Robin (Fig. 10-15); it creates the illusion of an objective likeness, exact and precise, yet careful examination reveals clear idealization—perfect symmetry of features, smooth sculptured form, and flawless skin.

Although David Hockney's *Celia in a Black Dress with White Flowers* (Fig. 15-16) seems to emphasize the positive-negative aspects of the richly varied interlocking shapes of the flowers and dress, attention ultimately centers on the delicately drawn head with its blending of likeness and idealization.

The British Museum's *Portrait of Andrea Quaratesi* (Fig. 15-17) is one of the few portraits believed to have been drawn by Michelangelo.

idealized portrait
A portrait that achieves a satisfactory resemblance to the sitter while simultaneously eliminating the physical imperfections of the face.

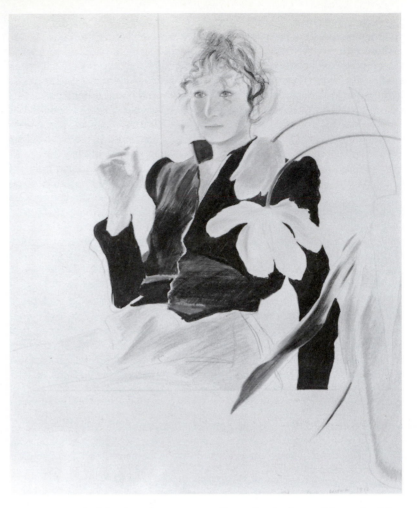

It seems probable that the image reflects both the unblemished beauty of youth and Michelangelo's tendency toward idealization.

Project 15.10

Draw an idealized portrait, of either yourself or a sympathetic friend (Figs. 15-16, 15-17). Determine how best to flatter your model without loss of likeness. Anyone harboring a desire to be a professional portrait artist would be well advised to focus particular attention on this project. Combine your newfound skills of objective sight from Project 15.9 with your notions of idealization. Be sure to use a flexible and easily erasable medium such as soft graphite, charcoal, or chalk (do not use crayon in any form). None of the idealized portraits discussed are large drawings, and because each includes the body, the heads are relatively small. Should you also want to include the figure, it is suggested that you first practice drawing just the head, making it large enough so that the features are not small and cramped.

The three idealized portraits discussed have been enriched by including specific details of clothing—plus architectural forms as in the Ingres drawing—and the suggestion of an interior space, with a still life, in the Hockney drawing. Be alert to opportunities to include such elements, not only for additional visual and compositional interest, but also as a means of revealing character.

The Psychological Portrait

Some drawings seem to mostly record externals (Fig. 10-10), while **psychological portraits** create the illusion of penetrating the surface to re-

psychological portrait
Beyond the revealing likeness, the portrayal of a person's inner personality or temperament made visually tangible through the artistic treatment of the facial features, tilt of head, relaxed quality, or stiffness of shoulders, neck, and head.

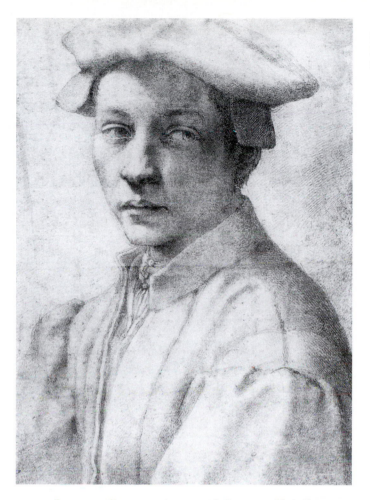

veal inner aspects of personality—tensions, withdrawn self-sufficiency, or warmth and sociability. Many of the portraits already seen have included visual clues that explore character as well as appearance. The variety with which artists are able to reveal personality traits, their own and others', is one of the most fascinating aspects of portraiture.

Walter Sickert portrayed the famous English caricaturist Max Beerbohm as a warm, sympathetic observer of life (Fig. 15-18). The raised eyebrows, heavy-lidded eyes, and slightly open mouth all seem to describe an inner life as much as they do external appearances. The raised hand adds an accent as though Beerbohm needed a gesture to give full meaning to his words.

The very turbulence of the crayon scribbles with which Oscar Kokoschka has drawn his *Portrait of Olda* (Fig. 15-19) creates a disturbing mood or at least one of quandary, which is intensified by the abstracted look in the eyes, the crooked mouth, and the thoughtful pose. The rather unusual combination of free execution, suggesting the artist's spontaneous approach to the act of drawing, and the sense of the subject as a tense, withdrawn personality seem paradoxical. The sensitivity of Kokoschka's perception is evidenced in his selective delineation of features, the hair and collar being drawn more emphatically than the subject's eyes. Olda's introspective nature, in contrast to Sir Max Beerbohm's outward focus, is immediately apprehended.

Alice Neal draws with power and subtlety. In her portrait of Adrienne Rich (Fig. 15-20), the bright, alert eyes and the controlled smile

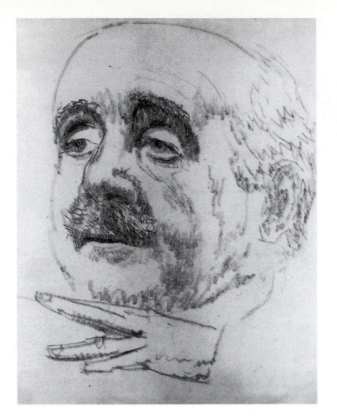

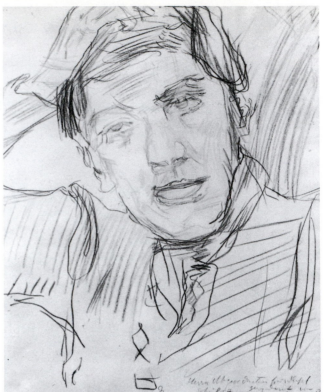

15-18. *above, left:* WALTER SICKERT (1860–1942; English). *Sir Max Beerbohm.* Pencil on cream paper. Sotheby's.

15-19. *above, right:* OSCAR KOKOSCHKA (1886–1980; Austrian). *Portrait of Olda.* 1938. Blue crayon, 17 1/4 × 13 7/8" (43.8 × 35.3 cm). Allen Memorial Art Museum, Oberlin College, Ohio (R. T. Miller, Jr., Fund). ARS, New York.

provide a clue to the tenor of the subject's thoughts. The entire pose, reinforced by the loose, easy drawing suggests a relaxed bemusement. In contrast, Mark Adams's *Margery* (Fig. 15-21) conveys a mood of melancholy quietude.

Project 15.11

Figures 15-20 and 15-21 are similar in subject, but the character and mood of the drawings are very different and can be credited only in part to the individuality of the subjects. To a much greater extent, the difference derives from the ability of each artist to recognize the most natural pose and revealing expression and to select media and technique suited to both subject and mood. Study the three drawings, noting the total appropriateness of media and treatment and the inevitable expressiveness of each subject.

As you gain confidence in your ability to render a likeness objectively, begin to introduce a note of subjectivity, allowing your drawings to reflect more than the external characteristics of your subject. Try to find the means to respond to the personality of your model in ways that are visually expressive.

Critique (Project 15.11) What personality traits or human characteristics are expressed in your drawings? What contributions do the media and your technical handling of the media make to the overall visual statement? Are there instances where the drawings appear to be less expressive than the actual subject? Or are there drawings that seem to exaggerate the actual expressive nature of the person you are drawing? Have lights and darks offered definitive modes of expression? Does texture or spontaneity play an expressive role in the visual language of your drawings? Have you created any paradoxical situations, as in Figure 15-19?

Often the personality of an individual is revealed as much through body language—posture and gestures—as through facial characteristics. One

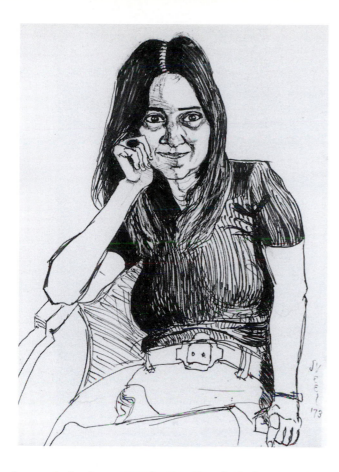

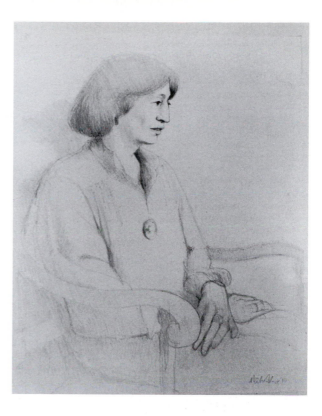

knows in looking at Catherine Murphy's drawing *Harry Roseman Working on Hoboken and Manhattan* (Fig. 15-22) that the model builder possesses the patience to sit for endless hours engaged in the most detailed work. Interestingly, Murphy's drawing technique demonstrates the same kind of dedication and patience.

Theophilus Brown apparently found greater visual interest in the pose of fellow artist Mark Adams drawing the figure (Fig. 15-23) than in the very ordinary seated pose of the model alone (Fig. 15-21). With little more than a simple, direct contour drawing of the figure in silhouette, Brown provides an immediate, recognizable, full-length portrait of Mark Adams standing at his easel in a pose of unaffected naturalness and ease, but also one of total concentration on the act of drawing. The drawing communicates a strong sense of individuality even to those who do not know Adams. Notice how the head of Adams in Brown's drawing is so similar to the aforementioned "tilted egg-shape" that characterizes a head in profile in Josef Albers's *Man in Profile* (Fig. 15-14).

A drawing that appears to be the culmination of many of the portrait topics discussed in this chapter is Leonardo da Vinci's pen and brown ink drawing *Five Grotesque Heads* (Fig.15-24), certainly a psychological depiction in portraiture. The impact of the expressionistic aura of the five heads and faces is so well established here that we find it difficult to look away—as when we were children and were taught about the impropriety of staring. Leonardo gives us ample opportunity to stare with abandon. We have the frontal view, the three-quarter view, and the profile, as well as the tilted upward and slightly downward poses—a brilliant composition of well-rendered forms whose faces exude a myriad of emotion. Each

15-20. *above, left:* ALICE NEEL (1900–1984; American). *Adrienne Rich.* 1973. Ink heightened with Chinese white, 30 × 22" (76.2 × 55.9 cm). Courtesy of Robert Miller Gallery, New York.

15-21. *above, right:* MARK ADAMS (b. 1925; American). *Margery.* 1980. Pencil, 24 × 19" (61 × 48.3 cm). Courtesy of the artist.

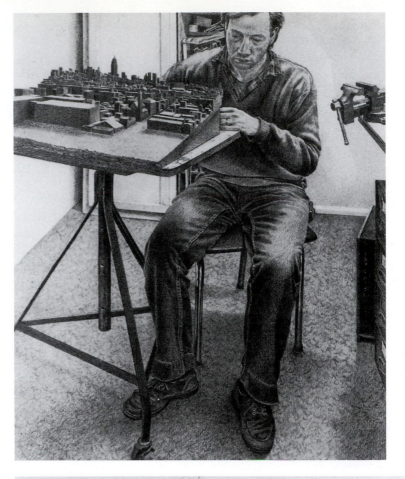

15-22. CATHERINE MURPHY (b. 1946; American). *Harry Roseman Working on Hoboken and Manhattan*. 1978. Pencil, 13 3/4 × 11" (35 × 28 cm). Courtesy of Lennon, Weinberg, Inc., New York.

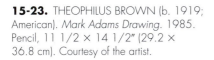

15-23. THEOPHILUS BROWN (b. 1919; American). *Mark Adams Drawing*. 1985. Pencil, 11 1/2 × 14 1/2" (29.2 × 36.8 cm). Courtesy of the artist.

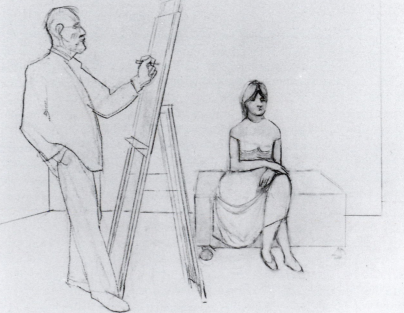

respective torso is compositionally well established in space—a personal touch and attribute from a true master of visual composing. Note how line variation, the buildup of tonal and textural areas, and the placement of each form in space work together in a poignantly descriptive way.

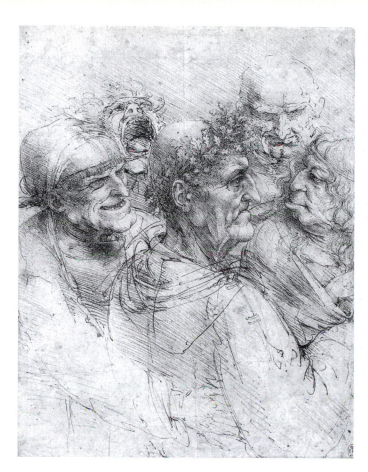

Caricature

Webster's dictionary defines **caricature** as "a picture in which certain features or mannerisms are exaggerated for satirical effect." While in many kinds of portraiture the minor eccentricities and idiosyncratic details of feature and expression are either minimized or completely eliminated (as in the idealized portrait), such elements provide the very essence of caricature. Caricature demands a special talent for selecting, sharpening, and unveiling the most convincing details of feature, head shape, posture, and particularly facial expression. Many portrait artists cannot caricature while many caricaturists cannot do a "straight" portrait.

Like all satire, caricature can be humorous and kindly, mordant and biting, or almost ribald in the gusto with which it depicts its subject. Visual recognition remains the essential ingredient for successful caricature, and for that reason most caricaturists focus their attention on well-known personalities, particularly politicians, who are often almost savagely caricatured in the printed news media.

The particular genius of the caricaturist has rarely received more brilliant expression than in the drawings of David Levine (Fig. 15-25). Less than a month after the 1980 presidential election, Levine's interpretation of the victorious Ronald Reagan preparing to assume the presidency beamed from the cover of a national periodical. The eyes, cheeks, and expansive crooked smile could be recognized immediately, yet there was something unfamiliar about the image. Levine, obviously responding to the repeated jokes about the true color of Reagan's hair, has depicted him white-haired and wrinkled, seated before a theatrical

15-24. *above, left:* LEONARDO DA VINCI (1452–1519; Italian). *Five Grotesque Heads.* Pen and brown ink, 10 1/4 × 8 1/2" (26 × 21.6 cm). The Royal Library, Windsor Castle, England.

15-25. *above, right:* DAVID LEVINE (b. 1926; American). *Ronald Reagan.* Reprinted with permission from *The New York Review of Books.* Copyright © 1980 Nyrev, Inc.

caricature

An exaggerated portrayal of the characteristic features or mannerisms usually of a well-known personage, intended for satirical effect.

15-26. HENRI DE TOULOUSE-LAUTREC (1864–1901; French). *Yvette Guilbert,* study for a poster. 1984. Pencil and oil on paper, 7 1/4 × 3 5/8″ (18.4 × 9.2 cm). Musee Toulouse-Lautrec, Albi.

mirror, an ample assortment of makeup containers before him. Symbolic of Reagan's years as an actor, the delicacy with which the lipstick is held perhaps suggests the deftness with which the makeup is to be applied. Levine's use of cross-hatching to emphasize features and create volume and three-dimensionality has been widely imitated.

Entertainers have always provided a special attraction for artists and public alike. Toulouse-Lautrec's drawings, lithographs, and paintings immortalized the colorful and eccentric Parisian music hall performers who were his friends (Fig. 14-29). "For Heaven's sake, don't make me so atrociously ugly," pleaded the horrified cabaret singer Yvette Guilbert when she first saw Toulouse-Lautrec's sketch for her show poster (Fig. 15-29). Later, when critics praised his interpretation and she realized the value of the poster to her continued success and popularity, her wounded vanity was considerably healed. The sketch reveals the artist's fascination with Yvette's ugly grace as he captures every nuance of feature and gesture. One cannot but take delight in the contrast between her almost clownlike makeup and the affected elegance of her pose.

Project 15.12

If you have never attempted a caricature, do so now. Regular features allow less potential for exaggeration than do strongly distinctive or irregular features. Distortion or exaggeration of one's particular physical characteristics or flaws often serves as the basis for caricature and certainly makes the subject easily recognizable.

Do several caricatures with a desired medium of your own choosing. Strive to recreate a fugitive yet recognizable image within the actual visual context of the person.

Illustration 16

Illustration is as old as civilization itself, writing having originated in easily recognized object drawings known as pictographs.

Perhaps the most encompassing definition that can be given for **illustration** is "interpretive visual language." If we accept that definitive meaning, then, any drawing, etching, lithograph, woodcut, painting, photograph, or sculpture that communicates descriptive information, ideas, or feelings could be labeled illustration. Art that emphasizes storytelling is often described—and sometimes dismissed—as being "illustrative." In essence, however, any picture, whether fine art or illustration, awakens something deep inside us and therefore has expressive merit.

illustration
Usually a highly detailed image that communicates a message, offers visual description, or portrays an episode (as in a story) through visual means.

Illustration Versus Fine Art

A distinction between illustration and fine art developed early in this century out of the clash between the traditional literalism of illustration and the modern art movement. The art of illustration has developed more or less independently from fine art for nearly a century. The difference between the two fields was perhaps the greatest during the late 1940s and 1950s, which were dominated by nonrepresentational art—the height of **abstract expressionism** and the advent of action painting. Today there are more influential movements afloat in the art world domain than ever before, and without a doubt, illustration reflects a full range of contemporary art styles at the same time that fine art evidences a renewed interest in the figurative and representational.

The apparent blending of the fine and illustrational arts seemed also to have started in the sixties, when leading pop artists began to introduce elements of illustration into their drawings, paintings, and prints,

abstract expressionism
An American movement in the field of painting that began in the late forties and emphasized a nonrepresentational style. The movement broke into two branches: *action painting* and *color field painting*.

301

16-1. VAN HOWELL (b. 1948; American). *Rothko.* 1980–1982. Pen and ink, 9 3/4 × 7 1/2″ (25 × 19 cm.) Courtesy of the artist.

MARK ROTHKO

VAN HOWELL

and major corporations began to use works by prominent contemporary artists in their advertising. Van Howell has cleverly blended the two—fine art and illustration—by allowing the head and hand of artist Mark Rothko to emerge from the familiar meditative and hovering rectangles typical of Rothko's work (Fig. 16-1).

Many drawings done as illustrations fit easily into the category of fine art and are exhibited and collected as such. Why, then, the notion that illustration and fine art must be viewed as separate, and not necessarily equal, art forms? Many major artists have worked as illustrators. Edouard Manet, a pivotal figure in the history of modern art who demanded for artists the freedom to work in the style of their own choosing, did illustrations for a French translation of Edgar Allen Poe's "The Raven"; Eugène Delacriox produced a series of lithographs to illustrate Goethe's *Faust* (Fig. 16-2). Among Toulouse-Lautrec's best-known works are the cabaret and music hall posters he designed. More than a century later, Jane Avril (Fig. 14-29), Yvette Guilbert (Fig. 15-26), and other such colorful, often eccentric entertainers continue to draw capacity audiences—not to the theaters, but to auction houses whenever original impressions of his posters come up for sale, and to museum bookstores, where sales of reproductions of the posters flourish.

16-2. EUGÈNE DELACROIX (1798–1863; French). *Mephistopheles Flying,* illustration for Goethe's *Faust.* 1828. Lithograph, 10 3/4 × 9″ (27.3 × 22.8 cm.).
The Metropolitan Museum of Art, New York (Rogers Fund, 1917).

De temps en temps j'aime à voir le vieux Père,
Et je me garde bien de lui rompre en Visière.

A technical distinction between "illustration" and "fine art" is that the former is created expressly for the purpose of commercial reproduction. Being concerned primarily with reproduction, illustrators often select media and techniques according to how inexpensively they will reproduce, rather than from any consideration of permanence. The circumstances under which commercial works are created also contribute to the notion of poetic and spiritual separation. While the fine artist works independently and from other driving motivations, choosing when, what, and how to draw, generally without having to please anyone else, the commercial illustrator works under the guidance of an art director and must be concerned about how the work will reproduce expediently. All of this creative activity must be funneled into the confines of a time limit and deadline shadowed by the responsibility of having to please the client. Beyond that, the illustrator must create an image that will be satisfying and understood by the greatest number of viewers. "You've got to please both the art editor and the public," lamented the legendary Norman Rockwell. "This makes it tough on the illustrator as compared with the fine artist, who can paint any object any way he happens to interpret it." (It seems appropriate to point out, however, that until late in the nineteenth century, most artists could be considered

commercial artists in that they worked by commission and were responsible for satisfying their patrons.)

One additional significant difference is that most illustrations are represented with text in some form, whether it be an article, story, or advertising copy. Although illustrations can be appreciated for imagery and technique, they cannot always stand alone when viewed out of context. Fine art, in contrast, while it might refer to something outside itself, is meant to be complete in itself. Furthermore, with fine art there are heightened, mysterious elements that make us want to return to the art museums for repeated looks and visual experiences. Granted, powerful advertisement images exist—but, unlike the works in permanent museum collections, they have yet to stand the test of time.

Clearly, however, artistic prowess holds an equal footing in both arenas. Generally speaking, the best illustrators were successful fine artists first; the weakest fine artists were never good illustrators—an interesting convoluted relationship, one as mysterious as the two definitions themselves.

Types of Illustration

The purpose of this chapter is to provide an introduction to illustration, the area of commercial art most closely related to fine art. A survey of different types of illustration, including a brief discussion of the purpose and requirements of each, will reveal that *A Guide to Drawing* offers a basic prerequisite course for illustrators as well as for fine artists. The illustrations reproduced are but a sampling of the remarkable range of drawings done in this diverse field. No attempt has been made to select only recent examples; like fine art, what is fashionable changes from year to year. For an expanded look at the richness and variety of contemporary illustration, you will want to linger over the illustration yearbooks that are published annually and skim through all the current magazines in the school library each month to keep yourself informed about what is happening in the field.

Commercial illustration in its various forms now appears to be divided between drawing and painting on the one hand and photography and computer/digital imaging on the other, with an apparent increase in the use of drawing—the medium that has always been most closely related to the act of seeing with the human eye and creating with the hand. There are four major categories of illustration—editorial, advertising, medical, and scientific—making its own demands on the artist. While versatility is an asset, most professional illustrators select an area of specialization.

Editorial Illustration Editorial illustrations accompany stories and articles in books, magazines, and newspapers. Although guided by an art director, the illustrator must have an awareness of the content and structure of each story, article, and story line of each to ensure that the choice of imagery, style, and technique is compatible with the text and grasps the essential meaning of the piece. In this case, the story precedes the image.

Book Illustration Nineteenth-century novels were almost always illustrated; today adult books rarely are. Illustrations are confined mostly to book jackets, special limited editions designed for book collectors, and what might be considered "children's books for adults," such as those created by Edward Gorey (Fig. 16-3) and David Macaulay (Fig. 9-6).

Book jackets, originally called "dust jackets," were intended simply to protect the covers of books. Today they are designed to attract the attention of buyers and promote sales. Some covers use only type;

wood engraving The technique of engraving done as a relief process on end-grain blocks of various hard woods such as maple, pear, or apple; the engraved lines are cut with a burin, receive no ink, and subsequently print as the white of the paper or negative spaces. The uncut, relief or raised surface of the woodblock receives the ink and transmits the positive image to paper when the engraving is printed.

relief

The raised surface in the printmaking medium of woodcuts where the negative shapes are the intended cut away depressions leaving the raised, uncut surface of the wood in relief; the raised, uncut, relief surface catches the ink from a brayer and prints as the positive image when transferred to paper.

16-5. BARRY MOSER (b. 1940; English). *Behold the Man.* Wood engraving. From the illustrated folio edition of the King James Bible. Published 1999 by Pennyroyal Caxton Press. Courtesy of the artist.

others add illustration, combining the talents of graphic designers and illustrators to suggest the essence of the book through visual means effectively, truthfully, and with immediate impact.

Contemporary book illustrations often depict character and establish mood rather than portray specific episodes from the narrative. One of Barron Storey's illustrations for *The Great White Whale* (Fig. 16-4) provocatively captures the mood of the book, suggesting the insane obsession of Captain Ahab, who stands defiantly erect against the battering forces of the sea, his ivory leg planted firmly on deck. Storey's handling of pen-and-ink cross-hatching remains very much in the tradition of nineteenth-century illustrations reproduced by the **wood-engraving** medium which is a **relief** printmaking process.

Artist Barry Moser, renowned illustrator for *An Illustrated Folio Edition of the King James Bible,* published by Pennyroyal Caxton Press in 1999, has revived wood engraving as his present-day expressive and illustrational technique (Fig. 16-5) in *Behold The Man* from the Gospel of John, 19:2. Many contemporary illustrators use this age-old technique because black and white line drawings are highly descriptive and are the easiest and most economical to reproduce. Note how Moser uses

16-6. MAURICE SENDAK (b. 1928; American). Illustration for "The Three Feathers" from *The Juniper Tree and Other Tales from Grimm*, translated by Lore Segal and Randall Jarrell. Pictures copyright © 1973 by Maurice Sendak. Reprinted by permission of Farrar, Straus & Giroux Inc.

the white of the paper as enhancement to illustrate the glistening of the blood dripping down the chest of Christ in Figure 16-5.

Illustration originates with and must be true to the words of the author. Good illustration should amplify the text but should not depend upon a literal caption to explain its meaning. The interdependence of text and image would seem to require that good illustrators also be good readers.

Children's Books Children's books, by tradition, are richly illustrated. In fact, much of the success of a children's book depends upon the contribution of the illustrator, since a child's imagination is activated through the combination of verbal and visual imagery. Text and illustrations go hand in hand; effective illustrations both follow and advance the story.

A survey of children's book illustrations reveals great diversity of styles. Literalness in representation assures visual identification, but this can be accomplished without sacrificing imagination and invention. While children's literature frequently incorporates fantasy and make-believe, skillful illustrators are able to treat the commonplace with whimsy, vividness, and excitement (Fig. 16-6).

Children are an appreciative but critical audience who expect drawings to be faithful to the text. While free to select style, the illustrator is not free to reinterpret even the most elemental detail of the text, as anyone who has ever attempted to satisfy a child's questioning can attest.

Anyone interested in illustrating children's books should become familiar with both what has been done and what is being done. Collected works of many of the best-known nineteenth- and early-twentieth-century

illustrators of children's books are available in paperback editions. The illustrations of Maurice Sendak (Fig. 16-6) have been the subject of a major study; they were also the focus of a New York auction in 1987.

Magazine and Newspaper Illustration While certain book illustrators like Edward Gorey (Fig. 16-3), Barry Moser (Fig. 16-5), and Maurice Sendak (Fig. 16-6), develop a personal style that remains relatively constant from book to book, illustrators of stories and articles for magazines and newspapers are expected to be able to change style virtually from one assignment to the next. Change is inherent in all aspects of contemporary life, particularly in the field of mass communication, in which capturing the largest percentage of public attention is, of necessity, the prime consideration.

The illustrator or photographer is often called on to provide a single major illustration to attract the attention of the reader and establish the character of a story or article in an effective and substantially truthful manner. Such images may tend to be symbolic, with their meanings immediately perceived when seen in relation to the titles of the articles. Because magazines and newspapers focus upon topics of current interest, there is the additional demand of meeting deadlines.

The range of articles printed in popular periodicals requires illustrators capable of working with a variety of subjects and also versatile in employing different media and their respective techniques without allowing technique to become more important than content. Doug Griswold's illustration of the earth seen as a skull (Fig. 16-7) suggests the boldness that is required for drawings to be reproduced on the newsprint used for daily newspapers.

Spot Drawings Spot drawings attract the attention of readers and provide visual interest for articles and stories that do not feature a major illustration. They are often related to the subject in a general way rather than being specific, as for example, David Suter's drawing of a lunch pail and work gloves for an article about unemployment (Fig. 1-11).

Spot drawings are often used as "fillers"—that is, simply to fill unused space as well as to introduce visual interest to a page. Since the need for fillers cannot be anticipated, they usually are unrelated to the surrounding text and merely exist as a charming or whimsical bonus of no intended importance.

Sports Illustration The ability to depict movement, excitement, and atmosphere is essential to successful sports illustration, which tends to be a highly specialized field. The sports illustrator must understand sports and be able to represent the human figure convincingly in action. Although the camera is able to freeze the image of figures in motion, photographs often fail to convey the quality of movement and excitement associated with sports precisely because the action has been frozen. In most instances, top sports illustrators are better able than photographers to suggest the feeling of energy and movement that fans associate with sports whether seen live or viewed on television. While sports illustrators frequently use photographs for reference, they have the skill to inject a sense of aliveness, vitality, and extraordinary physical accomplishments through clarification, simplification, and exaggeration. Witness the palpable energy, rhythmic motion, and extreme sense of movement, along with acceleration and speed, in Jason Howard's woodcut depiction of a bicycle race (Fig. 16-8). The image, with its left-to-right, white, slashed markings made by the quickly executed, lateral

16-7. DOUG GRISWOLD.
Courtesy of the artist.

cutting of the wood depicting the streaming hair of the athletes, is so powerful that one can almost feel the parting winds as the bicyclers pass by. Similarly, Bob Ziering's colored pencil drawing of runners (Pl. 12) combines fragments of multiple images and dissolving contours to suggest rapid, rhythmic movement with the stronger delineation of selected features to reveal both the concentration and physical effort involved in competitive racing. The drawing's captivating sense of movement, heightened by subtle gradations of color that define both the figures and the currents of air that surround them, far surpasses the static expression of a photograph. Aspiring sports illustrators should avail themselves of as much life drawing as possible, with particular emphasis upon quick sketching and gesture drawing.

Editorial Cartoons and Caricature There is a long and continuing tradition of political **cartoons** and caricatures as illustrations in popular periodicals. These brilliant, biting looks at the antics of national and world leaders have won Pulitzer prizes for some of their creators.

cartoon
A newspaper or magazine drawing or illustration that caricatures or symbolizes a person, event, or situation of popular interest, such as a politician or political party, usually in a humorous or satirical way.

16-8. JASON HOWARD (b. 1972; American). *The Bicycle Race.* Woodcut on pine printed on white wove paper, 12 3/4 × 19 3/8″ (32.4 × 49.2 cm). Courtesy of the artist. Collection of David Faber.

The impact of editorial cartoons generally results from the successful combination of visual image and caption, sometimes supplemented with dialogue. Political cartoonists depend almost entirely on broadly exaggerated caricature. Since their topics must be as current as yesterday's news, editorial cartoonists work under extreme pressure deadlines.

Feeding the public's insatiable appetite for information about the famous remains a primary function of popular periodicals. In addition to the ever-present photographs of such personalities, some magazines and newspapers continue the tradition of using caricatures of familiar politicians (Fig. 15-25), literary figures, and entertainers.

Advertising Illustration A second area of commercial illustration embraces everything done for advertising purposes. Fashion, product, and travel illustrations all rely upon visual flattery to arouse customer interest. Advertising illustrations generally are integrated into a layout that includes headings, copy, and the client's name. Unless the illustrator is also responsible for the layout, it is necessary to learn to work within a prescribed format to create a visually stimulating ad.

Fashion Illustration Fashion drawing falls into two categories: **reporting** and **advertising drawings.** Fashion reporting treats fashion as news. It is directed toward revealing new trends in fashion in drawings that convey the general characteristics of forthcoming styles rather than depicting specific garments in detail. Advertising drawings are designed to sell merchandise, and though often highly stylized, they are rendered with considerable concern for accurate detail (Fig. 16-9).

Because the style of representing fashion changes as rapidly as fashion itself, illustrators must be versatile, flexible, and imaginative. Not only must they be up to date, but they must also be able to anticipate and initiate change. Strictly literal representation, no matter how well drawn, lacks buyer appeal. In addition to his extraordinary renderings of garments, the drawings of George Stavrinos are distinguished by his ability to invent visually exciting settings for his models (Fig. 16-9). Ranaldi's drawing with its emphasis on sculptured planes of light and dark (Fig. 16-10) bears certain similarities to Figures 1-16, 8-4, 8-23, and 10-10.

reporting drawings
Drawings that make visually tangible an event or occurrence by communicating what happened. In fashion design, reporting drawings treat fashion as news.

advertising drawings
Drawings done by commercial illustrators and designed to promote and sell merchandise; though often highly stylized, they are rendered with considerable concern for detail.

16-9. GEORGE STAVRINOS.
Courtesy of Linda Stavrinos.

In the fashion field, competition between artists and photographers is keen. Artists have greater freedoms to change scale, exaggerate style, dramatize contrasts, and contextualize fashion. They also embellish, simplify, add, subtract, or eliminate according to the dictates of the industry. A skilled artist, working from any model, can totally transform the character of the figure at will.

The training for a fashion artist should include drawing from both nude and clothed models. There should be a keen understanding of anatomy as a precedent to knowing how the body works in motion, and understanding how the figure is constructed will permit effective visual distortion. Figures in fashion illustrations, while rarely realistic, must appear to have an underlying sense of structure, proportion, and balance. Pose, gesture, and movement, while exaggerated, must be convincing and plausible in order for the public to identify with the model—as if he or she were wearing the garment being modeled. Both structure and pose determine how a garment drapes, as do the weight and character of the fabric (Figs. 16-9, 16-10). A garment must appear to fit; it must follow the contours of the body and appear to move with the body. Although still-life studies of pieces of draped cloth perhaps seem uninspiring, fabric is the stuff that fashions are made of, and the human body the armature for the fashioned garment.

The ability to suggest and render different materials and textures in a variety of media and techniques is a basic requirement for fashion artists. Fashion illustrators generally specialize in drawing women, men,

16-10. RANALDI. Advertisement for Caumont from *Gentlemen's Quarterly*. 1985. Grinta Intntl. Corp., © Ranaldi 1985.

or children; only rarely do drawings of one include either of the other two. The category of fashion accessories provides an additional area of specialization in fashion illustration. Hats, bags, shoes, scarves, belts, and jewelry are, in effect, the province of the fashion still-life artist, who is expected to make such objects stylish and appealing without obvious falsification. This specialty requires an artist skilled at depicting detail and rendering textures and materials with a sense of flair.

Perhaps more than in any other field, one learns about fashion illustration by studying fashion drawings, fashion magazines, and window displays of fashionable stores. It is valuable to accumulate a file of outstanding fashion drawings that employ interesting and varied media techniques, as well as photographs of figures for reference.

Product Illustration The area known as "product illustration" includes almost anything that can be manufactured and offered to the customer. The illustrator is expected to depict commonplace objects with style to make them attractive or alluring to the public. While the objects cannot be falsified (truth in advertising), they can be idealized and dramatized. An unusual perspective can be introduced to intensify the form, while bold modeling in light and dark, the contrasting of descriptive patterns, and the dramatic rendering of surface and textures complete the effect.

Standard still-life experiences provide the basis of learning a variety of techniques useful for many product illustrations.

While in the most literal sense product illustration would seem restricted to depicting objects, illustrations created for catalog covers, CD and DVD albums, and to advertise movies, television programs, and other entertainment events are product- or episode-related. Kam Mak cleverly adapted images from ancient Egyptian wall paintings (Fig. 14-2) into a catalog cover for a purveyor of contemporary travel clothing (Fig. 16-11). Rich low-keyed color and an equally rich rhythmic pattern of shapes combine to produce a visual counterpart to the sounds of the Mississippi Delta Blues Festival (Pl. 16). According to illustrator Gary Kelley, "Some of my all-time favorite music has come from the Mississippi Delta, so this was a very personal expression for me. It's an extra treat when sound and image can connect for me like it does here."

16-11. KAM MAK. Catalog cover for Banana Republic Travel Clothing. Courtesy of the artist.

16-12. ANGELO K. BILDER (1898–1998; Greek-American). *A Cargo of Milk.* c. 1941. Graphite on cream wove paper, 20 × 16" (50.8 × 40.6 cm). Courtesy of Dorothea Bilder.

Angelo K. Bilder, an accomplished Chicago illustrator who immigrated to the United States in 1913 and worked in all media, recalls the ships and shipping yards of his youth in the graphite illustration *A Cargo of Milk* (Fig. 16-12). His skillful use of the medium and his compositional acumen, coupled with his ability to see forms in space while invoking meaning and association, give this drawing an air of intrinsic beauty and expressive value that distinguishes it from most illustrational art. To use these drawings as preliminary studies for fully developed color advertisements sets them apart in yet another way. The inherent elements of symbolic meaning and human association the artist struck early on in the drawings transcend the mere commercial reasons for their existence.

Travel Illustration　The extensive advertising program of the travel industry requires illustrations ranging from elaborate full-color paintings to spot drawings. Styles and techniques are as varied as the services provided; subject matter embraces figure, landscape, and architecture. Albert Lorenz relies upon extreme exaggeration of three-point perspective (discussed in Chapter 9) to lift his viewers high above midtown Manhattan and then focuses their attention on his client's hotel by darkening the buildings that surround it (Fig. 16-13).

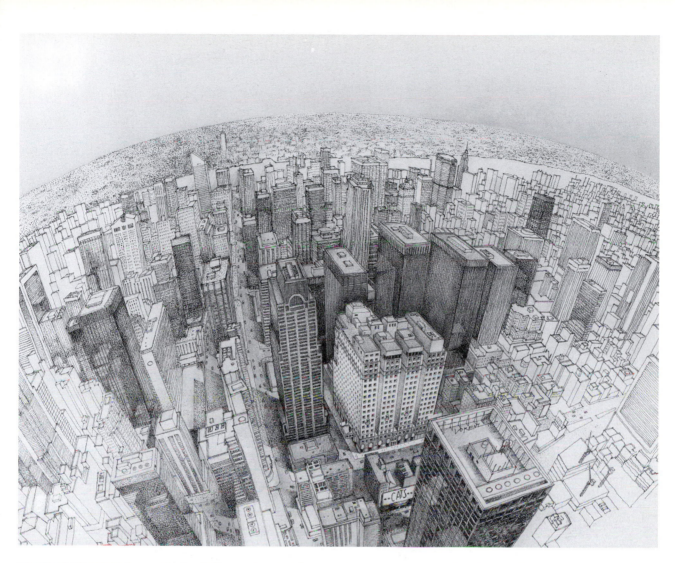

16-13. ALBERT LORNEZ (20th century; American). *Grand Bay Hotel, New York City.* 1990. Pen and ink with watercolor, 20 × 22" (50.8 × 55.8 cm) RYP. Robinson, Yesawich & Pepperdine, Inc., Orlando, Florida.

Medical Illustration Medical illustration is "the graphic representation of any medical subject made for the purpose of communicating medical knowledge." Medical illustrators need to have scientific background as well as extensive art training. Since absolute accuracy is imperative, even critical, the artist must possess highly trained powers of observation and meticulous draftsmanship (Fig. 11-1). The artist is called upon to do what a camera cannot do—clarify and simplify, select what is essential, eliminate the unnecessary to communicate effectively and completely.

Illustrations for articles published in medical journals are prepared in collaboration with surgeons, often from sketches made on location in the operating room as the surgeon describes to the illustrator what is to be revealed. The artist must have both the knowledge and imagination to visualize what is desired and to find the most effective means to communicate that information. The surgeon, as imagist, must also be able to describe accurately the extreme details of three-dimensional forms in relation to each other as they are revealed during surgical procedures. Judy Morley worked with graphite dust on Mylar to achieve the subtle chiaroscuro of the exposed eyeball and the sheen of metal surgical tools (Fig. 16-14). A number of major university medical schools offer specialized training in medical illustration, which includes learning to work

16-14. JUDY MORLEY (20th century; American). *Orbitotomy.* Graphite dust on Mylar.
Courtesy of the artist.

scientific illustration
Meticulously rendered drawings that depict an unusually articulated degree of detail; accuracy, clarity, and neatness are of prime importance in the field of scientific drawing.

with surgeons in the operating room. Admission requirements include completion of a premed program. Interested art students can prepare by taking classes in life drawing, anatomy, still life, perspective, design, composition, rendering, watercolor, airbrush, and mixed media.

Scientific Illustration Each of the scientific disciplines has its unique needs for illustrative materials. The qualities required for all scientific drawings are accuracy, clarity, and neatness (Figs. 11-1, 11-14, 16-14). Details of form and surface characteristics must be carefully observed and meticulously rendered. Forms must be lighted evenly without obscuring shadows. Stippling, because of its propensity for articulation of detail, is the most common method used for hyperrealistically descriptive shading (Fig. 11-14).

Art Directors

Illustrators need to be familiar with the traditional areas of subject matter and the art elements; they must use media and technique imaginatively and expressively (Figs. 16-1 through 16-14). It is also necessary to know about different methods of visual reproduction in order to best prepare drawings or paintings suitably for the reproductive process to be used.

Without a firmly established reputation, an illustrator cannot expect to be granted complete independence in making creative decisions. It is the art director who has the major responsibility for determining what an illustration will be and how it will be used. For this reason it is important that art students, especially those who might want to become illustrators, learn to follow assignments, accept criticism and suggestions made by instructors (acting as art directors), be willing to make suggested changes, and complete projects on time. Since most illustrators are required to submit preliminary portfolios of sketches for approval, students are urged to adopt the habit of making rough working drawings before starting out to do the finished presentation piece. By doing several sketches, the illustrator can cull ideas of

lesser impact early in the creative process and identify the strongest compositional possibilities.

Research Resources

Professional illustrators often are called upon to provide drawings for subjects that lie beyond their own personal experience. They must learn to use reference materials to search for information that will provide authenticity to their work. It is of incalculable value to know how to use the resources of libraries. Particularly useful to illustrators are picture collections maintained by major libraries. Several indexes also assist in locating published illustrations (drawings, paintings, photographs, prints) on specific subjects. *Illustration Index* (Volume 8) compiled by Marsha C. Appel (Scarecrow Press, 1998) has a cultural and historical orientation. It is of particular value because it indexes eight periodicals likely to be available in most libraries—*American Heritage, Ebony, Holiday, National Geographic, National Wildlife, Natural History, Smithsonian,* and *Sports Illustrated.*

Preparing a Portfolio

If you seek employment as an illustrator, it is essential to prepare and maintain a portfolio with examples of your best and perhaps latest work to show agencies, art directors, and potential clients. Never include any drawing with which you are not totally satisfied; it is better to include a few drawings of high quality than many of poorer quality. Be extremely selective. Play an objective role by putting aside any sentimental attachments you have to particular drawings, and include only your very best. It is also important that you keep your portfolio up to date. It is naturally unwise to show the same drawings if you make return visits to the same people.

Your portfolio should demonstrate both variety and consistency. Select pieces using different media and techniques, but be certain that your own sense of style is evident throughout. If you know what types of accounts an agency or art director handles, you can select pieces that most closely meet those needs.

Include any examples of your work that have been reproduced. If your illustrations have never been reproduced, it is possible and beneficial to have some pieces commercially photographed with prints made at a slightly reduced size from the original drawings. A sample of a preliminary rough with the corresponding finished drawing provides an indication of your ability to follow through.

Concentrate upon making the best possible presentation. All drawings should be clean and well matted. Use mats of uniform outer dimensions with window openings appropriate to the individual size of each drawing; smaller drawings can be grouped attractively in a single mat. Attach the drawings, with acid-free linen tape, to an acid-free backing board that is the same size as the outer dimensions of the mat and has been hinged to the mat along one side only with acid-free linen tape. Covering each drawing with a cut-to-size sheet of acetate is less troublesome than placing protective tissue paper over the entire mat.

Put as much thought and effort into preparing your portfolio as you did into doing the drawings. While it is the art that counts, art directors are influenced by the quality and degree of imagination evident in your presentation. Remember that art directors, as your potential

16-15. Diagram of hinging and matting procedure.

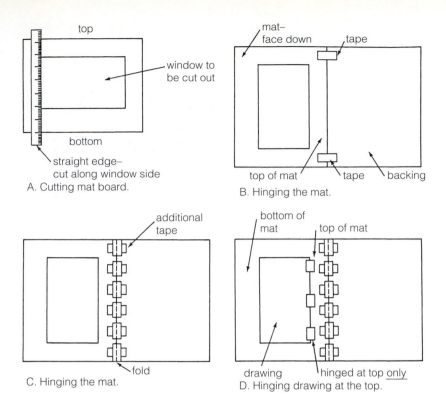

top

window to
be cut out

bottom

straight edge–
cut along window side

A. Cutting mat board.

mat–
face down tape

top of mat tape backing

B. Hinging the mat.

additional
tape

fold

C. Hinging the mat.

bottom of
mat top of mat

drawing hinged at top only

D. Hinging drawing at the top.

employers, have little patience with any hint of sloppiness or careless-ness regarding the way you treat and display your work.

Figure 16-15 exemplifies the professional formation and method of assembling the backing board and window mat for a work of art on paper. Acid-free materials are easily obtained and are considered the only professional way to display your work in today's marketplace. A general rule of thumb to abide by is that anything that comes into contact with the work of art over a long period of time should be acid-free (a neutral pH of 7.0) in order to prolong the life of the paper.

Expressive Drawing 17

If the subjects I have wanted to express have suggested different ways of expression, I have never hesitated to adopt them. . . .

—Pablo Picasso

The arts are the harbors for creative mystery and the vehicles for human expression. Just as composers are able to transform the sounds they hear around them into symphonies and other musical forms, so, too, do visual artists use the experience of *seeing* to create visually tangible impressions of the world through line, tone, and texture. Frequent mention has been made throughout the preceding chapters of the expressive qualities of drawing in the context of specific topics—the elements of art, media, and subject matter. The selection of the drawings reproduced, in fact, was prompted as much by degree of expressiveness as by topic considerations and approach to subject matter. Drawings, like prints, paintings, and sculptures, never fit into a single context, and although some drawings fit neatly into specific academic slots, their individual expressive natures—their **raison d'etre**—reach far beyond those common attributes that may bind them together. Most of the drawings in this book could have been reassigned with equal effect to other chapters, and almost all could be included in this chapter, titled "Expressive Drawing."

Except for purely technical drawings, in which all suggestion of individual style is deliberately avoided, a degree of expressiveness remains evident even in what is intended as a completely objective drawing—admittedly more so in some than others. What distinguishes one drawing from another is the uniqueness of each artist's use of different media. Another factor that identifies certain drawings as more profound than others is the degree to which viewers respond beyond mere recognition. This in turn relates to the degree to which the artist goes beyond simple description of form and subject to reveal an attitude or emotion, not only about the subject but also about the experience of seeing and

raison d'etre
French for "reason to be." In the art context the term is used when referring to the essential purpose of a work of art both as a necessary means of artistic expression, and also as a means of communicating visual language.

319

the process of manipulating media. The old adage "The heart has reasons it knows not of" applies to audience response in all the arts, for it is the arts, after all, that provide a means by which we identify and experience mystery.

Some suggest that there is a distinction between representational and expressive drawings; others, while agreeing that all representational drawings are not expressive and that all expressive drawing need not be representational, can see no reason to separate the two. Drawings can be, and frequently are, both.

Empathy

The legendary early-twentieth-century American painter-teacher Robert Henri pointed out to his students that "artists have been looking at Rembrandt's drawings for three hundred years," and in spite of all the "remarkable drawings" done since then, we are not yet done looking at them. Henri's suggestion that "the beauty of Rembrandt's lines, . . . rests in the fact that you do not realize them as lines, but are only conscious of what they state of the living person," is beautifully demonstrated in *Two Women Teaching a Child to Walk* (Fig. 17-1). The drawing reveals Rembrandt's sensitivity to human gesture and the extraordinary economy with which he reveals subtle and tender emotions. Every line is *expressive* as well as *descriptive*—no line is extraneous. This is what is meant by "Rembrandt's extraordinary economy of line."

Rembrandt, a dedicated observer of humanity, rarely depicted anything that could not be found within a few hundred feet of his doorstep, but within that microcosm existed a whole spectrum of human drama that he recorded with a sensitivity, honesty, and integrity that transcend time and place. Rembrandt drew, etched, and painted out of **empathy,** which is characterized as the capacity to identify with the subject, to conceive and share feelings and experiences, and to project this sympathetic attitude through the work of art. Rembrandt had the ability to fuse emotion with art to the point that his art became emotion itself.

Empathetic drawing extends beyond the response to subject, whether people, places, events or experiences; it also embraces the

empathy

The state of identifying with someone through the projection of oneself into that person in order to gain a better understanding of that person's character; a reaching out usually through an emotional channel that is perpetuated by tenderness and deep feelings of sympathy or compassion.

empathetic drawing

A drawing that bears evidence of the sympathy for, and understanding of, one person by another through visual portrayal.

17-1. REMBRANDT VAN RIJN (1606–1669; Dutch). *Two Women Teaching a Child to Walk.* c. 1640. Red chalk, 4 × 5" (10.2 × 12.7 cm). British Museum, London (reproduced by courtesy of the Trustees).

17-2. DAVID FINN (b. 1952; American). *Child Drawing a Chalk Line on the Ground.* c. 1988. Ink wash on white wove paper, 22 1/2 × 30" (57.2 × 76.3 cm). Courtesy of the artist. Collection of David Faber.

artist's response to the media selected and to the very emotional act of drawing. It is impossible for someone knowledgeable about art not to respond to the unlabored quality of Rembrandt's line, and to delight in the process of drawing, as did the artist himself.

David Finn's drawing of a little child drawing a chalk line on the ground (Fig. 17-2) infuses the media of **ink wash** and charcoal on a large, white paper surface, evoking the artist's empathetic response to a child's playful yet determined activity. The drawing portrays a child transforming his space into an atmosphere that has a special meaning for him beyond anything the adult world could comprehend. Indeed, it may capture a moment in the life of the child within the artist himself. Note the singularly expressive and translucent quality of the ink wash medium Finn selected to depict his sensitive interpretation of the weightless bodies of the little children. As with Rembrandt's line, Finn's work exhibits a mastery over ink wash—an economical use of material sending forth every possible nuance and force of expression.

It was pointed out in Chapter 12 that students frequently struggle needlessly with the belief that what they draw must be "artistic," which is indicative of a misunderstanding of the word *artistic*. They confront a corresponding dilemma with the concept of "expressive," often confusing it with "emotional." No subject is ever artistic until the artist infuses it with the necessary ingredients of selection, perception, response, subject reinterpretation, skillful media handling, and expression.

The images of Käthe Kollwitz mirror the sorrow of her life and times with such intensity that one is easily tempted to say categorically: "Käthe Kollwitz *is* expressive drawing." *The Homeless* (Fig. 17-3) reveals her deep compassion for people who suffer, while the impenetrable black symbolizes a despair known to all homeless people. As an image it is universal and timeless—one, that upon seeing it, is hard to put aside. Kollwitz was also capable of sharing moments of great tenderness, such as in *Peter Reading in Bed* (Fig. 17-4), in which the features and tones are drawn with a pencil that seems barely to have touched the paper.

Leonardo da Vinci can be credited with introducing delicacy of tone and subtle chiaroscuro as expressive elements. Until he realized and demonstrated the potential of light and shadow in establishing an

ink wash

A dilution of ink in water or solvent, applied by brush, most often used with pen-and-ink drawings to enhance the composition by creating varying degrees of semitransparent tonal ranges.

17-3. KÄTHE KOLLWITZ (1867–1945; German). *The Homeless.* c. 1909. Charcoal and wash, 13 3/4 × 12 1/2" (35 × 32 cm). National Gallery of Art, Washington, D.C. (Rosenwald Collection).

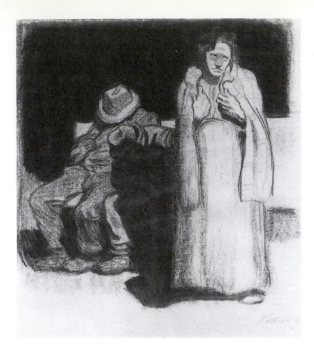

17-4. KÄTHE KOLLWITZ (1867–1945; German). *Peter Reading in Bed.* c. 1908. Graphite pencil, 10 1/2 × 14 1/2" (26.5 × 36.8 cm). Cologne District Savings Bank, Käthe Kollwitz Collection.

cartoon

A newspaper or magazine drawing or illustration that caricatures or symbolizes a person, event, or situation of popular interest, such as a politician or political party, usually in a humorous or satirical way. Also, a large drawing created to establish life-size scale for frescoes. Artists later used the technique to transfer large-scale images for paintings, tapestries, stained glass, and other large works (a cartoon was indispensable in the process of making stained glass).

sfumato

An Italian word meaning "smoked." The gradual, almost imperceptible blending of tones from light to dark in paintings or drawings; a technique used by Renaissance artists in combination with chiaroscuro for the visual enhancement of the overall tones within a composition.

emotional tone in such a magnificent drawing as the **cartoon** for *Madonna and Child with St. Anne* (Fig. 17-5), chiaroscuro had functioned solely to describe form and volume. Leonardo transformed chiaroscuro further by softening all hard edges so that light seemed to flow from one form to another, producing the effect of atmosphere and movement in space. As used by Leonardo, it is called **sfumato**—Italian for "smoked."

Drawings can be expressive, not solely because they are highly charged emotional statements, but also because they communicate an individual point of view and purpose. In Jim Westergard's "oil drawing" on paper titled *Insomnia* (Pl. 17), the artist visually narrates his feelings of vulnerability, loneliness, and the yearning for sleep on a seemingly endless international night flight, where finding it impossible to sleep, he roams the aircraft cabin and amuses himself by looking out at the

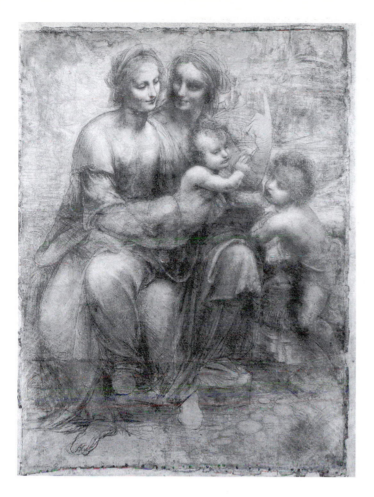

drypoint
Intaglio printmaking technique where a metal plate is drawn on with a steel point producing a scratch or ditch with a continuous or broken line of upraised metal burrs. When the line is inked and wiped, the burrs hold a slight residue of ink around them which produces a soft, velvety line quality when printed.

etching
The action of a corrosive material, such as an acid, incising a design into metal, as in *copper plate etching*. One of the techniques of *fine art printmaking* that falls into the category of *intaglio*, where lines and textures are incised into and below the original surface of metal plates forming grooves and rough textures that will hold ink that can then be transferred to dampened paper with the use of an etching press.

lithograph
A type of print created by one of the four major divisions of *fine art printmaking* involving a *direct drawing process* on Bavarian limestone (calcium carbonate) or aluminum plates. The process, in its entirety, engages the *antithesis of grease and water* where images are drawn with greasy crayons on the stone or metal plate, then etched with acid, effecting a process of chemical stabilization whereby the image remains grease-loving or oleophilic, and the nonimage becomes water-loving or hydrophilic repelling grease. Through a rhythmic process between *printer* and *sponger,* the litho surface is kept wet by sponging with water, then inked with printer's inks alternately, and finally printed on paper with a litho press. *Lithograph* is from a Greek term meaning "stone writing."

airliner's wing. Upon looking at the drawing, one experiences the tremendous sense of foreshortening, yet simultaneously the incomprehensible length of the plane's wing that symbolizes Westergard's sense of being held captive inside the plane over a long period of time.

Lacking as it may any visible sense of drama or emotion, Giorgio Morandi's *Still Life* (Fig. 17-6) might not readily be accepted as "expressive." It is, in fact, difficult to convince beginning students that an expressive drawing, **drypoint, etching, lithograph,** painting, or sculpture can be made from so little, from objects of such apparent insignificance—yet Morandi, with his unique and quiet talent, has done just that. Drawing out of deep respect for and attachment to the humble objects with which he shared his creative life, Morandi created expressive images as free of pretension and ostentation as he was himself.

What one feels about a subject need not be emotional. It might be interest in the space that a subject occupies or a response to line, movement, volume, or patterns of light and dark—whatever offers the greatest visual interest, with individual artists reacting differently to the same subject. Edouard Vuillard, for example, saw his studio—described as "a jumble of furniture, household objects, half-finished works and other Paraphernalia" that included a full-size cast of the Venus de Milo—with an empathy that no other person could have because it was his own (Fig. 17-7). The open, meandering soft-graphite pencil lines, drawn "with a hand that is as sure as it is light," according to one critic of the period, reveal much about the artist and his feelings. The French author

17-6. GIORGIO MORANDI (1890–1964; Italian). *Still Life.* c. 1954. Graphite pencil, 9 × 12" (23 × 31 cm). Private collection.

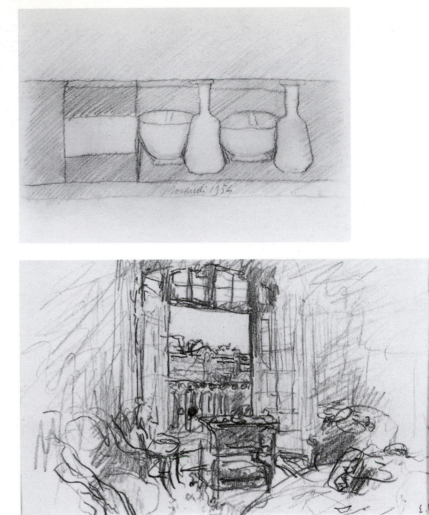

17-7. EDOUARD VUILLARD (1868–1940; French). *Interior of the Artist's Studio.* c. 1897. Graphite pencil, 4 1/2 × 7" (11.5 × 17.8 cm). Courtesy of Richard L. Feigen & Co., Inc., New York.

Andre Gide said, "I know few works where one is brought more directly into communication with the artist," and went on to describe Vuillard's style as "caressingly tender, I might even say timid."

Jack Boul's monotype *Venetian Light* (Fig. 17-8) reflects Vuillard's sentiments about the importance of interior space, in this case demonstrating the effects of light. In the "dark field manner," Boul removes black ink until his soft, swelling light folds in through the Venetian windows, causing the objects within to melt in a composition of reflective brilliance as they are washed in light.

Representation and Abstraction

Some artists, teachers, and critics believe strongly that visual reality is irrelevant, concentrating instead on abstract concepts of form and color—an argument that does not hold true and invites disagreement. Specifically, if they mean it is a matter of representation *or* abstraction, there is equally strong disagreement. If, however, what they intend is that in representational drawing the exact appearance of the subject is less important than the abstract principles of composition, there should be no disagreement. The former author, this revision author, and many others prefer not to view drawing as either representation *or* abstrac-

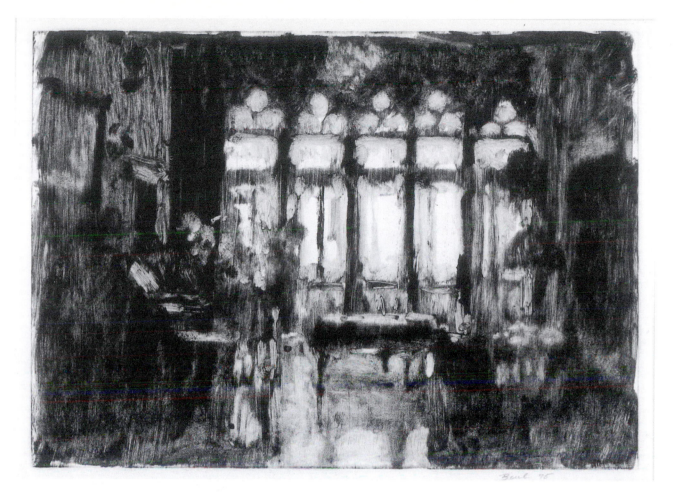

17-8. JACK BOUL (b. 1927; American). *Venetian Light.* c. 1996. Monotype, 8 × 11". Gift of the Friends of the Corcoran Gallery of Art. Courtesy of the artist.

tion, seeing it instead as a combination of representation *and* abstraction unified as a visual statement. Paul Klee said, "Art does not reproduce the visual; rather, it makes visible." This statement seems to put to rest any taking of sides in the matter and upholds the fact that artists do not choose representation or abstraction—artists simply choose to create. Even though all of the drawings discussed thus far in this chapter can be described as representational, is it not possible—even imperative—for us as artists and students to look beyond subject matter, realizing that no matter what the subject—representational, abstract, or nonobjective—each line, shape, value, texture, and color are part of the underlying abstraction that *is* the composition of each drawing? And is it not possible, for example, to find and appreciate a similar creative impulse in the handling of the rhythmic, gestural, linear patterns by Käthe Kollwitz (Fig. 17-4) and Cy Twombly (Fig. 8-5), even though one offers representation and the other abstraction?

The selected media that artists choose to work with produce the visual symptoms of that wonderful, yet fully unrealized variety, and everything visual artists do is an abstraction from the actual object, subject, or mere concept. The artist has the ability to identify any subject as worthy and then to extract the essential elements needed for a particular expression.

Many artists and artist/teachers, although not all, believe that until you learn to draw and depict things as they are (representation), until you have a strong grounding in composition (abstraction), and until you

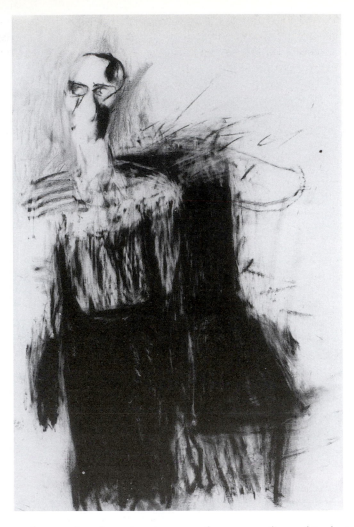

17-9. SUSAN ROTHENBERG (b. 1945; American). *Untitled.* c. 1984. Charcoal, 47 1/2 × 31" (120.6 × 78.7 cm). Private collection.
Courtesy of Sperone Westwater, New York.

intuitive drawing
Drawing activity controlled by instinct, feelings, emotions, bodily sensations, and visceral responses, as in the case of a haptic person; a drawing based on an intuitive response to a subject.

understand and master, to some degree, media and technique, as beginning artists you do not have the means or the freedom to explore your own creativity and expression successfully.

Susan Rothenberg describes her drawing *Untitled* (Fig. 17-9) as one made "with not much thought in mind other than it would be a figure partially dissolved by light." She further explains that the process was **intuitive drawing,** that the image emerged as she moved her hand over the paper, laying down bold strokes of charcoal, building rich dark shapes, smudging and erasing the lines and tones with her hand. The direct and uninhibited creative activity that can produce a drawing of such power and visual excitement becomes possible only after the artist has absorbed the fundamentals of drawing and knows about media and techniques—all of which can be taught. From that knowledge and experience comes the freedom to respond intuitively and explore, interpret, and express oneself in unique, individual ways. While an instructor can encourage such activity by equipping students with the tools, methods, and techniques with which to act, personal expression cannot be taught. Artists and students who think too much about what they are doing often find their work lacking vitality and excitement.

Theophilus Brown tells that when he was living and painting in New York in the early 1950s, Willem de Kooning visited his studio and after looking at some of his paintings suggested that Brown was "push-

ing style too hard." Picking up a pencil and a piece of paper from a table, de Kooning went to the window and began to make a drawing of a tree in the park across the street. "It's very simple. Draw what you see in front of you. Don't bother about style. Just observe what you are drawing very carefully. That's the way to work." De Kooning (Pl. 5, Figs. 5-22, 10-2, 17-14) was not advocating that the purpose of drawing was to imitate, but rather that you must understand what you see before you and be able to depict it accurately before you are free to interpret it.

Similarly, responding to the surprise of a young visitor at seeing a series of traditional still-life drawings pinned up around his studio, Georges Braque, who with Picasso is credited with inventing **cubism,** explained, "I have always found it necessary in all periods of my life to go back to fact so that invention does not become stale."

Of Degas it has been said, "To put it simply, he drew so well," whereas, of a successful young artist of the 1980s a national art critic commented, "He never learned to draw, and probably never will." He went on to explain that the artist traced projected images. The criticism was not that slides were used to project images, but that the quality of the line was without interest since the act of drawing became so mechanical—nothing more than a means to an end. In the beginning, and as you are learning your own way of image investigation, whether you choose representation or abstraction, choose to draw well.

Artist or Dilettante?

Learning to draw requires a host of accomplishments: learning to see intently, learning to perceive size, shape, and space relationships, learning to manipulate and control media and technique, and finally, mastering the basic skills of drawing as a graphically visual means to achieving expression.

Once these requirements have been met, drawing successfully involves dedication and hard work while developing an attitude of professionalism—first as a student and then as a practicing artist. The professional artist holds firm to the convictions that every experience related to drawing is a valuable pursuit, and the attitude that respects both the tools and the process of drawing is paramount to the final expression. It is important, even if you are a beginning student, to decide whether you are willing to make a commitment to becoming an artist or whether you are content to be a dilettante—one who dabbles in art. As with every profession, there can be fine lines of distinction between the truly committed and the dabbler, and yet there is an easily discernible difference between a professional artist and one who only plays the role of a professional artist.

The collection of drawings in this book represents the product of intense involvement by artists whose mastery over the means of drawing allows them freedom of expression in responding to all that they experience visually, physically, emotionally, and imaginatively—both inside and outside their studios. These artists have learned that life itself provides the linear, tonal, and textural ingredients of visual expression— and that they are the trained, sensitive receptors to life's clues, the visual technicians who perform the surgical fusions of meaning and association with media. In this sense, the artist is the visual initiator of his own responses, the shepherd of the creative processes, and progenitor of all

cubism
A style of painting originated by Picasso and Braque between 1907 and 1914 that uses multiple views of an object to emphasize its three-dimensionality yet acknowledges the two-dimensional surface of the picture plane.

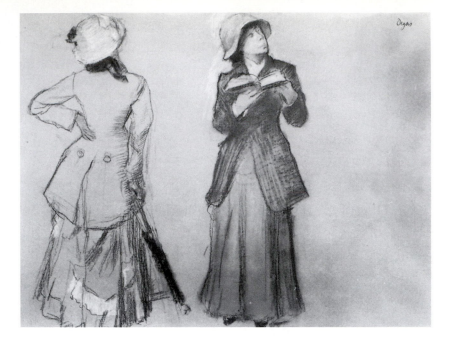

17-10. EDGAR DEGAS (1834–1917; French). *Two Studies of Mary Cassatt or Ellen Andree in the Louvre.* c. 1879. Charcoal and pastel on gray paper, 18 3/4 × 24 3/4" (48 × 63 cm). Private collection.

that we see hanging in museums, galleries, artists' studios, and homes of private collectors.

A critic commented that Degas seemed "continually uncertain about proportions" when he drew the human figure. The artist agreed that the criticism described exactly what he experienced as he drew. Although recognized as one of the supreme figure artists of his age, Degas knew no easy formulas for drawing the figure. Each drawing demanded total concentration on the tilt of the head, the lift of the shoulder, the manner in which the book is held, the way in which only a portion of a figure's weight is supported by an umbrella, the silhouette of a coat (Fig. 17-10). Perception? Most certainly, and also empathy, but an empathy that was rarely tendered toward the subject in a personal sense, as in the work of Kollwitz, but tendered only to the human figure as a form to be drawn. Degas explained, "There is love, and there is work, and we have but a single heart." His life was dedicated primarily to his art. (That his art was untouched by the depth of emotion that shaped the art of Käthe Kollwitz is evident in comparing Figures 17-3 and 17-10.)

What impresses us is the number of drawings that serious artists do, many of which no one but the artist ever sees. The Bibliothèque Nationale in Paris houses, in addition to his 38 notebooks, more than 500 individual sheets of drawings by Degas. Cézanne left over 1,200 drawings; Rembrandt, 1,500. It is said that Modigliani did as many as 150 drawings in a day. Giacometti, we are told, drew constantly—drawing was a way of life for him.

When Jennifer Bartlett rented a "memorably hideous" villa in the south of France during what proved an unpleasantly cold, wet winter, it was the inner need to be creatively involved rather than external inspiration that prompted a remarkable series of drawings. After rejecting the idea of attempting to paint under such conditions, Bartlett purchased a stock of paper (each sheet approximately 20 by 26 inches, or 51 by 66 centimeters), plus a full array of wet and dry drawing media. One day she picked up a pencil and, having nothing particular to draw, made a drawing of the villa's dilapidated garden, which she could see from a

full-length window in the dining room. It was to be the first of almost two hundred drawings of the garden that she did during the next fifteen months. Plate 11 is #122 from that series.

Responding Subjectively

The subjective depths of Mauricio Lasansky's *The Nazi Drawings* carry this identifiable element of human vulnerability even deeper as the artist indicates strong empathy with his subjects, capturing their character. Lasansky's aim was to portray the horror of the Nazis' treatment of prisoners in its concentration camps insofar as he, the artist, could respond to that horror and reinterpret it (Fig. 10-17, Pl. 13).

Just as some people learn to play musical instruments with technical facility, but without feeling or warmth, so, too, do some artists develop the necessary proficiency to draw well, but their drawings lack personal expression and interpretation. Once perceptive abilities have been developed and the required technical proficiency gained, one is free to begin drawing subjectively rather than objectively, although this isn't as easy as simply switching conceptual gears from the purely academic to the sublime. It takes practice to be able to recognize the shift. In fact, in the case of highly gifted drawing students, often the establishment of skillful interpretation, media handling and technical prowess leads naturally, perhaps even involuntarily, to more subjective interpretations of subject matter—sometimes even before the student becomes aware of it. When this occurs, it is important that the student not be too overtaken by the powers of subjectivity alone lest other elements of the drawing act begin to suffer. Subjective expression must be combined with sound drawing skills, developed through persistence and dedication. The ultimate expressive goal for the artist is to respond naturally and intuitively, without consciously having to decide how to respond.

Making Choices

Whistler decried "the purposeless copying" of every detail; Matisse cautioned, "What does not add to a drawing detracts from it." Selection and discrimination are an important part of expressive drawing; every line, shape, form, tone, texture, value, and color requires judgment and thought *before* the pencil is put to paper as well as throughout the process of drawing and after the work is finished.

Any creative act depends upon the making of choices. The intent of *A Guide to Drawing* is to introduce the student to a broad range of options and provide an awareness of how to exercise those options (these last two chapters deal most specifically with the artist's expansion of awareness.) Deciding what choices to make is up to the artist alone and cannot be taught. Too frequently, students plunge into drawing without taking time to question themselves about the best viewpoint, the most appropriate media and technique, or how they feel about the subject emotionally and what they want the drawing to convey. A few minutes of thought and observation before actually beginning to make marks on the paper will greatly influence the end product, but not dictate it. It is possible to begin drawing with a fully formed concept, only to discover other ideas emerging along with the images on paper. This is a natural part of the creative process, and mature artists remain ever alert and receptive to such impulses that call intuition and imagination into play.

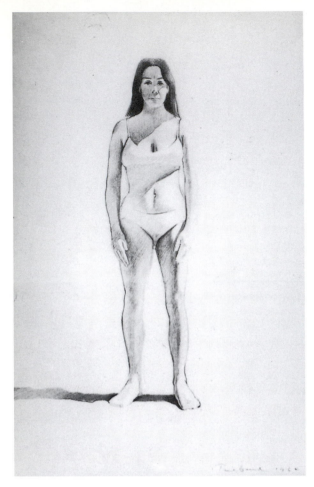

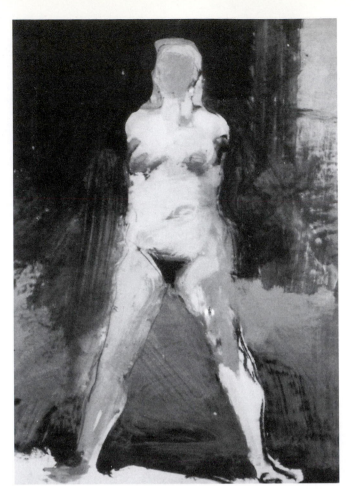

17-11. *above, left:* WAYNE THIEBAUD (b. 1920; American). *Standing Figure.* c. 1964. Graphite pencil.
Courtesy of Allan Stone Gallery, New York.
© Wayne Thiebaud/licensed by VAGA, New York, N.Y.

17-12. *above, right:* MANUEL NERI (b. 1930 ; American). *Mary Julia.* c. 1973–1975. Dry pigments, water, charcoal, and Conté pencil on paper, 41 3/4 × 30 1/4″ (106 × 77 cm). Private collection. Courtesy of the artist.

Looking at how three contemporary American artists—Wayne Thiebaud, Manuel Neri, and Willem de Kooning—depict a centrally placed female figure in a standing frontal position allows us to see how different individual responses can be to the same subject, pose, and composition. Thiebaud's *Standing Figure* (Fig. 17-11) appears, at first glance, to be a straightforward objective drawing. Thiebaud acknowledges an "academic" approach to figure drawing—his skillful use of traditional chiaroscuro creates three-dimensional solidity; the cast shadow anchors the figure firmly to the ground plane even though the space itself remains unidentified, while strong dark accents isolate the figure from an almost pure white background. The drawing, however, is not "purely objective." He has made certain choices that make the drawing uniquely expressive. Perhaps the most interesting is the distance at which he has positioned the woman behind the picture plane. Whether a deliberate or intuitive choice, it sets up a spatial condition—a psychological distance that involves the viewer in a very different way than does Manuel Neri's drawing *Mary Julia* (Fig. 17-12). Neri's faceless woman, thrust against the picture plane, creates an almost overwhelming sense of physical and psychological proximity, the impact made all the more emphatic by the dramatic black background creating deep space behind the figure. Neri explains that he draws, "to put down ideas for sculpture—gestures, positions, proportions." It is difficult to determine whether the arms of his figure are placed behind her back, or whether, like a piece of ancient Greek sculpture, she is armless. Neri's

expressionistic style permits such **ambiguity,** whereas Thiebaud's figure would appear incomplete without arms.

The physical presence of a model is so strongly felt in both drawings that the viewer can easily identify the combined activity of looking and drawing. The figure in Willem de Kooning's *Woman* (Fig. 5-22) serves only as a point of departure for his powerful, gestural calligraphy. Paul Cummings of the Whitney Museum of American Art points out that de Kooning "does not produce presentation drawings, that is, refined, complete pages made for their own sake. Most of his drawings occur in the process of evolving a vocabulary of images and strokes to be used in his paintings." Cummings added that de Kooning's "mastery of media allows him to concentrate on the act of drawing."

By constantly making drawings, artists gain an understanding and control of their means that allow complete freedom and certainty in their response to visual stimuli. While some people learn to draw with less effort than others, very few artists can claim to have been born knowing everything about art, as Gertrude Stein suggested of Picasso (which is easily refuted by looking at the various stages of Picasso's work to see the development of his compositional techniques). Even those who think they were born with unprecedented abilities and insights must learn to focus and discipline their natural talents. For others it requires a more conscious and systematic dedication to mastering basic skills that provide the means for expression. Matisse commented that he always wanted his work "to have the lightness and joyousness of a springtime which never lets anyone know the labors it has cost." The facility to draw seemingly without effort is, in effect, the reward for those labors.

More Than Technique

Mastery of different media and techniques only begins to facilitate expressive drawing. Drawing is dependent on more than flashy, accomplished technique and compositional cleverness. The artist must fuse intelligence, emotional response, instinct, and impulse with compositional skill and technical facility over time to produce a personal style, one that will continue to evolve. Choosing to adopt the style of someone else only results in self-conscious and mannered drawing that is a falsehood; attempting to be "artistic" often results in an equally self-conscious and contrived drawing.

It is particularly important, however, for students to be continually receptive to new ways of seeing and new ways of drawing in order to avoid repetition in their own work. Studying the methods of others and working as they do in pursuit of one's own eventual style, as has been suggested before, is a valid learning experience that introduces new ways of seeing, perceiving, and thinking. Young artists are cautioned that while style and technique can be imitated quite easily, imagination, intuition, emotions, attitudes, and accumulated knowledge and experience cannot, and it is precisely from those intangible and elusive elements that individual style and expression are born. Style is more than talent, skill, and sleight of hand; it evolves from an individual's own being. Style is not dependent on complete originality, but upon total individuality, manifested in a unique image that reveals a subject as it is perceived by one artist alone. As Picasso explained, he either chose or invented a style appropriate to what he wanted to express. The diversity

ambiguity
A state of visual uncertainty created by intentionally ignoring or distorting accepted compositional methods; the unconventional visual effects that result from the apparently purposeful attempt to create a sense of imbalance.

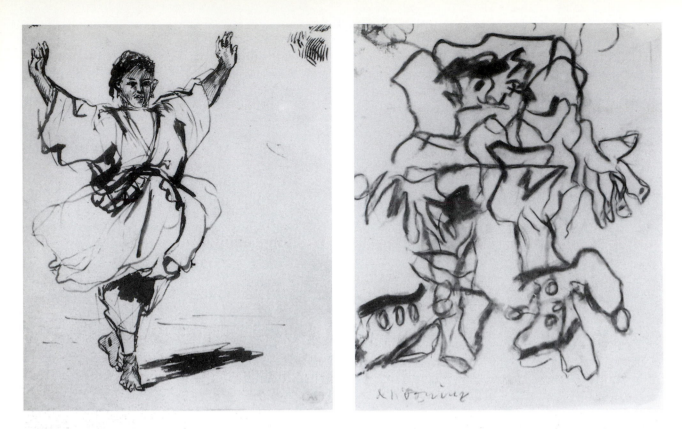

17-13. *above, left:* EUGÈNE DELACROIX (1798–1863; French). *Arab Dancer.* c. 1832. Pen and ink, 7 1/2 × 6" (19 × 15 cm). Museum Boymans-van Beuningen, Rotterdam.

17-14. *above, right:* WILLEM DE KOONING (1904–1997; Dutch-American). *Man.* c. 1974. Charcoal and traces of oil paint on paper mounted on canvas, 4' 3 3/4" × 3' 5 1/2" (1.31 × 1.05 m). © 1992 Willem de Kooning/ARS New York.

metaphor
In a work of art, a concept, symbol, or motif that carries an implied comparison or is used in place of some other idea in order to draw heightened attention to the visual statement for the purpose of enhancing its meaning.

of his styles is suggested, at least in part, by the variety of his drawings selected for this edition of *A Guide To Drawing.*

A comparison of Eugène Delacriox's *Arab Dancer* (Fig. 17-13) and Willem de Kooning's *Man* (Fig. 17-14) reveals an almost identical handling of line—Delacroix's dancer an image of lightness, fluidity, and grace; de Kooning's man clumsy, his movements uncontrolled. Philip Guston's *Ink Drawing* (Fig. 1-9) shares the same character of line without any apparent reference to recognizable subject matter.

Although Van Gogh's letters to his brother Theo document the struggle he endured in learning to draw, his early pieces have an intensity of expression in spite of, or perhaps because of, their seeming awkwardness and lack of facility. Yet, because of their unprecedented and strangely unique expressive nature, they have lasted as milestones of an evolving personal style.

Van Gogh approached all subjects—landscapes, still lifes, figures—with equal fervor, and with a sense of total identification. In a drawing dating from his early dark Dutch period, Van Gogh describes the stark and barren *Winter Garden at Neunen* (Fig. 17-15) in an essentially literal way, in sharp visual contrast to the frenzied convolutions of *Grove of Cypresses* (Fig. 17-16). The unique and articulate characteristics present in these two drawings are pure invention—the expression of his loneliness and personal torment.

Visual Metaphor

A powerfully expressive device employed by artists in all disciplines is the use of **metaphor,** which is an implied comparison of one subject with another. As applied to the visual realm, an artist may depict a particular subject that substitutes for, or symbolizes, another subject. For

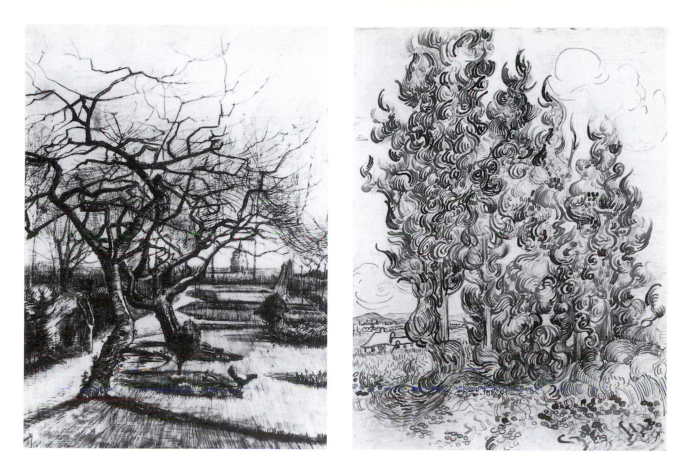

example, in 1504 Leonardo da Vinci received a commission to paint a large mural in the council chamber of the Palazza della Signoria. He chose the famous Florentine Battle of Anghiari as his subject, for which he produced a series of preliminary drawings. In one of the drawings from that series, a highly expressive work in red chalk entitled *A Rearing Horse* (Fig. 17-17), Leonardo's ability to use metaphorical meanings that launch out in many directions is clearly evident. Leonardo chose to use the powerful gesture of the horse tossing its head as a metaphor for the spirit of battle. Notice how the physical characteristics of the drawing change from the highly descriptive musculature of the horse's hindquarters to the eventual animation and writhing gestures of the tossing head. Leonardo exhibits his stellar mastery over live anatomical forms so beautifully that one can almost hear the sounds of the battlefield.

In Greg Murr's graphite and pastel drawing entitled *Predicament* (Fig. 17-18), the artist has skillfully chosen dry media with expressive powers of both subtlety and density, high contrast, and three-dimensionality. The dogs appear to be suspended from their vertical leashes in midair like puppets controlled by a puppeteer who places them on an accompanying receptive stage or surface—in this case, that of white wove paper. From the drawing's poignancy and the visual elements of density, contrast, and weight, we glean the profound impact of Murr's subjective handling of the four dogs in a public park, unfamiliar to each other, suddenly meeting their fellow canines for the first time—being unexpectedly thrust together as their owners casually traverse each other's routine walk paths. It is without warning that the dogs find themselves suddenly in each other's territory, both invading and invaded—hence, the title.

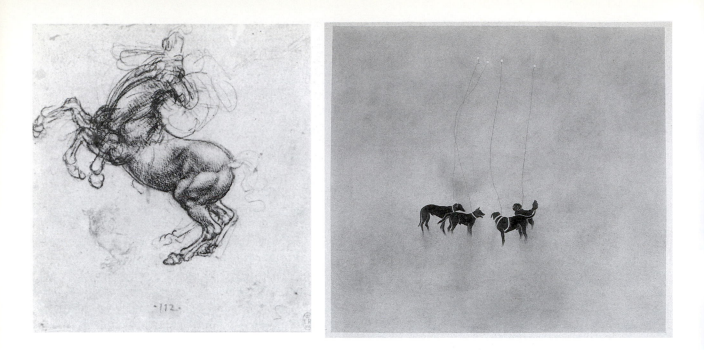

cacophony
A sudden, unexpected, often disharmonious visual aspect of a composition that arouses the viewer's immediate attention; an obvious and interestingly noticeable visual disharmony used in a positive way to strengthen or enhance a visual statement.

imagination
In art, the act or ability to envision fictitious, mental images that are present in the mind's eye but not in actual life; also, the artistic power to create images of a fanciful nature as metaphors for unrealized experiences that may, however, have meaning and association in real or actual life.

What a powerful human metaphor is expressed here in the feelings of surprise, uncertainty, curiosity, fear, shyness, and the territorial need for establishing instant domination. As we decipher the artist's composition, the individual position and distinctive body language of each dog conveys a uniquely different personality associated with a different set of visual sensations that respond to each other in completely different ways. In Murr's own affirmation of the metaphor, he states, "[T]here is an awkward beauty in our condition, a precariousness about the way we negotiate our environment and the means by which we interact with each other." Murr's drawing is an expressive work, a powerful comparison and exchange of meaning and association, a metaphor for the initial awkward **cacophony** of the unexpected—yet forced—interaction.

Imagination and Expression

Van Gogh stated that he never drew *from* **imagination,** but he always drew *with* imagination. Just as the external world provided the basis for Van Gogh's imaginative interpretations through his own experience and emotional responses, so, too, can the art elements—line, tone, texture, pattern—stimulate imaginative activity. Invention, improvisation, and imagination assume a greater role in Joan Miró's *Self-Portrait* (Fig. 17-19) than does observation. Although depicting himself with serious demeanor, Miró engages in imaginative play as a legitimate artistic expression. Any familiar shape or object can provide the subject for visual improvisation in the same way that a simple melodic theme can initiate elaborate musical invention.

Imagination and expression are manifested not only in *how* and *what* one draws, but also in *what* one draws. Artists have been encouraged to explore new uses and combinations of materials by the great expansion of media resulting from modern technological developments. Everything challenges artists' inventive powers if they allow technology to play a role in their creative undertakings. However, the abundance of new materials and the inventive attitude of techniques so characteristic

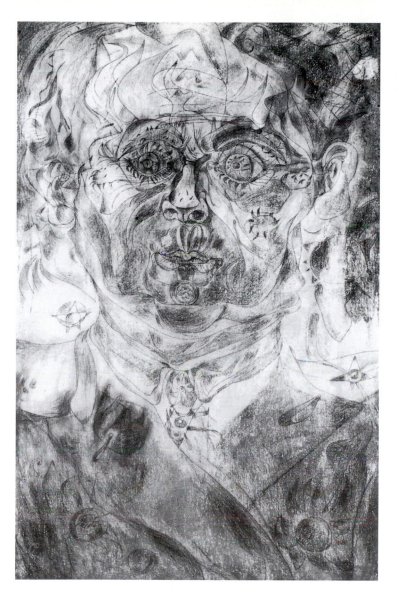

17-19. JOAN MIRÓ (1893–1986; Spanish). *Self-Portrait*. c. 1938. Graphite pencil on canvas, 4′ 9 1/2″ × 3′ 2 1/4″ (1.46 × .97 m). The Museum of Modern Art, New York (James Thrall Soby bequest).

of today is not an unmixed blessing. An undue concern with invention, with new materials and techniques, can distract one from more profound visual statements. Often when a technological process displaces the physical act of creation, it leaves a sterile, expressively cold, or even expressionless result in its wake. It is easy to become enamored of superficial surface qualities of slickness without giving thought to deeper levels of interpretation and meaning that constitute the major significance of works of art. It is also possible to flit from one fascinating material to the next without ever fully exploring the potential of any one. A period of exploration and experimentation is necessary, however, for every artist, because only by such a process does one find the materials best suited to one's individuality and temperament.

In Derek Besant's relief-intaglio print *All Around Us Birds Had Fallen Silent* (Fig. 17-20), a metaphor for a storm, we see a computer-generated image born of technology as Besant utilized the cutting precision of a laser surgical arm (the same computerized laser apparatus used in eye surgery) to cut the photo-image into the mipolan (linoleum) surface. Besant, a Canadian artist, wanted to combine technology with

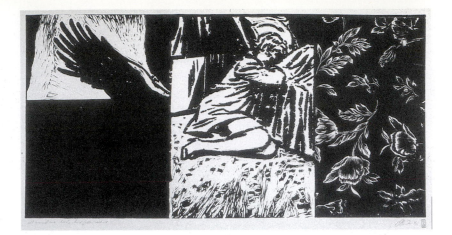

17-20. DEREK BESANT (b. 1950; Canadian). *All Around Us Birds Had Fallen Silent.* c. 1997. Relief-intaglio print, 14 7/8 × 29 1/4″ (37.8 × 74.3 cm). Wake Forest University Permanent Collection. Courtesy of the artist.

traditional tools to both draw and incise the image onto the linoleum plate. In the print we see the elements of artistic imagination, invention, mode of expression, and metaphorical references to the effects of the storm: young woman fearfully clutching the blanket as she crouches beside the bed; a stricken bird, its wing flapping against the window in an effort to find shelter—all of which form a complete visual statement in Besant's original print.

Mastery of Craft

Imagination and invention are of little value to artists if they have not mastered their craft sufficiently to provide visual realization for their concepts. If Picasso was not born knowing how to draw, he acquired the requisite technical skills early in life that allowed him to give form to all the inventions of his fertile imagination.

Chapters 17 and 18 reiterate, as was stated in Chapter 1, that expressive drawing requires more than an accurate rendering of form and skillful manipulation of media and technique. There are, unfortunately, no foolproof formulas or successful mechanical approaches to drawing with expression, nor are there predetermined standards by which to judge when a drawing is finished other than to consider it complete when it conveys exactly what was intended and when it can no longer be developed for the better. Hans Hoffman, one of the abstract expressionist painters, offered this metaphor that references the "act of parenting" when he said, "I know a work is finished when it doesn't need me anymore."

In the creative act, the artist must enact the beginning of the process and call a halt when the appropriate clues reveal it is completed. This is a huge responsibility. You must also decide what media and methods work best for you, and what approach is the most expressive according to what you want to convey.

The degree of detachment necessary in determining whether a drawing is successful is difficult to maintain while engaged in the process of drawing. It calls for the artist, in effect, to become another person in order to judge whether what was intended has actually been accomplished, and to decide whether technique and composition fully support and communicate the idea. The most difficult but most important question to ask is the by-now-familiar, "Would the drawing be interesting if it had been done by someone else?" Failing an honest positive

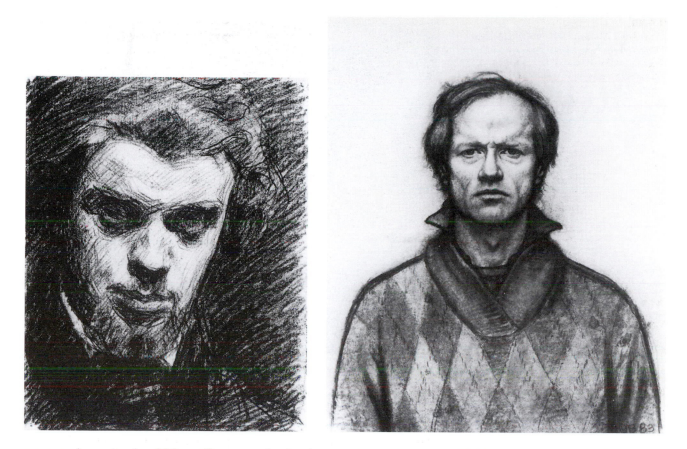

answer, the artist should be willing to redo the drawing. Complacency contributes very little to expressive drawing—in fact, it defeats it. Starting a drawing over can produce new interests along the way, creating the potential for the outcome to be better, richer, and even more expressive than the first attempt.

Self-portraits offer endless possibilities for exploring various avenues leading to expressive drawing. Lacking the availability of other subject matter, one has only to look into a mirror. Fantin-Latour found in himself "a model who was always ready, offering all the advantages; he comes on time, he does what you tell him, and you already know him before you start to draw him." As a student, after he returned from copying at the Louvre, Fantin would sit before a mirror and draw self-portraits from five until eight in the evening. Figure 17-21 provides an example of that concentrated activity. Fantin favored black chalk or charcoal for building the dense rich black tones that contribute significantly to the dramatic and expressive impact of his studies. He experimented with the placement of the source of light for heightened theatricality. Positioned directly overhead, the lamp creates deep pools of blackness from which his eyes burn with hypnotic intensity.

William Beckman's *Self-Portrait* (Fig. 17-22), drawn under a less harsh overhead light and with softer modeling, appears to project from the picture plane like a piece of low relief sculpture. The head and bust seem firm, yet not fully three-dimensional because of the flattening effect of the emphatic dark outline. The strict frontality and calculated symmetry of the pose are broken only by the irregular shape of the hair and points of the shirt collar. The overall effect is both compelling and disquieting.

17-21. *above, left:* HENRI FANTIN-LATOUR (1836–1904; French). *Self-Portrait.* c. 1854–1856. Black chalk and stumping, 11 3/4 × 9 1/2" (30 × 24 cm). Detroit Institute of Arts (gift of Abris Silberman).

17-22. *above, right:* WILLIAM BECKMAN (b. 1942; American). *Self-Portrait.* c. 1983. Charcoal on paper, 29 1/8 × 24 3/4" (74 × 62 cm). Courtesy Frumkin/Adams Gallery, New York.

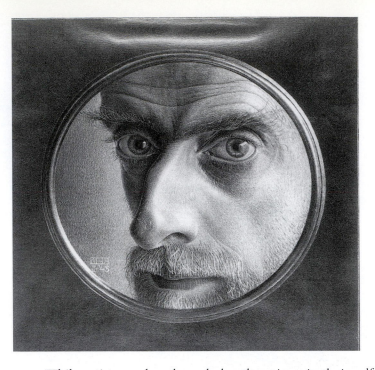

While artists rarely acknowledge the mirror in their self-portraits, viewers become conscious of the presence of an unseen mirror in William A. Berry's *Self-Portrait With Lamp* (Pl. 6), for example, because he has depicted the act of looking as part of the process of drawing. In contrast, M. C. Escher (Fig. 17-23) and Sigmund Abeles (Fig. 17-24) each chose to include the mirror itself in the drawing. The circular shape of Escher's shaving mirror and highlights on its frame are repeated not only in the irises of his eyes, but also in the eyelids and thin folds between the eyelids and eyebrows. Escher has successfully created the illusion, purely through inventive drawing, that his nose is pressed against the mirror surface. While artists often have built their compositions around models positioned in front of mirrors (Figs.1-2, 1-3, 8-22). Abeles depicts himself standing on a seemingly endless mirror. The drawing offers a curious juxtaposition between what is above the mirror (below in the drawing) and what is below or reflected (above in the drawing). The foreshortening is wonderfully strange and ambiguous—the head appears to grow out of his waist and he seems to be wearing his shoes upside down. We see no arms, which adds to the ambiguity of the foreshortening. The artist appears to be extremely tall, with his arms blocked from view by his decidedly wider hips, which are closer to the viewer than the shoulders.

While most people by nature are inclined to repeat what they can do successfully, a willingness to experiment leads to development of a stronger style and artistic growth in general. That does not mean that every drawing must be different; it merely suggests that you should avoid prolonged repetition of only those things that you are comfortable doing. In your quest for creative growth, remember that neither imagination nor style demands complete originality. When pursued for its own sake, originality, as we have seen, need be nothing more than your own unique interpretation and expression of seeing, perceiving, and feeling.

In Jim Dine's *Nine Self-Portraits with a Very Long Beard* (Fig. 17-25), the artist invites us to view his tremendous facility for creating variations

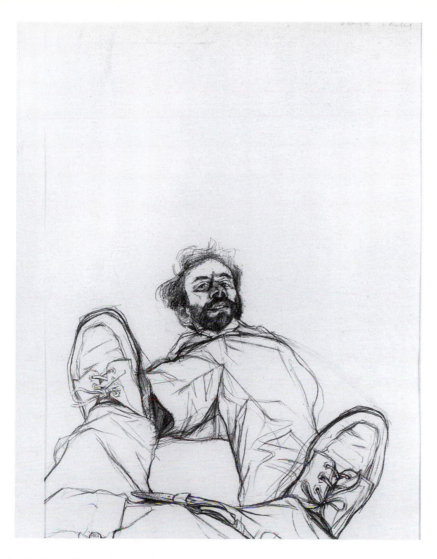

17-24. SIGMUND ABELES (b. 1934; American). *Self-Portrait on Mirror.* c. 1970. Charcoal, 28 1/2 × 22 1/2" (72.4 × 57.2 cm). Collection of Dr. and Mrs. Joseph B. Barron.
Courtesy of the artist.

in the handling of a single drawing medium, graphite, with the accompaniment of an eraser to produce elaborately undulating tonal expressions from portrait to portrait. Notice the repetition, yet the differing positions on the paper of each head as a separate visual adventure. (We can well imagine how monotonous the series of drawings would be were each head in exactly the same position on each sheet of paper.) Notice how much variety there is in the nine beautiful reinterpretations of the artist's face and beard. The nine individual personalities conveyed seem estranged from one another, and yet there is no doubt that they are all the same face.

Expanding Expressive Awareness

It is not uncommon to hear students say, "All I want to do is draw" (or etch or paint or sculpt or throw pots). If one chooses to be an artist, commitment is important, even imperative, and commitment is reflected in the eagerness, willingness, and persistence to do more than just settle for the easiest and most obvious solution to a project.

At the same time, however, art students are responsible for far more than just mastering the craft of drawing (or etching, painting, and so on). They must be willing to expand their awareness of other areas

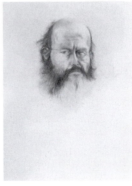

17-25. JIM DINE (b. 1935; American).
Nine Self-Portraits with a Very Long Beard. c.
1977. Graphite and erasers on paper, each
of nine sheets 30 × 22" (762 × 559 mm).
Promised gift of the artist to the National
Gallery of Art, Washington, D.C.

of learning and experiences beyond the studio environment in order to stimulate creative growth in their choice of and approach to different subject matter. Artists from all walks of life and different periods in history, as evidenced by this text on drawing, are some of the greatest "problem solvers" in the world. The process of making art has taken them on an expressive journey of discovering, investigating, finding solutions, solving visual dilemmas, and speaking a visual language that is cogent, succinct, descriptive, meaningful, and profoundly expressive of the human heart and mind.

The noted science fiction writer/author Ray Bradbury, when asked, said that he had never experienced "writer's block," because he had spent his life "feeding the muse." Looking, seeing, reading, and being aware of and sensitive to life are essential to all creative people; they are as necessary to an artist as learning to draw.

In the next and final chapter of this book, we will look even more closely at possibilities of expressive drawing by considering the complexities of joining together different drawing media.

Expressive Mixed Media 18

*Exploration in breadth combined with
concentration in depth requires the
particular discipline which characterizes the
artist: an inner discipline in which deep
satisfactions and dynamic dissatisfactions
alternate to stimulate continual growth.
Through such a discipline the art student
discovers and reveals himself and thereby
establishes the basis for becoming an artist.*

—Daniel Mendelowitz

At the beginning of every semester, the author of this revised text asks his students these questions: "Are your experiences silent? Do your lives have texture? Does your expression have form?"

There is a density and an inevitable multiplicity in life. In fact, in the broadest sense, our environments are laden with mixed media and myriad influences that teach and form us from childhood. There are multiple reasons for asking these questions. In answering them students learn to think more deeply about their creative potential and to recognize the importance of all our senses and their responses to stimuli in our daily lives. The sights, sounds, smells, tastes, and textures, along with all the other forms of expression in our environments that provoke our emotional responses, are the seeds of new expression awaiting the fertile soils of the student/artist's will to create. Wayne Thiebaud has said, "For the past 45 years I have been teaching drawing and painting and introducing students to the deep pleasure of learning how to draw."

This chapter on mixed media is an appropriate way to end this text, and it is only fitting that as students read it, they reflect on and review the drawings illustrated in the former chapters, as many of them are the results of more than just a single search in a single medium. Most, in fact, are mixed-media works done on a variety of different surfaces at a variety of different times in art history, and the one thing they have in common is the expression of the human heart. The artists who created these many wonderful drawings listened to their experiences, they felt deeply the textures of their lives, and they recognized the forms of their own expression.

Landscape of Mixed Media

When we consider the visual arena of the natural world, we readily see the effects of multiple complexities. As the artist sees, perceives, and extracts the essences of that world, he or she translates those complexities into visual expression by a variety of creative means. Often the complexity of subject engenders complexity of creative means.

The phrase *mixed media* implies far more than just the coming together of two or more materials on a multivaried surface. It also suggests the use of varied methods to create a rich and complex drawing that cannot be produced from a single medium on a common surface. Since the beginning of time artists have identified certain media as having the capabilities to produce certain desired effects. From the most primitive tools to the most complex, artists have specified the materials and techniques that will best fulfill their artistic goals.

Applying Sight Skills The underlying theme of this text is learning how to see more intently and describe through reinvention as the eyes direct the hand. Drawing is about extracting the visual vocabulary found in the simplest objects as well as in the most complex life forms. We can enhance this vocabulary through the use of mixed media.

For the most part, seeing has been addressed in terms of scrutinizing the subjects we are drawing. Now it's time to apply the same degree of passionate scrutiny to the surfaces upon which we draw. Applying our sight skills to our drawings is the follow-up exercise and has already been put into practice through the added feature of the critiques at the end of the appropriate project assignments in this revised edition. When our sight skills approach the level of our technical facility with drawing media, our images carry more expression.

Combining Materials The intrigue of mixed media begins with the blending of materials and technical methods of all kinds as inspiring processes in themselves. The studio, whether indoors or outdoors, is the artists' proving ground for converting their unrealized yearnings into tangible expression. Often the artist is inspired by the environment itself, or the environment may evoke a particular response not directly related to the environment but to another thought or feeling. Critic Joshua C. Taylor eloquently describes artistic inspiration in writing about layered complexities in the work of Robert Rauschenberg: "The provocation of unsettling alertness . . . to sense, to association, to memories and the flexibility of the mind . . . , renders the inert alive, and gives voice to what might otherwise stay mute."

Along with the technical explanations and projects in this chapter that will engage the student with a mixed media focus, it is also the intent to provide technical and conceptual unity to concepts discussed in previous chapters so that the student can approach mixed media both analytically and critically and learn the skills of visually deciphering his or her own avenues of creative expression in a more than fundamental way. Seeing and responding, orchestrating and refining, are an artist's most provocative activities, and will be the prescribed activities as well for studio classroom assignments in mixed media expression.

Expressionism and Media Considerations

As has been discussed through this text, drawing is about selecting the right tool and bringing it together with the right subject, then reinventing that subject onto a specifically chosen surface. Artists have discovered that there can be a powerfully expressive connection between the choice of material and the choice of subject; the choice of material can be critical to the success of an idea. Often, the desire to create a specific thing leads us to select a material or medium that seems best suited to the statement we desire to make. The attributes of line, tone, texture, color, shape, and the activation of the elements in space are the fundamental tools with which any artist attempts to give form to his inspiration. Drawing, being the most direct of all visual art disciplines, is often where we start.

The Specificity of Materials The longing to make a graphic mark by dragging a tool across a receptive surface has been with us since the beginning of time. When we expand that effort by adding other materials, we put into play more elements of potential expression. In the hands of a master artist, any tool in combination with a viable surface can become powerfully expressive. Even humble materials can produce an emotionally charged drawing, as evidenced in the work of Mauricio Lasansky (Figs. 18-1, 10-17, Pl. 13), leading us to the conclusion that our expression itself is an irrepressible force. In these mixed media works, Lasansky chose graphite pencils, red earth pigments, and turpentine washes for his repertoire. In his own words, "I tried to keep not only the vision of The Nazi Drawings simple and direct but also the materials I used in making them. I wanted them to be done with a tool used by everyone everywhere. From the cradle to the grave, meaning the pencil. I felt if I could use a tool like that, this would keep me away from the temptations that would arise from the virtuosity that a more sophisticated medium would demand."

The Nazi Drawings delve deeply into the human consciousness exposing the guilt of the religious community in the aftermath of the Nazis' slaughter. Lasansky says of drawing 23 (Fig. 18-1),

> And so in the twenty-third drawing they reappear: the bishop
> with the horror slowly disappearing from his face and giving way
> to a guilt-evaporating incredulity, and the infant corpse held
> shield-like against his chest. The dead infant with a skull-helmet
> covering its features has clearly become identical with the Christ
> figure it had been merging with in the previous drawing. The fal-
> cons have returned to perch symmetrically, unmenacingly, at four
> corners on the two crossbars. The bishop's cope is a collage made
> of pages out of Exodus, the same pages that line his mitre.

Artist as Orchestrator When a single medium is not enough to provide the variety of expression the artist seeks, he or she chooses additional tools that will create the intended effect. As an orchestrator, the artist strives for a harmonious balance among all the media applied to the surface, the ultimate challenge being to keep everything in play while being aware that changing any element, even in a minor way, will alter the total effects in either a positive or negative way.

In Robert Stackhouse's *Inside a Passage Structure* (Fig. 18-2, Pl. 18), we see a careful blending of wet and dry media on an expansive surface

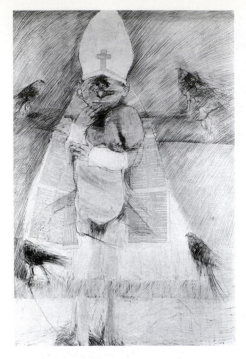

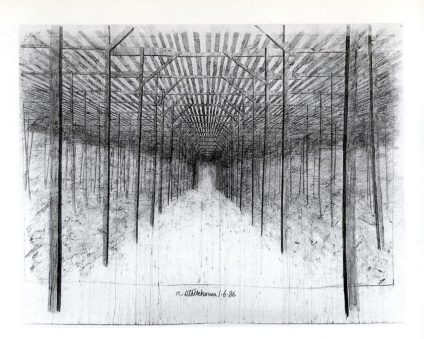

18-1. *above, left:* MAURICIO LASANSKY (b. 1914; Argentinian). *Nazi Drawing #23.* Graphite pencil, red earth pigments, and turpentine wash with collage. 67 × 46″. The University of Iowa Museum of Art. (On long-term loan to the Cedar Rapids Art Museum, Cedar Rapids, Iowa.)

18-2. *above, right:* ROBERT STACKHOUSE (b. 1942; American). *Inside a Passage Structure.* c. 1986. Watercolor, charcoal, and graphite on paper. 89 1/2 × 120″. The Arkansas Arts Center Foundation Collection.

of nearly symmetrically descriptive forms that take us not only into the deep space, but into the internal spaces of the drawing as we find our eyes wandering among the vertical beams to the left and right of the central passageway. This is an extremely powerful illusion of three-dimensionality on a large two-dimensional surface. Stackhouse has done this so convincingly that we feel as though we could simply walk into the space, perhaps even get lost in its depths.

Media of Previous Centuries

By comparison with the wide variety of artist supplies available today, the tools and materials available to the Renaissance artist were very limited. Between the fourteenth and sixteenth centuries, the Renaissance masters produced highly expressive works by ingeniously exploiting the few tools they had to reach immeasurable heights of creativity. We see this in Raphael's beautifully depicted red chalk drawing *Two Riders* (Fig. 18-3), in which the artist uses a single medium so skillfully that nothing is visually lacking. Albrecht Dürer's *An Oriental Ruler on a Throne* (Fig. 18-4), done in pen and ink, displays every kind of linear hatching, cross-hatching, and cross-contour hatching described in this book. The media are simple, and yet the drawing lacks nothing. One could easily assess that from Durer's pen flowed the inks of an unprecedented creative mystery.

Probably the first *dry* mixed-media drawing was one in which the artist used white chalk over charcoal to create the illusion of highlights. An example of this is Peter Paul Rubens's *Study for the Figure of Christ on the Cross* (Fig. 18-5). Notice the skilled attention paid to anatomy and the adroit placement of the figure within the picture plane.

Economy of Mark What we have been discussing in the works of these three artists is an "efficiency of means"— an economy of mark making so descriptive and expressive that few if any works since have surpassed their visual impact. When this efficiency is transferred to more complex compositional structures, the expressive potential magnifies.

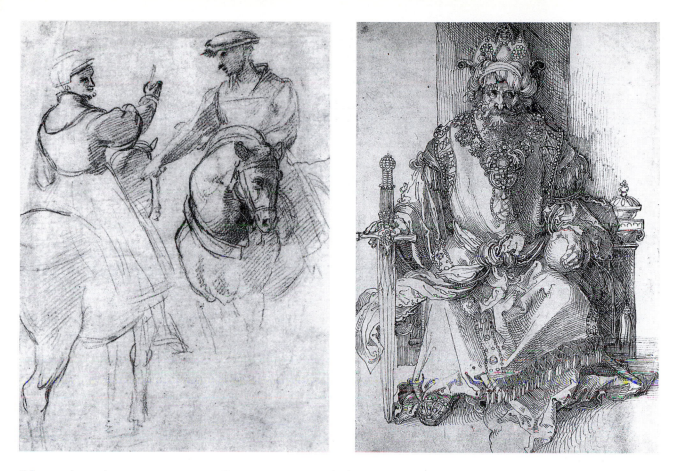

Often artists who attempt to magnify expression simply by using multiple materials fail because they lack the well-orchestrated harmony that must necessarily exist between the parts of the whole. Thus we can see that the effectiveness of a mixed-media work is directly proportional to the harmony of its visual elements. Look again at Raphael, Dürer, and Rubens. These works have continued to hold our attention for several centuries because of their inherent beauty and association to the lives and times of the artists who created them. They also inspire us to further exploration of the multimedia possibilities at our disposal.

Preliminary Mark as Gesture Another example of the use of dry mixed media is Raphael's *Combat of Nude Men* (Fig. 18-6), where we see an image done in red chalk over preliminary stylus work. Note the attention given to the anatomical structure of the human body and the gestural movements of the figures involved in battle. There was a significant moment when Raphael decided to enhance the preliminary stylus work with red chalk—a creative decision that has stood the test of time.

The preliminary marks that an artist lays down are often the determinants of the direction a work will take. Therefore, it is vitally important that initial drawing on a surface to which other materials will later be added be made with a distinct sense of purpose and sureness.

Experimentation

Choosing the right materials and combinations of materials is based largely on artists' existing knowledge about the characteristics of different media. However, in incorporating these multiple elements into a

18-3. *above, left:* RAPHAEL (1483–1520; Italian). *Two Riders.* Red chalk. 11 1/4 × 8" (28.6 × 20.3 cm). Albertina Museum, Vienna.

18-4. *above, right:* ALBRECHT DÜRER (1471–1528; German). *An Oriental Ruler on a Throne.* Pen and black ink. 11 7/8 × 7 5/8" (30.2 × 19.3 cm). National Gallery of Art, Washington D.C.

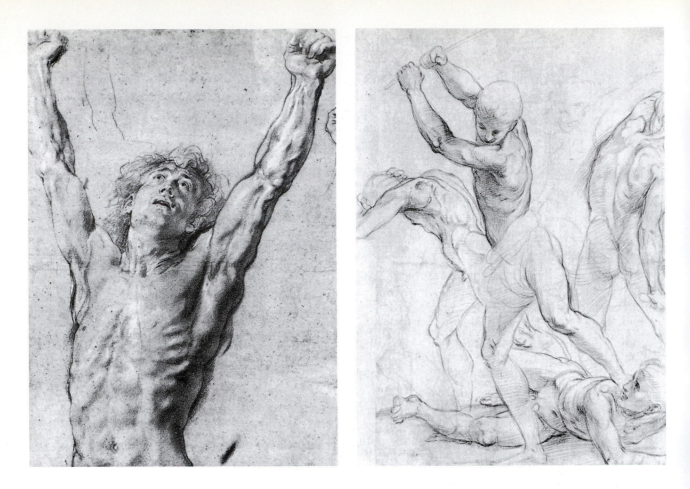

18-5. *above, left:* PETER PAUL RUBENS (1577–1640; Flemish). *Study for the Figure of Christ on the Cross.* Charcoal heightened by white. 20 1/4 × 15 1/2" (51.4 × 39.4 cm).
The British Museum, London.

18-6. *above, right:* RAPHAEL (1483–1520; Italian). *Combat of Nude Men.* Red chalk over preliminary stylus work. 14 7/8 × 11 1/8" (37.7 × 28.3 cm).
Ashmolean Museum, Oxford.

drawing there is always a danger of overdoing—a costly error that sends many potentially successful works of art to the incinerator. To avoid this outcome, it is useful to experiment—to see what visual effects may occur when certain elements are brought together on the working surface without previous knowledge of what the results will be—and then to direct those elements into a well-composed drawing.

The Working Process It is easy to ebb and flow with the working processes, particularly when multiple elements are interacting in such an interesting way, not noticing whether the work itself is straying away from technical virtuosity, resulting in nothing more than an experimental exercise that failed. On the other hand, there is always something to be learned from a failure—this is indeed part of the process of learning. One must be thoughtfully selective in the choice of tools and envision how they will respond to each other. Then proceed with the process of investigating and experimenting to see how they react with each other and what kinds of visual effects are derived from the marriage of materials you've selected.

Material's Relationship to Material The artist using multiple elements on the same surface must continually consider whether the addition of a single mark, area of tone or texture, or even an entire surface change enhances the whole expression or detracts from it. The variety of media and the wide-ranging expression of linear, tonal, textural, and spatial circumstances beckon the artistic mind into action, but it is important to maintain an objective view about what is taking place on the

working surface. The artistic act is one of deep exploration, and what the artist is after is that unfettered, **recondite** state of poignant expression that upon seeing it for the first time, startles even the artist himself.

But it is easy for artists to get lost in the process of creating and lose sight of what they are after. They often ask one another the question, Do you get what you want, or do you want what you get? For artists to achieve precisely what they are after requires striking a balance between yielding to the demands of particular media and remaining true to their objectives.

Project 18.1

Let's begin with something that is relatively simple, yet different from all previous projects in this book. Select a strong white paper of moderate tooth and of medium size. Using red and black Conté crayon, draw a still life, using black to establish the contours of the objects within the composition. Remember to incorporate as much expression as possible in the form of line variation by using varying amounts of pressure, creating a line that swells and tapers. Then use the red Conté crayon to further define the objects by drawing cross-contour lines describing the "turn of surface" of the individual forms in the still life. Also in red, develop the drawing still further by drawing hatched and cross-hatched lines where appropriate to further define the individual forms.

Take a blending stump and blend the red with the black Conté crayon. This mixing of the red and black particles will occur for the most part near the contour edges of the forms.

Critique (Project 18.1) The most important thing to assess is the distinctive roles that the red and black Conté crayons play in the drawing. They are individual media but of the same material, and they speak visually with different expressive voices in the composition. Previous projects have also involved the use of different media, but perhaps this is the first time you've considered the distinct differences of expression between two different-looking materials because of the red and black—even though they are the same material and respond in very much the same way.

Do the effects of the different crayons support each other in the drawing? Is the dominant role of one material apparent? Do you have a sense that the two need each other in the drawing? What if the red and black were reversed? How would this change the look of the individual objects as well as the entire composition?

In the final analysis, did you achieve what you wanted in the drawing?

Strengths of Single Tools

There are not only multitudes of tools available to artists, but also multiple variations of each tool. The twenty different grades of graphite alone as delineated in Chapter 10, Dry Media, give the artist greater expressive potential with a single medium than ever before. Kent Bellows and John Wickenberg exemplify this "purist" involvement in their drawings *Portrait of Rachel* (Fig. 18-7), and *MIA (Dead Bird)* (Fig. 18-8). Drawing exclusively in graphite, these two artists show us how one can achieve great expressive heights with a simple, inexpensive, and commonly used tool. Graphite as a single medium remains one of the most popularly used tools in drawing, and one is amazed at how different graphite drawings can look because of the wide range of draftsmanship skill of the different artists represented in this book (Figs. 5-14, 6-10, 10-14, 10-18, 12-4, 12-8, 13-18, 13-19, 18-7, 18-8, 18-9, 18-16). However, graphite is also applicable as a mixed-media component with both wet and dry drawing materials, and one often finds it in combination with a host of other mark-making tools. Richard Ziemann's use of brush and black ink

recondite
A term describing the quality of being indescribably strange and curious without means of explanation or evidence of reason. As applied to art, it describes a profound visual situation the comprehension of which is beyond the grasp of the ordinary mind.

18-7. *above, left:* KENT BELLOWS (b. 1949; American). *Portrait of Rachel.* c. 1985. Graphite with smudging and touches of erasing on ivory wove paper. 19 × 17" (483 × 432 mm).
The Jalane and Richard Davidson Collection. © The Art Institute of Chicago. All rights reserved.

18-8. *above, right:* JOHN WICKENBERG (b. 1944; American). *MIA (Dead Bird).* c. 1985. Graphite on cream wove paper, 16 1/2 × 26" (419 × 660 mm).
The Jalane and Richard Davidson Collection. © The Art Institute of Chicago. All rights reserved.

18-9. *right:* GREGORY PAQUETTE (b. 1947; American). *Rabbits (Flayed).* c.1982. Graphite and charcoal with smudging and erasing on ivory wove paper. 36 1/2 × 35 1/4" (927 × 895 mm).
The Jalane and Richard Davidson Collection. © The Art Institute of Chicago. All rights reserved.

over graphite (Fig. 13-13) shows us an example of using graphite with a wet medium; in Gregory Paquette's *Rabbits (Flayed)* (Fig. 18-9) it is used with another dry medium, charcoal.

Surface

Drawing tools are not the only consideration in mixed media—the variety of different receptive surfaces for the media is important as well. Artists today have the luxury of not only an extensive array of drawing media but also a wide variety of surfaces. The ways in which particular surfaces absorbed drawing media have concerned artists for centuries. We may speculate that even the prehistoric artist instinctively chose the

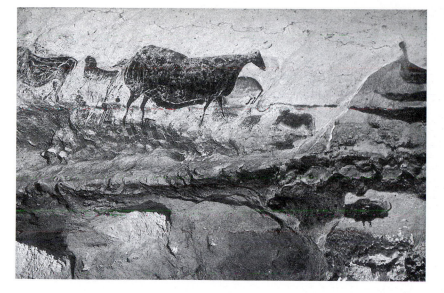

most desired portion of a rock wall's surface for the necessary picture plane that was to eventually become a completely developed composition (Fig. 18-10).

Project 18.2

Combine graphite line with pen and black ink line in the same drawing of a still life. Begin with graphite and draw until you have a sense of wanting to change media. Then switch to the pen and black ink and continue drawing. Complete the contour portions of the drawing with a relatively high level of finish, including a generous amount of descriptive line hatching, again using the medium you feel directed to use—either graphite or pen and black ink. It is important that you begin to develop an instinct about what is appropriate to use for different aspects of a drawing. It is also important to be as experimental as possible with media so as to develop a sense of their interacting capabilities and resulting visual effects. Allow the ink to completely dry and go back into the drawing with a variety of sepia (brown) wash tones and brush, covering over with wash the areas of darker passages as described by the line hatching. Allow the lighter washes to overlap the hatching lines onto the surfaces of some of the still-life objects. Try to develop a painterly sense of the wet media applications, allowing the brush strokes to leave their expressive marks.

When the drawing is dry, assess the lighter areas in particular—the lightest wash areas and the open paper surface. (There should still be portions of the white paper showing in the composition.) Using white Conté crayon or white chalk, emphasize certain linear aspects of the still life, allowing the composition to become more abstracted as you draw in white. Notice how even through applications of graphite, pen and ink, and ink wash, the tooth of the paper still takes on the white Conté crayon or chalk extremely well. Ink on paper, when dry, does not resist further applications of either wet or dry drawing materials.

Repeat this exercise several more times drawing other forms—the figure, the landscape, even a self-portrait using a mirror. The more familiarity you have with different media, the more trustworthy your instincts will become.

Critique (Project 18.2) How do the different media act together to form the wholeness of expression? How would the drawing change if any single medium were removed? Are you able to ascertain the proportional effects of each medium? Do they seem well proportioned? Would you increase or decrease the use of any of the media? What might happen if you reversed the order of application in the next drawings? Is there a logistical reason for the order of application? How might the expressionism change by altering the application process in any way?

18-11. *above, left:* HENRY MOORE (1898–1986; English). *Four Grey Sleepers.* c. 1941. Pencil, white wax crayon, watercolor wash, crayon, pen and black ink. 16 5/8 × 19 3/4″ (42.5 × 50.2 cm). City Art Gallery, Wakefield. Photo courtesy of the Henry Moore Foundation.

18-12. *above, right:* HENRY MOORE (1898–1986; English). *Pink and Green Sleepers.* Pencil, white wax crayon, watercolor wash, crayon, pen and black ink. 15 × 22″ (38.1 × 55.9 cm). The Tate Gallery, London. Photo courtesy of the Henry Moore Foundation.

mixed-media drawing

A drawing created by the interaction of a few or many different drawing materials that come to rest on a surface or on multiple variations of a surface. The artist selects different materials in order to enhance a visual statement and create visually interesting surface effects that cannot be produced by a single medium.

Invention of Surface As one plans to begin a **mixed-media drawing** of some complexity, such as Henry Moore's *Four Grey Sleepers* (Fig. 18-11) (created with graphite pencil, white wax crayon, watercolor wash, colored crayon, and pen and black ink), what approach should be taken? How do you determine where to start? How do you achieve the greatest degree of expression from the media you select? A look at another of Henry Moore's works (Fig. 18-12) affirms that the artist simply moves upon instinct with deliberate clarity and skill of media usage so that the visual statement is never weakened or jeopardized. In Moore's *Pink and Green Sleepers*, we see clearly the efficiency of drawing that allows every medium to be expressive. Be aware that there is a distinct difference between "surface richness" and "surface buildup"; the latter usually results when too much material is worked on the surface and the artist is out of control with the media. In Figures 18-11 and 18-12, notice the unique tactile surface qualities of each of the figurative forms existing in space, and how identifiably different they are from the immediate forms surrounding them. This is a truly brilliant work—a mixed-media masterpiece—a testament to what happens when a master artist speaks his language with multiple materials.

Project 18.3

Select a sheet of fairly heavy, absorbent drawing paper approximately 9 by 12 inches. Lay out your media: grease crayons (#1 litho crayons will do nicely), colored wax crayons (including white), graphite pencil, colored pencils, charcoal, pen and black ink, and sepia ink wash. Both the grease and wax crayons will repel the water-soluble inks, and if the crayons are applied to the paper first, the later applications of ink washes will not be absorbed in those areas.

Begin a drawing from a subject of your choice by laying out the forms in graphite. (The graphite can be thought of as a method of laying down preliminary lines; however, think of it as an integral part of this drawing.) Then follow the graphite with charcoal, emphasizing important contour lines by making them darker. Apply hatched lines inside several selected forms with the white wax crayon, knowing that these lines will remain white (having sealed the paper with the wax content of the crayon). You might decide to use the white crayon in the portions of the drawing you intend to remain the lightest. In a painterly and descriptive way, apply several different sepia wash tones to the drawing in the areas intended for tone, allowing the brush strokes to be expressive and indicative of the wet media process. Notice how the wash tones pull away from the wax crayon lines. Notice also that in areas

where the crayon seems porous by not completely covering the paper, the wash tones penetrate the openings in the crayon line, forming speckled effects of tone on the paper surface.

When the wash tones are dry, work back into the drawing, emphasizing form and the structural elements of the composition with pen and black ink and black grease or litho crayon to achieve a wide variety of linear blacks. Finish by adding conservative touches of color with the colored crayons or colored pencils.

Take your time and do several of these drawings in order to get acquainted with the media interactions and the evolving surface effects.

Critique (Project 18.3) What assessment can you make of the overall effects of the mixed media? Does the drawing seem cogent? Do the proportions of the different media seem to blend well, or are there certain aspects of one or two media that overpower the drawing? How did you feel about the execution of the work— the way one medium went down in relationship to another? How might you alter the order of applications in the next drawing?

What is the strongest aspect of the drawing? What is the weakest? What will you do differently next time using the same combination of media? How would you feel about this drawing if someone else had done it?

Evolving Surface It is a delightful experience to look at the surface of a highly involved mixed-media work, whose totality of techniques and interplay of materials cannot be easily deciphered, even by the trained eye. For some drawings a few different media can appear as many on the surface; conversely, other drawings can appear less involved when in actuality they have many materials and techniques in play. The point of any mixed-media involvement should be to strive for an economy of means regardless of how many tools and materials are used. There should be a cleanness and a clarity with regard to the use of any media as opposed to an overworked, fatigued surface that appears too heavily laden with material, causing one to wonder how many mistakes were covered over with further media applications.

Efficiency of Surface An example of one of the most well-orchestrated and efficient surfaces is Jasper John's *0 through 9, 1961* (Pl. 19), where the artist combines the two simple dry media of charcoal and pastel to build up a surface of spatial power and richness that conceptually identifies it as the synthesis of several centuries of art history. An earlier drawing of the artist's number series *0 through 9, 1960* (Fig. 18-13), a charcoal work on cream paper, refers us to a much earlier stage in the development of number series, indicating a state before the pastel was applied and before any blending or erasing techniques occurred. The drawing of the image in Plate 19 began in much the same way as Figure 18-13, with a few preliminary dry marks that developed into the complex weave of illusional textures that we see in one of the artist's largest drawings, in fact, the largest drawing he had executed at that time. As viewers, our perceptions of this intriguing drawing are that the size of *numbers* we are accustomed to is usually smaller than in this unusually large depiction. This powerful reinvention of numerals transparently placed in deep space, enabling us to see the number forms through one another on a two-dimensional surface, fuses the elements of fifteenth-century **grisaille** with the analytical cubism of Picasso and Braque from the early twentieth century. We are struck by the richness of surface attained in part by the (frottage) rubbing of a charcoal-laden rag over the paper surface while the drawing was hanging on a roughly textured wall of Johns's studio. In addition to the black and tonal gray ranges, there

grisaille
A monochrome drawing and painting technique using grays or grayish colors that was popular in the Renaissance as a way of emulating sculpture. The effects are sometimes heightened with gold.

18-13. JASPER JOHNS (b. 1930; American). *0 through 9, 1960.* Charcoal on paper. 28 7/8 × 22 7/8″ (73.4 × 58.1 cm). Collection of the artist. © Jasper Johns/licensed by VAGA, New York.

are eraser marks that produce modeling of forms, along with touches of color: yellow, red, and blue lines in the upper right and lower left with the lower right bearing an area of lavender pastel blended with charcoal.

Expressive Surface Nan Rosenthal and Ruth Fine say of Jasper Johns's drawings, "Jasper Johns' virtuosity as a draftsman may be known to the public through his prints, but the scale, impressiveness, intellectual challenge, and beauty of his drawings, and their centrality to his work, may come as a revelation." Figure 18-14, a mixed-media work in watercolor, charcoal, and crayon on two sheets of joined paper, informs us of the even deeper limits of his prowess as a draftsman.

In Isabel Bishop's *Two Girls* (Fig. 18-15), listed by the artist as simply a mixed-media work, we are intrigued by what she used and are forced to rely on our knowledge of materials and the clues that their effects offer us in order to arrive at some determination of how the artist achieved the effects created. Regardless of what materials were used, the results derive from the total effects of the surface.

Specially Prepared Surfaces This physiology of materials has long intrigued artists and has been the source of many stellar works of art relating to the interactive relationships of both conventional and unconventional tools and materials. In Jim Butler's drawings on gesso-coated wooden panels (Fig. 18-16, Pl. 14), the artist prepares wooden panels by applying between twenty and thirty coats of **gesso,** sanding the surface between coatings of gesso in preparation to receive the graphite. Butler uses a variety of tools to apply the powdered graphite and employs intermittent scraping with razor blades and sandings with fine sandpaper as a subtractive method until he begins to establish the desired forms. He then develops the tonal ranges of lights and darks that

gesso
A material used, generally in several thin layers, to prime wood panel or canvas surfaces in preparation for painting. It is made from plaster (dehydrated calcium sulphate prepared by firing gypsum or alabaster) mixed with sizing material.

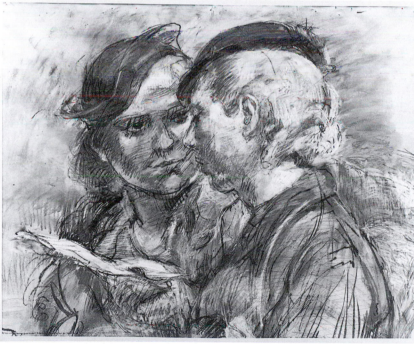

allow a visual *pushing* and *pulling* of the various compositional forms as he adjusts them in space.

Project 18.4

On four 9-by-12-inch sheets of Arches cover paper, either white or buff, make some drawings on a prepared surface by first stapling the papers to a heavy-duty drawing board. Place the staples 2 inches apart and at least 1/2 inch in from the edge

18-16. JIM BUTLER (b. 1945; American).
Sugar Cane. c. 1996–1998. Graphite on
wooden panel, left panel: 14 × 18";
right panel: 14 × 23".
Collection of the artist; courtesy of the artist.

of the paper sheets. Apply several thin coats of gesso to the entire surfaces of the four sheets. (The papers may buckle slightly as they absorb the moisture of the gesso wash, but will flatten again as they dry.) When they are completely dry, sand them lightly with fine sandpaper and a sanding block to ensure evenness. Apply several more thin coats of gesso and repeat the sanding procedure—gently.

With both graphite pencils and powdered graphite begin drawing, using the pencils first to become familiar with the effects of graphite on the gesso surface. Experiment with different grades of graphite pencil and different amounts of pressure, drawing on the tactile surface until you feel somewhat confident with pencil. Then apply powdered graphite with a fingertip to the surface by rubbing it on and blending it into the gesso coat. It may help to cover your fingertip with a piece of chamois hide to act as a barrier between the graphite and your finger, particularly if your fingertips tend to be moist. Rub with varying amounts of pressure and with varying amounts of graphite powder.

Try erasing with a white plastic eraser. You should get some immediately interesting results by erasing, depending on how smoothly you sanded the surface before applying the graphite. Try also scraping with a razor blade or an X-acto knife to create lighter passages on the graphite surface.

Make drawings on all the gesso-coated sheets, continually experimenting with different variations of graphite application. Later, try stretching several larger sheets of Arches and make some additive and subtractive drawings in graphite of subjects of your choice. In the beginning it may be advisable to select a drawing from a previous assignment and translate it into a graphite drawing on the gesso surface.

Critique (Project 18.4) How adaptable were you to something approached in a completely different way? Do you enjoy the indirect process of step-by-step methods, and of having to first prepare a surface at relatively great lengths even before you can begin to draw? Are you a meticulous person, one who requires a certain standard of professionalism when preparing to do something? Do you enjoy labored processes that require much time and steady devotion? Did your gesso surface work well? Was it receptive to the graphite and did you find it to be a consistently smooth surface to work on? Were there any uneven areas on the surface?

How descriptive of form are your drawings? Have you utilized the process to its fullest at this point? Were there inhibiting factors that interfered with your desired methods of graphite application? How would you approach this differently the next time you work in this manner? Do you have the sense of wanting to greatly expand the size of your picture planes? Are you encouraged by the aspect of being able to continue the drawings by simply adding and subtracting more graphite as you continually refine the elements of your compositions? Do you have the urge to try colored pencils, charcoal, even watercolor and ink washes on the gesso surface?

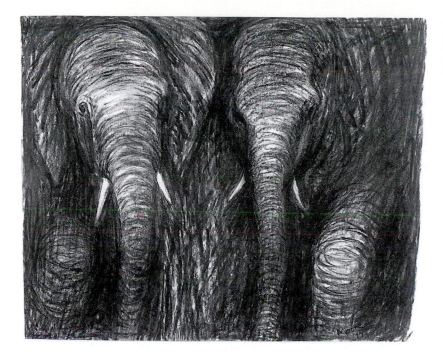

18-17. HENRY MOORE (1898–1986; English). *Forest Elephants.* c. 1977. Charcoal and black chalk. 12 × 15 1/4″ (30.7 × 38.6 cm). The Henry Moore Foundation.

Often, what ends up being a mixed-media work is not planned as such from the outset. There are many mixed-media works of art whose beginnings were relatively simple. That is, they began with a single medium, and only later, through the play-by-play decision-making process of the artist, became more and more media involved. An artist begins working and responds throughout the entire process to what is happening on the surface. In response to the preliminary marks he makes, the artist instinctively reaches for other tools or materials with which to amplify those initial strokes on the fledgling surface. For instance, what made Henry Moore choose two nearly similar media—black chalk and charcoal—in his drawing *Forest Elephants* (Fig. 18-17)? Can you detect any distinction between the media as you study the illustration? The softer charcoal is blacker than the black chalk—the chalk also appears to be slightly warmer and lighter, perhaps even grayish in tone in comparison with the cold rich blackness of the charcoal in the drawing. As Raphael decided to enhance his preliminary stylus work with red chalk (Fig. 18-6), so, too, Henry Moore made the decision to use charcoal and black chalk together purely for the linear and textural effects they gave him

Directness and Indirectness In the work of David Faber there is yet another rather extravagant method of surface preparation upon which the artist then draws. In his prints taken from etched and engraved copper and zinc **intaglio** plates, Faber often elects to use alternative materials to receive the printed images. One of these materials is plaster or gypsum, which is alkaline in nature and highly receptive to oily printer's inks.

In Faber's *Red Holstein Factor* (Fig. 18-18), he inked an etching plate with a variety of differently colored printer's inks that were mixed with varying amounts of reducing oils. After drawing some marks on the plate's surface, he poured wet plaster onto the plate, which was positioned inside a framework, forming the plaster into a tablet about 3/4-inch thick. During the chemically induced heating stage caused by hydration, the plaster hardens and the oils in the printer's inks act as a releasing agent, allowing the plate to break free from the plaster tablet.

intaglio
One of the major media divisions of fine art printmaking where the lines, tones, and textures of a design have been cut, scratched, or incised into a metal plate, either by hand or with acid. The linear grooves and textural depressions on the metal surface hold printer's ink, which when passed through an etching press transfers the design to paper. Intaglio is an umbrella term that includes engraving, drypoint, etching, mezzotint, aquatint, etc.

18-18. DAVID FABER (b. 1950; American). *The Red Holstein Factor.* c. 1999. Intaglio plaster cast monoprint with graphite and scraping. 13 3/8 × 10 3/8" (34 × 26.4 cm). The Corcoran Gallery of Art, Washington, D.C. Courtesy of the artist.

In this rather immediate process the alkaline gypsum and the oily inks fuse, causing the articulate transfer of the inked intaglio image on the plate to the plaster slab. After the plaster cures and is completely dry, Faber works back into the surface of the plaster with drawing tools, both adding and subtracting marks and enhancing the printed image in a unique way.

Variations of working back into prints utilizing drawing methods are prevalent among printmakers who are not always content to leave the printed image as the sole process. To have an intimate encounter with the printed surface by means of drawing seems the true finalizing act, and one that also affords great uniqueness and eldritch surface qualities impossible to attain from the printed image alone.

Visual Order

In Guillaume Apollinaire's *Aesthetic Meditations,* he states,

> Without poets, without artists, humanity would soon weary of nature's monotony. The sublime idea men have of the universe would collapse with dizzying speed. The order which we find in nature, and which is only an effect of art, would at once vanish. Everything would break up in chaos. There would be no seasons, no civilization, no thought, no humanity; even life would give way, and the impotent void would reign everywhere.
>
> Poets and artists plot the characteristics of their epoch, and the future docilely falls in with their desires.

18-19. GREG MURR (b. 1973; American). *Thirteen Ribbons. c.* 1999. Graphite and pastel on paper. 68 × 111″ (172.8 × 282.1 cm).
Collection of the artist; courtesy of the artist.

The pursuit of order is and has always been one of the most important, if not the foremost, objective in the artist's longing for creative resolution—the works of art being the symptomatic side effects of that longing. And like the surfer who awaits the next wave, anticipating the exhilaration of the next ride . . . hoping it will be different from all other rides, the artist poises himself in the studio amidst an array of media, anticipating the next wave, and an unknown ride into waters yet uncharted.

When an artist feels a creative force, he must rely on a plan, a scheme, a sense of order with which to explore new terrain. In Greg Murr's work *Thirteen Ribbons* (Fig. 18-19), he found himself confronted with a large span of paper surface that required him to respond. He chose the dry media of pastel and graphite with blending and erasing techniques to massage the tooth of the paper, leaving it permanently changed as a record of his aesthetic visitation upon the surface.

When artist Nancy Ingram launched her materials investigation that led to the large-scale mixed-media drawing entitled *Veneration of the Oracle: The Triumph of Iago* (Fig. 18-20), she responded to the suggestion of doing a type of mixed-media work she had never done before. In creating a statement about domination and subordination, she established a clear irony in the highly symbolic work, regarding herself as ruler over the array of recalcitrant materials that she carefully and determinedly called into play. In taking this unfamiliar approach to making an image, she metaphorically established herself as victor over an unknown force driven by the known universal laws of expansion and contraction, which inevitably worked against her at times during much of the execution of the large and ambitious work. In the end, as we observe Ingram's sense of visual order, we can see that she remained the victor.

Sketchbook Activities

Sketch subjects you wish to apply to the more complex projects of this chapter on mixed media. What kinds of subject choices are needed and have the most mixed-media potential?

As you continue to sketch, you'll notice improvements in the way you see, the way you understand form, and the way you depict forms with greater descriptive

LES TRES RICHES HEVRES DV DVC DES COCHONS

18-20. NANCY INGRAM (b. 1930; American). *Veneration of the Oracle: The Triumph of Iago.* c. 1998. Mixed media: Chine collé of drypoint print from plexiglass matrix, litho crayon, collage of paper cutouts, acrylic paint, acrylic polymer medium, Arches cover white and buff papers, Japanese **mulberry** paper on stretched raw linen, 46 1/2 × 107 1/8″ (118.2 × 272.5 cm). Collection of the artist; courtesy of the artist.

mulberry
The type of tree from which are extracted the white fibers of the inner bark that when steam-cooked and shredded become the main fiber ingredient of many handmade Oriental papers used in calligraphy and for drawing, painting, and printmaking.

life. It would also be a good time to look back over the pages of your sketchbook to note the evolutionary changes in the way you draw at present as compared with several months ago. You'll no doubt notice areas of improvement along with those that still need work. Do not allow yourself to become discouraged—keep sketching and drawing and remember that no one ever reaches the point of having learned everything there is to know about seeing and drawing. There are always deeper levels of insight and skills to acquire. Drawing is a lifelong pursuit.

Summary

Essentially, every surface an artist works on is reinvented from its former state. From the prehistoric cave painter's rock canvas to Nancy Ingram's portable stage, artists have discovered, developed, and selected the media of their choice for thousands of years. The many images in this text have exposed you to a plethora of different approaches, choices of material, visual effects, and styles with which to proceed, as Wayne Thiebaud so well stated, "in the deep pleasures of drawing."

Return to this book often for guidance and review of the methods and procedures outlined. Continue to use your sketchbooks as a diary into which you enter sketches as notes from the array of visual stimuli that you will continue to encounter during your daily routines. And remember, it is important to set aside a time to draw. Continue to be disciplined in this.

Glossary

abstract expressionism An American movement in the field of painting that began in the late forties and emphasized a nonrepresentational style. The movement broke into two branches: *action painting* and *color field painting.*

abstract symbols Symbols that have been visually simplified or rearranged to create visual impact and enhance meaning; they are often specific to certain cultures or political eras that represent a quality or circumstance.

abstract vision The imagined essence of premeditated forms arising in the mind of the artist whose intent it is to interpret a subject by analyzing and altering its recognizable forms and features by reassembling them into a nonrecognizable state with little or no reference to the original forms.

abstraction The extraction of an essence; an analytical study of an object or the formation of an idea apart from its tangible or recognizable form, as of the characteristics of an object or idea, whereby the virtues of an insightful rearrangement of form are substituted for exact representation.

active tooth The degree to which a paper's surface texture retains particles of dry drawing media and influences the resulting surface qualities of those media. An artist will choose a particular paper because of its active grain in or-der to attain the desired expressive results. See also **paper grain** and **tooth.**

actual texture A texture that is a real surface and can be experienced through the sense of touch; often used in collage or mixed-media works where the actual textured material is applied to the work of art and left unaltered by the artist—as in the art of the found object.

additive method The drawing activity of beginning with a white or blank surface and building up positive marks as lines, tones, textures, values; working from light to dark by the progressive addition of tonal marks.

advertising drawings Drawings done by commercial illustrators and designed to promote and sell merchandise; though often highly stylized, they are rendered with considerable concern for detail.

aerial perspective A drawing technique that reinforces the illusion of depth (initially mapped out by the rules of linear perspective) where contrasts of color and value diminish as objects recede into the distance, with lights becoming less light, darks less dark, until all contrasts merge into one uniform, medium-light tone. See **atmospheric perspective.**

ambiguity A state of visual uncertainty created by intentionally ignoring or distorting accepted compositional methods; the unconventional visual effects that result from the apparently purposeful attempt to create a sense of imbalance.

analogous colors Those colors adjacent to each other on the color wheel; any colors existing side by side on the color wheel.

analogous color scheme A color scheme comprised of any combination of adjacent colors on the color wheel as the main color statement of a work of art.

analytical sight Scrutiny; the impetus for drawing only what the artist actually sees; the opposite of intuitive or instinctive drawing. All works of art are to varying degrees analytical.

anatomical drawings Drawings that portray and make explicit the human anatomy, illustrating the interrelationships of skin, muscle, bone, and joint structures, all with proportional correctness to the human body.

angle of light The proximity, position, and direction of a light source in relation to an object that determines the length of shadows. A highly positioned source of light creates short shadows; a low light position produces long shadows.

ascending planes Planes not parallel to the ground or floor planes whose vanishing points appear above the horizon line.

asymmetrical balance Balance based upon a visual sense of equilibrium that can be felt more than it can be measured. There are no specific rules for asymmetrical balance except that of diversity.

atmospheric perspective A drawing technique pertaining to landscape where the attributes of linear perspective are viewed through special atmospheric effects created by the artist in order to display a greater degree of spatial complexity uniquely altering the vision of perspective by reinforcing the illusion of depth. See **aerial perspective.**

balance A major underlying principle of composition that unifies all the elements of design. It can be either symmetrical or asymmetrical.

bamboo pen A type of *hollow* reed pen imported from the Orient.

bistre A transparent brown pigment used to produce wash tones in pen and ink drawings obtained by boiling soot. See **wash** and **wash drawing.**

blind contour A drawing process where the eye is trained to follow the contours of what is being drawn, looking only at the subject, not at the paper. In this process, the hand moves the drawing tool in synchronization with the movements of the eye.

bond paper Familiar as stationery and computer paper, a lightweight, relatively smooth paper with a hard surface and tight grain appropriate for use with graphite or colored pencils, ballpoint pen, or pen and ink. It is available in pads or in bulk in various sizes.

Bristol board A very fine, hard-surfaced paper, manufactured in two finishes: *kid finish,* by virtue of its very slight tooth, facilitates fine graphite pencil work of medium hardness and rubbed pen and graphite combinations; *smooth (plate) finish,* a very finely toothed paper, encourages elegant studies in pen and ink or very hard graphite pencil and is available in different weights.

broken color A color scheme where more than one color is introduced into a shape or object to produce varied painterly effects. Also, a pure color that has been altered by the invasion of another color.

burnishing The excessive layering of various drawing media under pressure resulting in **wax bloom,** which can be corrected or lifted by pressing a kneaded eraser against the burnished surface, eliminating the polished appearance.

cacophony A sudden, unexpected, often disharmonious visual aspect of a composition that arouses the viewer's immediate attention; an obvious and interestingly noticeable visual disharmony used in a positive way to strengthen or enhance a visual statement.

calligraphic line Beautiful line. In the visual arts, when writing, drawing, engraving, etching, and painting, the beauty of line becomes a major aesthetic aim.

calligraphy Beautiful writing. In western culture it is done with a pen, in Chinese

and Japanese cultures with a brush. See **calligraphic line.**

caricature An exaggerated portrayal of the characteristic features or mannerisms usually of a well-known personage, intended for satirical effect.

cartoon A newspaper or magazine drawing or illustration that caricatures or symbolizes a person, event, or situation of popular interest, such as a politician or political party, usually in a humorous or satirical way. Also, a large drawing created to establish life-size scale for frescoes. Artists later used the technique to transfer large-scale images for paintings, tapestries, stained glass, and other large works (a cartoon was indispensable in the process of making stained glass).

cast shadow A shadow cast or thrown by an object onto an adjacent plane; one of the value gradations of traditional chiaroscuro. A cast shadow is darker than the core of the shadow.

center of vision Same as the **central vanishing point;** the point of intersection of the central line of vision and the horizon line.

central line of vision An imaginary line centered in the cone of vision, extending from the eye and meeting the horizon line at a right angle.

central vanishing point The point of intersection of the line of vision on the horizon line; same as the point of the **center of vision.**

chalk The term *chalk* covers a wide variety of materials ranging in texture from coarse to fine, from hard to soft and crumbly, and from dry to greasy, shaped into rounded or square sticks. It was originally obtained from natural colored earths that were cut or sawed into sticks. Fabricated chalk is made with prepared pastes of water-soluble binding media mixed with dry pigments and sometimes with additional substances such as inert clays, then rolled, pressed into sticks, and dried.

charcoal paper Textured paper abrasive to charcoal because of its hardness of tooth. In the drawing act, it receives a deposition of black carbon charcoal particles that adhere to its relief as well as fall into its recesses; available in different weights in white, gray tones, and muted colors; also for use with chalk, Conté crayon, and pastels.

charcoal pencils Thin rods of compressed charcoal encased in paper or wooden sheaths that offer cleanliness but lack the flexibility of stick charcoal because only the point can be used. Charcoal pencils come in different grades: 6B (extra soft), 4B (soft), 2B (medium), and HB (hard). (White charcoal pencils are also available.)

chiaroscuro From *chiaro* (light) and *oscuro* (dark), the continuous gradations of value, to create the illusion of three-dimen-sional form; systematic changes of value that produce visual states of high or low contrast in the depiction of forms as they exist in pictorial space or atmosphere.

closed composition Compositional format in which the art elements of form and structure are visually well contained by the edges of the picture plane.

closed form The area of a composition where a color, value, tone, or texture is confined within the contour or silhouette of an object or shape and thereby stresses visual separation from its surrounding elements.

cold press Paper with a moderately textured, matte surface, softer and toothier than "hot press" paper.

color In its purest sense, the condition produced by white light passing through a glass prism. A spectrum of color is the visual evidence of refracted or dispersed light rays of different wavelengths that stimulate the retina to see the different hues. The hue red produces the longest wavelengths; violet produces the shortest. Chromatic color is distinguished by qualities of hue: red, blue, and yellow as the primary colors; violet, green, and orange as the secondary colors.

color schemes Systems of color combinations that provide a sense of color harmony and unity. (See **analogous, complementary, double complementary, triple complementary, monochromatic,** and **split complementary** schemes.)

complementary colors Hues opposite one another on the color wheel; yellow and violet; red and green; blue and orange. Complementary tertiary hues also face each other across the color wheel.

complementary color scheme A color scheme that poses two pairs of complementary colors, such as blue and orange plus red and green, working together in the same work of art.

composition The structure of a picture as separate from both subject and style; the essential abstract design; the selection and organization of line, shape, value, texture, pattern, and color into an aesthetically pleasing arrangement embodying such principles of design as balance, harmony, rhythm, repetition and variation, dominance and subordination, and focus.

compressed charcoal A substance made by grinding charcoal into powder and compressing it with a binding material into chalklike sticks that are then labeled according to hardness ranging from 00, the softest and blackest, through 5, the hardest and palest.

cone of vision The shape of containment of all that can be seen from one stationary position without moving the eyes.

Conté crayon A semi-hard chalk of fine texture containing sufficient oily material in the binder to adhere readily and more or less permanently to smooth paper. It comes in sizes of ¼ inch (.6 centimeter) square and 3 inches (8 centimeters) long, in three degrees of hardness—No. 1 (hard), No. 2 (medium), and No. 3 (soft)—and in four colors—white, black, brown, and sanguine (Venetian red), which is the most popular.

contour The outermost extremities or limits of a shape, whether two-dimensional or three-dimensional, as in the skin or shell of an object, form, or volume; contour may be associated with the outline of a subject and may change with different viewing positions.

contour drawing Drawing that focuses on capturing in a highly descriptive way the extreme edges of a shape, form, or object, depicting it as separate from its adjacent or neighboring forms.

contour hatching Curved lines that follow the outer contours of the turning of form, allowing a more descriptive modeling of cylindrical and spherical subjects.

contour lines Lines that delineate the very edges of forms and separate each volume, mass, or area from its adjacent or neighboring forms.

contrast The visual effect of a striking difference between art elements creating a condition of compositional intrigue; opposites or complementary art elements that through their visual forces *set each other off* or draw attention and focus to each other or to particular areas within a design.

cool color A hue on one side of the color wheel—green, blue, violet, and their intermediate tertiary colors; any color opposite the warm colors on the color wheel.

copying The exact imitation of the drawings of the old masters strictly for the purpose of learning to see, learning technique, and learning about styles. The view is widely held that the most beneficial learning about drawing occurs from having as direct an experience of emulating the old masters as possible.

core of shadow The most concentrated area of dark on an illuminated sphere; one of the value gradations of traditional chiaroscuro; the core of the shadow receives no illumination.

cross-contour Lines that are drawn through, around, over, under, and across form to find the gesture and major lines of movement within the form.

cross-contour hatching Hatched lines existing on multiple planes that follow and describe the outer extremities of the three-dimensional surface undulations of a form.

cross-hatching A series or cluster of parallel lines, whether continuous or broken, that traverse other clusters of the same kinds of lines creating tonal and textural variations within a composition.

Cubism A style of painting originated by Picasso and Braque between 1907 and 1914 that uses multiple views of an object to emphasize its three-dimensionality yet acknowledges the two-dimensional surface of the picture plane.

dark field manner A technique in which the artist prepares a dark field on a picture plane and proceeds to remove the darks, allowing light to enter the field. This creates a composition of lighter passages that describe forms or objects existing within the dark pictorial space. It is the opposite of **light field manner.**

descending planes Planes not parallel to the ground or floor planes whose vanishing points fall below the horizon line.

descriptive drawings Usually highly detailed drawings whose images articulately describe what is seen.

directional lines Compositional linear treatment that establishes a particular or dominant mood or emotion from its linear emphasis through a variety of different line treatments yielding a visual sense of compositional weight and balance. The linear treatments may flow in the same direction or in opposite directions, each conveying different feelings.

direction of light The position of light that determines the direction in which shadows fall. When the source of light is to one side, shadows are cast to the opposite side. With the light at your back, shadows fall away from you. When you look into the light, shadows of objects before you are cast toward you.

double complementary color scheme A color scheme that poses two pairs of complementary colors, such as blue and orange plus red and green, working together in the same work of art.

drawing A division of the fine arts in which the artist makes a descriptive graphic mark of line, tone, texture, or value, by pulling or dragging a tool across a receptive surface or background—usually a piece of fine-quality grained or toothed paper.

drawing inks Saturated liquid pigments possessing great fluidity that may be used full strength with various types of pen nibs (points) for linear effects, or diluted with water to varying degrees of transparency, producing washes applied by brush to enhance pen-and-ink drawings. Among the most popular are India ink, China ink, sumi ink (all black), and various other quality colored inks such as Walnut, Koh-I-Noor, and Windsor-Newton brands.

drybrush The irregular or broken brush stroke effects of ink that ultimately diminish, created by dragging a less-than-fully-loaded brush lightly across a piece of drawing paper—especially one with some surface variation or high degree of tooth.

drypoint Intaglio printmaking technique where a metal plate is drawn on with a steel point that produces a *scratch* or *ditch* with a continuous or broken line of upraised metal *burrs*. When the line is inked, the burrs hold a slight residue of ink around them that produces a velvety line quality when printed.

eldritch A word describing an unexpectedly rare and eerie quality or an unforgettable, otherworldly presence, usually conspicuously out of place when and wherever found.

empathetic drawing A drawing that bears evidence of the sympathy for, and understanding of, one person by another through visual portrayal.

empathy The state of identifying with someone through the projection of oneself into that person in order to gain a better understanding of that person's character; a reaching out usually through an emotional channel that is perpetuated by tenderness and deep feelings of sympathy or compassion.

empirical perspective Perspective, that, unlike **linear perspective,** relies upon direct observation rather than a set of rules.

engraving A form of intaglio printmaking where line or stipple textures are cut into the surface of a copper plate, or other suitable surface, with a tool called a burin. The burin's lozenge point cuts and removes the surface material, leaving a relatively smooth V-gouge or depressed groove in its wake. Printer's ink is forced into the grooves. The effect is a crisp line quality similar to that of certain pen-and-ink drawings.

estompe A paper stump used for shading or blending tones. See **tortillon.**

etching The action of a corrosive material, such as an acid, incising a design into metal, as in *copper plate etching.* One of the techniques of *fine art printmaking* that falls into the category of *intaglio,* where lines and textures are incised into and below the original surface of metal plates forming grooves and rough textures that will hold ink that can then be transferred to dampened paper with the use of an etching press.

expressionism The visual traits or character of a work of art that communicates emotions and feelings as opposed to only being concerned with the *objective* and *subjective* realms; the way in which a work of art was conceived and made, as occurs in an *expressionistic response* to a subject by a particular artist.

eye of the mind That which perceives subjectively apart from what the physical eye sees objectively or concretely. Often referred to as "the eye of the soul."

figure-ground Within a picture plane, a compositional circumstance where the figurative elements read as the *positive shapes* and project forward from the background, which is read as the *negative space.*

fixative spray (workable) A type of fine, granular mist that dries quickly, forming a semiprotective, porous coating, and *fixes* or *holds* the fine particles of graphite, charcoal, chalk, and pastel in place yet allow the surface to be reworked.

fixed point of view A mandatory rule for linear perspective; an established, unchanging position from which an object or scene is viewed that enables the rules of linear perspective to be enacted.

floor plane Same as ground plane albeit for interior spaces. See **ground plane.**

focal points The elements or portions of a composition that form the main thrust or central emphasis and are visually supported or fortified by all other surrounding compositional elements.

focus The prime center of visual importance within a composition to which all other visual elements yield; it holds the viewer's attention because of its attractive and dominant influence on its surroundings.

foreshortened square A square seen in perspective while lying flat on the ground plane whose parallel sides converge into the central vanishing point on the horizon line.

foreshortening A term that applies to organic and anatomical forms seen in radical perspective, as in the portrayal of lines being shorter than they actually are, in order to create the illusion of correct size-and-shape relationships in space.

form The positive aspect or complement of space; the visible or recognizable configuration or shape of any object existing in atmospheric space; any structural art element separate from color, line, texture, material, etc. See **space.**

fountain pens Pens that are generally more convenient for sketchbook drawing—once filled, they eliminate frequent recourse to the bottle of ink (always a risk as dripping may occur when the pen is transported). The two types of fountain pens manufactured for drawing are the *quill-style* pen and *stylus-type* pen, generally termed *Rapidograph.*

frottage The technique of placing a sheet of paper over an actual, physical texture and rubbing the topside of the paper with the side of a graphite stick or Conté crayon, producing a positive impression of the relief of the physical texture. Artist Max Ernst was the first to use the technique in the production of a work of art.

full range A complete gradation of tones from the lightest to the darkest values.

gesso A material used, generally in several thin layers, to prime wood panel or canvas surfaces in preparation for painting. It is made from plaster (dehydrated calcium sulphate prepared by firing gypsum or alabaster) mixed with sizing material.

gesture The essential line or depicted state of movement of a live form.

gesture drawing A drawing done for the sole purpose of studying gesture whose objective is to capture the essential, descriptive movements of live forms in space, whether human or animal.

glassine An ultra-thin, frictionless, and translucent paperlike material used to "slip sheet" in between stacked works of art on paper—drawings, prints, or watercolors—protecting them from smears or surface abrasions.

gouache From the French word "wash," opaque watercolors used in painting whose pigments contain a *gum binder* and filler of *opaque white* such as clay that give a chalky appearance to the surface of the painting.

graphite A soft form of carbon found in nature and used as lead in pencils. It is manufactured in a wide range of soft to hard states and produces a lustrous, black, or gray-black mark when dragged against a receptive surface. The softer states produce darker, richer blacks than harder versions. It is also available in stick, chunk, or powdered form.

grisaille A monochrome drawing and painting technique using grays or grayish colors that was popular in the Renaissance as a way of emulating sculpture. The effects are sometimes heightened with gold.

ground plane A flat horizontal plane on which the viewer stands that extends to the horizon. In drawings of interior spaces it is referred to as the floor plane. See **floor plane.**

handmade Oriental papers Papers that are made by manually pulling a flat screen or sieve up through a water vat containing finely shredded mulberry fibers. The fibers come to rest in a flat, consistent sheet on the screen, which allows the water to drain through. The fibers are extracted from the inner, white bark layer of the mulberry tree.

haptic A word describing one of two extreme poles of artistic personality (the other being **visual**). Haptic, or nonvisual, people relate all forms of their expression to their feelings, bodily sensations, and subjective experiences in which they become emotionally involved.

hard pastels Pastels made from dry pigments mixed with a higher proportion of aqueous binder than in soft pastels, which makes them harder with a firmer texture. They are compressed into square sticks; their flat side planes afford rapid coverage of broad areas; the sharp corners make them effective for detailing and accenting. They can be sharpened with a razor blade and are also manufactured in pencil form.

hatching Repeated parallel strokes with a drawing tool that produce clusters of lines creating compositional values and tonal variations usually descriptive of form or surface.

high key The lightest values—white through middle gray on the value scale, in which case the darkest value is no darker than middle gray.

highlights The lightest values present on the surface of an illuminated form, occurring on very smooth or shiny surfaces; the intense spots of light that appear on the crest of the surface facing the light source.

horizon line A line that corresponds to the eye level of the viewer in linear perspective; the line where sky and earth appear to meet (provided the earth is perfectly flat and nothing blocks the view). The vanishing point (VP), central vanishing point (CVP), and the furthest end point of the center line of vision are all located on this line.

hot press One of the three standard grades of illustration board and watercolor paper characterized as having a hard surface that has been ironed and press-cured with heat and weight and possesses the smoothest and least absorbent surface; excellent for very refined, controlled techniques.

hue Local color; the quality that distinguishes one color from another.

idealized portrait A portrait that achieves a satisfactory resemblance to the sitter while simultaneously eliminating the physical imperfections of the face.

illustration Usually a highly detailed image that communicates a message, offers visual description, or portrays an episode (as in a story) through visual means.

illustration board A medium made by mounting different papers of relatively fine quality onto cardboard backing; available in three standard surface finishes: *rough,* which has the most active tooth; *cold press,* a versatile, medium-toothed surface; and *hot press,* the smoothest and least absorbent surface that is excellent for very refined, controlled techniques. It is expensive but highly durable and resists wrinkling when wet.

imagination In art, the act or ability to envision fictitious, mental images that are present in the mind's eye but not in actual life; also, the artistic power to create images of a fanciful nature as metaphors for unrealized experiences that may, however, have meaning and association in real or actual life.

inclined planes Planes not parallel to the ground or floor planes whose vanishing points exist on vertical lines that pass through the corresponding vanishing point on the horizon line.

inks Any fluid or semifluid drawing or printing materials that may be used in conjunction with various pens, brushes, brayers, or rollers. They are available in a wide range of colors. Some are soluble in solvents such as mineral spirits and turpentine; others are soluble in water.

ink wash A dilution of ink in water or solvent, applied by brush, most often used with pen-and-ink drawings to enhance by creating varying degrees of semitransparent tones.

intaglio One of the major media divisions of fine art printmaking where the lines, tones, and textures of a design have been cut, scratched, or incised into a metal plate, either by hand or with acid. The linear grooves and textural depressions on the metal surface hold printer's ink, which when passed through an etching press transfers the design to paper. Intaglio is an umbrella term that includes engraving, drypoint, etching, mezzotint, aquatint, etc.

intensity The degree of strength or brilliance; as related to color, the strength or saturation of a pigment; the brightness of a color.

intuitive drawing Drawing activity controlled by instinct, feelings, emotions, bodily sensations, and visceral responses, as in the case of a haptic person; a drawing based on an intuitive response to a subject.

invented texture A fictional or improvised texture created to heighten the imagined and descriptive forces of the surface quality of objects or forms within a composition.

kid finish paper Bristol board paper with a slightly toothed surface; it facilitates fine graphite pencil work and rubbed pen-and-graphite combinations.

laid finish paper Subtle paper texture characterized by faint lines visible when the paper is held up to strong light and caused by the structural elements, or the sieve, of the paper-making screen. Unlike the screen of wove paper, the laid screen is intricately hand sewn into the mold frame. See **wove finish paper.**

lettering pens As the name implies, pens used for lettering; they are available with round, straight, or angular nibs ranging in width from 1/10 millimeter to more than ¼ inch (.6 centimeter). Straight-nibbed lettering pens yield a line that in its stiff angularity recalls the line made by a reed pen. Wide lettering pens allow the rapid filling in of large areas.

life drawing The act of drawing from live models in order to record the movement, gesture, and essential physical capabilities of the human body as an aesthetically pleasing art form. Also, drawing from life in order to gain a mechanical as well as visual understanding of live forms and how they exist and move in space.

light The illumination of an object; a major component of chiaroscuro helping to define forms in space within a composition; that which makes sight possible.

light field manner A technique in which the artist begins with a light surface and progressively builds up an image by adding darker forms or shapes comprised of line, tone, texture, and value. Opposite of **dark field manner.** See **additive drawing.**

line The pathway of a moving point; the trail of deposited material or a scratch resulting from dragging a drawing tool or stylus over a surface. A line is usually made visible by contrasts in value or surface.

linear perspective A scientific method of determining the correct placement of forms in space and the degree to which such forms appear to diminish in size at a given distance.

lithograph A type of print created by one of the four major divisions of *fine art printmaking* involving a *direct drawing process* on Bavarian limestone (calcium carbonate) or aluminum plates. The process, in its entirety, engages the *antithesis of grease and water* where images are drawn with greasy crayons on the stone or metal plate, then etched with acid, effecting a process of chemical stabilization whereby the image remains grease-loving or oleophilic, and the nonimage becomes water-loving or hydrophilic repelling grease. Through a rhythmic process between *printer* and *sponger,* the litho surface is kept wet by sponging with water, then inked with printer's inks alternately, and finally printed on paper with a litho press. *Lithograph* is from a Greek term meaning "stone writing."

lithographic crayons Greasy crayons in both pencil and stick form that produce rich blacks and are made from carbon black, animal fat, wax, and soap. They come in a variety of hard and soft grades ranging from No. 00 (softest) through 5 (hardest). The softest crayons contain the most grease, making them adhere well to most paper surfaces.

local color The true color or hue of a surface as seen free from the effects of light and shadow; under illumination, local hues are lightened or darkened depending upon the degree of lightness or darkness of the source of illumination.

local value The actual, known value of objects perceived only when seen free from the effects of strong light and shadow.

low key The darkest half of the value scale with the lightest value being no lighter than middle gray.

manière noire French for "in the dark manner." See **dark field manner.**

medical illustration A type of illustrational drawing that offers visual clarity to medical conditions or anatomical circumstances, whether normal or abnormal, beyond that of a photograph since drawings have the capability to contain far more information than a camera is able to capture in an instant.

metal pen A pen that first appeared at the end of the eighteenth century; when used on very smooth, partially absorbent paper, the steel pen can be more completely controlled than its predecessors (quill, reed, bamboo pens) as the vehicle for sharp, detailed observation.

metaphor In a work of art, a concept, symbol, or motif that carries an implied comparison or is used in place of some other idea in order to draw heightened attention to the visual statement for the purpose of enhancing its meaning.

middle key On a nine-step value-range scale, the five values in the middle of the scale.

mixed media A variety of different materials used in a creative process for the purpose of heightening surface effects and increasing the visual complexity of an image.

mixed-media drawing A drawing created by the interaction of a few or many different drawing materials that come to rest on a surface or on multiple variations of a surface. The artist selects different materials in order to enhance a visual statement and create visually interesting surface effects that cannot be produced by a single medium.

mold-made paper High-quality paper possessing characteristic beauty and elegance, usually with a natural deckled edge, whose sheet size, texture, and weight are characterized by the uniqueness of a particular molded framework with a mesh of finely woven cloth or wire.

monochromatic A word describing a hue or chromatic variation of shades and tints of the same color attained by adding black to create shades or white to create tints.

monochromatic color scheme A color scheme in which an entire composition is composed of the descriptive value ranges of a single color with its shades and tints. See **shade** and **tint.**

monotype As a unique impression, a one-time drawing with printer's inks on a flat metal plate, which is then transferred to dampened paper with the use of a press. The French artist Edgar Degas is well known for his use of the monotype medium.

mulberry The type of tree from which are extracted the white fibers of the inner bark that when steam-cooked and shredded become the main fiber ingredient of many handmade Oriental papers used in calligraphy and for drawing, painting, and printmaking. See **handmade Oriental papers.**

multiple The term applied to the regular appearance of shapes or forms in a pattern. Also refers to fine art processes where it is possible to produce a series of consecutive images. In printmaking, for example, an edition is a series of "multiple originals."

naturalistic representation The depiction of subject matter in its most natural and unaltered state.

negative shape(s) In two-dimensional figure-ground relationships, the remaining or unoccupied shapes within a composition surrounding or aside from the positive shapes that maintain a visual importance equal to that of the positive shapes.

negative space or area(s) In figure-ground relationships, the spaces or areas surrounding the positive shapes that may also be referred to as ground, empty space, field, or void space. The negative spaces cause the positive shapes or forms to project forward, creating a three-dimensional illusion within a composition.

newsprint An inexpensive paper made of wood pulp used by art students for all types of practice drawing and expedient classroom studies such as gesture, contour, blind contour, etc. It has a smooth surface, yellows badly due to its acid content, and is most appropriately used with soft graphite pencil, charcoal, Conté crayon, and chalk.

oil pastels Drawing media that are similar to hard pastels except that oil has been added to the binder, creating a semihard state that adheres more readily to paper. Because oil pastels are not easily smudged, they work well for outdoor sketching. They are not easily erased.

one-point perspective A visual condition where all lines parallel to our central line of vision, whether to the side, above, or below, appear to meet at the central vanishing point (CVP).

opaque watercolor Gouache; watercolor pigments containing a gum binder and or filler of clay that when painted, create a chalky, opaque effect.

open composition Compositional format in which the images of form and structure appear unrelated to the size of the paper, creating the impression that the composition, unlimited by the outer edges, exceeds the boundaries of the picture plane.

open form A form whose value or values blend into the similar surrounding areas of the composition without noticeable or obvious separations; also, a form that allows the integration of various compositional elements, producing a feeling of movement and vitality.

optical color Color effects that are seen and read optically; the actual color the eye reads and the mind understands; tiny strokes of "pure red" in close proximity to tiny strokes of "pure blue" will be read and mixed by the eye to produce violet.

optical grays The actual gray values that the eye sees resulting directly from a variety of drawing techniques, usually involving dry media that can be blended for heightened atmospheric effects.

paper grain Same as paper tooth; the surface texture of a paper; the degree of roughness or smoothness of a paper. See **tooth.**

pastels Pure powdered pigments mixed with just enough clay, gum, or resin to bind them into stick form; except for differing amounts of wax and grease, they are similar to crayons and especially to chalks in composition. Pastels come in soft, hard, and oil versions in a wide range of colors. Pastel drawings tend to be fragile and require care in storing as their surfaces are easily abraded. Spray fixative may help preserve the surface but may also dull the color with too much use. See **soft, hard,** and **oil pastels.**

pattern Any compositionally repeated element or regular repetition of a design or single shape; pattern drawings in commercial art may serve as models for commercial imitation.

pen nib The point of a pen whether *quill, reed, bamboo,* or *steel,* which comes in a variety of different types and sizes and is used with fluid drawing ink; the nib itself acts as the ink reservoir and controls the flow and dispersing of the ink on paper; the style and width of the nib determine line quality.

pencil A wooden or paper cylindrical tool encasing a graphite, charcoal, crayon, or colored pigment rod of a wide variety of hard and soft grades; the most important and versatile drawing instrument since the end of the eighteenth century and the most commonly used drawing implement until the invention of the cartridge pen.

pentimento From the Italian meaning "to repent," a subtle or radical revision made by an artist when he changes his mind, or *repents* during the execution of a drawing, painting, or print. The vestiges of the previous image, whether totally concealed or not, either become more apparent through the fading of the outer surface, or have remained apparent and bear evidence of the abandoned creative intent.

perspective drawing The systematic method of representing and describing forms as they appear to recede in space through the use of converging lines that meet at a central vanishing point located on the horizon line. Also, the depiction of forms as they appear to the eye relative to distance or depth.

picture plane The area of a flat surface defined by its outer borders on which an artist creates an image; often the picture plane, out of necessity, becomes transparent, allowing the artist to create three-dimensional forms and objects that exist in both deep and shallow space as three-dimensional illusions.

plasticity The physical body characteristics of a material or substance, whether liquid or solid, that determines its use as an expressive art material; also the characteristics of form, concept, and compositional handling of subject matter. For example, a subject may be drawn in such a way as to increase its mass or volume and thereby increase its plasticity.

plumbago Same as *graphite.*

portraiture The art of portrayal; any of many wide-ranging approaches to the art of preserving a physical likeness whether truthful, idealized, psychological, or intended as caricature.

positive line, shape, form Established line, shape, or form that serves as the subject of a drawing and carries the intended visual dominance or subject meaning of a composition—whether representational or nonrepresentational. In figure-ground relationships it is defined by its opposite negative shapes. See **negative shape** and **negative space or area.**

powdered charcoal Charcoal in a powdered state that produces intense blacks and is used in combination with a chamois to produce rubbed areas of rich darks.

primary colors Red, yellow, and blue; called *primaries* because they are pure colors and cannot be obtained by mixing together any other hues.

printer's ink A heavy-bodied, oil-based, saturated ink made of carbon blacks or color pigment powders mixed with plate oil (derived from linseed oil). Printer's inks can be diluted with solvents so that they will flow from a brush to produce the painterly effects of monotype or ink wash.

psychological portrait Beyond the revealing likeness, the portrayal of a person's inner personality or temperament made visually tangible through the artistic treatment of the facial features, tilt of head, relaxed quality, or stiffness of shoulders, neck, and head.

quill pens Pens cut from the heavy pinion feathers of geese, swans, or wild turkeys, hardened by tempering with wet, heated sand, and shaped to a sharp or angular, coarse or fine point. They respond readily to variations of touch or pressure, producing a responsive, smooth, and flexible line. Today traditionally trained calligraphers are more inclined than artists to make and use quill pens.

quill-style pen One of several types of fountain pens. See **fountain pens.**

raison d' être French for "reason to be." In the art context the term is used when referring to the purpose of a work of art as a necessary means of communicating *language* as visual statement, and as a necessary means of artistic expression.

raking light The planned, controlled, and directed position of a lighting source that causes a "washing over" of illumination, producing a specified lighting effect usually limited to one side of an object or form.

Rapidograph pens Types of fountain pens that hold a supply of ink and have a central cylindrical point enabling the artist to move the pen in all directions without varying the line width; must be held perpendicular to the drawing surface for the ink to flow evenly.

recondite A term describing the quality of being indescribably strange and curious without means of explanation or evidence of reason. As applied to art, it describes a profound visual situation the comprehension of which is beyond the grasp of the ordinary mind.

reed pens Pens hewn from tubular reeds or the hollow wooden stems of certain shrubs and cut with various points to suit the user's taste. In general, reed pens are stiff; their nibs, or points, are thick and fibrous. The lack of supple responsiveness results in a bold line.

reflected light Light bouncing back from reflective surfaces; functions as fill-in light, making objects appear rounded by giving definition to the core of the shadow; one of the value gradations of traditional chiaroscuro. See **core of shadow.**

reflected shadow A shadow that bounces back from a nearby surface or object; one of the elements of the system of chiaroscuro. A reflected shadow is never as dark as a cast shadow. See **cast shadow.**

relief The raised surface in the printmaking medium of woodcuts where the negative shapes are cut away leaving the raised or uncut surface of the wood in relief; the relief surface catches the ink from a brayer and prints as the positive image when transferred to paper.

rendered Drawn, usually with a high degree of representation.

rendering A drawing displaying a high degree of detailed representation, interpretation, rendition, and other specific information about a subject; the word *render* is often used as a synonym for *draw* or *represent.*

repetition The unifying visual sense of regularity in the appearance of similar elements—lines, shapes, patterns, textures, colors, values, and movements within a composition.

reporting drawings Drawings that make visually tangible an event or occurrence by communicating what happened. In fashion design, reporting drawings treat fashion as news.

rhythm The visual manifestation and flow of repetition, variation, patterning, harmony of form, and movement within a composition; a flowing and regular recurrence of the art elements within the compositional structure of a work of art.

rice paper A misnomer for Oriental papers made by hand predominantly from the

inner fibers of the mulberry and other plants and having no relation to rice. It is a flexible writing and drawing paper used in China primarily for sumi painting.

rim lighting Illumination of only the outer edge of an object or form by light from behind the object or form.

rough tooth A characteristic of heavily toothed papers with a readily visible and pronounced surface texture as in charcoal or some watercolor papers.

sanguine Natural red chalk ranging from the color of blood to a brownish-red used for drawing and first discovered prior to the fifteenth century in European mine deposits; its first documented usage came in the late fifteenth century around the time of Leonardo da Vinci and other Renaissance artists; its usage spread shortly thereafter to other countries.

scale A proportional system of measurement set in accordance with an established standard; on a one-inch standard, an object whose height is one inch that is drawn in one-fourth scale will be drawn one-fourth the size of its original stature, or one-fourth inch in height.

scientific illustration Meticulously rendered drawings that depict an unusually articulated degree of detail; accuracy, clarity, and neatness are of prime importance in the field of scientific drawing.

scribbling Random, multidirectional lines used to build varied tones, textures, and densities and to define surface qualities, shape, and volume, or to capture gesture or movement as in a searching line. See **searching line.**

searching line An approach to drawing in which the hand and drawing instrument move freely and quickly across the paper surface either in continuous rhythms or in a series of broken lines. Sometimes they follow contour; at other times they draw through, around, even across form in order to find the gesture and major lines of movement within the form.

secondary colors *Violet, orange, and green.* The three colors resulting from the pairing and mixing of any two of the three primary colors: blue and red produce *violet*; red and yellow produce *orange*; yellow and blue produce *green*.

self-portrait An artist's portrayal of himself or herself using artistic expression to underscore temperaments or emotions related to his or her unique individual traits. The self-portrait has two functions: it allows the artist to use a cheap and available model, and it serves as a means of self-immortalization—often in an idealized way.

sfumato An Italian word meaning "smoked." The gradual, almost imperceptible blending of tones from light to dark in paintings or drawings; a technique used by Renaissance artists in combination with chiaroscuro for the visual enhancement of the overall tones within a composition.

shade A lessened degree of light caused by the blockage or partial blockage of directional light rays; as pertaining to color (low value), any color that has been darkened by the addition of black.

shade lines Contour lines of the shapes of shadows; lines that separate the areas of light and shade on an object, in a still life, or in the landscape.

shadow The state of being blocked or partially blocked from directional light or illumination; a precise area of shade cast by an object intercepting directional rays of light.

shape The flat, two-dimensional aspects of form as opposed to three-dimensional volume; when a three-dimensional form is reduced to a silhouette, the viewer is conscious only of its shape.

silverpoint A methodical drawing procedure where a thin rod of silver (about the size of a graphite shaft) is inserted into a mechanical pencil and used to draw on an elaborately prepared gesso surface. The silver metal point, which may be sharpened on sandpaper, yields a thin line of even width with a lovely gray color oxidizing to a grayish-brown with the passing of time. A highly recommended pencil-style mechanical holder is the Faber-Castell E-Motion Mechanical Pencil.

simulated texture A drawn textural illusion that emulates an actual texture or surface quality and is dependent upon the degree of illusion for its various visual effects.

simultaneous contrast A visual effect produced when complementary colors are placed in juxtaposition, which increases the apparent intensity of both so that they truly complement each other.

sketch A drawing done quickly with minimal or no elaboration but that may use scribbled lines or tones to suggest form, texture, and shadow.

smooth (plate) finish Bristol board paper with an extremely fine tooth that encourages elegant and detailed studies in pen and ink or very hard graphite pencil, and is available in different weights.

soft pastels Pastels made from dry pigments mixed with an aqueous binder and compressed into cylindrical form. They are soft and crumbly and nonadhesive, requiring use on a paper of decided tooth.

soft sketching papers Papers manufactured with a smooth tooth for use with soft graphite pencils, ballpoint and felt-tip pens, and colored crayon.

source of light Light that may be either natural or artificial. Natural light produces parallel rays; artificial light creates radiating rays. It is true that light radiates from the sun, but from a distance of 93 million miles, the rays are virtually parallel when they reach the earth.

space The negative aspect or complement of form; the atmosphere surrounding forms or objects. See **form.**

spatial Existing in space; surrounding objects and defining their proximal relationships to one another.

split complementary color scheme A color scheme that poses one hue against the two hues flanking its complement; an example would be yellow with red-violet and blue-violet.

spontaneous drawing Drawing activity performed as an instantaneous response to a subject or stimulus, as with *gesture drawing*, intended to capture the essential movement or vitality of a live form; to depict an artist's immediate and unique mode of expression.

stick charcoal Charcoal made by heating sticks of wood about one-quarter inch in diameter in kilns until the organic materials have evaporated and only the dry carbon remains. The finest quality of the stick form is called **vine charcoal.**

stippling The building up of surface and tonal descriptions through the concentrated use of tiny dots; the dots when closer together produce darker passages; further apart, lighter tones.

structure The inner core that determines, identifies, and organizes outward form; the planned or methodical network that serves as a matrix supporting and delineating the organizational elements in a work of art.

stylus-type pen A type of fountain pen. See **Rapidograph pens.**

subtractive method In the dark-field manner, the gradual removal of the dark drawing materials from within a black field creating shapes, forms, tones, or textures of lighter values by allowing light to enter into the composition; the building of light-value visual forms from within an initial dark field. See **dark-field manner.**

sumi ink A stick of solid carbon ink that is ground and mixed with water on a shallow stone with a water well. This procedure permits great control over the density of tones.

superstructure The usually unseen inner armature or skeletal network that directly supports and defines the shapes and outer forms of a subject or form; for example, the skeleton is the superstructure for the internal organs, muscles, and skin of the human body.

symbolic drawings Drawings whose images directly symbolize ideas and concepts.

symmetrical balance The dividing of a composition into two equal halves with seemingly identical elements on each side of a vertical axis.

synesthesia In art, a subjective sensation that occurs when one type of stimulus or response to a subject evokes another reaction or secondary response. In psychologi-

cal terms, a specific color, for example, may evoke a specific smell, or a specific smell may arouse a particular memory.

table plane Same as ground plane or floor plane, a term used to denote the flat plane of a drawing table surface when drawing objects on a table. See **ground plane** and **floor plane.**

tertiary colors The intermediate steps between the six basic hues—the three primary and three secondary colors; colors obtained by mixing two secondary colors.

texture The surface character or the tactile qualities experienced through touch; a sense of the "feel" of surfaces, of roughness and smoothness, hardness and softness; the illusion of tactility as in the illusion of a drawn texture albeit on a smooth two-dimensional surface.

three-point perspective A system for drawing three-dimensional objects in space on a two-dimensional plane that requires three vanishing points: both the left and right vanishing points of two-point perspective where lines recede on the horizon, and a third vertical vanishing point where lines parallel and vertical to the ground appear to converge.

tint (high key value) Any color that has been lightened by the addition of white.

tooth The abrasive texture of paper that makes drawing with dry media possible by enabling graphite, charcoal, chalk, crayon, or pastel to adhere when dragged across the surface, leaving rich deposits of drawn marks. See **paper grain.**

tortillon A paper shading stump used in combination with dry media for blending tones.

triple complementary color scheme A color scheme found within a single composition where three pairs of complementary colors work together contributing to the visual statement in a pronounced and harmonious way.

trompe l'oeil Rendering in its most meticulous form (from a French term meaning "deceive the eye"); usually applies to still life where the creation of poignant illusions convinces the viewer that he is looking at the actual object or objects represented.

two-point perspective The system of drawing objects not set square to the picture plane but set at an angle; it requires the use of both left and right vanishing points (LVP and RVP).

uniform texture Texture or textures that appear to be very similar and together create a tight harmony or an overall consistent quality, regularity, and oneness within a composition.

unity That ephemeral quality suggesting compositional "wholeness"; the quality of harmony, balance, and cogency of the art elements within a composition.

value Degrees of light and dark; the light and dark characteristics of color; the amount of light reflected by a particular color.

value scale A progressive range showing the incremental and consistent steps of change between extreme light and extreme dark.

variety A generic or specific condition of established diversity; descriptive term used to identify any number of conditional states of ranging multiplicities in a work of art; the antithesis of what is obvious or monotonous.

viewfinder A flat, rectangular, usually black cardboard sheet with a cut-away center in the shape of a square or rectangle through which one looks to frame a composition. It functions the same way as a viewfinder apparatus in a camera.

vine charcoal The highest quality of stick charcoal. Named for plant vines from which it is made and extracted through heating. See **stick charcoal.**

vision That which the artist sees with either the physical eye or the **eye of the mind,** as in conceptualizing an idea, feeling, emotion, or premonition before or during the act of drawing.

visual That which is seen or takes form in the "seeing" process; also, one of the two extreme poles of artistic personality (the other being **haptic**) where visual people concern themselves primarily with the visible environment instead of their feelings, emotions, or bodily sensations.

visual language Regarding drawing, an inaudible and visibly eloquent expression that communicates a message through graphic form; the purest form of visual communication manifested in all of the visual arts.

visualize To enact a mental picture or image not present to the sight; in the act of drawing, to give tangible form to what is imagined.

visual tangibility The proven aspect of visual reality; the ability to see an idea that has taken visual form.

visual tension A visual situation within a composition where the elements of shape, pattern, balance, harmony, and contrast all interact to produce interesting imbalances or cacophonies; some of the elements may be more pronounced than others, which creates a higher level of compositional interest.

visual whole The quality of a unified compositional state brought about by the correct degrees of balance, contrast, pattern, rhythm, etc. that produce oneness.

visualized drawings Drawings whose images represent realities of sight or cause the

viewer to visualize or see what is imagined in the mind of the artist.

warm color A hue on one side of the color wheel—yellow, orange, red, and their neighboring tertiary colors; any color opposite the cool colors on the color wheel.

wash Ink diluted with varying amounts of water or solvent that produces a broad range of transparent or semi-transparent tonal effects when brushed against a receptive surface, usually an absorbent paper.

wash drawing A drawing created exclusively by the use of ink washes of differing concentrations and dilutions applied to the paper surface with brushes.

watercolor paper As the name indicates, paper used primarily for watercolor or wash techniques. It is an acid-free, cotton-fiber paper available in a variety of different weights and degrees of sizing with an active grain or tooth that comes in three standard finishes: *rough,* a surface produced in the highest-quality papers not by mechanical graining but as the result of the hand-manufacturing process and best adapted to splashy, spontaneous techniques; *cold press,* a moderately textured matte surface paper; and *hot press,* the smoothest and least absorbent surface, excellent for very refined, controlled techniques. The different finishes come with varying capabilities of absorption and wet strengths, according to the weight and degree of sizing.

wax bloom An undesired foggy quality on a drawing's surface created by the repeated layering of colored pencils under pressure, which usually can be eliminated by rubbing the surface of the drawing lightly with a soft cloth; it is usually preventable by a light application of spray fixative.

wax crayons Inexpensive and brightly colored crayons made from dry pigments and waxy binders that adhere firmly to most paper surfaces, making them a relatively clean medium to handle.

wood engraving The technique of engraving done as a relief process on end-grain blocks of various hard woods such as maple, pear, or apple; the engraved lines are cut with a burin, receive no ink, and subsequently print as the white of the paper or negative spaces. The uncut, relief or raised surface of the woodblock receives the ink and transmits the positive image to paper when the engraving is printed.

wove finish paper Paper whose surface texture appears woven and is produced by the mesh of the mold, which is made of finely woven cloth or wire and evinces no lines or other embossed marks that are characteristic of the mold structure.

Index

Illustration Credits

Figure 1-1 National Galllery of Art,Washington, D.C. (Rosenwald Collection); 1-2 Fogg Art Museum, Harvard University, Cambridge, MA (bequest of Meta and Paul J. Sachs); 1-3 Frick Collection, New York; 1-4 Art Institute of Chicago, all rights reserved; 1-5 Courtesy of the artist; 1-6 Art Institute of Chicago, all rights reserved; 1-7 Courtesy of the artist; 1-8 Courtesy of the artist; 1-9 Whitney Museum of Art, New York; 1-10 Courtesy of the artist; 1-11 Courtesy of the artist; 1-12 Henry Moore Foundation (private collection, U.K.); 1-13 Museum of Modern Art, New York (given anonymously); 1-14 British Museum, London (photo Art Resource); 1-15 Museo Picasso, Barcelona; 1-16 Metropolitan Museum of Art (Alfred Steiglitz Collection).

Figure 2-1 Private collection; 2-2 Brooklyn Museum (purchased with funds provided by Henry and Cheryl Welt); 2-3 Susan and Herbert Adler Collection; 2-4 Cleveland Museum of Art (gift of Mrs. Henry White Cannon); 2-8 Vincent van Gogh Foundation, Vincent van Gogh Museum, Amsterdam; 2-9 Arkansas Art Center Foundation Collection (anonymous loan , 1980); 2-10 Art Institute of Chicago, all rights reserved. (gift of Mr. and Mrs. Douglas Kenyon); 2-11 Musée Calvet, Avignon; 2-12 Whereabouts unknown; 2-13 National Self Portrait Collection, Ulster Museum (no. 2526); 2-14 Arkansas Art Center Foundation Collection; 2-15 Sotheby's; 2-16 Courtesy of Galerie Louise Leiris, Paris; 2-17 Chrysler Museum; 2-18 Musée National d'Art Moderne, Paris; 2-19 Art Institute of Chicago, all rights reserved (gift of Potter Palmer, 1944); 2-20 Art Institute of Chicago, all rights reserved; 2-21 Rijksmuseum, Amsterdam.

Figure 3-1 Susan and Herbert Adler Collection; 3-2 Cleveland Museum of Art (gift of Hanna Fund); 3-3 Whitney Museum of American Art, New York (purchase); 3-4 Art Museum, Princeton University (gift of Frank Jewitt Mather, Jr.); 3-5 Collection of John Bergruen Gallery; 3-6 Wadsworth Atheneum (gift of Miss Emily Sargent and Mrs. Francis Ormond 1930.314); 3-11 Albertina Museum, Vienna; 3-12 Collection of Dolores Pharr Smith, Stockton, CA; 3-13 Whitney Museum of American Art. New York (gift of Alex Katz).

Figure 4-1 Metropolitan Museum of Art (Robert Lehman Collection); 4-2 Bibliothèque Nationale, Paris; 4-3 Nelson-Atkins Museum of Art, Kansas City MO (Nelson Fund 39-37); 4-4 Art Institute of Chicago, all rights reserved (Charles and Mary F. S. Worcester Collection); 4-5 Collection of Louis Clayeus, Paris; 4-6 Vatican Museum; 4-7 Worcester Art Museum; 4-8 Fogg Art Museum, Harvard University, Cambridge (bequest of Meta and Paul J. Sachs); 4-9 Musées Royaux des Beaux-Arts de Belgique Koninklijke Musea voor Schone Kunsten van Belgie, Brussels; 4-10 Courtesy of the artist; 4-11 Courtesy of Midtown Galleries, New York; 4-12 University of Michigan Art Museum; 4-13 Courtesy of the artist; 4-14 Pierpont Morgan Library, New York; 4-15 Courtesy of Christie, Manson & Woods, Ltd.; 4-16 Louvre, Paris; 4-17 Musée Toulouse-Lautrec, Albi; 4-18 Collection of Dolores Pharr Smith, Stockton, CA; 4-19 Museum of Fine Arts, Budapest: Majovsky Collection; 4-20 Detroit Institute of Arts; 4-21 Huntington Library Art Gallery, San Marino, CA (gift of Virginia Steele Scott Collection).

Figure 5-1 Arkansas Arts Center Foundation Collection (collection of Paul Magriel); 5-2 Licensed by VAGA, New York, N.Y. Collection of the artist; 5-3 National Galllery of Art Washington, D.C. (Rosenwald Collection); 5-4 Art Museum, Princeton University (acc. no. 48-137); 5-5 Bristish Museum, London; 5-6 Minnesota Museum of Art, (given in memory of Warrren Towel Mosman, 68.20.11); 5-7 Pierpont Morgan Library, New York; 5-8 Collection Anni Albers and the Josef Albers Foundation, Inc; 5-9 Museum of Modern Art, New York (gift of the artist); 5-10 Whitney Museum of American Art, New York, (purchase); 5-11 Vincent van Gogh Foundation, Vincent van Gogh Museum, Amsterdam; 5-12 Reunion des Musées Nationaux/ Art Resource, New York; 5-13 Musée des Beaux-Arts, Lille; 5-14 Art Institute of Chicago, all rights reserved; 5-15 Art Museum, Princeton University (gift of Mrs. Margaret Mower for the Elsa Durand Mower Collection); 5-16 Royal Collection, Windsor Castle; 5-17 Wadsworth Atheneum (bequest of George A. Gay); 5-18 Rijksmuseum, Amsterdam; 5-19 Philadelphia Museum of Art (gift of Dr. and Mrs William Wolgin); 5-20 Nelson Gallery-Atkins Museum, Kansas City, MO (gift of Mrs. George H. Bunting, Jr.); 5-21 Santa Barbara Museum of Art (gift of Mr. and Mrs. Arthur B. Sachs); 5-22 Hirshhorn Museum and Sculpture Garden, Smithsonian Institution, Washington, D.C.; 5-23 Rijksmuseum, Amsterdam.

Figure 6-2 San Francisco Museum of Modern Art (gift of the San Francisco Women Artists); 6-3 Courtesy of Terry Dintenfass Gallery, New York; 6-6 Addison Gallery of American Art, Phillips Academy, Andover, MA (gift of Winslow Ames); 6-7 Sotheby's; 6-8 Kunstmuseum, Düsseldorf (Lambert Krahe Collection); 6-9 Toledo Museum of Art; 6-10 Art Institute of Chicago, all rights reserved; 6-11 Arkansas Art Center Foundation Collection; 6-12 Estate of the artist; 6-13 Ryoko-in, Daitokujo, Kyoto; 6-14 Fogg Art Museum, Harvard University, Cambridge, MA (Greenville L. Winthrop Bequest); 6-15 Baltimore Museum of Art (Thomas E. Benesch Memorial Collection); 6-16 British Museum, London; 6-17 Courtesy of the artist; 6-18 Art Institute of Chicago, all rights reserved; 6-19 Arkansas Art Center Foundation Collection; 6-20 Whitney Museum of American Art, New York, (purchase); 6-21 Arkansas Art Center Foundation Collection; 6-22 Achenbach Foundation for Graphic Arts, Mildred Anna Williams Fund, Fine Arts Museum of San Francisco; 6-23 Arkansas Art Center Foundation Collection.

Figure 7-1 Yale University Art Gallery, New Haven, CT (lent by Richard Brown Baker); 7-2 Musée National de l'Art Moderne, Centre Georges Pompidou, Paris; 7-3 Musée National de l'Art Moderne, Centre Georges Pompidou, Paris; 7-4 Museum of Modern Art, New York (gift of Mr. and Mrs. Charles B. Benenson); 7-5 Private collection; 7-6 New Jersey State Museum, Trenton, NJ; 7-7 Courtesy of the artist; 7-8 Metropolitan Museum of Art, New York (purchase of Joseph Pulitizer Bequest); 7-9 Kupferstich Kabinett, Staatliche Kunstsammlungen, Dresden; 7-10 Estate of Mrs. Daniel Mendelowitz, Stanford, CA; 7-11 Courtersy of the artist (collection of Rita Rich); 7-12 Art Institute of Chicago, all rights reserved; 7-13 Art Institute of Chicago, all rights reserved; 7-14 Collection of Anni Albers and Josef Albers Foundation, Inc; 7-15 Private collection; 7-16 Art Institute of Chicago, all rights reserved; 7-17 Art Institute of Chicago, all rights reserved; 7-18 Museum of Modern Art, New York (gift of Mr. and Mrs. John Pope in honor of Paul J. Sachs). Photo Henry Moore Foundation.

Figure 8-1 Art Institute of Chicago, all rights reserved (gift of Tiffany and Margaret Blake, 1947.35); 8-2 Pierpont Morgan Library, New York; 8-3 Metropolitan Museum of Art. New York (Lehman Collection); 8-4 National Museum of American Art, Smithsonian Institution, Washington, D.C.; 8-5 Courtesy of the artist; 8-6 Detroit Institute of Arts (bequest of John S. Newberry); 8-7 Arkansas Art Center Foundation Collecton; 8-8 Whitney Museum of American Art, New York (gift of Mr. and Mrs. Benjamin Weiss); 8-9 Seattle Art Museum (Eugene Fuller Memorial Collection); 8-10 Wake Forest University Permanent Collection; 8-11 Photo courtesy of Terry Dintenfass Inc. New York; 8-12 Whitney Museum of American Art. New York; 8-13 National Gallery of Art, Washington, D.C.; 8-14 Private collection; 8-15 Courtesy of LewAllen Gallery, Santa Fe, NM. Photography by Dan Morse; 8-16 Rhode School of Design, Providence, RI; 8-17 Arkansas Art Center Foundation Collection; 8-18 Reynolda House Museum of American Art, North Carolina; 8-19 Courtesy of the artist; 8-20 Courtesy of the Nancy Hoffman Gallery; 8-21 Art Institute of Chicago, all rights reserved; 8-22 San Francisco Museum of Modern Art; 8-23 Art Institute of Chicago, all rights reserved.

Figure 9-3 Berlin, Staatliche Museen, Nationalgalerie, Sammlung der Handzeichnungen; 9-4 Musée Fabre, Montpellier; 9-5 Courtesy of the Allan Stone Gallery (Glenn C. Janss Collection); 9-6 Reproduced by permission of Houghton Mifflin Co; 9-7 Courtesy of the Gallery Paule Anglim; 9-11 Fogg Art Museum, Harvard University, Cambridge, MA (bequest of

18-18 Corcoran Gallery of Art, Washington, D.C.; 18-19 Courtesy of the artist; 18–20 Courtesy of the artist.

Color Plates

Plate 1 Museum of Contemporary Art, Los Angeles, CA; **2** Security Pacific National Bank, CA; **4** Achenbach Foundation fo Graphic Arts, Fine Arts Museum of San Francisco, CA (Mildred Anna Williams Fund); **5** Art Institute of Chicago, all rights reserved; **6** Courtesy of the artist; **7** Collection of Mrs. Alanson Appleton, San Mateo, CA; **8** Courtesy of the artist; **9** Courtesy of LewAllen Gallery, Santa Fe, NM; **10** Collection of Lila Gold, New York City. Courtesy of the artist; **11** Collection of Chase Manhattan Bank. Courtesy of Paula Cooper, Inc.; **12** Courtesy of the artist; **13** Courtesy of the artist; **14** Courtesy of the artist; **15** Rita Rich Collection. Courtesy of Barbara Krakow Gallery; **16** Courtesy of the artist; **17** Courtesy of the artist; **18** Arkansas Arts Center Foundation Collection; **19** © Jasper Johns/Licensed by VAGA, New York.

Agency Credits

Plate 11. JENNIFER BARTLETT (b. 1941; American). *In the Garden # 122.* c. 1980. Colored pencil on paper, 26 × 19 3/4" (66 × 50 cm).
Collection of Chase Manhattan Bank. Courtesy of Paula Cooper, Inc.

Plate 12. BOB ZIERING (20th century; American). Courtesy of the artist. First part of a triptych.

Plate 13. MAURICIO LASANSKY (b. 1914; Argentinian). *The Nazi Drawings # 19.* c. 1961–1966. Graphite pencil, red earth pigments, and turpentine wash on paper, 76 × 45″ (193.2 × 114.4 cm).
The University of Iowa Museum of Art. (On long-term loan to the Cedar Rapids Art Museum, Cedar Rapids, Iowa.)

Plate 14. JIM BUTLER (b. 1945; American). *Burnished Sky/River Mist.* c. 1993. Graphite on panel, 40 × 82″ (101.7 × 208.5 cm). Collection of the artist.

Plate 15. MICHAEL MAZUR (b. 1935; American). *Yard, November III.* c. 1984. Pastel, 29 1/2 × 29 1/2" (75.2 × 75.2 cm). Rita Rich Collection. Courtesy of Barbara Krakow Gallery.

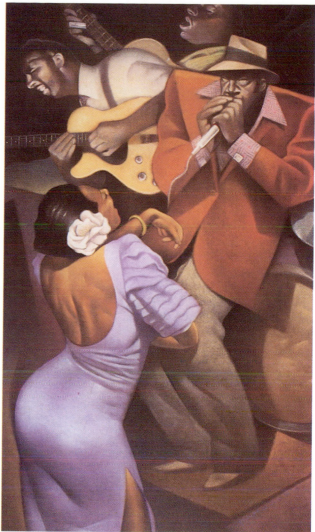

Plate 16. GARY KELLEY (20th century; American). Promotion for the Mississippi Delta Blues Festival. c. 1989. Pastel, 24 × 14". Courtesy of the artist.

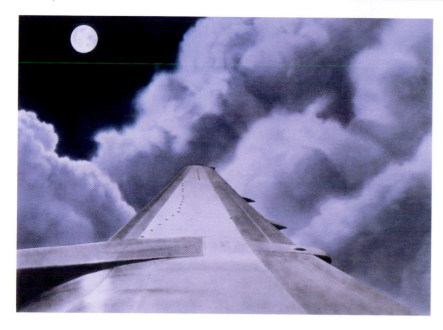

Plate 17. JIM WESTERGARD (1939; American-Canadian). *Insomnia.* c. 1990. Oil paint drawing on white wove paper, 23 1/16 × 32 3/16" (58.7 × 81.8 cm). Courtesy of the artist. Collection of David L. Faber.

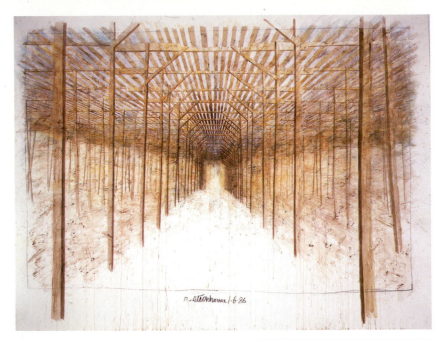

Plate 18. ROBERT STACKHOUSE (b. 1942; American). *Inside a Passage Structure*. c. 1986. Watercolor, charcoal, and graphite on paper. 89 1/2 × 120" (227.4 × 305 cm). Purchased with a Gift from Virginia Bailey, 1987. The Arkansas Arts Center Foundation Collection.

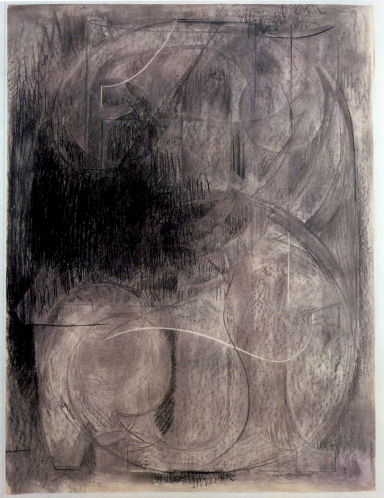

Plate 19. JASPER JOHNS (b. 1930; American). *0 through 9, 1961.* Charcoal and pastel on paper, 54 1/8 × 41 5/8" (138.3 × 105.8 cm). Jasper Johns/licensed by VAGA, New York, N. Y. Private collection.